CW01022727

EYE MIND

THE SAGA OF ROKY ERICKSON
AND THE 13TH FLOOR ELEVATORS,
THE PIONEERS OF PSYCHEDELIC SOUND

★

BY **PAUL DRUMMOND** FOREWORD BY **JULIAN COPE**

PROCESS

*This book is dedicated to
Stacy Keith Sutherland—a true Texan musical pioneer—
and to those who contributed but sadly passed away
prior to publication.*

*RIP
Daniel Galindo, Pamela Bailey, Roger Erickson,
Chester Helms, Jack Jackson, Jerry Lightfoot,
Sandy Lockett, Cecil Morris, Tary Owens, Lelan Rogers,
Doug Sahm, G.C. Sutherland.*

FOREWORD

Until now, the history of the 13th Floor Elevators has been one of the most important and exhilarating rock 'n' roll stories still awaiting the telling: an essential tale of truth-seeking, desert revelations, apostasy, pursuit by the lawmen, ignominious decline and dissolution, death and madness, rehabilitation and—ultimately—reconciliation. But our heroes' psychedelicized 1960s story has lingered out of reach thus far into the early twenty-first century because too many of its protagonists remained locked in a post-psychedelic fall-out, too close to the story to have the motivation to return there in order to retrieve it in text form, and too wary of strangers to open up and bring forth the hidden truths as they had each lived them. Until now, that is, when all involved have at last been corralled and interrogated by a fastidious outsider who took it upon himself to do the proper Sherlock Holmesian excavations necessary in order to bring us a Texan truth worthy of its founding fathers: Tommy Hall, Roky Erickson, Stacy Sutherland, John Ike Walton and Benny Thurman. Eight years or more in the researching, the endless to-ing and fro-ing to Texas—it's all here in this book. Such is the mindset of the obsessive visionary, and not for one moment do I believe that this task could have been carried out to completion by anyone less than a man of extraordinary strength and determination. I'm honored to say that man is my dear friend and a relentless pursuer of timeless truths, Paul Drummond. He's done it. I can hardly believe it, but the marathon is finally over. Please excuse my zealous enthusiasm, but this history of the 13th Floor Elevators is nothing short of a holy text.

Julian Cope
The Marlborough Downs

ISBN: 978-0-9760822-6-2

Process Media
PO Box 39910
Los Angeles, CA 90039

www.processmediainc.com

10 9 8 7 6 5 4 3 2 1

The publisher wishes to thank Paul Drummond, Max Fredrikson, Bill Smith,
Laura Guerrero, Bill Bentley, Josh Mills, and Jimmy McDonough for their
assistance with this book.

Printed on Exact Opaque recycled paper.

Design by Bill Smith

TABLE OF CONTENTS

INTRODUCTION

It is important that people grasp the idea that we are not afraid of nothingness. There is no empty space in nature, which we do not believe that, at one time, or another, the human mind can fill. It is clear what a terrible task we have undertaken, we aim to do nothing less than return to the sources, human or inhuman, of the theatre and raise it from the dead. All that partakes of the obscurity and magnetic fascination of dreams, those dark strata of consciousness which are all that concern us in mind, we want to see all this radiate and triumph on stage, even if it means destroying ourselves and exposing ourselves to the ridicule of a colossal failure. Nor are we afraid of the kind of commitment our effort represents. We conceive of the theatre as an authentic performance of magic. We do not address ourselves to the eyes, or to the direct emotion of the soul, what we are trying to create is a certain psychological emotion in which the inmost motives of the heart will be laid bare toward this ideal theatre we ourselves are groping blindly... Regardless of the degree of success of our performances, those who attend them will understand that they are participating in a mystical experiment by which an important part of the domain of the mind and consciousness may be definitively saved or lost.
—Antonin Artaud, *Manifesto for a Theatre That Failed*,
November 13, 1926

The 13th Floor Elevators cannot be compared to any other group in musical history. While the band were formed in Texas and existed from late 1965 to mid-1969, they were never truly members of the hippie culture, remaining strange anomalies and, ultimately, outsiders. Their story is a drama of the division between mind and body—the evolution of ideas and the development of music. The extent of their adhesion to a self-imposed, quasi-religious doctrine based around hallucinogens was remarkable, as was their unfaltering belief that they would discover new paths to enlightenment and a clearer understanding of the divine fabric of matter itself. While their story is a familiar progression—the struggle for initial success, the momentary fruition and the inevitable downfall—it is more interestingly the true secret history of psychedelia in America. The story of a triumvirate who engaged the new medium of

pop music to try and seriously express the newly perceived realities of the psychedelic experience.

Roky Erickson was the frontman and face of the band. A musically and theatrically gifted teenage singer, he possessed powerful vocal dynamics that could rival the most exciting and high-octane black performers of the era. Tommy Hall, an overly intelligent chemical engineering student, became their Svengali lyricist, proselytizing the psychedelic experience with evangelical zeal. Stacy Sutherland, a country boy from a simple farming background, possessed a deep foundation in roots music and became the architect of their new, unique sound.

Although they invented the idea of psychedelic music, their early association with hallucinogens, although legal, led to a dangerous existence, leaving them virtual outlaws during the psychedelic summer of '67. If Robert Johnson laid the foundation of popular music, then the 13th Floor Elevators seeded the roots of alternative music, absolutely refusing to compromise their message or music despite being constantly hounded by the authorities. They were the natural descendents of the country outlaws of the generation before them, and extolled the punk ethos a decade too soon. Although there were many refugees of the Sixties, the Elevators' saga reads like a rollercoaster ride to the end of the decade. By the end of 1969, Roky virtually re-enacted the plot of *One Flew Over the Cuckoo's Nest* when he pleaded insanity and was incarcerated in a maximum security unit of a prison for the criminally insane, Stacy was imprisoned in the jail Roky attempted to avoid, Tommy spent two years living in a cave with an LSD mafia cult, their bassist was drafted to Vietnam and the drummer was given involuntary shock treatments.

While the postwar boom accelerated American manufacturing and consumerism, no one foresaw the rise of a youth counterculture that would challenge the fabric of society from within. While much has been written about this period, particularly focusing on the celebrated San Franciscan scene, the Texas connection and the Elevators' story have remained a hidden history of the decade. While the 13th Floor Elevators can be viewed as an extreme example they in fact represented a microcosm of wider developments. What must be remembered at all times is the simple fact that as of 1965 there was no drug culture as we know it. Hallucinogens were legal, samples were being handed out unabated by chemical manufacturing corporations and drug testing was taking place on many university campuses. However, the vision of utopia that many tried to achieve by "turning on" led to a massive toxic overload by the end of the decade. New substances entering the equation, leading to the creation of a fully-fledged drug scene, facilitated this.

While much was achieved during the Sixties in the realm of social/racial/sexual politics, the attempt to form a new psychedelic society ultimately became self-defeating. Although the counterculture spawned many new mediums, it was the music scene (with its viable commodities: graphics, posters, magazines and records) that brought the revolution and the corporation into face-to-face confrontation. The counterculture didn't possess the means or infrastructure to distribute its wares. For a split second everything was new, pure and untarnished, before the scruples of the

unifying ideology (freedom from reclaiming the individual and building new community values, not based on personal greed) became compromised by having to broker deals with the outside world. While some bands started by manufacturing their own product, these were really devices for attracting deals with major record labels. The politics of how musicians negotiated with corporations was won and lost on an individual basis; there was no template for dealing with straight society.

The counterculture fundamentally changed Western society, primarily by forcing manufacturers to re-examine consumerism. Before, they dictated through mass production what products were available. The new generation of consumers worryingly began rejecting their goods and demanding to be recognized as individuals. By the early Seventies, manufacturers were "hip" and addressed individual choice by designing products to entice them back. 1965, when the Elevators formed, was a turning point. Everyone had witnessed the unbelievable success of the Beatles, who toppled Elvis and now there was the potential for someone to perpetuate the cycle. Established record companies were forced to desperately delve into an alien youth culture in the hope of signing the next big thing. The 45 rpm record, the medium created by rock 'n' roll a decade earlier, was still the currency of the music industry. The results were excellent—hundreds of bands with a basic grasp of their instruments and the fact that the *times were a-changin'* were funded to make some of the strangest pop music ever. After only two singles the Elevators were amongst the first bands to utilize the record album to its full potential and express their full manifesto. The record labels recognized the bands for what they were—a self-perpetuating revolution of disposable pop culture—and weren't committed to investing in long-term careers. Unfortunately, the optimism and experimentation of the mid-Sixties became the hard reality of the early Seventies, a climate in which many musicians could no longer create thought-provoking or original music. At the end of the Sixties, many underground musicians were left with nothing to sell but the other counterculture commodity beside music—drugs. This turned them into criminals, and gave straight society the moral high ground from which to condemn them.

The Vietnam War ended when it couldn't be won decisively. Similarly, there is no clear answer as to whether the Sixties counterculture succeeded or failed. The issues it raised, however, have dramatically altered the cultural dialogue. The story of the Elevators is a portrait of many of those questions being raised in their most extreme form.

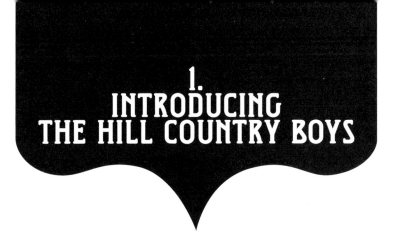

1.
INTRODUCING
THE HILL COUNTRY BOYS

Stacy had the biggest ego in Kerrville, and I had the second.
—John Ike Walton

It all started in Kerrville.

It was in this small town in the Texas hill country that three key members of the 13th Floor Elevators grew up, and it was Kerrville that would also later provide an important refuge and retreat. In fact, Kerrville's raw, rural history and connection to the landscape were as important of an influence as its musical heritage—its traditional cowboy stomp and Western swing translated into part of the energy behind the Elevators' unique sound.

Kerrville is a backwater town, situated along the cypress-lined banks of the Guadalupe River, about 100 miles west of the state capital, Austin. Many Texans regard it as a sleepy retirement town, woken annually by the folk festival, and it's hard to believe that in 1978 the Sex Pistols played a pickup gig there en route to Dallas. Yet a decade before Sid Vicious taunted his Texan audience (shouting "You're just a bunch of fucking cowboys"), Kerrville had already become an unlikely locus for spawning musicians who would help to create and define a new musical genre.

While future Elevators Stacy Sutherland and Ronnie Leatherman both attended Kerrville's Tivy High School, it was a chance meeting in 1963 between John Ike Walton and Stacy Sutherland that sowed the initial seeds of the 13th Floor Elevators, and the birth of psychedelic rock. In those days, drive-ins and parking lots were still the center of every teenager's social universe. One night, outside the Grove restaurant, twenty-year-old John Ike was showing off his banjo skills, when he suddenly found competition from the seventeen-year-old Stacy on guitar.

John Ike: I was sitting in the back of a pickup playing my banjo, and he came by with his guitar. The next day we met again—I saw him on the street down by the sports center and he had twelve tubes of glue and no models. He says, "Hey man, do you want to go sniff some glue?" and I said, "No, think I'm going to pass on that." The sports shop's proprietor told the police about Stacy buying so much glue and not buying any models... Stacy got wind of it and asked me if I turned him in to the law, which was ridiculous!

He may have turned down free glue, but John Ike was no angel—the teenager had a reputation for hot-rod racing. His newfound friendship with Stacy soon led to further small-town outrages, and by early 1965 they decided it was time to move to Austin, en route to Australia, where they intended to import bluegrass music. However, things didn't go according to plan.

Stacy Keith Sutherland was born on May 28, 1946 in San Antonio—at that time there was no adequate hospital in Kerrville. His family, who had worked in Kerrville for three generations, certainly wasn't poor—when Stacy was born, his parents, G.C. and Sibyl Sutherland, owned two ranches in the area and a house in the center of town. He had an older brother, Beau (named after "Beau Geste"), and a younger sister, Heather. Stacy's mother, a teacher, encouraged him from an early age to pursue his interests in art and music. Having lived through the dust bowls and the failed fortunes of the Great Depression, she wanted the best for Stacy, who was her obvious favorite. A great storyteller, she often acted out Mark Twain's books for the children, while sharing with them an obsession with the infamous Texas outlaws Bonnie and Clyde, as well as Pretty Boy Floyd. Her mother had kept scrapbooks filled with newspaper accounts and clippings of the pair's exploits that provided the only entertainment during the depression. It's clear that these stories had a profound effect on both brothers, and their later direction—Beau worked for J. Edgar Hoover in the FBI, while Stacy became one of Texas' most infamous musicians. One of the family ranches had twenty acres and a large stretch of land by the Guadalupe River—it was here that Stacy collected velvet ants, chased nighthawks and spent the rest of his time hunting or fishing. When he was seven, his father had given him a gun, much to Sibyl's displeasure.

> **Sibyl:** I just threw an all-out fit. I just couldn't imagine anybody in their right mind giving a kid of seven a gun. But I had one all my life and that's what you do—you learn and teach them. One day he came home dragging a rattlesnake that he'd shot and killed; it was longer than he was—that picture made half the magazines in Texas. But he wasn't so careful with it one night he'd been fooling around and it went off and my clock in the kitchen was hanging down, springs all out of it...

Stacy found his natural musical ear at an early age, and had learned basic chord structures on the banjo by the time he was three. He was once found bashing out Christmas carols on a friend's piano, even though he

had no knowledge of the instrument. There was little musical heritage in the family apart from his maternal grandmother, who played violin. Yet it was Beau who received the formal musical training, when his mother convinced him to join the school band and learn clarinet. When Stacy was nine, he requested a guitar for Christmas and begged his mother for lessons at Alamo Music in San Antonio. He was immediately disappointed after three lessons as they only taught the rudiments and not technique.

> **Sibyl:** He said, "This isn't what I want to learn. I don't want this ABC stuff." He said, "I want to learn progression." I said, "Well, what is progression?" He said, "It's where each musician does his own thing."

Stacy bowed his head and resorted to perfecting his own renditions of Chet Atkins songs that he had taught himself to play from records. The guitar provided Stacy with a means to create his own identity and rebel against his older, more athletic brother.

> **Beau:** We'd been extremely close as kids, growing up. I was very active in sports, I loved to play baseball and football, and poor Stacy always got dragged along because he was our fourth guy. Every day, when he wanted to play the guitar, I would grab him and make him go down and play baseball or football. He was the youngest. I was involved in a lot of school offices, I was president of the student body and I played football and tennis. Looking back on it I think what a burden that must have been for him to bear. This is a small town, and poor Stacy was just constantly hammered with, "How come you don't do this? Beau did this." I really think that opened up some of the avenues to music for him. Because it was one thing that our family really didn't do. I think he wanted to carve out an identity.

> **Sibyl:** I would take him and put him out in front of school, and I figured you couldn't go anywhere now. I'd say where were you and he'd say, "I was down on the river, playing my guitar… I looked at the door of that school and I could not go in."

In 1958, when Stacy was twelve, he managed to persuade his mother to buy him an electric guitar and amplifier. This allowed him to explore new sounds and emulate John Lee Hooker's echo-drenched electric recordings from the late 1940s and Buddy Holly's reverb-heavy 45s of the mid-Fifties. This coincided with a sudden inability to make it through the school gates; instead he'd slope off, dragging his friend Johnny Gathings down to the riverbank. As soon as word spread that he was off playing his guitar, other kids would slope off and join them. By graduation Stacy was well established as a popular local rebel. Despite Beau's efforts to encourage him to study, and insisting that a little work could produce straight As, Stacy's answer was always, "Why do that? My idea of a good afternoon is to cut home and go down and sit by the river and play my guitar." Beau had grown up listening to country and western music and soon recognized that Stacy was experimenting with sound outside its traditional confines.

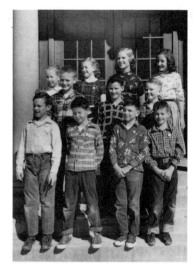
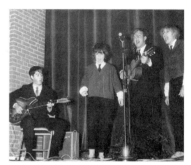
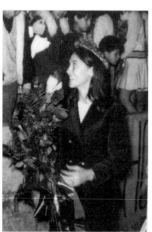
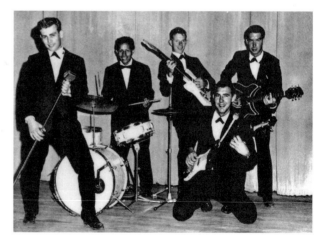

CLOCKWISE FROM TOP LEFT: (1949) STACY AGE THREE, COURTESY SUTHERLAND FAMILY COLLECTION; (CIRCA 1953) STACY FRONT ROW, SECOND FROM LEFT, COURTESY SUTHERLAND FAMILY COLLECTION; (1961) THE TRAVELLERS FOUR, L–R: STACY, OLLIE BROOKER, CARLTON WHITE, KATHEY BARTELL, COURTESY SUTHERLAND FAMILY COLLECTION; (1962) THE TRADITIONS, L–R: MAX RANGE, BOBBY SANCHEZ, BOB HUNTER, RANDY JACKSON, STACY, COURTESY RONNIE LEATHERMAN COLLECTION; STACY'S HIGH SCHOOL SWEETHEART, LAURIE JONES, COURTESY SUTHERLAND FAMILY COLLECTION

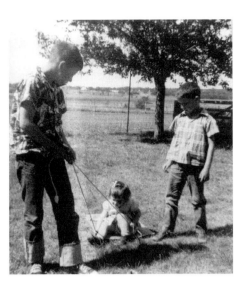
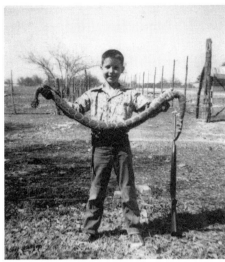

CLOCKWISE FROM TOP LEFT: (CIRCA 1953) BEAU, HEATHER AND STACY; (CIRCA 1953) STACY & RATTLESNAKE; STACY & MATERNAL GRANDMA, COURTESY SUTHERLAND FAMILY COLLECTION

In March 1961, when he was fourteen, he met his high school "sweetie," Laurie Jones, whom he dated on and off for nearly six years, right through the Elevators' bid for stardom, and Sibyl maintains she was the only woman Stacy ever truly loved.

During his sophomore year of high school, Stacy joined an ensemble called the Travelers Three, which was subsequently renamed the Travelers Four. Because their repertoire was mainly folk, Stacy's involvement was short-lived, and he went on to join James Dean lookalike Max Range's (pronounced Ren-gay) rock 'n' roll band the Traditions in 1962. "Little" Doug Sahm had scored a regional hit in San Antonio with "Two Hearts and Love," and the Traditions were hired as his stage band to tour locally. Afterwards Max and Stacy formed another high school rock 'n' roll band, the Signatures, in 1963. The musician's lifestyle immediately suited Stacy, and school became a thing of the past, leading to instant clashes with his mother. As she said: "We began having arguments and he'd stay out late at night, and I'd say there wasn't anything good happening after twelve o'clock, but he didn't even come alive till then! And finally, when he was eighteen, I said if you're not going to abide by one rule of this household maybe you need to get out there and find your own way, and he said, 'I'll just do that and show you I can,' and off he went."

There was plenty of religion on offer in Kerrville. His mother was Mormon, and his father Baptist (he eventually joined the Mormon Church at the age of seventy-one). Stacy duly attended the Centerpoint Baptist Sunday School from the age of six, and was baptized at ten. While orthodox religion couldn't fulfill his spiritual needs, Stacy's traditional upbringing filled him with a fear that prevented him from challenging it. Later, the awe he felt from nature was far greater than what he felt in church; this was reinforced by hallucinogens, and the countryside became his spiritual landscape and cathedral. Still, the Christian concepts of good and evil—particularly instilled in him by his maternal grandmother—haunted him throughout his life. Stacy matter-of-factly told his friends that his grandmother had been fighting off devils for ninety-three years. As a result, he viewed himself as "bad," and thought hallucinogens were a catalyst to divine understanding that would help make him good. His anxiety triggered bad drug experiences in which he had many repeated premonitions of his own untimely death.

> **Sibyl:** He said, "I know this book (the Bible) is true, but I can't live by it, it's too strict." And I said, "Nobody can live by it without the help of the Lord." He always had scripture open, lying on the windowsills, and when he found something that troubled him, he'd say, "What does this mean?" I tried to tell him that half the world didn't know what this stuff meant.

> **Stacy (K):** When I was a kid in church they told me the Kingdom of Heaven is within you, and I just took that point-blank to be true, I never actually thought of the Kingdom of Heaven being within me, or within you or whatever.

Although Stacy thought school had nothing to offer him, he excelled enough in art and music to secure a place at Southwest Texas College in San Marcos in 1964, studying art. He lasted almost a year, and he was taken by the work of the abstract impressionists, particularly Van Gogh, which was reflected in his own work.

Sibyl: One [of his paintings] hurts me to look at; we called it his Van Gogh period. He carried this book, *Lust for Life*, for about a year, everywhere he went. He started painting in blue and gold and he painted this boy's face; it's the most tormented face I think I've ever seen on a human being—doubt, fear and anxiety. He painted the angel Gabriel, and he had no face. He's blowing a trumpet and he's in a robe, wings, the whole bit—but there's no face.

The picture possibly relates to the time a fellow student turned Stacy on to hallucinogens for the first time. The student had read about peyote in a magazine, and recognized the small bud-like plant at a cactus ranch. As usual, Stacy was hanging out by the river when they decided to dice them up and swallow them.

Stacy (K): That was a bizarre trip—I'll never forget it. This one guy told me that it would make me feel strange. It was one of the most beautiful trips I've ever had. This guy's face floated off. We were sitting around a fire by the river, and the fire turned emerald green; everything was just real pretty emerald green. I was watching that and I could not believe it, and this guy's face turned into a mask and floated off up into the trees. It hit the top and I picked up a burning stick and threw it up and it hit the mask and when it hit the tree there were all these big green pearls floating. Too much! It was nice.

Aside from that early encounter with peyote, getting high was little more than idle experimentation. Billy Nesbitt, one of Stacy's close friends, used to set the alarm clock and stick his head in the oven, turning the gas off just in time. Inevitably one day the clock didn't work and his death put an end to that game. Alcohol was largely unavailable, but could occasionally be liberated from dances and enjoyed undetected later at parties in the woods. Marijuana was linked to jazz musicians, and Stacy had a natural tendency to think any association with drugs was "cool." While still at high school, he made trips to Austin to score marijuana and on one such errand he had a fortuitous first meeting with future Elevator Tommy Hall. Once enrolled in San Marcos, forays to Mexico seemed far easier, yet proved otherwise.

John Ike: Stacy conned this guy into taking him to Mexico in a brand new '64 Chevrolet, buying a pound of weed. They put the weed in the car's air cleaner. When you bought weed in Mexico at that time, the people who sell you the weed also turned you in to the customs—you can't win. So the police kept the car. They said, "We had word that this car is carrying narcotics. You boys get on home, best way you can." Finally, after about two or three weeks

they found the weed, and immediately contacted the school. So, not only did that guy lose his brand new car, but he also got kicked out of college, same as Stacy.

Although he managed to leave college without his parents finding out exactly why, his activities weren't going unnoticed by the local authorities. Knowledge of natural substances such as mushrooms, peyote and marijuana had been passed down by the older generations of cowboys and musicians, but there wasn't a youth culture that indulged in them yet—so sole blame for their presence was later put on Stacy. The cops had little to do after dark other than play cat-and-mouse with the town's youth, and Stacy and John Ike were their favorite prey. Stacy would look at his watch, smile and leave the house. A cop car would soon be on his tail, so he would proceed to drive them insane by making figure-eights around a car park while they followed and then immediately returning home, not having gone anywhere. The other favorite game for infuriating the cops was sunbathing in deckchairs, bathing suits and sunglasses late at night under the street lamps.

After dropping out of college, Stacy and John Ike teamed up and started their reign of terror on the town with motorcycles. John Ike owned a Triumph, and helped Stacy buy and fix up a BSA Thumper.

Sibyl: He had a motorcycle that John Ike helped him fix up, but we never knew that until he got four tickets in two weeks. His daddy paid the first one, and told him "I've never been in any trouble and there's no reason for it. I'm paying this one, and any trouble you get yourself in after this, you get yourself out of, because I won't be there." That's what made him get marked him as a troublemaker with the police, and from that time on they rode him, bug hunting, every time he was in town.

Having outgrown Kerrville, and with their youthful energy causing real aggravation with the cops, Stacy and John Ike decided to skip town for Australia.

John Ike Walton exemplified the cowboy-booted tall Texan, with a raw sense of humor and dry wit. Although he never fully participated in the wide-eyed, twenty-four-hour lifestyle of the rest of the band, John Ike was nonetheless far out in his own way. Although a multi-instrumentalist, it was the drums that suited John Ike's personality the most—his lanky stature fitted his drumming technique perfectly. He had a custom size thirteen-drum pedal made for his huge feet, while his long reach allowed him to utilize the "bell" in the center of the ride cymbal as a trademark style. While John Ike's natural manic energy corralled the band into activity, his family's oil money bankrolled its early endeavors.

John Ike was born on November 27, 1942, the youngest sibling of three, in Beeville, Texas, inland from the Gulf of Mexico. His "wildcatter" father struck oil on several properties to which he owned the profitable mining rights. John Ike spent much of his childhood on the coast in Port

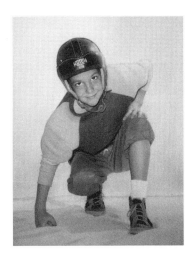

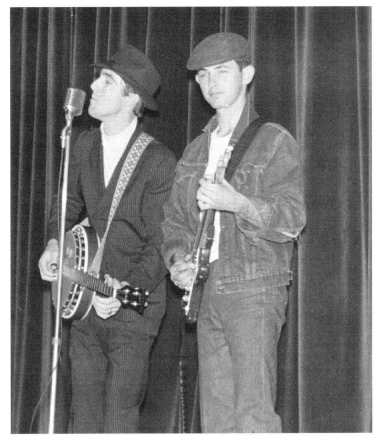

CLOCKWISE FROM TOP LEFT: JOHN IKE IN FOOTBALL UNIFORM; AT SCHREINER MILITARY SCHOOL, KERRVILLE, TEXAS; (1963) JOHN IKE PERFORMING WITH GARLAND ARNOLD, SOUTHWEST TEXAS COLLEGE, COURTESY JOHN IKE WALTON

Aransas before the family moved to Kerrville in 1950, where they built a huge, sprawling house on Fairview Drive complete with a swimming pool. John Ike attended the local school before transferring to Schreiner, a former military college. He proved a fair student, joined the band and learned the rudiments of music. Sight-reading, especially drum music, wasn't his forte, especially when rock 'n' roll emerged when he was a teenager. John Ike made an easy rebel. He loved excitement, but always knew when to stop before he got into serious trouble. He quit hot-rod racing after hitting a pothole in the road and tearing off the front of his car. He still won his race against Arnold Kocurek of the notorious Gear Grinders Club, who was a sore loser and drove off, leaving John Ike stranded with his wreck.

By 1957, he was convinced he wanted to play drums, so he bastardized what was available at school into a makeshift kit. The quality was limited, and soon his mother gave in and took him to San Antonio to buy his first proper kit. Once equipped with pearl Ludwig drums and Zildjian cymbals, he looked for opportunities to play. But Kerrville wasn't exactly the heart of rock, and his first foray into live music was accompanying a country band called Fiddlin' Phil Trimble and the Rhythm Ranch Hands after their drummer retired.

> **John Ike:** I didn't know hardly anything. But they were desperate for a drummer, and I had a set of drums. So even though I was—guess I was fifteen or sixteen years old then—they started teaching me how to play.

Although he had an opportunity to play, their repertoire only consisted of Western swing and songs from the 1940s—not what he wanted to play at all, and it wasn't until meeting drummer Johnny Bush and the Texas Top Hands, who'd had success with a song called "Whiskey River," that he found his style. When John Ike left high school, he enrolled in college at Trinity in San Antonio as a math student before moving to Southwest Texas College in San Marcos, where Stacy was also a student. John Ike flunked out in his sophomore year when calculus proved too much. Meanwhile, he was ingesting a wide variety of music, although country remained the staple—until John Ike witnessed one of rock 'n' roll's true stars, Jerry Lee Lewis.

> **John Ike:** Jerry Lee Lewis came to Bandera, of all places, in 1961 and played at the cabaret, and there were only about ten people there. I got to play on the same bill, and I watched his drummer [Gene Crisman]—he was a big influence on me. He played hard. He was the first drummer I'd ever seen who really played hard and fast, and did not let up. He was sixteen years old.

In 1962, before heading to college, John Ike toured with Sun recording artist Sleepy LaBeef around Texas. By 1965, both John Ike and Stacy had long since flunked college, and their infamy led to their plan to head to Australia, which started with a move to Austin to raise money for tickets

by playing the bars. One night, while hanging out at a drive-in, they had a chance meeting with another stray cat.

John Ike: I met Benny at the Dirty Martin's drive-in restaurant, you know, where they have carhops and stuff. He was out in the parking lot, and Stacy and I got out of my car, because we saw him with a violin. Well, I had my banjo at the time and Stacy had his guitar—we had just blown into Austin and I think Stacy was trying to score a lid of weed. We started playing in the parking lot.

Austin-born and bred, Benny Lynn Thurman was the Elevators' first bass player. A hyperactive child, he had a natural ear for music, and at an early age studied the violin. His strong Baptist upbringing made him spiritually inquisitive.

Benny: I'm the Benny of the bunch. I was born in '43, February 20, right at the cusp of Pisces. Well, I went to the Baptist church for twelve years, and everybody assumed I was a Christian. When I was about fifteen, I really felt—I don't know if they doped me, or I felt the pull, but I walked the aisle and dedicated my life to Jesus but I couldn't make it work for me. I couldn't make God fit into my life.

Following graduation in 1960, he attended the University of Texas to train as a classical violinist. When endlessly practicing stultifying music led to problems, Benny's father, a retired military officer, was quick to enlist him in the U.S. Marine Corps.

Benny: I was getting really tired of Vivaldi and Brahms in the practice rooms four hours a day. And all those stuffy people and the orchestra itself, you know? They very seldom smile. I wanted to get out and in three days I was [in the Marines Corps Reserve]—"Hello mother hello father, here I am at Camp Granada," that's the way it was, the song came out and I was there, "A" Company, First Battalion, Second Training Regiment, U.S. Marine Corps. So they said, man, you passed the test. They had nothing going on 'cept the Bay of Pigs at that time, no war. I turned twenty-one in the Marines, and I was in for life—but it didn't work out that way.

Even the strict discipline of the Marines couldn't rein Benny in: "I got out of the Marine Corps for sleepwalking, because I had a sleep dysfunction and I couldn't tell my dreams from reality. I had a rough time."
Supposedly he rode a motorcycle naked through the mess hall and walked down a runway wearing only a pair of shoes, which he tucked under the perimeter fence before scaling it. Having left the Marines in 1965, Benny found himself joining his father painting barrack houses near the military airport on 53rd Street.

Benny: I was kind of freewheeling around, and I ran into John Ike. I was going to the drive-in all the time. One night I was alone playing fiddle and he came up with a five-string. He and Stacy were trying

to get something together. They were cracking the egg, so to speak. Oh, he managed me during a hard part of my life, you know? I had failed in the Marines, I had failed in college, and I'd had my fill. John and I were both searching—we were searching for some way to make money off the talents that were left to us.

While Australia became a distant memory, Mexico became a more realistic prospect.

In mid-1965, the three traveled there on holiday, smoked the local weed, and eventually got it together to play. They'd stopped at a place called Club Malibu where they decided to break out the instruments and play bluegrass for the locals. They were thrown out but continued playing, and enough punters joined them for the manager to invite them back in again. Broke again after the vacation, Stacy and John Ike found themselves back in Kerrville, where they made plans to head to the Texan coastal resort of Port Aransas for summer jobs. While there, they chatted with one Mr. Plumley at a burger stand, who turned out to be the owner of a beach club called the Dunes. He offered them a residency if they returned immediately with a full band. They enticed Max Range to be their singer, but Ronnie Leatherman, a lifelong friend of Stacy's, wasn't due to graduate in time, so Benny was engaged on bass. Stacy named them the Lingsmen, which Benny recalls meant "Crazy. Ling is crazy in Chinese," and soon he renamed everything they owned to suit: the Lingsmobile, the Lingshack, etc.

In order to ensure the booking at the Dunes, they had to be liberal with the truth and pretend they were already a fully-fledged band. This meant that John Ike invested family funds in electric equipment (Stacy a Gemini 2 Rickenbacker guitar, Benny a Fender Jazz bass and Ampex amps) and a Rogers "swivomatic" kit. A basic set list was agreed on, consisting mainly of covers of the Surfaris and Beach Boys to keep the local surfers happy, mixed with R & B and British beat covers. With no time to rehearse, they headed straight for the coast—however, when it came to their first show, they were in for a nasty surprise.

> **Stacy (K):** John Ike has always had a rib about technical experience, it's like if a person hasn't been playing very long, well, John just refuses to believe that they have it. Benny was an incredible musician, he was playing with an orchestra, first chair, and he told us he could play bass. So when we went down to Port Aransas and plugged in at our first show, and we're all nervous, we hadn't played together. Max is up there and Benny says, "Hey man! I have to tell you something!" I'm going [whispering] "What? What?" He said, "I never played a lick of bass in my life." I freaked out: "Get it, get it!" He started watching me, and he hit the same frets I was hitting. He learned bass right there from scratch, playing live gigs. I'll tell you what, that blew me out!

Benny didn't know any of the songs because he didn't like rock music—he liked country and western. Luckily, Ronnie was soon on summer vacation: "Well, see, when Benny first started playing with them, he

wasn't real well on the bass, so I went down and played for two weeks during the summer of '65, and I played bass and showed him some of the runs and stuff." Somehow the band wasn't sacked, and they muddled through playing a mixture of surf and country, sometimes with Benny on electric fiddle.

> **John Ike:** Stacy learned some Lightnin' Hopkins stuff. He learned his style of playing from Lightnin'. He was real talented, but he was so mixed up. He was so unhappy. Oh, man. Stacy was never satisfied. Benny had a show. We didn't have a bluegrass set, but Benny would break out his fiddle and play "Orange Blossom Special." And people would dance real crazy and wild out there. We'd start off real slow and then we'd play it real fast. He was an incredible violinist.

Although Stacy's estimations of audiences of 6,000 may be exaggerated, the band did prove to be immensely popular, attracting huge crowds at the busy holiday resort. The band was offered $75 per member a week and lodging for their services, and the Lingsmen settled down for a summer of fun.

> **Benny:** We played "Bo Diddley," "Wipe Out," three-chord progressions. "You Really Got Me!"—The Kinks... We had our minds completely blown; the wind would blow in the seas and the pill heads—all kinds of pills for one-night stands. And there were a lot of senators' daughters.

They set up their own P.O. box as the Lingsmen, and it soon filled up with curious letters from Laurie, Stacy's sweetheart back home in Kerrville. Though leaving Laurie devastated him, Stacy's eye had already begun to roam. He enjoyed as much of the female attention as he could get, always claiming "I saw her first!" but that summer he soon discovered that the two things that really made him miserable were his relationships with women and drugs. He became involved with a girl from Dallas named Linda Sharpe.

The local rednecks started to take offense at the band's antics, their long hair and, particularly, Benny's earring. When one unfortunate in the audience heckled them, Benny stepped straight off the stage and silenced him with a single blow.

However the sight of one particular holidaymaker struck horror in Stacy's heart and left him unable to play. His family took their vacation in the nearest big shoreside town, Corpus Christi, and the sight of his mother in the audience proved too much.

> **Sibyl Sutherland:** He saw me, and he came up and he said, "What are you doing here?" and I said, "Well, don't I always come down here all the time for my vacation?" "Well it makes me feel funny, looking up and seeing my own mother standing there!" So that angered me and I went and got in the car. But my mother stayed and listened and she said that he was really good. I could hear him playing.

(1958) Benny, second violinist from left, McCallum High School Orchestra, Austin, Texas; both photos courtesy Benny Thurman

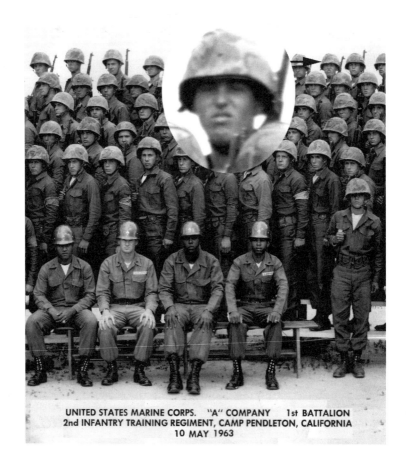

UNITED STATES MARINE CORPS. "A" COMPANY 1st BATTALION
2nd INFANTRY TRAINING REGIMENT, CAMP PENDLETON, CALIFORNIA
10 MAY 1963

According to band lore, before one of their earliest performances an old shrimper known as "Bottlehead" shot up Benny, Stacy and Johnny Gathings with codeine, which made them so sick they took turns throwing up in a pail off-stage throughout the performance. Soon John Ike, who was a natural rebel, found himself increasingly alienated by their antics, and it proved too much for Max, who elected to find his own accommodations.

Benny: Stacy, he had a hard, black soul, but he had a good dream. He was a barbiturate addict—you know, downers. Had to have something to hold him down. So, that's why he kept getting into trouble, because those things are tailor-made, I mean, you're not going to find them on the streets, and he was hurt worst of any of us chemically, because he couldn't get his drugs. You probably have to be a registered nurse working for a doctor to get the barbiturates that he was hooked on, or a doctor's daughter. [Laurie Jones' father was a doctor.] He was like constantly trying to hold his brakes on.

John Ike: Stacy and Benny got hooked up with this guy and he says, "I've got some coke." So he comes down with his rig of coke and gets Benny and Stacy off in their part of the house, showin' them how to shoot up cocaine. This was when Stacy was eighteen or nineteen years old. Stacy was talking to me when we were first smoking joints together, and he says, "Man, I saw a heroin addict today who had the coolest look." He was destined to be a drug addict.

The easiest way to score grass was to order, from a certain bartender, "a brandy, with a little something in it." However, Stacy wanted to score a large stash.

Port Aransas is at the top of a vast crescent-shaped stretch of islands that arc along the Gulf of Mexico coastline to the Mexican border. They include Padre Island seashore—one of the largest undeveloped stretches of coastline in the U.S.. Stacy and John Ike would often jump on the Bonneville and tear down the beach, popping man-of-war jellyfish as they headed south toward Mexico.

Toward the end of the summer of '65, Tommy and Clementine Hall had been to South Texas on a peyote-buying trip, and were taking a vacation on Padre Island on their return to Austin. They had spent a solitary two weeks without meeting a soul, and were preparing to head home when they noticed a peculiar magenta motorcycle that resembled a wasp, parked on the gas station forecourt. While admiring the bike, John Ike and Stacy returned and Stacy, recognizing Tommy as a kindred spirit he'd met in Austin, persuaded them to delay leaving and come and see them play.

Stacy (K): Well, I met Tommy, dig this: the first time, when I was in high school and we wanted to buy some weed, and like it was about five people in Austin from the university and we were going to make several exchanges, and we were over there and I ran into him at the Shamrock Bar, and we stood there and talked a while, you know, and that was it. I never saw him again. And, like, a year or so later we

ran into him on the beach one day and just got talking. And like he had some Acapulco Gold with him, we got stoned, we drank some Romilar [cough syrup with codeine]... and I had a really bum trip. It was too much...

John Ike: We met him in a filling station—he had kinda long hair and Beatle boots. So we knocked each other off as heads. I wasn't even a head, that was the first time I even smoked any dope, in Port Aransas with Tommy Hall; first we drank a bottle of Romilar, then started smoking some Acapulco Gold, and I was ripped beyond belief, man, I was hallucinating, houses were turning into monsters and walking across the land. We went to this stand called "Custer's Last Stand," but I don't remember being able to talk, and they asked us if we were from Russia because we were talking like wah, wah, wah, and they couldn't understand us. We couldn't understand each other. The cops came up, but Clementine jumped out of the car and said, "What's wrong, officers? We're a family and we're camped here." And they left us alone. If they'd rolled down the window and smelled the Acapulco Gold we'd still be in prison.

The Halls extended their vacation and hung out with the band, and although Tommy was working on poetry, there was no suggestion of a musical collaboration yet. Mutually impressed by each other, they exchanged numbers and agreed to look each other up in Austin. Stacy had found a new source of marijuana.

Stacy and Benny acquired a pound of weed for $100 and became so blatant in their dope smoking that John Ike banned any marijuana from the living quarters. Paranoia set in, and after moving their stash around different hiding places, they panicked and tried to sell it. Then Stacy spotted a solution.

Stacy (K): Everybody knew we were turning on. We had two cops on, Benny and I. You know the gunnery in Port Aransas? Well, he and I used to go up there every morning, man, and we'd sit up there, and you can see the whole island, and the pigs would drive up and they knew we were up there smoking. It would piss them off. And if they came up there we'd stash it in the sand. They'd walk all around checking in the sand and we'd ask them what they were looking for. It was a big sport in a way.

Stacy was a huge Kinks fan, and bastardized the riff to "Come On Now," the B-side of their current U.S. hit "Tired of Waiting for You," for a song called "Tried to Hide" about their stash. Although the original lyrics are now long forgotten, elements survived when it was recycled for the 13th Floor Elevators' first single.

You blew what you had and tried to sell it, you thought what you were and you tried to tell it, and when I got near, all I saw was fear, and I know you tried to hide, and you cried 'cos you lied about it...[1]

During their stay, the Lingsmen took the free ferry to the largest coastal town of Corpus Christi, where they came into contact with a wide range of musicians in for the summer season. The Carousel Club hosted local bands, including the Bad Seeds and Zakary Thaks. They hung out with twenty-four-year-old music veteran Glen Campbell, who had performed on recordings by Frank Sinatra, the Beach Boys, Nat King Cole and Elvis Presley. Campbell's career took off a few years later in 1967, when "Gentle on My Mind" made the national charts, and international stardom followed when he immortalized the Texan coast with the 1969 hit "Galveston."

In Corpus they followed up a recommendation for an off-the-beaten-track music venue called the French Beachcombers where they encountered Mr. Swamp Music—Tony Joe White. Like Campbell, he achieved international stardom with his 1968 hit "Polk Salad Annie." White had formed his first band, Tony White and His Combo, with Robert McGuffey on bass and Jim Griffith on drums, and had started playing nightclubs in Louisiana and Texas. After playing a grueling six-night-a-week residency for nearly eight months in Kingsville, Texas, for much of 1964, the Combo were running out of steam by the summer of '65. Since Max Range had distanced himself from them, the Lingsmen, impressed by White, invited him to the Dunes to see them play.

Benny: Tony Joe had it down, he was really practiced, I mean, man, they were so good. All of us went and listened to them, and sat around and picked with them. But he was a very religious-type person; he was just like Elvis when he wasn't misbehaving.

Beyond playing a handful of shows with Tony Joe, any serious consideration of forming a band together[2] was prevented by their undisciplined antics.

John Ike: Anyway, Tony Joe brought a guy over who wanted to be our manager. Tony Joe's a "redneck," he doesn't smoke dope, he's strictly into music. And I should have stayed with him. (Laughs.) We left Tony in Corpus Christi and that's the last we heard of him until "Polk Salad Annie" came out.

With their situation stalling on the coast and plans for Australia gone up in smoke, Stacy and his childhood friend Johnny Gathings drifted to Austin to visit Tommy and Clementine. For Stacy, the Halls' residence on Poplar Street was an education. He could get stoned and luxuriate in Tommy's vast record collection and limitless knowledge of blues, classical and jazz as well as the latest weird sounds, such as the Holy Modal Rounders.

He was also impressed by their lifestyle, which was much freer and more open than anything he'd experienced with Laurie. He viewed Clementine as "a super hip person—very cultured person," while she noted, "Stacy especially couldn't get over the fact that Tommy and I turned on together. His girl [Laurie] was so straight."

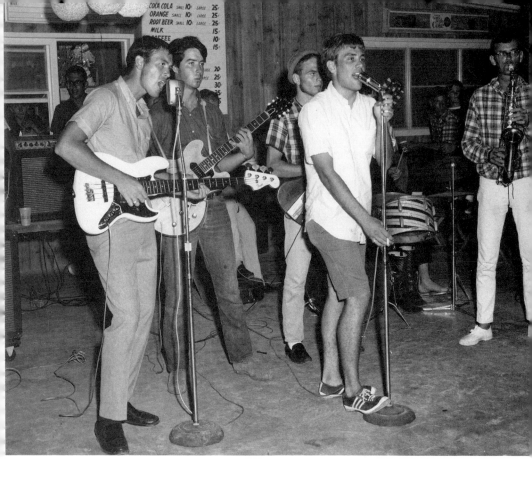

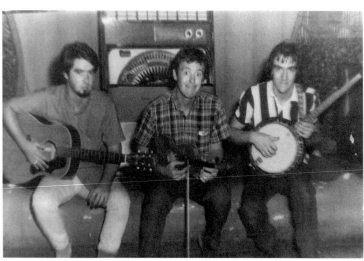

Top: (Summer 1965) Lingsmen & friends, Dunes Club, Port Aransas, Texas, L–R: Benny, Stacy, unknown, Max, John Ike (hidden), unknown; Bottom: (1965) Trip to Mexico, "first time up," L–R: Stacy, Benny & John Ike; (1965) The Lingsmen, L–R: Max Range, John Ike, Stacy & Benny, courtesy Benny Thurman

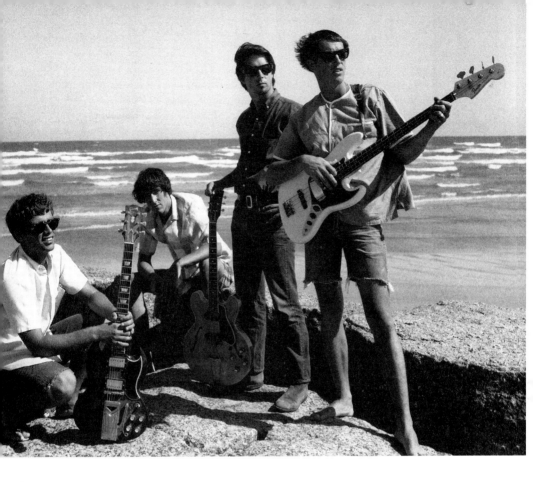

Stacy (K): Tommy knew about every form of music, that was one of the things that blew me about him, I mean, he could sit there for a solid week and put on different albums that would blow your mind constantly, stuff I'd never heard before in my life. We'd go to his pad, smoke dope and listen to hours and hours of music I'd never even heard before.

Having recognized the Lingsmens' talent, Tommy decided to take them to the Jade Room to see a young singer he regarded as the best in town. Although his backing band was good, Tommy decided the Lingsmen were the better band, and so on November 24 they descended *en masse* to witness Roky Erickson and the Spades. Having been introduced to Roky during the break, they jammed with him after the show, and persuaded him to come to Port Aransas to see them play. After performing just one song ("I Can't Get No Satisfaction") with the band, Erickson was convinced of their talents.

Back in Port Aransas, the Lingsmen were having the same old problems, and one evening while setting up for their regular show, John Ike got talking to a man at the bar that reminded him of Johnny Cash.

John Ike: We had a couple of policemen that were the security guards and they said, "D'you know who you're talkin' to there? That's the head of the state narcotics commission. You boys better get out of here. You're talking to The Man. He wants you guys." I said, "Thank you very much."

The Galindo brothers, Danny and Bobby, received an emergency booking from Max Range asking them come to Port Aransas for a show that evening. When they arrived they witnessed the old band loading their equipment and Bonneville motorcycle onto the back of a pickup truck, and beat a hasty retreat.

The vice squad raided the Lingshack the next morning hoping to find them still sleeping, but found only a scattering of marijuana seeds and stems.

Max's new band was named "Max and the Laughing Kind," and he continued to play the coast with various lineups until 1967. In 1967, Danny Galindo joined the 13th Floor Elevators.

1. The Bad Seeds, a band from Corpus Christi, recorded a retitled version, "All Night Long" (Hall-Sutherland) on the J-Beck label (J1005, 20th Jan 1966), released the same week as the Elevators' first 45, backed with "Tried to Hide." Their version contained further references: "well you threw it away and you changed your mind... now leave me alone and let me be."

2. The Lingsmen were never recorded, and despite developing new material with White, they do not appear on either of his 45s made around this time on the local J-Beck label.

2.
"THE EYES OF TEXAS ARE UPON YOU"
(THE CAMPUS CACTUS EATERS)

Musical creators have been, and are, the exponents and the victims of system, philosophy and attitude, determined for them by textbooks and classrooms, and by the atmosphere in which they grow; in short, by their milieu. Consequently the later history of Western music is of one system, one philosophy, one attitude, and it is characterized by successive bodies of practitioners made up of multitudes of innocent believers and sprinklings of individualists who are frequently unequal to the struggle of fundamental dissent with the musical practicalities.

—Harry Partch, Preface to *Genesis of Music*, 1947

Allow me to express now once and for all my deep respect for the work of the experimenter, and for his fight to wring significant facts from an inflexible native.

—Count Alfred Korzybski, *Science and Sanity*, 1933

Tommy Hall was the man with the vision that would become the 13th Floor Elevators. Although he wasn't a natural musician, he was equally a fan of most forms of music and possessed a deep appreciation and understanding of classical composition. Inspired by the innovations of Bob Dylan and the Beatles, in 1965 he decided to take the medium of pop music more seriously and apply it to his own ideas about enlightenment. Although many bands dabbled with psychedelia, Tommy's unique vision went further by using a hallucinogenic catalyst to transcend the barrier of the stage and evoke synesthesia—all of the members of the band, minus John Ike, would ceremonially take LSD and "play the acid" with the intention of extending the effect to the audience through their performance. Unknowingly, he retained the reforming zeal of a Southern preacher while simultaneously extolling a punk ethos.

Using his background in academia, Tommy combined science with spirituality—in short, he wanted to redefine God through mathematics. Although his single-minded pursuit of this purpose caused conflict within the band, he strove to create a meaningful body of work, and one that incorporated the essence of the divine. As he fashioned his psychedelic agenda, he also invented his own tools. Long before effects pedals or synthesizers, Tommy invented the electric "clay" whiskey jug to create new psychedelic sound effects.

James Thomas Hall was born on September 21, 1942. "I was raised in Memphis," he said of his childhood, "the world of Null-A non-Aristotelian reasoning." His father, Thomas James Hall, was a doctor; his mother, Margaret Perkins, known as "Perky," was a nurse. As a child, he lived on the outskirts of town amid the best of both city and rural life, spending much of his youth fishing, hunting or searching for fossils.

Tommy (K): My mother studied at the University of Southern California; we collected rocks together and sent files to the Smithsonian, and she even began a rock shop of her own…

While still in high school, he developed a taste for science fiction and read constantly, as well as developing an interest in the works of Hegel and Nietzsche before branching into psychology. He claimed to have an IQ of 180, which was often the only validation he offered in support of his ideas. Tommy's parents divorced while he was in high school; this caused financial strain on his mother, who continued to raise him in Memphis, while his father moved to Lubbock, Texas, and started a new family.

Clementine Tausch (Tommy's wife): Tommy's father took off with another nurse, and subsequently had two children. Whenever Tommy would stay with him, Tommy was made to feel very very much like the ugly duckling or the Cinderella in the situation. He hated being with his father and his stepmother and his stepsiblings; they were really awful to him. I think probably his father felt a little guilty.

Tommy (K): I got taught classical music [by my parents] when I was little, they just brought me right up into the upper class, just by how they trained me. They just designed me, they knew exactly where I was going to go. My parents divorced and we lived with [my father's] mother and grandmother, in like a farm or ranch house. I had a half brother and half sister. I used to go visit my father in Texas. I automatically had an interest, because he has money. I had to be super groovy to be my father's son. He was an ear, nose and throat specialist with a big clinic in Lubbock. He had a heated swimming pool and knew all the big Texas politicians. Living with him was like living in another world. I had to be cool, you know, know what to do, just shut up…

Tommy's Presbyterian upbringing had little affect on him. Years later, Stacy said that Tommy was virtually agnostic when the band first formed, which allowed him the freedom to approach any religious text

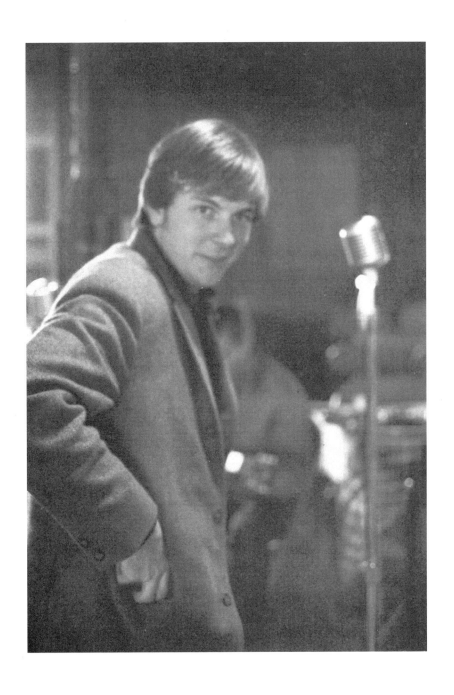

(1966) Tommy Hall at the New Orleans Club, photo by Bob Simmons

in a Gnostic fashion. After graduating from high school in 1961, Tommy wanted to study chemical engineering. Because his father now lived in Texas, he was given the choice of the University of Tennessee or the University of Texas in Austin. He visited Austin during the summer, and liked its bohemian feel. Austin was a big small town; its population fluctuated between 80,000 and 100,000. However, it felt a lot more important than just being a university town—after the November 1963 assassination of JFK in Dallas, Lyndon B. Johnson and his staff ruled Austin, Texas, America and the world. Its laid-back feel attracted a permanent supply of artists and beatniks on the trail to and from California and the East Coast. In those days, Austin had no commercial theatre, and the UT Arts and Drama departments were some of the only sources of creative output. Nightlife wasn't exactly wild either. Bars and music clubs were few and far between. The county was dry, so liquor couldn't be sold; beer joints were the order of the day. Tommy enrolled as a chemical engineering major in August 1961, with a minor in psychology. Ominously, the day he enrolled the wind was picking up, at the start of Hurricane Carla. At first he worked hard, and was eager to learn. He would spend hours debating politics, and was a member of the student Republican society.

Later, though, he discovered that there were more interesting bohemian activities on offer. There were after-hours jazz clubs on the east side of town, and for students there was the university "Chuck Wagon" and the dilapidated student quarters known as the "Ghetto." Above the entrance to the Chuck Wagon is an engraving threatening that "The Eyes of Texas are Upon You," but this was really a college canteen serving cheap food (seven cents for a white plate of mashed potato and white gravy and maybe some white bread) and provided a locus for political debate. Tommy loved to talk, but he soon realized that his conservative views were at odds with the hip crowd he wanted to impress, and therefore tempered his rhetoric. Another student, Californian Chet Helms, studied as a math major before switching to the liberal arts program between 1960 and '62.

> **Chet Helms:** There was fairly large interest in the beatnik thing, and, I would say by extension, poetry and folk music. I was part of a circle that met on Thursdays or Fridays in the student union building. It just kind of collected people who were interested in folk music. It was a hootenanny kind of thing. It wasn't really set up with a stage; people kind of sat around on these hassocks. They traded off on what people played. This is where I met most of these folks.

> **Tary Owens:** I was active in the folk music scene in Austin, playing at Threadgills and recording blues. He (Tommy) used to hang out at the Chuck Wagon with our crowd, but he really wasn't trusted—he was considered uncool. He was very into the folk music thing but he was different from all the rest of us. Whereas politically we were very left-wing, Tommy Hall was very right-wing. He was a member of the Young Americans for Freedom. It was a super-right-wing organization. That bothered me about him from the very beginning. And he was arrogant. His arrogance was really hard to put up with.

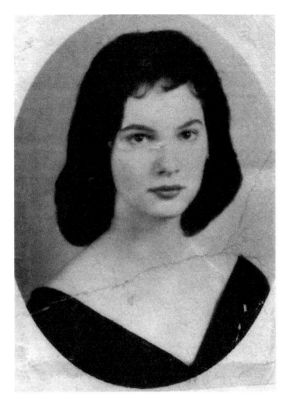

(1963) CLEMENTINE TAUSCH, COURTESY CLEMENTINE HALL

It was around this time that Tommy met Clementine Tausch, who also had her reservations about him...

> **Clementine:** I met Tommy in the Chuck Wagon. I used to go there every day and have lunch and I met Tommy. He was bearded and very arrogant, and I instantly disliked him and continued to dislike him for a full year. There was something about the way he just sat there and was really smug that bothered me. And the other people were turning into hippies around me and were getting loving and warm, which I liked a lot, and he was not loving and warm—he was never that kind of a hippie.

The student union's fledgling folk scene was an informal, open-mike system. Despite his politics, Tommy's large record collection, enthusiasm and willingness to loan rare recordings quickly ingratiated him with the folk crowd. He was encouraged to participate, and tried unsuccessfully to master the mandolin. One of the most important allies he made was Rayward Powell St. John, an artist, songwriter and

(CIRCA 1966) RAYWARD POWELL ST. JOHN AT THE UNION CANTEEN, PHOTO BY BOB SIMMONS

musician, whose multiple talents connected him with every facet of the underground scene. Powell arrived in Austin in 1959 from Laredo, Texas. After laying low for a few years, he enrolled at the university as an art student in 1962. Despite being raised an atheist, Powell joined the left-wing Unitarian church's folk ensemble on harmonica. Not possessing a natural singing voice, the folk revival allowed him to join with others rather than fashion himself as a solo artist.

> **Powell:** Folk music was a big deal. One of my friends [Stephanie Chernikowski] started what she initially called a club at the student union, but there were no dues. It was set up just to come with your instrument and play and sing if you had something to sing, raise your hand and just do it and people would join in if they knew the tune. And as a part of that and everyone coming there on Wednesday nights and just trading music, Tommy Hall appeared. I don't remember exactly when we became friends. Tommy was a drug pioneer and he and I had that in common. He and I never talked politics, but we were both Dylan fans. The only time that I ever realized what his politics might be, was when *Another Side of Bob Dylan* came out, where he did a number of social protest songs. Tommy just hated it. I think he was attempting the mandolin, and not particularly successfully. It is a very difficult instrument. And he also took up the jug. So that was how Tommy got into the jug. He met the rest of us probably as much through folk music as through anything else. And in that context I formed a group, I was in a group with a guitar player, Lanney Wiggins, and ultimately Janis Joplin appeared. This became the Waller Creek Boys,[3] an outgrowth of that folk music scene.

From the moment of her arrival from Port Arthur, Texas, in 1962 to study art, Janis Lynn Joplin had something of a reputation. She'd already

performed on New Year's Eve 1961 at the Halfway House in Beaumont and at the Purple Onion in Houston, and continued at the Chuck Wagon. Legend had it she'd been hospitalized for alcohol abuse in 1961 while at Lamar College in Beaumont, and had enrolled at UT to calm down. However, story has it that she once produced a bag of marijuana at the student union at UT mainly for shock value. At this time, drugs of any kind were treated with the utmost paranoia.

While the conversation at the Chuck Wagon was about searching for the "truth," the focus was on re-examining American culture beyond its historic relationship with Europe. Along with the re-discovery of true American roots came the interest in Native Americans, which validated experimentation with their sacraments—use of peyote and marijuana was soon justified. The Union scene was about building a sense of community through participation. Although Texas was a few months behind what was happening on campuses around the country at that time, there was communication between students. Young Austin residents heard about the latest sounds from friends on the East and West Coast campuses.

The campus social life also revolved around a humor magazine called the *Texas Ranger*. Gilbert Shelton, Lieuen Adkins and Tony Bell were largely responsible for it, although virtually everyone claimed to be involved, if only in order to be invited to the magazine's infamous parties. Tommy and Powell did some work at the magazine, as Tommy was eager to work in different creative fields.[4] Fellow *Ranger* and *Rag* contributor Bob Simmons remembers Tommy as a struggling comedy writer desperately wanting to be taken seriously. The social scene at the Union soon made a natural move away from campus, as gatherings started taking place at the "Ghetto." Situated over the road from Dirty Martin's Drive-In, this complex of dilapidated wooden-framed hovels collected fringe bohemians both by choice and circumstance, and had been home to UT students since the Fifties. Powell St. John lived there from 1962 to '64, and could be found in the yard every night drinking beer and playing music.

Many of the folk-inspired musical grumblings of the Austin music scene originated here. One important figure was John Clay (who supported the Elevators at their first appearance at the Avalon Ballroom in '66), who played the banjo and wrote his own songs. This had a big effect on Tommy, who by now was regularly hanging out but not really participating: "When I saw Janis on the street, she came up and hugged me. That was like a sign that I had been finally accepted at the Ghetto. The problem was that I had nothing to say—everything cancelled out. You know the politics wasn't the same, and you had to be careful what you said."

Although Janis didn't live at the Ghetto, like many others she treated it as a home away from home. The Waller Creek Boys, Janis, Powell and Lanney Wiggins performed at the Union most Sundays, and at bars in South Austin during the week, but it was their performances at the famous Threadgill's—an old gas station converted into a bar—on Wednesday nights that were most heralded.

The Ghetto was where Austin got over its hang-ups about experimentation with drugs. A lot of marijuana was smoked at the Ghetto, but it was not out in the open. Mild it might be, but marijuana was an incredibly

dangerous drug to be associated with in Austin in the 1960s, as the penalties were severe, so even a matchbox full was a constant source of paranoia.

Harvey Gann (Head of Austin Vice and Narcotics): In 1955 you could name the drug addicts. I only had four men on the vice squad and maybe two on narcotics, a small detail. And pretty soon things started developing, and you had 150 instead, and it kept multiplying—it was terrific, spiraling. It [marijuana] was a felony. If you got caught with a very small amount, just a recognizable and weighable amount more or less, you could get penitentiary time out of it. You'd get anything from two to five without any problem at all. Anywhere up to life if you were a second-time offender.

Burton Gerding (Surveillance Officer): Oh the Ghetto, it was a bunch of hippies, it was back to the Jack Kerouac crowd… mescaline, which was peyote cactus, grows wild all over west Texas, and marijuana, any identifiable amount was two to ten years for a felony… you had this mixture of legal and illegal. But they were as opposed to heroin and hard drugs as anybody else.

UT anthropology students seemed to have been mostly responsible for the experiments with peyote and mescaline in Austin. Chet Helms' anthropology student roommate introduced him to peyote.

Chet Helms: Other than my roommate, I was the first person that I know that ever took peyote. I had a roommate who was a graduate student in the anthropology department, and he had gone on a summer project with the university where they participated in peyote rituals and took notes. My anthropologist friend basically stumbled into a Lazas cactus farm and recognized these peyote cacti from these Tarahumara rituals and realized it was the same Latin scientific name. He bought a couple of plants, brought them home and ate them. He had an interesting trip that didn't leave him crazy, so we all tried it a couple weeks later.

The introduction of peyote to the Ghetto scene in 1960 changed its attitude toward drug experimentation. There was no party atmosphere surrounding it—practiced users babysat the curious through the experience. It was considered a somber rite of passage, and bore no resemblance to the later ecstasy of the Merry Pranksters' acid tests. Partly this was due to the fact that peyote wasn't manufactured and palatable like LSD—it tasted unpleasant, it was difficult to swallow and induced vomiting. The attraction, though, was seeing the world through brand new eyes. It could have a heaven-or-hell impact, conjuring warm visual distortions or triggering suppressed memories. Since LSD didn't arrive in Austin until 1965, peyote was the only food for the drug-curious. Tary Owens experienced peyote for the first time at the Ghetto during a visit to Austin in 1962. At first the cactus was diced up and simply eaten, covered by molasses to hide the bitter taste. Gradually, the whole process became more sophisticated, using a homemade paste that was put into capsules and then swallowed.

Tary Owens: At first, you would take it and it was hard to get it down. The first time you go through it, you're physically ill. You throw up. The Indians say that the throwing up is purging of evil spirits and purging of the toxins from your body, which to some extent is exactly right. If we'd have stuck with peyote we would have been all right and none of this other stuff would have happened. Because peyote made you so ill, it wasn't something you'd abuse. It wasn't something you could take every day. Your body couldn't tolerate that. It was so rough on your system.

Scientific and academic interest in the mechanics of the chemical mind started after World War II. It was the synthesis of LSD from ergot by Dr. Albert Hofmann in 1943, working for Sandoz Pharmaceuticals in Basle, Switzerland, that proved a defining factor in the introduction of hallucinogens into modern science. Up until the Forties, the brain was viewed as a physical entity with electrical messengers. Mental problems were addressed with physical treatments such as electroshock treatment or radical brain surgery. Although there was interest in hallucinogens, it wasn't until the 1950s that new chemicals (or "Cinderella science") were tested on the brain.

With the advent of the Cold War, United States intelligence agencies, informed by Nazi experiments with mescaline (synthesized peyote) and liquid marijuana as possible truth drugs, decided to determine its possible uses. In 1953, discovering how little natural LSD Sandoz had produced naturally from ergot, the CIA commissioned the Eli Lilly Company to produce entirely chemical LSD. When American scientists began publishing papers on LSD tests, no consensus was reached as to its use. Formal experiments reported madness and psychosis, Freudian outbursts and religious manifestations—300 millionths of a gram could create visionary enlightenment that rivaled the mysticism at the core of most religions.

Later popular figures like Dr. Timothy Leary[5] and writers Aldous Huxley[6] and Ken Kesey described, and in some cases proselytized, the mystical experience induced by LSD to the broader public.

Tommy, being an avid reader, was already fluent in the works of Huxley. His sudden conversion from right-wing Republican to "Turn-On Tommy," the self-styled on-campus guru, took many by surprise. Between 1962 and '64, as the talents of the anthropology and chemistry students developed the synthesis of raw peyote into mescaline capsules, Tommy Hall became one of the initiated; however, no one can recall how or when it happened.

By late 1963, Austin's beatnik proto-hippies were learning to be pot dealers and chemists and, for certain Ghetto residents, paranoia proved justified as the cops moved in. They huddled in the bushes in a back alley by the Ghetto, watching for any illegal activity. Soon the center of operations was forced to move to a new underground dwelling known as the "Mansion," at 702 West 32nd Street. The original occupants were Tary Owens, Roger Baker, Christopher Teal, John Moyer and Wali Stopher. This was when Roger Baker and Jim Moon figured out how to make pe-

yote more palatable: boiling down the raw cactus and putting the "goo" into capsules that were then painted with shellac to ensure the drugs were digested in the stomach instead of the intestine.

Unsurprisingly the Mansion was busted, but although the police found plenty of peyote, they could do nothing, as it was still legal. No marijuana was found because nobody was brave or stupid enough to actually keep it in their house, until the summer of 1963, when Tommy left halls of residence on San Jacinto and joined the hip community at the Mansion and began dealing marijuana. Financial benefits aside, Tommy believed he was dealing marijuana to spread enlightenment. He was one of the few willing to take the risk and set up runs to the Mexican border to score increasingly large amounts. While some of the early hippie elite complained that Tommy's enlightenment rap made him a bore, they were quite happy for him to take the risks. He was now becoming friends with some "proto" hippie elite: Chet Helms, Houston White, Wali Stopher and Jack Jackson.

Tary Owens: Somewhere along the line, somebody turned Tommy Hall on. I didn't trust him. I didn't really discuss drugs with him. And he could not keep his mouth shut. It all made me very nervous because I didn't want to get busted. The police had raided the Mansion and made a big splash in the paper—"Beatnik Pad Raided." We really were very careful. As soon as Tommy started taking peyote and smoking pot, he was a proselytizer and a dealer. He wanted to tell the world about it. It was very uncomfortable for me living in the same building with him, because he was dealing and, at that time, one joint would get you twenty years. So, it was very scary.

Tommy also applied his chemistry skills to synthesizing peyote into mescaline, making regular trips to Hudson's cactus farm for the raw materials. Morning Glory seeds were also on the menu and they came in charmingly titled packets "Heavenly Blues" and "Pearly Gates"…

Stephanie Chernikowski: It was before you could get manufactured LSD. The reason Tommy was into it was that Morning Glories were allegedly the source of LSD. He'd grind them up and feed them to you in a milkshake. I remember him cooking down peyote into a tea. All of it was nauseating… Peyote is one of the vilest things you'll encounter in your life, but he had all the chemistry down pat. I think it was all experimental at that point. Scoring it was not what it was about… I mean that's just not IT. Nobody ever asked me for a dime, I was always given everything. I knew him well and I never scored from him. Anything he gave me, he gave me because he felt I deserved enlightenment.

Clementine Tausch was living a few blocks away at 909 West 29th with her father and her two small kids. At the weekends, when her father headed to his ranch near Bulverde in the hill country, she started hanging out with her friends at the Ghetto.

Born in San Francisco in 1939, she had lived all over South America, as her father, Egon, was a military attaché for South America and Mexico.

While living in Washington, she had married Vincent Thompson and had a son, Roland, when she was seventeen years old, subsequently divorcing her husband while pregnant with her daughter, Laura. So, at 22 and with two small children, she moved from Seattle and enrolled at UT in 1961 as an English major, writing a thesis on the metaphysical poets.

> **Clementine:** I have two memories of interest about the Ghetto; one of them was Janis Joplin sitting in a rocking chair and she sang her to sleep. She'd done that several times, but this one time sticks out in my mind because she'd said, "You know, I'm gonna raise my children entirely differently from the incorrect way that my parents raised me. I'm a very firm believer in a totally traditional upraising and then the child can go wild, but I think you need to start out with a rock-solid background." And I had never ever thought that

this wild lady would say something like that. The other was that the city decided they wanted us out of there so they backed up a truck that had powder that you blow when you want to get rid of roaches and bugs, only they did it when we were in the courtyard. And blew powder all over us. And it happened twice. The first time I washed off my children and went home and told my father and he did nothing about it, but the second time I went straight home with my children covered in powder and then that was that! Because he didn't care what happened to the rest of us, but his grandchildren were not going to be powdered with poison. And since he was then working for Governor Connally, he had some say over what could be done and we were never sprayed again.

Tary Owens: I remember the first time that Clementine took peyote. The first time is quite often very frightening, and with Clementine it triggered a lot of things from her past that were very frightening to her. The wondrous thing about peyote, though, is that once you've faced your demons... there's this wondrous feeling of oneness with the universe with hallucinations, both with eyes closed and with eyes open, that is indescribably beautiful. For Clementine, after a really rough time with it, where she thought she was going to die, she started having a wonderful experience. Somewhere after this, she started seeing Tommy.

By the summer of 1964 Clementine, Tary and Gilbert Shelton (future creator of the Fabulous Furry Freak Brothers) moved into a student house on West 22nd Street Having avoided Tommy at the Mansion, Tary was perplexed to find that he was now dating his housemate. Tommy had moved out of the Mansion and moved to 905 Shoal Cliff, and his relationship with Clementine developed at the weekends when her father was away at the Wetmore Ranch.

Clementine: He walked around in Bermuda shorts with white gym socks—a really unattractive cat—he stood out in his unattractiveness. I think the reason I fell madly in love with him is that when he stopped being so unattractive, he looked so good in comparison, and it blew my mind. He got into Edwardian suits, and the first time he washed his hair and didn't plaster it back with grease, he was stunning.

As Tommy's appearance changed, so did his outlook—his argumentative, bombastic and conservative politics had been replaced by a new enlightened philosophy. Clementine thought he had an engaging and powerful mind and recognized he had also changed direction at college, and was now concentrating on psychology and literature. In Clementine he found a new mentor, who introduced him to literature and poetry. He wanted to use this knowledge to understand the gap between the laws of the rational world and the quantum world, and he believed that psychedelic substances were the catalyst to bridge the gap.

Clementine: He was constantly writing things. He was a freshman in English, so I tutored him. And I remember the reason he couldn't

pass freshman English classes was that he was having such a terrible time, because the professor would say I want an essay of, say, 300 words and Tommy would write an essay of 150 words and he would say 150 is all I can say on that subject—to say any more would just be redundant. He's very succinct. He does not blather all over the place; he is very, very compact and packs a great many images into a single phrase.

Although he had tentatively started to develop his ideas, he had a unique insight into the psychedelic world. For Tommy it was as if his eyes had rolled back and looked inside his head. Before him lay inner space, an infinite galaxy of new possibilities, communion with the architecture of the universe. As his ideas evolved they would begin to fuse religion, mathematics and quantum physics and even touched the boundaries of such modern theories as neurotheology (monitoring of spiritual feelings through the brain activity) and string theory (the very smallest components of matter are vibrating waves or "strings"). Although Tommy's introduction to psychedelic substances appears to have come through his involvement with the underground scene at the Ghetto, his decision to pursue and develop his own ideas appears to have come from the laboratory and contact with LSD.

Tommy had moved away from Chemical Engineering, finding the practical side of weighing and mixing compounds too demanding compared to the mathematics. He decided to concentrate on experimental psychology instead, and it appears likely that during this program he came into contact with LSD.[7]

Clementine: He was a psychology major and they used him in some LSD experiments in the actual university. And the horror of that was that he learned very rapidly that you do not take LSD with a bunch of men in white coats sitting round and looking at you. It makes you extremely paranoid, even if you're very stable, which he was. And the more he would react angrily to the horrible things they were saying and the way they were saying them, the more they knew he was paranoid. He was just outraged that while he was in this terribly sensitive stage, because he was a psychology major, he could also see himself from the outside. He was outraged that—here's someone who was totally vulnerable and you are asking these probing and stupid questions, and you are annoyed when the answer doesn't come out the way you want it when they're stoned—they can't get the answer out the way you want it. And so he said that never ever again would he allow anyone that he knew of to have any kind of drugs without a totally supportive, loving surrounding.

Throughout 1964 and '65 his newly discovered interest in the arts seemed to be taking him nowhere. However, his recognition of popular culture as an increasingly important medium meant that he was able to fuse his own ideas in a unique way. Inspired by Dylan's transition from folk singer to lyrical visionary on the *Bringing It All Back Home* album and the Beatles' newly informed direction on their *Rubber Soul*[8] album he

decided that pop lyrics were a suitable medium for his message. Although he now dismisses the lyrics he wrote for the 13th Floor Elevators' songs with mild embarrassment as early attempts at articulating his thoughts, they have endured the test of time as profound statements of the era.

Tommy's formal study of philosophy and psychology led him to the ideas of Korzybski (the father of general semantics) and more esoteric works by Gurdjieff and Ouspensky, which he fused with the creativity of Hesse, Huxley, Jarre, Ginsberg and Kerouac. Combined with his recent revelations of the possibilities of LSD, the old adage of looking through the wrong end of a microscope was true.

Central to Tommy's ideas was his study of G.I. Gurdjieff and P.D. Ouspensky. Gurdjieff, born in Armenia in 1866, trained as both a priest and physician; for two decades he traveled the remotest regions of Central Asia and the Middle East in search of lost and hidden esoteric knowledge. In 1915 he met Ouspensky, who documented much of Gurdjieff's teachings in his work *In Search of the Miraculous*, where Tommy found further validation of his use of hallucinogens as a catalyst to universal knowledge. Ouspensky documents Gurdjieff's four pathways to enlightenment, the disciplines of the fakir, monk and yogi, the fourth being a chemical fast track.

The other key text to Tommy's development was Alfred Korzybski's 1933 work *Science and Sanity: An Introduction on the Non-Aristotelian Systems and General Semantics*. Essentially written as an academic textbook, it often alluded to re-evaluating and recreating society's living systems. Its themes were central to the ideas of both the 1930s and the 1960s, social change, revolution and politics. Tommy's preoccupation with this text wasn't isolated: William Burroughs lectured to the CIA on the study of general semantics and writer Robert Anton Wilson also studied Korzybski in Dallas in 1966.

Although Tommy had loosely begun to form his philosophy of enlightenment, he didn't have a clear direction. In the fall of 1965, though, all the pieces began to fall into place. Tommy was positioning himself somewhere between Timothy Leary's academic psychedelic experimentation and Ken Kesey's[9] liberation from the science lab. He never believed in the recreational use of acid—yet, while he didn't criticize Kesey's frivolity, he did blame Leary for introducing acid to the masses.

By the summer of 1965 the first vial of blue liquid had arrived in Austin from the East Coast. Exactly who was the first to introduce it has become a point of issue. Tary Owens amongst others claimed it came via an unexpected source—Billy Lee Brammer. Brammer was born in Dallas in 1929. He'd worked for the *Austin Statesman* and *Texas Observer* as a journalist before being invited to Washington to work as an aide to Lyndon Johnson in 1955. His only novel, *The Gay Place* (1961), was published to critical acclaim, but few sales. It was a historical and political novel based in Austin and depicted a state of corruption and confusion, with a manipulative Johnson-esque character called Governor Fenstemaker. Johnson showed his displeasure by edging Brammer out of his staff and, by 1965, he was back in Austin with vials of LSD-25. Although he became active in the underground scene and continued to write, he never

TWO FACES OF BILLY LEE BRAMMER. TOP PHOTO BY BOB SIMMONS, BOTTOM COURTESY BOB SIMMONS

produced another complete work. The other source of LSD, according to Bob Simmons, was a New York hipster called Rick Lloyd, a close friend of Gilbert Shelton's roommate.

What was extraordinary about Austin was that the backwater university town had spawned a psychedelic culture, which burgeoned in 1962 prior to the wide-scale availability of LSD. In 1965, as LSD started to gather popularity, Austin's scene continued to develop due to its location as a haven between the triangular trade routes of the east and west coasts and Mexico. Former Austinite Chet Helms was now ensconced in the San Francisco scene and had made his own contacts. He was making regular trips between the east and west coasts and was a regular guest with the Halls in Texas. Soon it seemed that everyone was experimenting with this new wonder drug...

Chet Helms: Michael Hollingshead and various people had their ins into Sandoz early on, and had ways of getting [LSD]. I had an old friend named Tate Hall who was a Sandoz rep and brought all those things over here and handed them out rather freely to get people to try them. DMT, psilocybin, LSD. Really Sandoz was trying to figure out what could be done with them and what use they were.

David Hickey (from *Air Guitar*): I remember a great deal about the culture that surrounded dropping acid and not much about the "mystic, crystal revelations" whose lessons I immediately internalized, whose specifics I immediately forgot. Thinking back to those days now, from the vantage point of the present, I remember the people. I remember dropping acid with Gilbert Shelton and racing him to solve *The New York Times* crossword puzzle (after a while we forgot about the clues and just filled in the blanks with interesting words). I remember Duane Thomas, who played running back with the Dallas Cowboys, describing what it was like to play pro football on acid. (Very sexy once you started running, but very scary when you popped out of the tunnel and got blasted with all that color and light and noise.) The woozy musicology of bands like the 13th Floor Elevators, Bubble Puppy and Shiva's Headband were products of that original chemical experience—aids to enlightenment for the younger set, who would see the things we showed them and feel the things the lyrics made it possible to feel. My contemporaries, under the influence of psychedelics, tended to understand things rather than see them. Mostly, though, we just saw what was there, restructured, bejeweled and radically recategorized.

After the introduction of LSD to Austin, Tommy finally dropped out of UT. Acid was simply more important to him than his college work and he now dedicated himself to the underground scene. Although Clementine was determined to graduate she agreed to tie the knot with Tommy just prior to her final exams.

Clementine: We went to Memphis, Tennessee, because near there was a marriage mill. I'm crazy about Tommy's mother. She took LSD with us in Tennessee. What mother would do that? I sat there like a

spider in a spiderweb waiting to catch her in some mother-in-lawy type thing. And you know they refused to marry me because I didn't have identification and I couldn't prove that I was old enough, so we had to come all the way back to Austin and we walked into the judge's office and I was dragging my daughter behind me. I said, "We've got to get married." And he said, "You certainly do!" and he married us. He thought we had produced this child out of wedlock. I was in my go-go boots in the judge's office and I went straight to final exams in my boots and lace hose and my designer suit.

Tommy and Clementine continued to hang out at the Ghetto, but the scene was gradually coming to an end, and Janis and Chet Helms hitch-hiked to San Francisco in 1963. Janis was fed up with college life and was insulted by being voted "ugliest guy on campus."

Clementine (K): It was incredible there [the Ghetto], everyone would sit around drinking beer and telling silly jokes and then each one would tell the others how famous he or she was going to be. Janis was going to be a famous singer. Powell was going to be a famous artist or musician. Tommy was going to be a famous poet. Chet Helms was going to be a great entrepreneur.

Even as the Ghetto passed into lore, the folk scene continued at the University Union, and Tommy continued to try to master the mandolin while Clementine sang, and sometimes the Hootenannies were broadcast on the radio.

Following Janis' departure, Powell had formed a new band called Powell St. John and the Conqueroo Root. Although the Conqueroo went on to become one of Austin's main psychedelic rock bands, the original lineup was utterly different. The band was entirely acoustic with Powell on vocals, Tary Owens on guitar, Charlie Prichard on banjo and Ed Guinn on clarinet. They performed original songs by Powell in a traditional manner. An old friend of Janis and Tary's called Frank Davis started to casually manage the band and find them bookings. He later recorded their work and embellished the sound with backward recordings of pianos and similar ethereal effects to give them an otherworldly sound. On occasion Tommy sat in with them and played his new instrument, the jug.

Tommy had long been a fan of Jim Kweskin and the Jug Band, who had played with Bob Dylan in 1961 and released an album on Vanguard in 1963. They played good-humored renditions of traditional prewar tunes and utilized an old ceramic jug, creating a short low bass sound as accompaniment. Tommy sat in on jug with their jug player Geoff Muldaur when they played at the New Orleans Club in Austin.

A huge jazz fan, Tommy loved Charlie Parker, Mingus, John Coltrane and Miles Davis, and learned jazz-inspired runs on the jug, creating his own sound without having to master the discipline of a wind instrument. The jug was a slow, percussive instrument, so Tommy devised a way of using his voice to mimic fast jazz runs and use the microphone to pick up the resonance and reverb from the jug to create his own new style.

Although he had found the lyrical content of Dylan's "Protest" period

at odds with his own politics, the follow-up, *Bringing It All Back Home*, inspired him to further his own poetry. While the lyrics conveyed a new surrealist imagery, the use of an electric band was a noticeable and significant departure for Dylan. In July '65, whilst he experimented with the Butterfield Blues Band as an electric backing band at the Newport Folk Festival, Dylan was booed off stage and forced to return with an acoustic guitar to placate the audience. Dylan recently described this period as a "constant state of becoming," and following a few further controversial attempts at performing electric concerts[10] he debuted his electric tour at Austin's Municipal Auditorium on September 24, 1965. He couldn't have picked a more adoring audience—virtually the entire underground scene was there, tripping on acid.

> **Stephanie Chernikowski:** You have to understand, Austin was the only place on the tour that did not boo Dylan for being electric. I'd never seen anything like this show; I'd seen Elvis and lots of rock shows in the 1950s, but I'd never been to a show where things were chilling and frightening. Dylan's imagery was getting surreal...

> **Charlie Prichard:** I did go on acid that night, the show was real late starting and a whole bunch of people got upset and left. Dylan came out first and did his acoustic set and after the break came out with his electric band and a lot of people got up and left, but IT WAS GREAT... Well, it was a catalytic experience, we hadn't got there yet but we were heading in that direction... we were drooling over Telecasters.

> **Tommy:** I saw Dylan when he came to Austin with the Hawks and he was just fabulous, it was unbelievable and it was filled with all these heads and we all knew each other. I thought when Dylan did that, that opened up all the possibilities. I mean it was just like you could write your own songs; Dylan made poetry accessible to everybody. I mean for some reason it rang a bell in your brain so that you could create in this way. It turned into this medium, instead of a set kind of love song type of thing; you could be intellectual about it. With rock 'n' roll, you can say anything. It was like a more plastic medium that you could manipulate and be able to do things with. We were taking peyote... I could see things, and it was some kind of way to put down what I saw. When I saw Dylan, it was just something really far out. It meant things would get better.

What Tommy saw in the complexity of Dylan's lyrics was a capturing of dream-reality that could be applied to his fleeting acid revelations. Once this information had been wrestled from the other dimension to the conscious world he could articulate it for a wider audience in the same way that Edgar Allan Poe and T.S. Eliot had done.

While setting up the Conqueroo Root, Powell didn't limit his talents to just one project. Aware of the electric "kid bands" playing in South Austin, he became involved with The Chelsea in 1965. The main creative force was George Kinney, who had grown up with singer Roky Erickson. While George formed The Chelsea, Roky joined a band called The

Spades. With Roky at the helm, the Spades were proving a popular act at fraternity parties and school dances. In late 1965 they started a residency at the Jade Room nightclub near the university.

An old friend of Tary and Janis from Port Arthur, Jim Langdon wrote a live entertainment column called "Nightbeat" for the *Austin Statesman*. Although he was required to comment on recitals and dinner dances, he was also able to include brief and favorable mentions of his friends Janis, Roky and the Spades.

Tary Owens (AV): Jim, in the course of his "Nightbeat" research, was going to the clubs, and had gone to the Jade Room and heard Roky and the Spades. He was totally blown away by this kid who could sing like James Brown, like Chuck Berry, he could do absolutely anything. He said, "You've got to come hear him." So, I went down there and heard him and I was blown away by how immensely talented he was. I told Tommy about Roky. I've thought about why I told Tommy so many times over the years. It's maybe the worst thing I ever did in my life. He met us down there [at the club]. During the break I introduced them. I had no idea what was going to happen next.

3. Waller Creek runs north off the Colorado River, past the university campus and the Ghetto. Powell wrote "Bye Bye Baby," Janis' third single (Mainstream 666) with Big Brother & the Holding Company, released in 1968.

4. Tommy's only known contribution was called "Hints From Hairy," in the April 1964 issue, illustrated by Pat Brown. The piece consists of several inane and decidedly unfunny "tips" on how to save money by cutting corners, e.g. "Rid your dog of fleas and paint by rubbing turpentine into his coat (the hair will come out nice and glossy), also good for worms."

5. Dr. Timothy Leary first encountered hallucinogens in the form of Teonancatl, the "sacred mushroom" or "flesh of the gods" in 1960 in Mexico prior to conducting the Harvard Psilocybin Project in 1960-62. Psilocybin, a hallucinogen produced from certain fungi by Hoffman in 1958, was tested on divinity students and maximum-security prisoners. Although there was no clear conclusion, Leary realized he might have the catalyst to revelatory experiences connected with the very core of human nature. Michael Hollingshead introduced Leary to LSD, and he embarked on a mission to spread the word to other academics using beat poet Ginsberg's famous address book and Richard Alpert's (Leary's colleague) private plane. When his contract wasn't renewed in 1962, Leary was free to set up base at Millbrook, a vast estate which became the media focus for the Sixties "consciousness movement." Alpert and Leary's piece "The Politics of Consciousness Expansion," written for the *Harvard Review* in 1963, proved the catalyst that spread the word from the East Coast academic flirtation with hallucinogens. In 1964 Leary, Alpert and Metzner published a book called *The Psychedelic Experience*, inspired by the "clear light" described in the *Tibetan Book of the Dead*.

6. The writer Aldous Huxley requested crystalline mescaline from lecturer Humphry Osmond. Although he was quick to judge the affects of the drug as delusional, he understood it to be a catalyst to unlock "the mind at large." In 1955 he took LSD for the first time. His works *The Doors of Perception* (1954) and *Heaven and Hell* (1956) provided a template for those of the Sixties generation interested in hallucinogens. Huxley and Osmond's greatest contribution was their correspondence about what to call this new phenomenon. Huxley suggested *phanerothyme* (making the soul visible), "To make the trivial world sublime, take half a gramme of phanerothyme." Osmond wrote back, "To fathom or soar angelic, just take a pinch of psychedelic."

7. I found no record of LSD experiments at UT other than on rats.

8. This ideas and musical direction of this album was crucial to the development of the the13th Floor Elevators; it was released in the U.S.A on December 6, 1965, two days before they played their debut show.

9. Ken Kesey took a far less controlled and more theatrical approach to spreading the word of LSD than Leary. In 1958, during a writing scholarship he had enrolled in a government testing program at the Menlo Park Veteran's Hospital in California where he was introduced to psilocybin and LSD. While working on the graveyard shift as a psychiatric aide he began to write his first novel, *One Flew Over the Cuckoo's Nest* (1962) partly based on his experiences. The novel became an instant critical and financial success and Kesey used the money to fund his next project, the Merry Pranksters, whose mission was to "turn on" America. This took the form of "acid tests," and their most famous "stunt" was the journey to New York in 1964 in "Further" (a psychedelically decorated old school bus) for the publication of Kesey's second book. Upon reaching the East Coast, Kesey visited Leary in Millbrook, and the differences were apparent. Kesey and his Pranksters adopted a "no holds barred" attitude, while Leary maintained an atmosphere of controlled experiment.

10. The exact history and importance of Dylan's transformation from folk hero to electric artist has kept many music journalists employed. In Texas there's a theory that claims his conversion was entirely Texan. When the struggling nineteen-year-old Dylan made his recording debut playing harmonica for Texan singer/songwriter Carolyn Hester on her 1962 self-titled album for Columbia, her producer immediately signed him to the label. What interested Dylan was that Buddy Holly had helped Hester start recording with his producer and manager Norman Petty and his musicians. The speculation is whether the young Dylan was so influenced by these seasoned "electric" Texan players to want to form his own electric band, and following a couple of controversial attempts at introducing electric guitars to his folk set debuted his first "electric" tour in Austin, Texas, in 1965. Dylan did use Bruce Langhorne, Hester's guitarist, for his *Freewheelin'* and *Bringing It All Back Home* albums. Even if there was an element of truth to this theory, Dylan was undoubtedly maintaining his status as a cutting-edge musical force. Many British bands had already recorded electric versions of American folk or blues tunes including the Animals' version of *House of the Risin' Sun*—a song which Dylan himself had recorded for his first album in 1962. It's often considered that their performance of the song on the *Ed Sullivan Show* (October 1964) helped inspire Dylan's conversion to the electric guitar. Also, the Byrds were pioneering "electric" Dylan with their folk-rock covers of his compositions.

3.
WE SELL SOUL

From the very beginning, it was clear that Roky Erickson was a born entertainer. His mother missed no opportunity for him to develop his skills: he trained as an actor and singer, learned piano, string and wind instruments. By the time he was eighteen he had already established himself as a local celebrity. He had acted in theatre productions and performed in several rock bands, practicing and perfecting the styles of popular rock 'n' roll and folk performers. As a teen, he even penned a song that became a regional and then national hit.

As part of the 13th Floor Elevators, he was to become the cherub-faced frontman and rhythm guitarist. His songs were postcards from another planet, sent by one of the godfathers of punk. Adored by those in the "know" and unheard by the masses, he would become one of music's greatest victims—and survivors.

Roky's parents, Roger Erickson and Evelyn Kynard, met in Dallas in the early 1940s. In 1944 a talent agent had noticed Evelyn's singing and she was chosen to audition for Arthur Godfrey's national televised talent competition—the same competition that had launched the career of one of Roky's heroes, comedian Lenny Bruce, who won in 1949. But any serious career possibilities evaporated when Roger enlisted for duty in 1944 and hasty marriage plans were made.

Roger Erickson: I wanted to get married before I was shipped overseas, so I even got my brother in on the act. He was an instructor in the Air Force, and he arranged to have a bombing mission where they picked me up. We spent that night in the regiment and went down in the bomber to New Orleans and then to Dallas. He was my best man at the wedding that afternoon and then went up to Rhode Island to officers' training school.

Upon Roger's return from war he worked for a structural engineering firm in Dallas for a few months before enrolling under the veteran's program at the University of Texas in Austin to study architecture. The couple bought some land off Rabb Road, then two miles outside Austin's city limits. By the time work commenced clearing the land for their house, Evelyn was pregnant with Roky. Funds to finance the building work ran low so they dispensed with their rented apartment and Evelyn headed for the comfort and security of her parents' in Dallas.

Roger Kynard Erickson was born on St. Swithin's Day, July 15, 1947 at the Nightingale Hospital in Dallas. When Roger received a call in the early hours to say Evelyn was being admitted to the hospital he broke the speed limit and burst a tire upon reaching her parents' house so didn't reach the hospital in time for the birth. The baby was immediately dubbed Roky, a combination of the first two letters of his father's name (Roger: "I didn't want him to be a junior, because I detested those"), with the first two letters of Evelyn's maiden name, Kynard.

By now work on the house had progressed enough for them to camp out in the shell. Roger continued his studies at UT during the day, finishing specs of his own house and laboring on the site in the evenings.

They became the model postwar American family, heavily involved with the local church and every facet of social, artistic and musical activity open to them. Evelyn's "Arthur Godfrey" fame ensured her a role in the UT theatre group, singing in the choir at St. David's Church and running a music store. She also took voice lessons and performed with a vocal trio. Evelyn's interest in the arts spread to the family; at two Roky memorized and mimicked the words to all the records he had. Their close friends, the Kinney family, lived nearby on Kinney Lane. They also had a son, George, about Roky's age, and the boys grew up together.

In January 1950 the Ericksons had their second son, Mikel; their third, Donnie, arrived in November 1951. The three became Roky's first triumvirate, their father soon dubbing them the Three Musketeers—"when one was in trouble, they were all in trouble." The arrival of Donnie, however, wasn't without complications.

Evelyn: When Donnie was born, his lungs weren't expanded properly. The preacher walked in the room and it was like sunshine in the midst of a cloudy day; he said, "Just release the baby into Jesus' hands." That sounds easy, but it's not. So, you practice releasing the baby into Jesus' hands, and that takes him out of your hands. I could tell the third morning when he started breathing, I knew he was going to be okay, all my prayers—a miracle, but you can't tell people, they think you're crazy.

The event was also significant because it further reinforced Evelyn's already strong religious beliefs, particularly in the healing power of prayer. It was to be the first but not the last time that her faith was pitted against medical opinion.

The family's activity in the community meant that Roky became ac-

customed to public appearances. He was entered into every talent show, pet parade and local theatre production open to him. At two he appeared in the local press with Evelyn in support of the League of Women Voters, where it was noted "Mrs. Erickson's son, Roky, was getting a lesson in good citizenship." Later he was featured dressed as a clown, pulling brother Donnie and Dusty the dog in a wagon at a pet parade. Evelyn took charge of her sons' education in the performing arts and Roky had piano instruction from neighbor Alma Ward and cornet lessons from the Covingtons. He learned banjo and guitar from his mother. He also attended St. David's Church from the age of five and later sang in the junior choir.

> **Evelyn:** He was a straight kid—I'd taken him to church with me every day since he was five. Sang in the choir. I couldn't leave them at home unsupervised with their father, because he was sleeping. When he was taking piano at seven years old, he wrote two songs—one was about a frog, the other was about thunder. He wrote it all out, including notation.

> **Roky (NFA):** When I was four or five years old, before I could read, my mother had me take piano lessons from a neighbor called Alma Jean Ward. I also remember when I was about eight or ten years old that she took lessons on how to play the guitar. Then she would run home and teach my brothers and I how to play the two or three chords she had learned.

Rock 'n' roll was hitting the radio waves and he started to translate the music he was hearing by Elvis, Chuck Berry and Buddy Holly into guitar chords on his parents' guitar, and also to bash out Fats Domino and Little Richard songs on the family piano. Evelyn was so impressed by his progress that when he wanted an electric guitar, he got one. For Christmas 1958, Evelyn visited J.R. Reed's music store in Austin and bought all of her sons electric guitars and amps.

> **Roky (NFA):** I'd been messing around with guitar, and I'd play things like "Aura Lee"[11] and "Love Me Tender" and then I got into Bo Diddley a lot. And Little Richard was good; I enjoyed him. I like the way that sounds. He's had so much influence on me, his singing. I really learned from Little Richard.

While the unique singing voice of legendary Texan Buddy Holly had a lasting impact on Roky's style, it was the pure excitement of high-octane black performers such as Little Richard and James Brown that were to influence his performance the most. Their stylized screams, fused with his mother's operatic discipline of vocal projection, formed the basis of Roky's singing voice. Roky would skip school with George Kinney and the pair would practice their blood-curdling screams.

As the Fifties progressed and Roger's work as an architect grew, he made frequent trips away to lavish swimming pool conventions around the country. Roky was even photographed with Esther Williams,[12] the formation-swimming film star. The increased family profile on the Austin social circuit led to new pressures within the family. Evelyn lapped up the opportunity to become a sybarite, dressing the part and grooming her sons as the family climbed the social ladder. Roger's reaction was to escalate his alcohol consumption and stay late in the office. For Roky, it meant learning to become the perfectly polite and well-mannered eldest son, able to meet and greet as the whole family went on show. There were frequent family trips to San Antonio to see the latest movies and Roky even enjoyed golf as a hobby. However, under the middle-class success the cracks were beginning to show. Roky was an extremely emotional child, and was quick to observe the situation. As brother Donnie recalled, Roky coined the phrase "dad's an alcoholic and mom's a neurotic." Mikel Erickson also witnessed the shift in family fortunes translate into tension between his parents.

> **Mikel Erickson:** He was a good architect and he was making money. They always had parties, and they always had a stocked bar and drank a lot. Then one day my mother just decided she wasn't going to drink anymore. My mother was a heavy spender; she loved dressing the part. When we went to conventions and things like that, she'd spend thousands. Dad pretty much stayed in the office, and we'd see dad for an hour or two and my mother would have a list, bad, good, bad... and it was his job to go punish. He was an alcoholic, workaholic.

(1950) ROKY & GRANDPA JESSE ERICKSON, COURTESY EVELYN ERICKSON COLLECTION

Around his twelfth birthday, Roky broke his leg diving into the family swimming pool and ended up in the hospital, where complications were found. This led to Evelyn's first real confrontation with medical opinion, and her second miracle from the healing power of prayer.

Evelyn: They were going to take some bone from the hip and grind it up then operate and put the new bone into the leg that was broken. The prayer group said we should get another opinion, so I talked to our baby doctor, Dr. Coleman. He said he couldn't understand why they had said it wouldn't heal, because bone doesn't become bone until you're sixteen; it's just cartilage until then, and it should heal by itself. So here was this doctor who had known Roky, and this bone specialist saying it won't heal. So I said, "Well, we have faith in our doctor that the bone is cartilage, and we are just going to wait." We gave Roky raw milk, with all the nutrients left in, and that bone started to heal. The bone doctor was mad; he didn't like that at all.

Although Roky was naturally bright, he had missed a significant amount of schoolwork recovering from his leg injury. With the switch from Zilker Elementary to Porter Junior High, it started to become obvious that he had slipped behind. Although he still excelled in art and music, these were not considered vocational studies. With weakening parental

OPPOSITE PAGE, CLOCKWISE FROM TOP LEFT: ROKY, ROGER, MIKEL & EVELYN ERICKSON, COURTESY SUMNER ERICKSON COLLECTION; (1958) ROKY & ESTHER WILLIAMS AT A POOL CONVENTION, DALLAS, TEXAS, COURTESY EVELYN ERICKSON COLLECTION; (1960) ROKY, 7TH GRADE, PORTER HIGH SCHOOL, COURTESY EVELYN ERICKSON COLLECTION; (1963) ROKY, ARTHUR LANE, COURTESY EVELYN ERICKSON COLLECTION; (1964) CHRISTMAS, ARTHUR LANE, L–R: SUMNER, BEN, DONNIE, ROKY, COURTESY SUMNER ERICKSON COLLECTION; (CIRCA 1953) THE THREE MUSKETEERS, "WHEN ONE WAS IN TROUBLE, THEY WERE ALL IN TROUBLE." ROKY, DONNIE & MIKEL, COURTESY SUMNER ERICKSON COLLECTION.
THIS PAGE: (1958) AUSTIN CIVIC THEATRE PRODUCTION OF *ALICE IN WONDERLAND*, L–R: CINDY WINN (MARCH HARE), DANA WOMACK (DORMOUSE), ROKY (MAD HATTER), COURTESY EVELYN ERICKSON COLLECTION

control, Roky would slip off on unaccompanied trips to the cinema. He loved re-runs of old, trashy horror movies but his mother forbade him because she thought he might get too scared by them. Roky loved the spectacle—the darkness of the movie theatre and the anticipation of the performance. Although he loved to be frightened, it was his macabre sense of humor that made horror films so appealing and this link between the grotesque and humor would later provide him with a key survival mechanism. Roky later diffused the darker periods of his life by combining opposites—fear and humor, Christianity and Satanism.

In Rusk Maximum Security Prison for the Criminally Insane, Roky became the "Right Reverend Roger Roky Kynard Erickson." Following his release, he theatrically stated that horror was his new religion and even staged a signing of his soul to Satan in blood. When Roky commenced his solo career, he employed several horror film titles as autobiographical metaphor in his songs, "Creature With the Atom Brain" (electric shock treatment) and "I Walked With a Zombie," for his fellow drugged inmates. By the late Fifties, new gimmicks were being employed by showmen such as William Castle to revitalize the horror market. In 1958, Roky went to the Paramount Theatre to see a special screening of Castle's *The House on Haunted Hill*. The plot was enhanced by "Emergo," a twelve-foot skeleton which, on a cue from a line of dialogue by Vincent Price, flew out of a box next to the screen and up into the balcony on a wire. Then 1959's *The Tingler*[13] went several stages further. When Vincent Price removes a crustacean-like creature from a victim's back, the screen blackens as the creature supposedly kills the projectionist. Its silhouette is cast on the screen as Price urges, "Scream! Scream for your lives!" The monster is then supposed to savage the audience. Plants in the audience screamed until they collapsed, and were wheeled off on stretchers. Selected seats in the auditorium were also fitted with "Percepto" boxes, which vibrated to provoke pandemonium.

Roky had been enrolled in Austin's Civic Children's Theatre School from an early age, and appeared in several productions between 1958 and '59. These included roles as the Mad Hatter in *Alice in Wonderland*, Sonny in *Cat on a Hot Tin Roof* and Indian Joe in a dramatization of *Tom Sawyer*. How to break the barrier between the actor on stage and the audience member has been a traditional question in the theatre, and when Roky appeared in *Tom Sawyer*, he decided to apply some of William Castle's tactics in order to liven up his role.

John Kearney: Roky was always an actor. I remember watching him play Indian Joe. It was a presentation for elementary school kids. And when Roky came out everyone went, "wow, here's someone who's into the part." And when he chases Tom and his girlfriend, Roky, instead of chasing them 'round the stage, ran and jumped off the stage and into the front row of kids, screaming and howling. Really, all he wanted to do was entertain.

Although his fascination with horror and a heightened sense of theatre was to remerge later in his career, it was music that was the common

bond within his circle of friends. Indeed, he met John Kearney, the music teacher's kid, through his love of music.

John Kearney: I was an outsider because I was the teacher's kid. A mutual friend, Mitchell Howell, came to class with an album by Bo Diddley called *In the Spotlight*. We all recognized Bo Diddley, and they were surprised I knew it, and I was surprised they knew it. I spent so much time at the Ericksons' house, and we were both acolytes at the same Episcopal Church. It was the Episcopal youth groups that Roky brought his guitar to, and everyone loved him.

During the first and second grade, when he was seven years old, Roky and George Kinney had reaffirmed their childhood friendship. Now at junior high together, they shared the same lack of interest in schoolwork and enthusiasm for music. They vied for girls, often dating the same girl one after the other or at the same time. After school Roky and George spent most of their time at Arthur Lane, practicing their guitars where George remembers "there was never a shortage of little brothers to bother us." Roky's father's absences and his mother's preoccupation with his younger brothers meant increasing freedom for Roky. However, he had always been the favorite eldest son woken every morning by his mother with a glass of fresh orange juice. Now he wasn't receiving the same amount of attention and he started to "live" at musicians' houses. Evelyn didn't approve, but her parental control had weakened. However, he never really strayed that far or for very long.

Despite his love of rock 'n' roll and R & B, it was the folk scene that first provided Roky and George with a public platform to perform beyond friends and family. In 1961, they started hanging out at the beatnik cafés to watch homegrown folk artists like Carolyn Hester, who hosted a local TV show and commanded the boys' attention because she had hung out with Dylan. Interaction with the older beatniks led to conflicts with the school timetable, which Roky started to ignore in favor of expanding his musical education.

George Kinney: Roky was not a big drinker, but we used to get whiskey and drink it all the time. Roky and I'd already made our reputations as the militants, played guitar, smoked cigarettes—our teachers hated us. We had the whole image of the bad guys. So we skipped school one day and got a bottle of vodka, and went out to see a friend of ours, Mack Rawl. He was one of the early guys who befriended Roky and I and introduced us to the folk scene in Austin. Roky and I met Townes Van Zandt through John Meadows and Mack Rawl. Our mothers were the old guard, and then there was this middle stage, which was John and Mack and the Red Lion and the well-known beatnik places where you'd have espresso coffee and listen to folk music. It was kind of how the university people and us met each other. Roky played and sang some then. He wasn't really writing his own songs, he was mainly singing Bob Dylan songs and Peter Paul and Mary, folk music.

Mack Rawl lived a bohemian lifestyle, mattress on the floor, a fridge, a table and room where everyone threw their empty beer bottles. He would buy the boys beer and introduce them to the folk scene in Castle Creek, an area which remained bohemian into the late Sixties when it became hippie central. In 1962, Roky moved on to William B. Travis High School. The school's mascot is "The Texas Rebel," a role he and George perfected well, regularly bringing his guitar to school to show off and further increase his popularity. Although Roky and his Travis friends weren't a gang, there was a feeling of solidarity just from living in South Austin, this being the only high school south of the Colorado River. To hear the latest sounds meant driving to the edge of town, away from the city noise, and running an aerial to tune into stations broadcasting from Nashville and Tennessee. The best music was played on the all-night underground radio stations. Often the station itself would still be in Texas, but the transmitter was just over the border in Mexico.

> **Lynn Howell:** Teenagers in the late Fifties and early Sixties, you just lived in your car. Radio played a giant part in everybody's youth; those old AM tube radios when you get them out of town a bit, you'd get all these stations, and Wolfman Jack.[14] And their advertisers would be offering you a piece of the true cross and vials of Jesus' tears.

The radio stations didn't just pump out raw rock 'n' roll, they also provided a platform for fire and brimstone preachers whose delivery and rhetoric was every bit as theatrical and visual as anything from a horror "B" movie. An important way of ensuring popularity was to have perfected the latest tunes and be able to perform them before anybody else. Roky capitalized on this and made himself the center of attention. Having toyed with a country music phase, Roky soon began to emulate his heroes James Brown, Little Richard and Screamin' Jay Hawkins. This was more difficult and required a degree of privacy, as Roky liked to give the impression that he was a natural talent and didn't practice. So he and George used to slope off with a bottle of whiskey and find a derelict house to use as a practice room where Roky could practice his screams. Sometimes, according to George, Roky would scream until his throat bled. Soon he figured out how to project his voice in the same way an opera singer would to reach the back of an auditorium. As John Kearney recalls, "he had the scream, and the voice came out of the scream."

During this period he wrote his most famous and enduring song, "You're Gonna Miss Me."

Roky has confirmed that he wrote both "You're Gonna Miss Me" and "We Sell Soul" when he was fifteen years old. He's also acknowledged that there were a few songs that could have influenced the title. When Roky was fourteen, his favorite performer, James Brown, released "I Don't Mind," a key line of which is "... you're gonna miss me." Family members also recall hearing him singing Buddy Holly's 1958 "Early in the Morning"—"Well, you're gonna miss me, early in the morning, one of these days—oh yeah..." Another more obscure candidate was Muddy Waters' 1948 "You're Gonna Miss Me," which may not have escaped

(1965) Le Lollypop Club, Austin, Texas: Roky & Go-Go Girls Jacki Kellendorf & Patty Badillo, courtesy Paul Drummond collection

Roky's attention, as Charlie Prichard recalls that Roky was well-educated in the blues.[15] "He was the only person of that age that I knew who knew the difference between Blind Willie Johnson and Blind Willie McTell, and he was enthusiastic about both of them!"

> **Roky:** I just thought "You're Gonna Miss Me" up in my head. I listened to radio, at night before I went to sleep … and they had this one disc jockey on, Laveda Dirsch, and he would play songs like, Little Willie John,[16] [sings] "You better leave my kitten all alone," and they played that, lots of things, and I was just really influenced to play, and be a star like them.

As for the subject matter of the song it would seem obvious that it was directed homeward at the family situation from which he decided to make extended absences. Certainly his mother Evelyn believed so: "You know how you're gonna miss somebody when they leave. First time [he left home was] probably about fourteen... Where to? Friends, musicians'... learn music without paying for it." He was a really good student 'til he hit junior high. Four sons took a lot of energy out of me, and I was thirty-five,

trying to keep up with teenagers and babies at the same time." Many of those close to Roky over the years have commented on his family situation and the effect that it had upon him. He was used to being mothered and would always be comfortable with others doing things for him. His brothers, friends and band members often interpreted this as laziness in later years. Roky never carried his own equipment, and he never even tuned his own guitar. Still, his brothers clearly idolized him and looked up to him as a role model. Mikel, like Roky, left school before graduation and promptly got work chauffeuring Roky and the band around.

Roky often displays an incapable nature, and that seems to make people want to do things for him. He is also easily led. The fact that he went from center of attention to wayward son was obviously exacerbated by Evelyn's preoccupation with his younger brothers and by his father's growing alcoholism. However, he never fully left home as a teenager or as an adult. Arthur Lane proved to be the base he would return to when the outside world proved too much.

Clementine Hall, who got to know the Erickson family in 1965, had an interesting observation of Roky's role in the family and Evelyn's influence on him:

> **Clementine:** Evelyn is a sweet, sweet lady. She's batty and sweet, and she was batty and sweet then. She had an illness, a mental illness, and she used her son as a surrogate husband. It's just not something you do. Look at families where you have, say, five brothers. The eldest is rarely the infantile child, and yet in that family, he was. He was not the responsible older brother who does responsible things. Always in that kind of family the eldest brother is the one who is on time, is prompt, gets up, does all the stuff, because he has to be responsible for so many. Roky was a helpless child in that respect. He was babied, and babied, and babied by his mother into total helplessness. But I'll say for her that she also made him an extremely loving and generous person.

On May 27, 1963, *The Freewheelin' Bob Dylan* was released, just as Roky finished his first year at Travis. Roky had no complaints about babysitting his brother Donnie on a trip to New York, as it offered him his first real chance to get out of Texas. Roky packed his guitar and, along with his brother, took the bus to New York.

> **Roky:** Well, we just went up to New York and stayed with John Henry Faulkner, he was a Texas writer, a friend of the family, and he said if we came to New York we could stay at his place... they had folk singers in the village where we were hanging out.

> **Donnie Erickson:** I was so scared to be up there, thought some green stuff was going to come out of the ground, but Roky wasn't. We were playing in Greenwich Village, and Roky borrowed some guy's guitar, and he was doing "Freewheelin'" by Bob Dylan, and people just drew around him.

TOP: (1965) LE LOLLYPOP CLUB, AUSTIN, TEXAS: THE SPADES, L–R: ERNIE CULLEY, ROKY, JOHN KEARNEY (DRUMS), (ELF) JOHN ELI, AND JOHN SHROPSHIRE; (1965) JADE ROOM, AUSTIN, TEXAS: THE SPADES, L–R: ROKY (& INSET) CULLEY, ELI. BOTH COURTESY PAUL DRUMMOND COLLECTION

In 1964, Roky left home again, and this time he moved into a tiny, crypt-like, subterranean apartment on East 18th Street, just down the road from George Kinney, who'd left home six months before him. George however continued at high school while also working nights as a watch-man at the Texas Department of Public Safety, while Roky chose to stay in bed during school hours and come alive at night, drinking beer and playing guitar.

Roky was never that far from his family's home and was employed by his father to make large-scale copies of architectural plans using a die line machine. This earned him enough to support his bohemian life. For Roky the lack of a dedicated music teacher and the policy of drafting in parents to teach music was an indication that he should stop taking school seriously.

Ever the rebel, Roky continued to test the school rules to the limit. While hanging out at the beatnik coffee bars Roky had been introduced to marijuana. Now with the freedom of his own apartment he could hang out with his friends, smoke, listen to music and leave his door open to the less advantaged teenagers.

Terry Moore: I met Roky in the tenth grade and I remember there was a grocery store on South First where we were able to go over and buy beer without an ID, and we'd go drink a couple of beers before school. I was having trouble with my girlfriend and this was a school day, so I drove over to Roky's on 18th and of course he was still in bed. And he answered the door all groggy-eyed and said "Hey man, I got some beer and wanna get drunk." He said, "Put that away and come on back here, I got something better." He went in the back and got out his little half pipe, didn't have the stem on it, and loaded it up with pot. I'd never smoked pot before, we proceeded to fire it up and I got paranoid, "Oh, I've got to get back to school." At this point he wasn't coming to school at all and there were rumors all 'round about Roky smoking pot and at this time, in the mid-Sixties, smoking pot was akin to shooting heroin. There were whispers about Roky being a drug addict."

In 1963 John Kearney heard through the Travis grapevine from fellow pupil Jimmy Bird that following an argument with their drummer, the local band the Spades needed to recruit a new one. John sat in on drums and jammed and a week later was invited to join the band. Due to the lack of groups in Austin at the time, none can recall more than five existing; they regarded themselves as semi-professional even though all the players were aged between sixteen and eighteen and were still attending high school. They made good money picking up regular gigs at fraternity and sorority parties and dances by handing out business cards after school. No one remembers exactly how the name "The Spades" came into being. It would be easy to assume that it was meant as an homage to black music, and not meant to be derogatory. The only other suggestion for the name could have been identification with the South Austin gang called the Spades, although this seems unlikely, since the group's founders came from North Austin. Cousins Jack Roundtree and Ernie Culley, with John Shropshire on vocals, formed the original Spades. John attended Travis

High and was the link to South Austin. The band had three guitarists and no bass player, since no one wanted to be relegated to bass.

John Kearney: They already had the name the Spades when I joined. They had a reputation, as they'd been playing enough high school dances that people knew who they were. The bread and butter were the fraternity parties—during the summer you starved. Local festivals like the Blooming Watermelon Fund, church groups, and Catholic youth organizations.

In April of 1965, they released a single titled "I Need a Girl" on the local Zero label. It was recorded at the Austin Custom Recording Studios, which Kearney remembers as little more than a makeshift studio in a bank basement with a microphone suspended in the center of the room and a tape operator in the adjacent room. The result was a weedy, insignificant pop record. Although Roky had tested the water by making occasional appearances at the folk clubs, he was also interested in playing bands but was yet to debut with one. The original version of "You're Gonna Miss Me" was a rock 'n' roll song, clearly written for a band and never intended as folk material. However, until the advent of the Beatles' attack on the American psyche in February 1964, bands weren't yet the craze. In April 1964 the Beatles famously held all top five positions in the *Billboard* Hot 100 chart simultaneously. With their success came what was later dubbed the "British Invasion"—in fact a torrent of cash-in acts such as the Dave Clark Five, Herman's Hermits, Chad & Jeremy and Peter & Gordon. Bona fide bands—such as the Yardbirds, the Kinks and the Who—formed the second wave. However, the arrival in Texas in 1964 of the scruffy, surly, longhaired Rolling Stones was further validation for the sixteen-year-old Roky of his own appearance. An early Jagger/Richards composition, "Empty Heart," was issued in the U.S. on their second album, *12X5,* in October 1964, and its raw sound and harmonica break provided Roky with a template. The song was to become a favorite of his and he would later regularly perform it with both the Spades and the early Elevators. Predating Dylan's controversial "electric" tour which began in Austin in September '65, Roky chose Dylan's "Like a Rolling Stone" for his debut performance with an electric band. Just as he'd honed his vocal skills in private, he'd been rehearsing with his first band—the Roulettes—in secret and took everyone by surprise with his performance—not least of which was the principal, who disconnected the plugs to the amps.

John Kearney (AB): (At) Travis High School they have a talent show. And we and the Spades were the top bill, but much to my surprise—much to everyone's surprise—no one expected it, including me—and we'd been buddies for a couple of years at this point. They just said, "Okay, the next act is Roky Erickson and Joe Bierbower." And Roky has this horrible old Sears amp, and a very cheap electric guitar, and both of them look like they have been dragged through the mud for years. The amp rattles, but it doesn't matter. When Roky hit his singing and then blew into his harmonica, it just electrified everybody. Including me! And Roky just blew everyone away.

Evelyn had managed to secure Roky a rehearsal space at a strange-looking Franciscan Mission-style church on West Mary Street near Arthur Lane. Here he'd rehearsed his two original songs and a collection of Dylan, Beatles and Stones cover versions he knew from the radio, with fellow Travis students Joe Bierbower on drums and Gary McFarland on guitar. The Roulettes continued by playing a handful of shows at the Y youth club, and started to pick up gigs at fraternity and sorority dances. Roky soon decided to change the band's name to the Missing Links and added his friend Elf (John Eli) on guitar. What appealed to Roky about the new wave of British bands was their use of distortion on the guitars and amps. This was best characterized by Dave Davies, guitarist of the Kinks, on their 1964 hit "You Really Got Me," which was supposedly achieved by ramming a knitting needle through the speaker of his amp. Equally influential was the Who's first record "Can't Explain," released in the U.S. in February 1965. Despite the hard beat and pounding bass, the foreboding production gave the guitar sound a resonance that suggested extreme volume. At this time, the Beatles were actively experimenting with pushing the limitations of the recording studio and seeing what things sounded like if they allowed the dials to tip *into the red* and produce a new, uncontrolled sound. It was this that excited Roky, and was what he was trying to achieve by turning his guitar all the way up, and was reflected in the new name, "The Missing Links"—the third sound, the parts that couldn't be played, the resonance, distortion and feedback achieved by playing at loud volume.

The Missing Links were short-lived, as Jack Roundtree decided to get married and leave the Spades soon after the release of their single, and Roky was the obvious replacement singer. Roky duly joined, taking his friend John Eli with him, who was demoted to tambourine because they already had enough guitarists. Roky recalls that after rehearsals with the Spades he debuted with them at a fraternity party somewhere in Austin. This became their staple lineup and the band traveled around Texas performing at frat events in San Antonio and Dallas.[16.5]

> **Roky:** Frat parties—every once in a while you'd get a bad one. We played out by the lake and all of them were drunk, so they threw their glasses... Only, they weren't throwing them at us. They finished drinking their liquor and would throw their glasses on the ground and there was much broken glass all over the dance floor, girls were cutting their feet on it, trying to dance bare-footed.

The real proof of Roky's ability as a frontman was when he turned their worst performance into a triumph at the KOKE Radio Station Battle of the Bands at the Municipal Auditorium in Austin. This was by far their biggest gig to date, and they had no on-stage monitors and simply couldn't hear what they were playing. The "swimming pool" sound put them off, except for Roky, who continued unfazed, and although they lost to the Babycakes, their bookings escalated thanks to Roky's performance.

In mid-October, they played to an even bigger audience at the annual OU Football Weekend in Dallas. Following this, manager Gary McCaskill managed to book them regular club dates in Austin.

Le Lollypop was Austin's first real attempt at a discotheque complete with go-go girls. It was situated down on Riverside by the Colorado River and had a regular late Sunday afternoon slot for bands. As Terry Moore recalls, "Roky was out by the car and he was trying to get down the licks to 'Gloria.' He was listening to it on the radio, didn't take him too long; it's only three chords and then went inside and played it." The Spades' repertoire proved the perfect soundtrack for the girls to gyrate to while the audience attempted to emulate the latest dance moves. Roky had transformed the Spades. Although it would have been safer to record at least one cover tune, they had little commercial pressure beyond local demand, so they chose to record both of Roky's songs. Instead of returning to the Austin Custom Recording Studios, which were basic but up to RIAA standards, they headed to San Antonio, to the Texas Sound Studios, a cheap studio that largely catered to the local Hispanic music industry.

John Kearney: I was high as a kite, so I don't remember how I got to San Antonio. The studio was the size of a hotel room with one mike—I had to move the drums closer or further away to get the balance right, and Roky would have to stand closer or further away. It was exciting, we were young, and at that point considered ourselves musical veterans. I don't think we played the song more than two or three times.

What they recorded on Sunday, November 7 was to define "garage rock"—"You're Gonna Miss Me" was a masterpiece of deranged lo-fi, grunge rock 'n' roll mixed with Beat music. Its simple, arrogant lyrics suited its rebellious nature. The B-side, "We Sell Soul," was equally excellent, and for a fifteen-year-old kid to write a song that moved beyond the boy/girl, you/me formula of the day was quite remarkable. The bass gently introduces the rhythm in the opening bars before the guitars build to introduce Roky's first yelp, and his vocal remains central throughout the song while the soft mesmeric backing vocals hauntingly chant "we sell soul." Although Roky claims the song was about the band playing soul music, there is also an air of ambiguity, as "soul" could also be seen as being an early attempt as a synonym for smoking pot.

Around this time Roky's long hair started getting in the way. When Lyndon Johnson scheduled a visit to Roky's family church, Roky and John Kearney caught the attention of the secret service as they scanned the congregation and were asked to leave. Just before he was due to take his GED and graduate from high school in the eleventh grade, Roky was kicked out—Evelyn believes it was for his long hair.

Donnie Erickson: Oh, he was the most popular guy around. He was the poster child for long hair; he got kicked out of high school in tenth grade.

His long hair was blamed again, though in reality it was probably just a convenient excuse for the school authorities to rid themselves of a disruptive influence. Despite Evelyn being summoned to the principal's

office, fellow Travis pupil Terry Moore testifies, "He didn't get kicked out for long hair, Roky just quit coming! He just dropped out of school."

> **Roky:** Oh, I had long hair, and I just decided I didn't want to be in school any more, and I asked my father if I could quit and he said yes. I just didn't like it, for some reason it was getting on my nerves. Something about it was really bothering me.

The Austin club scene was experiencing a pre-Christmas slump, and Le Lollypop closed in early November. Austin's other nightclubs were looking for any new gimmick to pull in the punters—new jukeboxes arrived on the scene that played short film loops of girls dancing. The long-established Jade Room was feeling the pinch too, and decided to invite the whole Le Lollypop show, including the Spades.

The Spades, having beaten their local rivals the Wig to the enviable mid slot at the Jade Room, were able to start building a local following. Almost immediately they received their first recognition from the press.

> *Austin Statesman*
> **November 6, 1965**
> **Jim Langdon's "Nightbeat"**
> **Le Lollypop Admits It's Licked**
>
> New Go-Go Girls at the Jade Room: Manager Marj Funk has hired two new go-go dancers for her weekend entertainment to go along with the Rhythm Kings. They are Jacki Kellendorf and Patty Badillo, the latter formerly with the Le Lollypop. On Wednesdays and Thursdays, Marj says she doesn't need dancers to put on a show. ROKY ERICKSON and the Spades, along with their growing following, take care of that all by themselves. The band is sounding better and drawing bigger crowds each week. By the way, the group will make it down to San Antonio this Sunday to make the master tapes for their new record—two tunes written by Erickson himself.

The Jade Room belonged to the past, a dimly lit smoky old beer joint that needed a youthful breath of life. The bar had been set up by Doc and Marjorie Funk, who had previously run the Flamingo Lounge on Lake Austin before opening up the original Jade Room in the early 1950s. After relocating to an old grocery store on San Jacinto, Doc wanted the club to be more than just a beer joint. It was dark, velvet curtains over the plate-glass windows, painted jade green with car paint (later red) and the most striking feature hung from the ceiling—a huge papier-mâché golden dragon.

> **John Kearney:** It was a view into the pre-go-go era... Dark place, low light, the smell that old clubs have, something like an old pool hall, spilt beer, heavy smoke, but not unpleasant. The Friday night house band was called the Rhythm Kings;[17] they'd been there forever. I don't know how Gary McCaskill got hooked up with Marjorie Funk,[18] except one day he woke up and decided to do his job.

Evelyn, ever proud of her son, took Roger and some of her friends to see the band at the Jade Room. She was delighted to discover something new; her husband seemed less impressed, but dutifully made an appearance.

Aside from the Spades, the Austin music scene offered little in terms of competition. The Wig played many of the same cover songs as the Spades, but were pedestrian in comparison; their singer, Rusty Weir, was stuck behind a drum kit and couldn't rival Roky's dynamic stage presence. Although the university and Ghetto crowds considered jazz and folk to be the only authentic music, word soon spread of Austin's new teen sensation, and the bohemian elite descended on the Jade Room to see Roky for themselves.

At Jim Langdon's suggestion, Tary Owens had witnessed Roky and recommended them to his neighbors Tommy and Clementine Hall. Tommy and Roky met during the break and they immediately hit it off—Roky absorbing Tommy's "endless possibilities" rap while enthusing about Dylan.

> **Clementine:** We knew that the Spades were okay, but not terribly good—but we knew that Roky was something very exceptional. Roky joined us—he came and sat with us the first time Tommy and I saw him. He actually even came on to me—I was very flattered, because he was a beautiful young man! I said, "No, I'm married to this gentleman here on my right." Roky and Tommy loved each other, because Roky was very like a child. Very, very, very like a child. And Tommy's always looking for someone receptive to his ideas—who better than a child? So they were very fond of each other from the beginning.

Stacy, Benny and John Ike met at the Halls', and collectively dropped acid for the first time before descending on the Jade Room.

> **Stacy (K):** Roky was super intensity—you know what I mean? He was doing a lot of Byrds songs, Bob Dylan songs and Animals songs, "Tambourine Man"... Everybody was really impressed with him right away, and just immediately we decided we ought to get together. Tommy was more or less the middleman. Tommy contacted John Ike and told us he'd found a singer that he wanted us to come up to Austin to hear.

In late November, the inevitable happened.

11. 1861: "Aura Lee" by composer George R. Poulton was used by Elvis as the template for his 1956 hit "Love Me Tender" RCA 47-6643.

12. In her autobiography *Million Dollar Mermaid*, Esther Williams recounts how she took LSD as a regression treatment in 1959 after telephoning Cary Grant having learned of his treatment with the drug.

13. *The Tingler* also featured the first big-screen depiction of an LSD trip, which took the form of Vincent Price hamming it up in his laboratory.

14. Probably the most infamous and influential of these late-night wonders was Wolfman Jack, who broadcast on XERB 1090. His show ran from nine p.m. to three a.m. and consisted of rock with commercial breaks only for record packages from Uncle George's record store. Listeners were encouraged by Jack to buy these packages: "You gonna love this record package baby. Send your $5 to Big Forty, XERB, Chula Vista, California, so the Wolfman can eat tomorrow!" (*Mojo Navigator* No. 1)

15. It later transpired that a lot of the rare blues records he had borrowed via the university crowd he'd met at the folk coffee bars actually belonged to Tommy Hall's vast record collection.

16. Little Willie John, "Leave My Kitten Alone," released 1959 on King Records (5219).

16.5. During this period Roky was rumored to have been involved with another couple of bands, both of which he doesn't count, but acknowledges that he may have had some minor involvement. First was another Travis High band, the Delmores, which fellow pupil Billy Hallmark recalls Roky tried out with—the other members were all too intimidated by his stage presence. The next was the Fugitives, with George Kinney. While George and other family members recall Roky participating in this band, Roky doesn't recall any involvement. According to George, the Fugitives existed as a rehearsal band circa 1964, and played the odd party and high school dance. The lineup supposedly featured Roky and George on guitar and vocals, Gary Pounds on drums, and occasionally Billy Hallmark and Jimmy Bird, who both later joined George in the Golden Dawn.

17. The weekend slot remained with the Rhythm Kings, who had played at the original club since 1954 and guaranteed entertainment for the regular, older crowd. Diane Lazelle (Funk's daughter): "The Rhythm Kings did 'Stagger Lee,' 'Saints Go Marching In,' mixed group, One of the singers was kinda like a Ray Charles type. Daddy would start a snake line and everyone would join in."

18. Doc died in 1964 and Richard, their son, helped run the club and persuade his mother, aged fifty-three, to allow the younger bands a slot. Richard Funk: "I was running the club in the summers and mother was going to Alabama to visit her brother, for two or three months. So what we started doing was auditioning rock bands and what we did is we set it up so they had a night to play."

4.
BOOM
(EVOLUTIONARY,
NOT REVOLUTIONARY)

In ripples—and waves—the use and abuse of drugs that affect the human mind is spreading across the country. By the hundreds of thousands, perhaps millions, young Americans are tasting, testing and experimenting or going further with marijuana, with LSD, with uppies and downies of pep pills and sedatives, with speed and, a few, heroin.
—Associated Press, 1969

The greatest medical threat of LSD is the amount of paranoia and fear it produces among those who have never taken it.
—Timothy Leary

When you first turn on, everything is really clear and you're really organized; you know what you want to do and you do it. It looked so easy at first.
—Stacy Sutherland (K)

Austin Statesman
Friday, November 19, 1965
Jim Langdon's "Nightbeat"

Swung by the Jade Room Thursday night. ROCKY [sic] and the Spades are still packing them in and, in fact, are playing to an even more diversified audience than ever before. On hand Thursday night were the usual crowd of rock 'n' roll fans as well as a few small children with parents, a few horn-rimmed glasses adult spectators and members of the ultra-cool bearded set. When a band can draw that diversified an audience, their music must have some universal appeal to it.

In mid-November 1965 morale within the Spades was high. With a newly recorded single being mastered on November 18, they were hoping for a regional hit promoted by a statewide tour. "You're Gonna Miss Me" started to gain local airplay on KAZZ-FM the following week, and copies went on sale at J.R. Reed's music store on South Congress in Austin and at the Jade Room, where the band were booked in their usual mid-week slot. However the Spades' high hopes evaporated when their dynamic lead singer was poached by another band. The arrival of "members of the ultra-cool bearded set" at the Jade Room was merely a warning of the task force led by Tommy Hall the following week. Their entrance made such an impression that even Roky and John Kearney, who were performing at the time, noticed them. Mikel Erickson was running the door and he identified them immediately as the band he'd seen "playing at the Dunes Club—I remember coming back up to Austin and telling Roky about this 'bad band, man, real bad-ass band.'" As soon as he finished the first set of the evening, Roky, recognizing Tommy Hall and Lynn Howell amongst the crowd, stepped off the bandstand and introduced himself.

> **John Kearney:** I can see it in my mind. You noticed them right off. It was evident from the moment they walked in the bar room door that this was a whole different element. Their dress was not mod or pop—it was hip. Benny, of course, stood out, because he was very tall and wore an earring—the only people who did that at the time were merchant marines (for every time you circumnavigate the globe). And they looked like musicians. Stacy, I remember, had a goatee—beards were common, but the long hair... you were taking your chances. It was pretty radical stuff. Clementine was tall and beautiful and smiling. The night was a point of confluence where so many things came together.

> **Roky (NFA):** I was playing with the Spades at the Jade Room, and all of a sudden these four cats came in, and it was like they had auras around their heads, 'cause you noticed them. Like they came in and sat down, and I said, "I wonder who they are?" And then they came up and said, "Listen man, we're with a group called the Lingsmen, and what we want to do is put together a big group..."

The Lingsmen, beginning to feel the affects of the acid Tommy had given them earlier, knew they had found their singer. Tommy was slowly and subtly piecing his equation together, introducing the musicians to LSD and then to each other, although to what extent he contrived the evening wasn't clear—even to Tommy. However, Stacy recalled that every time he visited Tommy they talked about taking acid, but never actually did until they visited the Jade Room to see Roky perform. Meanwhile, Dana Morris had bought the Spades' 45 and danced to it on her coffee table with her girlfriend, before setting off to the Jade Room that night to see them play in person. After the Spades finished their second set, she felt that something was up. Not only did John Kearney leave early with his girlfriend looking upset but, more importantly, she couldn't get Roky's

full attention and in a bid to make him aware of her, she diverted her interest to his best friend George Kinney and began dancing with him.

Roky needed no persuasion to accept the Halls' invitation to their house after the club. Mikel dutifully loaded Roky's equipment and drove him over to meet them. The Lingsmens' equipment was already set up, and after a few joints were passed around it was their turn to perform for Roky. The combination of Stacy's guitar proficiency, John Ike's unique drumming style and Benny's upfront bass, blended with echo chambers, was enough to convince Roky that this was a tight, loud and dynamic band, behind which the Spades paled into insignificance.

> **Roky (RNR):** So I went over to their house and listened to them pick and I just... I couldn't believe it, man—they had echoes and everything all set up. Benny says, "Well, we're going to outer space," and flipped on the echo chamber and [it sounded] like a flying saucer takin' off, and then they'd start off their "Tried to Hide" and things that they had written so far. You just wouldn't believe them.

> **John Ike:** Roky just sat there. Because we didn't know any of his songs, we may have played something like "You Really Got Me" and stuff like that. We played blues jams, and Tommy started blowin' on this jug. And we didn't know what to think of that.

Tommy's inclusion in the session wasn't unwelcome, nor the clay whiskey jug he happened to have—it was the method in which he employed it that took everyone completely off guard. In a traditional jug band the player blows into the empty vessel to produce a slow and low percussive bass sound, whereas Tommy used his voice and throat to mimic fast, jazz-inspired runs into a microphone, and employed the jug to add resonance and reverb, creating an entirely unexpected new sound.

> **Mikel:** They proceeded to lock themselves in this room and all this music started coming out like I'd never heard before. Yep, they jammed and it was strange—like earthquake-type music, you know? Just jamming and the titter tattering of what you found out later on was this guy blowing into a jug. My recollection was that the police came to the door and asked them to turn down the music, and I beat on the door to get them to turn it down and there were disruptions and this one guy, who I found out was Tommy, told them, "Everything's OK. OK? It's an experimental thing. Everything's groovy. Everything's cool." So they said, "No it's not!" They were getting real paranoid.

The intrusion of the cops was a glimpse of the future. However, the evening would prove successful for all—and the next two weeks leading up to their first performance were a rollercoaster ride, one long blur from which only the foggiest memories have survived. Roky came to Port Aransas to see the band perform, gave his notice to the Spades, and band rehearsals began in earnest. Although everyone was elated, insecurities began to form immediately, in particular for Roky.

Roky (NFA): It was a real emotional thing, because John was a real good friend. Like leaving home. You don't wanna be cruel: So I joined the Elevators, and we just, at first, wanted to keep it real quiet, and then surprise them. Let people be hearing about us.

Clementine: It was absolutely magical and electrical. Then we had a problem—Roky says, "Now what am I going to do about the Spades? What I'm worried most about is John Kearney, because we're so close, and I don't want to hurt him." I said, "Well then, Tommy and I will go with you to see John and Susie." So we moved them into the second floor of our house and they lived there. We really felt strongly about ethical behavior because we totally believed in karma. We thought anything we handle badly is going to kill us.

Clementine was the eldest and a mother, and her solution was indicative of the nurturing role she would play, particularly for Roky. It also helped confirm that the band was being formed from a sense of community, which in turn blurred the fact that she and Tommy didn't actually have a role, even though they were integral in forming it. The others regarded Tommy as a non-musician, unconvinced by the jug as a viable instrument. It was clear Stacy would remain on lead guitar and Roky would join on rhythm, and although Benny was by far the best-trained musician, his bass playing was weak and in question. So it was debated whether Tommy on bass and Benny on electric fiddle would give them the other dimension. Yet Tommy transformed the jug through his love of jazz from its "hick" origins into a spiritual instrument, one that complemented and followed Roky's vocal harmonies as Echo followed the priest's voice in the Greek church.

John Kearney: As I recall, the original deal was that Tommy would play bass, and their unusual instrument would be Benny on violin instead of the jug. Later, somehow, this changed without Benny being able to vote. I'm not sure that Stacy ever considered the jug a real instrument, and I think he was taken aback when this change came in where Tommy would not play bass.

The jug was either an integral part of the band's sound, an unusual means of creating an organic "psychedelic" sound—a mouth synthesizer, long before such affects were available—or a relentless, warbling appendage. Tommy's idea was that the jug would embellish the Elevators' sound in the same way that the Byrds employed a twelve-string guitar to create their folk-raga-rock sound. John Ike took an immediate dislike to it, and felt Tommy wasn't even playing the thing properly. His opinion fluctuated between seeing it as a commercial gimmick and as a manifestation of his dislike for Tommy. Stacy felt it wasn't a proper instrument, but was unwilling to stifle someone else's expression. Later, he did take issue with it being applied to every recording, whether or not it was appropriate for the song. He felt that its prominence compromised his position as lead guitarist. However, the jug was to remain an integral element of the band's sound.

Unwilling to start another bassist from scratch, rehearsals continued with the jug, which could easily be drowned out and no violin. The band wanted to move quickly in order to establish itself as Roky's new band before the Spades single could take hold on the local market. It had risen to #28 from #49 on the KAZZ-FM chart two days before the band's first show. Worse still was that Roky was still contractually obliged to perform the remainder of the Spades' fraternity engagements until the end of December. It was decided that the best solution was to rehearse and perform as soon as possible and take the Spades' slot at the Jade Room. Marjorie was still running advertisements in the *Statesman*, unaware that anything was up, but the Squires played instead of the Spades the following Wednesday. The Spades' manager, McCaskill, told Roky that he'd made the wrong decision by joining the Lingsmen, and gotten in with the "wrong crowd." But Ernie Culley was leaving Austin for medical school and the other band members knew that time was up—there simply wasn't a replacement this time.

Austin Statesman
Tuesday, November 30, 1965
Jim Langdon's "Nightbeat"
11th Door Wins Its Beer License... Set Tonight

The 11th Door should be ready to serve beer tonight after having been granted a license.—ROCKY [sic] ERICKSON and the Spades have reportedly broken up, each to go their separate ways...

The Spades' manager wasn't the only one to voice concern over Roky's new partnership.

Tary Owens (AV): Tommy was a manipulator and, frankly, I never trusted him. I had second thoughts as soon as I introduced him to Roky that this might not be a good thing. Tommy used acid to manipulate the rest of that band, but it wasn't in a violent direction. Tommy wasn't a violent person, and he thought he was doing the right thing. He thought drugs were the key to the universe. They were all into this acid-delusional thing. It affected Roky the most, but there wasn't a single person in that band who wasn't physically and/or mentally damaged by what happened back then.

Tommy: Well, that's ridiculous. That gets me. He may have thought I was manipulating Clementine, but not the band. It was just a bunch of people who got together, all just smoked weed and, you know, Clementine included. I think we proved we did a good thing.

Tommy did have an agenda—a vision of a band as the medium for his message. The idea was that the band would take LSD and then "play the acid," provoking a synesthesic reaction from the audience.[19] Unfortunately it was virtually impossible to describe the temporary revelations of the psychedelic experience without actually being on the drug. Therefore, if the band—and possibly some of the audience—were tripping on acid, it

(CIRCA FEBRUARY 1966) ROKY, PHOTO BY BOB SIMMONS

(CIRCA FEBRUARY 1966) STACY, NEW ORLEANS CLUB, PHOTO BY BOB SIMMONS

would evoke and reinforce the message. The problem was how many of the band members would share his vision. The only way he could find out was to introduce it into the rehearsals. Although everyone had supposedly dropped acid the night they went to see Roky and the Spades, it's not known whether everyone actually took what Tommy handed them. Stacy and Benny had an appetite for experimentation, but also shared a redneck caution with John Ike. John Ike claims not to remember his first encounter with LSD. However, his second trip was to shape his future relationship with the drug and with Tommy. He freely admits that this whole early period of the band's history is a blur due to his drug use. Roky had been well aware of all the interest in LSD in the late Fifties and it appeared to be the perfect catalyst for creating a new heightened performance. Roky thrived on extremes and was well aware from theater training of the concept of breaking the barrier between the stage and audience. If Tommy was right and the band could "play the acid" and make the audience high, they would be reinventing ancient ritualistic traditions, creating a new type of performance.

> **Roky (RNR):** I saw a program on LSD before I met the Elevators. When I saw it, it was like the first time you ever hear about telekinesis, déjà vu or things like that. It really floors you. So we were for the psychedelic experience. We were always pushing that. See, a psychedelic will remind you that you don't need hard drugs. We were saying that people ought to open up their mind and let everything come through, like it says on "Roller Coaster." You don't need the hard stuff once you get into the psychedelic experience. Psychedelic drugs instead of hard drugs like heroin and methedrine, things like that.

The first time the band collectively decided to take hallucinogens at a rehearsal was a defining moment. In an extremely rare interview given in 1973, Stacy recalled the first time Tommy collectively introduced the band to LSD:

> **Stacy (K):** Later we turned on with him [Roky] again, and the first time we played we went out of this house and, man, ol' John Ike got ripped up. We got so stoned. John Ike looked up, he kept saying, "God, I can't believe this is happening." He kept looking really shook up, and I said, "What's wrong man?" He said, "We're going to heaven." I said, "What do you mean?" He said, "We're going to heaven, man, that's Adam and Eve. And we're dying, we're getting ready to split." And I didn't know what he was talking about. I said, "Listen, John Ike, you're on a rib." And boy that hit him and all of a sudden he freaked out and said, "What do you mean?" I said, "That's Tommy and Clementine, and we're just out here on acid." Benny was in a pretty groovy place, but he was mocking a lot of Tommy's philosophy. Tommy would explain it to us and told us we might have a bad experience where we thought we where dying, but he explained a little bit about rebirth and so forth, and so nobody really had any idea, of course, what it was going to be like if anything like that happened. And ol' John went on one right off you know.

Once we'd had an (LSD) experience, we all had this spiritual thing that happened together. I mean it was really a religious thing. We just all came on together and we were in a wonderland. And ol' Tommy had put us, with his knowledge, into a clear state. You know what I mean? It was a completely clear state of mind. And it was like you were free. Totally free.

Although John Ike claims he had no problems with LSD when we went to the Jade Room to see Roky, he seemed confused about exactly what Tommy had given him at the rehearsal. He believed Tommy had given him a rigged-up concoction of LSD and a speedball (heroin and methamphetamine). However, this was highly unlikely since Tommy was vehemently anti-speed and heroin, and the only powdered substance he was likely to be using would have been crystal mescaline. Whatever John Ike took had a profound long-term effect, and one of the immediate consequences was that he could no longer focus on his drums or keep time. When Tommy offered advice John Ike wasn't buying it.

John Ike: I had the worst trip anybody could imagine. I just didn't want to take any more. First time, nothing happened. The second time, Tommy gives me a massive dose—an overdose. He gives me a gelatin capsule full of it. He said, "Here. Take this." I said, "I don't want to take this. No, thank you." Then Stacy comes in, "Hey, man, listen. You've got to take that acid or you're not going to be in a place with us. And we want the band to be with us, man." And Benny comes in and says the same thing. So I said, "Okay, what the hell." I took that stuff. I was playing the drums here and the walls started to move. I mean I was out of control. My brain was out of control. I had no control and I didn't like it. It scared me. I was terrified of Tommy. I was terrified of all of those people. I didn't want to do anything but crawl around in the front yard of this house and look at the fields. It's weird. That stuff is—it might be fine for some people but—I'm not the same.

According to John Ike, Roky was completely zoned as well. Tommy and Clementine took charge of John Ike, as he was causing unwanted attention by scrambling around on his hands and knees outside, and obsessing about plants. They managed to get him inside and Clementine spent much of the night with John Ike lying on the sitting room floor talking him through it. At some point in the evening after any attempt at rehearsing was abandoned, some of the band decided to drive around Austin and look at the sights. Heading west from 38th Street, the road becomes bumpy and undulates—this became known as the first section of the infamous Roller Coaster drive. They then headed for the state capitol building, where they met fellow musician Charlie Prichard: "Benny was saying, 'I get this red haze right in front of my face. You get that don't you?' I never thought about it but I've been looking for it ever since. We went down to the capital building and stared right into the floodlights shining on to it, and drove around." They headed toward Mount Bonnell, a local beauty spot famous for its view over the city. The roads twist and

turn sharply around the hillsides; amazing views drop off to one side as you ascend to the top of the hill, where Austin sprawls out in a criss-cross of street lights below. Charlie Prichard recalls, "I remember we went up there and Tommy decided the lights of Austin spelled out, 'MY TOWN.'" When they returned to Tommy's house Benny became challenged by his new surroundings...

> **Benny:** They had candles lit and... Tommy liked Bach. And we took mescaline crystals, and it was real chief. I got away from Tommy. I escaped out the window and I crawled up into a tree and talked to a bluebird; all the trees and everything turned blue and that's where I got the light... the dream was so heavy, and I was so happy when the sun came up, I mean there's so many applications to the trip we were pioneering but you know I couldn't feel good about applying it to music.

After sunrise their trips had finally faded and each band member crawled back to their respective homes. It had been chaotic but somehow that evening had cemented the future of the band. Hallucinogens were to become an integral part of the band's existence. Creatively and as inspiration they were the catalyst that made the band unique. The events of that night cemented the roles each would play—Roky as the face and voice, Tommy as the vision and lyricist and Stacy the sound. Yet their individual reactions to LSD were still divided.

John Ike says that was the second and last time he took LSD. His confesses his memory of the early Elevators days had largely gone, and attributes his "paranoid schizophrenic" condition to his youthful drug use; it has since been treated with lithium.

Benny also found the new drugs hard to cope with. He was and is manic, suffering from such bad tension that he still has to take medication for muscle spasms. He has only recently come to terms with his experiences in the band and by taking part in this book, he has broken a long silence imposed by his family.

> **Benny:** Tommy was just too smart for me to even comprehend. If he got mad at me, you know he'd mentalize me around. I got real tender from that, he had the power and he wanted to play it right.

Tommy, on the other hand, was serious in his belief that LSD was a learning tool and to this day he believes in its benefits. He was able to source regular supplies of LSD from the East and West Coast student network in exchange for grass. Chet Helms was a close ally throughout and a regular visitor at the Halls' residence. Tommy saw John Ike's bad reaction as a blow to his master plan—but it was probably the only reason they could play in time at all.

> **Tommy:** We were naïve. It was my idea that we would play the acid. Well, you can only take it once a week. So that was a problem. So we all took acid, but John Ike had a bad trip, so that was the first hole that we had in the group because my idea was we would all be on acid

~ 80 ~

and then we would reinforce one another as we played. We played some shows when we were on acid and we had people come to us saying they were more stoned now, digging our group, than when they were on peyote. It had done that to their heads.

Stacy (K): As far as playing it, (being on acid) was a lot more intense. Like I feel I was a lot more imaginative on acid. We got tee'd in to a trip together, just really quite some of the greatest experiences I've ever had in my life musically were on acid. I remember one time we were playing and we were working on a song and it would be good, but it would have some kind of force; I can't explain it [except] that it was like another dimension, like a wave, a wall... it's like it only happened maybe six or seven times the whole time we were together and we never got it on record... but it emotionally effected me, raised me up.

Although Roky had apparently been "blown away" by his first experience, by his second he felt under control and wanted to take his good spirits home to experience his family. Evelyn denies what allegedly happened next—if Tommy and Clementine are correct,[20] it was to be the first of several occasions when Tommy rescued Roky from the back door of a mental institution.

Tommy (AC): One day, Clementine and I went tripping with Roky. At some point, Roky wanted to go home. Clementine thought he should come down more off the acid before we dropped him off at his mom's, but Roky insisted it was cool. I agreed with Roky and we dropped him off. I regret that to this day. We didn't know what happened later that night. The next thing we knew, a day or so later, we found he was in, I believe, Austin State Hospital! Tary and I knew someone who worked at the hospital, and he left a door unlocked for us. We went there and broke Roky out.

Clementine: I think it was the second time Roky got high with us. Evelyn was the one who decided he was out of his mind and needed to be hospitalized when he was high—she thought he was crazy, she refused to believe he was high. And Tommy and I had said "please don't make us take you home, we don't think you're gonna be safe there." "Oh, of course I'll be safe with mom!" "What if she sees you like this?" "She'll be fine." And she had him committed! I do know that while he was high, he was subjected to shock treatment, and that was when the biggest damage was done.

There was possibly an unconscious explanation behind Roky's artistic ambitions. There has been much debate over the years as to when Roky first experienced the symptoms of mental illness and what the route of the cause was. He has been diagnosed schizophrenic on several occasions, and here lies the problem. As of 2007 Roky will clearly tell you he has never experienced any symptoms of schizophrenia—it was all a necessary ruse to avoid the draft board in 1966 and jail in 1969. "Schizophrenia" is an unsatisfactory umbrella term for a range of disorders for which there is no

medical diagnosis, and the stigma can lead to marginalization and social control, often through excessive medication and incarceration—both of which he experienced. Today there is a serious lobby by many psychiatrists to argue that schizophrenia is a redundant and unhelpful diagnosis. Certainly Roky has a highly emotional state of being, informed from an early age by his equally neurotic parents, which manifested in a hysterical and eccentric personality. In 1973 Roky stated he became aware of his mental condition changing aged seventeen (he now refutes this). Aged eighteen onwards he embarked on a toxic overload, experimenting with a pharmacopoeia of illicit substances, supposedly typical of 40% of people suffering from "schizophrenia." In 1975, Roky surmised that although bands took drugs to keep on the road he used mind-altering substances as a means of retaining control of his mind.

From an early age, Roky made a decision to live his life on his own terms. He invariably stops taking the anti-psychotic medication he has been prescribed as soon as the symptoms begin to be controlled, preferring his natural mental state to the inhibiting side effects. Roky's use of drugs and chosen lifestyle were both therapeutic and destructive to his mental state. Roky's behavior during his periods of illness appear to parallel many of the generic psychotic symptoms (hallucinations, disorganized thinking, delusions).

While the "normal" brain can distinguish the sound of a constantly dripping tap and relegate it as useless information, someone suffering from a psychosis cannot differentiate and will react equally to all environmental stimuli until the accumulative bombardment reaches a cacophony—they cannot habitualize to their surroundings. The most obvious path to regaining control is simply to "scream" over it all.

Assuming Roky suffered from such symptoms, his life as a rock musician—playing at extreme volume, using feedback to create a "third sound," would have addressed this dehabitualization. Equally, focusing on reciting lyrics, familiar information patterns, would have the same effect. While the relationship between LSD and psychosis is ultimately territory for the research scientist, it is particularly relevant to Roky's life. LSD's effects can stimulate the central nervous system to redefine its surroundings through a brand set of senses, and the result can be synaesthetic. A blue object in the real world is only reflecting light back into receptors in the eye to make it appear that color. In an altered state of perception the object could appear as a different color or stimulate another sense entirely—the color could be smelled or heard. The way in which hallucinogens influence dehabitualization validates the psychotic perception where the surroundings are "emitting" too much information. In the Sixties, Roky coined the phrase "I'm transmitting but not receiving," which mirrored Nijinsky's anti-Descartian theory "God is the fire in my head, I do not think and therefore I cannot go mad." Historically there has always been rebellion in writers such as Baudelaire, Woolf and Poe, who chose their mental turmoil as a source of creation and a means of battling mundane normality. As George Kinney recalls, Roky devised and employed mental safety nets: "He always used to tell us, 'Put breadcrumbs on the trail when you go on psychedelic experiences so you can find your way back,' just

like the old Hansel and Gretel nursery rhyme. Early on, Roky never did get too far out, he had a way back and it was very down home. People who didn't know Roky never knew that side of him, very deeply rooted in the physical."

Playing "psychedelic rock" could have been very therapeutic for Roky Erickson.

Tommy was equally interested in challenging the workings of his mind to find the answer to the source and mathematics of the divine and the universe. While many writers and artists before them had tapped into unknown sources for inspiration, Virginia Woolf directly asserted "As an expert, madness is terrific, I can assure you, and not to be sniffed at, and in its lava I still find most of the things I write about. It shoots out of one, everything shaped, final. Not in droplets as sanity does…" This band was certainly going to be unique, set for a journey into inner space.

In the two weeks before their first gig, the whirlwind of activity and introduction of LSD led to a cloud of confusion over band leadership, a problem that was never resolved. No one ever established whether this was an entirely new project envisaged by Tommy, the continuation of John Ike and Stacy's old band or Roky's new backing band. John Ike couldn't deny that Tommy achieved a major coup by getting Roky, but he felt obliged to reinforce his position as the band leader because he'd supplied the bulk of the musical equipment and transport. Benny and Stacy both recognized this, but Tommy was operating in a completely different realm from the material band's functions.

> **John Ike:** That's the first and only band I could ever really say that I formed. Of course, without Roky—there's no telling what would have happened if Tommy hadn't gotten Roky. That was a monumental task, and all it took was three hits of acid and Roky was following Tommy around like a kid. Tommy started giving him acid and he had control of his brain—Tommy was twenty-two years old, and Roky was eighteen years old. And Tommy had dope. Roky liked dope. Then Tommy and I locked horns right away because I said to Tommy, "I'm handling the money in this band. This is my band." See, I got a bass player, lead guitar and a drummer. I said, "I pay everybody." I wasn't taking any more for myself, but I wasn't going to trust Tommy Hall, the guy I'd just met, with my future. Because he ripped them off bad.

The wrangling over establishing who had named the new project compounded the issue of whose band it was.

> **John Ike:** We sat down by the table and said, "We've got to have a name for this band." I said, "How about the Elevators?" Clementine liked that name and said, "Oh, well we've already thought about that." But they hadn't thought of that because we went directly from the band room to the table in the kitchen and I'd thought of it, and then she thought of "the 13th Floor." Then we put the "13th Floor Elevators" together as a name; well, she did, and that's how we got it. The next day, Tommy comes over and he says, "How about 'the 13th

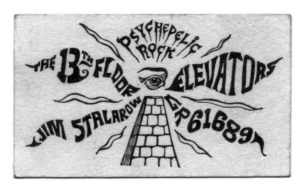

Floor Elevators'?'" At that point, Tommy claimed that he thought of the name. But Tommy was a liar and a thief.

Clementine: No, the band name came later than that first meeting. I remember very clearly the evening that the band was named. People will agree with me or not. At the time I was writing a gothic novel and I was lying in bed and Tommy said "We're trying to come up with a name for the band, do you have any suggestions?"—so I said, "Well, there are a lot of black bands that have names that kind of sound like this: Miracles, Temptations… Why don't you call yourself the Elevators? It's got that kind of a black, Motown sound." So he goes "Ah! That's good. That's good!" so he goes back into the living room and comes back about fifteen minutes later and he goes, "They liked The Elevators, but it's too short—it needs to have more tacked on to it." And my favorite number is thirteen—it's my lucky number, plus it stands for "m" in the alphabet, which is marijuana, plus most buildings do not have a thirteenth floor—so why not the 13th Floor Elevators?

Regardless of who named the project, Roky felt it suited their goal.

Roky (NFA): There's not a thirteenth floor in a building, so we said, "We're playing on it." It was like if you want to get to the thirteenth floor, ride our elevator.

Although Roky may have avoided band politics when it came to the rehearsal room, he was more than willing to exert himself. Powell St. John was one of the few people allowed into the closed rehearsals.

Powell: They had scheduled rehearsals and they all showed up and argued like hell. You wouldn't think enlightened people would argue like that, but they did. Mostly between Roky and the other members of the band. It was in the spirit of working things out and having got into a band after that I realized it was nothing that unusual. You get

together with your band and part of rehearsal is screaming at them. The times that I saw them live I believe that they were on acid. It sounded as though they were operating as a single being, a single unit. They were intuiting one another to an extent that I had never seen before. It didn't look like they had practiced the stuff, they were communicating almost telepathically. Now that may be my own prejudice, but that's how it appeared to me. I don't know how they could do it either, because when I took acid I couldn't do anything else but lie in one spot for twelve or fifteen hours.

Rehearsals initially took place in the living room of Tommy's new house, 403 E. 38th Street. The band would get stoned, set up and then jam. By the end of a session the living room floor would be an inch deep in Mary Janes wrappers (a candy that Tommy found amusing, as its name was also a nickname for marijuana)—but with neighbors on each side and Clementine's kids tucked up in bed, noise was a problem. Benny recalls they even set up in a tiny stairwell with John Ike's kit at the foot of the stairs and various members in doorways and perched on the steps. Rehearsals briefly moved to Clementine's father's ranch north of San Antonio before Yvonne, Benny's girlfriend, found an empty house on the outskirts of town. The Lingsmen were already a practiced band and they quickly agreed on a set of mutually known cover tunes by the Beatles, Stones, Them, Dylan and worked up Roky's "You're Gonna Miss Me" and Stacy's "Tried to Hide."

The band felt a pressure to perform immediately as gossip spread that they'd stolen Roky from the Spades to steal "You're Gonna Miss Me," which was still receiving local airplay. They also needed to prevent the Squires from establishing themselves in the vacant mid-week slot at the Jade Room. Marjorie Funk was willing to give Roky's new band a try but she wasn't taking any risks, so despite all the arguments over the name, they were immediately rechristened "Roky Ericson [sic] and the Elevators" in all the *Austin Statesman* advertisements. Later, as their infamy grew, it meant Roky's name was relegated to public enemy number one instead of being able to hide in the group anonymity.

So within two weeks of the band forming, preparations for their first gigs on December 8 and 9, 1965 at the Jade Room were finalized. This signaled a working relationship with Sandy Lockett, who became the Elevators' soundman and later informal tour manager.

> **Sandy:** I engineered the first gig at the Jade Room. They were using whatever could be gathered together, I used a remarkable rig consisting of stacks of KLHs and lots of Dynaco Mark 2 amplifiers. It was so difficult with the jug and the open mikes and the extreme, for that time, volume.

They managed to draw a decent crowd both nights at the Jade Room and most of Austin's hip crowd showed up, a large percentage of them tripping. George Banks, an artist with connections in the Houston club scene, brought with him James Harrell and Pete Black, members of the Houston band the Misfits, and an acquaintance of Tommy's, Jim Stalarow.

George recalls he joined the Elevators in Waterloo Park around the corner and diced up peyote, which they washed down with a quart of Coke. Everyone managed to keep it down, including George who managed to not throw up for the first time (although his wife did). As Benny recalls, he and Stacy also took another concoction: "Don [Grewer] hit me and Stacy up with meth, and John Ike bitched. We made it to the Jade Room—that was the first appearance that we was actually on top of the chemical we was taking and knew how to drive. And I did great, but the aftermath of it is just like cleaning up and trying to fit back into my family life."

The gig was a mixed success by all accounts; Roky spent most of the gig with his eyes focused on the mirror ball in an attempt to hold it together. They busked through a set based around Roky's Spades repertoire—Dylan's "It's All Over Now, Baby Blue," the Beatles' "I'm Down," the Rolling Stones' "Empty Heart," "Mercy Mercy," Them's "Gloria," James Brown's "I Feel Good," The Kinks' "All Day and All of the Night" and Roky's "You're Gonna Miss Me" and "We Sell Soul."

> **Evelyn Erickson:** I thought it looked good fun [laughs], sweet innocence... Roky came over and asked me, "How did we sound?" And I said, "Well, they don't sound like they're all together. Like, each one had their own drummer they were listening to."

> **Clementine:** I got in touch with Jim Langdon—he was wonderful. I said, "Jim, you've said wonderful things about the Spades, and I don't want to influence you, but I want you to hear these people." Well, he was not terribly happy with the new group because it did not compare to the tightness of the Spades, but they hadn't been together long enough to get really tight musically. We didn't mind that his review was less than whole-hearted and less than enthusiastic; after that he produced much better reviews.

> **"Nightbeat":** Closing out at the 11th Door tonight after a booming ten-day stand—Texas artist LIGHTNING HOPKINS. The great blues singer and guitarist has been packing 'em in at the club, even on week nights. Coming up next week in the blues vein will be three outstanding performers, including the first guest appearance of Port Arthur blues singer JANIS JOPLIN. Miss Joplin, who returns to Austin after a few years on both the East and West Coasts, is playing a Houston coffeehouse this weekend. Roky Erickson's new band—the 13th Floor Elevators—opened the Jade Room Wednesday and Thursday nights. The band drew good crowds both nights despite competition from one-night appearances of ROY HEAD and STAN. While Roky is still as exciting as ever, and the personnel of the new band sounds good individually, the group will need a little time to jell to match the continuity of the old Spades. And those who might have been curious as to the contribution of the amplified jug in the new group were probably disappointed, for the jug, even amplified, was hardly audible over the amplified guitars and bass.

The band had packed the club, so they were given a repeat booking the following week. This time it was Stacy who found the LSD experi-

ence too extreme, and it marked the first time Stacy was haunted by hallucinations of angels and demons, which would lead him to challenge Tommy's direction.

Stacy (K): The first really bad trip I had about the band was in the Jade Room. I was on acid and all of a sudden everyone in the audience turned into wax mannequins, and they were sitting there dripping wax on the table and I looked around and I'd been hearing these angels singing while we were playing, and I mean my guitar would lift, I could feel it just lifting up in the air. All of a sudden I heard demonic screaming, and everything got real red, you know how the Jade Room is, it was real red, I knew it was the end, I looked and saw that big serpent, the dragon, and I knew it was Satan, and hell. I turned around and said to John Ike, "I'm dying." This was about two weeks after he did the same thing, and I didn't know what he was talking about. He said, "Well, man, go ahead and die." And that just really blew me up and I just shacked my guitar and hit the door. I was going down the street and ol' Tommy caught me and said, "Man, where are you going?" I said, "Man, this isn't good. I'm going." And he said, "Well, you can die here just as well as down the street. We've got to play a gig." That was the first real vision of something bad, a negative presence...

With the first gigs out of the way, work began on their developing material. Although it was obvious from the outset that the Elevators weren't an average Austin band, they hadn't written any psychedelic material; instead it was their heightened sense of performance and reinterpretation of other people's songs that was supposedly "psychedelic." Early on in their career, the band performed at the University Union at Texas Rancher parties, and acid was dispensed to the audience while Tommy gave a brief introduction and explanation before the performance of what they were trying to achieve. Roky's explanation of the psychedelic sound correlates to the principle used in transcendental meditation, where three people speaking together magnify each other to equal the power of nine speakers.

Roky: We would put our amps on each other and it would create what we called the third voice, trying to form the feedback into a separate tune. And so it was called the third voice.

Bill Josey (KAZZ-FM's Rim Kelly): Tommy and I spent time between sets at one New Orleans Club live broadcast talking about the "lost chord." Tommy explained how the "lost chord" was created by what wasn't played and, therefore, perceived.

Although the band's intention was to create a new sound, there were obvious influences, such as the Yardbirds, which every member of the Elevators cited their as a favorite band at some point. The Yardbirds were important because they were amongst the first groups to break the blues copyist formula with a song called "For Your Love," which was

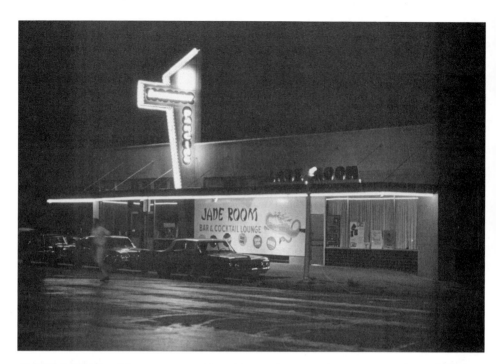

TOP: (CIRCA 1966) 1501 SAN JACINTO, THE JADE ROOM EXTERIOR, PHOTO BY BOB SIMMONS;
BOTTOM: (CIRCA 1966) JADE ROOM, NAILING DOWN JOHN IKE'S KIT, COURTESY JOHN IKE WALTON COLLECTION

TOP: (CIRCA 1966) JIM LANGDON & FRIEND DANCING AT THE JADE ROOM, PHOTO BY BOB SIMMONS
BOTTOM: (1966) BENNY & JOHN IKE AT THE JADE ROOM, PHOTO BY BOB SIMMONS

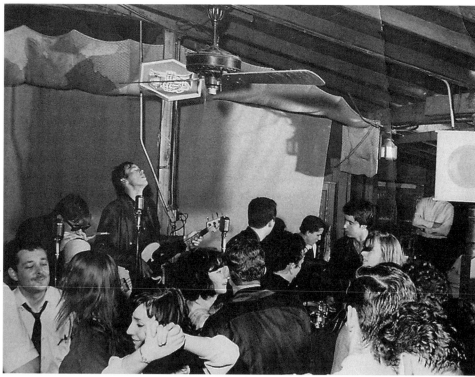

TOP: (1960) 1125 RED RIVER STREET, THE NEW ORLEANS CLUB, COURTESY AUSTIN HISTORY CENTER; BOTTOM: (MARCH 1966) NEW ORLEANS CLUB, L–R: JIM LANGDON (WEARING TIE), TOMMY, ROKY (BACK OF HEAD, NOTICE SHORT HAIR), JOHN IKE, STACY, PHOTO BY BOB SIMMONS

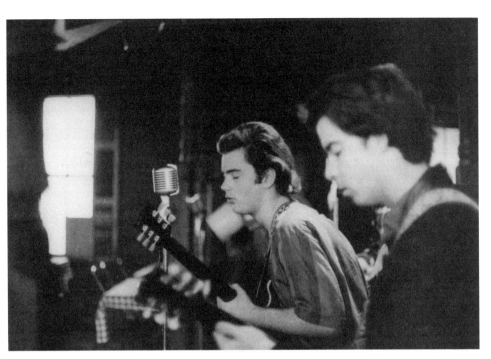

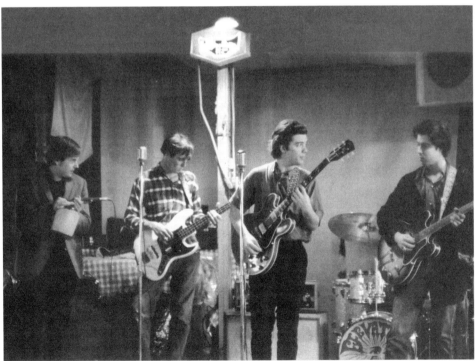

(FEBRUARY 1966) NEW ORLEANS CLUB
TOP: ROKY & STACY; BOTTOM, L–R: TOMMY, BENNY, ROKY & STACY, PHOTOS BY BOB SIMMONS

significant, because its guitar sound mimicked an Eastern sitar, a first step into rock-psychedelia. They were also extremely influential for extending the traditional middle eight of a song into a "rave-up"—a frenzied instrumental before returning to the song's familiar structure. This high-energy performance style was a perfect template for the Elevators to experiment without alienating their audience, who were primarily there to dance. Generally, their repertoire relied on borrowed material with simple lyrics and phrases that Roky could belt out and repeat over and over, working them into a frenzy as he built the song to a climax. This was his tried and tested performance style and it suited the band's driving pace.

Roky's incredible vocal dexterity, which could border on mimicry, meant they could effortlessly plunder any other bands' songbooks.

In terms of an outside influence on the Elevators' sound Roky once commented that there wasn't one other than trying to be psychedelic. However, the Elevators' sound was comparable to the early Who and the aggressive amphetamine beat of the British mod scene, which was reflected in their choices of cover material—the Stones' "Satisfaction" and "Empty Heart," the Kinks' "You Really Got Me" and, most extensively, Them's "Gloria," which became the eight-minute centerpiece of their set.

While the band was searching for their sound, Tommy was working on his psychedelic plan. Roky had only written three songs; "You're Gonna Miss Me" stayed in the set due to its obvious appeal, but his other two songs were soon to disappear ("We Sell Soul" would later be recycled with new lyrics, and "I Want to Die" died after the first gig). Beyond "Tried to Hide," Stacy had some riffs and Tommy was only too pleased for the mantle of lyricist to fall to him. He didn't become a fully-fledged band member until they began touring outside Austin and Stacy formally asked him to join so that they came across as a solid unit. Tommy felt Stacy's and Roky's songs lacked substance, and by writing new lyrics to old song arrangements, Tommy quickly began to formulate new material.

His first effort was to develop one of Stacy's songs into "Who Am I?" (later re-titled "Through the Rhythm"). Stacy wanted it to be a protest song against conventional society, specifically against school. Tommy was fairly unimpressed and tried to give it what he called "multi-dimensional textures." For Tommy, understanding acid was his sole focus, and this meant that everyday politics were secondary, if not irrelevant to him. Although he recognized the escalating political climate and the antiwar lobby, he felt distanced from it because of his politics, and being married with dependent children meant he was exempt from the military draft. Although Tommy's quest for a revolution of the mind was directly confrontational toward conventional society's teachings, he refutes that the band was overtly political.

Rather than fight the war against the war by adopting guitars instead of guns, as the MC5's manager John Sinclair's manifesto detailed in *Guitar Army*, Tommy's revolution was more Blakeian: "I must create a system or be enslaved by another man's, I will not reason and compare: my business is to create." (*Jerusalem*)

"Thru the Rhythm," however, is a fairly raw, punkish stab at society, condemning the "Establishment's" programmed knowledge, and raising the issue of why so many were dropping out of society via Leary's media, perpetuating the "tune in, turn on, drop out" challenge.

The lyrics for "Thru the Rhythm" were a first step in an entirely new direction—a shamanic rebirth through hallucinogenic sacrament and the recognition of irrefutable existence of the beyond: "After you trip, life opens up, you start doing what you want to do." Tommy's lyrics were in sharp contrast to the songs Roky had written for himself. Tommy was imparting information, while Roky was conveying emotion. Roky's songs were lyrically simplistic and dealt with one idea, although they often suggested more; "We Sell Soul" was about the excitement of "turning someone on" to soul music or pot?

Tommy was to introduce raw, far-reaching ideas. "Thru the Rhythm" was the first application of his studies of works such as Alfred Korzybski's *Science and Sanity*. As he changed the band's focus, audiences who witnessed the early dynamic performances with Roky hollering and shaking, Benny screaming and yelping, were alienated by subdued performances and criticized Roky for becoming an automaton, reciting increasingly complex blocks of lyrics. The assumption was that the band's performance lost something—the go-go dancers couldn't dance to their music anymore, but the band had chosen not to entertain Hicksville circa 1966, and were instead writing material that would earn them a virtually mythological status and lead to an international cult following. Tommy revitalized Stacy's song "Tried to Hide," which had simply been about hiding pot from the cops. Tommy wasn't impressed, and decided to experiment with applying a new writing style. Clementine had related a minor anecdote about Janis Joplin that perfectly illustrated her character.[21] Tommy chose to write about Roky's encounter with Sally Mann who began her career as *Rolling Stone* magazine's "super groupie" in Austin pursuing Roky. She got Powell to drive her to Roky's apartment, and when Tommy delivered Roky home after one of the first acid trips, Sally was waiting for him naked in his bed. Tommy was furious, as this was counterproductive to his higher vision of the band, so "Tried to Hide" became a Korzybskian warning about the people who "for the sake of appearances take on the superficial aspects of the quest."

Tommy and Clementine also continued to promote the band through friends in the underground network. One acquaintance was Jim Stalarow who, despite being only twenty-one years old, gave the impression of being a music business veteran on the New York folk scene, having been name-checked in an article about the S.D.S. (Students for a Democratic Society) in *Esquire* magazine which cited him as a major force behind the folk movement. This was supposedly supported by an impressive list of music industry contacts, including Dylan's manager Albert Grossman and Paul Simon. Impressed by the Elevators' first performance, he rang a talent scout in Houston called Gordon Bynum, who demoed and signed bands to labels. He recorded the house bands (the Six Pents and the Misfits) at a teen club called La Maison, where he'd met Stalarow.

Gordon Bynum: At La Maison I met this guy who was painting the ceiling and his name was Jim Stalarow. He thought he was a great performer and writer, so I took him to the studio and none of that turned out to be correct (he performed renditions of 1920s work songs), but we became friends. A lot of people would come by my apartment and talk until I fell asleep; Jim was one of those. I was a college kid who wanted to record groups, I'd never dropped acid, and I was frightened to.

When Stalarow brought Bynum to Austin to see the Elevators perform at a church in South Austin, he couldn't believe what he saw: "It was breathtaking—the precision. It was like those ice skaters, how can they do it? And so I said, 'Would you like to come to Houston?' and offered them a chance to record."

Meanwhile, positive newspaper reviews helped convince John Ike's mother Emma to invest in the band—but she was a shrewd businesswoman whose patronage wasn't without a price. She purchased much-needed equipment and started making suggestions that bordered on "managing" the band as Beau Sutherland remembers: "She came up with a novel idea, 'Well, let's all dress the same way.' You can imagine how that went over with this group of individualists. They were lucky to even be dressed, much less in the same thing!" All of this was too much for Tommy, who approached Stalarow to manage them. At least Stalarow could equal Tommy's mystical rap…

Gordon Bynum: Jim was talking to me and he held up two thumbs and his index fingers and made a triangle, and he said, "You know there is such a thing as the pyramid of ascending knowledge—most people are down here on the lower level and as you move up the pyramid the width decreases and so the knowledge becomes more condensed." He said, "When you reach the actual top of the pyramid, you can explain the essence of life with one word." As he said that he looks at me with a straight face, as serious as he could be, and he says, "I know that word." But he refused to tell me what it was.

Stalarow's credentials were enough cache with the band for a majority decision to engage him on a handshake deal, much to John Ike's displeasure. As manager, Stalarow ran up huge phone bills in an effort to arrange out-of-state gigs, printed the infamous Elevators' business cards containing the words "psychedelic rock," and arranged a recording session with Gordon Bynum. With Christmas fast approaching, the band started to go their separate ways. Roky honored several "last gigs" with the Spades and Stacy and John Ike headed to the hill country, making a crucial mistake as they left.

19. Marshall McLuhan, in his work *Understanding Media and the Extensions of Man* (1964), reached a similar conclusion, that man's next stage of evolution would involve a synesthestic relationship with his environment, and that humans would now evolve in an entirely different way.

20. **Chet Helms:** *Roger Baker was institutionalized back there and I visited him several times in some psychiatric hospital where they were going to sweat that socialism out of him with electroconvulsive therapy, you know? Not quite sure when I first met Roky, I remember I visited him in the institution, this was before music and all that.*

21. **Tommy:** *Clementine told me this story that Janis and Laney and Powell went to OU one weekend and Janis stepped on a can, right with her foot, and just walked along... like nothing was happening, so Laney said, "Hey Janis, you've got something on your foot!" and Janis doesn't say anything, and he says, "Janis, you've got something on your foot!" and she doesn't say anything, so he shouts, "JANIS, you've got something on your foot!" and she says, "Sorry, I can't hear you, I've got something on my foot." Right, that was the joke... These little examples of people saying these cool things, cool statements, then you started trying to do that yourself, you know what I mean, because you were taking acid and you were seeing really high things...*

5.
BUST

Since a series of commotions had raised their suspicions, Mr. Ray Boles and his wife Helen, the owners of North Lamar Hotel in Austin, had been keeping a watchful eye on the occupants of Unit 32. It started when a group of girls visited late one night.

John Ike: Laurie, [Stacy's] high school girlfriend, we had a lot of trouble with. She'd date other guys and he would run 'em off the road, and point a gun at 'em and threaten to kill 'em and all this kind of stuff. And Stacy was doing that and so Laurie blew him off. And then, after he got a little fame and fortune—and weed became popular and stuff—then his girlfriend brings three other girls and they come up to our motel. And they say, "Stacy, we wanna smoke some dope." So he says, "Sure." So we all get around there, and we're all smokin' up with these girls. And one of the girls freaked out on weed and got in the bathroom, in the shower. Shut the shower door and huddled in the corner of the shower. I left. There was nothin' I could do.

Another night, when John Ike and Stacy returned from a gig they were bundled into their room by waiting FBI agents. John Ike demanded a phone call and reached his mother's lawyer friend, Jack McClellan, who advised him to tell the agents to either charge and arrest them or leave them alone. The FBI was in fact searching for Stacy's friend, Wayne Walker, who had been staying with them for a few days while on the run from the army.

Boles then decided to play detective. As soon as John Ike and Stacy left without checking out on Christmas Eve to return to Kerrville, he and Helen decided to investigate the room on Christmas morning. Boles found exactly what he wanted, a plastic bag containing a green leafy substance in the pocket of a brown corduroy jacket hanging in the closet. Receipts from Osman's Sporting Goods identified the jacket's owner as the room's

former occupant, Stacy Sutherland. The jubilant Mr. Boles called the Austin police department at 9:30 a.m.; they arrived fifteen minutes later. He filled them in on everything he knew about John Ike and Stacy Sutherland, along with their friends, whom he'd identified as "Roger 'Rocky' Erickson, George E. Kinney and J. Thomas Hall," whom he believed "to be using and trafficking marijuana" and were "members of a small, local jazz band, playing in the Austin area." The police gave him the vice extension number and asked him to call as soon as Stacy and John Ike returned for their clothes.

Meanwhile, Stacy and John Ike were getting very paranoid in Kerrville. As Stacy discovered later, they had every reason—the police had been tracking them since they'd left Port Aransas. The Elevators were back at the Jade Room before the New Year, so John Ike and Stacy returned to the N. Lamar Hotel to settle the bill and retrieve the clothes. Relieved not to find the cops waiting for them, they rightly suspected the grass had been handed to the vice squad. This triggered John Ike's concerns about the band's activities, whether it was grass, LSD or Romilar. Although he'd stopped taking acid after his bad trip, he didn't directly challenge Tommy; instead he took the acid from him, but gave it to Stacy, who wanted it for his old friend from Kerrville, Johnny Gathings.

John Ike: See, Stacy said, "John Ike, give me the acid Tommy gives you and I'll give it to Johnny, he needs it." So I said, "Okay," he was my friend, we were getting along at the time. Stacy gave Johnny the acid and also a bottle of Romilar—Johnny flips out, and his sister calls the vice squad in Austin and said their names are John Ike Walton and Stacy Sutherland, they own such and such a car and they're at this hotel.

On January 2, the Elevators were preparing for their first recording session. Benny was billed with Roky at Arthur Lane for burgers and last-minute rehearsals of his bass parts. Although they started to rehearse their new psychedelic material, it was decided it was safest to re-record Roky's "You're Gonna Miss Me" coupled with "Tried to Hide."

Gordon Bynum had arranged a session with Walt Andrus[22] at his studios in Houston. Walt assumed he was simply engineering a demo session for a new band so they could experience the studio, when in fact he was embarking on a career as the man who recorded the weirdest Texas music of the Sixties.

Walt Andrus: I didn't know a lot about them then, they just came in and did it and everybody standing around with some microphones I'd put around the studio, real simple. I didn't think of wanting to produce them. After I got to know them a little better I was impressed by them, Roky was probably the most exciting singer I ever worked with, he had that charisma and an intelligence that he could do anything he ever wanted to.

The band themselves recall little of the session. It was only a three-track studio, so the band was recorded playing live collectively, reserving

the other tracks for vocals and guitar. It wasn't only Benny who was under pressure to get his bass parts right—Tommy felt stressed to get his jug runs right and prove it as an instrument on record. Roky's harmonica part on "Tried to Hide" significantly outweighed the jug but following this session the jug would replace his harmonica. For Tommy it was a direct way of evoking the drug he was experiencing and an attempt to "put the acid" into the song. Indeed, he succeeded in adding another dimension.

According to Benny, the band dropped acid the night before, which isn't unlikely, as Stacy later recalled that they made all of their recordings while on acid. They arrived incredibly early at the studio—when Andrus arrived, according to Benny, they recorded "You're Gonna Miss Me" in one perfect take, but problems were found when it was played back. Benny had brought his electric fiddle, still hoping he might get to record it on the old Lingsmen tune "Tried to Hide." He'd left it next to the recording desk and the magnetic pickup interfered with the recording heads and wiped the tape. As a result he was stuck, feeling marginalized on bass.

"You're Gonna Miss Me" became the song the Elevators were to be remembered for, and became a defining song of American Sixties garage music, compiled on numerous collections and used in film soundtracks. Andrus gave the band a strong sound that leapt from a 45 rpm record. He captured the jug sound perfectly as an "OTHER" sound which no one could determine—it sounded more like a second bass "going like crazy," as one TV commentator would later remark. It was the sound of the jug that brought the Elevators to the ears of Lelan Rogers, brother of country singer Kenny Rogers, who recognized the jug as a marketing gimmick he needed to sell the record.

It was decided that Bynum should create a new label "Contact" (the music would give you a contact high) to release the record, and the Elevators returned to Austin. Bynum contacted local music impresario Huey P. Meaux who directed him to Gasper Puccio at Houston Records for an initial pressing of just 500 copies. Bynum played the tape to Jerry Clark, and secured their first Houston bookings at La Maison teen club.

Back in Austin, the band performed at the Jade Room on January 6, 13 and 14. By now the band was confident and audience numbers grew as they laid the foundations for their reputation as an extraordinary live band. Not only had their performances reawakened the sleepy club scene from its slump but they had also become a local phenomenon that had elevated the club scene to as yet unseen heights. However, the band weren't simply offering entertainment; they were openly proselytizing the use of LSD which, although it would remain legal in Texas for another few years, was a dangerous move given the prevailing conservative climate.

Tary Owens: God, I wish there were some live recordings of the Elevators from that period. It was something new and the whole of Austin, what had been a small but growing group of neo-beatniks who were super paranoid that they were going to be busted, all of a sudden there was this whole scene of people that were taken by this band. There had never been a band like that before…

Jim Langdon conceded that the band were sounding "more rehearsed than ever" and was giving a running commentary in his "Nightbeat" column, which appeared twice daily in the *Austin Statesman*. Jim was an old peyote ally from the Ghetto and in mid-January he dedicated his whole column to a vivid and unique piece of "psychedelic" journalism.

Jim Langdon: I think they regarded me, you know, as somebody who would say nice things about them in the paper, help further their career... but I know Roky viewed me as much older than I really was! I tried acid twice, there were some people who were (taking acid at the gigs)—usually you knew who they were... probably a pretty small minority of people who would actually be out in a public place, stoned on acid. As I say, the paranoia was everywhere and most of what I saw was in private apartments and... with the blinds drawn, and that sort of thing.

"Nightbeat":
"Being and Nothingness Revisited"
TIME: Somewhere after eight p.m., somewhere before midnight.
PLACE: The Jade Room.
ATTRACTION: A band called ROKY and the 13th Floor Elevators.
SETTING: A dimly lit downtown beer lounge where all the action is on weeknights.
THE THING THAT CATCHES YOUR EYE IN THE DIMLY lit, smoke filled room is the gilded dragon, suspended above the bar and tables.
The smoke, reflected from a few well placed lights, suggests an incense burned to the gods that have no knowledge of you or I... but the eye of god is not important here... there is another eye (i), and this eye (i) gazes into the op-art syndrome... through the scene that changes, though things die... there is a girl. She is wearing funny clothing. She is wearing an outfit that is called an Op-art outfit... Op being short for Optical. But still it moves, one can follow the bouncing ball, as it were, follow the polka dots, spaced just right, oh yes, spaced just right, etc. the tune is not music, rather a pulsing something that pulsates, a throbbing that continues to throb... she moves, and the stripes and circles move with her... unreal images splattered upon a moving canvas... and now, the whole floor is aflame... moving in unreal movements, while dancing girls, oh so young, pantomime the act before its meaning... resurrect Van Gogh, in sun-splotched splashes... yielding to the dance the age demanded, and so, one after another the pieces fall into place. the age demanded... this needs no introduction... and yet, there is a girl with tight thighs who has forgotten what it is to touch while dancing... until she remembers and the movement stops. frozen, like a firefly trapped in amber, there is a sound that goes beyond all motion, it ripples off the walls like silent laughter, settles like darkness of an ocean. here, at least for one, the eye emerges belted by the bass drum's throbbing pedal. we cannot understand what they are doing... but we like it, are drawn to it like a magnet... it makes no sense, which is nonsense... still it moves.
"last call..."
"lights out..."
"paper cups, anyone?"

Thursday, Feb. 10, 1966 The Austin Statesman

Jim Langdon's Nightbeat

Unique Elevators Shine With 'Psychedelic Rock'

WHERE THE ACTION WAS:

Two Austin night spots shared the mid-week spotlight for hard swinging action on the rock 'n' roll beat Wednesday night, and neither rain nor hail could dampen the burning excitement that raged in both clubs.

At the New Orleans Club it was ROKY and the 13th Floor Elevators blasting out "Psychedelic Rock" for more than 300 people who jammed the club, while over at Swingers A Go Go, veteran rock 'n' roll star JERRY LEE LEWIS put on a dazzling show for a full house of some 500 persons.

Considering the weather, plus the fact that about 3,000 opera fans were making the scene at Municipal Auditorium, where the New York Met was closing out its Austin stand with a production of "Susannah," it was a pretty active night on the local front, all the way round.

The band backing him this trip, mainly out of Memphis, did their share in putting on a good show too. At the end of one of the wilder numbers, the entire band, including the drummer, was standing and wailing atop amplifiers, piano benches and trap stools.

Meanwhile, at the New Orleans Club, "Psychedelic Rock" was showing its effect on the wildly enthusiastic audience. The place was so jammed one could hardly move, which prompted owner ANDY PORTER to book the band for every Wednesday and Thursday night at the club from here on.

I, for one, would be reluctant to try to define "Psychedelic Rock" or attempt to outline just what it is supposed to do. But this much is certain: the Elevators are a unique group. No one has ever heard anything quite like the sound they put out, anywhere, and their appeal is not confined to members of the younger generation. This was apparent when scanning the crowd and discovering a good many middle-agers swinging right along.

Radio station KAZZ-FM was on hand Wednesday and presented a 30-minute, live broadcast of the band from the club. KAZZ staffers BILL JOSEY and RIM KELLY are among the band's biggest supporters.

In all, it was a wailing evening, and from the size of the crowd on hand for the band's debut at the New Orleans, it looks as though the scene can do nothing but grow.

•

By the way, ANDY PORTER isn't standing still with the acquisition of the Elevators.

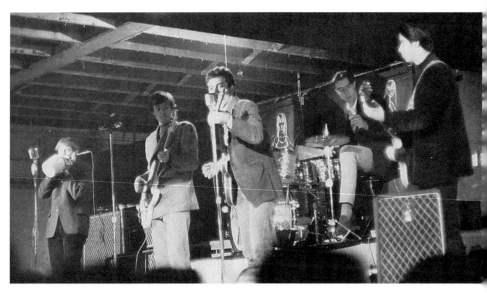

TOP: (FEBRUARY 10, 1966) *AUSTIN STATESMAN* NIGHTBEAT COLUMN: FIRST KNOWN USAGE IN PRINT OF THE TERM "PSYCHEDELIC ROCK"
BOTTOM: (1966) LA MAISON CLUB, HOUSTON TEXAS, L–R: TOMMY, BENNY, ROKY, JOHN IKE, STACY, PHOTOS BY BOB SIMMONS

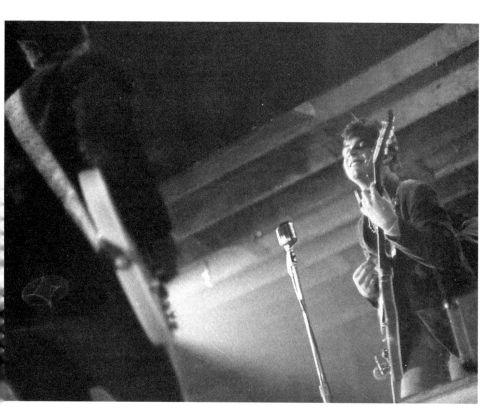

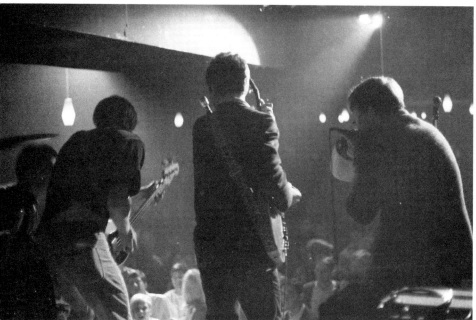

(1966) La Maison Club, Houston, Texas
Top: Stacy & Roky; Bottom: Stacy, Benny, Roky & Tommy, photos by Bob Simmons

PARTY: AFTER HOURS.
welcome to the night scene ladies and gentlemen welcome.
don't mind the freaks. their screams are adequately covered by the
sound of heavy feet... running swiftly.

After the mid-week insanity at the Jade Room, it was time for the show to go on the road. A side staple of fraternity and sorority parties and dances had the band headed for an entirely different audience in Houston. While the Austin crowd was largely made up of friends and college types, the Houston crowd was an immediate, larger and less critical audience at alcohol-free teen clubs. La Maison[23] was the perfect environment for the Elevators to introduce themselves to the Houston scene on January 15. The house bands—the Misfits, Six Pents and Baroque Brothers—had established a regular weekly audience who were quick to adopt the Elevators.

The band stayed with artist George Banks and Peter Black from the Misfits. Banks, in his early twenties, was a useful connection with contacts in the local music business, but was wary of being too indoctrinated by Tommy.[24]

During the week of January 17, barely two weeks after being recorded and only two months after the Spades version, "You're Gonna Miss Me" was once again available as a 45 rpm. A launch party was held at Austin's premier music store, J.R. Reed's, and the new Elevators record was quick to seal the fate of the Spades release (making it now a four-figure collector's item). The Elevators charted at #44 in the local KAZZ-FM Radio survey the following week, and Reed's reported it as one of the fastest selling singles they'd ever handled. Their popularity was unprecedented in Austin, which was then little more than a university town. Their Jade Room performances were causing pandemonium and traffic gridlocks as out-of-town fraternities chartered buses to come and see them play. As Marjorie's son Richard recalls, "They set the all-time records, they would do shows at nine p.m. and then empty the place out and bring in new people, 500 people I can remember; when they were playing you couldn't get within blocks there were so many cars, there would be Greyhound buses parked out the front. They were quite a group..."

Stalarow sent the new record to promoters in Dallas to secure bookings and everything appeared to be going like clockwork when "You're Gonna Miss Me" was inexplicably banned from the mainstream KNOW radio playlists. Dubious explanations were offered—that too many calls were being made to the station requesting airplay; then KNOW abruptly denounced the record as no good. Meanwhile the local FM station KAZZ ("Turns People On") continued to champion the record. Langdon was quick to condemn the ban in print the following day, and just as the band suspected they were being blacklisted for more covert reasons, the news paled into insignificance...

"Roky Erickson" was becoming a far too prominent name, and the authorities had decided it was time to act. Burt Gerding was placed on surveillance through the university scene, while vice squad sergeants Conner and Flores were detailed to Stacy and John Ike from January 19. While

they weren't exactly sure what the band was up to, it didn't matter—it was time to put the frighteners on them as Harvey Gann, lieutenant in charge of vice and narcotics, was having his reality threatened. The presence of Roky Erickson and his debauchery were a direct affront to the way of life he'd fought for in the war—and Gann was a proper war hero, the sole survivor of a plane that crashed behind enemy lines. On his fourth escape from a Nazi prison camp, he made it across Russia and arrived back in the United States the day before the war ended.

> **Harvey Gann:** There wasn't [crime], we thought we had a real good solid town... of course, in the beginning of the Sixties, the [drug] problem became acute. The Beatles, Dylan and Roky Erickson and all that group came along, and that was contradictory to what the police were trying to do: keep a lid on the drug problem. Like anything else, the squeaking wheel gets the grease... If you're out there trying to get attention, you're going to get it. You'd have to be an idiot not to see this was going to get you in hot water. One of the things that tends to irritate me about all of this, is that they seem to transpose noise, commotion and hell-raising into some valid form of entertainment...

Tommy's trips to Mexico to buy grass had become elaborate charades with Clementine and the kids dressed up for the perfect family outing and returning with the kids sitting on huge sacks of Mexican beans stuffed with marijuana. Any broken laws were contrary to his quest for enlightenment and his philosophical rule of thumb said that if you thought you'd get busted, you would. Austin's smoking community bankrolled the trips and once, when he failed to deliver, it resulted in the temporary confiscation of his beloved record collection.

Before Christmas Tommy secured a particularly large haul of grass, twenty-six pounds. By the end of January, it had dwindled to two pounds—more than enough for a felony and two to ten years. The bulk was stored under a couch in the garage in the driveway, and the evening of January 26, the kids spotted cops poking around the alley and alerted Tommy.

> **John Ike:** We saw the vice squad officers in the alleyway one day before the bust and Tommy said, "Oh, don't worry about getting busted, Gerding will give us a call and say get cool or we'll have to bust you."

> **Gerding:** To me, as both a policeman and as a citizen, I felt it was an assault on my culture, so it made it almost a personal thing.

Gerding's job was to be omnipresent in the youth culture, to the point he was no longer feared, because he never appeared to bust anyone. He genuinely liked his job, whether it was keeping an eye on the brothels on the city limits or shaking Lightnin' Hopkins' hand at the Eleventh Door Club, and often took bemused older folks on late-night tours to see the freaks at play. However, according to Gerding, his report, intended

for Gann's eyes only, was circulated around city hall and a decision was made that it was far better to make an example of Roky Erickson than risk arresting the "wrong" people. The sons and daughters of wealthy oilmen from Dallas or Houston might get caught in a wider bust and could cause a "big stink," which might negatively impact on lucrative endowments to the university from prominent oilmen. Busting the Elevators was a "let's scare them out of it" stopgap.

On January 26, Leonard Flores and E.L. Conner applied for a search warrant for room eighteen of the Bel Air motel, where Stacy and John Ike were staying, and Gann and the vice squad staked out Tommy's house until two a.m. Due to "a lack of activity" they didn't execute the warrants until 8:20 p.m. the following evening.

John Ike: Well, Gerding didn't call, and just about an hour before the police came in to bust us, Stacy, Roky and Tommy dropped some mescaline, so they were peaking while they were getting busted. Well, I was at the back door; there was a .45 automatic sticking in my face as soon as I started down the steps—and they said, "Get back inside the house," so they had me sit down and take my boots off and looked for drugs, individually searched all of us.

Stacy (K): Yeah, everybody was sitting around on mescaline… and we'd been smoking, there was pipes… And like they just walked in on us, it was too much of a trip. Tommy's little stepkids kept saying, "those aren't men momma, those are policemen." They used to call him "Tommy Turn-On." He was just flabbergasted; he just didn't think it was going to happen. It just blew his mind.

Clementine: Now I had heard that Lieutenant Gann, if he got any of the Elevators alone, would make sure that some of the younger members of the force would beat the hell out of them, because he felt that they were influencing the young people of Texas in a really bad way. I was in bed at the time when they busted in, and I realized that they really were gonna take Tommy. I called my father and said "Come get the children, I've got to make myself get arrested." They actually didn't want to arrest me, though they finally obliged me, and I'm glad because I was put into the same car and Tommy made it safely to the police station without ever having been beaten up. They knew the dope was in the garage, but they just enjoyed throwing all the china on the floor, and all the drawers out. And the children were hysterical, they were screaming, and my father came and my father took command—he was an army officer, and sorted it all out so that the police could do no more damage in the house, and called the lawyers and all that sort of stuff.

While searching upstairs, Gann found a bag of syringes and needles, which dated back to Clementine's first husband's tuberculosis treatment. She neglected to throw them out and Gann felt he had all the evidence he needed to prove heavy drug use. When Clementine's mother called Gann to inquire what the charges against her daughter, she was allegedly told possession of heroin. She had become addicted to morphine while

Top: (January 27, 1966) Police surveillance photo of Tommy's house on 403 E. 38th Street, with John Ike's van in front of the garage where two pounds of marijuana was stashed; Bottom: The evidence

recovering from an incident on the ranch when a pig mauled her arm. The horror of her daughter being associated with opiates was enough to cause a heart attack. Despite Clementine's insistence that only marijuana was involved, her mother refused to believe her and died a few days later in the hospital. The consequences of a marijuana bust were proving to be tragic in the most unexpected manner.

The officers' return from Tommy's house was listed as "metal sifter containing marijuana, a plastic bag containing marijuana, large cardboard box containing assorted quantity of marijuana in bags and containers, a small amount of marijuana from the floor board of 1966 Chevrolet Greenbrier, Texas, 1965 Registration License PGL 462." While the cops had previously secured evidence against Stacy, they now had Tommy, but Roky and John Ike were still clean—and it was Roky they wanted most of all.

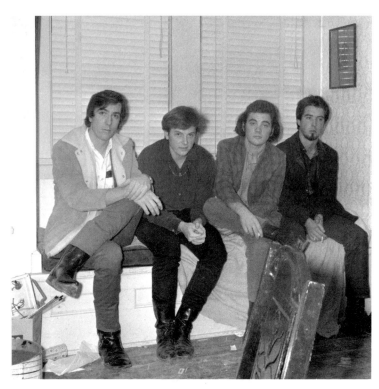

Top: (January 27, 1966) Police photo, L–R: John Ike—busted & tripping, Tommy, Roky & Stacy; Bottom; (January 28, 1966) John Ike's mug shot

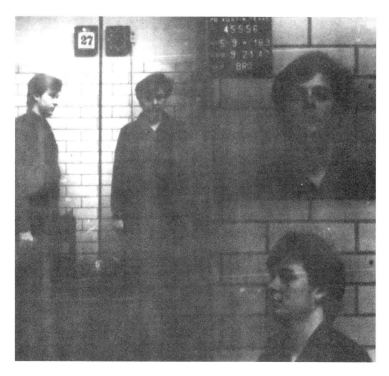

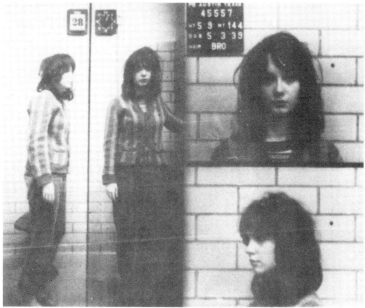

TOP: (JANUARY 27, 1966) TOMMY'S MUG SHOT;
BOTTOM: (JANUARY 28, 1966) CLEMENTINE'S MUG SHOT

John Ike, Stacy and Roky were put in a squad car and driven to Roky's apartment. What the police didn't know was that Roky had actually moved to a new address a few months earlier, effectively making their search warrant invalid. Although Roky had cleaned the premises, the cops still found his old pipe with burnt marijuana in the bowl and supposedly a big bag of grass.

With enough evidence against Roky, the police drove to the Bel Air to try and further incriminate Stacy and John Ike. The cops found nothing at the Bel Air and resorted to searching through the trashcans.

John Ike: They put Roky and I in a squad car… and Roky had already moved out of that place and there was nothing in there and one of these guys reaches in his pocket and says, "Look what I've found Roky, look what I found in your house." They were asking Stacy, "What do you think of LSD, tried any of that?" "OH NO, that stuff's too scary, I'd never try any of that stuff," and he was buzzing on mescaline. Anyway I was just terrified. They filmed us all walking down the hallway in the jail, my father saw me on television, this went all over the state… oh yeah, they were prepared for it… back then a marijuana bust was like heroin.

For John Ike and Benny, it confirmed their misgivings about Tommy Hall's activities, but ultimately it made the nucleus of Roky, Tommy and Stacy even stronger. The bust became a double-edged sword—it gave them notoriety leading to further popularity, but also led to a paranoid and nomadic existence, constantly moving addresses with no fixed base. After gigs they didn't hang around and socialize; ultimately, they were learning to be outlaws. The news of the bust spread across town like wildfire.

Stephanie Chernikowski: It was very, very frightening, because in youth there's a level of invulnerability that you ascend to because you assume you're protected because you are basically moral and good, so you really don't think they're going to get you. I think that's why a lot of people went home quickly and a lot of doors were locked and windows were pulled, I remember that as a night of drawn drapes, everybody sealing themselves in at home.

Lynn Howell: I was in the Jade Room the night word came that the Elevators had been busted, and all of a sudden half the room got up and ran straight to the bathroom and I swear the toilets flushed for half an hour!

Evelyn was contacted and rushed to the police station to see Roky.

Evelyn Erickson: It wasn't until about two in the morning when Jim Langdon called me and said I think you ought to know Roky's in jail… and I was home alone with four kids, Roger was in California on business, so they were all asleep, so I got dressed and went down to the jail and asked if I could talk to Roky, and they brought him out. I had a couple of jokes, because I was scared going down to the jail at two o'clock in the morning, alone. They treated me really nice, so I told

him the jokes and he laughed and I told him we'd need a lawyer. I was just scared by the whole thing; they said he was caught with marijuana. The next morning I woke the kids up for school and told them what had happened and told them we're all going to have to support Roky, 'cos it was in the paper the next morning, big news. We were paranoid after that.

Donnie Erickson: I was in eighth grade when they got busted, and the teacher was like, there's that guy whose brother got busted this morning. So, there was a lot of shame in that.

This was clearly a case of the old guard and the avant-garde. If a felony is committed, which possession of marijuana was, a complaint is filed by the police to the district attorney's office. The case is then put before a judge and a grand jury, made of "prominent" citizens. If they feel an indictment is warranted, they return against you and a court hearing is set. If you happened to be "favored" by these prominent citizens, then... The implications of the bust were manifold and the future of the Elevators was uncertain. Only two weeks earlier, the *Austin Statesman* reported that two guys had been sentenced to eight years' imprisonment for possession of marijuana.

The age of innocence was gone, and extreme fear and paranoia set in as everyone involved in the emerging scene realized a sense of impending doom. Every two weeks, a new rumor would circulate of another bust about to take place and the police didn't need to circulate misinformation, as Gann became the most feared man in town. Although drugs were in short supply throughout the spring of '66, no one would have guessed that "psychedelia" would become an international phenomenon the following year.

Powell: There were certain people that were always under the suspicion of doing something just because they looked like they might. I was one of those. And those people began to be scrutinized closely, and then of course coming out with a band that openly advocates taking psychedelic drugs blows your cover. I would imagine they had a list of people who just went to the gigs. It was really a very fascistic kind of setting they had going. The Elevators just made it really intense. After they began to perform publicly, I became more paranoid than I'd ever been—and I've always been paranoid. As it turned out in later years, my paranoia was not baseless. We were under surveillance all the time. We were followed everywhere we went, and why they didn't actually bust anybody but the Elevators I don't know.

Benny missed being busted as he was supposedly courting his future wife, Yvonne, but rumors circulated that the cops waited until he wasn't with them, because he shared his surname with Mace Thurman, the hanging judge known for his severe sentences for drug offenses.

Prior to the Elevators' bust there was genuine distaste toward substances that weren't an organic high; chemical drugs with the exception of LSD were out. After the bust marijuana was replaced with drugstore

highs: barbiturates, Quaaludes, codeine, Romilar. Peyote was replaced by its more palatable chemical equivalent, LSD. Benny drank Listerine straight from the bottle, which had a large percentage of alcohol at the time, and shot up Vicks inhalers.

Stacy favored downers and barbiturates and sniffed glue on occasion with Benny. Tommy, the purist, drank Romilar cough expectorant by the bottle (rock writer Lester Bangs also swore by Romilar).

Provided you don't make yourself ill and zone out, Romilar can make you feel focused and clear in a different way from marijuana and give you a sense of well-being. It didn't take long before Roky, Stacy and Tommy were so zoned on Romilar before gigs that John Ike literally had to pull them off the sofa and throw them in the van. Given the side effects of Romilar—the pinprick pupils and the bluish tinge to the lips—it's easy to understand why had they such an odd reputation; no one could figure exactly what the band were taking and why they were so hard to communicate with. The only other substances they were known to ingest were LSD, DMT, Iron Boy soda, an occasional hamburger and Mary Janes candy.

In the wake of the bust, Evelyn turned to the church for support to examine the bigger issue that affected the whole community, and she enlisted the prayer group to work on the "prominent citizens." Stacy and John Ike returned to Kerrville, where the Sutherlands took the news badly. Having bailed Stacy out of previous scrapes, this time they decided to opt out.

Along with Tommy, Stacy had the most concrete drug charges against him and, while quiet and brave on the surface, he had deep internal demons, which he controlled with barbiturates. LSD had offered him a new hope laden with spiritual potential. He was possibly the most religious of the Elevators at the outset, and argued with Tommy over their advocacy of LSD, as it challenged elements of his religious upbringing—when he experienced bad trips, he saw the band as false prophets. The stigma of the bust added to his local notoriety in Kerrville and the family took the shame collectively.

Sibyl: I tell you he (Stacy) was seeking for a sign, and if he found God he'd find Him like anybody else had ever found Him—through the spirit. But he went on a search for Him. He explained that to me about LSD, he said when he first experienced it he thought he had found something, he said, "I saw such beautiful things," he tried to tell me, "I saw a tree, one that had a diamond on every leaf, and it was so gorgeous," and I said that would scare me to death. And they thought you could learn through the cortex of the brain, he would tell me you could learn in minutes what it's taken people years to learn. He used to say, "I really believe this is something that will make the world love one another and stop all this war."

Clementine: I remember meeting Stacy's grandmother because she was surrounded by private detective books and magazines and things like that. She was the most paranoid person I've ever met. She knew that if she stepped out her front door, somebody was gonna mug her and kill her and do sex crimes on her. And she was always wrestling with devils, and Stacy used to say she wrestled with the

devil all her life long and she's made me wrestle with the devil. 'Cos Stacy was always wrestling with his own devils. He was the dark angel of the family. But he got that darkness from his grandmother. His grandmother always said he was gonna end up in prison. And he was terrified of prison, not because of being locked up, but he didn't want to be raped. And she told him he would be in prison and he would probably be raped. You don't tell that to a child. It was his grandmother. And the crazy side of Roky was his mother.

John Ike, meanwhile, had his van confiscated and the indignity of it being used for police surveillance. Many times the Elevators van was recognized parked in one of Austin's many alleyways. John Ike truly believed he'd had a surefire hit band and wanted to drive them to succeed. Although he tried to be hard and business-like, he also had a goofy, stoned sense of humor and he hoped after the bust that the others might see the error of Tommy's ways. More than anyone, John Ike felt the need to make the band work financially, but Tommy convinced the others that his dealing was bankrolling the band, while John Ike just saw their money funding more drugs.

The band emerged from the bust with their reputation intact, if not stronger. Their record was now number twenty in the local chart in Austin and thirty-nine in Houston. As with many shamanic practices, the shaman endures a humiliation in front of the tribe only to reappear stronger. While the wave of LSD use had yet to spread across America, these local boys had already become psychedelic martyrs.

22. Andrus had worked in radio and television for nearly a decade before deciding to become a record producer. As chief recording engineer at Gold Star Studios in Houston he'd had enough success with gold records such as Joe Hinton's "Funny How Time Slips Away" in 1964 that he'd progressed to building his own studio where he became known for his work with R & B artists signed to the Duke Peacock label.

23. The original La Maison De Cafe on San Jacinto was a beatnik coffee bar run by George Mancey in 1964. When Jerry Clark became a partner it moved to an old wooden church on Bagby and McGowan with huge stone steps leading up to a large assembly hall and a basement which housed a "wildcat" radio station. Although Houston had plenty of drive-in restaurants and movie theatres, there were few actual teen clubs which offered live music. In early January '66 the club relocated to an old Weingarten's grocery store on Richmond and Mandell Street. John Ike: *It was a gutted supermarket, they put a bandstand up there and that was it. It was a hole. No decoration or anything. They had go-go girls dancing on each side of the band, no lightshows, bring our own PA.*

24. **George Banks:** *I had a cousin that studied under Leary at Harvard and he whet my appetite for a spiritual adventure, I didn't know where I was headed. I just don't get it, Tommy'd want to take the guru position, he started some unique things in the beginning, got me off on it.*

6.
NOWHERE TO RUN?

January 1966 had been an extraordinary month for the Elevators. They had established a fan base in both Austin and Houston, and released their first record. The honeymoon period of uninhibited experimentation had been broken, paranoia was now reality and they had to come to terms with the repressive atmosphere that surrounded them. Until their court date was set, which could take months, they were stuck in Texas fighting for what they believed in, a fight that would become their lasting legacy.

With the stigma of the bust hanging over them and their families, it seemed provident to lay low and stay out of the public eye. Tommy and Clementine moved out of 403 E. 38th, leaving the band without a center of operation. This was the start of their nomadic period, staying at safe houses when they were in town. While Marjorie Funk took the safer option of booking the Wig at the Jade Room, Andy Porter, manager of the New Orleans Club, capitalized on their infamy and gave them a residency at his club. Their first gig at the venue took place on February 9, which Jim Langdon described in his column as "a real battle of the bands" (between the Elevators and the Wig) with further competition coming from Jerry Lee Lewis playing at the Swingers Club. However, the first performance by the post-bust Elevators packed the club to capacity and was simultaneously broadcast live by Bill Josey and his son Bill, Jr. (known on air as MC Rim Kelly) on their KAZZ-FM radio show. Following the move to the New Orleans Club came the development of their repertoire, which consciously started to move away from crowd-pleasing cover tunes and taking an altogether more complicated psychedelic perspective. The New Orleans Club offered the Elevators a much better base than the Jade Room, and it was there and at the La Maison in Houston that they established themselves as a live band. Many people, including Roky and Tary Owens, have lamented the fact that the early Elevators shows at the Jade Room weren't recorded for posterity. It's an amazing testament to the band that so many people I interviewed regarded that period as a unique moment in Texas music.

The area of Red River around 12th Street was known for its Mexican and Spanish restaurants. Prior to becoming a club, the New Orleans (which dated back to the middle of the nineteenth century) had been a Mexican restaurant. As you went in you entered a piano bar themed in an "Old World" decor. This consisted of a long polished bar, crumbling plaster work and a faded mural of a New Orleans-type street scene. The piano bar had long been the residence of Ms. Ernie Mae Miller, who played and sang requests amongst her renditions of old-time tunes. The original stone building leaned into a hillside and whenever the club needed to expand a wall would be knocked out, propped up with poles and two or three steps would take you into the next makeshift room. The back bars were used for performances by various jazz combos and Dixieland bands. When the Elevators came to play the club, as many as four or five rooms had been added that steadily climbed their way up the hill.

Langdon continued to support the band in his "Nightbeat" column, and his review of their first New Orleans show included the first known usage in print by a music journalist of the phrase "psychedelic rock."

At the New Orleans the set list was honed and expanded. Tommy strongly believed everything had a meaning, and this philosophy was applied to their choice of cover tunes. Almost every song in their set now had a coded drug reference, whether as an ironic joke or a direct attempt to define their beliefs. These included: James Brown's "I Feel Good," Bo Diddley's "Before You Accuse Me (Take a Good Look at Yourself)" and the Animals' hit, "We've Gotta Get Out of This Place." While inclusion of the Rolling Stones' "I'm Free" and "(I Can't Get No) Satisfaction" had deliberately ironic overtones, "The Last Time" had particular weight until the outcome of the court case, as each gig was performed as if it were the last.

The Beatles song "The Word" was also given an unlikely and unusual arrangement. Tommy had been quick to recognize the Beatles as more than just a teen sensation. When their album *Rubber Soul* was released in mid-'65, it communicated their new influences: Eastern culture, marijuana and Bob Dylan. This record became the soundtrack to "those in the know" during the winter of '65/'66.[25] Roky, too, was a huge Beatles fan, and performed songs like their rocker "I'm Down" with the Spades. "The Word," however, carried a more positive message that suited the band's philosophy: "Say the word and you'll be free, say the word and be like me, say the word I'm thinking of... have you heard, the word is love."

Stephanie Chernikowski: I remember Tommy responding to "The Word" when *Rubber Soul* came out, and saying, "This is the gospel! It's the gospel," and Dylan was the gospel too...

Prior to the bust Tommy's house was still the logical base from which the band operated. Roky, Tommy and Stacy would spend much of their time there tripping, reading and writing material. Stacy and Tommy had co-written songs together, and soon Tommy and Roky started to work together. The songs written by the band and Powell St. John in this early

period are autobiographical, and attempt to identify both the internal and external nature of their experiences. During the post-bust period, the band was still immensely active, despite the obvious restrictions: Repressive atmosphere and surveillance were a reality. Roky had moved into an apartment in a house downtown on 6th Street, and the Halls left E. 38th Street for W. 38th Street. Songwriting was one activity that could be done behind closed doors and Tommy would often be there trying to write words while Roky endlessly strummed riffs on his guitar and a parade of visitors came and went.

The first song, jointly composed by Erickson-Hall-Sutherland, was "Roller Coaster,"[26] which was to become their first bona fide "psychedelic" masterpiece. It was a departure from the pounding, driving beat of the rest of their set, with a slow burning start and a strange jump in tempo as it gears into the main riff. The song was typical of how Roky, Tommy and Stacy would write songs together, Tommy scrawling down lyrics and passing them to Roky, who would sing them immediately to whatever riff he happened to be playing, while Stacy interpreted it into a band arrangement.

The song emphasizes the importance of self-discovery by means of learning from texts handed down from previous generations—specifically, for Tommy, the works of Korzybski (*unsane*, someone whose behavior "lacks clarity of their actions") and Gurdjieff ("the fourth way"—hallucinogens as a learning accelerator). The lyrical style owes much to Dylan's recent *Bringing it All Back Home.*

As the band saw it, the developing culture was taking them on a spiritual pathway. They all had strong family backgrounds in various denominations of the Christian religion. The journey that they had all embarked upon became a new spiritual adventure that caused them to be confronted with their religious upbringing. Religion was not yet part of the equation; Tommy was concentrating on re-evaluating "learned" knowledge from books and the potential "accelerated" knowledge that he believed would come from psychedelics. Many of Tommy's ideas would progress into a quasi-religious manner that correlated to modern theories such as neuro-theology (scientific demystifying of the spiritual experience). As Tommy explained at the time, these high states were like a siphon where all the possibilities feed into you, and when you came down the connection was lost. Therefore the problem remained: how you can pass information between the two states, the experience of which he likened to the rush and exhilaration of a roller coaster ride.

After the bust, possessing marijuana was not an option, but there were many friends who were willing to help. It had become necessary to establish stashes—friends would drive out to a remote location by the town lake or Mount Bonnell and hide ready-rolled joints or bags of grass in given locations, marked by a specific traffic sign etc. The Elevators' favorite stashes were located on the Westlake Highlands of the Colorado River opposite Mount Bonnell. Their local landmarks were eight thirty- to forty-foot high radio towers that were lit up with red lights as huge beacons in the night sky. The drive from Tommy's house on 38th takes a steep dive as you cross Red River and this be-

came known as the first part of the "Roller Coaster" drive, which was to become a pre-gig ritual.

The drive took them out to the "rollercoaster ride"[27] where Sandy Lockett lived near Bull Creek, a house featured in Brammer's *The Gay Place* and a future refuge for the band. Mikel Erickson, who was not yet partaking, was often required to do the driving. The long, rambling drive, with its many twists and turns, ensured that they weren't being followed. They could then get stoned and enjoy the view, then drive back downhill through Bee Creek and the low water crossing to Enfield Road and onto Clawsdon Road, known as Rollercoaster Hill.

During the "age of innocence" prior to the bust, this had been a popular drive while on acid. Now it became a route of necessity. There had been jokes that you could hold your breath when high and use telekinesis to make the traffic light change color. This had become a running joke as Elevators "groupies" Pam Bailey and Liz Henry remember, but it soon bordered on paranoia.

> **Pam Bailey:** They used to make us hold our breath at every sign. We used to have to hold our breath every time we saw a red light. It made the light change...

> **Liz Henry:** We were living in Benny and Yvonne's attic, and each day Benny wouldn't let us out of the attic until we'd smoked a joint with him, and at that point Benny was pretty far out. He was way out. We overheard him one night; Yvonne goes "Benny, honey... you are crazy," and he goes, "I'm not crazy, you are, I'm not crazy, you are, I'm not crazy," and the thing he thought was crazy was that there were spy cameras at all the stop signs that would record who drove through the intersection... and here in Austin, about a year ago they put video recorders in stoplights. Benny wasn't wrong; he was just ahead of his time!

Benny lived a few blocks away from Tommy and often called by to check out what was happening. Since the Lingsmen he'd felt restricted by the band lineup and was feeling increasingly frustrated. When he did visit, he felt further marginalized by the songwriting process, as Tommy and Roky would sit in a corner reading from a huge copy of Gurdjieff's *All and Everything*—Tommy had heard that Bob Dylan had drawn inspiration from the book. Benny often had to wait his turn in order to find out what was in the book.

Benny, like Tommy, was a talker, and he'd taken LSD's revelatory visions as purely religious and wanted to express his own quasi-religious view but when he proceeded to profusely enthuse about the Lord and the heavenly culture, Tommy seemed dismissive. Benny still carried his fiddle with him and when challenged often whipped it out and played his reaction. He was also taking a lot of speed, which Tommy disapproved of and declared were "Hitler's drugs." In the early Sixties, it was popular with university undergraduates and writers (allegedly Billy Lee Brammer frequently used it to write Lyndon Johnson's speeches) but by the end of the decade its use had reached epidemic proportions,

(February 1966) "Fat" Charlie Prichard & Benny at costume party at Conqueroo's Caswell House, Austin. Benny blew the amps with his fiddle.
Caption courtesy Stacy; photo by Bob Simmons, *Nightbeat* Magazine, December 1966

with a massive "Speed Kills" campaign. Speed was relatively easy to obtain in various strengths, either in the form of slimming pills or as a methamphetamine.

By February 1966 Benny was starting to crack. The mixture of his natural disposition, the spiritual revelations, the angst from speed was too much. He was also paranoid and suspicious about the bust and any possible connection between Tommy and the cops. He avoided band meetings at their house and if he did attend he refused to accept a drink.

> **Benny:** Tommy Hall... he didn't have anything but he had the head, he was just a natural tinker and trader, and he couldn't play music but he played jug. He had good rhythm and he had writing skills, so he was the main man. Playing music, you're transmitting... in the form of a pure thing that comes from your soul, your heart, and by dilating your eyes you can see the light in people's eyes. I wasn't getting along too good with Tommy because I didn't approve of his lifestyle... moving around from house to house like shadows you know. Well, I was looking for a different type of good time. I didn't like him too much, but he was smart.

The second song Roky and Tommy wrote together was called "Fire Engine," based on their DMT experiences. If LSD didn't lead you to believe in other dimensions, then DMT would. They likened the rush experience of DMT to rushing upward in an out-of-control elevator, or to the excitement of riding a fire engine rushing through the streets with the sirens blazing, and the chaos of the whole situation and disorientation of a major fire—all taking place in a short space of time.

Dimethyltryptamine (DMT) was synthesized in 1931 and demonstrated as a hallucinogenic in 1956. In the Sixties Sandoz was manufacturing and distributing DMT alongside other products, such as LSD.

Tryptamines had been in use in their natural form since ancient times. South American shamans used yagé or ayahuasca, derived from psychoactive plants, to form magical drinks or snuffs that were used to probe the spirit world. Pharmaceutical DMT often comes in liquid form that is smoked by heating it in a glass pipe until it vaporizes, smelling similar to burning plastic. The effects are almost instant, taking effect within ten seconds, triggering complete separation of mental and physical being. As long as the eyes remain closed, the hallucinations can be so complex and alien it's unbelievable they've been created by the human mind. Although the experience may last only ten to thirty minutes, DMT wasn't for the faint-hearted, and its use didn't catch on.

Benny definitely found its effects unhinging.

> **Benny:** Roky stung me on DMT and I said, "Fuck you, this shit is poison." Well, he wanted to make an impression on me. God dang, he had three angels with him, you know, it was like the first time me and him ever met. We sat on a rocky ledge out there and smoked before we knew what was what, but I knew where it was going—straight to hell.

Stacy had his girlfriend and close friends in Kerrville and left between band activities with John Ike, leaving Roky and Tommy's friendship to blossom in Austin. Tommy was four years older than the eighteen-year-old Roky and effectively took on a quasi-parental role, "tutoring" him in his studies and ideas. Although Roky could be easily led at times, and often displayed a naïve, childlike innocence, he never did anything he didn't want to do. He hated the mundane and had a natural grasp of abstract ideas, so Tommy was an attractive mentor, with his spiel of the unknown.

Clementine (AV): Roky and Tommy were mad about each other and everybody loved one another in the beginning. Tommy was the adult sage; Roky was the childlike student. Sparks would fly because Tommy wanted Roky to be more adult-like while Roky wanted Tommy to be more father-like. Tommy could get very mature, very staid, and almost cold in his approach to Roky.

QU: Was Roky mothered by Clementine?

Stephanie Chernikowski: Yes, unequivocally. Everybody wanted to take care of Roky, he was the little angel boy, he was younger than everybody. Clementine and I were both very protective of this fragile little creature that had this incredible voice and gift. Roky was sweet and very malleable... he just struck me as a really sweet, vulnerable kid.

Clementine: There were two people who woke me up all the time— one was Tommy, who would wake me up in the middle of the night with his lyrics, and the other was Roky. He would literally steal into my house or into my motel room and take me out of Tommy's bed—there was never anything improper, incidentally, between us, ever. But he would steal me because he knew that I was a willing audience, and he would drive forty miles up into the hills of Austin and show me this unbelievable sight, or we would be down at Corpus Christi and he would say, "You've got to come out and see the beach at dawn." So I would have to get up, and put my coat on over my nightgown and wander, and go sit up shivering on the edge of the beach and looking at it with him. So those two people woke me up 'round the clock. And that's what I was good at. I was kind of an earth mother then, and I was very good at mothering them. Roky is... was very like a child. Stacy and Roky were like brothers for a while. It was really a very family-like thing.

The other dominant female presence in Roky's life was still his mother. Her teenage sons dominated much of Evelyn's life and she admits that she didn't have the strength to deal with the wealth of emotions it involved. Unlike others of her generation, Evelyn was quick to adapt to teenage issues rather than to condemn. While she appeared to keep an open mind and many remember her as the sweet Christian lady who was always there to help, she thought everything could be solved by prayer.

Although Clementine never considered herself a part of the band, she was integral to its development. She abandoned writing her first novel to support Tommy's ideas and mother the band members. Her home became a rehearsal space and post-gig flophouse. The only time she freaked was when John Ike woke up on the floor and surveyed the previous night's devastation and joked, "Clementine don't keep a very tidy house." But the solidarity of the men started to annoy her when it became exclusive, as housemate John Kearney observed.

John Kearney: There's a hard core of chauvinism, first of all from the hill country, second of all from the times, yes this was the time of the pill and equality but not the women's movement, as it became. Clementine would get very upset when we would all eat peyote, and the guys would all grab the tape and sit in one room and she and Susie, my ex-wife, would sit in another, and Clementine would say, no, this isn't right, we should all be together.

Roky and Stacy were quick to realize that their behavior was affecting Clementine, and approached her with a request that surprised both her and Tommy.

Clementine: Roky would come over [to my house] with some tune he'd made up, and he'd sit down and play it and Tommy would take notes and in no time flat there'd be a song. Tommy was extremely fast. That's why I was really shocked when one time Roky and Stacy came to me and asked me if I would like to write some lyrics, and I went "I can't do it like Tommy does! He whips those suckers out!" "Well, we don't have to have everything done quickly. You can do some lyrics if you like and you can take your time." I got to go to my parents' ranch for a weekend to write "Splash One." I got to be left alone to do it, whereas Tommy could sit in the middle of total chaos and write a great song. And often did. Roky said to me, "I want the refrain to be 'I've seen your face before, I've known you all my life,' and that's what he wrote. The rest was mine. Tommy said to me the other day, "Now remember, I wrote 'cuts you like a knife,'" and I almost died laughing, because he didn't like that song. He liked it when I wrote it, and he was a little offended that they had come to me and asked me to write lyrics, and he didn't want somebody else coming up on his wing like that without warning him, and that was the worst line in the whole song, so he would never have said that. Ever, ever.

The song was the first departure from the Elevators' driving sound. "Splash" was one of Roky's buzzwords of the period, which he used to describe almost anything in a tabloid fashion—"Oh, that'll make a real splash." The "splash" in the song being psychedelics, and the "now I'm home," the comedown.

Roky had come up with "I've seen your face before, I've known you all my life" after sitting opposite Janis Joplin at a party, both of them silently staring at each other with great empathy.

Tommy had long recognized Powell was the best songwriter in Austin. They shared a history of peyote at the Ghetto and Powell chose Tommy's house as the setting for his passage into the world of LSD. Powell sat in on harmonica at a few rehearsals and Tommy approached him for material. Powell had been quietly developing his own psychedelic ideas parallel to the Elevators. Following Janis' departure to California and the demise of the Waller Street Boys, he flirted with working with George Kinney and the Chelsea, and formed the Conqueroo Root, but the Elevators superseded everything else that was happening. He was one of the few who were allowed to watch the Elevators' closed rehearsals and sat in on harmonica on occasion. He'd written new material, inspired by the British beat boom and informed by psychedelics. He'd head over to Tommy's house to try out his new material, and often Roky, having gulped down two bottles of Romilar, would pass out on the bed, guitar in hand, halfway through a song. "Kingdom of Heaven," "You Don't Know (How Young You Are)" and "(Living On) Monkey Island" soon entered the Elevators' set and later dominated much of side two of their first album.

But there was often a huge difference between Powell's intention for writing the song and the Elevators' use and interpretation of it (expressed in Tommy's infamous sleeve notes).

> **Powell:** The actual genesis of "You Don't Know"... came while I was watching a performance of theirs... The groupies at the stage front, they were mesmerized by Roky. And I just thought that most of them at that time had no idea of what was going on, they weren't hip, they hadn't taken the proper drugs and they were looking at it from the perspective of children. I had the idea maybe that Roky would sing it and that it would be a personal message from him.

Tommy's Korzybskian re-evaluation of the song was the young generation viewing the old guard's materialism "as childishly unsane." "The Kingdom of Heaven" was perfectly assimilated into the Elevators' agenda as the "reinterpreting and redefining of God."

> **Powell:** To me, "Kingdom of Heaven" was a song about awareness and a realization that everything in your reality is generated by you, yourself, and it's all internal. Even though things seem to be external, the reality is what's inside of you.

"Monkey Island" reinforced the idea of alienation from conventional society.

> **Powell:** "Monkey Island" was very autobiographical. It was about my experience of the cultural matrix of that time. Well, you know monkey islands... any good zoo in America will have a monkey island because they're such fun and I felt like being on a monkey island... you would be there looking out at all those humans watching you and carrying on the struggles in your own life in isolation and protected from everyone by a moat around you.

Q: Rednecks. You were beaten up?

Powell: Actually one punch was all it took, they broke my nose and knocked me flat... kicked me a few times, got back in the car and drove off... I suppose it was a rite of passage. It was because I was wearing Beatle boots, that was it pretty much, and I had my harmonica bag and I was walking down the street late at night.

Q: So it would it be fair to say this song was about the relationship between the rednecks and the hippies...

Powell: Oh yeah!

Another Powell song from this era, "Make That Girl Your Own," wasn't psychedelic, "just good ol' boy sexual politics." This was not the last Elevators song relating to Stacy's preoccupation with his tortured relationships with women. He was horrible to be around if he didn't have a girlfriend, constantly arguing with the others, "I saw her first!" Stacy had met Linda Sharpe in Port Aransas but was acting coy because he didn't want to lose his high school sweetie Laurie.

Powell: I just remember she was really gorgeous... and Stacy, he was kind of oblivious. So I thought here's this girl and, man, you better get with it, here's this prize, dropped right in your lap, go for it...

John Ike: She was a little bit prettier (than Laurie)—she was probably elected most beautiful girl and all that kind of stuff but he and Linda Sharpe broke up because he couldn't stay with girls very long because he was too possessive, too argumentative and always on heavy drugs. He had problems with girls. They only lasted with him about, you know, about a couple of weeks.

The 13th Floor Elevators were conceived and designed to be a psychedelic conduit for their audiences. In late '65, early '66, both San Francisco and London were advertising "Trips" festivals, but no one was actually focused enough to determine a broader ideology, let alone a psychedelic manifesto.

Yet neither were the Elevators operating in a complete vacuum. The phrase "psychedelic" was beginning to enter the lexicon but any prior reference lacked real substance or overt usage. There had been a few rare examples in connection to music. Roky, Tommy and Stacy were all Holy Modal Rounders fans and probably aware of the lyrics to their 1964 song "Hesitation Blues" which contained the word psychedelic. A less obvious example was "LSD-25," the B-side title of the Gamblers' 1961 single, which was merely a surf instrumental. Kim Fowley apparently advertised his novelty record "The Trip" as "psychedelic" in the *L.A. Free Press* in mid-'65. While there had been the short-lived L.A. band The Psychedelic Rangers (featuring future Doors drummer John Densmore), it was the Charlatans who are most noted as an early example of

a band connecting music and LSD. In June 1965, they made their debut performance at the Red Dog Saloon in the Nevada desert while tripping on acid. While the poster for the show has become known as the "seed," the germ for Californian psychedelic graphics, the music owed more to re-workings of 1920s honky-tonk tunes than forming the foundations of psychedelic rock. While important, the Charlatans' scene was about tripping and living a psychedelic nineteenth-century fantasy, as their later recordings revealed.

Handbills for Kesey's December 1965 acid tests are identifiably psychedelic in design, but it wasn't until Wes Wilson's superb "Can you pass the acid test?" handbills in early '66 that mentioned the word psychedelic in conjunction with music ("The Merry Pranksters and their Psychedelic Symphony"—the Grateful Dead are billed as "rock 'n' roll").

While all of this is splitting hairs, it's important to give a foundation to just how curious the Texan scene really was in relation to the rest of the country. Austin remained a backwater university town, largely informed by the unofficial campus network. Despite the L.A. club scene's flirtation with psychedelic terminology, it was San Francisco that was beginning to evolve a real subculture with alternative dress codes, graphics and social gatherings centered around music. However the new music was referred to as the regional "San Francisco Sound," nothing wider, all-encompassing or psychedelic.

None of the colorful external trappings of Californian underground culture — beads, bells, etc. — had yet to infiltrate Texas, which remained decidedly bohemian. The Elevators certainly didn't dress like hippies, or even beatniks. They retained an outsider, rebel image, preferring work wear: jeans, "rough out" boots, checked work shirts and Tommy's army surplus pea coat. While posters were beginning to define a new look for the new culture in California, Austin artist John Cleveland did design and paint one-off posters for the Jade Room windows (none of these are known to have survived). However, his business card design (circa January '66) and blazing eye and pyramid design for the Elevators' bass drum head still remain two of the earliest known examples of Sixties psychedelic graphics.

With the loss of Tommy's house, the band desperately needed rehearsal space. Evelyn managed to negotiate the use of the former St. Joseph's Mexican Catholic church on West Mary Street in nearby South Austin, where Roky rehearsed with the Roulettes. The church was now empty and in private hands, so the band rehearsed there for a short period before rehearsals were moved to a ranch belonging to the Waltons on the east side of town. Previously friends, fans and Roky's groupies had hung out, but now at Tommy's demand, rehearsals were closed, with passwords for admittance. The ranch was to enter Elevator folklore because of "the steering wheel of the world"—the nickname for the ship's steering wheel mounted in the ranch's driveway, where often some tripped-out person would be found gently steering the planet through the solar system.

The band was finding it hard to survive. Houston remained an important refuge from their infamy in Austin. Door money from gigs was hardly

ANGELS Attic Presents...
13th Floor
ELEVATORS
DD 24th & Latter Daye
ON the Courthouse SQUARE
8 till 12 PALESTINE $200/Person
FEB.
Saintz

(FEBRUARY 24, 1966) EARLIEST KNOWN FLYER, COURTESY PAUL DRUMMOND COLLECTION

enough for five people to live on and dope-dealing cash was now gone. One time when Clementine visited them in Houston, she was shocked by their situation—the band was living on powdered soup broth from a vending machine.

The Elevators continued to make the New Orleans Club their home while the Wig and the Baby Cakes shared the Jade Room. As Jim Langdon reported in "Nightbeat," "Conversation when the Elevators played was impossible; there existed only a one-way dialogue, with Roky Erickson telling the crowd that 'the Kingdom of Heaven is within you.' The scene had almost religious overtones as cliques of eager listeners experienced group catharsis."

While the Elevators fashioned their new sound, based on a mixture of Texas stomp, rock 'n' roll and rhythm and blues, the Conqueroo were very different sounding from the earlier incarnation with Powell, who now fled the repressed atmosphere in Texas for Mexico.

Now an electric blues-based band that stabilized around the lineup of Charlie Prichard, Ed Quinn, Bob Brown (rhythm guitar) and Daryl Rutherford (drums), they also had the first Texan psychedelic lightshow provided by Houston White and Gary Scanlon who had ventured to New York and San Francisco in the winter of '65, and learned from the early Family Dog lightshows. Upon their return to Texas in early '66 along with Travis Rivers, they set up the Jomo Light Disaster. What started as a collection of projectors, clock faces and food dyes developed over the following year as they experimented alongside live performances by the Conqueroo.

While the Elevators had to maintain a low profile and constantly moved around, the Conqueroo were very much in evidence at Caswell House on West 15th Street, which became such an underground focal point that Gilbert Shelton later immortalized the house and "Fat Charlie" (Prichard) as Fat Freddie in the *Fabulous Furry Freak Brothers* comics.

While today the house is a celebrated museum and landmark, in the

Sixties the top half of this huge nineteenth-century house (complete with turret and spire) was rented by the band as a home and rehearsal space while the downstairs was occupied by a deaf, elderly couple. Ken Kesey's Merry Pranksters even parked up there while passing through town in 1966 causing a constant stream of traffic to glimpse their infamous psychedelic bus "Further."

Now firmly established at the New Orleans in Austin, the Elevators started to expand their live circuit. They booked themselves to play fraternity parties and dances in Austin while Bynum's contact Steve Gladson secured them a booking at Rice University in Houston. As they traveled, so did an entourage of friends and fans. When they played their first show on the Gulf Coast in Galveston, Stephanie Chernikowski was there. Her strongest memory of their show was a show-stopping version of Powell's "Kingdom of Heaven" followed by chemically heightened walks on the beachfront to examine the natural phosphorescence glowing in the water.

"You're Gonna Miss Me" was proving to be a hit in the Dallas clubs, and the band were being courted by Dallas booking agents. Gordon Bynum couldn't figure how the record was selling so well there until he was invoiced by Houston Records for further pressings of "You're Gonna Miss Me" which he hadn't authorized. It seemed Huey Meaux had supplied the demand, so the Elevators headed for Dallas.

When the band played an en route pickup gig at the Courthouse Square in Palestine, they weren't pleased to enter the club (after near bust) to hear their support band, the Latter Daye Saintz, playing "You're Gonna Miss Me." The song's success was such that in their absence it had become a mandatory cover tune for local acts and the Elevators needed to reclaim it by booking local clubs. Despite their celebrity, support slots with Sonny and Cher in Dallas, Austin and Houston were cancelled due to poor ticket sales.

Previously the band had felt the pressure to record their first single before a rival band could supersede their sound, however they now needed to preserve their repertoire and arrangements in case they were busted again. Bynum had published three of the band's original songs in February to ensure their safety, and organized a further recording session at Andrus Studios. While Bynum was hoping for material for a second single, he also wanted to interest larger record companies. Despite being initially impressed by the band's show-stopping arrangement of Them's "Gloria," he favored their cover of Buddy Holly's "I'm Gonna Love You Too."

As a document of the band's development, these recordings are crucial. It provides the only examples of early non-psychedelic compositions such as the Hall-Erickson "You Can't Hurt Me Anymore" and St. John's "Make That Girl Your Own." These recordings also provide early versions of "(Living on) Monkey Island," "Roller Coaster," "Now I'm Home (Splash 1)" and "Where Am I? (Thru the Rhythm)," with the original lineup of Benny on bass. Roky is still very much in evidence as a rock 'n' roll performer with Buddy Holly's "I'm Gonna Love You Too" and "Everybody Needs Somebody to Love." The songs have a fresh, live

feel despite that these were three-track recordings made over a handful of takes. The jug seems to have been afforded little attention and, apart from a solo run on "You Can't Hurt Me Anymore," it isn't a predominant feature. Tommy's technique of using the natural reverb of the hollow jug to echo his vocals can be easily heard during the intro of "Roller Coaster." On later recordings reverb and echo were added to disguise the fact that it was a human voice, making it sound instead like some early form of electronic synthesizer.

Unable to leave Texas until the outcome of their trial, the band spent the spring playing the widest live circuit their bond would allow, continuing their residency at the New Orleans and performing in Galveston, Houston and Dallas. Meanwhile, "You're Gonna Miss Me" reached number two in the local KAZZ-FM Fun 40 and they were becoming Texan legends, attracting out-of-towners to their Austin shows and taking their fan base with them to out-of-town shows. John decided to rent the American Legion Hall in Kerrville for $10 for a "homecoming" show complete with a psychedelic lightshow. The cops got wind of the booking and instructed the owner to leave the doors locked. However, the owner had a grudge against the police, and decided to let them play as agreed on March 11. The cops were furious, and demanded that both Stacy and John Ike's parents had to be present before they would let the show go ahead. They still hung around looking for any excuse to shut them down.

> **Beau Sutherland:** The first thing that amazed me was the fact that they could pick up a phone back then and they'd come in from all over to put a concert together. They had a concert where they appeared at the American Legion. By then they were drawing in pretty good crowds and were somewhat famous. I guess the thing that most amazed me is that they seem to be on the verge of a new sound, a new world. When they used the amplified jug in some of the sounds, they were experimenting with something entirely new. You like to think back and think, "Gee, if they'd had the proper management and if they'd all behaved themselves they might have been as big as the Beatles some day."

> **Houston White (Jomo Light Disaster):** They conned me into going down to Kerrville and hanging up my sheets down there... in an awful place, some really horrible old chicken-shit lodge hall... concrete blocks, just fucking cowboy's kids who thought they were the Rolling Stones. Powell, Sally Mann, nobody else who was hip was there.

The following day the band returned to Austin, where they were scheduled to play the Teodar Jackson benefit at the Methodist Student Center on March 12. Tary Owens organized the show, and it was a unique and eclectic bill. The show quickly entered folklore, as it was the only time Janis Joplin and the 13th Floor Elevators appeared on the same stage. Since Janis had departed the Ghetto scene, she had continued traveling between the east and west coasts of the U.S., but after being refused medical help for amphetamine addiction, she returned home to Port Arthur to recuperate. By late '65 she began singing again and soon returned to the

Austin scene, where she was still performing as a solo singer accompanying herself on autoharp.

Although the Elevators arrived late as usual, Tommy had turned up early in time to see Janis closing the first half of the show. He was so taken by her performance that he enthused about "what if" she joined the Elevators as a second vocalist. Janis seemed to have been equally impressed by the Elevators' loud, electric performance and she supposedly approached the band and asked if they'd ever thought of having a girl backing singer. Despite much rumor and conjecture, the story has persisted that Janis sang with the Elevators; however, this is nothing more than wishful thinking. Her performances were still a far cry from the charged, hollering blues singer she later became in San Francisco, and Roky's influence on her transformation has been widely underestimated.

Tary Owens: Janis came up for it, and it was one of her first major appearances in Austin before she went to California. It was also during this time that she was toying with the idea of a singing slot in the Elevators. Janis was very influenced by Roky. I don't know how close they were. At that point she wasn't doing any rock 'n' roll. She was doing acoustic blues, very much in the Bessie Smith mold. She didn't sing with them at that event. She did an early set by herself. It was her first venture into singing a modern blues song. She sang Ray Charles' song, "Drown in My Own Tears," which she did beautifully. That event was not taped.

Q: Were the Elevators billed as the headline act?

Tary Owens: Yeah, at that time they were still playing magnificently. They got there at the very end of the event. They'd just been busted and they were doing the song, "Before You Accuse Me Take a Look at Yourself." They did it absolutely beautifully.

Q: Irony intended?

Tary Owens: Absolutely.

Jim Langdon: Janis would have been doing a single stand-up blues/folk-oriented type—either acoustic guitar, or she may have had her autoharp, you know. She probably did "Going Down to Brownsville," "Codeine," very much in the blues to folk idiom. Well, she never said anything to me about thinking about joining the band. I know that other people had this dream marriage in their heads, getting Roky and Janis together. I'd heard people mention it, but Janis herself never discussed that with me. I don't see or hear any of Roky's influence in her work—unless you want to say both of them could scream!

Roky (NFA): Janis Joplin blew my mind, man. She was a real person, and she blew your mind just to meet her, as much offstage as she did onstage. She was so real of a person that it's no wonder

she made it. We did some benefits together. We loved her; she needed to get her own name more than as just a member of the Elevators. She had to be known as Janis Joplin, and I had to be known as Roky Erickson.

Chet Helms: She (Janis) told me she'd been performing with the 13th Floor Elevators. She always belted, but her screaming, that came from Roky. What became clear to me was that there was a dramatic change in her stage presence.

Meanwhile, despite Tommy's strict regimen of LSD washed down with Romilar, other members of the band were still curious about other substances. Benny overindulging in crystal methamphetamine and his growing paranoia and frustration with the band was soon to manifest in a desperate attention-seeking act.

During one of the earliest New Orleans gigs in February, Benny (complete with new haircut and shaven eyebrows) was playing on stage with the band. What happened next, during what would be the Elevators' farewell performance before leaving Austin, is one of the few rare insights into the internal dialogue of a band member while playing and tripping.

Although Texas does get cold during the winter, it's rarely more than a series of cold fronts moving through, but the weather is prone to sharp and dramatic changes, nicknamed "blue northern." One minute it can be oppressively muggy and hot, and then the sky darkens, the temperature drops thirty degrees and thunder and lightning will strike, with a sudden hailstorm followed by vast quantities of rain so heavy that you find yourself in a half-inch of standing water. During one of the Elevators' shows at the New Orleans, such a storm hit.

Sandy Lockett: This was one of the earliest New Orleans gigs, and the New Orleans was peculiar in that it had no stage. The performers stood right on the floor, same level as the dancers, and that made it interesting this evening because the fellows had indulged remarkably in one thing or another before the gig and it was a very hot evening. And the place was packed, so it got extremely hot indeed and so everybody was sweating like the dickens, including Benny, who finally got down to a T-shirt with holes in it and a falling-off pair of blue jeans. And as he continued to play bass he began to get a stranger and stranger expression on his face, so nearly horrified. And he was nearly bald at that time, shaved to a buzzcut, and there was sweat running all over him. After a while he began to pick up one foot and then the other and looked at his feet while he was playing. Finally, at the end of the set he rushed off into the restroom, where he said, "Oh my gosh! I'm bleeding! I'm bleeding! I was standing out there and blood started coming out of the roots of my hair and it dripped down my shoulders and across my chest and down into my pants and I was stepping in it and everybody out there dancing was dancing in my blood!"... That's all right, Benny, you'll be OK, we'll fix you right up."

25. **Charlie Prichard:** *I remember the Elevators being sort of holed up after their first bust, but there were two albums that got us through the winters, that were incredibly part of the fabric of our lives, one was* Rubber Soul, *which was the first time as Tommy put it that the Beatles came out and said, "we're conscious"… and the other was* Bringing it All Back Home.

26. "Roller Coaster" is incorrectly credited to only Hall and Erickson on their album *Psychedelic Sounds of the 13th Floor Elevators*, IALP1. Gordon Bynum originally published it on February 23, 1966 as "Roller Coaster" EU926296: Tommy Hall & Stacy Keith Sutherland & R. Erickson.

27. Rollercoaster roads: Ranch Road 22/22 to Balcones Drive which winds around Mount Bonnell Road to the peak of Mount Bonnell before it snakes down the hillside overlooking the Colorado River to Capitol of Texas Highway and up the hill to the radio towers where the marijuana stashes were.

7.
THE BIG "D"

By the spring of 1966, the Elevators were struggling to expand upon their sphere of influence. The trail to California was firmly barred by the court bond, and there was only one logical place to relocate—Dallas. The Elevators had achieved an equal measure of fame and infamy in Austin, and while Houston offered a younger, more appreciative audience, it lacked the promoters and music industry contacts Dallas could offer. Their farewell performance at the New Orleans signified a strange achievement, as they had outgrown the college town for many reasons.

They had started to meet criticism from some of their contemporaries. While some felt the band had been opportunistic and "stolen" Roky for his hit song, others from the early hippie crowd made it clear that they didn't buy Tommy's rap. The early hippies in Texas weren't the stereotypical flower children, nor were they urban East Coast hard drug takers; they were a strange hybrid of individuals, liberal rednecks, beatniks and college dropouts. Many freethinking Austinites still carried guns and shot and ate things. Tommy's rap was beginning to rub people the wrong way. He had an answer for everything and wanted to explain to people what *he* thought was happening to them. This divided public opinion between those who found him a coherent and experienced guide and those who didn't want to be "fenced in" by his ideas.

"Contributing bystander" Bob Simmons refused to take the "stench of enlightenment" too seriously and commented, "Tommy always liked philosophers whose last names looked like the bottom line of an optician's eye chart…"

> **Lynn Howell:** The guys, I liked them all except Tommy. Tommy was just, you know, like Clementine… They were too weird. Tommy really wanted to be some sort of prophet, that's what he really wanted to be, but he wasn't smart enough to pull that one off. But he was always trying to explain something deep. "I know, I know… you don't have to tell me that shit… I know, I got eyes, I can see." Some people think he was speaking great heavy thoughts… so?

George Kinney: In Austin, they didn't take Tommy that seriously; they should have. Even the old Austin hippies, Tommy was way too far out for them, they didn't like that... Tommy made you feel as uncomfortable as shit, you talked to him, did you feel uncomfortable? Strange, isn't it, and Texas is really like that too; you've got some strange combinations, that's part of it, the redneck hippies and guns are involved. These guys were raised clean and clear and killing things and when they saw the light above that, they came from a stronger position because they'd already been through the whole blood and guts Vietnam thing and still went to the next level.

Many viewed Tommy as a valuable collaborator and guide, someone who was simply more experienced than them. Powell St. John saw himself "halfway between Tommy Hall and John Ike Walton—I bought some of it, but not all of it." Although he read Leary and Alpert's *The Psychedelic Experience*, he was able to write insightful songs based on his experience of LSD without the application of theory, unlike Tommy. Tommy's rhetoric could still come across as arrogant and bombastic, rarely explaining himself or giving background to his views. He employed the terms "upper and lower class" to define a class of intellectual rather than as a put-down. Tommy's use of the word class related to the Gurdjieffian model of enlightenment with the masses inhabiting the bottom of layer of ascending knowledge; and the idea often comes across as insulting. While the Elevators preached "the Kingdom of Heaven is within you," they were still anomalies within their own developing culture: Turned-on rednecks simply didn't want to be lectured to. The growing "consciousness movement" had no template for a modern psychedelic society.

Relocating to Dallas, the Elevators made an appearance at La Maison in Houston, March 20, before their first known live appearance in Dallas on March 25, at the massive Market Hall alongside seven other acts. They made a live TV appearance on WFAA's Channel 11 *Sumpin' Else* TV show at four p.m. the same day. The footage has long since been wiped but the audio tracks, including the warm-up material, have survived, providing an excellent snapshot of the band's live sound. Although Ron Chapman, the show's host, made a hilarious attempt to interview an incommunicable Tommy about his jug playing, its important document is the performance of "You Really Got Me." By the middle of the song the band departs from the original structure, the jug oscillates, punctuated by Benny's yelps while Stacy's guitar slides off the rails into a free-for-all freak-out.

Stalarow and Bynum had managed to organize enough gigs to keep the band busy in Dallas until late April, and many of the loyal Austin and Houston fans made the pilgrimage to see them at regular club haunts like Lou Ann's off of Central St. John Ike took on the thankless task of herding the other band members (stupefied on Romilar and acid) off the couch and into the van. Although John Ike conceded "Tommy loved gigs," he wasn't always in a fit state, and prior to one early performance Tommy arrived so out of it that he didn't even have his jug with him. The band panicked and desperately searched the venue for a substitute. Stacy found an empty

entertainments unlimited presents at

MARKET HALL

* 13th FLOOR ELEVATORS
* CHAPARRELS
* GARY FERGUSON
* NOVAS
* PREACHERS
* SENSATIONS
* GENERATION X
* SHARON LIEBOW

free cokes & sprite (while they last!!)

$4.00 a couple in advance $5.00 couple at door

BUY YOUR TICKETS AT

PRESTON TICKETS, MINSKY'S MUSIC, MIRACLE MUSIC, MELODY SHOP (INWOOD)
PRESTON RECORDS, VILLAGE RECORDS, LAKELAND MUSIC

FRIDAY, MARCH 25
Table Reservations Available
LA2-0563 - LA8-6390

SPRING CLEAN UP

(MARCH 25, 1966) HANDBILL, MARKET HALL, DALLAS, TEXAS,
COURTESY DENNIS HICKEY COLLECTION

kerosene jug, but there was no time to clean it out before the band made the stage, and by the second song Tommy had passed out from the Sterno fumes. Typically, it fell to John Ike to scour the antique shops in the hill country for spare clay jugs.

In Dallas they played a healthy balance of covers and original material so as not to alienate their new audiences, and usually the band were obliged to open and close their set with their hit single to affirm their identity. The band felt they relied on being high in order to communicate on a higher level, and things usually hung together musically with John Ike, who didn't partake, in anchoring the band's timing from his drum stool. Benny did his best to keep up, while Stacy's guitar formed the framework of the song and Tommy oscillated along. Roky had an incredible memory for words and had no problem accompanying himself on rhythm guitar. Performances only seemed to become completely unhinged when they couldn't score LSD or Romilar and they experimented with other substances to recreate the high. Stacy and Benny found that amphetamines helped contain and control some of the effects of LSD and gave their sound a driving edge. Promoters and agents often found the band hard to communicate with, and no one could determine exactly what they were indulging in. During the filming of *Sumpin' Else* it was noted that the band were seen drinking Listerine mouthwash, which was then largely alcohol-based (and remains one of Benny's tipples to this day).

On another occasion, things really started to degenerate when Stacy

and Benny, broke and sober, got bored of being cooped up in the Carlton Motel in Dallas, staring at the dirty balding carpets and watching Lord Buckley on TV. According to Benny, Bynum had booked them to perform at a Dallas auditorium with the local band "The Five Americans" for future broadcast, but much to John Ike's annoyance Stacy and Benny didn't make it, having sniffed too much glue.

The presence of the large William Morris Booking Agency had helped lure the band to Dallas, but following a meeting no deal was made. With their initial batch of bookings beginning to run out, they ventured further east, playing smaller venues such as The Box in Beaumont. Desperately in need of a gig, the band put Stalarow to the test—although he succeeded in getting them a booking at the Club De Milo, trouble started as soon as the band struck up with their hit tune. The club's manager told them to turn the volume down, play a different kind of music or get out, so they packed up and left. Soon the band parted company with Stalarow.

Clementine: Did you ever hear what Tommy called [Stalarow]? The turd in boots. He was an awful, awful, awful person. He was very, very corpulent, and very greasy, and very obsequious. Eeugh! I don't know how that happened! I have no idea how he managed to take over, but he had a fast line—a very fast line—and he just sort of pushed things around, and we went "Well, at least we're going somewhere." There had to be someone who would organize us. There had to be someone who would get these guys out on stage, there had to be someone with some kind of a connection. So, anything will do as long as something happens.

John Ike wasn't slow to take the opportunity to start trying to run the band his way. He called his mother, Emma, and persuaded her to come to Dallas for business talks. She recognized the band's potential, and understood that they had successfully managed to create their own following in Austin and Houston, but needed a stable venue to capitalize on their success in Dallas. She agreed to re-house the band in a middle-class suburb while they searched for a suitable venue to open their own club. A typical American grocery store, similar to the Jade Room and La Maison, was found on N. Collett Street; Mrs. Walton agreed to sink several thousand dollars into the venture of opening a 13th Floor club. When Powell St. John rolled into town to check on their progress, he was horrified at their uninhibited lifestyle, and was convinced the only reason they weren't being busted was because they must have been under constant police surveillance.

Meanwhile, John Ike signed the band with a local booking agent called Jerry Ray. Ray immediately contacted Gordon Bynum and inquired whether he owned the name "13th Floor Elevators." Although Bynum had the band under contract, he confirmed that he didn't. John Ike promptly registered the name solely in his name and called Bynum.

Gordon Bynum: They had gone to Dallas and—this was really bizarre—I got a call from a guy and he asked me if I got copyright of the name "13th Floor Elevators." John Ike called me and I told him

I had an idea for a song for them to do and he said, "Well, we're not going to record for you anymore and we're not interested in any of your ideas."

Local celebrity Dale Hawkins, who'd scored a 1957 hit on Checker Records with "Susie Q," was working as A&R and producing for a small label called Abnak. He'd had recent success producing "The Five Americans" and been impressed by the Elevators' no-nonsense Texan beat, so suggested that they should try and record with his engineer Bob Sullivan.

Dale Hawkins: I heard the group and thought they were commercial, I felt insecure in signing them to the label I was working for because it was rather shaky at the time. I recommended that they continue to work with Bob Sullivan since the rapport there was compatible.

The band, impressed by Sullivan's track record, demoed their second single at an undocumented session circa April 1966. They recorded an early arrangement of "Reverberation" that differs greatly to the released version. They also completed another track, "Splash One," which ended up being used for the first album. Sullivan, 40, was an experienced producer and was unfazed by the band's unconventional behavior or the fact that they were clearly completely out of it, "What I remember most was their demeanor. They were so stoned out that you could walk in and say, 'Hey, the building's on fire,' and they'd say 'cool, man.' [Laughs.] They were just that laid back."

Throughout April, although interest in the band continued to grow, no real major label interest was forthcoming. There were a few independent labels in Dallas, but none that could really offer much more than Bynum had. "You're Gonna Miss Me" needed to be broken out of Texas and licensed to a larger label if it stood any chance of becoming more than a regional hit.

Unlike much of the Texan music industry, who still thought the Beatles music was an insufferable din, Huey Meaux understood the new beat sound. The story goes that he was determined to crack the Beatles' "hit formula," and had locked himself in a hotel room with a stash of their records and Thunderbird wine, only to emerge when he'd figured it out. His prognosis was that the beat should be on the beat, like a Cajun two-step. He instructed twenty-four-year-old Little Doug Sahm to grow his hair long and form a band, which Meaux christened the "Sir Douglas Quintet" to make them sound more English. Their 1965 single, "She's About a Mover," was a brilliant hybrid of Texas stomp and British beat, and charted on both sides of the Atlantic. Meaux was sure "You're Gonna Miss Me" could be a hit, and was determined to license it to a bigger label. When Big State Distributors in Dallas contacted Meaux for further copies of "You're Gonna Miss Me," he allegedly pressed up three more batches at Houston Records. His attempts to interest the director of acquisitions at Hanna-Barbera's record division in California had failed.

In late April, the Elevators had made a triumphant return to Austin for two dates at the New Orleans, which coincided with their grand jury hearings at the 147th Court of Travis County. Whereas before they had been

NIGHTBEAT

★

By JIM LANGDON

Still on guitars, it was like old home week at the New Orleans Club Thursday and Friday evening where ROCKY ERICKSON and the 13th Floor Elevators made dramatic return appearance at the club.

Dramatic, in that some 1,000 people showed up over the two night engagement, literally jamming every available corner of the club, both indoors and out.

It was really amazing, witnessing the walls of people, set in motion to the psychedelic sounds of the group which, if anything, has improved since its last dates in the Austin area.

And this was where the action was. From the latest in "POP" outfits and hair styles, to the more conservative customers . . . all reacted much the same to the band's exciting rhythms.

And that reaction was affirmative.

TONIGHT!

ROKY

AND THE 13th FLOOR ELEVATORS

8:30—11:30

THE NEW ORLEANS

1125 Red River GR 8-0292

(APRIL 30, 1966) *AUSTIN STATESMAN*, 'NIGHTBEAT' COLUMN & AD FOR NEW ORLEANS CLUB SHOWS, APRIL 28–29

drawing audiences of 500 to 600, after their absence, according to Jim Langdon's column, they commanded over 1,000, who crammed into every inch of the club. Evelyn Erickson mobilized her prayer group, and the Waltons hired Les Proctor, an ex-DA with political clout, in an attempt to influence the grand jury to be lenient. Both attempts failed, and the police complaints were upheld. Charles Pitts, the grand jury foreman, duly filed the court returns on May 2 and 5 confirming their cases would go before a judge. Warrants for arrest were issued on May 5, and the band was dragged into court to hear that their $1,000 bond would be upheld until further trial.

Again the band felt threatened by the fear of jail and pressure from their musical contemporaries. The initial wave of dross from what would be later dubbed the "British Invasion" had passed, and new recordings from the underground clubs were starting to break the American airwaves. While a wave of LSD had hit the London elite in the early Sixties, the amphetamine mod beat still drove much of the music. The Who's first American album, *The Who Sings My Generation,* was released in April 1966 and its contents combined frenzied James Brown covers and original material set to a raw, uncompromising sound. In March the Yardbirds issued the groundbreaking *Shapes of Things to Come,*[28] which was a complete departure from the normal pop idiom with Gregorian chant-style backing vocals. With almost an album's worth of material still unreleased, the Elevators felt trapped and needed a record company immediately. With court cases looming, the future of the band looked increasingly gloomy and, panicked by their lack of offers, they decided to go for the only one on the table.

Bynum had encountered Ken Skinner from the Houston-based "International Artists Producing Corporation"—in spite of the label's grand title, its meager output to date was entirely based on licensing releases from other small local independent labels. Bynum had immediate reservations about Skinner's credentials and dismissed the label. To Skinner, the Elevators were the worst bunch of unprofessional, shambolic punks he'd ever heard, their record a complete din and their demeanor and appearance a disgrace. However, Bynum and his one-off "buzz" record were perfect fodder for the fledgling label, so he discussed them with IA president Bill Dillard. Dillard was more optimistic, and decided to call them up for a meeting in late April.

Inspired by the name "United Artists," Fred Carroll had conjured up the impressive-sounding International Artists to attract major label interest for his band the Coastliners. Following local success in October 1965, "All right"/"Wonderful You" was picked up by the Back Beat label and, having no further need for the International Artists name, Carroll sold it to a strange conglomerate for the $35 cost of the label printing blocks. A pair of lawyers, Bill Dillard and Nobel Ginther, a music business hustler and publisher, Kendall A. Skinner, and a studio boss, Lester J. Martin—inspired by the success of the Beatles and Rolling Stones—were eager to get into the "lucrative" music industry. Dillard and Ginther had no previous experience whatsoever, but were convinced that if they found the Texas Beatles, they could stand to make a lot of money. Meanwhile, Skinner worked as their A&R man while Les Martin hoped new bands would pass through his "Jones and Martin Recording Studio," co-owned with Doyle Jones.

Bill Dillard (AB): Ken Skinner was just a cheap crook. He wanted to pay twenty percent royalty. I said, "Ken, there's no way we can pay twenty percent royalty." He said, "You promise them what they want and you pay them what you want them to have. That's the way it works." I said, "From the way you describe the Elevators, they're the most unruly group around. You set up an appointment." They said they wanted thirteen percent royalties. I took out my briefcase and I said, "I'm going to try and educate you in the record business." I put down the printing costs, the label costs, the pressing costs, what was involved in the manufacture of the record. If you want an honest count, you're not going to get thirteen percent royalties. I told 'em I'd pay three-and-a-half percent on a one-year contract, with four one-year options. Anyway, they agreed. And we left with a contract and the master tape that had "You're Gonna Miss Me" on it.

Although the band went into the IA offices to sign the contract for "You're Gonna Miss Me," they managed to defer actually signing themselves to IA as an act. George Banks accompanied the band and witnessed Benny's reaction to the contract: "I was in the office when everyone was signing contracts. Benny was always very sharp, he like read the contract, and he whips out his fiddle! And plays what he thought of the contract, didn't even speak!"

In early May, Walt Andrus was paid to mix the Elevators demo tapes for IA to hear, and the band were back in Dallas on May 9 making their second appearance on *Sumpin' Else*. The band rattled through their performance with a truly demented and fiery amphetamine drive. They played a pared-down version of "Gloria" to warm up the audience, followed by "Fire Engine," "You're Gonna Miss Me" and "Roller Coaster," which were all broadcast. Off the air they performed a version of the Stones' cover of Don Covey's "Mercy Mercy" and their B-side, "Tried to Hide," delivering a truly incendiary performance of "Roller Coaster" that left the show's host with little to say but "WOW!"

A few days later, on May 15, the band was scheduled to support international chart-toppers the Byrds at the William Rogers Auditorium in Fort Worth Dallas. The show was reported to have been a huge success by Jim Langdon, and Roky and Tommy both remember it being a good show; but as usual they struggled to actually get there in Tommy's beaten-up old Rambler in time to perform.

Roky (NFA): We played with the Byrds in Fort Worth, driving an old car—I mean, we were poor. The carbon monoxide was leaking into it, and finally the devil, or God, looks down and says, "Hey, man, I can't handle it anymore." Bam, and he stops the car and says you're not riding in it anymore. So we got a ride to the concert, and everything was all right.

With a new record company in Houston and plans for the proposed 13th Floor club being blocked by the city council due to a technicality (lack of adequate parking), the band decided to quit Dallas and return to the Austin and Houston club circuit. The band played several shows at

La Maison from late May into early June, which has led to many fans' nostalgic memories of them as the house band when in fact they didn't play the club more than half a dozen times, according to John Ike. Several ramshackle and partial recordings date from this period, because the Misfits' lead guitarist Jimmy Frost was in the habit of recording his own band live, and often taped the Elevators too. The Elevators' performances don't rank among their finest, and contrast strongly with the excellent TV performances. However, the crude stereo perfectly captures Roky's stage presence as he dominates the proceedings, rattling out a cleverly tailored balance of original psychedelic material and crowd-pleasers so as to not alienate their teenage audience.

The band was also packing the New Orleans in Austin on May 25 and 26 while rival bands the Wig and the New Edition battled it out for Jade Room bookings. Aside from the usual dances and parties, the band largely toured the state of Texas promoting their record while making appeals in the courts. One particular circuit the band traveled was known as the "A" road, made up of Highways 6 and 1960 out of Houston, which ran through Addicts, Alief, Arcola and Alvin and, as usual, the Elevators' appearance in small towns at honky-tonk bars meant attention, and the unnecessary cat-and-mouse game with the Texas Rangers continued, with many near-miss busts.

In early June, the band played a run of shows back at the New Orleans, which also coincided with the next round of court action. This time the band's lawyer, Jack McClellan, was on the defensive, making counterclaims against the Austin police force. He argued that the evidence had been gained illegally, and in turn issued subpoenas against the arresting officers in the hope of suppressing the evidence. The idea was to instigate a pre-trial hearing so that the testimony of the cops would be a known factor, prior to the trial.

With IA imminently about to repress "You're Gonna Miss Me" for national distribution, the band needed to prepare for promotional appearances outside Texas. Assuming they weren't locked up for the next decade, they planned to tour the Californian ballroom circuit. However, Stacy and Benny were fast becoming a liability and Roky and Tommy gave them an ultimatum: Quit speed or quit the band.

Stacy (K): [Benny's departure happened] in a negative way. Just taking speed all the time. Staying up three or four days at a time. He wouldn't come to practice. I had a really bad reaction because I loved ol' Benny so much, man, and I was guilty of the same thing… I started out with him; both started chipping, shooting a little speed, going to gigs, half of them on acid and us on speed… All of a sudden I started to get real nervous and everything, and started causing a clash, you know what speed does… you get uptight and ready to snap at people. It got really out of hand, ol' Benny was wanting ol' John Ike to fight him and Tommy and everybody, cursing each other like dogs. They told him, "Look, you're in a bad place, you're on methedrine, quit!" They told me the same thing at the time. As far as an emotional clash, it was worse between Tommy and Benny than anybody else in the group.

Although John Ike would constantly yell at Benny to "get down on the bass" and stop following Roky's lead vocal, so he could control the rhythm section from his drums, Benny was a useful ally. If Benny left the group, it would upset the band power structure as John Ike viewed it. John Ike: "Tommy and Roky came to Stacy and said, 'Benny's shootin' speed. We gotta get him out of the band.' See, if Benny was in the picture, I had the majority of the band. It was my band. Because I got Benny and Stacy and all. And Benny was not a very good bass man. He was a violinist and he didn't think 'bass.' I couldn't play drums to his bass part comfortably."

Not only was Benny's bass playing letting the band down, but his general demeanor and well-being was edging toward chemical degeneracy. Meanwhile, being left out of the songwriting, Tommy ignoring him and the stigma of the bust had increasingly frustrated Benny and now his chemical relationship with Stacy was being challenged.

Tary Owens: Benny went really off the deep end. He was the first visible casualty of the band. It was as much speed as it was acid. Mixing the two. He would come to a mutual friend's house and he'd have a baggie full of lawn grass cuttings that he thought was marijuana. Benny was too wired. I think he quit rather than being fired. You could just see it. He was too out there.

After Roky and Tommy had spoken to John Ike and Stacy, it became their job to approach Benny. Benny supposedly took the news well, feeling a sense of relief that his career as a psychedelic pioneer was over. Although John Ike let him keep his bass and amp, Benny went straight to work under the watchful eye of his father at the Piccadilly Cafeteria in Austin and retired from music for nearly a decade.

Benny: I had shaved my head and they were just devastated, that's when Tommy really pulled away from me. But I did what I did. Mainly I got out of the Elevators 'cos it was a little bit too much for me. I wasn't a good enough bass player anyway.

Q: Did you not want to go to San Francisco with the band?

Benny: No I never, I just turned my back away from there. I was physically ill, I was mentally ill and I was afraid they were gonna come and get me if I didn't get straightened out. So I stayed here and worked... forty hours in a bakery, all that hard peach type work, just like strenuous, and I got my health back. Father was a war guy and all the chefs had been in Korea and so I sorta had to step away from the movement and peace and kinda get hard again, I didn't play any more music after that...

28. Roky had already been hugely inspired by the Who's loud and furious sound on their first three singles which had been released throughout 1965; their most famous, "My Generation," was released the same month he recorded "You're Gonna Miss Me" with the Spades.

8.
ESCAPE TO
SAN FRANCISCO

There was only one possible new Elevator—Ronnie Leatherman. He was from Kerrville, which was immensely important because he shared a musical history with Stacy and John Ike, who were the foundation of the band's sound. Inspired by Paul McCartney, Ronnie had none of the era's misgivings about being "relegated" to bass guitar. Having learned basic Spanish guitar from a science teacher, he sold his car at the advent of the Beat era to buy a Silvertone bass and amp.

Ronnie Maxwell Leatherman was born in Kerrville on January 31, 1948. His father was a local painter and decorator, while his mother was a housewife and secretary at the local Baptist church. Ronnie started playing ukulele at an early age, and later took trumpet lessons. When he saw Stacy performing with the Signatures at Tivy High School he realized what he wanted to do. When the Signatures split and Max Range formed a new band, Ronnie turned up at a rehearsal and announced, "I'll be your bass player"... Although Ronnie was a good student, playing soccer and basketball, he also did his fair share of slacking off. Ronnie had a keen interest in motorbikes which was his introduction to John Ike and hot rod racing. Having played around town Ronnie got a call to join a band backing an old country singer called Dennis Crow. When he got to the gig he discovered John Ike sitting in on drums, who was planning to leave for Port Aransas with Stacy and Max. Although Ronnie was an obvious choice on bass, he still had a few more months before high school graduation.

> **Ronnie:** First time I saw the Elevators was the first time I played with them. It was kind of hard. Felt pretty much out of place all night, especially since they had such a following; and of course a lot of them really liked Benny but they liked the way I played too. There were a lot of people glaring at me.

(CIRCA 1952) RONNIE MAXWELL LEATHERMAN, KERRVILLE, TEXAS, COURTESY R. LEATHERMAN

The transition between Ronnie and Benny was swift. Stacy approached him explaining they were having difficulty with Benny, and then Roky and Tommy came to Kerrville to jam and pick with him before checking out his band, the Penetrators, at the American Legion Hall in Fredericksburg. Apart from the kudos of having the Elevators arrive at his gig, Ronnie was doubly thrilled when they pulled him aside and asked him to join the Elevators. Stacy taught him the set list and joined Roky rehearsals in Kerrville.

By the summer of 1966, the New Orleans club had succumbed to pressure from liquor law enforcement to stop hosting live bands, so the Elevators played the Swingers club on June 20 and renegotiated their regular slot at the Jade Room where Ronnie made his debut on June 29. Benny played the first set as his farewell performance and Ronnie took over the second. The band spent much of June back in Austin due to the imminent court hearings but planned their escape to California. Much of the record industry was based in Los Angeles, but with strong Texan contacts at the San Franciscan ballrooms, it was the best place to launch the band. International Artists (IA) had taken over production of their single at Houston Records, and copies began to trickle out in late May. IA made feeble attempts at finding promoters and distribution on the West Coast, with Dillard insisting that a reluctant Skinner should include the Elevators amongst a handful of singles he was promoting on the West

Coast. In L.A., Skinner played them to Lelan Rogers, brother of country singer Kenny, who was intrigued by the strange jug sound he couldn't get out of his head.

> **Lelan:** I was at an R & B label called Omen Records that a gentleman by the name of Chester Pipkin and I were running, and it was at a time when we were trying to get some hits, and we weren't. At about that time a guy named Ken Skinner showed up and he had about four or five records on International Artists records. And I heard one that I liked, and that was because of the jug, and that was "You're Gonna Miss Me." I thought, I can work this record for you.

Rather than try to license the record himself, Lelan offered to promote it for two cents a copy. When Skinner reported back to Texas, Dillard called Lelan and offered him the job as IA's "national promotions man." Lelan accepted, and immediately started to plug the record from the West Coast through his network of DJs and radio contacts. As soon as "You're Gonna Miss Me" began to oscillate over the national air waves, sales took off. The first known charting outside Texas was on the WQAM chart in Miami, Florida, June 25, 1966 when it was still charting in Dallas on the Contact label as late as June 23. When Gordon Bynum realized it was charting on a different label, he tracked down Dillard immediately. The exact circumstances of the band's signing to IA were a confused mess, if not a complete fiasco. The band members over the years have done their best to distance themselves from any personal responsibility, preferring to blame Bynum for selling their contract to IA. However, since they'd decided to dismiss their contract with him when they licensed "You're Gonna Miss Me" to IA, they left him with little option but to sell his interest to IA.

Insult became injury when Bynum saw that Ken Skinner was being credited as publisher [on the B-side], and also producer. Things started to become really confusing when the labels were amended to the original Contact label credits. As the record began to chart in regional radio surveys, Hanna-Barbera re-contacted Huey Meaux to say they now wanted to pick up the option on "You're Gonna Miss Me." Meaux told Hanna-Barbera they could have it, and called on Dillard to tell him he'd better lease it. Skinner argued that they shouldn't lease their only hit, but was ignored, and a representative of Hanna-Barbera visited Houston with an advance, and collected the tapes for pressing on the West Coast.

Since only a verbal agreement was made with Hanna-Barbera, Dillard flew out to L.A. at the beginning of July to finalize the hard copy. When he and Lelan stepped into the president's office, further confusion ensued. The Hanna-Barbera representative who'd made the deal turned out not to have the authority to do so. In the argument that ensued, Dillard called them all liars and said he'd only deal with either Mr. Hanna or Mr. Barbera, because maybe *they* had the authority. It was later alleged by Tom Ayers, director of acquisitions for HBR in Hollywood, that Dillard had tried to swing a deal whereby Lelan Rogers was given a top promotions job at HBR. According to Dillard he picked up his coat and stormed out into the car park, closely followed by the president of HBR.

Bill Dillard (AB): Lelan noticed the guy who owned a pressing plant pull up in the parking lot. Lelan said, "That's who I was taking you to see. We'll just talk to him right here." So we walked over and Lelan introduced me. Dalton was his name. Lelan said we had a hit and needed some pressing. The guy said, "What's the name of your hit?" Lelan said, 'You're Gonna Miss Me' by the 13th Floor Elevators." Dalton literally turned white. Now, this president was standing over there close enough to hear. Lelan said, "What's wrong?" Dalton said, "Hanna-Barbera said the record belonged to them. He told me"—pointing to the president—"they had this record. I've been pressing it for them. I don't want to give you any problems." I said, "How many did you press?" He got real iffy. I said, "Well, how many have you shipped?" And he got real iffy. So I turned back to this guy who was president. I said, "I think you need to get on the horn. I'm going to have a lot of people out there looking for this record, and if I find one copy—one copy—of this record on the Hanna-Barbera label, there's going to be a new name on that building. I've got a bunch of people out there promoting this record, and they've got another job as of now." And we did find one—in Miami. As far as I know, that's the only place that it ever got out to. There wasn't many, 'cause we only found one. They didn't hurt us [sales-wise], so I didn't do anything. Anyway, that's the Hanna-Barbera story.

Hanna-Barbera took Dillard seriously, and no copies of the California pressing are known to have survived. However, a few copies pressed at the Nashville plant were distributed and began to chart in Florida. Needless to say, these have now become prized collector's items.

IA switched production from Houston to Rainbo Records in Hollywood using the inferior HBR record stampers that contained a crude fade at the end of "You're Gonna Miss Me," making it four seconds shorter than the original Texan pressings.

In the interim, bootleggers took advantage of the confusion, and several counterfeit issues appeared on the market, all originating from the HBR stampers. During its brief assault on the American charts, "You're Gonna Miss Me" was subjected to continued label variations, designs and bootleg issues, making it one of the most confusing and collectible records of its era. Despite weeks of sales being mismanaged, the record eventually registered on the national charts. Although it featured in the *Cashbox* and *Record World* listings, its longest run was on the *Billboard* charts, entering at #123 on July 23, 1966, and peaking at #55 the week of October 8, vanishing without a trace the following week. Regionally the single charted far higher, entering many local radio surveys and charts in the top ten. The Elevators joined a slew of American bands' singles, such as the Music Machine's "Talk Talk," the Count Five's "Psychotic Reaction" and Question Mark and the Mysterians' "96 Tears," that ended up as "one-hit wonders" during the summer of '66.

How the record, which sold over 60,000 copies, would have performed if it had been properly marketed and distributed by an established label will never be known. While IA managed to place one advertisement

in each of the trade magazines, the single's success was solely due to the hard work of Lelan Rogers.

Although relations between the band and IA were soon to sour, the band were initially thrilled. As John Ike recalls, "They did a pretty damn good job for a small independent record label there, 'cos we were number one in pretty much every town in California. It hit big; considering it was a three-man record company out of Houston, Texas, it hit real big. Actually it was a one-man record company; it was Lelan Rogers that did the promotion."

The record was sold by pure old-school hustle and contacts, and no attempt was made to promote it by marketing the band's image. Despite the angelic Roky's obvious teen appeal and a dynamic stage performance, IA were too inept and frightened to let the band be seen or heard through photographs or interviews. On June 23, as the single first charted outside Texas, four reels of material were mixed down at Andrus Studio in Houston for possible release as a first album and to find a potential follow-up hit. The Elevators' future was still in the balance, and if nothing else a follow-up 45 or album would capitalize on their infamy.

John Ike: I don't think International Artists treated us right, but there was nobody else in Texas doing anything. We didn't even think we had a future, except play a gig here or there and have some fun playing some music. We never thought we could have albums that sold. We never thought we could have a hit record, never even dreamed of it. When they said it was number one in Sacramento, California and this guy called up and wanted the band, we were gone.

While John Ike worried about the band's long-term future, Tommy was fed up with dealing with promoters and contracts, and was more concerned with preserving the essence of the band's message. He decided that if their fate was sealed with IA, then they should understand the group's perspective. Nobel was a "local boy" who had grown up with Elevators soundman Sandy Lockett in Houston. So Tommy, armed with LSD and a copy of Dylan's recently released *Blonde on Blonde* album, decided to pay Nobel Ginther a visit. Allegedly Tommy gave him acid and put on Dylan's "Visions of Johanna" as proof of the high levels pop music was now entering. Ginther supposedly pleaded with him to turn it off and sat out the rest of the trip while Tommy explained his ideas. With Ginther "converted" and "in the know," a contract was drawn up.[29]

Q: Did you sign a contract?

Ronnie: Yeah, when I got in the band that was one of the first things we did. We all signed it at the same time before we went to California. Anyway they signed a contract with Bynum and he sold them to IA and it said in there he could sign them to anybody. And Roky wouldn't sign, or his parents refused to sign a release for him to sign. Roky and me were eighteen, so I had to have a release to sign for my parents to sign.

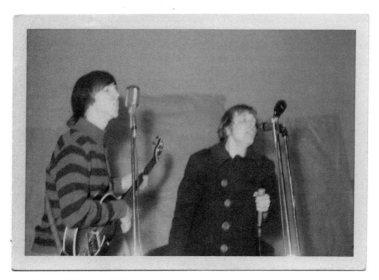

(JULY 1966) RONNIE & TOMMY, PHI DELTS LEGAL FRATERNITY PARTY, AUSTIN, TEXAS,
PHOTO BY DAVID CRAIG

Roky later likened signing to IA as "like handing Einstein's theory
of relativity to a cop. And that's what happened, I handed them all this
genius..." The band remained in Austin throughout July, playing the
midweek slot at the Jade Room twice a week, alongside a number of
private engagements. One such party was a strange Greek society party
called the Sigma Nu.

Stephanie Chernikowski: Probably the most vivid description I can
give you is of a party I was invited along to. I remember the first thing
that struck me was the oddity of the certain friction at that point be-
tween the hippies and the straights. And here are these guys, these
straights, who are all dressed in formal attire, who have hired these
little ragtag gypsy musicians, who are loaded and are singing about
getting some. The whole thing seemed to me like watching civiliza-
tion going through some strange evolution. I guess the power I saw
in the Elevators that night was most remarkable because normally I
saw them with their own kind, they were preaching to the converted.
Here you have an audience of razor-sharp, straight guys and girls, and
I mean the thing I noticed first was the girls were going ape-shit over
Roky. Then all of them, men and women alike, just started dancing.
They started out very formal, looking like they'd walked out of the
pages of magazines and of course there was serious drinking, and so
they're getting sauced and the music is hypnotic, and before long
they're dancing, before long there's a group just hovering around
the band. You can see they want "it." They don't know what "it" is
they want, but they want "it," they know there's something there
and they want to get close to it. By the end of the evening they're
falling down drunk and cutting themselves on champagne glasses,
you could see the formality disintegrate throughout the evening,

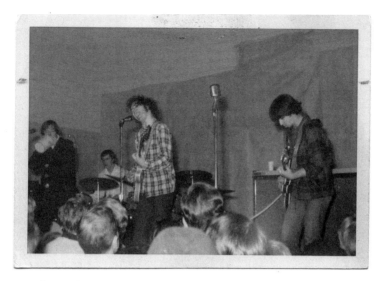

(July 1966) L–R: Tommy, John Ike, Roky & Stacy, Phi Delts Legal Fraternity party, Austin, Texas, photo by David Craig

and the intoxication not just with alcohol but with ideas they had not previously encountered. I'm sure they didn't listen to the words, but just the feelings they got from the band were infectious, and infectious to see.

One of the largest nationwide crazes of 1966 was the camp and kitsch adaptation of the comic book hero Batman for television. The success of the *Batman* series led to a feature-length film, which premiered at the Paramount Theatre in Austin on July 30. Austin had prepared for a Bat-epidemic throughout July, as the *Statesman* predicted a repeat of Beatle-mania when fans had camped outside the Paramount for *Hard Day's Night* tickets. The Elevators, longtime comic book fans, were eager to benefit from all the press attention focused on Austin. Jade Room advertisements featuring the Elevators had Batman logos next to them and, smack bang in the middle of an article about the premiere attracting international press coverage, there was an Elevators advertisement. There was much excitement over the movie's new secret bat weapon, the Batboat, which had been built in Austin and tested on the Highland Lakes under top security. This was due to be unveiled onstage at the Paramount, together with the arrival of the film's stars in the Batmobile and Batcopter. It would appear that some of the press ventured out into the Austin nightlife, and certainly one newspaper article by R.U. Steunberg mentioned that "a local band by the name of Roky and the Elevators" played a show at the Jade Room.

Shortly after Batmania had evaporated, Austin became the focus of national media attention again as chilling headlines reported the Whitman killings. About midday on August 1, people started falling down dead in the street before it was discovered that the shots were being fired from the top of the University of Texas tower. People rushed home to fetch their

guns and return fire, spreading further chaos. Whitman murdered a total of fourteen before the police gunned him down. The killings shocked and stunned the nation.

Although the horror of a real crime had little bearing on the outcome of the Elevators' trial, it helped put their situation into perspective. Maybe the real threat to society didn't lay in their visible and youthful rebellion.

On July 28, it was reported in the Austin papers that the band had appeared at a court docket call and received a September 19 trial in front of Judge Mace Thurman. Thurman had the reputation as the "hanging judge" for any drug-related felonies. He never gave probation or was lenient in any drug-related cases. The band fully expected to be picking cotton for the next ten to twenty years.

Jack McClellan (K): Judge Thurman knows a lot of law, but he's strictly a whore. I liked the hell out of him, but he's thoroughly corrupt. These guys all have to run for office, and it's convictions that make the front pages... weed cases had begun to assume more ominous proportions. It was Thurman's practice to never, ever grant probation in any marijuana case.

However, there was some unexpected news. The hearing was brought forward a month, and D.B. Woods, an elderly, non-criminal judge would be presiding. Two rumors perpetuate—firstly, that Mace Thurman was taken ill and another judge simply replaced him. However, while earlier attempts by Evelyn and her prayer group to influence the grand jury failed, she maintained her belief in the church as a way of solving her family's problems. The district attorney's wife, who bellowed to her prayer group, shared her concerns for the youth and as a result the Elevators' court hearing was brought forward when Mace Thurman was on vacation.

At the pre-trial hearings in June, Jack McClellan had based suitable pleas on the police evidence; Stacy and Tommy's attorney Holman Brooks would plead guilty. By doing so, they waived a jury trial and any further examination in the hope of lenient sentences. However, no one was prepared for the actual outcome of the court hearings. Stacy and Tommy's cases were filed at 9:55 a.m. on August 8, 1966, John Ike's at 11:32 and Clementine and Roky's at 11:33 a.m. Before midday they were all back outside the courthouse wondering how they all walked free.

Both John Ike and Clementine's cases were thrown out due to "insufficient evidence to obtain a conviction." Roky's case was dropped because of technicalities on the search warrant; not only was he no longer a resident at the address but the warrant had the incorrect street number.

Jack McClellan (K): They had the wrong address on Roky's search warrant, they had Tommy's number on Roky's street. In their sloppiness, the narcs blew it. They planted him anyway, with stuff they'd found at Tommy's house. At the hearing, Harvey Gann got the idea that I was going to raise hell about them rushing in without knocking, so he volunteered the information that he'd served the warrant personally as soon as they'd corralled everybody into the living room.

That tied him to his own bad search warrant. It was a happy accident, because he misunderstood what I was after, he lied his way into the truth. That sprung Roky. As for the rest of them, because they were the first group of white middle-class kids to get busted, the DA wasn't that interested in putting them in the penitentiary.

In Tommy and Stacy's case, where the evidence was real, the new judge allegedly misunderstood that a small amount of evidence had been seized, rather than that a small amount had been tested as evidence. Tommy and Stacy, much to their surprise, were each given two-year probationary sentences.

Clementine: Well, we went in absolutely terrified, and we were absolutely bamboozled when we came out and it wasn't the horror we thought it would be. Everybody was telling us that we would never be heard of again. So we were absolutely shitting green, if you don't mind the expression. And then... this is one of the reasons I'm eternally grateful to Roky's mother. Evelyn happened to belong to a prayer group with the district attorney's wife, and Evelyn told the prayer groups they needed prayers over Roky about this whole situation. And apparently the DA's wife worked on the DA, and what the DA did was, he picked a day for the trial when Judge Thurman was not going to be there and he brought in a non-criminal, a civil judge, an elderly one from another area who knew nothing about the situation. And the way the DA described our stash was "we examined a small amount of marijuana." Now, it's true that he only examined a small amount, but there was a large amount. But the judge heard the words "small amount," and that was deliberate. He says words to the effect of "well, don't ever do this again, boys." And we came out of there alive only because of the fact that a switch had been pulled on the judges and the DA set it up in a certain way. And he could only have done that because of his wife, and his wife could only have done that because of Evelyn's prayer group.

Regardless of the favorable outcome, the court case had proved an immense stress for all of the band and their families. As part of the judgment, Lelan Rogers was named as a responsible citizen, who would aid the probation services and vouch for Stacy and Tommy's movements. Although this allowed the band to continue performing, it now gave the record company unprecedented and direct control over their engagements—no shows could be played without signed contracts by them.

For the police it had been an infuriating defeat and the band were gaining a mythical reputation as "unbustable" despite dozens of attempts throughout Texas. However, the probation conditions prevented Tommy or Stacy from entering "places where intoxicating beverages are sold," which meant they couldn't play clubs or beer joints and were required to "work faithfully at suitable employment, subject to the approval of the court" and they weren't allowed to leave Travis County, let alone the State of Texas. The police had them in a very tight noose.

But the Elevators had no intention of staying to fight; their plans

were to leave immediately. Tommy and Clementine were now living in an apartment above their attorney's and swift arrangements were made to relocate their probation to San Francisco. At the time it was common practice to remove the offender from the environment in which they had offended. Within four days of the trial, Tommy and Stacy's probation had been cleared and filed and the band hit the road for San Francisco on August 13, 1966.

With the band set to rendezvous for their first gig outside Texas in Redding, California, Tommy, Roky and Stacy loaded the speakers on top of the Rambler. John and Ronnie rolled out of Kerrville, while their newly appointed roadie, Cecil Morris, drove the van with the rest of their equipment. The Austin party crowd was already beginning to disperse and move away from the repressive atmosphere in Texas. Powell St. John had left for San Francisco via Mexico, and numerous other friends and acquaintances prepared to make the trip. Chet Helms had established himself at the Avalon Ballroom in San Francisco, which was fast becoming home away from home for many estranged Texans.

Stephanie Chernikowski: I think there was a sense that the community was there [San Francisco] and they wanted the community. Austin has a slacker value system, and success is worth it and condemned simultaneously. And people really hold it against you if you leave. There was a migration; as much as there was a very powerful community here, it was very tiny and very alienated and the entire superstructure was unsympathetic to music, drugs and long hair, eccentricity... it was straight society in Texas. I think most of the people who went were seeking a more positive environment, and here there was an amazing creative energy in Austin considering its size and the atmosphere at the time. Austin has always been the oasis in Texas, and the university has always been a pretty sophisticated international faculty. And when the folk scene started, it was viewed by the rest of the state as communists and pinkos and weirdoes who were going to corrupt their children. Of course, there was emptiness when the Elevators left, like they never existed.

While en route Ronnie and John Ike stopped in Amarillo, Texas, where John Ike noticed a small and baffling sign, which warranted further investigation.

John Ike: We were drivin' down the street in Amarillo, lookin' for a hamburger joint, and we saw a little sign stuck in the dirt. And it said, "Yardbirds"... And it had an arrow. And, we all were just, "No, no. Not in Amarillo, Texas." So, we thought, "Let's go see." So we followed that arrow to another arrow and then we stopped at a gym. And we went in there. And there was Jeff Beck and that guy with that kind of a pointed nose who sang with them [Keith Relf]. And you know, they were just beginning and they were playin' "Shapes of Things"... in Amarillo! In this gymnasium, free! They really knocked us out. Really. They were good. Well, the Yardbirds were one of the best English groups there ever was...

The next stop was the pickup gig in Redding.

John Ike: Tommy had a Rambler station wagon, and he couldn't get the speakers in the back of the station wagon and we'd already gone, and so he puts them up on the roof and ties a tarp on them. Facing up! Well, the tarp blows off on the way to California, they don't know it and they hit rain in Tucson and it ruins the speakers. And we got to Redding and we had no PA. We didn't think anything about it and we hooked it all up. And then I thought, wait a minute. What if it rained on those speakers, man? What's the guy doin', a genius like Tommy Hall, what's he doing putting the speakers outside the car? We had no PA, and we were playing out on a tennis court type situation, and we had to have an extension cord to get the power up to the bandstand. There was no vocals, nothing. We just jammed around and everybody danced around, the Californian kids didn't care. We bought speakers the next day.

After the Redding fiasco, the band continued to San Francisco, stopping to play further pickup shows in Fresno and one of promoter Bill Quarry's "Teens 'n' Twenties" dances in Sacramento. Once in San Francisco, the band was amazed by what they saw. For many who experienced the psychedelic movement, it was the summer of 1966 and not '67 that was the real period of change and discovery. By '67, the world's media had caught on to the sights and sounds of the hippie culture and became one of the many suffocating factors that contributed to its downfall. But for the moment, LSD was still legal (banned in California on 10/6/66, or 666, as the hippies understood it), the major ballrooms had just been established and San Francisco was the musical center of happening America. Upon arrival, the Elevators found that rumors of San Francisco's tolerance of the evolving bohemian lifestyle weren't exaggerated. Whereas they had been anomalies back home in Texas, they were now true outsiders. To begin with, none of them had really traveled; they felt self-conscious because they had come fresh from the courtroom and barber's chair in Texas. Not only did their short hair bother them, but they also didn't dress like hippies and they weren't hip to the new fashions, language or customs. Furthermore, they bore the embarrassment of a hit single that was ascending the Bay Area Pop Parade. This proved to be a mixed blessing—while it had earned them headline billing at the both the Fillmore and Avalon ballrooms, it also presented them as a pop act in an emerging alternative musical culture.

Having barely even set foot in San Francisco, Tommy immediately headed straight back to Texas to collect Clementine, her son Roland and the rest of his possessions. They agreed that Clementine's daughter Laura would stay in Texas with her grandparents until they got settled. This was the first return trip of many, and often jeopardized bookings. Tommy and Chet Helms shared a similar view of the usage of marijuana and LSD, and its "redistribution." Chet's frequent visits to the Halls in Texas, and Tommy's subsequent return trips home, had a lot to do with this. As Clementine and Tommy drove into town, "You're Gonna Miss Me" screeched from the radio, confirming that this was their city.

The plan was Tommy and John Ike dealt with the bookings and sent details back to Lelan Rogers in Houston to finalize the show contracts. They knew that Chet was running the Family Dog, but they were still trading on old news and the Elevators' big premiere in San Francisco became another fiasco. By August 1966, the two rival ballrooms, the Avalon and the Fillmore, were now well established and being run, respectively, by Chet Helms and Bill Graham. The history of these two venues was full of animosity and resentment, which the Elevators walked straight into.

Graham was a hard worker with a street attitude, who saw the acid tests as a new model for promoting live music. He began with a series of appeal parties featuring bands like the Jefferson Airplane and the Warlocks (Grateful Dead) for the San Francisco Mime Troupe, who had been busted in Golden Gate Park. He battled police harassment, and managed to win a permit to run regular shows at the Fillmore Auditorium. Fearful of the lone responsibility, he asked the Family Dog collective to run alternative nights at the venue.

The Family Dog was a loose collective of dope dealers connected to the pre-Charlatans crowd who had run the first head shop in San Francisco from late 1964, selling an array of knick-knacks, antiques, dope pipes and rolling papers. Luria Castell wanted to use their proceeds to fund events in an attempt to legitimize the new scene. Named after the "dog house" on Pine Street where the standard joke was "Oh, who does that dog belong to?" "Oh, it's just the family dog." They promoted a series of shows at the Longshoremen's Hall, October 16 and 24 and November 6, 1965. When they realized the November show clashed with Graham's first Mime Troupe benefit, they panicked, fearing the fragile scene couldn't sustain two events in the same night, and asked Graham to delay his show and in return they'd help produce his next benefit for a credit at a venue they'd secured called the Fillmore Auditorium.

Chet Helms volunteered at all the shows, claiming to be the first person to introduce a strobe light at concerts. Since leaving Texas in '63, Chet, a Californian but part-time Texan, hosted parties at his house on 1090 Page Street These centered around organic psychedelics and jam sessions that led to the formation of Big Brother which Janis Joplin later joined. According to Helms, he approached Luria in February '66 to put on Big Brother but he found they were broke without any deposit for venues, so he made a deal to do the show under the Family Dog name; however, he got a call saying she'd split to Mexico and that he inherited the name and "a bunch of furniture."

Both nervous about taking on the Fillmore alone, Helms and Graham decided to share the venue, either producing shows together or on alternating weekends. But their differences became immediately apparent; while Helms was an instigator of drug culture, Graham never indulged. Bill Graham was so paranoid about being spiked with acid he refused all open drink canisters (members of the Dead allegedly got him by placing liquid acid around the ring pull of an unopened soda can). The final Family Dog show at the Fillmore was headlined by the L.A. band Love in early April, and by the end of the month they were housed at the Avalon Ballroom on Sutter and Van Ness.

The Elevators soon found themselves in the middle of the feuding ballrooms. Tommy made a verbal agreement with Janis' boyfriend, fellow Texan Travis Rivers, to book the band. Travis booked them with Graham at the Fillmore on August 26 and 27, and not with Helms as Tommy expected. However, Graham was furious with the band, even though he'd secured them ahead of his rival, because he wanted them under exclusive contract and they'd booked another show supporting Van Morrison and Them at the Longshoremen's Hall. The Elevators were out of their depth; clearly the Californian music business was more cutthroat than anything they'd experienced back in Texas. Fully aware of Graham's hard reputation, Roky, Tommy and Clementine ventured to his office at the Carousel Ballroom for a dressing down in Californian booking etiquette. A huge photo of Graham shooting the finger immediately took Tommy aback.

> **Clementine:** They had difficulty when they first arrived, because they were slated to play Longshoremen's Hall through one manager, and at the same time Travis River decided he was our manager too, and he set us up to play at the Fillmore. And I vividly remember being hauled into Bill Graham's office and cut into little pieces. He said, "You do not come into this town and sign up to be exclusively with me and be at the same time at Longshoremen's. You cannot do that." He says, "I'm an old street fighter, and you'll never work again." Bill Graham was not happy, but even Bill Graham could be charmed by Roky. Roky was irresistible. We came out of there able to do both shows.

The Longshoremen's Hall venue was on the docks of North Beach, and had previously hosted the notorious acid tests. En route to the show they turned on the radio, and "You're Gonna Miss Me" came screeching out across the airwaves. They proceeded to change stations and, in total, four were playing their tune. When the Elevators arrived they opened the wrong door and walked straight into a meeting of angry Longshoremen who ran them out. The Elevators were booked to support the Irish band Them, who had been playing a residency at the Whisky-A-Go-Go in L.A., but rumor got back to the band that a member of Them had been busted for pot upon arrival in San Francisco. The tour fell apart on the West Coast, and the band supposedly turned down bookings because they couldn't extend their work visas.

> **Ronnie:** We were supposed to be booked with Them, they got busted for pot, and I'd have loved to have done it, especially meet Van Morrison. We had seen some big crowds, but to really see wilder crowds—people really into doing their new thing. That was our first night and it was unreal. Well, we played probably a little louder than most of them, we usually turned everything as far as it would go...

Many of the Texans already in California went to see the band, and even Mikel Erickson drove his mother and brothers on a round trip to San Francisco specifically to see the show. With their first show a success, the real test was how they would be received at the hip Fillmore Auditorium, and whether they could redeem themselves with Bill Graham. Between

bookings the band explored San Francisco, took the opportunity to see their heroes, the Yardbirds, at the Carousel Ballroom with the Harbinger Complex on August 25.

This became a key gig for the Yardbirds. Jeff Beck, growing tired of touring, found the pleasures of the new San Franciscan culture more interesting than playing with the band, and didn't show up for the gig. That night's show marked the first time Jimmy Page played lead guitar with the band despite being a session veteran on recordings with the Who, Kinks and Them. After the show Chris Dreja was relegated to bass, and the Yardbirds had two dueling lead guitarists for the rest of the tour. Beck quit, threatened by Jimmy's presence and ability. For the Elevators it was a key event for the wrong reason. Their new roadie, Cecil Morris, was also keen to see the Yardbirds, and parked the van outside the venue without unloading the equipment from the Longshoremen's Hall gig. Someone ripped off all the band's equipment. With their first major show the following evening at the Fillmore, this was clearly a disaster. Luckily Sherman Clay's music store was frequented by many of San Francisco's bands and with bookings at the two major ballrooms and a hit single, the Elevators managed to secure new equipment.

This time, instead of using Mrs. Walton's money, it was IA's turn to bankroll the band, and they took full advantage by ordering new Standel amps. For Stacy, reverb was the key the Elevators' sound, so he bought a new Gibson 330 guitar and a twin reverb amp with fourteen-inch speakers—but not all of the new amps could be supplied in time, and Ronnie made do with an amp the Jefferson Airplane had traded in. Now fully equipped, the band found themselves in the same unenviable position as most of the new San Francisco bands, weighed down by large monthly repayments. Worse still because IA underwrote their recoupable debits, it gave them even greater control over them.

Billed as the "13th Floor Elevator [sic]" the band played their only appearance at the Fillmore on the 26th. It's possible that since none of the West Coast band names were plural that promoters and poster artists used their name in the singular on most of their West Coast posters. However, other than that they realized that the band's identity and origins were a complete mystery anyway and Greg Shaw's music fanzine *Mojo Navigator* reported on August 23 that "... the Thirteenth Floor Elevator [sic] is a local band, apparently having no connection with a group out of New York having the same name, which group has reportedly broken up..."

Their support, the Great Society, had only been billed at the Fillmore once before, but their singer Grace Slick's face adorned the posters since they had a strong local following at smaller clubs like the Matrix. Their sound was a hybrid of laid-back, folk-inspired rock with Eastern tinges that was being labeled "raga-rock." Their set included early versions of two of the era's most famous songs, "White Rabbit" and "Somebody to Love." Third on the bill was the Sopwith Camel, who also had a pop hit in 1966 with a song called "Hello, Hello."

The evening's entertainment would have been an interesting snapshot of the emerging music scene had it happened as billed. According to mixed memories, the Elevators only honored the Friday night show, which

the Great Society didn't play, and Sopwith Camel did. The second night Country Joe and the Fish replaced the Elevators, and the Great Society played support.

The show, marred by bad feelings with Graham, was quickly forgotten, although Ronnie, who was less involved with the politics, felt they played well and filled the auditorium.

> **Tommy:** So like we did our third show on Friday, which was our opening show, a special thing I guess. And Bill Graham hated us... he thought we were really amateurish and stuff like that and it was our first show in town and we were kind of schizoid from the whole trip. And so when we settled down we started playing better shows...

In terms of underground credibility the Fillmore wasn't the best venue to play. Graham's choice of recent bookings (the Turtles, Sam the Sham and the Pharaohs, the Wailers, the Mindbenders, etc.) was provoking angry criticism from *Mojo Navigator*'s Dave Harris, who dismissed them as commercial Top 40 "schlock shit." *Mojo* then reported a few weeks later that Graham had declared he wasn't going to book Paul Revere and the Raiders, and would stop booking Top 40 acts. As always, the Elevators were anomalies: they had short hair, a hit single in the national charts but played louder and harder than anything San Francisco had witnessed.

29. Although it's impossible to deduce exactly when the Elevators finally signed to IA, it's most likely it was mid- to late-July 1966. On July 27, 1966: Emma Walton signed three years' granting of rights to IA for her interest in the band, which were later turned over to Tapier Publishing in return for $7,500 to be paid as per contract by IA for the publishers rights.

(1966) Handbill designed by Mouse for Avalon Ballroom, September 2–3.

9.
HAMBURGERS AND ACID

On August 8, 1966, the Beatles released their new album, *Revolver*, in the United States. Their previous "proper" studio album, *Rubber Soul*, had hinted at their new direction and that of popular music. *Rubber Soul* incorporated a wider scope of influence from folk, Eastern and soul music. The title itself was a bastardization of "plastic soul," a phrase black musicians leveled at Mick Jagger's take on their music. If *Rubber Soul,* reinforced by Dylan's contribution, had opened the eyes and ears of the world to "pop" as an art form, then *Revolver* opened its mind to higher ideals, and is now considered to be the height of the Beatles' creativity.

Whereas *Rubber Soul* had proven a huge influence on the Elevators, the release of *Revolver* passed them by—they were in court the day of its release. The Elevators then hit the road for California at the same time as the Beatles' last-ever tour kicked off in Chicago. The Beatles had incorporated the workings of the recording studio into their sound to such an extent that it had become an integral part of their sound. New material, such as "Tomorrow Never Knows," simply couldn't be replicated live on stage. Although they did attempt live versions of new songs like "Paperback Writer," their disdain for their live performances showed as they stuck to performing half-hearted versions of earlier material. Regardless of the Beatles' stage resignation, the Elevators were preparing to take on the West Coast with their fiery brand of psychedelic music, armed with tabs of LSD and a jug with a microphone in it. It seems ironic that the Beatles gave their final live public performance in the home of the newly emerging music culture of San Francisco. From Wes Wilson's poster design, you would easily have been mistaken that the show was an underground happening at one of the psychedelic ballrooms, and not the world's favorite band performing at the gigantic Candlestick Park stadium.

Following their haphazard arrival in San Francisco, the Elevators arrived at the Avalon Ballroom. With part-time Texan Chet Helms running the venue with a mainly Texan staff, they were finally home. Chet had

found Tommy and Clementine accommodations with his business partner, Jim Arnold, right in the center of operations.

Chet Helms: I never saw them perform [in Texas]. I heard through other friends out there, I was pretty tight with the Stopher brothers, Janis and Powell. When they came out, they thought they were coming to play for me, and when they arrived here and learned they were not playing for me, they refused to play for Graham and he was mad at them and never booked them again, and they always played for me after that.

The Avalon Ballroom was located at 1268 Sutter Street, built in 1913 for the Puckett Academy of Dance, and was one of the smaller ballrooms in the area backing onto the far grander and ornate ballrooms of Van Ness Avenue. The Avalon was situated up a flight of stairs above a furniture store and, with its red flock wallpaper, balconies and fireplace, was a trip back in time. In the Sixties, the area was better known for its car dealerships than for its live music venues.

Word of mouth had already spread about the Elevators, and their first appearance at the Avalon attracted many of San Francisco's hip musicians and music fans. The Grateful Dead's Jerry Garcia, interviewed by *Mojo Navigator*, name-checked the band, likening their style to the "San Francisco Sound," and interestingly commented that they sounded a little like Big Brother, whose singer Janis Joplin had now found her full powerhouse voice, care of Roky. The Elevators themselves felt at home in the Avalon, all agreeing that they had settled into playing better shows.

Sharing the bill was fellow Texan Doug Sahm and the Sir Douglas Quintet. He had already left Texas in March 1966 due to a minor marijuana bust at San Antonio airport. He too found the transition to Californian audiences bumpy, receiving mixed reviews in *Mojo Navigator*, but he had no doubts that the Elevators should be on the West Coast; his only criticism was that they left. In 1999, he was still reticent and regaled John Ike, in full earshot of a Texan cop, "Those cops were rabid, you should have got out of Texas and stayed out! Never gone back!"

Q: Did you take acid for the first Avalon performance?

Ronnie: Oh yeah, Tommy didn't let us go on without taking it... I always took a little; he always took a lot (laughs). I usually took a half or a quarter, I wasn't quite ready for the whole thing yet... those first few days I was pretty new at it. The show (Avalon) I thought was great, I thought went real well, I mean it was a big place... and it was full all the way to the back.

John Ike: The Fillmore was a dump. The Avalon was a palace. We loved to play there. They gave away free acid at the door; it was a heaven for us! There were some black policemen out there, and they were cool. There really was no backstage area, there was one sofa and two chairs and there was this little place where you open up the doors and you go out (on to a ledge). We went up there before we

did our show and people saw us and thought, "Ha, they're smoking a joint in there." Everybody was crowding in there to get a toke off the joint, so there's about thirty-five people in a nine-foot area sucking on a joint, about to fall off the roof of the building. We went out there and did our stuff and yes they [the audience] did dance, they were blown away.

Many people interviewed who saw the Elevators' first Avalon performance were amazed by the band and the sheer volume compared to what the local acts were cranking out. Yet no matter how successful the band had been at filling the ballroom that night, fellow Texan Jack Jackson was disappointed by the audience reaction.

Jack Jackson: The Elevators knew they had a way into the West Coast through the fellow Texans on the music scene and that was going to be their big shot. I think they knew about Van Morrison and Them coming in and making it in the ballroom scene, and then you get a contract. I saw them right alongside what Them was doing with "Gloria." Van Morrison used to like throw back his head and let out the screams but Roky had the scream that would knock your socks off. At that time I thought they had the songs, the good looks, the talent, they could have made it big. Janis Joplin had done it from Texas. Here I am, loving their music, sitting back in the Ballroom and checking out the reaction of everybody... and they were a bit put off by it. The Californians didn't know exactly what to make of it. I remember when John Clay, this crazy banjo player, tall, skinny guy, he would honk and spit in a handkerchief, and stick it back in his pocket and continue. He came on before they did, and that horrified the hippies because here's this hick. The jug is very frenetic, and these people were trying to be sooo coool and soooo laid back, but it was a little too much for them. So that intimidated them. If you go in there stoned on acid and his jug is playing and it's so relentless, some people couldn't stand it... and ahh so I could see right away we had a problem, they weren't as enthusiastic as I thought they were going to be. It wasn't the same reception as you got with Quicksilver... or Big Brother, house band kind of thing.

How the Elevators were perceived in San Francisco is a hard question to answer. Although they were undeniably psychedelic in their outlook, they remained outsiders in every meaning of the word. While Janis became a poster child for the hippie-chick look, the Elevators hadn't yet made any concessions to adopting hippie attire, and with the stress of the recent bust they retained much of their standoffish paranoia and didn't hang around to socialize after performances. Somehow the band failed to evolve with the San Francisco musical culture in the same way that the local bands did. Instead, they locked together and took an extreme amount of acid.

The Elevators still played an eclectic mix of rock 'n' roll and original material, which had appeased their audience back home. Unlike the San Fran bands they didn't play long, improvised jams or meandering guitar solos. The jug was either a unique invention or an unwelcome intrusion

GOLDEN STAR PROMOTIONS presents

13TH FLOOR ELEVATOR

and

The NEW BREED

WITH THEIR HITS - "GREEN-EYED WOMAN" AND "I'VE BEEN WRONG BEFORE"

SAT. NITE, SEPT. 10

8 p.m. to 12 Midnight

Santa Rosa Vet's

Adm. only $2 MEMORIAL Don't Miss It!

(1966) HANDBILL FOR SANTA ROSA VETERANS CLUB, SEPTEMBER 10,
COURTESY PETE BUESNEL COLLECTION

in the music. However, even if you argue that the jug was an unnecessary appendage on a rock 'n'roll cover, in an original song it would be a perfectly fused, integral part. The Elevators were conceived as an electric band delivering a psychedelic mantra from the outset. While this was Tommy's chosen medium and message, many of the Californian bands had evolved from more traditional acoustic roots to electric instruments. In contrast the Grateful Dead, despite their reputation as accomplished musicians, hadn't been conceived as an amplified, electric band, and their long semi-improvised jams betrayed their bluegrass roots. John Ike, with his kit chained to his drum stool, hit the drums harder and more aggressively than any other drummer on the West Coast. If the leather strap on his custom-made size-thirteen drum pedal broke, he simply kicked the drum instead. Stacy and Ronnie barely moved and instead menacingly flanked Roky, who twisted and screamed until his slight frame shook. They didn't speak between songs, they didn't exactly dance or put on a show; instead they delivered a loud and uncompromising barrage of music, saturated with intense lyrics and information.

To Texan ears, many of the San Francisco bands sounded sloppy and under-rehearsed—in particular, their old friend Janis' new band Big Brother and the Holding Company. Even the Dead's Jerry Garcia, when questioned about Big Brother's musical ability in September 1966, acknowledged that "those guys are pretty new at electric instruments... and they still have to get used to what comes out and what doesn't come out."

> **Stacy (K):** I really and truly don't feel like anybody was in the place—out there, at that time—that we were in. I really don't believe so at all. I'm not saying we were necessarily wise in what we'd been doing, but we'd been taking acid constantly, I mean for long periods of time. And Tommy was really a genius, he knew so much about religion and philosophy that he'd lecture to us, and write, and read, and write, and read. It was just constant. And those bands out there, they didn't really take acid 'til later. They didn't affect me spiritually, like most of my favorite musicians, but they were a bunch of kids too. Those ballrooms out there had the best sound of any place I'd ever played... it's the way they're built, and the acoustics and everything are really incredible... They'd be passing 'round gallon jugs of acid through the audience... and you'd walk around and there was just smiling faces. It was in the days when the actual innocence... the flowers and love, and of course it got rank, man.

> **Houston White:** Those motherfuckers couldn't play, not the Elevators but everybody else, you know, the Grateful Dead were really awful and Jefferson Airplane were grim... I mean they got real good later on. They just weren't happening, and that was the thing, the Elevators were so obviously in command of their instruments and they had it together. Big Brother and the Holding Company were awful... if it hadn't been for Janis they'd have never gotten across the street.

Even the hippie publication *The Oracle* was prone to mocking the local musical endeavors, stating "the music played by groups such as the

Grateful Dead, the Great Society, Big Brother and the Holding Company and the like... is a rhythmic music played by people who are essentially musically illiterate." This was part of the wider problem in California in 1966—there was little to no music press to attract. *The Oracle* didn't concentrate on music reviews, neither did the *Berkeley Barb,* and the *Mojo Navigator* was little more than a two-page fanzine, largely interested in homegrown gossip and talent. Even in Texas, the Elevators had managed to get regular coverage in the mainstream press.

San Francisco was also changing at an incredible rate. As news spread throughout the States of the emerging alternative culture, San Francisco became swamped in an avalanche of musicians, observers, runaways and draft dodgers. The sheer number of new arrivals threatened the fragile structure of an alternative society that was beginning to evolve, and then the world's media descended to chew it all up and regurgitate through mainstream media. There were even hippie sight-seeing bus tours for curious and bewildered grannies. In 1966, everything was cheap—accommodation, food, grass—but by the end of the decade, the core emphasis of giving and helping had changed drastically as everything inevitably became a commodity that could be profited from. Even by 1966, some of the locals were obviously feeling the weight of change, often becoming resentful of outsiders. But the Texans had the Avalon, and soon everyone said "Howdy."

> **Jack Jackson:** The Elevators weren't loaded down with beads and bangles and they didn't have the hippie attire. And I'm telling you, the hippies out there were vain, show-off people, and more than once I heard cutting remarks, even when I was in working for the Family Dog, from some of the women—"Oh, you only just got here..." A real 'we're the crème de la crème and we got the beads'... and the Elevators weren't into that at all. They were wearing their scruffy clothes, old boots and whatever; they were not into the paraphernalia kind of thing, so that intimidated them.

Despite the Avalon being a perfect home away from home, it was largely the venue and not the band that attracted the crowds; John Ike realized this when he found out what they could get paid elsewhere. Unlike today, where a promoter has to promise the band a fee related to their level of success, if John Ike is correct, the Avalon paid a flat $100 per man per show.

Following the Avalon booking, the band was due to return to Texas, their tour of duty complete, unless they could find themselves further bookings. Luckily, a keen young promoter had spotted them when they were in Sacramento en route to San Francisco. He was absolutely blown away by their live performance (and their hit single), and saw his first opportunity to promote a band on the brink of national success. Although John Ike had given him the brush-off when they met, he did tell Tolin of their future bookings. Following their Avalon success, Steve got straight back in touch with the band having negotiated twice the fee John Ike had been offered for these future bookings. For once they made the right deci-

sion and hired Steve on the basis that he would double whatever they were offered. Their only problem with him was when he offered suggestions for their image. Says Ronnie, "Steve was just a goofy guy. Being called the Elevators, he suggested we should dress up like elevator operators!"

Steve Tolin: No, I don't recall that. My role was to get them work and never discuss their clothing or image. I was not their manager, I was simply getting them jobs and giving them input about the San Francisco marketplace and assisting them in staying alive. I did not get to know them. I enjoyed them, but they were a group from Texas, I didn't have a lot of interplay... I watched the Elevators playing and I saw the reaction in the crowd and the Elevators tore up the evening. The kids loved them; they were a phenomenal, phenomenal group. They were getting a lot of airplay, and I was delighted to pick up a national group. And I wasn't exposed as to whether they were on LSD or not on LSD, which was not my world. I didn't hang with them afterwards, I just got them jobs.

Despite what the hippie elite made of the Elevators, the mainstream had a keen eye on their movements, and within days of their headline billing at the Avalon, Tolin was approached by Dick Clark's production company, who wanted the band to appear on Clark's national TV show, *Where the Action Is*. In terms of a pop career, this was a major step forward, and the band signed AFTRA contracts (American Federation of Television and Radio) on September 9.

Tolin had done a Monkees promotion with KFRC radio's general manager Tom Rowland, and with no regard for the underground culture, they set about booking the band as a pop act throughout the Bay Area, at every dance, memorial hall, bandstand, armory and club that would hire them. Although there are no exact details of their bookings in mid-September, from the band's accounts they played everything physically possible. Often they drove to tiny towns, to play obscure venues such as "Our Lady" at Mount Carmel Church teen club in Redwood City (with the Venus Flytrap) and then drive to another gig miles away, often playing two, maybe three shows a night. The combination of John Ike's work ethic and Tommy's desire to spread the message meant that Tolin had no problem getting the band to agree to a grueling schedule.

Clementine: There was one marathon tour that they took of California where they played three different shows in one night in very far apart, out of the way places. They sweated while they're out there, and then travel through cold weather to the next show and get up there—in damp clothes, and perform outdoors and do it again—three nights in a row. And all of them held up. Roky had all the words right and the musicianship was perfect, I don't know how they had the stamina to do all that and be high at the same time on LSD, but they did. At a country-type place they tried to bust us but Roky saved us... and they seemed to know who we were, they were treating us like heavy drug people. I sat in the back seat with Roky and a policeman and he turned to Roky and said "I've been questioning

you now for about twenty minutes—I bet you're ready for a shot!" and Roky was all innocence, looked at him and said, "No thank you, I don't drink." And the guy left us. Roky could get away with murder, he was so genuine.

During September, the band worked probably harder than any other month in their career, and added to their haphazard schedule they dropped acid nearly every day. But the problem with Tommy's mission was that LSD takes a minimum of three to four days to clear the system before another hit can be taken and its full effects experienced properly. This put a real pressure on the band to decide when and where they would drop acid for best effect. From Tommy's point of view, multiple bookings were a bonus because it meant that two or three shows could be played on a hit of LSD. Later on in their stay on the West Coast, Ronnie remembers they developed a pattern of playing once every four days. Fueled by LSD and youthful energy, the band hit the road on a chaotic tour of the Bay Area and, as usual, the police wanted to bust them at every opportunity. Roky was proving something of a teen idol with Californian girls; at one gig in Modesto he was nearly pulled off the stage by screaming fans, their first real experience of groupies. After the show the band received a hot check from a promoter who had made a practice of closing accounts after shows and ripping bands off. However, the District Attorney was brought in and the band recovered their $800 from the show.

It wasn't until their old friend Janis returned from Chicago in mid-September that they started to mix with San Francisco's musical elite. Janis had left town on August 23, almost as soon as the Elevators had arrived, and had been playing a string of poorly-received gigs at Mother Blues in Chicago with Big Brother and the Holding Company. Although Tommy knew Janis from the Ghetto era, it was Clementine who was the real point of contact, and she was pleased to see her old friends out in San Francisco playing their "freak rock."

Although the Avalon is remembered for pioneering new psychedelic bands, it also played host to several performers who were more synonymous with the previous decade. Bo Diddley, Howlin' Wolf, Chuck Berry, Muddy Waters, Big Mama Thornton and Bill Haley and the Comets all played shows at the Avalon. Bo Diddley had headlined four consecutive Avalon bills from late July to mid-August, and remained involved in the scene. Upon Janis' return, while Roky, Tommy, Clementine were still staying with Jim Arnold on Fell Street, they went to dinner with Chet.

Clementine: Janis was so thrilled. The phone rang and she answered; she says, "Who is this, I'll tell him who this is, he's not here right now, but you can't be who you say you are—oh man, you're putting me on. Okay, sing something." And she goes, "Oh my God, you are! You're Bo Diddley!—My name is Janis Joplin, you probably haven't heard of me"—and do you know what he said to her? She almost fainted—he said, "Haven't heard of you? You're the best white blues singer in the nation!" Oh! She couldn't believe that. She could not believe it; she said, "Pinch me Clementine! Pinch me! I can't believe Bo Diddley said that to me!" And Chet says, "Oh, he

just wants to come here because he can play the slot machine." Chet had a rigged slot machine that would let his guests win. So they loved playing that slot machine—Bo Diddley was crazy about that slot machine.

Most of the members of the Grateful Dead had attended the Elevators' first Avalon shows, and John Ike recalls being approached as he left the stage with an invitation from one of their hangers-on to join "The Dead." At the time he hadn't a clue what she was talking about. Although Tommy recalls meeting the members of the Dead after the Avalon show and being invited out to Muir Woods, the band didn't visit until Janis, who was the Dead's neighbor, took them for a visit.

Clementine: One of my favorite things that we did was we went out and stayed with the Grateful Dead, they had an old girls' camp, and it's magnificent country with giant redwood trees. And up in the top of these redwood trees, they had built a deck to get high in. The safest I've ever felt in my whole life was up at the top of these redwood trees turning on with the Grateful Dead, because we knew there was no way police could bust in on us in a big hurry. Janis took us out there. So there was also her band, and there was the Elevators, and then there was the Grateful Dead and all of their old ladies, and all of our hangers-on, and everybody all up there getting very, very high together. And the thing that I liked so much, because I knew this was true in Austin, and the musicians at that time were very generous with each other, and very hospitable, and not in the least bit competitive or spiteful or anything like that—it was a very loving time. Well, we were thrilled to find out that that also existed in San Francisco. Here these guys were established—the Grateful Dead were established, and so was Janis. We're not, and because we have a number one hit we're suspect. And because we had short hair we're suspect. We had come from the trial and we all looked like what later would have been described as punk rockers. Having two strikes against us—having short hair and having a number one hit single. I expected them to look down on us and hold us off in some way, and they didn't.

Back in Houston, International Artists felt pretty pleased with themselves. They'd managed to crack the pop market with their first concerted effort, and following the HBR fiasco they ran a full-page advertisement in *Billboard* [August 6, 1966], declaring "An Explosion From Houston Texas—A National Hit—You're Gonna Miss Me—owned and distributed by International Artists Records." There was reason to celebrate, as their new protégés were playing headline shows, booked to appear on national television and each week their single went a few places further up the national charts. While Lelan dealt with the Elevators' bookings in California, he searched through the band's recordings for a follow-up single. On August 18, Lelan booked listening time at Jones' studio for the "Gordon Bynum Tapes," and on September 13 he requested that Andrus Studios make dubs from the masters and demos. The record company was

preparing a cash-in album of old demos and a follow-up single without any consultation with the band.

While Lelan had given the band sound advice to leave Texas and to capitalize on the success of their single on the West Coast, his choice of second single led to an ensuing struggle that would seal the fate of the band. He went with Bynum's choice of a cover of Buddy Holly's "I'm Gonna Love You Too" backed with the sedate "Splash One," and test pressings were ordered from Nashville Recording Company in Los Angeles. Although Roky sounded great as Buddy Holly on acid, this was not the direction Tommy wanted them to pursue. The rest of the band agreed because the old recordings were crude (with Benny on bass) compared to the new line's refinement of the material. They were also furious that IA had access to material they had recorded with Bynum, which compounded the myth that Bynum "sold them to IA." If they'd honored their deal with him in the first place, they could have controlled the material themselves.

Despite Dillard's calls, the band resisted returning to Texas to complete an album's worth of material. They were deliberately prolonging their stay in order to hang out for major label interest. According to Stacy's friend Jerry Lightfoot, Stacy later confessed that they took the IA contract about as seriously as they had Bynum's.

The deal with IA had been made out of desperation to distribute "You're Gonna Miss Me" and attract major label attention in the hope that they would buy out IA's contract.

Jerry Lightfoot: Well, Stacy told me they [IA] threatened to come out there and take all his equipment, and the record company said we want you to come back and make another record. They could have done anything at that point, they were wide open... it snapped it; it took them from a point where everything was possible and put them into a place where only certain things were possible. Because the idea was to play the ballrooms out there and get a deal... and what I'm telling you is the bare bones of something that was going on. Sandy Lockett can probably tell you exactly... that's what Stacy told me, and he believed it. He told me that's what happened. He said, "They took our shit so we had to go back and record, only way we could get out of the deal." The idea was to go back, straighten up, make this great record, and it just didn't work out.

Sandy Lockett: It was a very confusing period. And by that time International Artists' plot had thickened to the point where... well, I'm the son of many generations of lawyers so I ended up being their kind of frontman in dealing with those crazy fellows. That was an interesting time. That was a strange bunch of people, Nobel who... you know was just a rich guy, who didn't quite know what to do and, as a matter of fact, Nobel Ginther and I had grown up together in River Oaks. Of course Lelan Rogers, who is a strange kettle of fish if there ever was one! And then there's this unusually crew-cut, carrot-top, Bill Dillard, who was kind of a strange fringe lawyer type. And they were... in the recording business for something besides the record business, I don't know what.

John Ike: Oh, let me tell you this, man. Our manager [Steve Tolin], he told us, "I've been contacted by Capitol and Columbia Records and they want you guys to sign with them." We said, "Oh no. We can't sign with them. We're happy with our record company." Happy with our record company? We were, at the time. They'd got us out of town, we had a number one hit all over California, we had all the dope we could smoke, we had girls and we had rock 'n' roll. [Laughs.] What else is there? We had it all and we owed it to Lelan Rogers.

In order to appease the record label's thirst for follow-up hits, and to prevent them from releasing an album of old material, Tommy negotiated the band more time by brokering a compromise—the band would return to record a second single, while they prepared an album's worth of new material. While most of the songs that appeared on the Elevators' first album, *Psychedelic Sounds of...*, were written in Texas prior to the trip to California, they hadn't been filtered through Tommy's psychedelic agenda and formulated into a solid body of work. Ronnie, John Ike and Cecil all rolled into the Houston Holiday Inn on September 18, with the others joining them the following day. Although IA brought in Bynum to help supervise the session, he didn't produce it, and was dispatched to Evans Music to rent Stacy and Ronnie Gibson amps. Meanwhile, Bob Sullivan was flown in from Dallas to engineer "Reverberation," which they had previously demoed with him in Dallas. As Ronnie recalls, "We did 'Reverberation' and 'Kingdom of Heaven' in Jones' studio... only two songs." In the absence of acid, the session was fueled by DMT.

After mixing the following day, the band flew back out to California on the 22nd and commenced the most grueling day of their short pop career.

September 23 is an extreme example of the band's schedule, and one of the only days documented during this period. Instead of relaxing and arriving in L.A. cool and collected for their first national TV appearance, the band stayed aboard their insane rollercoaster of a schedule. The day's activities began at six a.m. on board a ferry circling Alcatraz prison in San Francisco Bay. The event, hosted by KFRC radio (known as K-Freak) was the prize for their competition winners, and the band performed at seven a.m. They then headed straight to the airport and flew down to Los Angeles to film by the swimming pool at Dick Clark's house in Encino. As friend and fan Liz Henry recalls they had little idea of what to expect—"they did one of these bandstand-type shows and they made them lip-sync it and pretend to play... it totally freaked them out, they had no earthly idea what to do."

This was the heart of the music industry establishment. The ultra clean-cut and smiling Clark had taken over *Bob Horn's Bandstand* at the age of twenty-six in 1956. It had been a weekly music show on local Philadelphia Television since October 7, 1952 until it was broadcast nationally in August 1957 and renamed *American Bandstand*. Production was moved to Los Angeles in 1964, and the show aired weekly on a Saturday afternoon. The show established Clark as a major force within the shaping of the American Top 40 charts. Clark capitalized on his success by piloting another music show, *Where the Action Is*, for CBS.

The show was the staple of bands like Paul Revere and the Raiders, who scored national success with hits such as "Just Like Me" while at the same time demeaning themselves by dressing up in ridiculous period military uniforms and goofing around in front of the camera. Given the poolside setting and bikini-clad audience, the band is hilariously overdressed. Tommy was firmly buttoned up in his trademark pea coat while Stacy was heavily buttoned into his coat and avoided any camera interaction. John Ike passed as more relaxed in jeans and jacket, while brief glimpses of Ronnie revealed him to look like a Sixties pop star with a violin bass and round sunglasses (which Tommy insisted he also wore all the time). Roky, meanwhile, sported his usual attire of checked work shirt and jeans. The Elevators lip-synced a performance and camerawork was severely limited due to the swimming pool which facilitated mainly wide shots interspersed by the occasional close-up; nevertheless it's one of only two surviving celluloid snapshots of the band together.

> **Stacy (K):** He (Dick Clark) was a pretty sharp character, stern businessman I thought in real life, but as soon as that camera came on, it was all young, healthy, vibrant, American... That smile is all show, you can believe that. We did "Where the Action Is," it was as nuts for him as us...

> **Ronnie:** We took Dick Clark this soda made in Fredericksburg called Iron Boy, but it didn't have a label, it had a cap with this guy doing a muscle. We gave him a six-pack... he never wanted any of it, everybody thought we had acid in it and they thought we were trying to give them acid. He probably pitched that!!!

The two further gigs that evening, both miles apart, were at the Rollarena in San Leandro at Bill Quarry's "Teens 'n' Twenties," and the other in San Rafael. They hit the road immediately after filming their contribution, leaving their manager Steve Tolin to wrap things up with Dick Clark's production company, who instead offered him a job as his PR man.

Where the Action Is, featuring Lee Dorsey and the 13th Floor Elevators, was broadcast at 3:30 p.m. (in Texas, transmission times vary from state to state) on September 26, marking their first national TV appearance.

With Tolin no longer at the helm, bookings slowed to maybe two shows a week. Following the return to San Francisco and the remainder of their stay on the West Coast, the band's solidarity changed as they spread out over three different bases in the Bay Area. The model they had established in Texas was overlaid on the Californian landscape. John Ike, Ronnie and Cecil found a "new Kerrville" in the small town of Larkspur across the Golden Gate Bridge in the San Pablo Bay Area. Roky, Tommy and Clementine decided it was time to move on from Chet Helms' partner's house and set up camp at a cheaper apartment in the Haight area [on Fillmore with McAllister]. Stacy, as before, led a semi-nomadic existence between the two.

Meanwhile, back in Texas, the band was sorely missed. Stories trickled back about their achievements and their newfound status as pop stars and darlings of the underground. Stacy was homesick as always and, preferring to ignore his new pop star status, made the occasional trip back to see Laurie.

Toward the end of September, the vacuum left by the Elevators' absence was too much for super fans Pam Bailey, 20, and Liz Henry, 18, who decided to skip school and head out west. They found a ride with Stacy's friend Wayne Walker, the same person the FBI had tracked to Stacy and John Ike's room at the Lamar Hotel in Austin in '65. Wayne's father disagreed with the war in Vietnam and, when his son was drafted, broke him out of the military base in the trunk of his car. He'd been on the run ever since. Wayne's father, aware of the growing community of draft dodgers in San Francisco, said he'd pay the girls' way if they helped him reach the city safely.

Liz Henry: So we drove out there with Wayne, which was a trip in itself, and then we got to L.A. and we're heading north to San Francisco and Pam turns the radio on and hears this "guddumbab dubah" (jug impression) and it's number four on whatever radio station that was, and we're going "Golly!" And we meet them at their gig and they said come back to the apartment with us... and we said okay, and somehow I ended up sleeping with John Ike—and I told him I wasn't going to ball him, so he gets down on the end of the bed and starts doing this [makes squeaking bed sound], and I said, "What are you doing?!" and he says, "Well, I've got to make it sound like I'm getting something." [Laughs.] That kinda set the tone for the proceedings right there, indeed.

Despite being secretly amazed that the band were headlining shows over nationally successful bands that they'd heard of back home, they weren't going to give the boys an easy time. Liz Henry commented, "They were such hicks, these goat-ropers from Kerrville... Well, they hadn't been anywhere before, they were just awestruck, you know they all went around like... [jaw open]."

Q: Tommy Hall?

Pam Bailey: Weird!

Liz Henry: Weird!

Pam Bailey: Weird.

Liz Henry: Weird... I bet I never said ten sentences to Tommy.

While John Ike, Ronnie and Stacy were happy to entertain, the others remained largely aloof and unapproachable. Tommy didn't have much time for their antics, and had retreated into his new abode with Clementine and Roky under his charge. The others, meanwhile, were fair game,

and appreciated the new Texan blood. First off, the girls decided that it was about time the band should at least try and look like rock stars. So far the band had made no concessions to the San Francisco fashions, and only made brief shopping trips for gifts to take home. Stacy had bought a bag for his high school sweetie, Laurie Jones, which was made out of an elephant's scrotum. John Ike was singled out for victimization and voted most in need of attention.

> **Liz Henry:** John Ike decided he had to get himself some boots, the soft leather Indian kind that come all the way up to the knee with fringing, and he came rolling back in the next day... "Oh, cool boots, John Ike, where'd you...?" "Oh, I had a sandal-maker make them for me, and I got a discount on 'em." [Singing] "John Ike, John Ike, don't lie to me, where did you get the boots so fine? I fucked the sandal-maker, got a discount of 2.89!" He got mad as hell because we'd insinuated she'd only given him a discount of $2.89... John Ike just looked so dorky, everybody else you could let slide... John Ike you just really couldn't.

The girls soon became a recognized part of the band's entourage, and they continued to be amazed at how revered they were by other musicians and fans alike. After hanging out in the new Kerrville, the girls spent time with Stacy, who was living in a Texan-run house in the Tenderloin just down the street from the Avalon. Stacy refused to buy new clothes but agreed to some restyling.

> **Pam Bailey:** Stacy decided he didn't look evil enough, because his goatee grew in red and his hair was black, black, black... so we dyed it black... so he would look evil (hahhahah).

Cecil, the "band boy," was set for further ridicule. His hair had grown out and was starting to curl under his cowboy hat which he complained looked "fruity," so the girls set it in pink foam rollers. Amongst those living there were Texans Jack Jackson and Wayne Walker. Within a month of being out there Wayne had taken enough "purple acid" to earn himself the nickname Goofy Grape. In Texas they had been "one big ol' family," and now everyone was spread across the Bay Area. The girls decided it was time to go find their old friend Roky.

The apartment Tommy, Clementine, Roky and Roland lived in was in the Haight area, on Fillmore and McAllister. The local black youth didn't take kindly to the influx of white hippie kids who were taking over because of the cheap rents, and leaving the apartment was like running the gauntlet. Roky was usually dispatched to get supplies since he could charm his way out of almost any situation; however, Stacy hated visiting and demanded an armed guard. One night Tommy was slammed against a wall with a baseball bat held to his head, and when the assailant demanded money, Tommy replied, "Jesus, do you think I'd be living in that rat-hole if I had any bread?" The final straw came when his beloved record collection of blues 78s was stolen after a demonstration spilled into a series of street disturbances. Although trouble on the streets never reached the

(1966) Marathon day show #3, Bill Quarry's Teens'n'Twenties, Rollarena,
San Leandro

scale of the Berkeley riots in '68, minor disturbances continued and the National Guardsmen patrolled the streets for several weeks in anticipation of further trouble. Eventually it got so bad that they moved into a house in Oakland with Tary Owens and his wife Madeline.

Allegedly Pam and Liz eventually tracked Roky down at Janis' one night. He was babbling so madly that she'd given him an injection of heroin to calm him down. By the end of September it was becoming undeniable that Roky was starting to become unhinged. On top of the daily dosage of LSD, the pressure of the band's schedule was proving an enormous physical and mental drain. While physical stamina could be enhanced artificially, the mental stamina required to perform the increasingly complex lyrics to the new songs was proving to be too much. Roky was under constant pressure from Tommy not only to be word-perfect but also convey the true meaning of his lyrics in his delivery. Although Roky had an excellent memory for hundreds of songs, he was being saturated with difficult lyrics, which was hard for someone who primarily communicated through his actions. Putting on a good rock 'n' roll show and providing entertainment had become secondary to using the medium for spreading the word. Soon Roky started blanking on stage and would turn to the band and indicate that they should jam until he could continue. Other times he'd simply freeze, and on occasion Tommy even had to pull him off the stage.

> **John Ike:** In California he walked out on the stage on a bummer, forgot all of the words to all the songs and says, "I can't play, man." He went and drew a blank on the stage. I said, "Don't worry about it Roky. Stacy and Tommy and Ronnie and I'll play."

> **Ronnie:** Well, he did that at more than one time; he just kind of spaced out and would just turn around and start playing.

While recollections of this period are extremely mixed, it's certain that while the band stood on the razor's edge of fulfilling their potential and becoming one of the first underground bands to break through to the mainstream market, two of the band's key members were effectively shut away in hiding. Tommy and Clementine cloistered Roky away in order to let him recuperate. This led to confusion and weirdness amongst some of their closest friends, as they found a protective veil denying them access to Roky.

> **Jack Jackson:** So I went along with my old buddy "Magrew"; we were both hardcore Elevators fans, and so we made a point of going over to the house where they were living. And this was the stage where Tommy and Clementine were being very, ah, "Roky's not doing too well today, I don't think it would be good for you to see him." We were basically run off by Clementine and Tommy. And they were both getting into the voodoo wizard trip. Tommy got worse as time went on, with gowns and staffs with magical da de da... I'd seen a lot of Texans go out and not be able to deal with the situation... I've got to be honest, I blame Tommy for the whole troubles of the band

out there. They were so intent on orchestrating the whole thing, instead of letting Roky see people that he knew who could have had a reality link, instead of cloistering him away from the world. It was very frustrating, but I got the impression that at that point they had taken main control of the whole concept of the group.

Somehow, Roky had changed—combined with any faint tinges of mental problems, he was living an acid-fueled lifestyle, with the added stress of the draft board, who had caught up with him. Although San Francisco had a much-publicized reputation for draft card burnings, this didn't prevent the terror of them pursuing you, and refusal to cooperate with the Selective Service Bureau was a crime. As Wayne Walker experienced, they were impossible to shake. He left San Francisco for Mexico, but the FBI tracked him down. He had hidden up the chimney when they raided the house he was staying at, but lost his grip and fell down and had to give himself up. Ironically, Tommy and Stacy were automatically exempt because they were on probation for a felony; clearly it was better to be a criminal. Despite being a pacifist (Roky, unlike many of his fellow Texans, never went hunting or fishing), he had no history as an objector and couldn't build a case based on political grounds. Many American citizens felt the war was unjust. At the time of Kennedy's assassination in November '63, there were only 15,000 American troops in Vietnam; the civilian draft started in August 1964, under Johnson, and continued until February 1973. Roky had just turned nineteen years old in July 1966, and was now the average recruitment age for the civilian draft. The draft targeted every fit male in the country—even English actor Davy Jones, who was working on the *Monkees* TV series, was deemed recruitable.

Tommy and Clementine had always taken on a parental role in their relationship with Roky and decided to guide Roky through beating the draft board. Between them they constructed a plan that would require Roky to employ all of his skills as an actor while Tommy concocted an almost Gurdjieffian form of method acting for him. In his teaching, Gurdjieff set his pupils physical hurdles in order to overcome mental barriers. The idea was for Roky to complain of back pains while presenting a suitably disoriented and disheveled appearance to support his suffering. Tommy used Asthmador as part of Roky's draft avoidance regimen. This was an asthma relief preparation that contained the active ingredient Atropine, a psychoactive compound present in both mandrake root and belladonna. Asthmador either came in powdered form, which was supposed to be lit and inhaled to clear bronchia, but could be misused by placing it in gelatin caps and swallowed. It also came in cigarette form in an unintentionally psychedelic red and green packet.

Belladonna has had magical powers attributed to it since the Dark Ages, and its use as a poison is well known, but it had also been "discovered" as a drugstore high in the Sixties. Leary is reported to have stated that he'd never heard of a good belladonna trip. Atropine is the same substance present in Mandrax (from the mandrake root), which was heavily abused by Pink Floyd's madcap leader Syd Barrett and has often been attributed to the final crack in his sanity. While people became suspicious,

a few friends were aware of the situation, like John Kearney, who was also out on the West Coast.

> **John Kearney:** Okay, there's the draft board thing and the strangeness concerning it, which I never really understood. But I had the impression Tommy was in the driver's seat, and Roky was going wherever. I think Tommy's method was to beat Roky as well as to beat the draft... Roky's draft board should have been in Austin but it turned out to be in Frisco; the word on the street was that Texas officers liked you to leave the area you had been busted in.

> **Q:** He was using Asthmador?

> **John Kearney:** It was over-the-counter belladonna... I believe it's related to the Datura root, which the Indians used in Mexico, for their visions and things. It has a nasty reputation. Why Tommy would have had him smoking that, ahh... Roky was not crazy when he came back from Frisco; Roky started to play up the crazy routine and me and the ol' boys still argue this one, I still maintain it's an act, but one of my old friends said when it started it was an act but now it's the only way he knows. But he wasn't that way then.

Roky attended his first draft hearing at the beginning of September, shirt half-untucked, hair disheveled, eyes dilated, and mumbled his way through to a postponement. This was merely avoiding the issue, and he was soon called back and required to prove medical evidence. Tommy and Clementine dropped him off at the hospital for a spinal tap, thinking this would be an end to the matter; however, he was required to return for further tests and the pressure, added to his other excesses, tipped Roky over the edge, and he was supposedly hospitalized.

> **Roky:** Well, I had to go to do some tests. And then I had to have a spinal tap done so I could tell them I was sick, and didn't want to join.

> **Q:** Was there actually anything wrong with you?

> **Roky:** No.

> **Q:** You faked it.

> **Roky:** Yep, right... I told them I was having pains in my back so I couldn't work in the army.

> **Q:** Pretty frightening?

> **Roky:** Yep.

The situation got worse, as Roky recalls: "I was walking along the street and the cops picked me up and wanted to see my identification. Apparently I didn't have the right ID, I was from Texas. If you weren't from San Francisco you were a risk to them. So they took me to a mental hos-

pital and checked me in and luckily it was a nice place, for the bigwigs."

Sandy Lockett: Roky was pretty much nuts when he started out on this trip, and he was really nuts by that time. What happened to him was that he'd taken too many strange things, and what probably kicked him over the edge this time was that in order to present a suitably messy appearance for the draft board he had been smoking a lot of Asthmador cigarettes. They imitated a lot of the symptoms of various respiratory inflictions, and they also put you into an opium haze. And so, because he was getting called on by the draft board all the time, he'd toked up on these and showed up in a complete mess—and that, together with the various things he'd take for gigs, just finally kicked him over. He definitely made all the attempts to seem as fucked up as he could for that purpose and this was kind of an engineered thing, but it soon became clear that they had serious plans for that boy. We had to ply him out of San Francisco State Hospital. Tommy and I had to sneak up there in the middle of the night and zip him out the back stairs. They were going to try both electro and insulin shock therapy and all sorts of things, so we knew we had to get him out of there. And so we made sure we knew where he was and brought him some clothes and commando-raided him out of there.

This wouldn't be the last time Tommy had to smuggle Roky out the back door of a mental institution, and later on all these instances would transpire as evidence against him.

John Ike: Yeah, it was hard, really. But the main thing that was hard was watching Roky; it was depressing what was happening to him. And then somehow Tommy got him back to a situation where he could go in and do the first album. Stacy lived in San Francisco; Ronnie, Cecil and I lived in San Pablo, and the only time we had any contact with those people was at the gigs. We didn't know what they were up to or what they were doing. They were late. They were always late. If I didn't go get them and get them in the car, they were always late. Tommy left California and went to Texas to visit and came back, and that goddamn Rambler broke down and I had to pay for the goddamn flight he took from Arizona to California, had to charter a flight to get to the gig; I was pissed because he went back to Texas. Tommy, he was constantly going back and forth.

Q: Why?

John Ike: Well, we can't talk about that.

Q: Dealing?

John Ike: I suppose, I'm not sure, definitely maybe. [Laughs.] I mean, Stacy would ride a cab out to our house in San Pablo, and he'd be broke. And this happened every weekend. I'd say, "Stacy, why are you broke, man? I just gave you three hundred bucks!" We played the Avalon Ballroom and we were getting two hundred there and we

were going little places with all these little Longshoremen's halls. We were playing all around the Bay Area, and doin' real well. And makin' good money. I said, "Where's your money, man?" I tell you what, man… Tommy really got a lot of money from Roky and Stacy over the time they were together, and didn't provide them with anything but hamburgers and acid. And they were broke, always. Coming to me for money. I was the manager. I handled the money in the band and I wouldn't let Tommy do it.

Strikingly, none of the Elevators, during any of the interviews conducted for this book, ever had a bad word for each other, beyond the obvious Hall/Walton rift. However, in 1985 Roky (KUT) did say, "I didn't have much money, because Tommy Hall hogged all our money. I didn't enjoy that all that much, that Tommy Hall had all the money and I didn't… but I still had a good time."

From Tommy's perspective, informed by the hippie ethics of the day, the band wasn't about personal financial gain, it was for personal education. While now he would be seen simply as a drug dealer, by being able to supply good LSD to others, he was helping them travel through inner space and discover themselves from the inside. But the effect it was having on the band members was beginning to show.

Stacy (K): John Ike and Ronnie were staying in a little town, I can't remember, seems like it was Larkspur, outside San Francisco. Already there was a bunch of clashes going on. We just got together for gigs, that's about all the group was really doing at that point… a lot of the first negative waves started coming into the group when we were in San Francisco… all kinds of things, all kinds of delusions started to develop. Like religious delusions, like one time we felt like we were delivering a message… it was really, I can't explain it; it felt like we were obligated. That's what I was trying to explain about Roky, when he kept turning on after he started flipping out, it was an obligation that he felt, because of what he BELIEVED to be true. And we were all really into that place at that moment, and we were starting to get heavy kickbacks.

Stacy's way of "spreading enlightenment," as his brother Beau recalls, was to pay for his friends to fly out to San Francisco so they could experience what he was experiencing. As Wayne Walker later explained to Beau, "One day Stacy got him and they drove down to the coast. They drove to an isolated area, parked the car and got out. They were walking along the beach. It was a really pretty day in California. Instead of the usual fog rolling in, there was bright sunshine and the water was clear and blue and everything. Stacy told me, 'I don't understand why people spend so many hours in churches. This is the only time in my life I feel really close to God.'"

10.
PSYCHEDELIC SOUNDS OF...

\mathbf{A}t the end of September, the band was back at the Longshoremen's Hall in San Francisco, where the cops were still frisking the audience for weapons following the recent street trouble. As usual, Pam and Liz were in attendance and were once again amazed that the Elevators were headlining over Sopwith Camel, a band with a national hit. They also witnessed less well-received shows such as one in Fresno, full of squares who had no idea what to make of the band. Following the early evening teen show on September 30, at the National Guard Armory in San Bruno with two little-known bands, the Westminster Five and the Inmates, they headlined the Avalon for the second time supported by local heroes Quicksilver Messenger Service. The girls arranged to meet the band at Fosters, a late-night cafeteria where they were intimidated by "three huge, humongous biker, bull dykes" until John Ike rolled in clutching a case of Iron Boy, "Here girls, try this, just a sip?" Like everyone else they thought it was the special potion that got the Elevators high…

> **Liz Henry:** They had top bill over everybody we'd heard of. We were going "They're getting top billing over Quicksilver Messenger Service!" And everybody, all the other bands were going, "You're with THE 13th FLOOR ELEVATORS?" I mean bands like Big Brother!

In October 1966 Dillard decided to end the Elevators' delaying tactics and summoned them back to Texas with the threat of releasing the old recordings and freezing payments for their equipment. Even if Tolin had received inquiries from other record labels, no serious offers were forthcoming until 1967 when Elektra supposedly offered to buy the band's contract from IA. The band took Dillard seriously and began a disjointed return to Sumet Studios in Dallas.

Ironically, October 8, the day the band left California for Texas, "You're Gonna Miss Me" reached its peak position in *Billboard* at #55, and mysteriously disappeared without a trace the following week. The record had maintained a slow and steady climb up the charts for twelve weeks and was selling in large enough volume to be targeted by bootleggers and counterfeiters. There has been much speculation within the Elevators' camp as to what happened. The conclusion was that the band was subject to another covert ban by the record industry. The same week the record vanished, LSD was banned in California on October 6th and many believe the music industry reacted by banning longhaired bands that openly advocated the drug. MGM Records openly declared it would cull its roster of any bands with associated drugs—instead, it became an excuse to shed some of its lesser-selling artists while retaining acid guzzlers such as Eric Burdon, who lyrically advocated the counterculture (they later signed the Velvet Underground, who'd written a song called "Heroin").

The circumstances of the recording of the Elevators' first album have been the subject of much confusion. John Ike has maintained a story that has become legend—that they were forced back to Dallas, refused a hotel and went straight into the studio upon their arrival at three a.m. and recorded the whole album in one night. Surviving paperwork shows he was almost right.

> **Stacy (K):** The first album we cut, it was really a bum deal. They'd been telling us we'd be going to Nashville and all this and for the first album they called us from California to Texas and wanted us to do a few sides. And we came down here and they got into a big hassle with us about money and everything, and time, the time of the year and all this. They said, "Y'all are either gonna cut the album this weekend or we're gonna release all these tapes we've got." And they meant it. And they were trash tapes, just studio jams and shit. So we went into the studio and stayed three days and nights cutting an album and, like, most people spend longer than that on one song.

Tommy certainly wasn't prepared to issue an album that simply cashed in on the success of their single. He wanted to compete with the content of albums by the Beatles or Dylan, and was forced at short notice to fashion the band's original songs into a complete and coherent body of work. His overall concept was to apply a psychedelic mantra, informed by his study of general semantics and semantic memory via Korzybski to their songbook to try and arrange the songs into a playing order that would best describe the psychedelic experience. The problem was formulating "psychedelic" justifications for material written previously by Roky and Powell and forming them into a whole.

As they commenced the long drive from San Francisco to Dallas, Tommy realized his concept for their psychedelic manifesto was short of the penultimate message. The song would be a warning to the curious traveler not to fail in his quest because the ultimate goal, the "Kingdom of Heaven" lay at the finish. Roky taught the music for the Spades B-

side single, "We Sell Soul," to the rest of the band in the back of the van while Tommy wrote new lyrics, the result becoming "Don't Fall Down." The contents of *Psychedelic Sounds of the 13th Floor Elevators* were Tommy's calling to the individual to recognize that there were new possibilities available to change the relationship between the self and soul. He wasn't yet able to construct lyrics that communicated beyond the calling. He was still at the point where LSD gave an elusive insight into the universe and being able to manipulate the acid revelations was like chasing the horizon. His attempts to go beyond were yet to come on the band's second album.

The band finally arrived at the Dallas Marriott Motor Inn at 1:30 p.m. on October 9, having driven straight from San Francisco without a real break. Having briefly crashed for a few hours, they were met in the late evening by IA bosses who arrived from Houston. Much to the band's surprise and amazement, they were introduced to their new "producer," Lelan Rogers, for the first time, and then they were ordered into the studio to begin recording.

> **Lelan:** My first meeting with them was when they turned up at Sumet in Dallas. They drove back from San Francisco and met, and we started recording there at two or three o'clock in the morning. It was fun. I was younger then [thirty-eight years old]; we recorded the first one at Sumet Sound with a gentleman named Sullivan, he had a three-track studio.

Lelan and Dillard went across the road to the Pizza King restaurant while the band set up their equipment. Depending on whose story you listen to, Tommy had grass stashed in his clay jugs and the band set about getting loaded for the imminent session. The band duly took LSD (except John Ike) and had approximately twelve acid-driven hours before it wore off. Typically, it didn't pass without incident. By the time Lelan and Dillard returned with carryout pizza, tea and coffee, pandemonium had broken loose.

Sullivan had tried to bar the doors and get the session started; however, Tommy was outside meditating on a stump before climbing up on the studio roof and began his vocal preparations for the session (yodeling as Sullivan described it), which attracted the attention of some cops.

> **John Ike:** Tommy was sitting on a stump in a vacant lot in Dallas, at three o'clock in the morning, with long hair, and he was meditating... and here come the cops. Stacy had stashed a little weed in the studio. They flushed it down the toilet but it didn't flush. That stuff doesn't flush, it just floats to the top! [Laughs.] And so Lelan was out there trying to talk them into leaving. And they wanted to know why this guy was meditating on a stump at three o'clock in the morning. [Laughs.]

Nobody told the band what to do; they just tried to coax them through the session. In fact, the band spent just four hours recording the bulk of their material until dawn broke, and then spent the next six hours edit-

SAN BRUNO
A-GO-GO
PRESENTS
THE 13TH FLOOR ELEVATOR
THE INMATES
THE WESTMINSTER V
FREE DOOR PRIZES
NAT. GUARD ARMORY
3RD AVE. - SAN BRUNO
FRI. SEPT. 30 8:30 PM
ADMITSION 2.00

Advance tickets can be purchased at the following locations:

SHERMAN CLAY
Hillsdale Shopping Mall, San Mateo

A.B.C. MUSIC
San Mateo Ave., San Bruno

BRONSTEIN MUSIC
Grand Ave., South San Francisco

OR CALL
588-5674

PREVIOUS SPREAD: (1967) GENERIC POSTER RIPPED OFF THE BAND'S FIRST LP COVER, ILLUSTRATING THEIR SIGNIFICANCE ON THE SF SCENE. THIS PAGE: (SEPTEMBER 30, 1966) FIRST SHOW OF THE NIGHT, NATIONAL GUARD ARMORY, SAN BRUNO, COURTESY SUMNER ERICKSON COLLECTION

ing and mixing. John Ike certainly felt a lack of communication with the control room—they just kept getting them to perform another take while they played with the levels.

Gregg Turner: Did Lelan ever give you trouble about the performances?

Roky: No, he never did, really. He'd say, "Could you boys speed it up a bit—we're payin' for this time" or something like that and I'd say "who is this weird man with the white hair?" He was weird-looking; his head was red as a beet.

Lelan: They were usually a one-take band. And they had their ideas about what they wanted it to sound like. And I was more of a babysitter than I was a producer, I'm the first one to admit that, we just locked the doors and we would do one take and then play it back and if they liked it we'd take it and go onto the next one. Oh yeah [laughs] great group, lots of energy, the guys were all really good.

Following a few rehearsal takes to get sound levels set, the band systematically performed their material, listening back to the performances and recording over the unsatisfactory takes (hence the lack of actual outtakes from the session but several alternate mixes). The first song attempted was "Roller Coaster," and it was soon discovered that it was best to record Tommy's jug as an overdub since he was struggling to keep in pitch with the rest of the band. So the band followed the same technique used at Andrus Studios, essentially playing live on one track, the second used for overdubbing jug and the third for vocals. There remained the eternal issue of the presence of the jug within the music. Lelan clearly thought it was what made the Elevators unique, and Tommy certainly felt it was their trademark sound. Stacy felt it took center stage too often and compromised the opportunity for his lead work.

Tommy (MF): We just didn't have that all together when we started to record the first album. We first did "Roller Coaster" and I really busted that up and everybody hated me for that—you know I went off-key and stuff—but it wasn't my fault cause I had only done that a couple of times live and I just wasn't ready for my part. I was kind of querying about the instrument myself. But when I heard the recordings I realized that it really worked. I looked at what I was doing primarily from a writer's standpoint and was kinda just playing along with the band—and luckily that's how the band felt also!

John Ike: Because the jug was so loud in that song, "Roller Coaster" that it drowned out a lot of the lyrics. That's what I hated about the jug. Roky was singin', doin' real good and then here comes this jug. You know, Lelan pipin' in the jug, "Put the jug on ten!" You know? [Laughs.] They don't care about the lyrics. It's that jug that makes people like the Elevators! That's the way Lelan felt about it. He was just there, drinkin' coffee.

Bob Sullivan: The 13th Floor Elevators came in and tuned up and they were playing so loud—I mean the control room windows were rattling, shaking—I thought the putty was going to come loose. The vibrations on the building... a great extermination took place, it was hilarious, I looked down and spiders were scooting across the floor. No one produced them really. They just went in the studio and said we're going to do this, let's do it. None of this stuff had overdubs, it was all one take through and let's move on. We nailed some of those songs the first take. I mean, we'd play it back and they'd say that's great, let's go to the next one.

Lelan: So when I was doing the first album in Dallas, we went back to the hotel one night after the session, very tired, and we were going to get a bite to eat, go to bed. And they were having a gathering of socially prominent people at this expensive hotel. They all had their tuxedos and evening gowns on, and when I walked into the coffee shop with this group, everybody was holding their noses as though we all stunk. Just keep in mind the era—we were socially un-acceptable. But I had my two lawyers with me; they normally came with us so they couldn't kick us out. It was obvious we couldn't get waited on; people were trying to get rid of us. So I got up and went over and told the cashier, I said, "I don't want to create a big scene in your restaurant, but this is a very famous recording group from England, and if the people in here find out who they are it'll create pandemonium because they'll all be wanting autographs. Just get us some scrambled eggs and then we'll go." So she said, "Who's in the group?" I said, "It's the Rolling Stones, that's Mick Jagger sitting there"—I was pointing at Roky—and she said, "Oh my God, my daughter's bought all their records, let me get an autograph." So she runs over there with a pencil and Roky is sitting, saying, "Wow, man, what's going on?" And I said, "Just sign whatever you want to," and he can be quite mad, so in a few minutes we had everybody in the place... we came from totally socially unacceptable to totally socially acceptable. It will show you where people's heads were. But we finally got to eat.

The following day, the band spent a further five hours trying to finish recording the album, working on the new song, "Don't Fall Down," and another four hours completing the mono mixes. On the 11th they spent three hours beginning a crude stereo mix and ordered twelve- and seven-inch acetates to be cut at the rival studio Rhodes Recording Service. They then headed to Jones Studio in Houston to complete "Don't Fall Down."

Ronnie: We spent hours on "Don't Fall Down" and then we gave it up because everyone was too tired... and then we went to Houston to Jones studio. I don't know why we didn't finish in Dallas... And the worst part was they remixed it after we mixed it and sent it off to California to have it pressed. But I always liked Lelan. He tried to—he really wanted to work with us, but he had to deal with the lawyers that had no idea about the music business.

(1966) Mouse-designed handbill for Avalon Ballroom show, September 30–October 1

(1966) Postcard for San Mateo college show, October 15, courtesy Paul Drummond collection

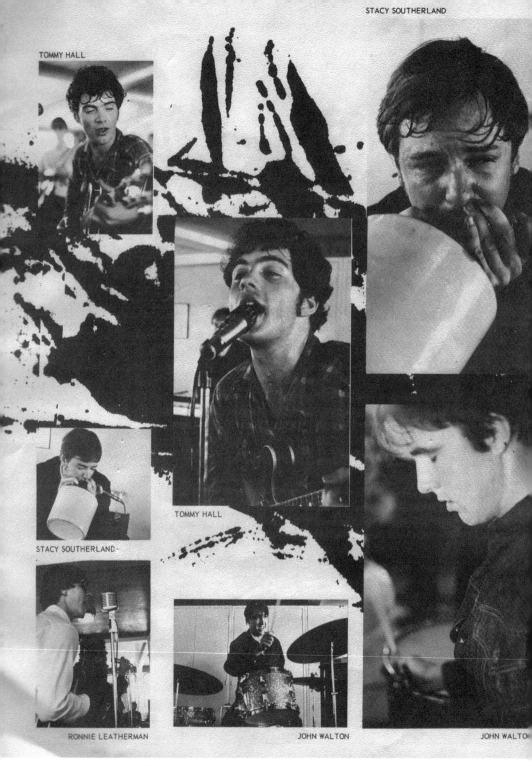

STACY SOUTHERLAND

TOMMY HALL

TOMMY HALL

STACY SOUTHERLAND

RONNIE LEATHERMAN

JOHN WALTON

JOHN WALTO

(OCTOBER 15, 1966) PAGE FROM SAN MATEO PROGRAM, PICTURING SEPTEMBER 23 MARATHON DAY SHOW #1,
KFRC POLL WINNERS BOAT TRIP AROUND ALCATRAZ, COURTESY J. KAHN

~ 184 ~

IA never understood the dark resonations of Mr. Sutherland's expression, a common problem for many bands. The (American) Decca label called the Who's producer, Shel Talmy, to tell him he'd sent them a faulty master of their second single, and he had to explain that the strange sound was reverb and that it was meant to sound that way. While Stacy lost out on reverb, IA ensured that the jug, the Elevators' trademark, was audible in the mix, sometimes to the detriment of his guitar and Roky's lead vocal. While the technical difficulties in production marred the perfect product, the overall content within was clearly one of the most startling, original and accomplished records of the era.

After the Houston session the band headed for California playing pickup shows in Albuquerque, New Mexico the next day (which they arrived extremely late for), and in Santa Fe the following day. The band had to be back to headline a large Saturday night college show with six other bands in San Mateo on October 15. Hosted by KFRC's Steve O'Shea and put together by Steve Tolin, this was clearly a big event with lots of radio promotion and handbills, postcards and even a program (with all the names on the photos screwed up).

More importantly, that weekend was the Avalon Ballroom's first anniversary. There were a series of shows over the weekend, the lineups of which have merged together in people's blurred memories. The Sunday show was better remembered, but not billed as the legendary "All Texan Night" featuring Janis Joplin and Big Brother, the Sir Douglas Quintet and the Elevators who, due to the uncertainty of their appearance, were billed as "a surprize visit." That afternoon the Artist's Liberation Front's Free Fair took place in Panhandle Park. The Grateful Dead, Quicksilver Messenger Service and Country Joe and the Fish all played in the open air, with a poor sound system, free food and walls erected for people to "express themselves on." The day's events then switched to the Avalon when Jerry Garcia and Pigpen from the Dead formed a one-off jam band called the "The New Peanut Butter Sandwich" which included David Getz (Big Brother), David Freiberg and Gary Duncan (Quicksilver).

Liz Henry: The Grateful Dead are going "We're on the same bill as the 13th Floor Elevators!" The Grateful Dead could not believe that they played a gig on acid, they were astounded.

Pam Bailey: The keyboard player, Pigpen, he was going, "they don't really play a gig on acid?!" Eight million years later I tell this story and people go yeah sure... Grateful Dead, ha ha...

Mojo Navigator: They (Peanut Butter Sandwich) did a very long and boring pseudo Butterfield blues instrumental. The most interesting group musically was the 13th Floor Elevators. They are a really freaky group. They look strange, they sound strange, and they are all good musicians, doing all original material. The lead singer, whose voice is truly odd, also plays guitar pretty well. The drummer is excellent. They have one guy who does nothing but boop-boop-boop with a jug. The songs they do are new and different.

Following the album sessions the Elevators decided to drop the cover tunes in favor of promoting their own material. With an album of original material ready for imminent release Tommy was cemented at the forefront of the band's direction as a fully-fledged psychedelic band. Once again this pitched him against John Ike, who preferred to balance the set list with dancehall numbers.

The Elevators were booked for a show at the Monterey Fairgrounds on October 22 with support from several local bands—37 Scene, English Leather, Color Us Sound and Beau Modes. After this show they had a week off before their next engagement. Most of the band went en masse the following day to see the Yardbirds at the Fillmore Auditorium. With a formidable eleven amps on stage, this show featured both Page and Beck playing lead guitar and, according to Jimmy Page, was one of three occasions when the dual guitarists actually worked together. The performance was reported by the *Berkeley Barb* to have won over the "nascent local audience." Meanwhile, Tommy and Sandy Lockett returned to Texas to battle it out with the record company.

Following the single sessions at Jones Studio on September 20, master and reference discs had been cut for a new 45 rpm at Rhodes Recording Service in Dallas on September 28. However it still wasn't clear whose choice of second single IA had opted for: Tommy's ("Reverberation") or Lelan's (Buddy Holly's "I'm Gonna Love You Too"). The band were divided; Stacy as always had his reservations, feeling they should have tried a safe option to establish the band before issuing potentially alienating psychedelic material.

> **Stacy (K):** I think if we'd stayed on a level like "You're Gonna Miss Me" a little longer, it would have been wiser too, instead of moving right up immediately into what we wanted to do. We went too fast.

> **Tommy (MF):** We knew that it takes groups several albums to make it but our problem was that we never could come up with a second single. We were a purely intellectual, album-oriented band and still at that time everything was singles-oriented. Well, we tried a whole bunch of them. Roky wrote "You're Gonna Miss Me" and I should have made him write something like that.

After arguments over the second single, the next round was to supervise the production of the album, which Tommy initially considered calling *Headstone*. John Cleveland, who had designed the early Elevators graphics, was enlisted to supply the cover art for the album. The result was one of the most arresting record covers of all time, and one that always features in modern "100 Best Album Covers" books. The artwork for *Psychedelic Sounds of the 13th Floor Elevators* couldn't have described the music inside better. Its crude, childlike lines writhe with implied psychotic movement. The use of clashing, complimentary colors makes it undulate further, a true masterpiece of pop art design.[30]

As for Tommy's sleeve notes, they were a raw attempt to articulate his general semantics studies and solidify them in terms of his "Elevators

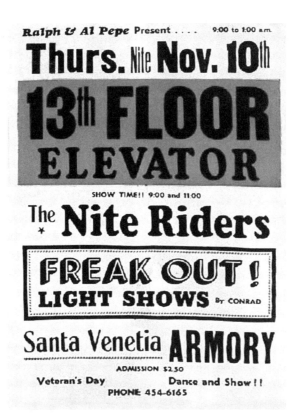

(1966) Poster for Santa Venetia Armory show, November 10, courtesy Dennis Hickey Collection
(1966) Handbill for Maple Hall show, November 25, courtesy Dennis Hickey collection

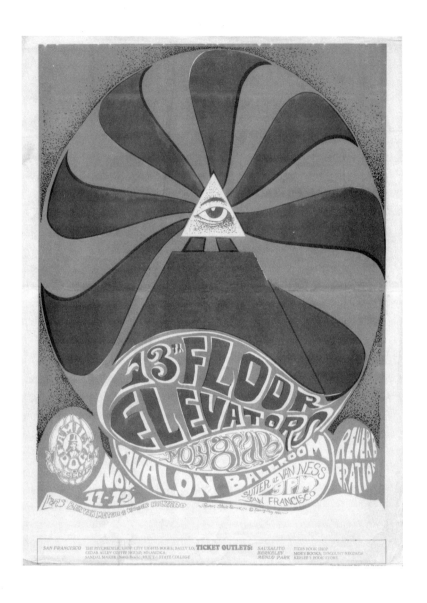

(1966) STEVE RENICK'S HANDBILL FOR AVALON SHOWS PROMOTING "REVERBERATION," NOVEMBER 11–12;

(1966) *RECORD WORLD* NOVEMBER 5 AD FOR BAND'S SECOND SINGLE

rap." Beyond the song lyrics, they are the only known surviving example of Tommy's written ideas during the Sixties. However, he wasn't entirely alone in his direction; the December '65 edition of *ETC* (a quarterly general semantics publication) had examined psychedelic research in relation to semantics with contributions by Leary and Osmond. While the overall style and flavor of Tommy's writing cribs mainly from the rhetoric and style of Korzybski, the second introductory paragraph married this with his adoption of Gurdjieff's "Fourth Way" (the use of chemicals as a fast track to enlightenment). Once again Tommy's standing point sounded overtly political in its attack on the establishment and the current status quo, something he'd deny.

> **Sleeve Notes From *Psychedelic Sounds of...* LP:** Since Aristotle, man has organized his knowledge vertically in separate and unrelated groups... Science, Religion, Sex, Relaxation, Work, etc. The main emphasis in his language, his system of storing knowledge, has been on the identification of objects rather than on the relationships between objects. He is now forced to use his tools of reasoning separately and for one situation at a time. Had man been able to see past this hypnotic way of thinking, to distrust it (as did Einstein), and to resystematize his knowledge so that it would all be related horizontally, he would now enjoy the perfect sanity, which comes from being able to deal with his life in its entirety. Recently, it has become possible for man to chemically alter his mental state and thus alter his point of view (that is, his basic relationship with the outside world which determines how he stores his information). He can then restructure his thinking and change his language so that his thoughts bear more relation to his life and his problems, therefore approaching them more sanely. It is this quest for pure sanity that forms the basis of the songs on this album.

The remainder of Tommy's sleeve notes are the application of the theory to each of the song's contents. Although this is tenuous at times (because some of the material predates his ideas) he freely admits this. Tommy aimed for a bigger whole, a cohesive lineage or "concept" to tie the songs together, which ended with the ultimate goal: The Kingdom of Heaven.

> YOU DON'T KNOW HOW YOUNG YOU ARE explains the difference between persons using the old and the new reasoning. The old reasoning, which involves a preoccupation with objects, appears to someone using the new reasoning, as childishly unsane. The old system keeps man blind to his animal-like emotional reaction.[31]

> THROUGH THE RHYTHM shows the results of applying the old system and its ramifications. The new system involves a major evolutionary step for man. The new man views the old man in much the same way as the old man views the ape.

> MONKEY ISL.A.ND expresses the position of a person who has discovered that he no longer belongs to the old order.

ROLLER COASTER describes the discovery of the new direction and purpose to man's life, movement in that direction, and the results. The pleasures of the quest are made concrete in FIRE ENGINE.

REVERBERATION is the root of all inability to cope with environment. Doubt causes negative emotions which reverberate and hamper all constructive thought. If a person learns and organizes his knowledge in the right way—with perfect cross-reference—he need not experience doubt or hesitation.

TRIED TO HIDE was written about those people who for the sake of appearances take on the superficial aspects of the quest. The dismissal of such a person is expressed in YOUR (sic) GONNA MISS ME.

I'VE SEEN YOUR FACE BEFORE—(Splash1) describes a meeting with a person who radiates the essence of the quest. There is an outpour of warmth and understanding at the instant of meeting between two such persons, just as if they have been friends for life.

DON'T FALL DOWN refers to the care that must be taken to retain and reinforce this state.

THE KINGDOM OF HEAVEN IS WITHIN YOU. The Bible states in "Proverbs" that man's only escape from the end foretold in "Revelations" lies in his reinterpreting and redefining God.

The arrival of Cleveland's artwork at IA, followed by Tommy's sleeve notes, apparently caused Dillard and Ginther to hit the roof as Sandy Lockett recalls, "The cover very nearly got rejected, which would have been a tragedy... a terrible thing." This was scary stuff if you're the boss of a record company in Houston in the mid-Sixties.

John Ike: I mean, here you are in a record store, how could you turn that down in a record store? Everything else has a photograph of somebody on it, you know? And you come across that. You'd buy it. [Laughs.] Just to see what's inside it!

While the cover art stayed, as did the sleeve notes, the album running order was reprogrammed for the pop market, placing the hit single first. The concept of the album's running order forming a psychedelic guide that added up to a greater whole than the sum of its parts was lost. If the front cover wasn't arresting enough, then the back cover was simply a bizarre battle of ideologies. Lelan Rogers was supposedly responsible for lifting a pyramid and eye (complete with thirteen floors) from the dollar bill and planting it in the center of the back cover, creating a psychotic split. While Tommy's rap occupied the left side of the divide, Lelan's spin ran down the right side—he name-dropped as many music industry insiders and chums as he could in order to connect them with the product. Despite Dillard claiming expenses for a trip to Texas 'n' Tanner in San Antonio to "proofread" the sleeve layout, the back cover has led to even further mystery and confusion. Roky is miscredited as "Rocky Ericson,"

and Powell St. John as John St. Powell. At the time, this was seen as a deliberate attempt to avoid paying songwriting royalties.[32]

> **Powell (AV):** By the time the group began to record with International Artists I was out of the country and if any attempt was made to locate me to get my approval it failed. I can but assume that Lelan Rogers figured that I might turn up eventually and so I was listed as John St. Powell in an attempt to protect International Artists from liability in case I decided to sue. In the summer of 1967 Lelan and his partner showed up in San Francisco. They had a check (I don't remember how much) which they said was payment for the use of my material. I declined and told them that I intended to use the songs myself and that they had been copyrighted by my own publishing company Mainspring Watchworks Music. I never heard from them again.

> **Stacy (K):** Tommy was writing some of those explanations for the songs and, you know, they weren't really the explanations at all really. Like "You're Gonna Miss Me"... Roky had made before we'd even started... whatever, it freaked me out. But he kept telling us, "Man, this is going to cause a stir." He says, these people have never seen anything like this... and he says, "This is going to cause a controversy." And, in a sense, it did.

Often Tommy would cite songs by other people as influences on his own writing, when in fact it was impossible, since they wrote them after him. Roky seemed to share Tommy's non-linear time frame when it came to the meaning of his song "You're Gonna Miss Me." In 1973, he re-evaluated what "You're Gonna Miss Me" might actually be about. This interpretation was far more Texan, along the lines of Bobby Fuller's "I Fought the Law" instead of the Beatles' or Kinks' "you/me" formula. Regardless of any criticism over the convoluted nature of the sleeve notes, Tommy did a brilliant job. The fact that he left generations of fans puzzled and bemused has only helped perpetuate the myth of the Elevators.

Although IA did take Sandy's advice and used Columbia in New York to master their records to vinyl in the future, for their first album they ignored him. After the two-day session in October, the band left Texas thinking they completed the mono and stereo mix of their album (in 1966, even the Beatles didn't take an interest in the stereo mix). Dillard returned his Hertz rental car to Dallas airport, flew directly to the West Coast and took the tapes to be pressed at Rainbo Records in Hollywood. They returned a test pressing to Houston on October 29, and by then it was too late…

Dick Clark re-booked the band to record a performance for the Halloween special on his main show, *American Bandstand*. They were due to fly to L.A., but Tommy had left enough acid for the whole band in a beaker. Clementine, thinking it had been left out for her, drank the whole lot. She was out for three days, as she put it—"just when I was coming out of it, complete with trench mouth and shot kidney, as we went south to do *American Bandstand*."

Tommy, Clementine and Roky drove to Los Angeles, stopping en route in Santa Barbara to stay with fellow Texan Russell Wheelock. The others decided to fly down the morning of the filming, and since John Ike didn't want the hassle to putting his drums on the plane, he only took his painted drumhead, assuming that since it was a music show they would supply a kit. When they arrived there were no drums to be found and the band were unceremoniously ushered into dressing rooms and told by an officious production assistant to don gorilla costumes for the Halloween show. When news reached Dick Clark that the band were so pissed off that they were refusing to budge, he personally came to the dressing rooms to sort the matter out. For Clark, this wasn't the first time he'd encountered a revolt from "serious artists." They explained their case, and he thought for a minute and called the production assistant—"Go tell Paul Revere and the Raiders to do it, they'll do anything!"

The band lip-synched another performance of their hit and this time they looked more like professional musicians. Roky wore a tailored suit and gave a bizarre performance, his eyes screwed tightly shut, mistiming his famous screams while adopting a strangely hunched pose and even performing funny little Chuck Berry-inspired duck walks during the guitar breaks. According to Ronnie, this was typical of his stage performance and not the pained results of the draft board spinal tap. While Roky hammed it up, Stacy stood motionless and menaced the camera. The funniest of all is John Ike, who might as well have worn the ape suit as he's briefly glimpsed hidden behind cutout palm trees on the jungle set, miming on an imaginary drum kit.

What happened next has become legend. Dick Clark bounded up to engage Tommy Hall in some mindless banter following their lip-synch performance:

Dick: Hey gentlemen, how are you. [To Tommy Hall:] Do you have to have a lot of lung power to do that (play the jug)?

Tommy: Yeah you have.

Dick: So you can get different sounds out of it too, huh?

Tommy: Yeah, yeah, you kind of have to be vocally strong.

Dick: Who is the head man of the group here, gentlemen?

Tommy: Well, we're all heads.

Dick: I'm cutting this short because I know you're on your way to an airplane and if I let you go right now, you've got half a chance of making it. We sure appreciate you coming by. [Laughs at John Ike.] Come back and visit our palms anytime. Thanks very much. The 13th Floor Elevators, ladies and gentlemen.

While the network did not appreciate the drug culture pun, the *American Bandstand* Halloween special, featuring guests "Billy Stewart and

the 13th Floor Elevators," was aired on October 29 throughout the U.S. It marked the Elevators' most prestigious television appearance, and their last stand as pop stars.

While the others flew back to the Bay Area, Roky, Tommy and Clementine decided to explore the L.A. clubs and headed for Sunset Boulevard. During '65 and '66, the Sunset Strip area had been re-populated by droves of Rolling Stones/Byrds lookalikes, and many new rock clubs such as Pandora's Box, the Whisky-A-Go-Go and Gazzarri's had opened up to cater to bands like the Seeds, Chocolate Watchband and the Doors. Although the Elevators could have possibly fit into the electric "garage" sound of L.A. somewhat better than the hippie San Francisco scene, their single had failed to break in L.A. as it had in San Francisco. By early November, when Roky et al. were visiting the area, things were already starting to turn nasty. Local business owners had started demanding an end to the twenty-four-hour lifestyle, and that the city impose a curfew. The police were starting to get heavy on the streets, and the first of the famous Sunset Strip riots, immortalized in Buffalo Springfield's song "For What It's Worth," was starting to kick off.

30. Although John Cleveland did eventually move to San Francisco and worked at the Avalon, there was probably one good reason he didn't become one of the era's most celebrated poster artists: Texan Jack Jackson commissioned the Avalon poster artists.

Jack Jackson: *HA! God, [shouting] John Cleveland comes to San Francisco and I give him a place to stay in my apartment and he steals my old lady... I don't believe it.*

Q: *That's why he didn't do any posters?*

Jack Jackson: *I don't know why he didn't. He was an artist's artist, painting away cranking out these things and if people didn't like them he didn't care. Devil-may-care artist.*

31. *Science and Sanity,* **p. 41:** *As always in human affairs, the issues are circular, our rulers who rule our symbols, and so rule a symbolic class of life, impose their own infantilism on our institutions...This leads to nervous maladjustment of the incoming generations which being born into are forced to develop under the un-natural (for man) semantic conditions imposed on them. In turn, they produce leaders with the old animalistic limitations. The vicious circle is completed, it results in a general state of human un-sanity reflected again in our institutions. And so it goes on and on.*

32. Powell St. John arrived in San Francisco in late '66 following adventures in Mexico; he soon began writing and playing autoharp with a band called Mother Earth, fronted by Texan singer Tracy Nelson.

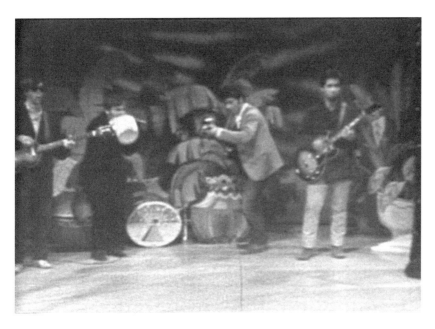

MIMING "YOU'RE GONNA MISS ME" ON *AMERICAN BANDSTAND* HALLOWEEN SPECIAL, AIRED OCTOBER 29, 1966
L–R: RONNIE, TOMMY, JOHN IKE (HIDDEN) ROKY, STACY.
DICK CLARK: "WHO IS THE HEAD MAN OF THE GROUP HERE, GENTLEMEN?"
TOMMY: "WELL, WE'RE ALL HEADS."

11.
DON'T FALL DOWN

After their return from L.A., Roky, Tommy and Clementine moved to Oakland while keeping "communications" open through the Family Dog house on Fell Street in San Francisco. Stacy, Ronnie and John Ike had meanwhile relocated to the Fireside Hotel in Sausalito across the Bay. Wherever the Elevators were, they were infamous, so much so that when Stacy's old friend from Kerrville, Johnny Gathings, hitched to San Francisco, he was walking down Haight Street for the first time when he was recognized by fellow Texans who delivered him straight to Stacy's door where he found him stringing his guitar. Pleased to be reacquainted, they dropped acid together and went in search of trouble. They ran into the nephew of one of the Ventures and having learned all of their records while studying the guitar, Stacy repaid the favor by turning the guy on to acid. Unfortunately they were busted trying to score some grass, and the cops hauled off the unsuspecting kid for further questioning, leaving Stacy and Johnny to walk free.

Stacy didn't like the San Francisco clubs, and preferred the after-hours musicians' scene, which began about one a.m. in Sausalito (after the San Francisco clubs closed). One of the main focuses was the Ark, an old paddle steamer converted into a club. Often Stacy, Ronnie and John Ike could be found hanging out in jam sessions, or just picking with many other leading musicians of the day (Lee Michaels, Stephen Stills & Buffalo Springfield, Skip Spence, Peter Lewis of Moby Grape and members of Steppenwolf).

Some of the members of Moby Grape also lived next door to the Fireside Hotel. The group was created largely around Skip Spence, the multi-talented musician who'd first achieved success as the drummer with the early Jefferson Airplane. Wanting to be a guitarist, Spence left the Airplane after the first album to form Moby Grape with Jerry Miller, Peter Lewis, Bob Mosley and Don Stevenson. Following their disastrous public debut on November 4, 1966, at the California Hall in San Francisco, when they performed to rows of empty seats, they were scheduled to play the Ark, which they also used as a rehearsal space.

Clementine: We went to hear the Grape at the Ark, and Stacy stood there worshipping these guys. Then one of the band members got on the mike and said, "We've heard that the 13th Floor Elevators are in the audience, and we're not going to play anymore because we don't want them to steal any of our material." Stacy was in tears.

A week or so later Moby Grape were booked as the Elevators' support act. The Elevators were beginning to promote their new single, which was sent to DJs from October 17 and was hitting the shops from October 28. Following a show at the Santa Venetia Armory on November 10, they were booked for the next two nights 11 and 12 at the Avalon, and their last known Californian show at Maple Hall on November 23.

Moby Grape continued to feel an exaggerated threat from the Elevators and did everything they could to upstage them. Not only did they put on an energetic performance, dancing and boogieing all over the stage, they also allegedly sabotaged the Elevators' sound.

Clementine: Another time at the Avalon, playing with the Grape, when I was backstage, one of their guys—said to the soundman to turn the voice up high and then low down, up and down. And then I realized they were doing it while the Elevators were on, to sabotage the show. Roky's voice would be so loud it would hurt your ears, and then you couldn't hear it. I made a beeline for Chet, and he raised hell with the guys.

The sad truth was that Moby Grape need not have resorted to such low tactics to upstage the Elevators, since they were in pretty poor form anyway. Pam and Liz were backstage trying to coax Stacy into putting on "a show," but he was having none of it. He knew they couldn't follow Moby Grape's crowd-pandering performance; it simply wasn't their style.

Liz Henry: We went to see Moby Grape play, they'd opened for the Elevators and their guitar player is just dancing all over the stage—and we're going, "Stacy, you're going to have to boogie!" and he's going, "I can't boogie, you hick!" and we said, "You've got to!"... so we're looking at Stacy's boogie and he's got his guitar—all paralyzed, nothing moving!

If the first night's show was a challenge in not being upstaged or sabotaged, then the following evening was even worse. This time it was Roky's fault.

Johnny Gathings: We were at some old house in Haight-Ashbury, John Ike, Stacy and me. And I was listening to Bob Dylan's album *Bringing it All Back Home*, and we'd all taken LSD, and John Ike and Stacy were arguing about music, and we went downtown to play and Roky turned up sick, so they asked me if I wanted to play and I said sure. Well, I had to. At the Avalon Ballroom it was the highlight of my little career. That was the night with Moby Grape. I remember the poster, it was the Saturday night.

If the story's true, then Roky wasn't sick; he and Tommy forgot to turn up and the band jammed their way through a semi-improvised set, while Johnny filled in Roky's guitar parts, and "band boy" Cecil Morris attempted some of Roky's vocals. Roky and Tommy turned up but were in the audience when they realized they should be onstage and scrambled up to finish the last fifteen minutes of the set. While the Elevators' reign on the West Coast was coming to a close, Moby Grape was emerging as one of the best-loved bands of the area. Their three lead guitarists, who all sang and contributed material, predated the slick singer-songwriter super-bands of the Seventies. Their first album was released in June '67, and five singles were simultaneously issued at once to much fanfare and no sales. However, Skip Spence's true genius was yet to shine, with the release of his obscure but sublime album *Oar* in 1968.

IA had assumed that the new single would follow the success of its predecessor without any form of promotion. They ordered ten thousand red day-glo stickers to adorn the new album jackets, announcing "This album presents the hit singles 'You're Gonna Miss Me,' plus 'Reverberation.'" Initially, the single sales looked good. November 19, *Billboard* featured it in their "National Breakout" singles review, claiming "Wild, far-out lyrics put to a hard driving beat, and the result is a sure-fire winner destined for a high spot on the Hot 100." The following week, the single entered the *Billboard* charts at #129, but promptly disappeared without trace the next. It even failed to catch on regionally.

With sole attention at IA being focused on the release of the mono album, the single was allowed to die, selling only 6,000 copies by the year's end, compared to 60,000 of its predecessor. Dillard, Rogers and IA associate Chuck Dunaway finished the stereo album remix at Sumet on November 21 and 22, 1966, and sent it to be mastered to vinyl at Rhodes on November 30 before the tapes were shipped for pressing at San Antonio's Texas 'n' Tanner while the mono copies were also pressed at Rainbo in California. Aside from Lelan, who knew how to work a hit tune, no one at the label had any experience at making records, let alone in knowing how they should sound. The IA bosses didn't care—it all sounded like an awful racket anyway.

Independent Music Sales in San Francisco were the first to place orders for *Psychedelic Sounds of the 13th Floor Elevators* on November 18. Mono promos were sent out on November 26 to all major U.S. cities and AM radio stations, and stock copies started to hit the record stores where "You're Gonna Miss Me" had charted the highest—California, Texas, Detroit and Florida. A stereo edition followed in January '67. The earliest known review was in Austin, in the *Rag*; the album was first listed in *Billboard* as a new release on January 7, 1967. This was typical of the period: Album sales lagged behind singles sales and weren't listed until weeks after their actual release.

International Artists, out of a mixture of fear, ignorance or stupidity, didn't promote or distribute the single or album at all. But this was just the start of IA's incompetence. They simply didn't know how to promote a band, let alone one as unique as the Elevators. Fearful of adverse press

leaking out over the bust and their association with drugs, IA simply decided to do nothing. With no band photos or interviews, this was merely the beginning of what became the mystique of the Elevators. Instead they blindly soldiered on, demanding more product in the hope that some of it would sell.

With the Elevators' brief departure, their groupies Pam and Liz had also decided to return to Austin for a visit.

Liz Henry: We had $12. So, well, I know we'll hitchhike, we were on acid, stuck our little thumbs out and hitchhiked to an airport and got a ride with the president of the school board of Los Angeles County in this little airplane.

Pam: This was one of those acid revelations, "What are we doing on this road? There's all those people with airplanes right over there." So, my theory was the people who own airplanes never get to show off. So we decided we'd go be girls and let them show off for us... and it worked.

Liz: "Excuse me, do you have an airplane? Yes? Are you going anywhere near Austin?... Can we come?"... And he let us fly his plane!

Benny had been busy in Austin, working at the cafeteria with his dad and, on rare occasions, he sat in on fiddle for impromptu appearances with others' bands, such as the Babycakes. His use of speed had continued uninterrupted, as did his sermons on the Lord. Bored, but inspired by the girls' stories, he decided to set off for San Francisco to see where everyone had gone. Benny and Yvonne, with the girls in the back of their Volkswagen, headed up Route 66, fueled by Ambars[33]...

Benny: Yvonne and I came in to town, and it was a cold, blue hell day... I played for Powell St. John and I watched poor old Janis Joplin (with Big Brother and the Holding Company) and them play at the Fillmore and they were having a rehearsal and they were real sloppy and everything.

Q: Did you track down the Elevators?

Benny: No I didn't mess with them after John cut me off; I went through the meth analogue, LSD and cannabis... we had Benzedrine, Benzedrine and Benzedrine daily, put it in the coffee. When you're considering "Before you accuse me, you better take a look at yourself," you'll find out that that is you. That's the main theory I want to get through to you. The reason the way I am to you is your fault.

Roky: Yes, [I saw Benny], he said he was a changed man. He wasn't doing speed, wasn't using the needle. And so people said, whether he was changed or not, they didn't want him around because of what he had done.

Benny still had no musical aspirations at this point, yet he still hadn't

given up on the core message of the Elevators. Benny had effectively become a psychedelic preacher, delivering his own wild interpretations of Bible texts fused with his own acid revelations. Though Yvonne witnessed his dementia growing, she was helpless to stop it. Benny preached to anything and anyone. Now he'd arrived in San Francisco to spread the word. Tary Owens unexpectedly witnessed Benny in action.

Tary Owens: This experience on Haight Street at the doughnut shop... it was probably two in the morning. I was tripping on acid; I'd gone down there to get some munchies. Benny comes into the place with his fiddle and a Bible. First he starts playing the fiddle and gets everybody's attention. Then he starts preaching. And it was really sad.

Benny still owns the Bible in question, a large, leather-bound book with a metal clasp on the side, safely hidden inside a first-aid box and stored in a secret hole. The multi-colored diagrams and drawings he has embellished it with show something of his efforts to decode its meaning. The outside has been lovingly decorated with coins, jewels and other clockwork gizmos that have made it a work entirely of his creation.

When the advance copies of the *Psychedelic Sound* album reached San Francisco in late November, the Elevators remained blissfully ignorant that IA had remixed their album, and that a badly mastered cheap and cheerful Rainbo test pressing had been given the all-clear for production. While "You're Gonna Miss Me" screeched from the grooves of a 45 rpm record, the album sounded muddy and stuck in the grooves. Nonetheless, they held a small launch party on a houseboat outside San Francisco. Benny was invited. The boat was a floating acid laboratory that belonged to two of Tommy's acid dealers, who became agitated when Benny laid on their freshly dosed sheets of blotter acid. The celebrations over, it was time to head back to Texas for Christmas. Everyone was homesick, but none more so than Stacy. The internal dynamic of the band had been spread too thinly in California with Roky and the Halls in Oakland and the hill country boys in Sausalito across the Bay. Stacy wasn't buying the hippie rap any more than he accepted Tommy's every word. If the band was to retain the integrity of its mission, it would have to return to Texas. Although they fully intended to return to the West Coast, they never did.

Clementine: They were so homesick. They were horrifically homesick, and Stacy was the most homesick of all, and he was so in love with his girlfriend he couldn't bear being separated... and also, Stacy didn't like the California scene. He's not a California boy—he just wasn't the surfer-type person. And he liked the solid rock Texas scene, the down-home. The down-home was very important to him, and there was nothing down-home about San Francisco with the hippie free love and psychedelics, dancing around and a lot of irresponsibility and all that sort of stuff. And it did not appeal to Stacy in the least, and he wanted home. His trips became longer and longer, and it became harder and harder to pull him out of Texas.

(1966) CHRISTMAS, ARTHUR LANE, AUSTIN, TEXAS. BACK ROW, L–R: MIKEL, DONNIE
& ROKY; AT TABLE, L–R: BEN & GRANDMA KYNARD, SUMNER

Undoubtedly, the Elevators' return to Texas in 1966 is the sole rea-
son for their relative obscurity now, given their status within the musical
community at the time. They were listed alongside all the main San Fran-
cisco bands in a national *Newsweek* article that labeled San Francisco the
"Liverpool of the West." For many reasons, they had arrived on the West
Coast too early, and failed to stay long enough to sign one of the fabled
major label deals. They had arrived at a time when many of the key San
Francisco bands were still in an embryonic stage, while the Elevators
were already proficient musicians, with a natural frontman who could
equally appeal to teenagers and serious music fans. While many of the
hippies were still worried about "selling out," the Elevators were already
prepared to embrace elements of the pop world as a necessity (such as the
Dick Clark shows) to convey their message. While a West Coast scenester
might disapprove of television appearances, their fans in Texas saw the
Elevators being beamed into the unsuspecting households of America as
a major coup against the establishment. It just took longer for the majority
of San Francisco musicians to be indulged by lucrative major label deals.
By 1967, the whole San Francisco counterculture went sour, and follow-
ing a summer of hosting the world's media, the residents of Haight Street
staged the "Death of Hippie" in Golden Gate Park. This was a symbolic
act of defiance to recognize and declare the original spirit deceased.

Things had changed since they'd been out in San Francisco. Roky and Tommy embraced the new psychedelic culture to the point where they didn't practice their instruments. While the others saw the possibility of becoming professional musicians, Roky had used his guitar for composing and a means of sonic attack on stage. His interplay with Stacy had diminished, as he preferred to hide behind a wall of feedback and distortion, partly for musical experiment but also to stabilize and culture his "altered" state. He'd transformed from a hyperactive kid into a lazy stoner. Once again, Stacy was the swingman caught in the middle. Not only was he the musical foundation of the band, but also a psychedelic freak himself. LSD isn't an addictive substance, and one that most people would be unable to endure on a regular, day-to-day basis. During his stay in San Francisco, Stacy started to feel he'd taken enough, and started to question the band's direction. He had a naturally addictive nature, and was also falling prey to the developing drug scene. What had begun as a naïve and romantic flirtation with building a new counterculture had become overwhelmed by the sheer influx of people from all over the United States—and, naturally, they began taking advantage and profiting from each other. Drugs were being bought and sold at a profit as one of the ways to sustain a hippie lifestyle, but soon the professionals moved in and old perennials such as heroin and cocaine were introduced. The Grateful Dead's extended family took real issue when cocaine became prevalent, which they firmly believed was being forced into the market by the CIA to destabilize the psychedelic society.

Tommy: See, there was evils here, Stacy was trying to stay away from people doing smack. So, it was the best thing, we were able to get back and tell everybody…

George Banks: When the Elevators first got back to Austin from California they were in some kind of recovery. I was never around them shooting heroin. But I know that was a problem out there.

The heat from the draft board was increasingly escalating for Roky, to the point where it was best dealt with in Texas. Tommy and Clementine were beginning to drift apart as well. She elected to stay on in California and move their home in Oakland back to Fell Street and the Avalon crowd. She would then join them in Texas for Christmas. Tommy got a $200 sub from IA on December 3 (the amount he usually spent on batches of LSD), and the band left for Christmas in Texas. There were many reasons why the Elevators left California, and there were even more why they never made it back. Although securing good bookings had become a problem since Tolin's departure, John Ike was fully aware that they'd pretty much played out their welcome. The hit single was gone, and the second had failed to catch on. There were bookings to be had in Texas, and there was the record company to challenge. The album was out and the band needed a national tour to promote it. Typically, as they left they performed with one of the strongest lineups they had played with—Buffalo Springfield and Moby Grape—and en route to Texas, they stopped in Santa Fe to play

their final gig with another credible band from the era, the Butterfield Blues Band. Maybe if they'd stayed and promoted the new album, things could have been different, and certainly Chet Helms warned them not to leave, as he knew that if they did they wouldn't make it back.

Upon his return, Roky set about seeking psychiatric help to thwart the draft board. On December 13, he successfully made a court application to restore his rights following the bust. Since his attempts at feigning physical disability had failed, this left him free to plead his case around mental instability.

Sandy Lockett: Things were exceedingly rocky for Roky. Oh, absolutely running scared all the time. Well, everybody tries to forget it [the draft], but it was terrific with him. During this period, the Christmas season in Houston, the draft guys got so hot on the trail; I had to take him to a private psychiatrist of my acquaintance. In fact, I'd gone to him years before in Houston. He was heavy duty on the board of everything and knew all the draft guys, and I had come to quite a good understanding with him, so I said, "Hey Ronald, this guy is completely nuts, and they're trying to get him in the army, and if you'll let me bring him over to your place, I think you'll have no problem in saying this in such terms that even the draft board can understand." And he said, "Well, bring him over." And you know I never paid his bill. After he'd done his magic, the draft distress eased off, but that still left the dope and the nuttiness distress.

Help also came from another mysterious character on the Austin scene, Dr. "Crazy Harry" Hermon, who would later come to Roky's rescue again. The thirty-six-year-old Austrian-born research psychologist was definitely an outsider and the polar opposite to the medical norm in Texas. His eccentric "jet set" air, his advocation of unconventional therapies[34] combined with his Federal license to prescribe LSD put him in direct contact with the Austin underground where he helped fight many draft causes on medical grounds.

While the *Austin Statesman* welcomed the band back as returning heroes, the local underground press—UT's *Rag*—were shredding[35] *Psychedelic Sounds of...* for its poor recording quality and Tommy's indecipherable liner notes. However, Bob Simmons' savagely hilarious and honest critique didn't inform the band of anything they didn't already know. International Artists had failed them by releasing a second-rate product that hardly represented their talent and still had them under contract. The band feared that if they crossed IA, an injunction might be slapped on them preventing them from promoting the album and touring the rest of America. They needed to return to Houston to negotiate a national tour and the future of the band. Despite reservations from everybody, Tommy was still convinced that IA were a good bet simply because he'd taken acid with Ginther. However, as Ginther admitted in 1973 (Kaum), "there was the MESSAGE, which at the time I truthfully didn't even know what they were talking about." As long as Tommy had enough funds to perpetuate the cycle that turned music into money into psychedelics and back into music, he was happy. However, he did want the band to achieve a high level of success.

While so much had been achieved during 1966, the problem now was how to battle to keep the band on the road. End-of-year accounts from IA were truly amazing, despite over 60,000 records sold and, after playing extensively, the band still owed the record company $1,337.02 at the end of the year.

IA, meanwhile, had no great plan for the band. They promised an East Coast tour and in the meantime simply demanded more material should be recorded.

The Elevators appeased their Texan audiences with shows in San Antonio, and then hauled themselves up at the Holiday Inn for a spate of shows in Houston, including two at the Living Eye and the Catacombs Club, before they headed their separate ways for Christmas.

While most of the band headed for the hill country, Roky returned to the family home in Arthur Lane whilst Tommy and Clementine went to her father's ranch outside Kerrville. Clementine tried to persuade her daughter to join her in San Francisco, but her father reinforced Laura's wishes to stay in the countryside with her horses. Clementine eventually returned to San Francisco empty-handed and without Tommy, and their relationship immediately began to grow more distant. Meanwhile, there had always been a strong magnetism between Roky and Dana Morris, given the fact that George Kinney and Roky often dated the same girls, it looked like the same pattern was going to perpetuate. Dana became pregnant in the spring of '66 and married George that summer, when Roky had disappeared to San Francisco. Back in Austin, Roky decided to pay his old friends a visit.

Dana Morris: George said, "Oh, Tommy and Roky want to move in with us," and I didn't want them to. George was in the Power Plant [later renamed the Golden Dawn], but we were all concentrating on Roky at that time. I was pregnant and I couldn't listen to Roky's music; it hurt me. I loved Roky and I knew it, but I was married and going to have a baby, so I didn't want to be touched or moved by Roky. So I couldn't hear him or be around it. So three days after Lenicia was born, George had gone to work, it was pouring with rain and she'd been crying all night—and I hear a knock and Roky's standing there smiling, and he saved me, and so I said "The baby's crying," so he said "Give me the baby," and he said that and Lenicia stopped crying. And we all sat there. I was spiritually, but not physically, able to get together with Roky.

The New Year started off well with a listing for the album in *Billboard*'s "New Action Albums" and a favorable review ("Psychedelic Sounds abound in this powerful rock LP. The album should quickly establish them on the LP chart") in the selective "spotlight pick" the following week. There was hardly any dedicated music press in the Sixties; *Rolling Stone* wasn't published until November 1967. *Billboard*, *Cashbox* and *Record World* were basically industry magazines and, beyond the full-page advertisements for records, were a dull read. IA didn't place a single advertisement for the album in any trade publication.

In April, San Francisco's *Mojo Navigator* fanzine gave the album

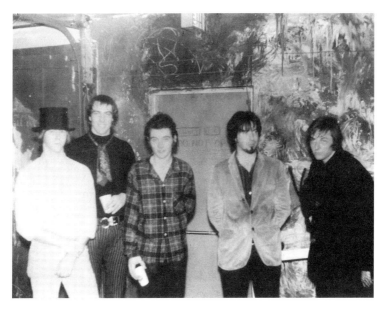

(EARLY 1967) CATACOMBS CLUB, HOUSTON, TEXAS, L–R: RONNIE, JOHN IKE, ROKY, STACY & TOMMY, PHOTO BY GEORGE L. CRAIG

a largely favorable review, but this merely preached to the converted. Interest in the group also came from Europe, but IA proved so greedy in demanding absurd advances that only two companies proceeded to license material. Riviera Records in France issued a four-track, extended-play 45 rpm and Hansa in Germany released the hit single coupling. In early '67, copies of the new *Psychedelic Sounds* album were being imported to Britain, and Andrew Lauder of Liberty Records attempted to license it. However, IA again quashed any deal by asking for an absurd $25,000 for an album by a band no one had ever heard of.

Back home, IA seemed lost as to how to press and distribute a record. With "You're Gonna Miss Me," they simply had to fulfill a demand, and who knows how many more sales were lost to bootleggers due to incompetence. The album was pressed and shipped in erratic quantities over a number of weeks, which must have impacted its chances of charting. *Psychedelic Sounds* wasn't the only album by an enigmatic band that would later be re-evaluated as a classic after having sold badly at the time—similarly, Arthur Lee and Love's *Forever Changes*, which seemed to define the Summer of Love for many in Britain and reached the Top 30, but scraped in at #154 in the U.S. charts.

While the quality of the material was never in doubt, the second single coupling was way too far out for its day. While Lelan's proposed coupling would have been a more promising commercial release, the band was inadvertently taking the first step toward becoming a cult band. Although the 45 would have fared better ten years later during punk, it simply sunk without a trace in late '66. The intention was still to attempt chart success

and "fame," but Tommy had misjudged the commercial market. While he felt he'd succeeded in reporting what was happening within the youth of America, he failed to see the bigger, commercial picture. Few of the San Francisco bands achieved commercial success with a 45.

Despite the disappointment over the sound quality, this hasn't marred *Psychedelic Sound's* status as one of the true gems of the era. In fact, lo-fi has since become a genre in its own right, and this has only helped elevate the album's status further. In fact, this album has become such a cult classic that its influence on contemporary music can be charted every few years since its release. While the Elevators had managed to ensure their place in history as one of the most uncompromising bands of all time by issuing a psychedelic punk rock masterpiece housed in the greatest psychedelic artwork to ever grace an album sleeve, they weren't to be forgotten—instead, they became musician's musicians. Having directly inspired Janis Joplin's voice, Roky's recorded vocals found influence in Britain with Robert Plant, lead singer with Led Zeppelin, which emerged from the ashes of the Yardbirds in 1968. ZZ Top owes a massive debt to the Elevators' sound, especially Stacy's guitar work. Beyond the Sixties and early Seventies the significance of this album would continue to be proven by its influence on most subgenres of both mainstream and alternative music, from pre-punk onwards.

Billy Gibbons (2006, *You're Gonna Miss Me* documentary): I first heard Roky and the Elevators in Houston. I said, well, that's it. It had a fierce backbone in R & B and blues, an enjoyably frightening intensity. And then Roky Erickson, one of the finest rock singers since Little Richard, Jerry Lee Lewis. His voice was so cutting and fierce and manic. In terms of out-and-out wildness, it doesn't get any better. There's no question about the impact that these rather unassuming guys, from Texas of all places, would have. They're to be credited with lots of things. Drinking Listerine for kicks, for one. There's still a suspicion to this day—the bands of the Bay Area were still drawing on this folk-based kinda thing, and when the Elevators showed up, things changed real quick. The Elevators were the big heroes, they were the guys. There was no way they couldn't make it.

But their story was about to take a far darker and more interesting turn that would lead to their lasting mystique and infamy, turning them into a truly cult band.

33. Ambars were another drugstore high, such as dexamyl, "the housewife's favorite," designed to stave off depression while vacuuming the house: "Mood elevation within 30–60 minutes and significant value in depressed and verbally inhibited patients."

34. Including hypnotism, nude therapy and LSD use in regression therapy. When a bill went before Congress in April 1967 to limit the use of LSD, Hermon testified against the proposal arguing it would restrict its use in therapeutic cases. Hermon was also registered to grow marijuana, however, by the end of the Sixties Captain Gann, the narcotics squad and the Department of Public Safety raided his offices and confiscated the plants, effectively running him out of town. He was next heard of in Buffalo where he had joined the mysterious underground "Neo-American Church." Founded by Arthur Kleps in 1965, at its height the church had a membership of over 10,000 and condoned the use of hallucinogens as a religious sacrament.

35. **Bob Simmons:** *Rag,* **December 12, 1966, Volume 1, Issue 10:** *Well, well, what have we here? Why from the looks of it I would think "A special Christmas Album from the 13th Floor Elevators." But no, it's just a cover designed by Austin artist John Cleveland. The colors (red and green) are quite timely though. If I didn't know better I would say what a clever marketing ploy. The first thing that I would like to make a snide remark about is, of course, the album notes. My thanks go out to the Elevators for taking the time and effort to explain their songs. The complex imagery and symbolism would be nigh impossible to figure out without these definitive aids. Then again maybe it's just the engineering of the record that makes them hard to understand. In any case it really overjoys me to find out that if I turn on I will be able to restructure my thought processes and I will be able to slip the bonds of Aristotelian thinking (as did Einstein). The wonders of dope! The quality of the recording is such that the vocals are almost unintelligible. It's my understanding that there is a reason for this. The producers were afraid that if the words could be understood that they would be banned from airplay. If they are so afraid of the Elevators' material why did they sign them in the first place? While I am asking questions, allow me to ask a few more. Who is John St. Powell? Do they mean Powell St. John or is this some new face in the songwriting crowd? Why does Lelan Rogers have to thank everyone he ever knew on the album? Wouldn't letters be less expensive than type setting? Why... oh never mind. Why don't they just shoot Lelan Rogers? Luckily for the Elevators the album does say "The Psychedelic Sound." This will certainly assure them of a large market of aspiring hippy types who wouldn't dare miss the latest in mystique fetish objects. Watch out psycheburbia! Here they come... EEEEEEEEYOW!*

Bob Simmons: *Re: My review of the Elevators' first record. I caught hell for my negative response. I wrote it in a fit of disappointment that the record did not really capture the sound and excitement of the band. It was a real quick and dirty effort by Lelan Rogers. I wanted them to sound like the Stones' records or the Yardbirds and it just sounded tinny and strictly lo-fi. Everyone wanted it to be a booster, but I couldn't in good conscience "boost" something that sounded so second-rate... in an audio sense. Truly they were an amazing band... Such a strange denouement for such talent.*

12.
ALL SURROUNDINGS
ARE EVOLVING

The Elevators had returned from California with an aura of success, but nobody knew how to capitalize upon it. With their status as "the local boys dun good," the Elevators couldn't simply return to the midweek slot at the Jade Room. Everyone had witnessed what could be achieved in San Francisco. Concerts were an important social event, a gathering of the tribes, and the problem now was—how could this be translated to Texas?

Everyone concerned—the record company, the band, their entourage—literally sat around a table. One obvious candidate to solve this dilemma was Houston White. He had already traveled to both New York and San Francisco and developed his "Jomo Disaster" lightshow accordingly with his partner Gary Scanlon. Many of the various clubs they'd operated at—the Fred, the Library and the IL club (Ira Littlefield) were now defunct, and he shared the same basic problem of what to do next. With the Elevators' enormous drawing power, Sandy in charge of sound and Houston the visuals, they had everything they needed for a successful show. Between phone calls from Sandy in Houston and Houston in Austin, the answer was found: Why not create their own production company and put the show on themselves? They named themselves the Electric Grandmother,[36] and hired the Doris Miller auditorium. This was a significant step for the Austin music scene, which would lead to the birth of the Vulcan Gas Company (Austin's first proper psychedelic dance hall).

In the interim while IA floundered about how to promote or tour the band, the Electric Grandmother shows served well to herald the Elevators' triumphant return. The size of the venues cemented their return as pioneers of psychedelia and the crowned kings of Texas music. The media ban they had experienced prior to their Californian tour had evaporated, and despite the disappearance of their former champion Jim Langdon and the "Nightbeat" column, the local press were now behind them with an unprecedented wave of pre-publicity.

The Doris Miller auditorium was named after a black American Pearl Harbor hero and was situated away from the main city nightlife. The building is a typical curved roof postwar municipal hall, equally suited for use as a dance or sports hall. With a small, low stage at one end complete with proscenium arch and velvet curtains, it's more reminiscent of a school hall. An undocumented band, the Human Factor, who weren't billed on the poster, opened the show followed by the Conqueroo and the Elevators, who were back with a set list entirely of their own creation—gone were the audience-appeasing cover tunes. A significant feature of this performance was the jam session at the end, performed with members of the Conqueroo. This apparently proved such a success that it was to become a feature of all the Electric Grandmother shows.

Roky (NFA): When we jammed with the Conqueroo... we could just jam with them and feel like we had complete freedom to really blow some people's minds with our talent.

The show was also promoted by one of the earliest known attempts at a Texan psychedelic poster and handbill. Prior to this, John Cleveland had hand-painted one-off posters for the Elevators at the Jade Room (none

TOP: DORIS MILLER AUDITORIUM, AUSTIN, TEXAS, PHOTO BY PAUL DRUMMOND;
BOTTOM: (1967) TICKET STUB FOR ELECTRIC GRANDMOTHER SHOW, AUSTIN, TEXAS

of which are known to exist). The artwork by local artist Mark Weakley was decidedly art nouveau in its influence, and was limited to black with one color to curb costs. The Doris Miller was an undeniable success, with press estimating a turnout of over 2,000, which led to the booking of the far bigger City Coliseum for the second show.

While the Elevators and their associates brought Texan audiences up to date with their newfound experience, they looked to IA to negotiate a national tour, beginning on the East Coast and working its way down to Florida. IA weren't opposed, but they simply had no experience. In fact this was a tall order for the time: There weren't any tour managers as such. Hendrix successfully returned to the States in the late Sixties by inheriting an infrastructure of roadies and promoters inherited from his manager and from Chas Chandler's touring days with the Animals; the stadium bands of the Seventies followed the same routes.

IA promised a tour but stalled by demanding new recordings, which was their answer to everything... justified by the fact that the cops would be out to bust the band again. With a hit single under their belt and their first album only just released and in need of promotion, the band knew these were merely delaying tactics; besides, they had yet to profit from recording. No one could understand why IA just wasn't doing ANYTHING. A new album was an ominous task, the band having had no time to develop new material. A session were scheduled from January 17 at Andrus Studio but only lasted two days, and the project was abandoned with only three new recordings in the can. As Mikel Erickson confirms, the lack of material was an issue—"I was in the studio... well, they'd get into the music, but they didn't have a lot of tracks there."

Roky had "collected" new material from Powell St. John in San Francisco, and there was enough unrecorded old material, as well as covers, to pad out an album's worth of material. But the band didn't want IA to have material in the can, so they only recorded a single's worth of material. They had worked up two new originals that were already proving popular with audiences, "(I've Got) Levitation" and "She Lives (in a Time of Her Own)," and also recorded the band's ironic cover of Bo Diddley's "Before You Accuse Me (Take a Good Look at Yourself)."

The first song was a brilliant example of Tommy's ability to turn ideas based on higher plains of reality and fashion them into pop lyrics. The song was also on a lighter note and not so heavily entrenched in his preoccupation with LSD.

John Ike (K): Tommy was definitely into astral projection, having the spirit leave the body at will. He kept telling us there were cases of entire groups of people doing this together, a group exit. I really think he kept pushing this because he was insecure, because he didn't want to try something like that alone.

The band was also angry about the hurried nature of their previous studio time and refused to be rushed. Also disagreements over the way in which the band should be recorded slowed the progress. Tommy wanted to capture the essence of the band performing collectively on acid, which

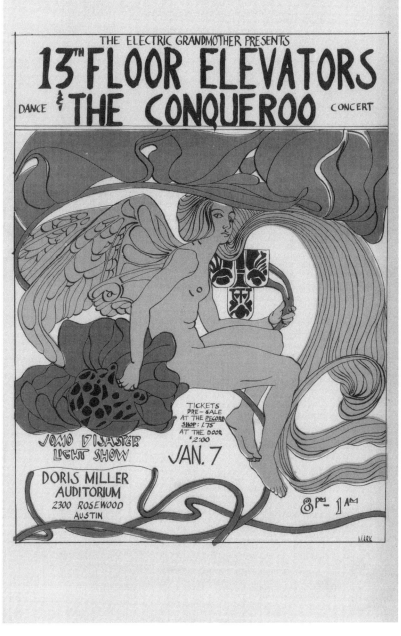

(1967) POSTER BY MARK WEAKLEY FOR ELECTRIC GRANDMOTHER, DORIS MILLER SHOW, JANUARY 7,
COURTESY PAUL DRUMMOND COLLECTION

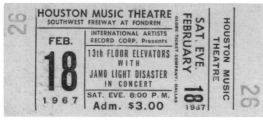

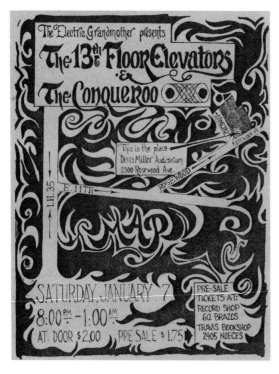

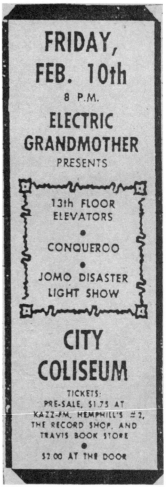

CLOCKWISE FROM TOP: THE CITY COLISEUM, AUSTIN, TEXAS, PHOTO BY PAUL DRUMMOND; (1967) JANUARY 2 *THE RAG* AD FOR DORIS MILLER AUDITORIUM; (1967) FEBRUARY 8 *AUSTIN AMERICAN* AD FOR SECOND ELECTRIC GRANDMOTHER SHOW AT CITY COLISEUM; (1967) TICKET FOR THIRD ELECTRIC GRANDMOTHER SHOW, HOUSTON MUSICAL THEATRE, COURTESY PAUL DRUMMOND COLLECTION.

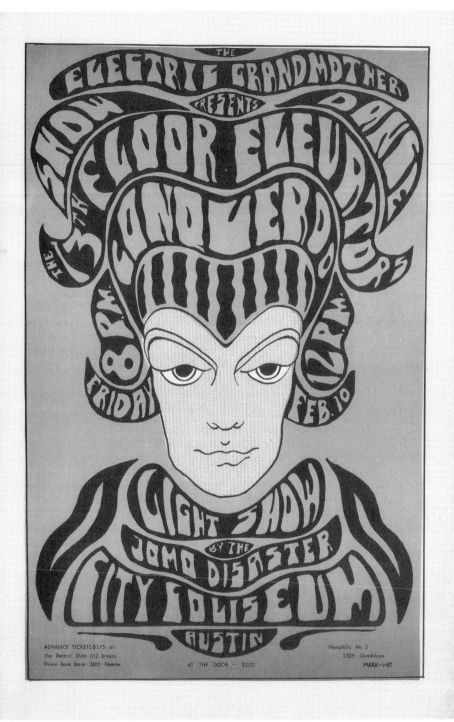

(1967) Poster by Mark Weakley for City Coliseum show, February 10

conflicted with Stacy's desire to record the individual parts separately so they could control the separation of the instruments when mixing.

The dilemma over the sound and recording was ultimately left in the hands of Walt Andrus, who had delivered a clear, powerful sound on "You're Gonna Miss Me" and "Tried to Hide" using only three tracks. There were virtually no sound effects available, but both he and Frank Davis were masters in acoustics and knew the limitations of the studio sound. Not only had the studio been purpose-built by Walt and his father, but he and Frank had constructed the recording equipment themselves, and only they knew how to use it, which gave them control, not IA.

> **Frank Davis:** At that time we were really into I guess you'd say acoustical effects, instead of electrical effects. God, the sound was just beautiful, all tube amps and there was just absolutely no way that anybody could use those tapes except for us, it was good quality and nobody else could screw it up!

With more studio time than ever before, and the additional task of working out relatively new material, it meant the band could labor over each performance. And as a result, Roky's vocal became an issue. Tommy began to debate how each phrase should be delivered or conveyed. As a result, Roky became tongue-tied and a further day of vocal dubbing was spent on the 20th.

> **John Ike (K):** [Tommy] was making minor modifications on the pre-text that Roky was missing some people on this level or that level. Whatever he was coming up with on his own, he was getting directly out of the books he was reading and turning into a poetic rhythm. But when he tried to tell Roky how to sing something, it was pitiful. There were only about three notes Tommy could sing and he ended up raking Roky over the coals...

The mix of the song used for the 45 release double-tracked the lead vocal (a common practice on the Beatles recordings), so it sounded like it had a short delay/echo. Again, as with "You're Gonna Miss Me," Andrus listed the recordings as "LP demos" even though it was destined to become their next single. Despite being mastered at Columbia in New York it was badly pressed to vinyl by both Rainbo in California and Tanner 'N' Texas in San Antonio. However, Andrus' surviving safety masters are a testament to how much the band had developed and embraced the recording process. The clarity of the recordings and instrument separation give a true glimpse of how impressive the band sounded at this point. Sadly, this session was the last known studio recordings with the Leatherman/Walton rhythm section. The two band originals were amongst the very best in the band's recording history.

IA immediately issued "(I've Got) Levitation" backed with "Before You Accuse Me" as a new 45 on February 7, 1967, holding back the other new composition for later release. Paperwork shows that a massive number of promo copies were sent out but Billboard passed over its re-

lease altogether and regardless that Bob Austin, the publisher of *Record World*, was a close ally of Lelan's, the Elevators only received a cursory mention in the magazine's singles review column, acknowledging it as "thick folk rock with psychedelic dressing up. The kids will like the aura" and received a four-star rating. Meanwhile Dale Hawkins and the local Dallas label, Abnak, managed a full-page advertisement for the Five Americans and their "Western Union" 45. However, in early February IA did try a truly surreal and limited campaign. They paid for seventeen radio spots on KNUZ-FM and sent eight telegrams to various distributors with the catchy slogan "*Levitation is a virus. Help spread it with airplay.*" "(I've Got) Levitation" died the death of its predecessor. It peaked on Austin's KNOW radio at #20 in March, and reportedly received a fair amount of radio play in Houston but failed to grace any other known radio surveys outside Texas.

Back in Kerrville, having deflated from their seemingly triumphant return to Texas, the band was in a state of flux. Details of the fabled East-Coast tour had yet to materialize and the recording sessions had proved a confusing episode. Houston was now their center of operations, but the band rallied in Kerrville.

Austin was no longer regarded as a safe haven, and they needed space to rehearse away from people. Kerrville started to become an important hideaway. Heat from the authorities never ceased, and the band largely relied on a network of friends and followers to ensure they didn't run unnecessary risks. Even if they weren't in possession of marijuana, it didn't mean the cops wouldn't plant it on them. While the Elevators were in Texas they were in danger, even in Kerrville. While Ronnie was cautious, John Ike, who had now stopped smoking weed, joked the band should rename themselves "the Easy Marks." Tommy still felt he was justified in his actions, and acted like he had a protective shield, but he was simply lucky not to have gotten busted again. As Ronnie observed in 1973, the band "felt the heat just about anywhere, except Tommy, who believed the cops would never bother him—he seemed to think he was doing everything right, and if he did get busted he'd get out of it."

Stacy's family had two ranches in the area and one just outside town provided perfect cover. To get to the ranch house, you had to drive uphill, passing through a series of cattle gates. From the hunter's cabin, where the band rehearsed, any law enforcement could be easily seen miles away, and the band remained relatively safe. Alternatively, they used Robert Eggar's ranch on the other side of the Guadalupe River. This gave equally good cover, with a long drive and barren field out front, which meant any approaching traffic was visible.

Beau Sutherland: Stacy told me one time that Kerrville got to be a kind of a refuge for them. When they were out on the road performing, there were all the drugs and craziness. Particularly before John Ike and Ronnie left the band, Kerrville was always the thing to do. This is a nice, peaceful place. You don't hear sirens and a lot of noise. They felt like they were away from all the law enforcement harassment. Neither one of them wanted to come out here a whole lot unless

they had a good reason. They would come back, and I really think they did some of their best writing here in Kerrville. They would sit out here at this old ranch house and just spend weeks out there. So, I think they thought of it as a sanctuary, they would work on their music and write and then you'd see them take off again.

As much as Kerrville provided relief, the Elevators were still under heavy scrutiny. Kerrville City Council had secured a copy of their album for analysis and took issue with Tommy's chemical mandate on the back sleeve. With the band back in Kerrville, Emma Walton decided it was time to address some of the band's issues. While she was aware of local resentment caused by their album, she didn't condemn the band. She felt that IA was exploiting the band's drug situation in order to sell records, and therefore they were paying the band a disservice by failing to promote them. She now resented her significant investment in the band because they had returned from a supposedly successful tour as paupers.

Emma Walton (K): Basically I'm a businesswoman. I feel I know what can make money, and I know the Elevators could have made a lot. I believe that the Elevators could have been as great as the Rolling Stones. When the band formed, it was really a time for excitement for the parents of the boys because we felt they were going to be incredibly successful. Unfortunately, when it came down to money I got caught... I became afraid to abandon my son to the group not because pot scared me but because acid did. He just doesn't have the temperament to take LSD, but Tommy does. I went to see them myself and if their music appealed to young people that was fine, because I think that young people should know what's going on. I do believe, though, that they should be educated to the effects of drugs, it's everybody's free choice. I would say marijuana smoking is no more [harmful], really, than our cocktail drinking. I have never been totally against the drug culture, partly because I'm against this nation being as alcoholic as it is. Tommy could not correlate the fact that you have to live in this world; you cannot just go off into the land of fantasy. Tommy didn't realize, you see, that you have to rent a ballroom to play, and the guy who owns the ballroom probably isn't into drugs too. He wanted the whole world to think as he thought. Of course, IA recognized that there was this tremendous surge for the group and that they'd sell records because of their drug image, so rather than going to John Ike and trying to help him control Tommy, they let Tommy go all out—like printing that piece on the back of the first album. So many people resented that, and became bitter, ardent enemies. You know it's dangerous to get the establishment down on you, especially through ignorance. The best thing to do with the establishment if you're against it is to acknowledge it exists.

Exacerbated by their lack of fortune, she decided to launch a last-ditch attempt to rescue her investment and the band's future. Firmly believing in the band's ability, and dumbfounded by their situation, she headed to Austin to engage their former lawyer, Jack McClellan, to sort out the mess. Jack agreed to the task, and over the next two months came

up with a solution to the band's future, proposing to set up a management company for them.

Jack McClellan (K): In walks John Ike's momma with one of those big accordion folders full of papers, and just turned it upside down on my desk saying, "Here, this is the 13th Floor Elevators. If you can organize them and put them on a money-making basis, you're hired." She said she'd been pouring money down this rat hole for a long time.

Although Tommy was spending an increasing amount of time in Houston, he and Roky virtually lived with the Kinneys and Kearneys in Austin. Dana had refused to allow the Kearneys to move in prior to having the baby, but she now relented, tired of domestic life. Having missed Roky, she was pleased to have him back in Texas, and so Roky and Tommy moved in.

Dana Morris: We were all living in this house and Roky and I were sitting on the couch together. They all moved in with Tommy, and so Roky and I would take acid and I would tell him I loved him. I don't know what George thought, but we'd stay in the room all night talking on acid, and everyone gave us that space. One night, George had gone to bed—he worked for the state, I don't know where Tommy was, but John and Susie and Roky and I were all sitting in this bedroom. All of a sudden John and Susie were giggling and laughing... somehow we didn't hear them, somehow we were having a conversation, but we weren't talking, our lips weren't moving, and Roky looked at me and I looked at him, and "Let's Spend the Night Together" was bursting in the room, and I went up to him and said, "Would you take me on that rollercoaster ride?" And he said, "Yep" and off we went, up this hill, but what we were doing was finding a place to be alone and be together. He took me to this house that was deep in the woods and nobody lived there and we were together, in this beautiful house... After that morning came up upon us, I was crying and saying, "Okay, we need to be together." Roky and I figured out later why things had gotten off track.

However, Dana was now married and had a new baby, and Roky was also in a steady relationship with a girl, Judith. Tommy was starting to spend more and more time in Houston, leaving Roky to his own adventures in Austin.

John Kearney: I remember the boys coming back for a brief bit, but it didn't turn into a brief bit therefore the classic mistake of the hero returns and nothing happens, but it didn't look like that at the time. Roky was with a woman called Judith, a ball of fire. Roky stayed with Susan and me, we lived with George Kinney and his wife Dana and things got... very... the stay with George and Dana was decidedly unhealthy. As it turned out, Roky and Dana were trysting as George worked hard to pay the rent. I remember little of it, an aura of degeneracy.

(1967) The Houston Music Hall Theatre, Southwest Freeway at Fondren Road

Their next show, at the City Coliseum in Austin on February 10, was by far the most ambitious show the band had played in Texas to date. In order to fill the venue they now had to rank alongside James Brown and Ike and Tina Turner in terms of tickets sales, but with an estimated 2,000 turnout for the previous show this was more than possible. This time posters and handbills, designed again by Mark Weakley, were printed in much larger numbers and sold at the venue—psychedelia was selling.

As before, the Conqueroo gave support and supposedly Pete Seeger— the same Pete Seeger accused of pulling the plug on Dylan's first electric attempt at Newport Folk Festival in 1965—made an unbilled early evening performance. Again the show proved to be a huge financial success, and confirmed the band's popularity as they packed the house. After the show they were mobbed by female fans, which completely freaked out Tommy, since he had been out in the woods during the day and had ended up covered in poison ivy all over his face and hands. The only detraction from the show's overall success was the size of the building, which stretched the ability of the sound crew. But Austin had its second taste of a psychedelic happening on a large scale, as it had never seen before.

Despite the success of their large-scale shows the band also returned to the lucrative clubs on the coast and played the Safari Club in Baytown with the Countdown Five on February 15. As their rhythm guitarist, Steve Long, asserts: "The Elevators were really, really way ahead of everybody else..."

The third Electric Grandmother show was booked for February 18 in Houston. This was even more ambitious than the previous events, and unfortunately IA had decided to get involved with the running of the show. (Houston White: "It was done in conjunction with International Artists and that's where we figured out what kind of assholes they were.") IA decided in lieu of a new album that they would record the show for a live record. The show was booked at the recently built Houston Musical Hall Theatre, also known as the "theatre in the round," because the seats were laid out 360 degrees around a revolving stage. This was a bad choice of

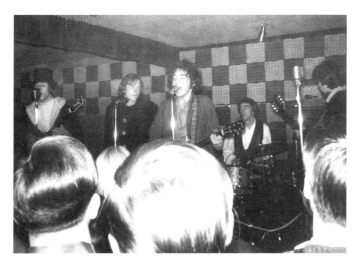

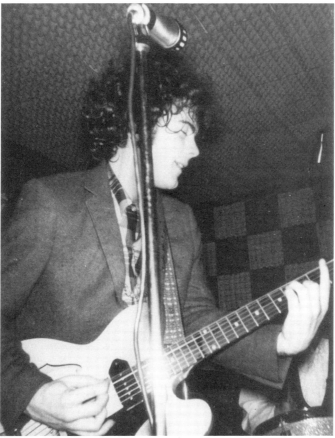

(CIRCA MARCH 1967) SUPPORTING ROY HEAD THE TRIO, HOLIDAY INN CLUB, LAKE McQUEENEY, TEXAS.
TOP, L–R: RONNIE, TOMMY, ROKY, JOHN IKE & STACY; BOTTOM: ROKY, PHOTOS COURTESY BOB SNIDER

location for a freak show because Sharpstown area had been developed in the Fifties to become America's largest subdivision, comprised of Houston's first air-conditioned malls and new homes, and the cops were out in force for a night of easy pickings. Paranoia spread from the band to IA but it was too late to reschedule; IA had plugged the show on KILT-FM's "Weird Beard" hour, and sent ticket mandates out to practically every record store in Texas. Things got stranger still as IA took preventive measures. They'd invested in a '64 Pontiac Rambler and a trailer for the equipment, which Lelan recalls personally vacuuming prior to shows in case any marijuana debris was lurking in the upholstery. Stories abound of the screws in the back of the amplifiers being loosened so the cops could open them easily to check inside. IA also hired off-duty police officers to deter the band from taking drugs and ward off any virulent or predatory cops. Everything was riding on this one show, the band's biggest in Texas. And the level of paranoia, anticipation and stress affected everything—the band were held in the Holiday Inn in Austin and driven to Houston at the last minute, protected by their private security.

Walt Andrus: Lelan was mainly a promoter and he seemed to have some sense that if somebody was causing some excitement, he could get a ride on it... I always felt they (IA) exploited the band's drug situation... I wasn't that close to it, but I had a very negative feeling about it. They used to carry the band around in a van that was locked from the outside, that kind of stuff. I tried to do one live album at the dome building, so we set up some microphones to get some of that effect, which was interesting. Frank made some microphones that rotated on hydraulic booms but Roky, he couldn't finish a tune, he'd come on and forget what he was doing...

Frank Davis: It was the epitome of the problems that they had... a madhouse, FBI guys—it was out in a domed place, mad! I didn't know how they could do it. There were some really strange things going on, International Artists spent a lot of time keeping the cops away... and they had bought these cops, ex-FBI, whatever, they'd follow them around to protect them from the locals. And Houston at that time was unbelievable; it was like a Nazi encampment here... it was awful.

Lelan: Knowing how bad the police wanted to bust them, I arranged with the police department... Policemen used to get $2 an hour when they worked off-duty, and they were happy to get it, so I hired four or five rooms in the Holiday Inn and arranged to hire three or four people out of the vice squad to protect this superstar rock group that I was bringing to town. So I got the detectives rooms on the same floor and then brought the Elevators down from Austin to play. And so they were escorted and protected by the police for two days and nights. I had protection for a group they were trying to bust and they never knew it until afterwards.

Charlie Prichard (Conqueroo): It was hard to take the stage, there was no backstage; you used to have to go through the audience. I

don't know how it was perceived, but it sure was weird being on that stage while it turns around, even though it does it really slowly, one spin every half hour. When you play it's not unusual to focus on someone in the audience and not necessarily to play at them, it's nice to have something to relate to that's not disappearing to your right. We were pretty strange for those environs at that time.

John Ike: Just before we went on, Stacy comes up to me and says, "John, I'm scared, I feel like a two-year-old child." I went and turned this over to Jack McClellan, my lawyer. I said, "Jack, Stacy feels like a two-year-old child. He's dropped a bunch of acid and he's gotta go on in thirty minutes." So Jack takes him outside and sticks a joint in his mouth. He gets him even higher than he was! [Laughs.] Needless to say, it didn't work.

Jack McClellan (K): This friend of mine was saying, "What's wrong with Stacy? You gotta take the sharp end of the acid off with some grass." Stacy was lying on the goddamn floor, groaning. This guy [an off-duty cop] was about seven feet tall and three hundred pounds, straight-looking, and he freaked Stacy out. He just looked like a big cop, standing there in that hotel room. Finally this dude gave him a couple of joints and cooled him right out, but we practically had to carry him on stage. The kids loved it. No wonder the narcs considered it their sacred duty to eradicate these cats...

Stacy, particularly, suffered from stage fright and, given the scale of the show, the paranoia, the hired cops, the pressure of the recording and a large hit of pure Sandoz acid, it's no wonder he was "out on a rib." Interviewed in 1974, he gave a detailed and vivid account of his terrifying experience...

Stacy (K): It's not that I felt that I had to keep taking the drug... it was like I didn't believe the drug was bad. I believed that it was good, if you can understand that? All the time I believed it was here through God, you understand what I mean? I believed that it was really a means by which we could tap the source, everything... and, like, I didn't think of it as being bad, I thought of myself as being bad... but the drug was showing me that I was bad. One time I was in a motel room; we were getting ready to play a show at the Musical Hall in Houston, and it was the biggest show we'd ever done in Texas, and we took some Sandoz acid. And all of a sudden, I lost control of my body and I got down on the floor and I'd never experienced anything like this before, and I looked up and Tommy and Roky were turning into wolves, hair and teeth, I mean wolves... man! And in my mind I was hearing the echo of space, and rays of light were shooting through the roof. And I kept remembering the scripture in the Bible, "Beware the false prophets," and all of a sudden here was a vision in light that we were wolves and we were spreading drugs and Satanism into the world, and I had never realized it, because of an Antichrist influence. And all of a sudden I was bad, and these angels walked in the room and they had light shining on them, bright, and they all gathered 'round me and they were the jury at my trial.

And this one angel stepped up, and he was offering me a job, and it was really just our lawyer [Jack McClellan], and Roky and Tommy and one of Roky's friends named Jack Scarborough. And I knew who they were as people, and I knew they were in a model level... you know, conception, and I was talking to God, and they were spirits in a position of influence on me and a decision that had to be made in my life. And I couldn't make it, know what I mean? And we went to the show and all of a sudden Roky put his hand on my shoulder and said, "Man, you've been here before." I knew what he meant, but I thought he meant, "YOU HAVE been here BEFORE." [Laughs.] He said, "Man, I'm sorry you're just here because of me," meaning "I put you in a bad place"... possibly. I thought he meant my whole existence and purpose was to be a guitar player for his voice, I felt like I was going to turn around and a bolt of lightning come through the car and explode... and the spaceship would come. And we got to the Musical Hall, and I went inside and the devil was there, and he had this tall pointed hat on, and he was the emcee for the show, and he was "Weird Beard," the number one disc jockey in Houston, and he looked at me and he had a goatee and a sorcerer's costume on... and I was bad and he knew it. And nobody else in the room could see, and this narcotics agent that we hired to travel with us had to guard us, because they were always trying to put pot on us, was standing beside me and I didn't want him to know I was freaking out. And the devil walked up to me and started asking me how his pointed hat looked, and every time he twisted his pointed hat his nostrils would flare... I ran outside and looked up at the sky and there were clouds of blood floating in the sky... and I called John Ike and Ronnie up and said I've got to go to a hospital, 'cos I lost it. And they kept saying, "No, man you don't want to do that, because if you go to a hospital the psychiatrist is going to see you flipped out on acid and they're gonna start hassling. You might as well work it out yourself." So, I said, "Okay, I'm just going to try and go with it" and we went inside and the show was starting man, and it was the biggest show we'd ever done! [Laughs.] And as soon as I took off down the ramp man, I looked down there and I saw the lightshow and the revolving stage and it represented Hades, and Satan with his cape was leading us down into the arena. And all these kids were around and I thought, we're going down there to tell people to get stoned and if the world ends right now I've had it. And I said, "Man, I have to get to a preacher..." I was gone, I really thought it was the end, you know. I couldn't talk to either [Tommy] or Roky that night, see, because they were the wolves... I was a wolf too. I got on this rib and I ran for the door and one of these wolves jumped in front of the door. And I thought they were going to stake me on the floor, because I was a wolf too, see? I said, "Man, we're mad." But anyway, that angel, he told me I was going to the penitentiary, and that I was going to lose this chick [Laurie Jones] I had been going with for eight years... And we were planning on getting married. And when I came down about two or three days later I just blew it off, just said, "Man, too weird!" and I never thought about it... and a few months after that I lost that chick, and a year and some and I was in the penitentiary. That really happened, I swear.

There was one element of the vision that Stacy didn't recount in 1974, but did relate in 1977. The angels at this trial warned him of three prophetic happenings in his life. Firstly, the end of his eight-year relationship with Laurie Jones; secondly, his incarceration in a penitentiary (just as his grandmother had promised him); and a third, which was too terrible for him to relate, but was presumably his premature death.

The jam session with the Conqueroo, which was regarded as a high point of the previous shows, didn't work as well with the musicians standing back-to-back on the circular stage, as no one could really hear what was going on. While it's not the free-flowing psychedelic jam one would have hoped for, it's an enjoyable period piece with many highlights. Although it's largely derivative, it kicks off with a rave-up of jug, keyboards, drums, guitars and harmonica that closely resembles "Blue Suede Shoes" and "Roll Over Beethoven." Following the dry Elevators' set, the audience sound enthusiastic about some good ol' rock 'n' roll. The rest of the session includes jazzy moments featuring saxes, keyboards and even some woodwind and jug belted out over a wall of guitar and thumping drums. There's a meandering run-through of Dylan's "It's All Over Now Baby Blue" followed by a brilliant "She Lives" featuring some excellent keyboards. At least everyone sounds like they're enjoying themselves and unwinding from a tense evening. After cries from the audience of "Come on, Roky!" the super-band blasts through another driving jam, which often flounders and then breaks down. Roky shouts "So long!" and the tape cuts.

Following the show the band went to Andrus Studio to hear their live recording. Beyond the disappointment at the tape being changed over at the beginning of the band's rendition of Dylan's "It's All Over Now Baby Blue," no one had much to say. The Houston Musical Hall was disastrous in terms of their career, but the recording is still surprisingly listenable—if this was the band without their lead guitarist. It provides a unique insight into their set post-San Francisco—entirely made up of original material (aside from the Dylan number). The show opens with the Weird Beard/The Devil screaming "Their new single, Levitation! Levitation!" The song sounds distinctly empty without Stacy's guitar, and Roky does his best to propel the song along before abandoning the vocals mid-verse, and the song comes to a messy ending followed by a smattering of applause. "Roller Coaster" is another fast and frantic version with howling guitars that create a distinctly dark and scary atmosphere marred by some of John Ike's drum fills, which miss their mark. The band bluffs their way through "Fire Engine," as Roky skips lyrics throughout. The rest of the set is reasonable, with Roky missing lyrics and even entire verses. John Ike's drumming is strangely off-kilter all evening, sounding like he's beating the living hell out of his drum kit in order to leave the building.

Roky manages a superb warbled scream at the start of an otherwise weak "You're Gonna Miss Me," and the rhythm section manages to rally to deliver a menacing "Kingdom of Heaven" before they end with a decent version of their new song "She Lives." The recording was buried until 1988, when part of the first reel was issued with the wrong date and

location by a small British label. Although an authentic Elevators live album was aborted, IA didn't give up on the idea and later released the abominable *Live* LP in 1968, which consisted of earlier studio recordings overdubbed with fake applause.

If the appearance on *American Bandstand* had marked the band's last stand as pop stars, the Music Hall show abruptly ended the rise of the Elevators as a band. From now on they would truly become a cult band, remaining a dark secret trapped within Texas, preaching to the converted. The stress of the show had proved an unpleasant ordeal for all concerned, and the Electric Grandmother decided to split with the band. For Sandy Lockett, the last straw came when Mrs. Walton/Jack McClellan questioned his decision to re-equip the band with new Standel amps, and he decided his skills could be put to better use elsewhere. As Jack McClellan admitted in 1973, "I sort of ousted Sandy Lockett from power, without really knowing it at the time." Sandy used it as an opportunity to jump ship and join the production company, who renamed themselves the Vulcan Gas Company and continued their working relationship with the Conqueroo.

While the band and their contemporaries had done everything possible to capitalize upon their status as returning heroes, IA appeared to be antagonistically attacking their progress. While it is understandable that a company run by lawyers was fearful of promoting a bunch of drug-fueled freaks to the wider market, they were also failing to serve their own self-interest. It was almost as if the Californian tour had been a useful means to keep the band out of the way while they spun the single to the music industry rather than to the music-buying public. The failure of the Musical Hall show further fueled IA's paranoia and lack of trust in the band. They were simply too frightened to allow the band to be seen or heard in interviews or photos, and yet used the drug situation to exploit and control them at the same time. Lelan Rogers, the man solely responsible for spinning the first single, repeatedly failed despite strong material. It was still presumed he could hype the album to success via his influence on a network of DJs and promoters. However, a promotional trip to the East Coast to market the album and follow up interest in bookings for an East Coast tour with shows from Florida to Maryland resulted in nothing but confusion.

Lelan: Yeah, well, one of the greatest, strangest things that ever happened was that right after they released the first album I took it to New York to Record World and I met Michael Jefferies, who managed Jimi Hendrix. He'd just found Jimi and wanted to take him and the Elevators back to England with him, and he said he would make them as big as the Stones. And I called, and the guys didn't want to go.

John Ike: I remember Lelan saying Jimi Hendrix's manager wanted to take us to Europe, but that was bullshit. We didn't have the chance; you bet we'd go… we were starving here.

Mrs. Walton was now challenging IA's inertia, and Jack McClellan had confronted the company over its obligations to the band, and

expressed serious concerns over the validity of the promised East Coast bookings.

Jack McClellan (K): IA wanted to send them all to New York. Lelan Rogers told me he'd just spoken to Murray the K that they were all set up to do an Ed Sullivan show. My theory was that they were going to get to New York City and be on the skids there, just like they always were, and would have lost track of each other, like San Francisco.

While IA were frightened of publicity, they were in favor of touring. While in New York, Lelan followed up offers from DJ (and self-proclaimed Fifth Beatle) Murray the K to fund an Elevators tour. Contact with Murray the K had originated with George Banks. Peter Yarrow of "Peter, Paul and Mary" fame hung out with George after a show in Houston, and returned to New York with copies of the album and convinced Murray the K to fund an East Coast tour.

George Banks: Peter Yarrow used to call me literally every week and say, "When are these guys going to get up here?" It was my connection and I don't know where it went from there. I dealt with Tommy because he positioned himself as head of the group, even though it was Mrs. Walton's money... if there's something different about the story I'm telling you then it's because John Ike's mother didn't trust them because of the trouble they got into in San Francisco, and I believe that.

With the band's legal and financial situation under investigation by Jack McClellan, it meant any proposal by IA was now in question. Jack McClellan started to make phone enquiries, to check the validity of bookings.

Jack McClellan (K): I got shined on... I approached this forthrightly as a lawyer, and assumed that anyone I called for information about anybody would tell me, just like they did in my business. At that time I didn't know the music business. Back in New York they didn't know the band, and if they did it was "eh." I told them, don't let these record guys give you any shit, "Yes, they're available, but under the right conditions." Hell, I certainly wasn't holding them back. I just wanted some integrity on how they were handled.

With no vision for the band, IA simply booked them locally into an overlong residency at the Living Eye in Houston. This only added insult to injury and helped expedite the disintegration of the band's morale. IA didn't usually make bookings, they only finalized concert contracts, and their decision was clearly a means to keep the band within their control.

Sandy Lockett: A lot of it was the International Artists people trying to keep a leash on them. It was a dreadful period and they were stuck in Houston. IA, for one thing, would not give them money but would pay for their food provided they got it from a particular restaurant.

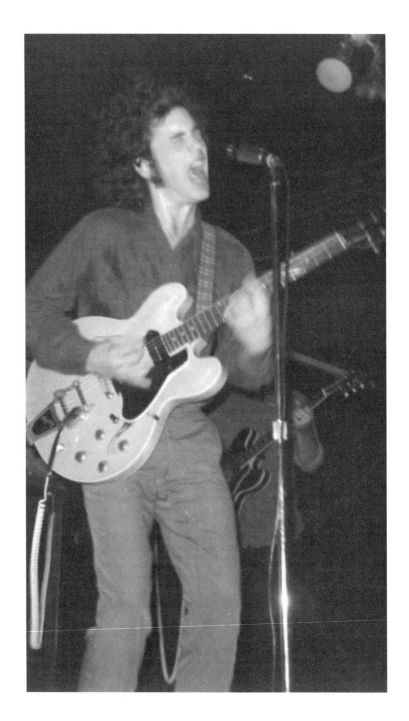

(circa May 1967) Roky & Stacy at the Living Eye, Houston, Texas, photo by Jerry Lightfoot

Ronnie: That's when they had us there in Houston and we were going nowhere, you know, playing—we played the same club probably fifteen weeks in a row, the Living Eye... It just went on and on and on. And that's when John Ike and I decided this isn't gonna go anywhere. 'Cos we were playing there for $750 and we could have been paying in Florida for $2400 a night.

As everyone argued over the band's direction, the momentum was lost. Instead of touring out of State they played a string of obscure club dates in eastern and southern Texas. They played a one-off appearance at the Teen Canteen at St. Luke's Methodist Church in Houston, and then returned to the Gulf Coast to play a Catholic girls school in Galveston with the Syns. During the summer of 1966, several beachfront clubs had opened—such as the Grass Menagerie, the Bamboo Hut and the Midnight Hour—and were drawing audiences of up to 1,800 a night. Jerry Clark, who ran La Maison in Houston, had also opened two clubs, the Surfside-a-Go-Go and the Bawana-a-Go-Go. Although the scene was beginning to wane by '67, the Elevators joined the circuit also playing at the Bayshore and Gun Club in Baytown. At one of the Baytown shows, they shared the bill with fellow ex-chart act Sam the Sham and the Pharaohs. Having finished playing, the cops decided to conduct a thorough search of their equipment and dismantled everything before allowing them to leave. Lelan Rogers also recounted a similar story of a pre-gig Baytown search.

Lelan (SP): People in Texas were not ready for drugs at all. At all! Once I took them to Baytown to do a show. We used to go and do the dances. The kids enjoyed the music—just music. Charge $2 to get in at the door, rent a hall, make a little money—but down there we got nailed in the parking lot by Texas Rangers, the sheriff, the police chief... all but the FBI. They took all our equipment out of the back of the van. They had screwdrivers and pliers. They took every amplifier apart, tubes out and had them scattered all over the parking lot. We got there at seven o'clock and at ten the kids were all on the inside waiting for the Elevators. They knew we were getting busted... I kept them clean. The law used to vacuum the cars. They carried hand vacuum cleaners and they'd vacuum our cars looking for seeds. So, you can bet your ass I vacuumed before we left. I had them turn their pockets inside out, and if you've got a trace get rid of it or we'll all go to jail. So the kids at the place that night went and got other equipment and set it up for us. We just picked up the pieces and threw them in the van and went in and played.

Instead of playing significant events such as Kesey's last ever acid test, held on March 16 at Rice University in Houston, the Elevators stalled completely. They played the launch of a new psychedelic club in San Antonio called the Mind's Eye on March 10 and 11, supported by the Argyles, who had recently split and reformed as the new house band, "The Mind's Eye"; the band also supported the Elevators at the Holiday Inn Club (not the hotel) in the tiny town of Lake McQueeney, north of San Antonio. This was a truly obscure venue, situated on the highway

between the Germanic town of New Braunfels and Seguin. The Elevators were playing support for the Roy Head Trio. Head had enjoyed a large degree of national success in 1965 with a single, "Treat Her Right," with his former band the Traits. Ironically, as Ronnie recalls, Stacy had always stated, "Man, we need to get out of here like Roy Head." Now the two former Texan chart acts were sharing the same bill in a tiny town. Photos from this gig show that the Elevators hadn't tempered their theatrical flare, Ronnie having dropped the trademark sunglasses in favor of a cape and John Ike's father's wedding top hat.

Despite their lack of a profile, the Elevators were still being recognized locally as originators of psychedelic music. In February they were voted fifth in the *Houston Post*'s best local bands poll, which was won by Neal Ford and the Fanatics. In the *Houston Chronicle* on March 19, TV host Larry Kane termed them "the best of the psychedelic music makers," alongside Jefferson Airplane and the Blues Magoos. They were also name-checked as one of the new psychedelic groups by *Billboard*'s *Soundmakers* magazine, albeit as a San Franciscan band. Meanwhile, their third single "Levitation" stalled on Austin's KNOW chart at #20 on March 17.

At the end of March, IA was still trying to force the band back into the recording studio, and booked time on March 29. "Tommy Hall and party" checked into the Alamo Plaza Hotel on the downtown and down-market Old Spanish Trail. The session at Andrus Studio lasted barely a couple of hours, with only one reel of tape being used. The session is listed as a demo session; however, nothing from this session is known to exist or to have been documented. On April Fool's Day, one of the most bizarre sessions of all time took place. The Red Crayola, IA's newest signing, entered the studio. With Roky floundering in Houston, he eventually ended up guesting on their sessions.

36. Charlie Prichard of the Conqueroo had previously been in a band named Tom Swift and his Electric Grandmother.

12 1/2.
THE PARABLE OF
ARABLE LAND:
THE STRANGE CASE OF
THE RED CRAYOLA

One Saturday afternoon, Mr. and Mrs. Rogers were shopping at the Gulfgate Mall in Houston to replace a dead parakeet, when they passed a small crowd listening to a KNUZ-FM battle of the bands. While Mrs. Rogers continued into the mall, Lelan paused to watch the crowd reactions, fascinated by the effect the three guys making strange noises on stage were having upon them. Whether the band won or lost isn't known, but they were offered a recording contract anyway.

> **Lelan Rogers (SP):** Three of them [were] up on a stage that had four or five different kinds of instruments, and they could not play a note. They were just making noise and they were really putting the people on: I was watching, and the young people were getting off, thirteen, fourteen, fifteen-year-old teeny-boppers, really getting off watching whatever this was—this no-nonsense music. And them getting off, the older crowd, twenty-five to eighty, wanted to be part of what the youth was enjoying... I was watching the faces of the crowd, I figured anybody that was able to put on a crowd like that—there's got to be a market.

The original Red Crayola consisted of Mayo Thompson, an art history major and philosophy student, Steve Cunningham, also a philosophy major, both at the University of St. Thomas, and Rick Barthelme, who studied fine art at the University of Houston. With so much further education based in the arts, it was clear it would be something "different." In fact, many Texan musicians failed to understand why they were afforded an album: There were plenty of good unsigned garage bands that knew the chord progression to "Satisfaction," and the Red Crayola certainly didn't. They took great relish in the fact they couldn't play "Eight Miles High" or "Hey Joe," although they did try at earlier gigs.

Mayo Thompson had been involved with an early comedy act called the "The Seventy-Three Balalaikas" who only performed twice in two years. Following that, he played at the original La Maison when it was still a coffee bar in a house. He got to know Frank Davis and Guy Clark through the Jester folk club, and Clark was briefly involved with the early incarnation through Rick Barthelme. After Mayo met Steve Cunningham at university, they formed the band in mid-'66. Rick Barthelme named the group "The Red Crayola" after the kids' coloring crayon, and as an homage to Mayo's art teacher mother Hazel. With a keen interest in art history it was no surprise that the band applied and adopted many of the ideologies associated with visual artists working in sound. As Mayo asserts, "We noted the Dada effect; Yoko figured in the world of possibility; Futurism felt flawed by will to power." Rick knew John Cage personally through his studies, and while Stockhausen and modern composers were an influence, the Red Crayola went off on a tangent largely of their own creation. By late December all the band's material was self-written and comprised of a handful of songs and improvised pieces. The impromptu pieces were more performance art, with audience members or friends often joining them on stage to collaborate. These gathered a life of their own and became another entity which was named "the Familiar Ugly" to differentiate these pieces from the band's work. While the Red Crayola could "pull it off" when they performed in art galleries, the more traditional rock clubs like the Living Eye often regretted booking them. When they played Love Street in Houston, owner Cliff Carlin wasn't impressed when they rolled a big old rock onstage and beat on it. While they passed as entertaining, they were terrible as a band in his opinion. The audience divide was also apparent when they performed at La Maison for the Archi-Arts Ball held by the architecture students of Rice University.

The *Houston Chronicle* ran an article about the band in January called "Are All Sounds Music?" which concluded, "although they defy description, their sounds must be entertaining. More and more people are listening to the Red Crayola." In February they attempted a session at Andrus' studio under the auspices of Bob Steffek, who'd had a hit on Shazum Records with a song called "Wild Woody" before setting up his own label. He produced a session that remains unreleased, which consisted of an early version of "Dairy Maid's Lament" (which was rerecorded for the band's second album) and an instrumental track. Two months later, the band signed to IA and was back at Andrus to record an album. While the band had plenty of songs, the resultant album heavily featured their auxiliary lineup, the Familiar Ugly, and on April Fool's Day the session consisted of a three-hour Familiar Ugly freak-out. People rang bells and clanged Coke bottles, a small girl brought in a collection of dolls and pulled the cords so that they said "momma" and someone played a chest of drawers by jogging the drawers up and down.

Mayo Thompson: The core of the Familiar Ugly were Frank Simons, "Red George" Farrar, FRB. Rapho, Jamie Jones. I'm probably forgetting someone. There were others, close friends such as Elaine Banks, Carolyn, Barbara Metyko, many others, on the night [there

INVOICE

ANDRUS PROD⁻ ⁻TIONS
3204 BROADWAY — MI 4-3894
HOUSTON, TEXAS 77017

INVOICE NUMBER 1149

SOLD TO _International Artists_ SHIPPED TO

CUST'S. ORDER NO.	OUR ORDER NO.	INVOICE DATE	TERMS	SHIPPED VIA	DATE SHIPPED	SOLD BY
		4/1/67	Net 10			

QUANTITY	DESCRIPTION	UNIT PRICE	AMOUNT
	Session on Red Crayola +		
	50 Friends		
	3 hrs.	30 00	90 00
	2 reels ½" Tape	18 00	36 00
			72
			126 72

Thank You

(1967) Andrus Studio sheet for April Fool's Day session with Red Crayola and the Familiar Ugly, courtesy Paul Drummond collection

were] fifty or so. A guy kick-starting his Harley-Davidson chopper is the first sound.

It's amazing that a record company run by essentially conservative lawyers could have signed yet another freak act to its roster, but after the Elevators anything seemed possible, as long as it was new and the kids appeared to like it. The new gimmick Lelan saw in this band was the Familiar Ugly and not the songs themselves. While no Elevators were present at this session, Roky was bored of kicking his heels in Houston and attended the studio recordings a few days later on April 10.

Mayo Thompson (RU): I used to see Roky around. We got along. He was an interesting guy. But he was already quite out there in some ways. "Unstable" only in relation to our norms, on another wavelength from the beginning. My impression of him was that he was an extremely sensitive person and extremely talented, with a great deal of energy, power, charisma. But in a certain sort of sense, somebody who needed somebody to take care of other kinds of affairs for him on some level, that's all. Taking seriously the idea of taking acid every day is questionable. Even to me at the time, being a wild child or whatever, you look at that and you go, boy, that's extreme. He was one of those people who just never had any doubts about what direction he was going in. It just never occurred to him to think, could this be the wrong thing to do? No! This is it, this is what's happening. But Tommy Hall mediated. Tommy was playing

the translator for us on the first night: "You must show Roky the changes." One could look at Roky and know that he knew exactly what was going on, that he knew what we were talking about, he could hear the music, and he knew what that was. And he did it. You can hear that he did understand it, because these elements that he had fit perfectly into our program.

Punctuating and segueing the freeform pieces are five recognizable songs. Of the actual songs recorded, four were released on the album, two of which Roky appears on, playing a haunting harmonica line on "Transparent Radiation" and keyboards on "Hurricane Fighter Plane." The other two songs, "War Sucks" and "Pink Stainless Tail," are equally excellent and worth investigation even if most people may struggle with the Familiar Ugly pieces. The album is, overall, a psychotic mix that has rightly become regarded as a masterpiece of the era. Various tracks from the album have been covered over the years, including the Cramps doing "Hurricane Fighter Plane" and the Spacemen 3 releasing a cover of "Transparent Radiation" as their second single. At the time, the reception was mixed—one story goes that Murray the K was sacked for playing "War Sucks" on air, and in Texas it was generally received as a joke and a waste of time. The material simply went over people's heads. Roky still finds the album challenging but interesting, commenting that it was being "difficult for difficult's sake."

IA's second album came in yet another suitably warped and psychedelic cover, the first of a series by George Banks, now under the pseudonym of "Flash Graphics." It was released in both mono and stereo, although there were problems with the stereo mix.

Walt Andrus: Well, unfortunately I made the master in mono, and the stereo version I did by doing what we called "miracle sound" where you make a copy of it and flange and get it a little out of phase, swoosh it around some.

Mayo Thompson: Lelan'd obviously thought about what we were up to, how to get it down, and exploit it. We profited from his suggestions. He egged us on during the Familiar Ugly sessions; during the recording of the songs, he suggested this or that—our playing "War Sucks" in the form of a modal jungle groove thing rather than as the rock progression it had been, is down to him. Lelan's liner notes reflect his speech and attitudes in general, the kind of talk, the level of hype, hip, spin and buzz that informed everything he was and did, at least around us…

While Lelan appears to have taken on more of a production role than the Elevators afforded him, he was largely a record company facilitator, and Walt Andrus and Frank Davis were in control of the desk. However, having heard some of Frank Davis' own work from this period, the freeform pieces bear more resemblance to his "sculpting of sound." For IA it has become another legendary release, and confirmed their role in preserving the Sixties Texan freak show for posterity.

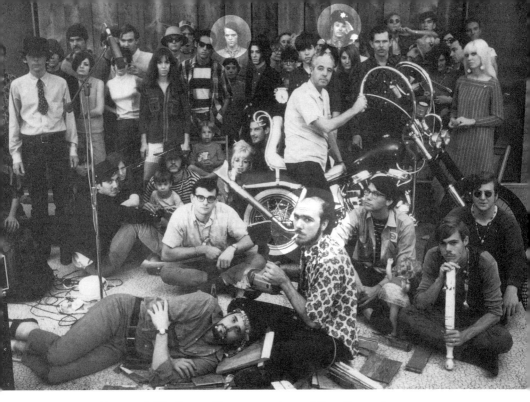

(APRIL 1, 1967) THE FAMILIAR UGLY, BACK ROW (CIRCLED): STEVE CUNNINGHAM, MAYO THOMPSON. FRONT: RICK BARTHELME (BRANDISHING POWER TOOL); LELAN ROGERS (SITTING ASTRIDE CHOPPER), PHOTO BY WALT ANDRUS

Following the studio sessions, the Red Crayola followed the trail to California with bookings at the Angry Arts festival (June 29) and three performances at the Berkeley Folk Festival (July 2–4). Reactions to their live set of electronic improvisations were mixed. One reviewer wrote, "The bomb of the festival was Houston's Red Crayola, a freak sound group who did nothing but get audiences uptight. The Crayola ought to learn that there is a difference between electronic sound with substance and electronic noise." Ten years later, a piece in *Rolling Stone* was slightly kinder in hindsight:

"Visitors to the coast never seemed to outstay their welcome: even when a mysterious Texas band named Red Crayola showed up in Berkeley to play one hour's worth of unmediated screeching feedback, a polite—if stoned—audience felt reticent about being critical or leaving the hall."

Chet Helms skipped booking the band at the Avalon, and they made the inevitable trip back to Texas.

13.
POLARIZED INTO EXISTENCE

By the early summer of 1967, the Elevators had seriously lost all momentum, and their future looked fragile. Although attempts were being planned to "save" the band by others, they remained in a perpetual state of chaos. While Jack McClellan feared the band would lose track of each other during an East Coast tour, the truth was that they had become sidetracked and lost in Texas. Although Tommy would get depressed if nothing was happening, as long as they made chemically charged live appearances, even without a clear plan for the future, then they still existed in a time and space of their own creation. Roky was beginning to see that the band was flagging and argued with Tommy about why they should bother making a second bid for stardom. Stacy, John Ike and Ronnie had glimpsed in California what being real musicians could be like and contemplated leaving. Stacy was undecided. While Tommy held court in Houston, Stacy, John Ike and Ronnie remained in Kerrville and Roky in Austin where a young, adoring fan base clamored for the kudos of getting high with the infamous Roky Erickson. The Elevators were left in a strange state of recovery, caught in a vacuum of their own creation. Roky had plenty of places to crash in Austin but mainly stayed back at the Kinneys'. Exactly how Roky viewed his future is hard to tell; those around him give varying reports. Some remember him as heavily spaced out, with the first cracks of declining mental health starting to appear, his natural disposition giving way to a lifestyle fueled by acid, speed and constant stress from harassment by the authorities. Childhood friends such as George Kinney observed small changes in his behavior patterns:

> **George Kinney:** One of the best things you could do was go out and eat with Roky. Because, when he ate, he'd go "Oh my GOD! God, that was good!" Everything was so great to him; everybody else was going "God, this guy's weird!" So, when I started noticing that there were fewer and fewer of those experiences, like we didn't eat as much... Somehow, this whole idea that you could dance in that world and still return to this world and play it cool wasn't there any more, and I suspect it was drugs—acid, speed, just too much for a human being to deal with, short-circuit stuff. There's definitely a physiological element there...

Alternatively, there are tales of him as the wide-eyed pied piper, look-ing after and babysitting those new to the psychedelic experience. The truth is probably a mixture of the two; certainly he and Tommy appear to have come back and continued with the same abandon they showed in San Francisco. When Roky and Tommy were in town together, they often held court at the Kinneys', and as soon as word spread, people started arriving in droves. While Roky was still a huge local celebrity and the focus for the new underground, Tommy was seen as the teacher.

In the spring, the Kinneys and Kearneys were forced to move from the house on 38th Street to the Castle Hill area of Austin, which later became the hippie haven in '67, and Roky and Tommy moved in temporarily.

Dana: Every time Roky and Tommy came back into town they'd come to my house and I'd always want to hoard all of Roky's time... 'Cos I was so glad to see him, but then thousands of people would show up and line my living room. We didn't let anyone uncool enough to take drugs hang out with us. This was a spiritual journey, we took marijuana and we took acid and anything else was trash, we weren't turning on to get high. Tommy was a great teacher, Tommy would protect us, he would tell us things about acid and explain it so we could get the most from it, he was very technical, walked you through it. People were jealous, we had the most fun, we laughed, giggled and we were kids. Tommy showed us things on acid that people would probably... I remember one night we all took acid and there were people sitting on the floor, leaning against the wall all the way 'round the room... there had to be thirty people there and all of a sudden I'm going, "No, no, nooooooo..." and Tommy looks at me and I'd freaked on acid and I'd never freaked on acid... I loved acid. Tommy went over to Roky and said, "Would you do something with her, she's going to cause a mass freak-out here." So Roky says, "Dana, come here," and he puts his arm 'round me and I go, "Nooooo." So Roky couldn't calm me down, so Tommy gets up and walks over and I'm sittin' on the floor and he grabs me by the hand and walks me out like a stern father and Tommy and I went outside in the yard and sat on the grass and he said, "Okay, Dana, what's wrong?" I said, "I'm dying," and he said, "Okay, go ahead and die, hurry up," and I went, "Tommy, Tommy! Tommy!" and this child was born in my voice, I was witnessing my own rebirth. And I looked at Tommy as I was saying this in the littlest voice and he's smiling at me with so much love. And he said, "Now do you want to go and see the pretty lights out in the hills?" And I said, "Yes." So we gathered a few people and got in the car and we went out to the lake and looked at the lights.

With the droves of friends and fans they were attracting too much attention, making themselves easy targets, and John and Susie elected to move out. Tommy and Roky soon found a small top-floor apartment on West 5th Street, which they moved into with Roky's girlfriend Judith. However, his personal life was beginning to get far too complicated and starting to have a huge effect upon him. He and Judith weren't quite working out—his freewheelin' lifestyle meant she wasn't receiving all

the attention she wanted and despite dating the number one hip musician in town, she started fooling around behind his back. Regardless of the uncertain nature of the band's activity, Tommy was keen to resume work on developing their second project. He saw the band's future in recording a meaningful body of work and had viewed the planned return to the West Coast or the East Coast tour as a distraction. Tommy was also aware of the stress Roky was going through and tried to get their focus back on working.

Tommy (K): We were living in Austin and I was pumping him full of Sri Yukestwar Giri's Holy Science book, but this chick was really being shitty to him and it was fucking up his head. Everything was perfectly normal until all of a sudden he was doing amyl nitrate, he was with this chick, you know, stupid, sex trip... AMYL NITRATE! I mean excuse me. And he didn't even love the chick and this chick finally left him for a guitar player and he just flipped out and he was just different, messed up in the head, just broke... I don't know what it was. When you're young, you can be totally focused on this other person, so that it's really an insult to you that this chick can go to somebody else, and especially if you're supposed to be this really super cool singer. It just got to him. He was going through all these changes, because he's not very egotistical, he just had a groovy way of doing things; he'd go on adventures. This chick couldn't understand that, I tried to say things to her but she was the opposite pole to Roky.

Dana: I didn't want to be with George and I missed Roky, but he'd met this girl named Judith and she was his first girlfriend he could write about... and so Roky came in one day with George and Judith and said, "Come on Dana, let's fix steaks." And I didn't want to be around him... I didn't want to know Judith or see Roky happy with another woman. So, I did become friends with her and I liked her and she did start confiding in me... She should have never made the mistake of telling me she was cheating on Roky. So I went to Roky, and Tommy was in the room; Roky, Tommy and Judith shared an apartment, and I said, "Roky, you need to know she's going behind your back and cheating on you, it's just breaking my heart that she's doing this to you." I said, "My first allegiance is to you"... and Tommy leans over and just goes, "NO."

Roky and Tommy made a writing pact to work exclusively together on the next album, Tommy's lyrical vision set to Roky's music. Whereas the previous album had dealt with the realization of the quest for enlightenment, the second project needed to establish exactly what information was needed to achieve it. The previous album had its foundation in general semantics, and the new project was Tommy's attempt to incorporate his understanding of esoteric texts into his own model for enlightenment, correlating Eastern mysticism and Western science. He was also under pressure from within the band to deliver something more cohesive than simply proselytizing the use of LSD. He'd been studying a number of texts and been formulating interpretations of the Hindu Vedas and Chinese Buddhist Tantras uniquely paralleled by Western scientific study of

quantum physics in an attempt to scientifically decipher the components of the divine and eternal life.

Roky, however, wasn't the only person having personal problems since his return from California. Stacy, since his vivid revelations of the band as false prophets, bitterly argued with Tommy over their message. He not only challenged Tommy's dictatorial advocacy of LSD, but he had deep-rooted concerns over the lyrical content, which he felt was "negative." Stacy wanted the band to take an altogether more spiritual foundation but without direct reference to any specific religious text, which he felt would be sacrilegious. In many ways Tommy and Stacy had little in common outside the band and hung with an entirely different crowd of friends. Stacy often described a lot of Tommy's canon of knowledge as "bullshit" or "poppycock," feeling it was far too convoluted and unnecessarily complicated. However, both men had a deep-rooted connection to the project they had started, which neither of them were prepared to abandon. Given Stacy's growing doubts, it's hardly surprising that he made no further collaborative compositions with Tommy on the second album. Stacy wasn't jealous or competitive; he knew he would be given space to express himself musically later. From this moment on Stacy took on the mantle of interpreting the band's music and sound, working with the rhythm section while Roky and Tommy instigated the material. In many ways, Tommy was taking the route Stacy wished for, a more open and all-encompassing view of the route to enlightenment, but he wasn't yet prepared to relinquish LSD as an aid to his work. Although Tommy appeared to be on the brink of realizing and articulating his own vision based on an all-encompassing multicultural view of different religious and philosophical sources, his progress was challenged by the turmoil the band was going through. While Tommy and Stacy debated the philosophy, Tommy encouraged him to face his demons in terms of Chinese Buddhism, the primary demon being the mindset of someone who withdraws.

Jack McClellan (K): Stacy always appeared to me as being very confused about who he was. He knew what gave the band its sound. Sometimes he'd say, "Tommy's ruining my life." I tried my damnedest to get Stacy on my side and he'd vacillate back and forth. I don't know what Tommy was telling him, I can only judge by what Tommy did, which was give everybody acid all the time...

John Ike: Stacy would come to me literally in tears, whimpering because he was so terrified, so incredibly freaked, and Tommy would have a long talk with him and give him some more acid.

Stacy (K): It was organized and really well planned at first. You know what you want to do and you do it. I had a lot of ideas that I never really did put down and we got on the road and started traveling. I never spent the time working, you know, I realize that's a mistake now; we weren't disciplined enough at the time, eating acid all the time and everything else, getting together to play, while we traveled and our show wore down—it got to where it was a grind. It lost its feeling because of the money and the touring, we just kept going.

We never got together to work on material. Then we came back to Texas and got popped... It finally got to a point where, I don't know, it was an uncomfortable mixture of ideas. We got into really bad arguments about what was taking place. Well, we realized we both had really different beliefs and at the time Tommy didn't believe in God, as a being. See, I believed in God as a being because I was a country boy, raised in a Baptist family, and we're both on acid and it was a really religious debate with us. I'd get upright with mixing Biblical scriptures with music. Because Tommy would be trying to do one thing so sincerely as an artist with his writing and at the same time some of his words might not really be singable. It really had a point, an impact he was trying to get across as a writer, but it would contrast with Roky singing it, and with us musically sometimes, and at the same time his ideas were so good that we believed in him. But when we first started freaking out, Tommy would say, "You are just on a rib because of yourself." I think that's got to be right because all this psychedelic is doing is allowing me to take a look at myself. So if I fucked up and I take some more acid and I get more fucked up, that's what it did to Roky... and that's how Roky went out on the limit for a while. It felt like we were obligated... That's what I was trying to explain about Roky, when he kept turning on after he started flipping out, it was an obligation that he felt, because of what he BELIEVED to be true. It's something I believe in spiritually, I used to get scared when we were doing shows, you can ask him man, I used to have him walk and talk to him for hours before a show because I'd be freaked, but I felt I was really supposed to be in that place. I really believed it because—I believed it was a clear state... but it began to be, oh, just warped...

John Kearney: Me and Susie were the first rats out of the ship [Baylor Street]; later it all collapsed. Suddenly Roky and Tommy were living upstairs in one of those cool, old apartments on West Fifth Street (it's gone now), and Tommy had the front room. We went 'round to visit and very often Tommy would be locked in his room and had taken a lot of acid and he was working on "Slip Inside This House," reading a book called *Secrets of the Golden Flower*, and he would come out and talk to me about what he was doing and mostly you just listened, he likes to do the talking and it all made sense at the time, marvelous sense, but you can't dance to it. Wonderful. Tommy is... how can I say it? I love Tommy, he was very good to me, very forthright and direct and caring, but he started to project his personality to such a degree of intensity that it was possibly becoming very hard for Roky to be Roky. And perhaps very hard to get out of the shadow of Tommy; he is a strong personality. Stacy, too, was very strong—we had a good joking relationship but he was always distant; not in a way that he wouldn't talk, he wasn't shy, it was like a black cloud enveloped Stacy... as if something was going to happen, it was going to fall on him, for what reason I have no idea.

With all the turmoil, the band played relatively few live shows and Roky worked on new song structures, while Tommy was busy fashioning his ideas into lyrics. One of their co-creations written in the apartment

was arguably their finest song, "Slip Inside This House." Although music journalists, fans and fellow musicians have generally agreed that this song is the Elevators' masterpiece, its meaning is often impenetrable.

Uncharacteristically long for an Elevators tune, it clocks in at over seven minutes. Its structure borrows more from Dylan's "It's All Right Ma (I'm Only Bleeding)" and "Gates of Eden"—complex blocks of lyrics throughout—rather than being lengthened by a long meandering guitar solo; the Elevators always remained far too punk for that.

The title of the song came from Clementine:

Clementine: Tommy and I were driving around in this very elegant neighborhood and I said, "My favorite thing to do when I find a beautiful neighborhood like this is just to slip inside the house mentally and picture myself walking up and down the stairs, and going into the living room and having something to eat or read, whatever. I loved to slip inside people's houses. And that's where he said, "Tell me that again!" But, that being said, Tommy required very little help.

Roky was sitting in the apartment playing his guitar one day when he had an epiphany, only to have Tommy seize upon it and run away with it before he could develop it himself. Although Roky co-wrote the song and now acknowledges it as one of their finest works, he has had mixed feelings about it from the time of writing.

In Buddhism, tuneful harmony is meant to lead to enlightenment, and Roky had unknowingly provided the repetitive chord structure that gave Tommy the perfect vehicle to convey his lyrics. As Roky acknowledged in 1973, "I was beginning to write this thing; I thought it was like Beethoven, and somehow that vision gave me the energy to write. Tommy heard what I was doing and said, 'That's out of sight, can I put these words to it?' I finished the music for the piece and he did the words. I didn't understand any of what he was talking about at the time." Tommy admitted years later, "I tried to communicate, but it is true that we never, I never, sat down and, you know, explained the lyrics to him."

Tommy, being a lyric writer and not a songwriter, relied solely on Roky or Stacy to provide him with a melody or rhythm he could fashion lyrics to, and often they felt the lyrics seemed forced to fit their music. However, while "Slip Inside This House" was the perfect fusion of lyrics and music, it had entered new territory by employing a Shakespearian blank verse poetic rhythm that didn't facilitate Roky's natural singing voice, let alone his trademark scream. Not only did Roky not understand what he was singing, but also the way in which he was required to sing it. In his opinion the music had also changed and become tamed and controlled; there was no howling feedback, the edge had gone.

The song corresponds to Tommy's initial vision of the band as a vessel through which information could be communicated. However, if the information had become so summarized and condensed that not even the band understood it, then how could the audience? When questioned about the song's meaning, he has candidly indicated that there may have been a

secret last verse that clarified the whole, which was only ever performed live. However, this is seriously unlikely, since Roky was never able to remember the lyrics and Tommy was forced to admit the new material was proving too hard to perform live.

> **Tommy**: On stage, he couldn't remember. When you play music behind words, you're building up all these different dramatic things that are what gives the idea to play higher things. He couldn't get the words right though. It was just repetition. We couldn't play a complete song that was a whole thing in itself, it was really frustrating...

If the idea behind "Slip Inside This House" was to provide a calling to the audience to find out what the Elevators were about, then the answer or reply was contained not in a secret verse but the last song of the project, "Postures (Leave Your Body Behind)." The whole second album, *Easter Everywhere*, largely hinged around Tommy's fusion of esoteric texts into his own vision, which fused elements of the Tao, the Bible, the Hindu Vedas and the Buddhist Tantras with quantum physics and the Big Bang theory. Ironically, as the foundations of *Easter Everywhere* were being formulated that spring, its delay was due to the band's own "rebirth" as they were forced to confront their situation.

Prior to concentrating on the writing process, Tommy had already started to disengage himself from the everyday workings of the band, becoming increasingly centered on his goal, and alienating the band who found his lack of commitment increasingly frustrating.

> **Ronnie**: Well, we came back mainly to record and we also had jobs booked on the East Coast. We had just finished *Psychedelic Sounds* and they were going "well, we need to start working on the next one" and cancelled our East Coast tour, we had from Florida up to Maryland, plus, you know, spreading our albums in that direction. I really think if we would have been able to do the East Coast I think we could have gotten a lot bigger. And I think it would've held everybody together a little more than, you know... at that point we were all still not sure which direction we were going in, and all of a sudden a great big company threw a wrench in the middle of everything, you know, and said "well, this is where you're going"—and downhill was right!

Meanwhile, Jack McClellan was now acting as the band's personal manager and was planning to set up a management company called 13th Floor Incorporated, largely to manage the band's finances. Jack had appointed an Austin-based booking agent called Talent of Texas to start booking the band again. However, Tommy was skeptical over the new developments and reacted antagonistically toward McClellan's attempts to salvage the band, not wanting any control falling into John Ike's hands, squarely blaming him for the disappearance of the East Coast tour. The band began to splinter.

> **Tommy (M)**: We had a lot of trouble. Like he (John Ike) totally messed things up for us as far as the East Coast because he was always quib-

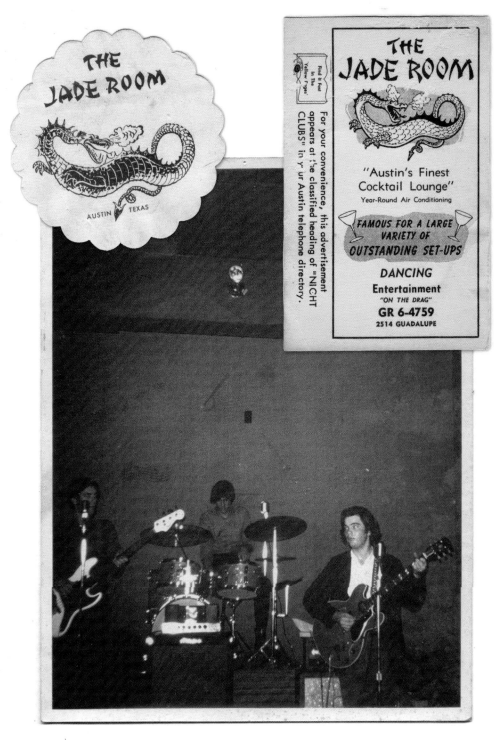

EPHEMERA: BEER MAT & DRINK MENU COURTESY DIANE LAZELLE.
PHOTO: 13TH FLOOR ELEVATORS AT THE JADE ROOM, PROBABLY THEIR FIRST PERFORMANCE, 8TH DECEMBER.
L-R: BENNY, JOHN IKE & ROKY, COURTESY EVELYN ERICKSON COLLECTION.

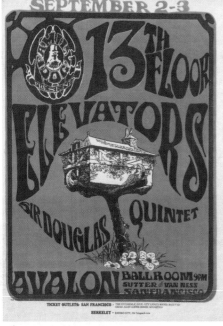

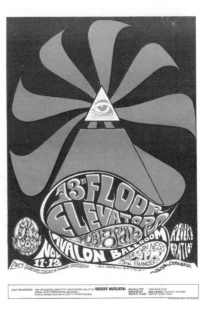

CLOCKWISE FROM TOP LEFT: OCTOBER 16, 1966, POSTER & HANDBILL DESIGN BY MOUSE STUDIOS. AVALON
FIRST ANNIVERSARY, REMEMBERED AS THE ALL-TEXAN NIGHT: JANIS, DOUG SAHM & THE ELEVATORS. BILLED AS
"SURPRIZE VISIT" BECAUSE OF DOUBT THEY WOULD MAKE IT BACK FROM RECORDING THEIR FIRST LP IN TEXAS;
MARCH 15–16, 1968, LOVE STEET (SIC) HOUSTON, TEXAS; 1966 SEPTEMBER 2–3 AVALON POSTER BY MOUSE STUDIOS.
NOVEMBER 11–12, 1966, AVALON POSTER BY STEVE RENICK.
OPPOSITE PAGE: FEBRUARY 18, 1967, HOUSTON MUSIC THEATRE POSTER BY J. MOORE.

INTERNATIONAL ARTISTS

PRESENT

IN CONCERT

FEB 18 SAT

8 PM

THE 13TH FLOOR ELEVATORS

THE CONQUEROO

LIGHTS BY JOMO DISASTER

HOUSTON MUSIC THEATRE

IN ASSOCIATION WITH THE ELECTRIC GRANDMOTHER

TICKETS:

ADVANCE SALE - $2.50 ; AT THE DOOR - $3.00

Available at your favorite record shop today.

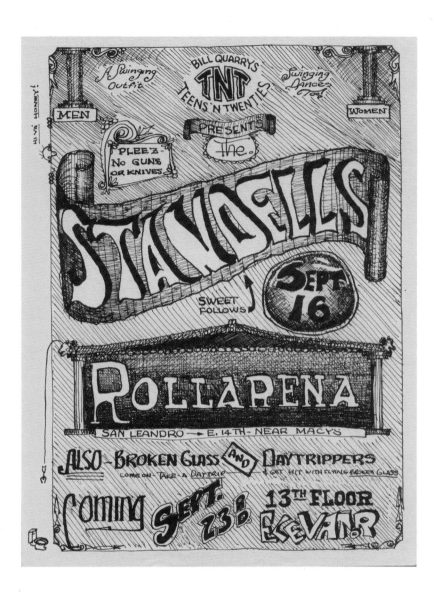

SEPTEMBER 23, 1966, "MARATHON DAY" SHOW 3 HANDBILL BILL QUARRY'S TEENS'N'TWENTIES.
OPPOSITE PAGE: APRIL 15, 1973, REUNION SHOW AT SUNKEN GARDENS, SAN ANTONIO, TEXAS,
COURTESY PETER BUESNEL COLLECTION.

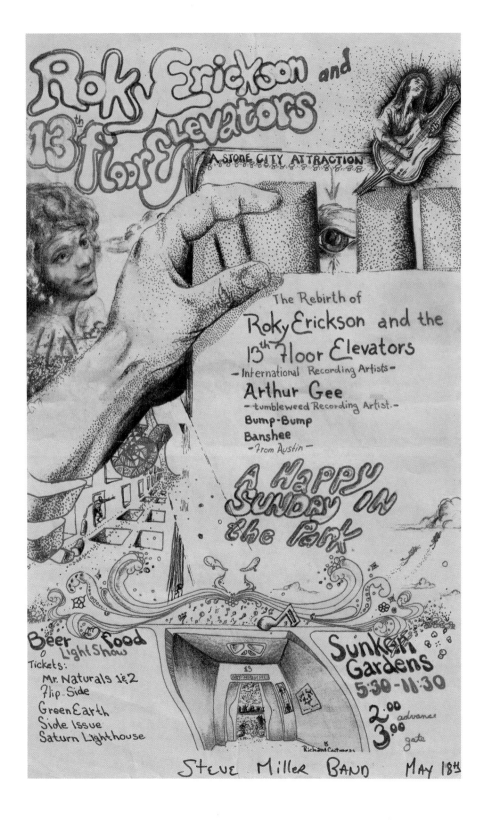

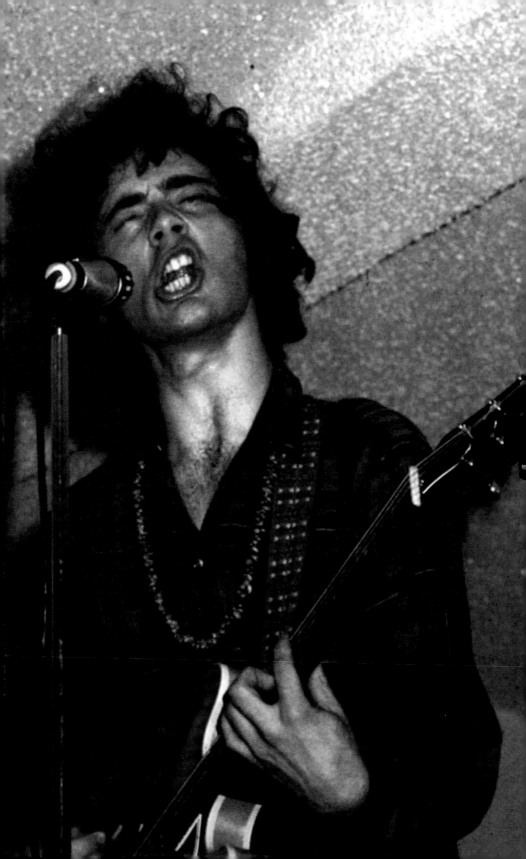

BILL GRAHAM PRESENTS IN SAN FRANCISCO

13TH FLOOR ELEVATOR

GREAT SOCIETY

SOPWITH CAMEL

FRIDAY AUG. 26

SATURDAY AUG 27

FILLMORE AUDITORIUM

Photo by Herb Greene

TICKETS SAN FRANCISCO: City Lights Bookstore; The Psychedelic Shop; Bally Lo (Union Square); The Town Squire (1318 Polk); Mnasidika (1510 Haight) BERKELEY: Campus Records; Discount Records; Shakespeare & Co. MILL VALLEY: The Mad Hatter SAUSALITO: The Tides Bookstore; Recall Pharmacy.

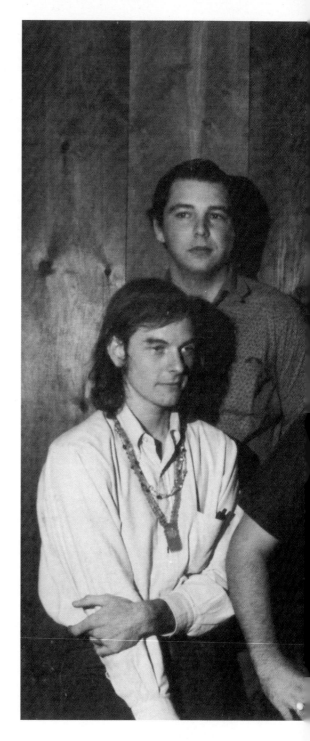

PREVIOUS SPREAD, LEFT: ROKY AT THE LIVING EYE IN HOUSTON, PHOTO BY RUSSELL WHEELOCK

PREVIOUS SPREAD, RIGHT: AUGUST 1966, ARTWORK FOR POSTER, HANDBILL & POSTCARD FOR FILLMORE SHOW. THE BAND ONLY PERFORMED FRIDAY NIGHT, SUPPORTED BY SOPWITH CAMEL. THE GREAT SOCIETY & COUNTRY JOE AND THE FISH PLAYED SATURDAY NIGHT.

THIS PAGE: SEPTEMBER 1967, *EASTER EVERYWHERE* SESSIONS, ANDRUS STUDIOS, HOUSTON, TEXAS; BACK ROW: DANNY GALINDO, LELAN ROGERS, DANNY THOMAS; FRONT ROW: TOMMY, STACY & ROKY, PHOTO BY RUSSELL WHEELOCK

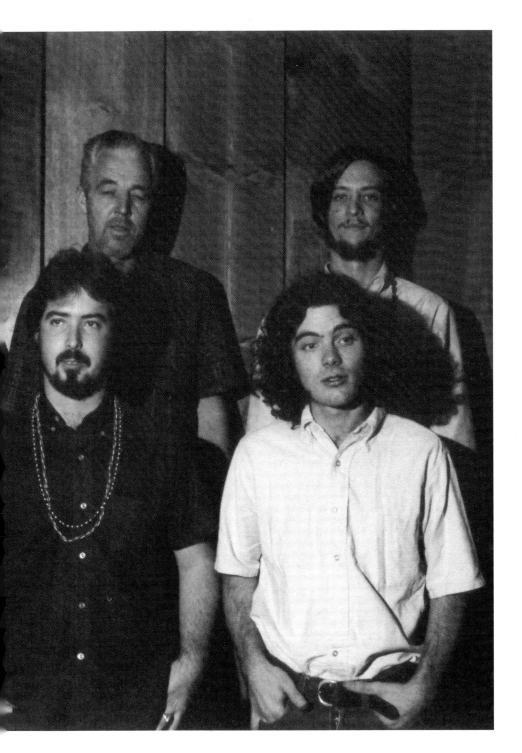

TOP: 1966 *PSYCHEDELIC SOUNDS OF THE 13TH FLOOR ELEVATORS* COVER BY JOHN CLEVELAND
BOTTOM: 1967 *EASTER EVERYWHERE* COVER BY GEORGE BANKS

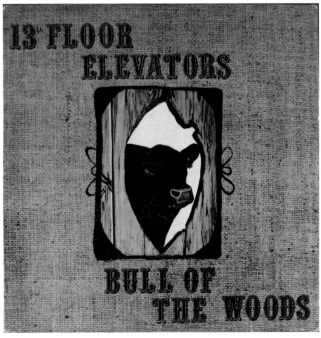

TOP: 1968 *LIVE* COVER
BOTTOM: 1969 *BULL OF THE WOODS* COVER CREDITED TO LLOYD SEPULVEDA

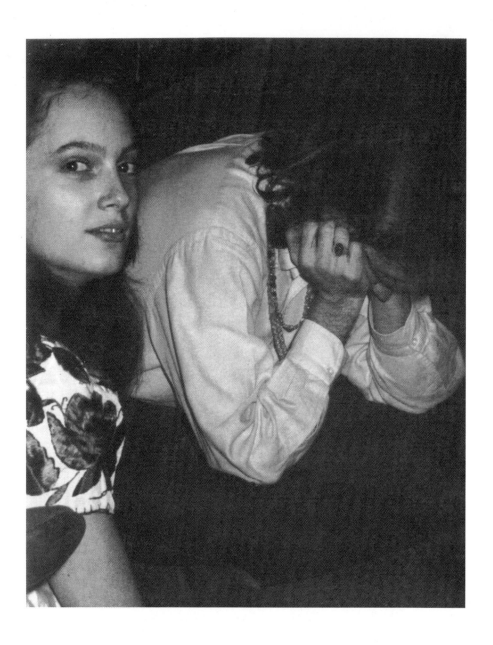

SEPTEMBER 1967, ANDRUS STUDIOS, CLEMENTINE CONSOLING TOMMY AT THE END OF *EASTER EVERYWHERE* SESSIONS

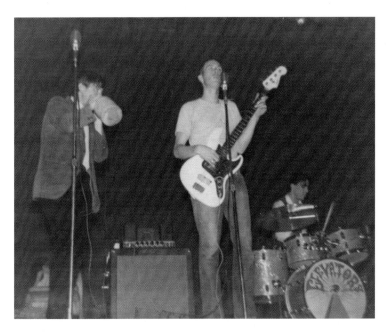

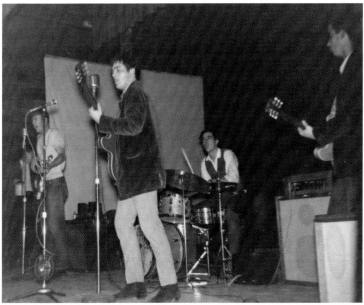

MARCH 12, 1966, BENEFIT FOR AILING BLUESMAN TEODAR JACKSON, AUSTIN METHODIST CENTER.
THE ONLY TIME THE BAND SHARED THE BILL WITH JANIS JOPLIN IN TEXAS.
TOP, LEFT TO RIGHT: TOMMY, BENNY, JON IKE; UNKNOWN PHOTOGRAPHER, COURTESY PAUL DRUMMOND COLLECTION
BOTTOM, LEFT TO RIGHT: TOMMY, BENNY, ROKY, JOHN IKE , STACY

PREVIOUS SPREAD, LEFT: COVER OF BENNY'S PSYCHEDELIC BIBLE HE USED TO PREACH FROM IN SAN FRANCISCO 1966
PREVIOUS SPREAD, RIGHT: PAGE FROM BENNY'S REWORKED BIBLE, COURTESY BENNY THURMAN
TOP: HALLOWEEN 1963, ARTHUR LANE, LEFT TO RIGHT: ROKY, GRANDMA ELSIE KYNARD & EVELYN,
COURTESY EVELYN ERICKSON COLLECTION.
BOTTOM: ROKY ERICKSON, AUSTIN, TEXAS, 2004, HAVING BEEN TO VOTE FOR THE FIRST TIME IN HIS LIFE,
PHOTO BY PAUL DRUMMOND.

THE SMOLDERING BANANA PEEL

PRESENTS

THE 13th FLOOR ELVATORS

THE WIG

AND

THE GENTLE DEBACLE
PSYCHEDELIC LIGHT SHOW

AT DORIS MILLER AUDITORIUM
THURSDAY NIGHT
APRIL 13
8:00 P. M.

TOP: (APRIL 14, 1967) *AUSTIN STATESMAN* AD FOR SWINGERS CLUB, AUSTIN, TEXAS; BOTTOM: (APRIL 13, 1967) HANDBILL, DORIS MILLER

bling about who should manage us. We tried to book gigs in New York but he called the people up and told them that the people hadn't booked us and they cancelled everything.

Stacy (K): [We wanted to blow off Tommy and Roky], at the time it was almost sane, considering the condition everything was in. I considered it, sure, because we weren't working and the group was breaking up. I was trying to find the best path to follow... and at the time, Roky was spaced out, you know what I mean? I had talks with his old lady, told her whether I could take him out and he could keep picking... that's when John decided that we ought to get another singer. I don't know, it went from bad to worse... I got back with them anyway... and we started, you know, using side musicians with the group, but that didn't work, and finally it got really rough, the sound and everything...

April saw their return to Austin for a series of shows booked by their new booking agents. The band returned to the Doris Miller Auditorium on April 13, supported by former Jade Room rivals the Wig. The show was advertised as the Smoldering Banana Peel, after the fad of drying out and smoking banana peels to get high, as immortalized by Donovan's "Mellow Yellow." The show was promoted with advertisements in the *Daily Texan*, simple black type handbills and—the latest craze—searchlights in the sky to mark the venue. The show's organizers attempted to repeat the multimedia psychedelic event the Electric Grandmother staged, promising "Laurel and Hardy movies, psychedelic slides, oil lights and strobes."

Ronnie: The Wig were a little bit more psychedelic, they had some newer stuff. It seems like it didn't have such a big turnout and we had a whole lot of trouble with the sound, it had something to do with the electrical system was varying with the wattage coming in and out and that made everything pretty weird.

The following day the band played the Swingers Club, returning to the City Coliseum as part of an all-nighter with five other bands. A few months previously the band had been breaking new boundaries in Texas; now they were simply retracing their footsteps with absolutely nowhere to go.

While mixing the new Red Crayola album, IA paid Walt Andrus to try to mix a rough album's worth of Elevators material together from what was left in the can. This was countered by the setting up of 13th Floor, Inc. to co-ordinate the band's future. The firm's principals were Jack, the legal department, Juanita Holman (wife of Jack's legal partner) as secretary and Emma Walton, investor. With the band back on the road, Jack proposed to counter some of IA's control over the band, ensure them a livable wage and address their debts. The way in which IA paid the band was challenged. All revenue from record sales and live appearances went to IA, who allegedly paid hotels, advances on equipment, food tabs at restaurants, recording costs and cash advances, and absolutely every possible expense was treated as a recoupable cost before the band saw a dime.

The 1966 end-of-year figures had painted a dismal picture with the band owing the record company money despite selling thousands of records and commanding up to $2,000 a night on the West Coast. All funds generated flowed through IA, and nothing returned in the form of a livable income. Jack's answer was to put the individual members on a sliding scale of payment—the first money earned they would keep, and after that expenses would be met. The band would then draw a basic salary of $75 per man per week, after which Jack, and the board of 13th Floor, Inc., would draw a salary. After trying to get the band's immediate finances established, he started to examine their contracts. Stacy and John Ike particularly expressed the opinion that the band had somehow been hoodwinked into signing watertight, long-term contracts that treated them unfairly.

Jack McClellan (K): Their recording contracts were the first I'd ever seen, but goddamn! They gave up everything to this company, all rights... they were like fucking slaves! In return, the company agreed to "do the best it can"... no standards spelled out to judge the record company's performance, no standards set out for accounting, nothing!

His answer was to draw up his own contract that would clearly state each party's responsibility to each other. He then contacted the musician's union to vet his new contracts and examine whether the IA contracts met with union guidelines.

Jack McClellan (K): My attitude toward IA was thumbs down on the motherfuckers. Not only were they horrendous rip-offs as a record company, they couldn't even sell any fucking records! Mechanically, they put out an inferior product, their discs wore out right away. The Elevators were about all they had, so they really wanted to hang on. As their manager, I engaged a booking agent and started getting them gigs. They were unbelievably popular, everybody wanted the Elevators... why were they such paupers? I couldn't understand it. I grabbed a business agent from the musician's union and said, "Look, help us out!" She took a look at the contract I'd written up for them and said it was the fairest, most airtight thing she'd seen.

However, the musician's union weren't prepared to fight for the Elevators despite Jack explaining that IA was deliberately "dragging their feet and penny-pinching... their motive to keep the boys' financial condition weak, in order that [they] may take them over completely..."

The key issue was why IA wanted to retain a band that they clearly were so frightened of promoting. Were the Elevators being kept as an expensive joke? When confronted, Ginther conceded, "After we got to see what we were trying to make money off, we all began to get a little bit uptight." Why, if the label was too scared to promote the band because of their drug habits, didn't they sell their contract to another interested label? Surely they were failing to serve their own interests as well as the band's. Now convinced that IA were not only ripping the Elevators off but also

doing the band a serious disservice by not promoting them, Jack's ultimate solution was to try to free the band from their contracts once and for all. By setting up their own management company, Jack believed that "they were set up to be in control of the product they played; the corporation had the power to set up their gigs, to veto their recording contracts..."

Unfortunately for Jack, the 13th Floor Elevators were a law unto themselves and, instead of ensuring their long-term future by logical analysis of the band's situation, it only heightened their problems further and sped up their disintegration.

> **Beau Sutherland:** There were so many people involved that were pulling these guys in different directions. John Ike Walton's mother at one time was a semi-manager/agent. Who knows what these guys were thinking. If they'd just had somebody smart that could have managed them, they could have managed the opportunities that they had. I guess the only person who tried to manage them was Mrs. Walton. She tried to put a firm hand on them. She tried to line up a nice place for them to stay, but they were such a group of rebels, I mean, who could control them?

Although the band appeared to be back on the circuit as a live act, they were also extremely unpredictable as Jack, in his role as personal manager, soon found out. The Elevators simply existed in a time of their own—Elevators Acid Time—which absolved them of any professional responsibility. With Sandy Lockett gone, Jack accompanied the band to gigs and had soon found his new role a thankless task. He had the unenviable job of dealing with irate promoters, while hoping that some, if not the entire, band would arrive at the same gig, in the same town, on the same evening. While John Ike would roll in from Kerrville followed by Stacy and Ronnie, and make the correct venue, Roky and Tommy would often be at the wrong venue or even in the wrong town.

One story about the Elevators that perpetuates and illustrates not only their untogetherness but also the pathetic way in which they were surviving on a day-to-day basis: some of the band had gathered at the Ericksons' house on Arthur Lane; they had a gig booked in Houston in half an hour, which was at least a ninety-minute drive if they were lucky, but they had no transport—so they borrowed Evelyn's car on the pretense of going to the store to buy her some groceries. After the show, the band found they didn't have enough gas to get back to Austin and had no money, as usual. The only answer was to pay Lelan a visit at two a.m., palms extended, and beg for gas money. Lelan was duly awoken and, after some persuasion from Tommy, handed out $5 bills before being allowed back to bed.

At another show out at the Lake Austin Inn, the band played with the Lost and Found, and Jack realized what he was up against.

> **Beau Sutherland:** I can't tell you how many times Stacy would tell me that they'd get a contract to appear somewhere and they'd show up, holding their breath, hoping everybody would get there. Sometimes it would be right down to the end.

Jack McClellan (K): I remember one time that I really pissed off Tommy and Roky. They had this gig at a beer joint outside Austin and they were late getting there, of course, so the houseman was raising hell with me... and finally they came out to play and, after half an hour, they quit. I marched backstage and said, "What the hell are you doing?" And Tommy said, "Oh, we only do half-hour sets." I asked him if he'd explained that to the man when setting up the gig, and he said no. I said, "Bullshit, motherfucker, you're playing forty-five-minute sets because that's the custom 'round here." I told him I'd fire his ass... They went back on, oh shit, they were celebrities...

On April 30, just three days after the official launch of 13th Floor, Inc., a report by Scott Holtzman in the *Houston Post* announced "Rocky [sic] and Tommy have exited the 13th Floor Elevators, leaving them with no lead singer."

However, this was just the beginning of Jack's problems, the start of internal wrangling that split the band in two, ultimately leaving IA's incompetence unaddressed.

Jack McClellan (K): Right away, it began to be apparent that the band was composed of two factions: Emma Walton being the actual force behind one, with John Ike and Ronnie, the other being Tommy and Roky, and Stacy was the swingman. Stacy was the band. By far and away he was the best musician, the one with the most soul. Ronnie ran a close second. John Ike had the most enthusiasm and he was clearly the sanest one.

Meanwhile, not only were the gigs starting to suffer, but rehearsals in Kerrville were also starting to break down. Roky couldn't perform the words, Tommy was insisting on everyone taking acid while they played and live band arrangements of the new material were degenerating into meaningless jam sessions. As John Ike observed in 1973, "Jesus, they got so high that practice sessions, concerts, everything became a jam. Well, anyone who can tune can get trashed out and jam, but who wants to hear that?"

Although band observers had long wondered what the long-term affects of using acid would be, the answer as of spring 1967 wasn't clear, as Powell admitted: "We were all wondering what taking that much acid would do to these guys, and while carrying on the life of a working musician at the same time. We were watching for psychic crumbling..." Now it was the turn of the band to question its productivity in relation to their music. While John Ike was a natural voice of discontent, Stacy was expressing doubts, and Ronnie conceded that one of their biggest problems was "mostly just Tommy's idea that everybody ought to take acid all the time, especially when we played or practiced... We had been working on all the other songs, pretty much—out at Stacy's ranch, at the hunting cabin... 'Slip Inside This House' and all this, but we never got to record them."

Despite pressure from within the band, Tommy remained firm in his belief that he was working on a refined form of consciousness and that

acid was still an important tool in that quest. The Elevators were still a huge attraction, and despite their reputation as an awesome live act, Roky and Tommy's erratic behavior meant that shows weren't being performed as contracted. Their booking agents, Talent of Texas, were finding it increasingly hard to book the band because promoters weren't willing to risk it. IA had tried to solve the problem by holding the band in a hotel room prior to shows and then driving them themselves. Talent of Texas faced the same problem and came up with a new and desperate measure.

Also signed to their books was a band called Bryan's Blokes. They played covers of British chart material at frat parties, but soon they had a new role as substitute Elevators. They were booked to support the Elevators, and when Roky or Tommy failed to show, the house lights were darkened and the lightshow was concentrated on the band so no one could see who, exactly, was on stage. The situation got steadily worse when Stacy started playing truant. Even if Roky and Tommy didn't make a show, the band could still go on, but if Stacy didn't show then the musical foundation of the band was missing and the show didn't hold together. Eventually, Bryan's Blokes became so rehearsed at playing Elevators songs that they eventually knew the whole setlist, which they played as an alternative to their British numbers at underground clubs. As Ronnie recalls at the Living Eye, "There was a band, they did all Elevators stuff! This one other band just copied everything, it was kinda nice but they'd do it and then we'd play... that was kinda weird." The situation became so confusing as to who the real band was that some advertisements had to expressly state "the original 13th Floor Elevators."

> **Sibyl Sutherland:** Stacy would have a job and he might get to a little corner grocery in a nearby town, and people would go, "Oh look, it's Stacy!" And they'd gather 'round and he'd play for them all evening and just forget all about that he was supposed to be at a certain place at a certain time. Roky did this too, so between him and Stacy, they caused people to dismiss them and let them go.

Eventually Talent of Texas went out of business citing the Elevators' total disregard for playing as contracted. In return for their failure, they reported the band to the Internal Revenue Service, claiming the band were earning significant sums without declaring it. Ironic, given their penniless situation, and it was up to Emma Walton to drive to the IRS in San Antonio to plead the band's poverty and redirect their attention to IA.

After a rehearsal at Robert Eggar's ranch in Kerrville, Ronnie and John Ike were driving over a wooden bridge across the Guadalupe River with Stacy when they broke the news that they were going to leave the band. This was no hasty decision, but a battle for the heart and mind of the group. By electing to leave, they were forcing the issue. As John Ike had registered the band name "13th Floor Elevators" a year ago, he could refuse to let the others continue to use it. He and Ronnie sincerely believed there was a future for the band and they needed to leave Texas. They had witnessed the buzz of the flourishing San Franciscan musical community, which made the Texan club scene appear a stagnant dead

TOP: SHACK ON THE GUADALUPE RIVER, EGGAR'S RANCH, KERRVILLE, TEXAS;
BOTTOM: HUNTER'S CABIN WHERE THE BAND HID OUT DURING THE SUMMER OF LOVE, SUTHERLAND'S
RANCH, KERRVILLE, TEXAS, PHOTOS BY PAUL DRUMMOND

end. Their plan was to break the band away from IA and sign a new deal on the West Coast, where they sincerely believed major label offers were open to them. Many of their former support acts had now signed lucrative deals, and many mainstream bands were beginning to show psychedelic influences. Since Stacy's original plan had been to sign with a major label in California, they hoped he would split with them and bring Roky and Tommy along too. Stacy was a crucial force in the band; whichever way he turned would dictate its future. If he joined them, and Roky and Tommy refused, they would be forced to find more reliable replacements. Given the current situation, it simply looked like the band wasn't going to continue. Meanwhile, Jack McClellan was preparing to sue IA and free the band from their contracts.

However, instead of the great escape, the situation degenerated into a triangular power struggle between IA, John Ike and Tommy. The dynamic between Tommy and John Ike had somehow worked until now, the two extremes being equally important in producing the band's unique persona. While Tommy felt John Ike's adverse reaction to hallucinogens was the first crack in his master plan, John Ike anchored them in the real world and helped facilitate Tommy with the "thinking" while he organized the "doing." However, Tommy wanted to maintain the status quo and stay with IA. He felt he had reached a level of understanding with IA by taking acid with Ginther, and this could be hard to achieve at another label. This meant he could concentrate on his ideas without becoming involved in business. Making money or repaying debts were irrelevant to his vision and, as Tommy expressed in 1973, "the band was really just a device for our own education, so that it could pay for itself. In other words, we were just feeding back education so we could make some money, so we could make more education."

> **Jack McClellan (K):** God knows what they lived on. See, Tommy was able to go in there to IA and get these piddling little handouts—maybe fifty bucks to last him a couple of weeks. Totally unsatisfactory trips like that. But all seemingly cool with Tommy, since he got to buy as much acid as he wanted. What did he care about eating or paying back his debts, or that Momma Walton was out thousands? He seemed to be sold on Ginther personally, because he'd once dropped some acid with him, which shows how sophisticated Tommy was. By the time I latched on the band's bankroll, the pattern was already established. Any time they got a couple of hundred dollars together, Tommy would fly up to San Francisco, buy a bunch of acid and fly back. I finally indulged John Ike to the extent of letting him buy a motorcycle just because I felt Tommy had appropriated so much of their bread. He wasn't hoarding it for himself, oh no! He was spending it on all of them. But you can see why John Ike insisted on managing the band, so he could protect his share. I was supposed to clean up all that shit, and what I actually did was just accelerate the process of their disintegration. All this was irrelevant to Tommy. He was willing to sell his soul for stardom; he was willing to let himself be screwed by these straight guys. John Ike wasn't; Roky didn't know.

The IA bosses were shrewd businessmen and did what every record label practices, divide and conquer: recognize the band's hierarchy and prey on their weaknesses. IA made further empty promises to replace equipment, book a national tour and give them more studio time for a new album. Tommy felt that a return to San Francisco would cause more problems than it solved and that by sticking with IA, which was hungry for product, he could gain increased artistic control.

Despite rumors of offers from Capitol and Columbia, Elektra Records had allegedly approached them with a serious offer. The label was celebrated largely for its folk music, but had started having success with rock bands like Love in early '66 and had successfully moved into the rock market. Love's frontman Arthur Lee recommended another L.A. act, the Doors, who issued their eponymous first album in January '67. While not as overtly psychedelic as the Elevators, it was one of the few albums of the era to actually lyrically attempt to address the psychedelic experience. Psychedelia was beginning to enter the mainstream market. Other major label acts were soon following suit; the Jefferson Airplane released their second album *Surrealistic Pillow* in February, which, although essentially folksy, had its trippy moments. The Byrds evolved their "folk-rock" sound into "raga-rock" with studio effects on the excellent *Younger Than Yesterday*, issued in March. This album followed on from the Beatles' recent backwards sound effects and was brilliantly fused with their love of Dylan. Although neither of these two LPs had the driving sound of the Elevators, the Doors did. It made absolute sense that the Elektra label that later signed two of the noisiest bands of the Sixties (MC5 and the Stooges) would have wanted the Elevators. Although Jack McClellan was skeptical, he acknowledged that there was interest. Nevertheless, Ronnie firmly believed there was a clear offer from Elektra, and they were serious about buying out of their contract with IA.

Jack McClellan (K): I have no evidence that they had serious discussion with any big record companies. I do recall having talked with one gentleman, who indicated, "Yeah, if you can get them loose from International Artists, we'd be very interested..."

Ronnie: At the time there was a possibility that Elektra Records was interested in us, and if we would have just held out, you know... I don't know, a lot of ifs... There was a deal where Elektra Records wanted to buy us... and offered I think $100,000, and IA didn't want to sell. I think we would have been a little better off. But then they promised them that they'd get them out on the road soon and—they bought them all this new equipment—all these new Standel amps... newer models than we had, and then three months later they took it all back and traded it in for stuff for the Bubble Puppy, you know... that way they stuck with them, I just didn't trust them.

With Tommy sticking with IA, John Ike cracked. He had largely managed to survive with his enthusiasm for the band and goofy sense of humor still intact—until now. In his eyes, Tommy had become the single focus for the band's failings, and he set about vilifying him. If Tommy could be

discredited and his authority broken, then maybe the band could continue. Other than manufacturing Roky's consent to join the band with psychedelic drugs, everything Tommy had contributed seemed detrimental. The jug was an annoying appendage that detracted from the professional musicianship of the band. Besides, who needed meaningful lyrics? They were unnecessary for people to dance to. He also suspected that Tommy had taken undue credit for Roky's songs. Furthermore, Tommy's complex lyrics compromised Roky's dynamic performance and stifled his voice. Worse still, Tommy attempted to coach Roky in how to perform the lyrics with the music, which infuriated John Ike, since Tommy had a range of three notes. Then there was the question of drugs. Tommy's criticism of other bands such as the Rolling Stones for taking speed and his denial that acid was even a drug was beginning to wear thin since the fiasco at the Houston Music Hall, which was all the proof John Ike needed that acid was poisoning the group's sound.

> **John Ike (K):** I couldn't believe the other guys weren't in the same condition I was when I took that stuff. I knew one thing, my mind was wasted and my body was wracked, and I had died and gone to heaven the very first time. It was Tommy's trip that nobody could be a whole meaningful person unless he took psychedelic drugs... that was his hold on the band. Roky was going crazy, Stacy was going crazy and I said, "Fuck you, man," but all Tommy could say was, "This band isn't just a way to make a living, it's a way of life." Tommy was quite literally a filthy human being... If you look at all those old pictures of him playing you'll notice he wore a heavy coat and it soaked down with sweat. From the front it was bad, but from the back it really got outrageous. We'd almost gag on stage. After three or four gigs, we couldn't ride in the same car as him; he must have had no sense of smell...

> **Stacy (K):** John Ike really felt bad because he didn't take acid, he was secretly ashamed, he wanted to take it but he was deathly afraid of it, and I could understand why.

John Ike's enthusiasm was gone. The situation had become unworkable, and he felt betrayed and cheated. He was willing to risk his future in the band by challenging Tommy's authority, which he believed had directly caused the band's decline. While John Ike felt devastated by the band's situation, his mother Emma had a surprisingly balanced view of the situation.

> **Emma Walton (K):** As for the boys, they each had a touch of fame out there in California, and I think it had great impact on each of them, perhaps—in John's case, to his detriment. I think if John hadn't had to hassle with IA so much about money then he'd have been more inclined to go along with Tommy, but the constant conflict just made him a nervous wreck.

Unable to actually leave due to their contracts, i.e., until suitable replacements were found, Ronnie and John Ike continued to play with the

(MAY 14, 1967) *DAILY TEXAN* AD FOR NEW ORLEANS CLUB

band at the Living Eye. While the new Vulcan Gas Company put on highly successful and well-publicized shows at the Doris Miller in May, the Elevators managed to scrape through a handful of appearances in Austin. At the Torch Club they held an open audition for a new drummer after their set.

> **John Kearney:** The word went out that every drummer that wanted to audition with the Elevators was to come. Del Rutherford who was one of the better drummers did, and several others... and the thing I remember about the gig was that they were playing their own music by that time, but the go-go girls couldn't dance to their music and that's not a good sign, when people can't get up and dance, wow, skating on thin ice.

On May 14 the band was back at their old haunt the New Orleans Club. A mixture of rumor of the band's split and impostor members meant that the advertisements in the *Daily Texan* clearly read "TONITE! Rocky [sic] and the Original 13th Floor Elevators..." Not only was this one of the last-ever shows to feature John Ike and Ronnie, but it was also their last Austin appearance. Typically, unforeseen circumstances dictated the future. Although auditions had started to find a new rhythm section, Stacy remained irresoluble when it came to his future and the final fate of the band continued to hang in the balance. Stacy elected to remain with Roky and Tommy because he still believed in their quest, but conversations back in Kerrville with Ronnie and John Ike continued to cause him doubt. They had a good case for leaving Texas and starting fresh, but without Roky and Tommy, the Elevators wouldn't have been the same band.

However, the final straw came when, two days after the Austin show, Stacy was busted by the Kerrville cops and was found in violation of his probation, which meant he couldn't leave Texas without becoming a fugitive.

> **Sibyl Sutherland:** Well, he was taking a boy home that was drunk; of course he wasn't supposed to be 'round drinking or anything. And

they arrested him for that.

Heather Sutherland: They got in a fight...

Sibyl: ...and were yelling and screaming and somebody called in and reported them and he says he was trying to make him get in the car so he could take him on home, and the deputy, when he rode up, said "Ha, smart boy, we got you," and they'd told him, leave town or we'll plant it on you, we'll get rid of you one way or another, and they really had a campaign on.

Heather: He'd probably been drinking himself.

Sibyl: Well, he may have been...

What appears to have happened was that Stacy was trying to get a drunken friend out of trouble, and his efforts to keep the guy inside the car got reported. When the cops showed up to investigate the commotion, they found in the back of the car exactly what they needed, marijuana stalks, stems and seeds, the debris of someone rolling a joint. This time Stacy wasn't so smug; his arch enemy, the local vice squad officer, Tommy McDaniels, had him at last.

Stacy's arrest appeared to signal the end of the Elevators completely. Whether he favored splitting with John Ike and Ronnie for California or being persuaded by Tommy to stay was irrelevant; he now couldn't leave Texas for the foreseeable future. With any hope of rescuing the band's future seemingly in tatters, all that was left for Jack to do was to spring his last two remaining clients from their contracts so that they could head for the West Coast. Despite his bullish façade, the personal implications for Stacy were devastating. In a further cruel twist of fate, this meant that with no money he became subjugated to the record company lawyers who spent the next two years stalling the clear-cut case of probation violation. Being a true Southern gentleman, he remained loyal and honored his side of the bargain with the company to the bitter end, no matter how infuriated or despondent he became. The "black cloud" had moved firmly into place, and his premonitions were starting to come true. His long-term girlfriend Laurie, whom he'd dated since March 1961, split with him that summer. Time in the penitentiary now seemed inevitable, just like his grandma had predicted. Stacy, already over-emotional, now had genuine cause for his dark moods, which were to earn him the nickname the "dark angel."

While the evidence was being tested, Stacy was released and the band were still due to play their slot at the Living Eye in Houston on Friday (May 19) and Saturday (May 20) nights. The band was approximately into the fourteenth week of their overlong residency. The club had had various house bands, including the Red Crayola and the Misfits (later the Lost and Found), but the Elevators had proved one of the longest running. The club itself was decorated with suitably psychedelic regalia, a black-and-white checked floor over which the dry ice rolled, huge eyeballs painted on the walls and a heartbeat sound that pulsed through the PA system. During

the Elevators' tenure they had various support bands, including the Lemon Frog, Thae, the Smoke, Fever Tree and Elevators impersonators Bryan's Blokes. IA weren't taking any chances, and took the precaution of booking an off-duty cop as security again, who stood at the side of the stage. Despite the shabby state of the band, club regulars confirm they could still perform well right up until the end.

> **Jerry Lightfoot:** Last time I saw them do a meaningful gig was at the Living Eye in '67. I remember watching Stacy playing and he set up a riff, might have been "Levitation," and all he had was an old Standel amp and this old setup. He sent this riff off and with the echo it got to where the echo was chasing itself, and he set this whole thing up where it was chasing this lick around the room, literally... and John Ike and Ronnie were so on it, perfect... truly psychedelic, and then Roky just stepped up and blew your head off... it was fantastic! Fantastic!

Jack McClellan, too, despite his reservations over their music, admitted when they got it together they had something that really worked.

> **Jack McClellan (K):** The way most bands tried to get that psychedelic hypnotic effect was just by turning up the volume. The Elevators had extrapolated on that and also used a lot of feedback. Oh, it was chaos... when they really got cooking; they didn't even have to be playing together. It was such a homogenous din they created, it didn't matter, it was mostly a shuck, and yet there was something there. The teenyboppers loved Roky, he had lots of soul. Stacy was simply one of the best blues guitarists I'd ever heard, especially for a white boy. He practiced quite a bit, as did John Ike and Ronnie, although Tommy and Roky never did. I tried to get them to listen to African music, get them into multiple rhythms and out of 4/4, so they could get the same hypnotic effect without all the godawful noise and feedback, I figured once the newness of Tommy's gimmick wore off, they'd have some solid music to fall back on. Just before they split up, Tommy had begun to discernibly contribute to their overall sound. He never actually played the jug anyway, just the microphone; by the time they quit he'd finally evolved into doing a rhythm with it. It was kinda acidy, like the acid roar. Once in a while they really swung, when Stacy was together and when they played the blues, I stopped whatever business I was doing, grabbed a gal and took her out on the dance floor and started to slide.

The following week the band were back at the club for their regular gig, however, on Thursday the court of Gillespie County ordered a warrant for Stacy's arrest. As usual this was executed with the maximum amount of macho overkill possible. Instead of simply issuing Stacy with court papers demanding his appearance at a court hearing, the Houston cops went for the full spectacle and arrested him while he was on stage. Just as the Elevators were striking up with the second song of their set, the cops who had been waiting in the club made a move to arrest Stacy, and the crowd acted accordingly.

John Ike: One time at the Living Eye in Houston, they [IA] hired an ex-narcotic cop to stay with us to keep the other ones away, and that same night the Houston vice squad comes in and arrests Stacy offstage and the cop we had was in the dressing room while we were onstage. So Stacy got arrested anyway!

Stacy (77): I had them jump up on stage one time when I was playing, and they grabbed me, right in the middle of "Fire Engine." And I handed one of them my guitar, it was turned up full blast, it started screaming while he didn't know what to do with it. And they took me through the crowd and the crowd started throwing Coke cups and stuff at them and started rushing at them and stuff and they freaked out and pulled their guns out and backed out to the car. And it really upset this one cop, man he freaked out, because he thought they were going to mob him, you know. And I was on acid and everything and my head's spinning 'round and he got me in the car and told me he was going to kill me. He said "I'm going to take you outside of the town, and I'm going to kill you. And I'm going to tell them downtown that you tried to take my gun away from me, punk." And he'd go like this at me, you know [gestures] and I'd jump and see stars... I didn't think they were really going to do it, but I was so freaked out on acid, man, when we turned out on the freeway heading out of Houston, I freaked out. I started saying, now wait a minute man, can we calm it down. [Laughter.] I freaked, when they took me out of town and turned around, they just wanted to shake me up, and they knew I was on acid...

Q: Bet you were really glad to get to a police station.

Stacy: Oh yeah, I was really glad, I was...

Ginther got on the phone and "pulled some strings," but he failed to get Stacy out on bond (this time set at $5,000) in time for their appearance on *The Larry Kane Show* the following [Saturday May 27, 1967 11:30 a.m., Channel 13] morning. Word had spread of Stacy's arrest, so everyone tuned in to see if he'd been released yet. He hadn't, and yet the band attempted to perform "Don't Fall Down." The choice of song and Stacy's absence meant that Roky's performance was thrown, even though he was miming. "Never quite sure, never quite sure," Kane commented.

Despite the uncertainty of the band's lineup, tentative bookings had been made on the West Coast. Wherever Stacy's final loyalty lay was now irrelevant; the final decision had been made for him with the drama of his arrest. A court hearing was scheduled for June 8, and he was no longer free to leave the state of Texas. The band was booked for their first show on Saturday, June 3 at KFRC radio's Magic Mountain Festival in Marin County. The program boasted an impressive lineup which included many of the best acts on the West Coast: the Byrds, Tim Buckley, Country Joe and the Fish, the Doors, Jefferson Airplane, Moby Grape and the Seeds. The Elevators were also booked back at the Avalon Ballroom at the end of June. Chet Helms was cautious about giving the band headline billing, and gave them second billing to the Charlatans. When Mayo Thompson

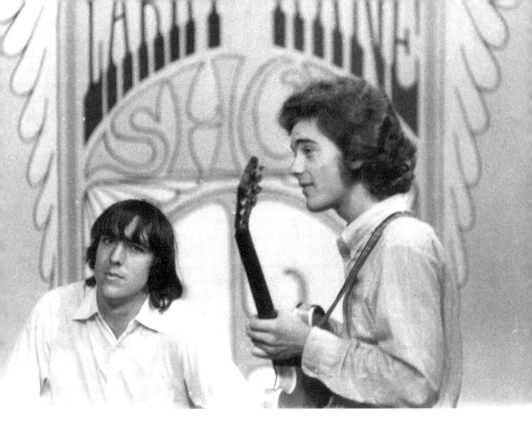

(MAY 27, 1967) JOHN IKE & ROKY APPEARING ON *LARRY KANE SHOW* TO MIME "DON'T FALL DOWN." STACY WAS IN JAIL, PHOTO BY GUY CLARK

arrived at the Avalon trying to secure the Red Crayola a booking, he recalls, "We cooled our heels on Chet Helms' couch outside his office one afternoon, couldn't help overhearing him talking to someone about the Elevators and their travel problems. As Mr. Helms' conversation seemed to go on… we left." Even though the band's lineup was in turmoil, Tommy maintained that they wouldn't have played alongside a band named the "Charlatans" anyway.

Jack McClellan prepared for all-out conflict by suing IA on behalf of his remaining clients. To actually sue IA was a hard move for Emma Walton, as the Waltons knew both the Dillard and Ginther families personally and, particularly, Ginther's family had been socially prominent in the Kerrville area. However, IA's anemic assessments of the band's financial status didn't tally with their estimated earning capacity. As Emma Walton put it, "they [IA] were lazy and incompetent," and since they hadn't bothered to promote the boys, she was going to teach them a lesson by recouping her investment.

The exact situation wasn't known, and Jack had to make an educated guess as to how much IA were holding out on the band. At this point Stacy was sticking with Tommy and Roky, so John Ike surrendered the band name in return for the nullification of the remainder of his and Ronnie's contracts. As Ronnie recalls, "Because John Ike owned the name and let

THE KERRVILLE, TEXAS, COPSHOP WHERE STACY WAS A FREQUENT GUEST, PHOTO BY PAUL DRUMMOND

them use it... we got out." Although this meant John Ike could no longer play the Avalon as the Elevators, it did mean he was free to go and form a new band with Ronnie.

> **Emma Walton (K):** Roky is eternally fresh-faced and young. Neither he nor his mother will ever grow up. He is certainly artistic and poetic, but at the same time he has no mentality at all, as far as the logistics of becoming a successful performer go. He goes into a strange state of high exhilaration, but he can go down into a state of severe depression just as abruptly. I think he needs some kind of constant psychiatric counseling.

> **Jack McClellan (K):** There was only one reason why I got away with as much as I did... they understood that legally I knew what I was doing and that if it ever came to a fight we'd all be on equal terms. When we sued IA, we literally didn't know what the situation was. It was a special, well-recognized type of civil action. Finally, I wound up suing IA for accounting and we settled the case by them releasing John Ike and Ronnie from contract. At that point Stacy swung back under Tommy's control.

For IA, John Ike's departure was a huge relief and they now had the band firmly under their control. Why they didn't sell their contract to a major label, given Stacy's situation and their paranoia over their drug activities, can only be explained by the fact that they had nothing else to work with. However, for John Ike the split was never satisfactory, and to this day he still doesn't feel like he ever reached closure, and continues to try to engage a lawyer to fight his cause and somehow claw back the money due to the band.

Lelan: A lot of problems (with law enforcement)... I know that Stacy got busted and Nobel made some arrangements for somebody to get him set free, and it cost a lot of money. Well, the big drain on IA was constantly trying to fight the law enforcement and the Elevators, because they were not co-operating. They did what they wanted to do regardless, and it was a drain... it was always costing a lot of money because if there was any records of it they would probably owe the record company 40 or 50,000 dollars because they were playing them a salary and paying their rent, they were feeding them, they were paying the studio time, they were leasing equipment, just a whole bunch of things you know. And I don't know exactly, I don't condemn them for it, it was just the time...

Jack McClellan (K): I split out, and John Ike and Ronnie followed me out [to the West Coast]. I was in a state of shock at the time.

As John Ike and Ronnie prepared to head to San Francisco in an attempt to pick up where they'd left off, it seemed like their former band had reached the end of the road. However, about a week before their departure, band rehearsals resumed in Kerrville.

14
EVERY DAY'S ANOTHER
DAWNING—
"EASTER EVERYWHERE"

\mathbf{B}y the time he approached his nineteenth birthday, Danny Galindo felt like a veteran of the Texas music scene.

Born in San Antonio on June 29, 1949, he moved to Austin to study a degree in nursing and courses in dentistry, biology and music at the University of Texas. Inspired by the black music he heard on the radio in '62 and '63, Danny bought himself a Takamine electric bass and rented an amp. On the way home he stopped at a friend's house and formed a band. Although Danny never lost his ear for soul music, he inevitably started listening to the English bands that were selling American blues back to the States. In mid-1964 the Stones made an unsuccessful attempt to crack America. The second engagement of their first tour was an appearance at the Texas State Fair in San Antonio on June 6 and 7. Bill Wyman recalled that the audience consisted of kids and cowboys, who wandered around watching the rodeo or looking at the agricultural displays while the horrified Stones took the stage after a troupe of performing monkeys. Two of those kids were the Galindo brothers, and soon they were playing their own gigs in San Antonio, covering the hits of the day.

In the late fall of '65, Danny and Robert received a desperate call from Max Range in Port Aransas on Mustang Island near Corpus Christi—his backing band, the Lingsmen, were leaving town that night and the Galindo brothers and their fellow Loose Ends (they could never end a song) arrived to see the Lingsmen beating a hasty exit. The Loose Ends were renamed the "Laughing Kind" for the gig and lasted a handful of shows before returning to San Antonio. A few months later, Danny heard "You're Gonna Miss Me" oscillating across the radio waves and was immediately taken by the sound.

Danny: I instantly snapped and liked that song, I was a really big fan, I used to drive up here to Austin to watch them play... What were they like? Most of the time I was standing there with my chin on my collar going "Wow!" (Laughs.) It was not just a band playing, the whole thing was an experience... it was all happening between the people in the crowd, each of them and that was energy going in all these different directions, there was some sort of strong, very strong connection and that's where the cultist thing came from... to make contact with human beings based on a totally nonverbal communication. And that was an experience.

In mid-April 1967, the Elevators were playing the Doris Miller and Danny had agreed to split the gas money with his drummer friend Danny Thomas. Danny Thomas had never seen the Elevators, but was strongly urged to go by his roommate Charles Brooker (who had grown up with Stacy in Kerrville). En route, Danny Galindo decided to stop off at a little rail house out on Riverside to score something for the concert. The two Dannys were deep in the middle of a jam session when a motorbike thundered up and a mystery guitarist joined them.

Danny Galindo: By late that afternoon, we had somehow diverted ourselves into "Puff the Magic Dragon"-land and we were at this house that was just up on a ridge. So we could play as loud as we could, 'cause at the time the cops didn't even have the vaguest notion of what we were up to. [Laughs.] So Danny and I got up and we started jamming and it clicked and Danny and I were really playing well. And Stacy walked in the door, and we didn't know who he was, "Oh, a guitar player! Man, let's get..." So he pulled out his guitar and we kept on jamming. As I remember it, it was magic the way we was playing together; little did I know... where that connection was coming from at the time. But I was totally blown away, that's probably one of the times I really impressed myself... And later that night we went to the Elevators concert and the whole time I was sitting up there really digging them, but I was thinking, "Goddamn, man, there's no way in the world this band sounds as good as Stacy and Danny and me a few hours ago"... That's very cocky and egotistical, but that's honest...

Luckily, Galindo had the foresight to slip Stacy their phone numbers.

Danny Thomas: I was back at college caught between the military draft and life on campus; neither appealed to me. The call was from International Artists Producing Corp., in Houston, to come to interview for the job as the Elevators' new drummer. I was in the car headed for Houston within an hour of that call. I met the band the same day at Noble Ginther's law office in the Americana building in downtown Houston. I had only smoked pot a few times and had never taken drugs. I arrived dressed in a coat and tie with shiny shoes, and the guys in the band were in jeans and leather with Indian beads and cowboy boots. I never auditioned. Roky and Tommy took Stacy's recommendation without question... we just drove to

Kerrville and went to work... We always had a great time—it was a magic summer.

Danny Thomas had a very different musical background to the Elevators' previous drummer. Born on January 15, 1948, in Charlotte, North Carolina, Danny had studied the rudiments of composition and received a formal musical training. Like Galindo, he was largely influenced by soul music and had toured the Carolinas from 1960–64, playing drums with the Caravelles, and then toured the Midwest for two years with the Soul Brothers, opening for acts like Curtis Mayfield and the Impressions. Upon commencing studies at Trinity College in San Antonio in '66, he began performing in impromptu jazz combos with Galindo at pickup gigs outside cafes.

In June 1967, the world's most popular and successful band released the era-defining *Sgt. Pepper's Lonely Hearts Club Band*. This was the Beatles' first album to be released in America as the band intended, without tracks being culled by Capitol Records.[37] The band had forced the industry to finally take the medium seriously, rather than simply as a collection of hit singles, B-sides and filler material, and the release of *Sgt. Pepper* ushered in the age of the album. The Beatles cleverly assumed the role of an imaginary band, which allowed them to depart from any preconceptions and experiment with the new genre, psychedelia. However, the unifying concept was abandoned after the second song, only to reappear in the reprise of the title track. Despite the Beatles' album being heralded as a psychedelic masterpiece, the only song to deal with the idea of different levels of existence was George Harrison's brilliant "Within You Without You." While the rest of the world was exposed to mainstream psychedelia, the Elevators, the earliest pioneers, missed bathing in any of the reflected glory. Instead they lived as virtual outlaws, holed up in the Texan Hill Country.

After months of needless delay, their possibilities of touring dashed, the band was forced to start from scratch again. New members were engaged with no fuss, no meetings and no auditions. With Roky and Tommy accepting Stacy's recommendation, they had written the songs and Stacy was the band. The rendezvous was Stacy's parents' ranch in Kerrville. With the recording sessions only two months away, the band resumed their semi-structured rehearsals. There were no concessions for the new members, who were forced to negotiate their way through the anarchic chaos and somehow learn the material.

Stacy (K): We had a bunch of material... but if strange musicians get together, it takes months before they can really communicate... we didn't have time to get into each other's groove. It was much more mechanical from that point on than the original group... I think they saw it entirely as we had a record going... I don't think either of them were really interested in the trip at all.

Q: What happened when they first got zoned?

Stacy: It was really a groove, it was fun, it was like watching somebody go through it again...

Danny Galindo: I thought Tommy Hall was very eccentric, and really my relationship with Tommy and Roky was very distant. I don't really think they felt like we really were... I think they felt we were filling in... that they had lost something they could never really have back. And it was a real loss to them to lose John and Ronnie. First of all, they were an incredible part of their sound; second of all they had played with them a long time. So when Danny Thomas and I got there we had huge shoes to fill. And we did the best we could, I don't want to say we ever filled them, but we did the best we could and in the process the sound of our music changed.

Danny Thomas: When I was first hired to go work on *Easter Everywhere* at Stacy's ranch, the first night Roky played his guitar from dusk 'til dawn! I had never been in a band like this before, I was trying to lay down on my bunk and get some sleep. After going through that on my first night, anything after that was "Well, this is the trip..."

Galindo at least had the advantage of knowing the back catalogue and some drug experience. He'd come fully loaded with the biggest cap of pure crystallized mescaline he could find. However, given Danny Thomas' musical discipline he didn't mind being thrown in at the deep end and viewed the chaos as liberating and an opportunity for limitless experimentation. In contrast Galindo was a perfectionist who was rarely happy with how he or others played; there was always the potential for an ultimate performance. Although he was fully aware that his time with the band was to be his greatest lasting kudos, he seemed ill at ease during his tenure.

They were both extremely aware of the looming pressure of the studio appointment in two months' time.

If anyone had previously doubted Stacy's role as musical coordinator, then he was to prove himself now. Roky and Tommy made little effort to communicate with the new recruits, mistaking Galindo for an Italian, and they remained largely in their own realm, leaving the band to Stacy. They had written the bulk of the new album and Tommy directed his attention to Roky's lyrical delivery and to devising jug parts based on his understanding of classical composition and harmonics in traditional Indian music. Roky was a self-taught and undisciplined musician; he never attempted to write down chord or song structures for any of his songs. Although Stacy was hardly a conventional person, he was by far the most traditional musician and took a folk approach to learning and interpreting Roky's music. It soon became apparent that although Roky had written the music, the only person who had learned the songs and was able to play them was Stacy...

Danny Galindo: By the time I got started with them, Roky was in the state where he couldn't tell me the chords to his tunes. Sometimes he could not remember the words and he could not remember

OPPOSITE PAGE: (SEPTEMBER 1967) ANDRUS STUDIOS, HOUSTON, TEXAS. L–R: DANNY GALINDO PLAYING STEEL
SHEET TO CREATE THUNDER ON "EARTHQUAKE," TOMMY & STACY, PHOTO BY RUSSELL WHEELOCK;
TOP: TOMMY & CLEMENTINE, PHOTO BY RUSSELL WHEELOCK; BOTTOM, L–R: LELAN ROGERS, TOMMY, ROKY,
DANNY THOMAS, STACY & DANNY GALINDO, PHOTO BY GUY CLARK

where he was at in the song. So, it was very difficult to learn the material. The only way I could play was to go to the part he was at, when he went to it, and it was never the same. Instead of telling me the chords Roky would show me the position he was in, and I'd go "well, good... ohh"... but I could figure out when to get there by watching the guy's hand, so I became pretty good at reading him... man it was so hard for me. See, all the drummer had to worry about was tempo, I had to be there on every beat, you know, like note, I had an incredibly tough time. Now Stacy HAD learned the song... I don't know how he did.

However, Danny Thomas was concerned about defining his role in the band because his approach and style of drumming were completely at odds with John Ike's and in turn his style would alter the whole band's sound. Luckily, the first song rehearsed, "Slip Inside This House," was sufficiently removed from the old material to give him an opportunity to prove his proficiency. John Ike, curious and surprised by the band's reorganization, stopped by the rehearsals to investigate, eventually sparking a friendship with Danny Thomas.

Danny Thomas: Roky's guitar playing is adding something from another realm, something I can't describe. I'm a theoretically trained musician, and I know arranging, I'm not just a drummer who keeps the beat. I was involved in the arranging and musical theory, not claiming any credit for it but simply saying I can speak about the difference between Roky and Stacy's musical ability. Roky was self-taught to the point where he played what sounded good, even if he didn't know what the finger was or what the name of the chord was, but he would remember it. And it was absolutely avant-garde and way ahead of its time and unique in itself. In his rhythm playing, he's sort of like an invisible guitar player, but that gave it an "Elevator" feel. When you heard the first few seconds you knew it was the Elevators. It should be credited to Roky because it was a wall of sound approach, which was very difficult for me to get used at first. They were just used to the drummer taking the lead and keeping up and whenever it started to lag, he would push them further and they would step up again. That was where they got their energy from. I got my energy from premeditated arrangements with planned hook lines and changes, what I call "stops, pops and turn-arounds," so they had to adapt to my style as well as me having to adapt to their style. I was a theoretically trained drummer who came from funksville, with a lot of syncopation, not just hell-bent thrashing at the drums like John Ike. So therefore these musicians had never played with a drummer like me before, so they didn't know what was going on. And "Slip Inside This House" gave me the opportunity to prove myself, and I kept it rock-steady through the whole song, but kept it edgy.

While John Ike and Ronnie declared the rehearsals unworkable, it wasn't for the new recruits to question the working practices. Roky's strange quirks and eccentricity was to be learned from, interpreted and responded to. Depending on your vantage point, he was either transmit-

ting back a musical vision from a higher level of existence, or simply too spaced-out to communicate in conventional terms. Although this seemingly abandoned pursuit of inner worlds was deeply unconventional in their locale, elsewhere in the world this preoccupation would have been treated as perfectly ordinary. What is important about Roky during this period is his transition; he had "elevated" and joined Tommy in the position of being a band "godhead." Many felt Tommy had become increasingly dominating, supposedly the teacher but increasingly pursuing his own path, leaving the others behind and only concentrating on Roky. Roky's role was to deliver Tommy's information in the way he required, even though he was communicating less in terms of forming, discussing and explaining his ideas. Life was becoming increasingly restrictive for Roky inside and outside the band.

Roky had either been deified as psychedelic godhead by the adoring underground scene or as yesterday's failed pop star. Straight society had no qualms labeling him the ringleader of a semi-criminal element that was poisoning the minds of the youth, and he was now living as an outlaw as a result.

Despite the remote location of the Sutherlands' hunting cabin, the Elevators remained a target for local law enforcement. Stacy's bust meant he had to stay in the boundaries of Kerr County until after his hearing in June, so they couldn't run him out of town and now the rest of the degenerates from the band had joined him. The band were sitting ducks, stuck on top of a hill. But as long as they remained near the cabin, they were relatively safe.

Sibyl was their alarm system, and the only way up the hill was severely hampered by a series of cattle gates.

The small wooden hunter's cabin where the Sutherlands had their herds of goats and sheep was only a stone's throw from the main ranch house. During the hunting season the cabin was rented to visiting deer hunters. Although Stacy's parents actually lived in the town on West Water Street and had a second ranch in Centerpoint, they'd spent a lot of time at the ranch house observing the band's activities. Although Sibyl liked the polite Danny Thomas and the angelic Roky, she found Tommy difficult and rude—yet putting up with the boys was just another way of treating "her Stacy."

Outside the safety bubble of the cabin, the band was seriously at risk and so began a long summer of cat-and-mouse with the cops. Although the Dannys often stayed in Kerrville, they usually drove to rehearsals from San Antonio. While Danny Thomas was still naïve enough not to feel the heat, Galindo was paranoid from the outset. He made a conscious attempt not to stay in Kerrville, and when he did he stayed at Stacy's parents' house on West Water Street, not at the ranch. Every time he approached the town limits he began to sweat, as he knew the cops had a keen interest in busting the band at any opportunity. The protocol became to stash bags of grass before the town limits and return under the cover of darkness to retrieve them. Safely back at the ranch, grass could be rolled into joints that were then deposited at various markers under the cover of night for later consumption.

Danny Galindo: Like I was telling you, I used to stash joints, roll them up and put them in a Marlboro packet at the base of a sign that said "so and so five miles." We'd roll out and grab it and get back in the car and be moving again before the cop car that was behind us came over the hill... We'd smoke on it and burn it down to a stub and by that time they'd be pulling up next to us, Stacy would be eating the roach and by that time ... those are kind of fond memories...

Despite the presence of his band members, Stacy was still the focus for local hostility. His continued freedom perpetuated the myth that the band was "un-bust-able." A number of recent incidents fueled Sibyl's fears that someone might take exception to Stacy parading around town infuriating the authorities. One night after rehearsals, Stacy and Danny Thomas found a young black musician slumped in a ditch near the ranch and saved his life. The previous summer, the Sutherlands had employed a couple of Mexicans who'd made it across the border. At the end of the summer, one had killed the other at the hunting cabin and made off with his pay. This was all too close to home for someone who constantly feared the worst, and she feared Stacy would be next. Her next-door neighbors informed her that the police had even approached them to drill a hole in the side of their house so they could keep constant vigil on Stacy. On another occasion Sibyl's car had been confiscated in Austin after Stacy had borrowed it, and for some unknown reason the police chief's brother was driving it when it was shot at several times—Stacy was blamed, giving the police further grievance.

In sharp contrast, Beau Sutherland was working in Houston for the federal government.

Beau: Mother and Daddy were telling me stories of what went on with Stacy. It just amazed me, because I had chosen to go to work for U.S. Customs. We were concerned mainly with huge loads of marijuana and cocaine being smuggled across the border. When I heard that Stacy was being followed around in Kerrville by the local police—they all thought he was the biggest dealer in Kerrville—and it really hit home for me. On one hand I wanted to put all the major dope dealers away, but on the other hand I felt sorry for a lot of the kids that were just experimenting with it. I guess it hit me really hard when I was working with the Drug Enforcement Administration later on. I managed to look in some of their files, and I saw they were pulling my mother and father's telephone records. It just struck me as kind of a tragedy.

While the rest of the band riled the cops, Roky's life had grown even more complicated. When asked about this era, he responded, "That's kinda a cloudy place there..." Following his split with Judith, Dana separated from George. She'd left the baby and split back to her childhood town of Kerrville with Roky. They piled all of their combined possessions on the back of a borrowed truck that inevitably broke down before they reached Kerrville, where they shacked up in a hotel apartment for the summer. With no real plans, the two of them embarked on

a summer of pipe dreams, taking acid, rehearsing with the band and hiding from their responsibilities.

Dana Morris: After I left George, Roky and I headed for Kerrville… George came to Kerrville to try and find us, and we're living in this hotel, taking acid, having the best time, and teaching me the lotus position and how to leave my body. It was beautiful. We started getting a lot of flack because I'd left my baby with her father, the world was coming down on us, all our friends, a big scandal. People started coming 'round, friends from my old school, and they were going to beat Roky up, about eight of them. This is a small town and they'd heard, and they wanted to make sure I was okay. So Roky's in there washing dishes, so I say, "Everything's great, I'm with the man I love…" Roky shook their hands and they came in, got to meet him…

So the ballad of Roky and Dana began with a massive moral outrage in the Summer of Love.

Lelan Rogers and Bill Dillard visited Kerrville to check on the band's progress. Lelan was in no doubt that the band needed to be out of harm's reach: "They were rehearsing up in the hills in Kerrville, up in the mountains where they wouldn't bother anybody."

On June 8, Stacy was at the Travis County court in Austin to argue why his probation shouldn't be revoked and his two-year sentence imposed. His record company lawyers now protected their investment and took full advantage of exploiting the complicated technicalities of Texan law and Stacy's liberty remained intact for the time being. Stacy knew he was only prolonging the inevitable and the stress manifested in further dalliances with downers and barbiturates, and a dark cloud was moving over him.

Although Sibyl secretly liked the band's music from the safe distance of the ranch house, their long stay was proving too much of an intrusion, with the mixture of Tommy's weirdness and the band's general sloppiness, and so she had her husband G.C. kick them out.

Sibyl: Irresponsible! Tommy, that was the weirdest boy I ever knew in my life. He was rude… I would try and talk to him, because I wanted to know something about him, after all, I was treating him. I would come and say something to him and he would be reading some weighty tome and he'd get up, close his book and walk out. Just ignore me, like I wasn't worth answering, until I was just seething at him… Tommy picked up a [cock] roach and ate it, all those feelings of revulsion are just… "It's just protein." If he hadn't got in there you [John Ike and the band] might have made it, nobody knew anything about LSD at the time. They thought they'd discovered some great thing, where you could learn in minutes what it took a lifetime to learn, that it went through the cortex of your brain, and you would gain all this instant information.

John Ike: That's what Tommy believed.

Sibyl: While they were out at the ranch I was buying food and taking it out but they would leave all the lids off the jelly jars and they would drink tea all day, which was all right by me except they spilt it, sugar and tea all over the floor and you stuck when you walk. I'd go out there and mop and mop, I'd find cups and things under trees, irresponsible. Finally my husband told them to leave and they left some appliance plugged in and it burned and melted and it could have burned the whole house up.

The band shifted operations to Robert Eggar's ranch. The riverbank of the Guadalupe flanked them on one side and a long open field protected on the other, exposing any intrusion by law enforcement. Adjacent to the main house was a corral, and opposite was a series of small wooden huts, which the band camped in. Rehearsals also alternated with Doug Fossler's ranch for extra safety. By now the band had started to learn to work together musically, either working up existing songs or simply jamming together. Roky and Tommy's writing sessions in the spring had yielded some new material, but there still wasn't enough for an entire album, so word was sent to Clementine in San Francisco, and her arrival mid-summer wasn't without event.

Clementine: Yes, our relationship was a whole lot looser, although we were very attached to each other. But Tommy thought it was a good idea for us to welcome other people into our marriage—open it out a little bit. I loved Tommy very much, but I didn't really want to possess him. And also I felt that if he grew in a different direction from me, he had every right to. Tommy said, "You've got to get back here—we need you here when we're making *Easter Everywhere*." On the way there I had a miscarriage, and so I checked into a hospital in San Antonio. It turned out the doctor who helped me with my miscarriage was the doctor who years before had delivered my son, which was a wonderful thing to find out. And then I went and recuperated at this little ranch where they were rehearsing. I mostly lay around on couches and stayed with them and watched them. Played mother to them.

One particular Roky composition that had found little favor with Tommy was handed to Clementine on a cassette tape. On a visit to her father's ranch near Kerrville to see her daughter, she began to write lyrics to Roky's melody. The new song, "I Had to Tell You," retained the subdued warmth of her previous composition, "Splash One," and became one of the Elevators' few quiet songs.

They were working on the song when Mikel Erickson made a rare visit to the closed rehearsals, and its unusual beauty struck him as much the deep level of secrecy that now surrounded the band's activities.

While the band rehearsed in Kerrville, John Ike and Ronnie had attempted to re-launch their careers in San Francisco, but toward the summer's end they were back in Kerrville.

John Ike: We tried to get something going with different bands, but

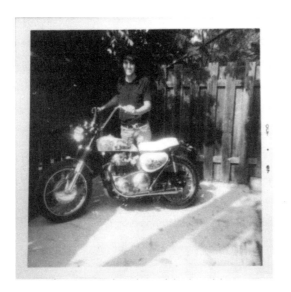

(October 1967) John Ike and new bike 13th Floor Inc. had afforded him for lack of payment, courtesy John Ike Walton

nobody... none of them panned out. We took a lead guitar player with us, Johnny Richardson (from the Wig), he was really good. He'd just got married and he left his wife to go out there to hang out with a rock 'n' roll band. And she called him and said; you know, "Either get home or stay out there." [Laughs.] He went back home.

Ronnie: I had an offer to play with the Grass Roots... they were looking for a bass player, but I was still sticking with John Ike and trying to do something with him. I probably should have gone with them, because the next month they had a big hit...

The Grass Roots had fourteen Top 40 hits, including seven gold singles and one platinum. However, they weren't a real, but a side project for songwriters P.F. Sloan and Steve Barri. When their first single took of a band had to be hired to promote it, but resigned when they realized session musicians would be used for recording. John Ike has always maintained that as soon as the 13th Floor Elevators left California another band stole their name and capitalized on their absence; the second band recruited as the Grass Roots was an L.A. band called the 13th Floor.

With John Ike's career stalled and the Elevators about to leave Kerrville to record in Houston, the Waltons launched another legal assault in case the resultant album was a huge success. On July 24, it was agreed that Roky, Tommy and Stacy would pay the Waltons 40% of their royalties from the next two albums (and 30% after that). John Ike was also claiming $240,000 in damages and Emma Walton $86,400 against IA Producing Corp, International Artists Records, Inc., Tapier Music Corp. and Tapier Publishing Company. IA wired the usual $200 sub to Tommy in Kerrville

on August 22 and the band checked into the Chief Motel on South Main in Houston the day before recording was scheduled on the 25th. Roky left Dana in Kerrville, advising her "You're going to have to go back to George." For Dana there was no going back, and she rang a girlfriend in San Francisco and left for the West Coast. As soon as sessions started, they stalled while the next legal interjections from the Waltons were addressed. In order not to waste any studio time, IA rushed the Lost and Found into the studio to record instead.

Roky, Tommy and Stacy signed 10% of future writers' royalties to Emma Walton and agreed to pay Emma $7,500 in the form of an advance on record royalties through IA ($1,100 on release of *Easter Everywhere*, 25 cents on each album above 4,400 sold, excluding the first album). For the remaining Elevators, it was just another annoying blow to an already unsatisfactory situation. For the Waltons it was a last chance to try and claw back some of the money they had invested, but as usual IA remained a black hole. In December '67, when John Ike received royalties for the two songs he performed on *Easter Everywhere,* the check, payable for $4.06, bounced.

On August 30 the band were back in the studio. With the band in town for a month IA billeted them at the slum-like Western Skies Motel, which Golden Dawn drummer Bobby Rector fondly recalls...

Bobby Rector: To show how bad this motel was, we checked under the bed to make sure we hadn't left anything, and there was something under there, so we pulled it out... it was a potato that had been growing in the mud and dust and had taken root in the carpet... it was... ohhh...

Back in Houston, they had a far more aggressive urban police force to deal with than the Kerrville cops, and the number of near-miss busts escalated. As Danny Thomas recalls, "We would not take the same path twice, because we were street-smart and we knew how to keep them off our trail." However, Danny Galindo was so paranoid that he elected to stay with an old college friend instead of with the band. Yet on one of his visits to the motel he managed to flush a jar of grass down the toilet as the police were kicking the door in. The real "acid test" for the Elevators was whether you could handle spending a night in jail while tripping; as Danny Galindo recalls, there was real paranoia: "Could you handle it? Could you handle it?" It wasn't long before Danny Thomas experienced it.

The recording sessions lasted exactly a month at Andrus Studio, between August 25 and September 25, immensely costly and time-consuming by IA standards. Lelan Rogers took the production credit and once again was the company man who babysat the project. The band, as always, recorded while tripping on LSD, which meant erratic hours usually starting at midnight. Typically they would record for a couple of hours, listen back, rehearse and resume recording until the early hours when they came down off the acid.

As Stacy confirmed, "we were taking acid constantly when we cut it." And, as usual, Tommy felt everyone would benefit from taking it.

Lelan: Tommy, I remember, put a little acid in my cup of coffee while we was recording and Stacy came and told me about it, said, "Don't mess with it, because that'll really put you in a different place." And I didn't and I really got after Tommy after that! So what, we all got along good, they were just kids, kids of the Sixties. And you know the guys were great, but they always did things in their own time—all worked at night. I always thought *Easter Everywhere* was probably the best album we ever done.

Stacy (K): He was the Silver Fox, Lelan was an ol' cat. He had those white shoes on, you know? And he was a [laughs] just a groovy dude... He'd smoke weed with us, he didn't want the other two (Dillard and Ginther) to know... He'd say, "Don't tell on me"... I liked Lelan; he'd stand in on all our sessions. He really knew we were getting a bum deal and really hated it... but he was providing for his kids, and he got fucked over by the other two good.

Q: Did he ever do psychedelics?

Stacy: No, he never did turn on acid. He was an older fella, like hell I guess fifty-five, fifty something [b. 1928, thirty-nine in 1967].

Q: You felt he understood your music?

Stacy: Sure do.

Although Walt was present and engineered a large amount of the sessions, it was his colleague Frank Davis who was credited as the album's engineer. One reason for this was that Walt had recognized the Elevators' unfulfilled commercial potential and recorded their song "Splash One" as an "easy listening" pop song with a local band called the Clique. This version, released in August '67 on his Cinema label, soon started to chart locally and was picked up by Scepter Records in New York, who had some mild national chart success with it.

Stacy wasn't happy with being back where they had started at Andrus Studio. Despite the implications of his probation, restrictions that prevented him from leaving Texas, he was still clinging to the hope that IA would honor their promise to record the band in Nashville, which they did not. However, the Elevators recording in Nashville would clearly have been a disaster; unsympathetic studio staff would have little time to facilitate their erratic or eccentric working practices, let alone their drug usage. Andrus Studio had Frank Davis, who was utterly sympathetic to the band's wishes, and like them, preferred the freedom of working at night. IA weren't being cheapskates by using Andrus Studio for the nighttime sessions; Walt charged his top rate of $40 an hour for the inconvenience. Although Frank was thirty-two, and therefore considered a grown-up, his keen sense of fun and ability to play meant he was the perfect person to capture the Elevators' sound. He smoked dope, even grew it, but was very wary of where he left his coffee cup, lest it be surreptitiously dosed.

There was an intense level of trepidation as they approached recording the new album. They only had a little more studio experience than the previous album, and they felt a huge pressure and obligation to deliver a perfect album of material, performances and sound. It was accepted that this was Tommy's vision and Roky's tunes, but Stacy was adamant that, unlike their previous album, he was going to capture the full intensity of the band's sound. He wanted to emulate the Beatles' recording process by recording the bass and drum tracks first and then recording each instrument as a separate track to give greater clarity and separation. The studio had been specially upgraded to a state-of-the-art eight tracks (the Beatles recorded *Sgt. Pepper* on four tracks at Abbey Road), which allowed far more experimentation with overdubbing new sounds and effects. However, Tommy wanted to capture the essence of the band playing live at their chemical peak. Roky agreed, thriving on the excitement of the performance (usually playing the same song differently every time depending on his mood) and not systematically laying down instruments track by track. Stacy won his case. Danny Galindo had his reservations from the outset; the band was under-rehearsed and simply needed each other to be able to complete a good take of a song. This became apparent on the first and longest song attempted, the unbelievably complex "Slip Inside This House."

They started with the hi-hat cymbal, which never really changes throughout, and then tried to move on to adding bass and guitars but no one knew their part well enough except Stacy. With the song arrangements unfinished and the band still not gelling 100% musically, Danny Galindo and Tommy managed a compromise with Stacy, as Walt Andrus recalls: "They cut all the tracks live and then Frank went back and replaced each instrument so they had total control and separation on it."

On September 2, the band unearthed the unreleased track "She Lives (In a Time of Her Own)" from the January '67 sessions. Tommy fully intended to use this and "I've Got Levitation" as part of the *Easter Everywhere* project, and so they decided to mix "She Lives" to contrast the present band's sound with the old rhythm section.

> **Frank:** Stacy wrote the guitar parts and he had a real flavor, a real definite flavor that was unlike everyone else's, but Stacy was kind of, I would say, down-to-earth, I guess more than anyone else, but he could certainly get whacked out. In some ways he was the most traditional. Although the bass player and the drummer were great, they didn't have to do too much work. Stacy, Tommy and Roky were really the nugget of it.

Roky was either rebelling, unwilling or unable to adhere to the discipline of the studio. When it came time for him to overdub his rhythm guitar parts, he'd never tune his guitar to the same key as the others; he'd turn his guitar all the way up to ten, jump up on top of an amp, and refuse to stop playing at the end of the song. As a result, Stacy was forced to tune all the guitars to the same key, and often he'd overdub his performance of Roky's parts over Roky's flawed takes. As Jerry Lightfoot remembers,

Stacy grew to resent Roky, and complained, "Goddamn it, he can't even tune his own guitar!"

For Roky, the studio was now becoming a restrictive burden that didn't allow him to express or enjoy himself.

> **Roky (NFA):** It seemed like it was more curbed. You have to experiment with your guitar before you can find out what you're doing. Like, I feel the whole idea of creation was forgotten later on in the years, you know we weren't creating as many new experimental vibrations… it got kinda blasé, to me it did. You know when I first started it we were playing all this screaming feedback and everything and now all we're doing is just… you know, "Slip Inside This House." You know there isn't enough feedback and there isn't enough excitement in it on the record. But the idea is captured and people, they like it. The Who came out with this song called "Can't Explain" and they have lots of feedback and fantastic drumming and they quit doing that and start doing stuff like "Tommy" and you're let down from it…

> **Tommy:** It's half and half because the words are states of mind, and the music is the emotion you feel with that state of mind.

As Danny Thomas observed when interviewed by *Mother* magazine after recording the album, "It's like the lyrics have the main emphasis and the music is used as an accent and vehicle for the lyrics." The studio atmosphere was also proving too much for Danny Galindo, who was finding it hard being in Texas' most legendary band when such rudimentary musical issues were being fought over.

> **Danny Galindo:** I think Frank was frantic with the case that we were impossible to work with. And he had to work with us… so he was in a very compromised situation, he recognized what was happening but he didn't act on it or speak on it. His body language told me that recording this album was driving him nuts… because he could hear a lot of things none of us wanted to hear… He had a more realistic perspective, and what sounded good to us sounded like shit to him… So by the time you put all these tracks together, they sounded like a cacophony of dissonance. But you see, that was the whole problem; none of us could communicate because we were so into ourselves. There was always some sort of unrest, constant negative vibes; it was there all the time. Roky's guitar was so loud in there that you can't hear it… Roky wouldn't talk to me in a rational manner. He'd do things that made me mad, like hiding behind the amps. In the studio he seemed kind of lost; he'd gone beyond the point of being together, and a lot of what we were doing didn't make sense to him a lot of the time.

Danny Thomas didn't necessarily share Galindo's assessment of the tense atmosphere, and maybe some of Galindo's appraisal was down to the fact that the Elevators had unwittingly hired another agitated and amphetamine-fueled bass player. Unfortunately, he found a co-conspirator in

Stacy who acknowledged, "Galindo started buying a few grams of speed, and that's where I got on it again. Well, it was just a mistake I made. I just started... passing the time, idle mind, devil's workshop..."

The next hurdle was the building tension between Roky and Tommy. Tommy was becoming increasingly demanding, making it incredibly hard for Roky to express himself, while constantly keeping him dosed. With Tommy's constant examination of his every breath and added pressure from Stacy over his guitar playing, Roky gradually started playing truant from sessions. Tommy felt a huge responsibility to make the lyrical content really mean something. This often led to last-minute changes, and he would hand Roky notes or pin them around the studio. While Roky did his best to become word-perfect and incorporate the changes, it was when Tommy exerted pressure on Roky to give the perfect reading that problems started. Tommy wanted poetic rhythm, and although he was doing his best to facilitate him, Roky really wanted to be hollering his guts out; everything was becoming too controlled for his liking. Tommy strongly believed that every word had to mean something, as did its delivery—the projection, harmonics, intonation, enunciation all were vital in the audience's total understanding. Tommy's fastidious ear gave Roky little room for interpretation.

Frank Davis: Tommy Hall never confronted me. I guess he thought everything, in this department, was taken care of. Tommy would, like on Roky's vocals, he would be right in his ear while he was doing it. The funny thing about it was, he was mostly right. I kind of hate that. He was the least musical, but he could hear the tone of voice and almost like the projected image from the timbre of the voice. He was great at it. He was absolutely right on. Just right to the nut. The way I understand it, everything was symbolic. If you had come in off the street, you wouldn't have any idea what they were talking about. It wouldn't be just dope talk. Boy, I tell you when they would be discussing the problems of the delivery of certain voice lines, it was like listening to Chinese verbiage. It was IN-CREDIBLE, and if you ever caught a thread of where they were going, I swear your feet would get off the ground. It was the most amazing experience because they totally talked in these amazing analogies that were just extraordinary; there's nothing else you can say about it. Tommy had the words. Roky could have read the dictionary and just given you chills.

Walt Andrus: I'm not someone who glorifies the drug culture, I never did do acid with all these guys, so I am like from another planet in many ways. I remember Tommy'd come through and Roky would be sittin' on the couch and he'd open his mouth and Tommy would just throw stuff in... They were just reckless with all that stuff. But they were burning it just so bright, that everybody thought it was wonderful, that little burst they had there. They pretty well were organic in the way that they did things and experimented with the sounds in the studio. Tommy tried to act like the Czar of everything but it pretty well gelled.

Stacy wasn't happy either; he felt Roky's natural talent as a singer was being stifled by the over-complicated lyrical content of the material. Although Stacy did try to intervene to keep the recordings from lagging behind schedule, he ultimately had to concede creative control to Tommy.

Stacy (K): It cramped him [Roky], though... Tommy's writing was kinda like singing an encyclopedia, know what I mean? 'Cos he's soulful, and Roky's used to rock 'n' roll, all his life he used his voice like an instrument... but when he's having to pronounce certain words and so forth, it's like he's having to read from an encyclopedia or something; you know it's hard to find his vocal.

Danny Galindo: It was tense between Roky and Tommy, because I think Tommy wanted to be in control and therefore wanted Roky to accept everything he suggested, and of course Roky, having a mind of his own, didn't always agree with whatever Tommy was trying to get across. There were many instances... I felt Tommy's suggestions weren't always appropriate, he wasn't full of shit but sometimes I'd have to agree with Roky. Well, Roky couldn't learn the new lyrics; well, he'd learned them and Tommy would hand him a note and go, "no, do it this way"... [Laughs.] I could sense ol' Roky thinking, "you dumb ass... I just got these old ones learned and now you say... no, no, no! Do these." I remember Stacy'd jump all over Tommy Hall when he'd do that. "Goddamn it Tommy! It's good enough, can't you just leave it alone!" [Laughs.] And Tommy's favorite phrase was, "That's because..." He had an explanation for everything. So I remember Tommy in the studio, and only hearing, "and that's because... well, that's because." And I'm severely ripped and it started echoing and echoing through my mind. "That's because. Well, that's because." I went through this nonsense trip with that phrase that didn't go anywhere. I always remember Tommy for that phrase.

Roky and Tommy had little concept of how to achieve what they wanted. As long as everything remained in a constant state of flux, which was facilitated by the luxury and novelty of the eight-track recording studio, everything could be manipulated and deferred. When time started to run out and decisions needed to be finalized, tensions between them reached a head and a heated debate over the core beliefs of the band broke into a brief physical fight. Apparently no one was paying that much attention when the conversation first started, but Tommy was apparently insisting that the core of the band's message was "information," whereas Roky argued it was "emotion." Who lunged at whom first was far less important than the irony of the whole situation.

Frank Davis: It was like one of these, "Did you read the note on the door?" I mean it was just like, far out. I mean it was just this incredible spiritual thing. It was like the pope and some goddamn saint just knocking it out over which path to glory they should take. You see the whole dichotomy of these grand spirits and brotherhood of man and these guys, just like monkeys, just beating the shit... I mean,

pulling their hair... The fight wasn't anything compared to the irony. To see these people I'd come to consider saints coming to blows over something so tedious. Tommy loved to be final... I think Tommy thought he was just the leader. How much more perfect could it be? Tommy was the lecturer and Roky was the one that was full of spirit. It was one of those symbiotic relations.

Roky walked out of the sessions for a few days and got some head space. While Tommy dominated the lyrical content, the songs Roky co-wrote with him were every bit an Erickson production. Despite the change in tone of the material and the labored vocal sessions, Roky's patience with Tommy won through and his vocals retained all of his emotional intensity without his trademark scream. Despite many of Roky's guitar parts being re-recorded by Stacy, the hooks and ideas were undeniably Roky's, and Stacy always remained faithful to Roky's style and flavor. The sessions resumed with the reappearance of Clementine (along with new boyfriend Bob McClellan) who coaxed Roky back into the studio on his own to work at a mellower pace and a set of acoustic recordings that allowed Roky to be Roky. In severe contrast to the testimony of Roky being completely out of it, he delivered precise and considered renditions of much quieter and contemplative songs.

With only the two of them in the studio, Clementine broke her silence and agreed to sing harmony with him. They recorded an acoustic version of their song, "Splash One" from the first album and Powell's "Right Track Now," both of which remained session outtakes. When it came to recording their new song, "I Had to Tell You," it wasn't arranged for the full band, only a peculiar solo arrangement[38] that Roky performed for friends. With Roky back, the band slowly returned. Danny Galindo was doing his best, as usual, to listen in and watch Roky and to work out his own parts, and he came up with a guitar part based on Clementine's vocal harmony. Much to Danny's surprise when Roky heard him playing it, he adopted it instead of the original arrangement of "I Had to Tell You." With the band working as a unit again they recorded another largely acoustic number, "Dust," before recording "Slide Machine" as the full electric band. Roky gleaned the song from Powell in San Francisco in '66. There was much confusion over what this song was really about, even within the band.

Q: "Slide Machine," a lot of people at the time interpreted this song had something to do with syringes? Danny Galindo thought so.

Powell: Oh yes, that was not my intention, but I understand how people would interpret it that way. There was another song I did for them, "Right Track Now," that has been interpreted the same way and that was not my intention either. Again that was an autobiographical song about having a new awareness, and the right track is the right path. I wrote "Slide Machine" while I was in Mexico, and when I got to San Francisco Roky came by and asked if I had any new material and I played him that and went back and did what he normally does, which is change them all around and scramble things. There's a lot of uncertainty about what that song means. Literally

what it meant for me was when you're traveling in rural Mexico you'll find a lot of recurring road signs, "It is prohibited to leave rocks in the road" It always puzzled me why anyone would leave a rock in the road, or why enough people would do this to warrant a sign. But I think there were people who'd rock the roads and so they had rock graters that were always plowing off the roads to keep them open... and the slide machine is a road grater, which pushes stones right off the road. There's "stones" in there which is double entendre... In those days there was one group of Mexican society who had the reputations as the "marijuanas"... and that was the military, "My lover here has got a dozen names, sometimes I'm not equipped to play her games, she's sought by soldiers and they keep her tame"... that's a reference to weed.

Despite the occasional flare-ups between the band members, most of the studio time was spent working together as a unit to achieve the best possible results. Given the previous division of opinion over the jug's inclusion on nearly every track, more studio time was dedicated to trying to vary the texture and sound. Few, if any, electric sound effects were available to the band, and so different types of microphone were experimented with. Instead of holding the microphone next to the mouth of the jug and recording the mixture of Tommy's vocal and the echo from inside the jug, Frank experimented by dropping different types of microphone inside the jug itself. He used a condenser mike without the top, and a ribbon mike for a more solid sound, but most of the time a dynamic mike was used. Also they constructed a thirty-foot-long, ten-foot-wide by nine-foot-high chamber, covered in ceramic tiles, to record the jug in. Frank used a theatrical vocal mike positioned three feet away from the speaker and recorded the huge resonance created by the chamber.

The band experimented with other instruments, as Mikel recalls: "Roky played cornet in a band at school, he's good at harmonics. He and Danny Thomas play cornet on *Easter Everywhere*. Overdubbing it... that was quite a scene." For the song "Earthquake," they hired a huge thirty-inch gong to try and create a thunder effect but settled on a huge sheet of metal hung from the studio ceiling played by Danny Galindo. However, none of the extra instruments are particularly evident on the finished mix.

The only genuine band outtake from the *Easter Everywhere* sessions was a song called "Fire in My Bones." While the Erickson-Hall composition was equally as strong as any of the other material on the album, it was left off in favor of Dylan's "It's All Over Now Baby Blue," which the Elevators had chosen to deify with their own veil of mysticism.

IA decided to document the sessions, and two associates of the band were recommended to come in and photograph them at work. Guy Clark had been the assistant art director on the Larry Kane TV show, while Russell Wheelock was an old college friend of Tommy's. The results were used on the back of the record jacket and became the only photographic evidence of the band to grace an album cover.

As the allotted studio time drew to a close, the situation became in-

creasingly intense for Tommy. He could have spent another month, two months, continually rewriting and perfecting what he wanted to convey. In Gurdjieffian prose Tommy had "the fear of drowning in the overflowing of his own thoughts." Many people testify that they saw Tommy with a huge pad of paper writing lyrics as the band played before him, while Clementine testifies that the creation of material was immediate and there wasn't enough time to record or preserve half of the ideas, lyrics, licks and melodies. In fact, Tommy tended to edit and summarize his ideas to such an extent that he ran out of material for a complete album. For instance, "Slip Inside This House" was the whole album in condensed form, and writing material of that calibre proved impossible without more time. When any artist embarks on a new project, the first tentative marks on a blank canvas or first notes are incredibly seductive, creating tantalizing fields of potential, and it is far harder to surrender the work as complete than to remain in a prolonged state of creative flux. Could Tommy ever complete his final statement as he envisaged? Much of the revelatory insights created by LSD are fleeting and illusionary, and even if one can see the bigger void beyond the terrestrial illusion, it can't necessarily be brought back, articulated or expressed in this world. Tommy became increasingly agitated and broke down in tears as he saw the allocated session time drawing to a close. Clementine did her best to encourage and console him, but the pressure was simply too much and he decided to quit the band.

37. Prior to *Sgt. Pepper*, the fourteen-track UK albums were cut to twelve tracks because royalties were paid per track in the U.S.. Also, the extra material could later be compiled to create more product for a product-hungry American market.

38. **John David Bartlett:** *He was staying at Noble Ginther's house. Noble asked some of us to come over because Roky was all alone and not playing. Noble thought this was a bad sign. Jerry Lightfoot and I would go over to this upper-middle-class suburban house and sit in the "kid's room" and play acoustic guitars and sing. It was hard to get Roky to play but he finally took a guitar and started slowly strumming this C to G kind of thing and then started to sing "I Had to Tell You." Jerry and I couldn't believe what we heard... IT SOUNDED LIKE BELLS RINGING. His voice and the guitar merged and there were these clear, clean sounds like bells!*

15.
LIVIN' ON—
THE COMPONENTS OF GOD

God is covered with the dirty marks of the hands of man.
—Antonin Artaud

'Tis a lesson you should heed,
Try again,
If at first you don't succeed,
Try again,
Then your courage should appear,
For if you will persevere, you will conquer, never fear
Try again.
—William Edward Hickson
(quoted in the preface to *Science and Sanity*)

If a distinction could be made between the Elevators' first two albums, it would be that the first was a raw blend of garage punk while the second was a more refined and laid-back blend of electrified desert blues. Despite the Erickson-Hall songwriting pact, *Easter Everywhere* was once again a disparate collection of material, with only half the songs being penned by the duo especially for the project. However, this did not detract from the end product, which proved a far more solid body of work. This time Tommy constructed the material so that the end was embedded in the beginning—each side of the album was meant to work as a circular whole[39] and the opening and final track answered each other.

According to an earlier running version of the album, the final song was "Dust," but rather than end with the death of the physical body Tommy switched it to "Postures (Leave Your Body Behind)," which dealt more obviously with reincarnation.

In the band's first and only interview, given to Houston fanzine *Mother* on November 20, 1967, the interviewer got more than he bargained for when he innocently asked Tommy to explain the album title:

> **Tommy:** Well, [the title] comes from the idea of Christ Consciousness. And realizing that you can be born again; that you can constantly change and be reformed into a better and better person. It's like a progressive perfection, and Easter Everywhere is sort of the combination or culmination of this idea as echoed in the public. It's like everyone is snapping to this; that there is a middle ground between the Eastern trip and the Western trip, and that is by learning to use your emotion and realizing what emotion is and why it is there and how to control it from a pleasure point of view so that you don't get hung up in a down place. It's just the idea of rising from the dead all over, everywhere.

Where the previous album's content [the realization and acceptance of the path to enlightenment] had been carefully explained in the rhetoric of general semantics, this album wasn't as easy to penetrate. While the overall coherence of the songs is more refined and ethereal on *Easter Everywhere* than on the first album, the thread of ideas based upon Buddhist, Hindu, and Gnostic scriptures are evaluated from a Western, Christian perspective. The album's structure and lyrical content tried to assimilate ideas from as many esoteric references as possible that extolled the pursuit of eternal life through divine enlightenment and rebirth. The Stations of the Christian cross, the Kabbalah tree of realms, Tarot, the Rosicrucian order of the Mastery of Life and Freemasonry were all part of Tommy's equation to parallel the concept of eternity.[40] He wanted to show that all religions had their foundation in the same pursuit of ultimate spiritual truth, and chose the structure of the Tantric chakras as his model for the path to spiritual enlightenment, cross-referencing the similarities with Christianity.

To tackle the mystical concepts behind *Easter Everywhere* one perhaps should begin with the cover. Tommy selected two images from a Tantric art book that he wished to use for the album cover. His favorite was a photograph of an eighteenth-century painting that hung in the National Museum of Indian Art in New Delhi, depicting a meditating yogi and the alignment of the seven chakras within his body. Tommy felt this was a suitable illustration for his model of the pathway to enlightenment and eternal life—the basic idea being that in order to evolve, each of the seven chakras along the spine have to be mastered until enough wisdom has been gained to engage and use the third eye (which corresponds to the pineal gland, that governs the hormonal function of the human body). The movement and passage between the chakras is often likened to rebirth and resurrection. The opening of the third eye leads to total awareness and the divine state of Nirvana. Once Nirvana has been reached, the soul rejoins the collective primeval life force. With every subsequent rebirth the soul retains a latent knowledge of its previous existence, and therefore immortality has been consciously achieved.

Stacy took issue with Tommy's immortality claims and vetoed the front cover on the basis that it directly referenced one religion without

interpretation. The image was relegated to the back sleeve. Instead the front cover depicted a primeval Eastern sun, meticulously redrawn by George Banks from a Tantric art book and printed on a gold background, the symbolic color for the divine in many religious artifacts. Below it he graphically represented the band's name as Buddha's blazing red eyebrows. The loose concept was that an album cover was almost the same size as a human head, and if it was held against the forehead, Buddha's eyebrows would overlap yours and the sun would represent the open blazing third eye, that above this was the seventh chakra, the ultimate realm of Nirvana—*Easter Everywhere*. The record cover, a square, represented the universal symbol for the physical world, and the sun, a circle, was the symbol of the spiritual world.

Tommy's complex sleeve notes on the first album were meant to explain the band's ideas but led to much confusion. *Easter Everywhere*'s back cover depicted a meditating yogi surrounded by photos of the band. While revealing their identities for the first time, the back cover also furthered the mystery. Roky was presented as a wide-eyed youth, Stacy was theatrically bathed in red light and Tommy was photographed with his finger to his lips as if to say, proceed with respect and caution. IA spared no expense on the album jackets—gold ink, full-color photos and a lyric inner sleeve—but the package still had a disconcerting crudeness that set it apart from more mainstream products.

"Slip Inside This House" was the foundation and key to the album's greater whole. The song basically attempted to weave together the symbolism of many different esoteric texts into one calling—with Tommy saying, "come to us, we have the information." While the structure, as previously mentioned, emulated Dylan's "Gates of Eden," it bears relation to such works as the *Rubaiyat of Omar Khayyam*,[41] and employs much of the same symbolic imagery—birds, water, dust, saints and sages, Moses, etc.

> **Tommy (K):** We were competing with Dylan as far as taking over the Word. Like Omar Khayyam, Dylan saw that too, in the Rubaiyat... He talks about when a ray of light goes round the sun, it bends, that's the power of deduction. We have to understand that the West represents the manipulation of matter—the East, the analysis of matter. The West has evolved the way it has because of its contact with matter. It's really what we're doing now, just collecting linguistics through phenomology and general semantics. We go farther out than any other present thought I've been able to observe, although I don't know how far out the Rgvedas and other chanting people are...

Indeed, much of Tommy's terminology and rhetoric originated from both the Hindu Rgvedas[42] and Buddhist *Hevajra Tantra*—"Shell of foam," "seven stars," "seven paths," "lightning inside," "well of unchanging," "dance of creation." The song is peppered throughout with references to far larger concepts that are never expanded upon. The first verse alone conjures up the ancient Bedouin tribes of the Sinai, the Buddhist egg of creation, alpha brainwaves found in meditative states and river power (the first of several water references, the scientific conduit of all life).

The Vedas chronicle the ideas of the Aryan tribes often referred to in translation as gypsies or nomads, which parallels the Bedouin tribes, and Tommy later uses this concept of "twice-born gypsies" to relate to both physical birth and birth by ritual. The line "you are always risen from the seeds you have sown" directly refers to the karmic process of reincarnation, the obvious correlation being the Buddhist reincarnation of a life essence through differing forms and the Western Darwinian theory of evolution. The lyric "from the egg into the flower" relates to both the Hindu Vedas and Chinese Buddhism—the cosmic egg giving birth to the flower of creation from which the world is born.

In Hindu teaching, the chakras located along the spine from the coccyx to the top of the head are often likened to houses. Through meditation, each base or house is mastered before one can learn to pass energy between them and ultimately reach the state that is clearly referenced in the lines "all your lightning waits inside you, travel it along your spine." Likewise, many other disciplines use similar constructs to depict stages of spiritual development, as Gurdjieff explained to Ouspensky:

"Certain teachings compare man to a house of four rooms. Man lives in one room, the smallest and poorest of all, and until he is told of it, he does not suspect the existence of the other rooms, which are full of treasures. When he does learn of this he begins to seek the keys of these rooms and especially of the fourth, the most important room. And when a man has found his way into this room he really becomes the master of the house, for only then does the house belong to him wholly and forever. The fourth room gives man immortality and all religious teachings strive to show the way to it. There are a great many ways, some shorter and some longer, some harder and some easier, but all, without exception, lead or strive to lead in one direction, that is, to immortality." —P.D. Ouspensky, *In Search of the Miraculous*

Tommy (K): Once you got a high enough vibration, it would be everything. Because "form" is this higher vibration. You can do this because the extension of the vibration is the extension of the cause. You're able to dial yourself up into that geometric structure. The main thing that song, "Slip Inside This House," talked about was how to utilize the systems of your body to free yourself from a dependence on this level of existence.

In addition, Tommy also wanted to reference and correlate the band's "outlaw" status to the *tituli*, the "household of the faith"—the clandestine meeting places of the early Christian brotherhood of disciples, who carried the "word" from household to household.

Tommy (K): During the time of Christ, they were spreading the message while they were under a lot of pressure. They got together and developed a philosophy, and so did we... One reason I employed the image of the house is that it stands as a symbol of the mind, a mental construction, like a whole place to live. There was

one main message: look, we've got the information, if you want the information, then come here and get it, if you don't you won't come at all. As with all callings, everybody snaps to it at different times. All we had created was our own directory to certain levels of spiritual realization.

From "Slip Inside This House": Four and twenty birds of Maya / Baked into an Atom you / Polarized into existence / Magnetic heart from red to blue.

The first line of this verse resembles the eighteenth-century recruitment call to enlist pirates for voyages. The line "four and twenty blackbirds baked in a pie" refers to the pirate Blackbeard's ruse of luring other ships to his by faking a distress call and then attacking the rescuing crew. The shanty has lived on as the nursery rhyme "Sing a Song of Sixpence," but went through other adaptations, one of which uses the line "four and twenty birds of Maya baked into a mudpie."

Tommy (K): The Indians' major concept is Maya. This means that we can reconceive in higher states. Basic practice in model building allows us to deduce structure of cause, causing structure. Notice the packing data in Utopia. The processes in the universe are results of translations of data into more efficient storage units on higher levels. Thus environmental changes are tags of these transformations. By deducing from these events the higher units become visible. Psychedelics provide the energetic code to help in the view of these levels by our senses. Feeding these generalizations back to this level lifts the whole effect.

Throughout "Slip Inside This House," Tommy alludes to ancient numeric systems, but held short of his real aim, which he still pursues, to interpret the divine through mathematics and sacred geometry.

The lyrics mention "shrink the four-fold circumstance" and, according to the *Hevajra Tantra,* "everything goes in fours"—four noble truths, principles, joys, moments. All the divisions of the thirty-two nerve channels are broken down by divisions of four, as are the four "centers" of creation described by Buddha, which are depicted as divisions of the lotus petals: eight, sixteen, thirty-two and sixty-four. Again, in the line "from the egg into the flower," Tommy references a work from Chinese Buddhism he was studying, *The Secret of the Golden Flower,* which represents the cosmic egg of creation from which sprouts the lotus, which usually has thirty-two leaves, representing the thirty-two nerve channels.

The "four and twenty" reference is also applicable to the Aztecs, who used two different calendars. One utilized Mayan numerology and had four suns, representing water, wind, fire and earth, lit by the cosmic fifth sun. This is often depicted on circular stone calendars, which have twenty days to the month—but the pyramids were also used as calendars having four staircases leading to the square pinnacle. In parallel, the Bible utilizes multiples of four symbolically (twelve tribes of Israel, twelve apostles, twelve foundation stones for the New Jerusalem, four holy beasts, etc.)

and in the book of Revelation (King James Version, Chapter 20 Verse 4) the dead are seated upon thrones, and those who have not worshipped the beast "lived and reigned with Christ a thousand years."

Maya is often described as the supernatural, the mystic power of god and the mother of nature, the birds representing her messengers. Maya can also refer to the illusory image of reality or "invisible potential energy," which correlates to similar ideas in Taoism of the "plain of infinity of nothingness," which parallels modern scientific theories such as quantum physics and string theory,[43] the divine dance of creation, which instigated the creation of matter and life.

> **Tommy:** You could call it existential mathematics, the mathematics that brought everything into being. And the whole trip is to understand how the suns, the galactic clusters and super clusters are all expanding, and all of that, the map, the originating map, the initiating map, all of that would cause a pattern.
>
> **Q:** So you're going back to point blank, the very beginning?
>
> **Tommy:** That's right... there's no Big Bang... you start from it.
>
> **Q:** Are we starting from the "nothings" then?
>
> **Tommy:** Yes.
>
> **Q:** Well, before there was "nothing" there were "primeval fields of potential," the potential for matter to be created, as far back as anyone can go to the essence?
>
> **Tommy:** Well, you have to go back to the structure of mathematics... I'm really working on complexity theory.[44]
>
> **Tommy (K):** I had seen Bodhisattva[45] as atoms, these atoms would be manifestations of the life force, being-ness. It has to do with the components of God. There is a common physics uniting the universe. It's connected, this connection has to do with the cause of the universe, the reason the universe is caused is because it's fulfilling its purpose.

Another area where science has recently encroached on divinity is the controversial study known as neurotheology. Studies using electromagnetic fields on the brain suggest that spiritual experiences are in fact frontal temporal lobe seizures, which begs the question, has God placed an antenna in your brain? It has also been suggested that religious experience is an evolutionary need in the form of survival technique; we simply require a high being to exist for our own well-being. However, while science over the last few centuries has attempted to demystify religion, many would argue that it has always been known that it was the exploration of inner and not outer space that would reveal the source of the creation... the Kingdom of Heaven is within you.

Seven stars receive your visit
Seven seals remain divine
Seven churches filled with spirit...

Modern Essenian theory (a branch of Judaism centered around John the Baptist, from which it has been suggested that Christianity later evolved) teaches a sevenfold peace, a spiritual discipline based on Jesus' seven pathways (body, mind, family, humanity, culture, earthly mother, heavenly father). In Vajrayana Buddhism (and other Tantric traditions) there are seven directions: the four compass points and also up, down and inner.

Seven is also the prime number revealed in the Book of Revelations—seven stars, seven churches, seven seals, seven trumpets, seven lamp stands, seven thunders, seven angels, etc. In layman's terms, the seven churches in Asia Minor (now Turkey) from which Christianity spread are supposed to have secret meaning. The seven angels of Jesus' right hand are the seven stars (the constellation of Pleiades) that govern the seven lampstands which stand in the seven churches that represent the seven lampstands surrounding the Throne of God. These too are constructs for the path to enlightenment. The first church, Ephesus, symbolizing "feed from the Tree of Life," the second, Smyrna, symbolizing "nothing to be afraid of in the second death," and so on through the different churches...

Water was employed as a reoccurring theme throughout the song to parallel Biblical and Buddhist/Hindu references and also to encompass Darwinian evolution theory (all life evolving from the sea to land and still retaining water as the conduit for fertilization of the egg).

Subtleties of river power
They slip inside this house as you pass by
If your limbs begin dissolving
In the water that you tread
All surroundings are evolving
In the stream that clears your head
Find yourself a caravan like Noah must have led...

In the *Hevajra Tantra,* divisions of the nerve channels are broken into "moments"—"diverse, ripening, dissolving and signless." There follows a Biblical reference to Noah/water/floods and a further water reference, "high Baptismal glow," which directly refers to spiritual rebirth via ritualistic cleansing with water—as utilized by many religions. In terms of Tommy's East/West parallel: Luke 3:16 John (the Baptist), "I baptize you with water, after me will come one who will baptize you with the Holy Ghost and with fire," and Chinese Buddhism text *The Secret of the Golden Flower,* "The eye is the light of the body. Man is spiritually reborn out of water and fire." The final reference, "water brothers," relates to the Rgveda,[46] but also indirectly to the Bible via Robert Heinlein's iconic novel *Stranger in a Strange Land*, the title of which comes from a quote by Moses.

One-eyed men aren't really reigning
They just march in place until
Two-eyed men with mystery training
Finally feel the power fill
Three-eyed men are not complaining
They can yoyo where they WILL
They slip inside this house as YOU pass by
Don't pass it by.

Tommy Hall: One-eyed men are people who are in power, who are forced to just manage the thing going forward, without an awareness of what they are doing. They're not spiritual, in a way. It's kind of political. What I'm saying is that they have to do these mechanical things, what they're doing is just automatic. Two-eyed men are just ordinary people. It's like the last possible chance that the people have to be able to take over, because materialism has completely [gained control]... it's a culture war.

While it illustrates the fundamental Buddhist belief that the physical world is a barrier to spiritual liberation, the one, two and three-eyed men also relate to the Hindu Vedas, and are a contemporary reference to Herbert Marcuse's 1964 work *One-Dimensional Man*, which states that individuals must free themselves of the demands of a consumerist society in order to really be free.

"Slip Inside This House" was the calling to investigate the Elevators' message, and a signpost to the necessary information; "Postures (Leave Your Body Behind)," the last song on the album, was the logical answer or reply.

If you're wonderin' what's on your mind
It's the one keystone people keep tryin' to find
The state of mind that puts you there
In evolutions everywhere
Is creeping back from the affair
So leave, leave, leave your body behind...

If "Slip Inside This House" was an overflowing cornucopia of esoterica, "Postures" was largely informed by the Chinese Buddhist text *The Secret of the Golden Flower*. The book's translator, Richard Wilhelm, notes in his 1931 Foreword that "the psyche and the cosmos are to each other like the inner and outer world. The eternal Golden Flower grows once all entanglements with the external world are left behind." As Wilhelm describes, "a man who reaches this stage transposes his ego, he is no longer limited to the monad but penetrates the magic circle of the polar duality of all phenomenon and returns to the undivided One, the Tao."

Tommy: It's your own personal pathway, so that people who don't do this particular kind of information that we're talking about here are going to be going downhill... they're going to have more emotional, depressive cycles because they're what Korzybski calls unsane.

You have to go with how you're designed, in other words you have to evolve, and that's the problem with the hippies... see, they went counter to the evolution; I came up with the idea of "creeping back" ["Postures": "In evolutions everywhere, is creeping back from the affair"] and that wasn't my idea, by the way, it was from Holy Science by Sri Yukestwar Giri.[47] That's the Self-Realization Fellowship, you know, *Autobiography of a Yogi* and, well, I read that in the Sixties. You get this picture of all the different levels of the universe that they're looking at... so you've got the mantras that are the different minds. As far as I understand, you're separating from the outside, then when you go up, everything becomes one, once you have this information I'm working on, then it enables you to see more.

Tommy's departure from the Elevators was short-lived, as Clementine persuaded him back by bursting into floods of tears to demonstrate what the project meant to her. In the meantime, Stacy was allowed to record one of his songs, "Nobody to Love." Despite Tommy's opinion that Roky should sing the lead vocals, Stacy insisted that the song was far too personal and autobiographical (relating to his split with Laurie Jones) to surrender to anybody else, and sang lead vocal for the first time. In comparison to the other recordings, "Nobody to Love" was knocked out without the same laborious recording process as the previous tracks. With the allocated recording time expired and the recording budget spent,[48] Frank Davis and Walt Andrus were left the monumental task of editing and mixing the *Easter Everywhere* project together, which began on September 26 immediately after the recording concluded. The band kept a watchful eye on the proceedings while preparing for their imminent return to the live circuit. In mid-September they had taken a break from recording to play their first live engagement at Rice University in Houston, but inexplicably failed to play the free "Love In," organized by the Vulcan Gas Company in Austin's Zilker Park, on September 24. Walt and Frank orchestrated the madness in the studio as various band members helped out and were allocated faders to operate during the album's final mixes, which were finished on October 6.

> **Frank Davis**: Well, the mixes were the most extraordinary thing, like when you plan the movements of a ballet, the choreography was just extraordinary; it took three people on the board...

> **Tommy**: And during the mixes there were all kinds of different speaker systems that we used, trying to get it right or trying to hear it but, ahh... I wish I could explain to you what an experience it was doing that album. That was just something.

> **Walt Andrus**: *Easter Everywhere* is something that... no one will ever know how good that really was. Because the mix! The clarity of the original recording was immaculate... I brought in some little itty bitty speakers, that was the first experiment to see what it'd sound like on a car radio, and so the initial mix was real bottom-heavy compensating for the small speakers... I offered to mix it for free but there was too

much wrangling going on over at IA. The original eight-track masters to it don't exist any more, so you can never go and fix that... that thing was just beautiful, and all the pressings I've heard were...

Once again International Artists proved their incompetence, and despite the expensive gold ink on the album cover (which flaked off on your fingers), the album was once again poorly mastered and cheaply pressed to vinyl. Having paid so much attention to the separation of the instruments and the clarity of the sound, everyone was devastated by the weak stereo and thin resonances hidden in the grooves. Walt Andrus kept a few safety mixes, which are a testament to the dynamic sound they had really achieved.

Luckily, the content overcame the disparaging sound, and although *Easter Everywhere* lacks some of the raw aggression of its predecessor, it is generally considered by the band, their fans and music journalists as their finest work, and "Slip Inside This House" is generally considered a landmark recording. The self-doubt and the huge sense of responsibility to preserve the Elevators' message for posterity had been successful, and they recorded one of the best albums of the decade.

The album was swiftly mastered to vinyl and arrived in Texan record stores within a month. To coincide with its release, the band embarked on what can only be considered the smallest publicity tour ever. They managed a few local gigs, a local TV appearance, an album signing and their first-ever interview for a Houston fanzine.

Instead of a national publicity tour, their return to the live circuit was an inauspicious and low-key show at a small club, in a tiny town north of Houston called Spring, "the home of redneck hippies" as *Mother* magazine described it. Many old fans simply weren't prepared for the change in material, and expected the same dynamic performance as in the old days. While the Elevators had always been celebrated for their antagonistic intensity, with each member vying to play lead instrument while somehow maintaining a perfect cohesion, they were struggling to hold it together. However, the band was back in a quieter and more demanding guise with new songs that didn't accommodate Roky's rabble-rousing screams. Instead of floor-filling crowd pleasers, Roky continued to stumble over his delivery of Tommy's lyrics. Often he found himself repeating the same lines over and over again, much to Tommy's dissatisfaction and irritation. Once again the band's live performances were marred by the presence of speed, with the old dynamic of bass player and lead guitarist indulging before performances.

Danny Galindo: See, Tommy tried to ritualize that [pre-show taking of LSD], we'd all drop acid at the same time, maybe two or three hours before we were scheduled to play, and that way we would all be at the same level. I'd naturally defy it, it's not that I objected to that but it was, "Well, Tommy, you know I was planning on taking some speed tonight, but I'll take some acid along with it." [Laughs.] At least from my point of view I felt like I was the rebellious one. I remember the gig [at the Dungeon]. Yeah, by this time I was using a lot of speed, I hadn't quite crossed the line to addiction. But when

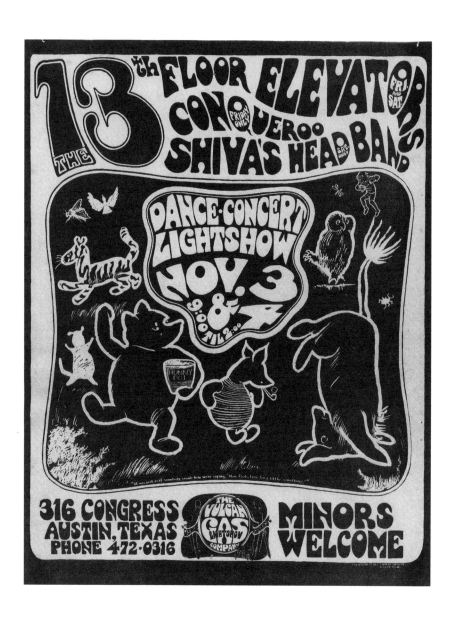

(1967) HANDBILL, LETTERING BY GILBERT SHELTON, ARTWORK BY LIEUEN ADKINS FOR VULCAN GAS
COMPANY SHOWS, NOVEMBER 3–4, AUSTIN, TEXAS

(1967) December 4 *Rag* ad & ticket for second Vulcan Gas Company shows, December 8–10

you're using a lot of speed there's magic, too, that's the problem, the drug-induced magic, and I was experiencing that. But I was in a good mood, I felt great...

Mother: All thoughts of an Elevators reformation seemed to be cherished nostalgically. The new group left me doubting that it could be little more than an exploitation of their earlier reputation. Having sat through a performance of the Lost and Found and a fight that involved about fifty people, the 100 or so people drifted toward the main stage where the Elevators were to appear. Stacy and Tommy were first on stage, followed by a new drummer, Danny Thomas, and a new bass-man, Dan Galindo. Then Roky. Bluntly, Roky had looked better. They plugged in, sort of tuned up and broke into one of the worst performances I have ever witnessed by any group. They had no PA and the jug was inaudible. The new members, understandably, loosely faked their way through the seven or eight songs they played. What I had admired as the tightest most powerful rock band six months ago was now no better than the 100 or so bands I had seen try to imitate them. Roky's voice had lost that certain edge he used to maintain and what used to be an urgent plea was now more of a sympathetic plea. His screams that were once worth the price of admission were now nothing more than ragged shrieks.

Following the Dungeon show, the Elevators played an engagement as part of a package show in front of possibly the biggest audience of their career, the annual OU Football Weekend in Dallas. With the last gig a shambles, the band retired to the seclusion of Robert Eggar's ranch in Kerrville for much-needed rehearsals. The band compromised their set accordingly and, considering Roky's difficulty remembering the new lyrics and the fact that they were appearing before thousands of beer-swilling football fans, the band returned to a mixture of crowd-pleasing cover tunes. Once again Tommy called for closed rehearsals with no visitors and no exceptions; however, one person was determined to cross the line. Dana had managed to regain some control of her life, fulfilling her role as mother and living back in Kerrville, where she'd briefly dated Stacy.

Dana: [Roky and I] were both with other people. I'm driving 'round and I go, "I don't love this man, I love Roky and I'm going to tell him." It's obvious I'm not going back to George and Roky's at some ranch in Kerrville. Tommy insisted on closed rehearsals... and I had been with Stacy a little bit, so I came up and knocked on the door. Tommy opens it, saying, "Dana, we insist on closed rehearsals, you can't come in here." So Stacy's smiling, rises up thinking I've come to see him, and I said, "I want to tell Roky something," so Roky calls a break, so we walk out into this field, and it's a full moon. He says, "Was there something you wanted to tell me?" And I said, "Yes, I love you, I simply love you." It pleased him, it was like I had gotten through, able to talk clearly...

In the Sixties there would be huge gigs the evening after the OU football game, and this year the headline act was Mitch Ryder and the

Detroit Wheels, who had recent chart success. Local talent bolstered the show, and the promoter had booked "L.A.'s Hippest Psychedelic Group," none other than the 13th Floor Elevators. This booking is testimony to the band's warped view of themselves. The record company would have seen it as exposure and Tommy would have probably seen it as an opportunity to spread the word to the skull orchard that unfolded before them. However, many of the old Elevators crowd made the show but were desperately outnumbered by the jocks...

> **Danny Galindo:** Yes, it was terrifying. Mitch Ryder and the Detroit Wheels were the headliner... we were third up. Dear God, you know, we got up on stage and I looked and kept my head down and thought, keep going, keep going, keep going... man I looked at the horizon. A good gig? No, awful, terrible. In the first place the people at that particular party weren't our audience, they were basically straight, middle-class, drunk types, they had no interest in what we were doing at all. And you know what? I'm really glad they didn't. I was so glad when it was over.

> **George Banks:** The OU weekend, a very big deal in Dallas. We all got very wasted and I guess I must have been on a bit of a bad trip, and Roky asked me to sing with him onstage and I really didn't want to go on stage, and it was a very chaotic time. The entire environment that weekend—just a big drunk bash, and they played the convention centre, which is huge, even though they were on the stage which was eight feet high; the ceiling was almost endless, huge place. I got bummed out and Mikel had to walk me out of it. And I remember Roky singing, "Walking the Dog"... and I remember saying that's me!

Although the Dallas show was another debacle, it's impossible to subjectively comment on the Elevators' live performances during this period, since no recordings are known to survive. While the new generation of Houston fans appear to have accepted them with open arms, the old Austin friends and fans treated the new lineup with skepticism. The Elevators next appeared on the *Larry Kane Show* in Houston around October 21 to promote their forthcoming album release. The band's big Austin comeback was at the new psychedelic ballroom, the Vulcan Gas Company, which opened on South Congress in full view of the state capitol building on October 27, 1967. The Vulcan Gas Company was the continuation of the Electric Grandmother collective, who had continued to promote shows around Austin, and consisted of Houston White, Sandy Lockett, Gary Scanlon and Don Hyde.

> **Sandy Lockett:** It was the Lebanese mafia; the building belonged to the guy who owned the shoe store next door... Joe Dacey. Sweeter guy you could not imagine, he put up with a whole lot of bullshit.

The building itself was a typical post-Civil War commercial building built in 1884 by W. B. Smith as a dried goods warehouse. It had stood

empty for quite some time, and was used for storage by the Salvation Army. Although the Vulcan provided a much-needed focus for underground talents, it was being put together on a shoestring, as Lynn Howell remembers: "It was a great big old room, no creature comforts whatsoever. Benches to sit on was about it, nothing as much as a table or chair... there was some benches against the wall, so if you got a bench by the wall you could sit and lean at the same time, that was the best." Supplies of firewood were liberated from around Austin and used to construct the stage. When the Salvation Army failed to respond to requests to remove their booths, they were nailed together to form the toilet cubicles. There wasn't enough money to hire a contractor, so Houston and Sandy rigged the electrics themselves, enough to power the extended lightshow and sound equipment. The uninviting interior was transformed from the projection booth into a living mass of light and color. Future Rip-Off Press and *Fabulous Furry Freak Brothers* comic creator Gilbert Shelton was engaged as art director, and drew and commissioned posters for the venue. He designed the "Vulcan Gas Company" sign, which was erected as a gigantic cutout above the entrance. However, the grand opening nearly had to be suspended after an escapade with the cops that resembled a *Furry Freak Brothers* comic strip.

Sandy Lockett: The morning of the opening, Houston and I were nailing together the stage when someone knocked on the door, and it was the police, who had come to carry away Houston. And so they dragged him off by the ear and did plenty of jeering about "I guess you guys won't be opening this evening." Well, they were awfully stressed when he was back by three o'clock and we went back to nailing the stage. It turned out to be a terrible mistake on their part, because what they were arresting Houston for was selling some LSD to a narcotics agent and the upshot of the thing was that Houston's lawyer pointed out they couldn't arrest him for selling LSD because it wasn't illegal. Can you imagine the rejoicing?

The Elevators were unavailable for the "grand opening"; some viewed their headline performance at the second event as a major event, while others felt their hold was over. Although Lynn Howell feared the latter, he still had to concede that their music could affect an audience. "They'd already made their flash in the pan. It was music you'd never heard before, if you were taking drugs, sure, you thought you were levitating a lot of the time. If you were taking acid... the way they played 'Earthquake'... it shook, plain shook."

The cops were out in force to keep an eye on the proceedings and Burt Gerding was secretly honored to have his photo included in the lightshow. All the freaks were in one place where the cops could keep an eye on them, and even the local businesses were pleased; the Vulcan had no license and the local bars and restaurants took full advantage, buying extra coolers and filling them full of quarts of beer. Despite reports of "outrageous goings-on" every time he made an unannounced inspection, it was simply a bunch of kids having a good time on a Saturday

night and Dacey refused pressure to revoke the lease. Austin finally had its own psychedelic ballroom, the only place within a thousand miles you could regularly congregate with like-minded people that wasn't a teen club. Beyond providing a platform for homegrown talent such as the Conqueroo, Shiva's Headband and Johnny Winter, the Vulcan drafted in Canned Heat, the Fugs, Moby Grape and the Velvet Underground as well as hosting many respected blues artists starting with locals Mance Lipscomb, Lightin' Hopkins and later Sleepy John Estes, Muddy Waters, John Lee Hooker, Jimmy Reed and Big Mama Thornton. For the Elevators' first performance Roky's family dressed in their finest for the occasion and many of the fans came chemically charged—which is why their performances went unremembered, as Houston and Sandy recall...

Houston White: I remember, but a lot of folks seemed to have a remarkably good time.

Sandy Lockett: Not without help...

Certainly for the Elevators' new recruits, the Vulcan was the perfect new home and a welcome respite from their previous bookings—even Danny Galindo was happy.

Danny Galindo: We had an extraordinary gig down here at the Vulcan Gas Company. Oh, God, was it incredible. Here's a whole segment of people that are coming under the wing of the cult, so to speak. And all of a sudden here is this beautiful place for us to go. That had all of the overheads and the pulsating blobs, you know, and the oils, and everything felt very secure because everybody in the joint was going "wow." You know, everybody was making this contact that was really, felt really personal and warm, it was somebody you'd never seen in your life before, but that kind of magic was going around. I think that during that period of time it was the most liberated I'd ever seen Austin.

Whether the first Elevators' performance at the Vulcan was a return to form isn't known, but Stacy took full advantage of an acoustic anomaly the Vulcan possessed to create a huge amount of reverb.

John David Bartlett: In those days you only had certain ways to get reverberation and in a studio it was mainly done with a metal plate. Behind the stage there was a huge room and back in the corner there was a metal plate with a cistern that had been dug into the bedrock into a big teardrop, which was six feet deep. What they did was, they put a speaker down there and dropped a microphone in there and that was the reverb for the PA system for the Vulcan Gas Company. And it was after when the arguments started: "That's too much reverb! That is way too much!"... "NO it's NOT, is there any way we can get more?"

Following the shows at the Vulcan, the band continued their ping-pong existence of flitting between Austin and Houston. Mikel Erickson had set up camp in an apartment on 8th Street, which was often occupied by both Roky and Tommy. He worked at the foreign car clinic on the same street and was allocated the task of chauffeuring the band, keeping Tommy's Rambler on the road while fixing up a motorbike for Roky. Despite being a keen supporter of his brother, Mikel had always reserved judgment about Tommy's motives. On one particular visit, Tommy displayed how vicious his sense of humor could be, aided by Bandit, Danny Thomas' capuchin monkey, that he was prone to feeding acid—possibly in the hope that if he dosed it enough it would evolve into a higher being.

Mikel Erickson: They came into town and were visiting. And we were all sitting in the living room listening to the Beatles... all tripped out, smoking pot. And Tommy had this monkey, used to feed it LSD, stuff like that, and this monkey got on this guy's hair and this guy was going on about his divorce... and Tommy's just sitting there laughing. Laughing at the guy while he's pouring his heart out, and Tommy Hall's just dying laughing. And this guy just walked out and nobody saw him leave. So I said, "Where'd he go?" "Oh, he just walked out! Ha... ha-ha. Ha." I said, "Man, he's not familiar with Austin." I was the caretaker, so I had to go out and drive around town, and I finally spotted him where the Vulcan was and he's staring in Scarborough's window at the wedding gowns crying, 1:30 a.m. in the morning. Tommy was a very hateful person... a mental type thing.

The band was soon back in Houston to mime a performance of "Slide Machine" on the *Larry Kane Show* on November 11. The following day they were in Austin performing at their old haunt the New Orleans Club for a matinee and evening show. The next day the band hosted an "Autograph Party" at the University Record Company and a similar event was also held in Houston. On November 5, Scott Holtzman reviewed *Easter Everywhere* in his "Nowsounds" column in the *Houston Post*. Although his review was extremely favorable, he commented, "There is a mystical charisma which follows the Elevators wherever they go... The saddest thing about the album is that the presence on the singers is so cloudy that unless you follow the lyric sheet thoughtfully provided with the album, you won't realize just how well these young men are writing. Some unknown element hides Roky Erickson's excellent singing abilities. As a listener, I want the singer to get more personal with me. I don't want his voice hidden so often behind the musical jug, which has become identified as their sound but is growing tiresome from overexposure. When I hear the Elevators' tapes over giant speakers, I get that personal feeling, but somehow it is lost in the transition from tape to disc on a small machine at home. Don't get me wrong. This album is a must for any Elevators fan. In fact, it is already the fastest-rising album in Houston."

That was about the sum of album press, apart from their first-ever interview, which took place at the IA offices on November 20. Larry Sepulveda was setting up a new Houston music fanzine called *Mother* (which ran to three issues), and he and Cal Stanley went to interview the

band. Stacy didn't show up, and Roky was described as "contemplating his existence," and barely uttered a word as Tommy and the Dannys handled the talking. Danny Galindo enthused about all the advertisements IA were going to place in the trade papers, but none of these materialized. The band felt this album would catch on because other artists like the Doors and Hendrix were beginning to sell records, which had helped establish a market for their music that hadn't previously existed. Although Tommy complained that many of the "other" groups who supposedly play psychedelic music were just imitating the sound, he reaffirmed his belief in the power of the record album as having another dimension, which can reinforce the written word.

> **Tommy (M):** It's looking at phonograph records as a new book and a new kind of feedback man is giving himself… Man has the power to identify with anything. If you want to turn yourself into a Coke bottle you can, and it's much easier on psychedelics. So, man in the future is going to be sitting in front of one of these albums, not necessarily ours, and the album will do a thing to him that would be like music and would not normally be expected. It would make him totally disassociate his actual ever-continuing self from his perishable eggshell earth presence, and he would go to a completely different world. And the more he does that, the more he can learn about that world of immortality, which is just a feeling. That's what we're trying to play in our music, the immortal theme, because it's like Christ said, "We're already immortal from in front." It just knows that feeling or mood that is what everyone is trying to put down on record for man to remember.

In the interview the band also discuss the importance of their live shows and Tommy confirms his commitment to the idea of the band acting as a vehicle to communicate with the audience. He explains, "Right now, as our playing live gets better and better, we're approaching it from an emotional viewpoint rather than a musical one. As our music develops, we, as a group, develop emotion together… It would be hard to compare us with anybody else because we're concentrating our thing on designing geometric states of mind."

> **Danny Galindo (M):** It's group communication, and that's something we're developing right now. Danny Thomas and myself work together as much as possible. As we work, things will come more natural and soon we won't have to think about the beat. It will just be there. Danny will know what to do, I'll know what to do and, along with Roky and Stacy, we'll produce a picture, a musical picture with each part different but all fitting together perfectly. Right now there are a few spots and cracks, but they are rapidly filling.

Although Danny certainly seemed optimistic about the band's future as a live act in the interview, this was soon to sour. The band were booked to play five nights in a row between November 22–25, twice at Love Street Light Circus in Houston, then Columbus Hall in Bryan, Texas, the Safari

Club in Baytown, and then back at Love Street for Thanksgiving on the
30th. The quality of the shows appeared to vary as much as the lineup of
the band. There were three problems—Roky's presence, Roky's absence
and Stacy's truancy.

> **Danny Galindo:** We had a big problem with Roky's volume. It was
> a way of tuning us out so he could perform it the way he wanted to
> perform it. And you could do that with us, so all the time his amp
> was on maximum, wide open. Totally goofy... he'd come between
> all of us so we had to play to him, which broke the continuity. It got
> to where we felt we could play the songs better if Roky wasn't on
> guitar, and at a much later point that's what happened, we got Roky
> the smallest amp we possibly could... and then we quit playing to
> Roky. We knew how to get through the material, so the three of us
> stayed together and went, and it'd be up to him to keep up... that'd
> been the solution to it, and we'd sound good and it worked... it was

killer, he couldn't drown us out. I was never sure why he was doing what he did. He was unable to express his thoughts and feelings, so I think it was some of his frustration coming out.

Again Roky was either rebelling or comforting himself with a therapeutic wall of noise… no one could diagnose the cause. Although Roky was prone to not showing up for shows unexpectedly, Stacy also started playing truant—he'd simply get sidetracked en route. He'd run into friends as he was leaving Kerrville and end up pulling out his guitar and playing for everyone; eventually he'd end up enjoying himself so much he'd forget about the show.

Danny Galindo: I can remember a couple of nights at Love Street where Stacy didn't show up, so everything we did was a spontaneous arrangement of what we were doing. It was incredible to me that all of a sudden Roky found skill and played far beyond what I thought he was capable of… incredible playing, I never thought I'd be turned on by his playing. There was a night or two when Roky wasn't there, and we were able to reach the same place with Stacy. We switched into jam mode. Stacy would vocalize, do some of his tunes, and Tommy sang backup. I don't remember him taking lead, but he sang backup and played his funky jug. Stacy used to hate that jug, man. He just had to put up with it and I could tell how much it got under his skin to hear that… From my point of view, it was definitely an appendage, an add-on, but it was a way of making us different. The jug did set us apart but it wasn't central to our way of performing. Some of those gigs went by so fast I didn't even realize that we were at the end of the gig; of course that was the result of using all kinds of amphetamines and LSD…

Unknowingly, the band had entered a new phase, as a truly cult act. Much of the Texan youth had caught up with psychedelia as the next big thing, and the Elevators were their focus. Fans wrote to the record company asking why there wasn't a fan club and whether they could start one. The band's infamy and psychedelic mantras still spoke volumes to their new, younger audience, who took the band's quasi-religious message at face value, as the myth of the Elevators had perpetuated. Stories circulated and evolved into tales of the band levitating, defying matter by dissolving through walls and lifting objects by telekinesis.

One typical story involved the band playing a show in Baytown. Amongst the Houstonites who followed the band to the gig was Bill Gammon. Bill spotted Roky leaning against a wall outside of the club; both of them were tripping on Blue Cheer acid, which Tommy had just received from the West Coast.

Bill Gammon (K): I thought I'd catch Roky a bit off-guard… I stood next to him and said, "Roky, are you a fire sign?" He didn't say anything for what must have been a minute or two, and then he looked up at me and said, really softly, "No, Bill, but you are." Then he vanished inside the club. I was stunned, I don't know if it was the acid or

the fact that I was a fire sign, Aries, or just the way Roky unknowingly put me down when I was trying to be so heavy and hip... so I started walking down the beach, which was totally deserted. Then I noticed that there were some letters spelled out in the sand and someone had written A-R-I-E-S in big capitals. There on the beach was a full replica of the zodiac done in beautiful details. Directly in its center was a book about astrology, left open on the chapter on Aries, which was discussing the precociousness of the Arian character. There wasn't a footprint anywhere... it doesn't matter who believes a story like that, people pretty much believed whatever they wanted to about the Elevators, and especially about Roky.

In December the band was back in Austin for a three-day run at the Vulcan. This coincided with the release of the new single "She Lives" coupled with "Baby Blue." Yet again, it sunk without trace, and is only known to have charted in Florida, where "You're Gonna Miss Me" had previously proved immensely popular.

Meanwhile, on December 2 *Billboard* listed *Easter Everywhere* as a "Special Merit Pick," and a review stated "Call it intellectual rock or musical flights of fancy, except for tunes that sound almost like each other, this group is inventive overall. 'Earthquake' and 'Slip Inside This House' both race with psychedelic sounds; 'Dust' is slower, filled with folk music qualities. Stereo is not very good."

Following their run of Texan shows, the band was still expecting to embark on a national tour. The first city outside Texas was Detroit, home of the MC5, and a perfect musical scene for the Elevators to visit. The band were also booked by Chet Helms at the Avalon in San Francisco and in Santa Rosa, California by Texan promoter Ray Ruff, who had scheduled a support slot with Them. However, once again the band was doomed to remain in the drudgery of their Houston circuit. For Danny Galindo, enough was enough—his enthusiasm was spent. The end looked inevitable, and Danny decided to get out and start something new.

> **Danny Galindo:** I think my last gig was at Love Street Light Circus in San Antonio, and I believe Roky was about an hour late in coming down from the dressing room. He was in sheer terror. He got up on stage and he looked around a few times and he went back around his amp and hid. Luckily for me, I had a friend there that was a keyboard player, he came up and Stacy and I and him and Tommy just shook it, you know? But that was... for me that was the point... the last straw. So, after the gig was over, I don't know who I told or how I told them, but I said I'm not going to be available anymore, and then I left.

Although Roky's erratic behavior had been a factor in Danny's decision to quit, his own drug paranoia contributed. As dreams of touring out-of-state faded, the menace of the law enforcers overwhelmed him. Just as John Ike and Ronnie had judged the band far too dangerous to be involved with, Danny too decided to avoid the heat and disassociated himself from the band. Clearly, Roky was struggling with the perceived

pressure and was paranoically convinced that "they" were out to get him. He'd also given up on any real chance of chart success and really didn't see why they should bother. Tommy, meanwhile, still retained enough self-confident optimism to hold the band together, convinced that the contents of *Easter Everywhere* would prevail via the new FM radio stations (which played like-minded records by other "psychedelic acts").

A new bass player, Danny Valero, was auditioned by Danny Thomas to fulfil their live engagements until Christmas. Although the band had stalled once again, Tommy remained convinced that Houston *was* to become the new home of the recording industry, and therefore the band was well situated to take advantage of it. He'd become ensconced in the adoration of teen clubs opposed to the critical elitism of the Austin crowd. Just before Christmas 1967, he noticed a young and adoring female fan in the audience and became transfixed by her while he performed. Gay Jones and her friends were all fans of the English bands, and weren't really interested in American groups—however, while most local bands simply played cover tunes, the Elevators were known for playing only their own material.

> **Gay Jones:** Well, I must have been about fifteen, and I really wasn't supposed to be in some of the clubs. I was a little studious girl, and I'd tell my parents that I was off studying. The local bands here that weren't good, they were copying the Byrds and whatever, and you got sick of that and so the Elevators were playing something unique. It seems like an afternoon or an early evening performance, not in our part of town at all; well, my friend Terry and I went to a hall. I was sitting and everyone was so mesmerized by Roky, so I was observing Tommy and he started observing me and our eyes connected and then he really started connecting and of course he was probably stoned out of his brains... then I think they took a break and I was talking to my girlfriend, "Do you like 'em?" And the next thing people are tapping me on the shoulder and standing at the end of the aisle, going 'come here' ... and Tommy was standing there going... [panting] almost couldn't talk... it was just like we met, our souls connected and afterwards I gave him my phone number and it went on from there.

Tommy and Gay's relationship started as typical teenage dating; every time he was in town, they'd drive around, listening to Motown and rolling joints in the car. On one occasion a passing police car showed a little too much interest in the huge box of grass on Tommy's lap, which he threw out of the window. Unfortunately, it blew back in and got stuck in his long hair. The police pulled Tommy out of the car, but seemed blind to the greenery adorning his hair and let him go. Tommy and Gay were dating regularly enough for her mother to insist that she give Tommy a Christmas present, and wrapped up some of her dad's cologne to give to him, which made him giggle like mad.

Almost as soon as the *Easter Everywhere* sessions concluded, IA were demanding new material for another album. There was no opposition from the band, who understood that until the record company's lawyers swung Stacy and Tommy's probation so that they could leave Texas, their

only means of wider communication was the recording studio. While IA finalized a deal to purchase major shares in Gold Star Studios in Houston, the band returned to Andrus to work on a possible new single written by Roky and Tommy called "Never Another (Like You)."

Despite his reservations about the band, Danny Galindo was curious enough to temporarily return for the recordings. The resultant session would have been lost had he not brought the demo tape of his new band, the Eccentrics, and handed it to the engineer, instructing him to record the Elevators over it. In Danny's opinion, what was captured on the tape "smoked"—it was the magical essence, when the Elevators' sound really gelled, the spontaneous interplay between Stacy's guitar, his bass playing and Danny's drumming. Thomas also felt that the recordings made between the second and third albums showed the true potential of how the band could have developed as a cohesive unit had the lineup remained intact. Certainly the music on the tape displays an as-yet-unheard fluidity, drive and authority. The guitar/bass/drums build during the middle section of "Never Another" and hit the cusp of rock music being truly psychedelic, a repetitive, sustained drone: a combination similar to the '68 John Cale Velvet Underground, the "Tomorrow Never Knows" Beatles and the hardest resonations of the Detroit MC5/Stooges sound. The remainder of the material recorded was several instrumental takes of early working versions of two of Stacy's tunes, "Moon Song" and "It's You." Nevertheless, the attempt at recording a new single, let alone an album, stalled. IA opted to release "Slip Inside This House" edited down to a radio-friendly four minutes, backed with "Splash One" in the hope that they could mop up a few extra sales in the slipstream of the Clique's recent success with the song.

Despite participating in the weekend session, Galindo wasn't willing to rejoin the band and returned to San Antonio.[49] Chet Helms had agreed to book the band once again for three nights at the Avalon Ballroom in San Francisco, albeit fourth on the bill, and once again the band remained in Texas.

The Elevators needed a permanent bass player and everyone hoped Ronnie Leatherman would rejoin, partly to placate Stacy, but Ronnie was experiencing extreme difficulties with the draft board and was unable to commit.

Duke Davis was already signed to International Artists as part of the Starvation Army Band, and had recorded with Lelan as the Grits, so he became an obvious candidate. He had also known the band since '65 and had been there at the beginning when Roky showed up in Port Aransas to see the Lingsmen play. Born Earl Wayne Davis on November 19, 1947 in Rhode Island, he'd grown up in Texas and acquired the high-school nickname "Duke" on the back of Gene Chandler's 1962 hit "Duke of Earl." Duke received a call from IA's booking agent Mason, and in January he became a 13th Floor Elevator.

Duke Davis: It was kinda funny because having met everybody in the summer of '65 and then a couple of years after that I was working at International Artist records with Lelan Rogers so I said yeah, why

not? I was close to Danny Thomas, he was trying to bring me up to date with what had happened, how it had evolved. I was close to Stacy; he was so far off into all the dark energies by then. There was a lot of tension between Stacy and Tommy. A lot of the politics in the works I wasn't privy to that. Tommy and I weren't close. I knew Roky pretty well but that could change from day to day. One time we were in Victoria, we drove up together and he got into this thing about Lenny Bruce for two days, he wouldn't let it go, he thought he was Lenny (Roky identified with Bruce's struggle with the authorities). I remember we had a gig in Houston and he missed the gig because he was in the bathtub talking on the phone and he chewed on the phone cord and got shocked. All kinds of weird things were happening with him.

The band continued their regular Love Street gigs while being holed up once again at the Western Skies Motel pending recording. The band played about a dozen shows over the next four months while they also attempted to start the new album. As before, the quality of their performances varied due to whoever showed up and what condition they were in.

Q: Were they still trying to play every gig on acid?

Duke Davis: [Laughs.] That was pretty much a given.

Q: Were you able to do it?

Duke Davis: Yep, there were times, I was able to do it a bit, I don't know how well. I remember we were at Love Street one time and we were all on acid and I had a big stack of amplifiers and after the show I went to go offstage and I thought my amplifiers were the door. Trying to walk right through 'em. I felt, as far as the live thing, you just never knew what was going to happen. It was a pretty unique thing, and of course that was the connection with the audience, because probably 75% of the audience was on LSD as well; it always amazed me to watch the audience. We could sound great and we could sound terrible, and the audience was still being right with us. They'd sing every word Roky sang but there were times when Roky would be singing one song and playing another and the band would be playing a third song. It was that crazy, but the audience would be right with it and know exactly what was going on. Weird.

39. **Q:** *You mentioned how angry you were when your material is compiled and the songs are jumbled up. Was the sequence something you really worked on?*

Tommy: *Yeah, exactly. On the album* Easter Everywhere *it made a whole bunch of loops. And in those days you had these turntables that when they got to the end they would just repeat it, it would just play it for hours and hours the same album...You would go through it and at the end of it you'd realize what the meaning was of songs earlier and then you'd go through again. It would assert itself.*

40. In Catholicism the process of Jesus being condemned leading to his eventual rebirth is charted in fourteen stages. Each stage or station is a point for meditative prayer representing a model for the path to eternal life. The original Judaic Kabbalah has evolved into different disciplines over the centuries, to the Golden Dawn and Hermetic Kabbalah. In the Kabbalah, and its occult use as practiced by the Hermetic Order of the Golden Dawn, the ten aspects of the divine being are placed into charts of realms. The themes contained in the ten songs of *Easter Everywhere* correlate to the ten realms depicted on the Kabbalistic tree. For example, the third realm, Binah, represents understanding; the feminine correlates to the high priestess in the Tarot="She Lives (In a Time of Her Own)." The eighth realm, Hod, splendour, the astral plane and repressed energies channelled from the subconscious="I've Got Levitation." The first realm, the Crown, the goal of human evolution, the assimilation of all spiritual knowledge, Nirvana, relates to both "Slip Inside This House" and "Postures," the beginning and the end. Tommy: "The religious element was only just barely articulated... you know the idea of Easter and rising from the dead... you know you could almost look at it from the Tarot."

41. Eleventh-century Islamic scholar, poet and mathematician.

42. Particularly R.T.H. Griffith's nineteenth-century translation of the Rgveda (Vedas of Recited Praise).

43. The theory that fundamental building blocks of matter could be "strings" that are vibrating at a certain resonance rather than actual particles.

44. Complexity science, the study of complex systems based on networks: chaos theory, human economics, cell systems, etc. which can only barely be mathematically modelled.

45. In Tibetan Buddhism, a Bodhisattva is someone who seeks enlightenment for others, not only themselves.

46. Rgveda II-XXXVI—(this hymn is also known as Son of Waters/Brother of Waters) "He, Brother of Waters, of permanent colors hath entered here as in another's body," refers to sharing of collective wisdom. It should be noted that Tommy denies that Heinlein's book was an influence. Regardless, the book's title comes from a Biblical quote by Moses, who was saved from Pharaoh's order that all Hebrew firstborn were to be drowned in the Nile by floating downstream in a basket. He later returned to Egypt to release the Hebrews from slavery and God directly intervened to part the Red Sea and allow them to escape. David Crosby also referenced "water brothers" in his lyrics for the controversial song "Triad," about a *ménage-à-trois* which the Byrds recorded but refused to release.

47. Sri Yukestwar Giri wrote the *Holy Science* book in 1894, which set out to show the eternal truths and similarities between Hindu and Christian beliefs. He stated that evolution expands from era to era in a circular manner; the more enlightened the era the easier it is for people to become liberated from the cycle of death and rebirth. Incidentally he's featured as the top left cut-out of the Beatles' *Sgt. Pepper* album cover.

48. 128 hours and 30 minutes over the month at a cost of $6,500.38, which IA actually paid (October 6, 1967) on completion.

49. Danny Galindo's next venture was to sign back to IA with a new band formed with his brother Bobby and Billy Hallmark from the Golden Dawn called The Rubayyat (later known as the Electric Rubayyat). Although the band played extensively around Austin and are fondly remembered, their lone 45, a cover of Tim Hardin's "If I Was a Carpenter," doesn't do their reputation any justice.

16.
JERUSALEM:
SUPERSONIC HIGHWAY

Although the Elevators had previously benefited from the anonymity that the sheer size of Houston offered them, they had now became trapped in a vast, sprawling metropolis, where even walking down the street made them a target. Despite healthy levels of paranoia and self-inflicted anxiety, there were also very real dangers. Although the sight of longhairs and freaks became a more common occurrence, so did the level of hatred and resentment toward them. The game of cat-and-mouse with the cops in Austin two years ago now paled in comparison to the tough urban police in Houston, and the genuine hatred from rednecks. In early 1968, the Elevators became lost in Houston the same way they had become separated in San Francisco.

Despite his moments of lucidity during the recent sessions, "Roky Erickson" had once again become a very frightening role for Roky to perform. The prospect of being billed to appear at a given time and place caused Roky so much anxiety that he simply chose to avoid it. The anxiety manifested itself once again with a now trademark Band-Aid worn on his forehead. Whereas previously he had explained that he was "transmitting but not receiving," his current explanation was "if I speak too loudly I'll break the world in two." He was also convinced that "they were out to get him" and began adopting different pseudonyms. Roky had always created theatrical stage names, such as "Emile Schwartze," but now he was showing signs of a fractured personality. In mundane settings, such as diners, he would sign his tab Mike Read and on occasion the band had to perform under another name. Roky's persecution paranoia meant he led a nomadic, no-fixed-abode existence of crashing around various open houses. On several occasions, Nobel Ginther offered Roky sanctuary at his own home in a middle-class suburb of Houston. However, being a freak in such an upmarket neighborhood caused even greater anxiety, because cops saw it as an outrage that the band were being protected by supposedly upright citizens and lawyers.

Regardless of trying to distinguish fact from urban myth, the stories from this period illustrate the level of the perceived threat. Russell Wheelock had moved back to Houston from California and had a respectable job as a teacher; however, when his freaky friends came to visit it made him decidedly nervous.

Russell Wheelock: I'd got this job in a black school and it was a real redneck place. And one night there was a knock on our door and it was that whole damn bunch, Ed and Charlie [members of the Conqueroo] with their hair out here, crazy-looking, and they didn't get inside quick enough, and someone saw them and I tell you it was like we could have been killed, it was that crazy there. Some guy made a blind on his balcony and would sit out there at night with his shotgun in order to get someone and he actually shot somebody from up there, it was unbelievable in those days... when they saw Fat Charlie and Ed they just about went berserk.

More alarming are Sandy Lockett's recollections of an incident that allegedly happened to Stacy.

Sandy Lockett: Stacy actually got one of the famous police department swimming lessons... oh yes, it used to be a common thing. A couple of rogue cops would take someone that had annoyed them to the bridge over Buffalo Bayou, about a thirty-five-foot drop to the Bayou, which was quite shallow, and they would simply throw you in.

Q: That happened to Stacy?

Sandy Lockett: Yep. And of course it was an open sewer and difficult to climb out of, about half the back was lined with buildings that went clean down to the water, and so maybe you could find a window sill to hang on to... it was a bummer. And his fears, physical and metaphysical, just overcame him and I can remember him sitting on the end of the bed just... with the blue horrors, and you could mistake it for the DTs or overdose or something, but it was sheer human terror. This wasn't the only time he got overwhelmed with such things... but it was certainly one of the worst.

Meanwhile, there were growing tensions between Stacy and Tommy. Stacy objected to Tommy's preoccupation with mainstream religion, while Tommy frowned on Stacy's choice of lifestyle. Stacy began to distance himself from the everyday activities of the band for several reasons: it just seemed too dangerous to be involved with, and he found that he suffered from bad acid trips, which led to further conflict with Tommy over the use of LSD. While the band seemed to be stalling, Stacy became agitated to the point of needing distraction. Unfortunately this had come largely in the form of "skin popping" amphetamines and his new choice of drug—heroin. The prospect of building a psychedelic society of new possibilities was fading, and for many it descended into a fully-fledged drug culture, which Stacy fell victim to.

Q: How did Stacy relate to Tommy during this period?

Jerry Lightfoot: Told me it was "Poppycock," exact words of Stacy's. Stacy wanted to be invisible, he didn't want anybody knowing his

business, and so he tried to separate himself. Everybody has this idea of bands being this communal thing, five guys who agree on everything, 90% of the time it's one guy, full of himself enough to get the thing done. It's not a democracy. Stacy really believed in that band and thought it should go, but it reached a point where Roky should have stopped taking drugs, and he never got a place to dry out, he seemed like he never got a chance to get a breath. He kept getting worse. Tommy thought that using speed was bullshit, "You're using Hitler's drugs now." Stacy's taking bennies and he got to a point where he felt like he'd taken enough LSD, maybe just take it once in a while...

Q: Why did he switch to heroin?

Jerry Lightfoot: That's where you go, that's the best one... It's a very isolated, cocoon type of thing; he was looking for some peace. Good God, everyone in the world knows what heroin does to you, but look at how many junkies there are. And people don't take enough to party, they take enough to stay sick and then people start dying.

Stacy (K): I got into smack in Houston, I was depressed, but I had also been doing a lot of speed and I was really tired of it. I had a roommate who dated this chick and she was supposed to bring over a gram of speed but she scored heroin instead. We were both leery of doing it, but we tried it and oh, it hit the spot. I wasn't planning on getting strung out, I was just gonna chip with it... and cut it off when it started fucking with me. And I didn't catch it. I just freaked out.

Stacy displays his usual degree of self-denial, choosing not to mention his dalliances with the drug during '66 in San Francisco.

Tommy, despite his Presbyterian upbringing, had remained largely agnostic at the start of the band, but his rhetoric was now sounding increasingly more like that of a card-carrying Christian than a pioneering and all-encompassing Gnostic. Stacy strongly objected to his adoption of mainstream religion within the band's message, and so Tommy got around this by demanding an hour to lecture his ideas before concerts. Proselytizing any deviation of mainstream Christianity, let alone in conjunction with LSD, while in the Bible belt was a very dangerous situation to put the band in.

Stacy (K): [Tommy would] have big crowds of people coming over to the house, and sitting around while he lectured. He started telling me, "I want to lecture an hour there every performance." I started arguing with him about that, somehow, man, I knew that was bullshit. 'Cos he'd get up there and start raving, "God is LSD" and all this, man, and these cops would come up and say, "You better collect that guy." And I'm getting uptight... it was really a rebellion, it got to be a revolution instead of a band, you know.

Duke Davis: There was so much tension between Tommy and Stacy they pretty much stayed away from each other. Tommy had the pep talk thing he'd do before we'd play.

Q: What would he say?

Duke Davis: A lot of it was so far out, he was almost talking like Roky, it was about what the purpose of the music was in terms of the metaphysical realm. A lot of it didn't make a lot of sense to me; I was the new kid, I was trying to remember what key things were in.

Gay Jones: I remember going to a little town, could have been Baytown, that was very conservative, Southern Baptist, not accustomed to this look, behavior. And I remember being really horrified one night in this hall with these sheriffs standing around and it seemed like someone booked them and they didn't know what they were getting and this band shows up, and the old boys are standing around with the tobacco going, "Who are THEY?" And they're playing and nobody is clapping and it was awful. The next thing I hear is Tommy up on stage grabbing the microphone and talking about LSD, and I remember being horrified and looking at the sheriffs and they're looking at each other. I thought, "What are you doing?" He got to a point where he told me he was taking acid every single day, so he was living on it and not eating...

Following *Easter Everywhere*, Tommy disengaged from the band and relaxed his totalitarian hold over their direction. It was generally understood that since Stacy had made a commitment to Roky and Tommy to record the *Easter Everywhere* project, he would be allowed to address his stockpile of material on the third album. The band ceased to be the main focus for Tommy's ideas, and he concentrated on developing them through workshop meetings at his new apartment on Louisiana Street in downtown Houston. Although the meetings weren't viewed as social gatherings, one of Tommy's neighbors would often have parties, and the news that one of the 13th Floor Elevators lived in the same building often attracted unwanted visitors, much to Tommy's annoyance. Although he relaxed in terms of the band, friends witnessed a marked change in Tommy, both in his attitude toward others and the way in which people reacted toward him. While he had formerly adopted the role of a psychedelic guide or shaman, he was now beginning to lecture in a dogmatic way.

Gay Jones: There was a long corridor with rooms off it, but huge rooms, he had huge murals on the wall, big, huge Victorian velvet sofa, wood paneling... I noticed that various people would form a group and sit at his feet. It was very disturbing to me and ridiculous, and then here I am, younger than anyone, saying, "Can we have a conversation?" I think people were intimidated by him, it was so intellectual. Tommy would say, "Sit up here." He'd say we were the king and queen. A lot of people thought he thought that he was Jesus Christ... and I didn't get that impression. He was trying to raise his consciousness to the highest possible point. Which is possibly what Jesus was doing. A lot of people misunderstood that. I never saw him as trying to say, "I'm the way." He was not egocentric. There was an artist next door, Dale Montan, who had parties there, where

some people had moved in who were on the edge of the scene and who were into getting out of their minds and having wild parties, which Tommy didn't want any part of... because you've got droves of people coming in drawing attention. Not a good thing, because you don't know who's turning up.

One of Tommy's "followers" was Fred Hyde, who regularly hung at Tommy's apartment during this period.

Fred Hyde: Tommy had the greatest apartment down there that you'd walk down this kind of an underground thing and there were artists and he'd just hold court down there. He'd play albums and everybody would be loaded, you know, smoking DMT or hash or weed and he'd just be running his rap all the time and we'd all just be totally infatuated by everything that Tommy said. I think it was such an unsure time and he really appeared to have it together better than any of us. There were people who said, "ah, the guy's full of bull," but those people were of no importance. So, Tommy just grew and the whole scene evolved around him.

With IA now holding major shares in the old Gold Star Studios, nearly all the acts on the roster were ordered into the studio to begin projects.[50] Stacy began to demo new songs with Danny and Duke in Studio B, with Fred Carroll as engineer, on February 7; the first track attempted was a simple Stacy love song, "Wait for My Love." But the Elevators' sessions stalled because Lelan had secured a handshake deal to record Lightnin' Hopkins with his manager Mansel Rubenstein, who operated out of the back room of a pawnshop on the corner of Dowling Street in Houston.

Lelan: Lightnin' had a rule of thumb that he worked by, and that was you don't pay him any royalties... You have all the publishing, you have everything and you give him $1,000 per song, that's it!

Duke Davis had barely had a chance to start recording with the Elevators when Lelan Rogers poached him and Danny Thomas as session players for Lightnin'. They played on four cuts on the resulting album, which was recorded over two sessions at Gold Star on February 8 and 14, 1968. Meanwhile, Stacy hung around the studio hoping to be invited to play with his hero. As a consolation, Dillard took Stacy and Tommy out for lunch and bought Stacy some new guitar picks and Tommy a couple of music books on the IA expense account. As Danny Thomas recalls, Stacy commented that his association with Lightnin' was "the most important event in my life... and he was right. Lightnin' and I were very close friends for about two years. I was his drummer both in the studio and on the road between Elevator gigs."

The Lightnin' Hopkins session proved one of Lelan's proudest achievements, and he even managed to get Lightnin' to sit down and talk for almost an hour about his life history (a fragment of which was later used by Lelan on the *Epitaph for a Legend* album released in 1980). Lelan's involvement with mixing and editing the Lightnin' sessions meant he

was occupied until February 21. However, he mysteriously left IA before he could begin the next Elevators album.

Allegedly, Nobel arrived drunk late one night at the studio with a couple of female companions. He stumbled into Lightnin's sessions and made some derogatory comment about making him play a song again for his benefit, causing a furious reaction from Lelan, who was supposedly fired on the spot.

Stacy took complete control of the third album sessions effectively banishing Roky and Tommy from the studio until he'd recorded satisfactory music tracks, and then invited them to add their contribution.

On February 13, he was back in the studio to record material that has survived in name alone—"Now the Time is Autumn" and "I Still Miss Someone." The following day he spent seven hours reworking "Wait for My Love," a song that was doomed to be endlessly tampered with until it ended up being rewritten by Tommy. On the 18th, Stacy attempted to finish the music track for "It's You," a track that would be completed with vocals, but was never released.

> **Roky:** When we first started the Elevators the whole thing was to make sure everyone agreed on something before we did it... see, *Bull of the Woods* (the new album) was the idea of not having the whole band agree to everything that was being done. So I don't really remember those songs, Stacy probably wouldn't even show them

to me. He would be paranoid if he said anything to anybody about it that his ideas would be rejected in the end.

Duke Davis: I remember the title "Beauty and the Beast" being flown around, but by then it had pretty much become Stacy's project. Roky was out of the loop, Tommy was totally removed, Stacy would go in the studio and record by himself, lay down some ideas and then later on we'd get together and work on them. The beautiful thing about the Elevators was that Stacy had the sound, Roky had the voice and Tommy had the lyrics. And that chemistry changed and once Tommy fell out of the mix, Stacy became the driving force and I thought it was good because by that point he was battling the heroin addiction so bad I thought this is a great positive thing for him. It could really help his life, make him more creative and bring him out of his dark energies.

At this point the only thing keeping the band together was a restaurant tab IA had set up at Ogger's Diner on Balfort Street As usual, the band was utterly beholden to the record company for handouts, IA refusing them an actual salary because they believed it would be spent on drugs. Tommy treated this as a lifeline and transferred the tab to a waffle shop on Louisiana Street called Dobes, where he ate every day for practically three months. For Stacy, too, it was his only guarantee of a meal.

The third Elevators album, *Bull of the Woods*, is generally believed to have started life under the working title "Beauty and the Beast." Although artwork exists bearing this title, Tommy strongly denies that it was even started. It was to be Tommy's next project after Stacy's album. His governing theme for the project was a manifestation of his insecurity and fear of an Electra complex behind his relationship with the far younger Gay Jones. Over the ensuing months he obsessed over the thought that Gay would want to date other men, which led to paranoid interpretations of her actions. Depending on what color Gay wore or what she ate, he would interpret her choices as indications of hidden desires.

Stacy's self-doubt meant he dismissed a lot of his demos rather than risk rejection from Roky and Tommy, but he had finally finished enough material to enlist them on February 22. This was the first and last time the band collectively collaborated on the new album. The Elevators started at one in the morning and attempted to finish the vocals on "It's You," the result being a strange combination of ensemble vocals mixed with Roky's lead. Roky and Tommy drifted off to leave Stacy and the rhythm section to record what Carroll noted on the session sheet as "several bad takes on the music track of 'Moonsong.'" The session ended at 8:30 a.m. and Roky returned to the studio at midday to find it empty—save for the IA bosses, who talked him into recording material on his own.

In three hours, Roky laid down several takes of "May the Circle Remain Unbroken," playing guitar and vocals and overlaying meandering Vox organ parts. Not only was this the first song he'd written entirely on his own since "You're Gonna Miss Me," but it was a complete departure from the traditional Elevators sound—no drums or no jug, just a keyboard and guitar. The rest of the Elevators arrived back at the studio and blasted out

what turned out to be their swan song, "Livin' On." This Hall-Sutherland song was a masterpiece of self-realization and perfectly captured the band's defiant mood—they were still a musical force to be reckoned with.

Duke Davis: Yeah, I remember that, "Livin' On," which I thought was a magical moment. I remember that because there was so much dissension going on creatively, and trying to get Stacy involved and Tommy back in. Everybody on the same page. The feelings were pretty good that night, and I think that was one reason the track "Livin' On" was a real special moment... it was turn the tape on and go.

With "Livin' On" complete in one session, the band focused on "May the Circle Remain Unbroken." By this point Gay Jones had arrived, and John David Bartlett was also present. Takes two and three were spliced together and everyone in the studio began softly joining in on backing vocals (mixed out on the final version). Stacy got John David Bartlett to clink a large glass ashtray while he manipulated the sound through a series of Echoplex units daisy-chained together to create a haunting effect. This was a trick Stacy had often deployed on stage to build up an echo-ridden wall of guitar sound, but this was the first time he'd recorded the technique—albeit using an ashtray. As Roky recalls, "See, they would have these new experiments they would be working on... and not have it okayed by the whole band."

Along with "You're Gonna Miss Me" and "Splash One," "May the Circle Remain Unbroken" is the only song from the Elevators period that Roky still regards as his own. When it came to articulating the band's message for the third album, it was Roky who succeeded in his own uniquely simplistic manner. Roky's approach was the antithesis of Tommy's and highlighted the complexity of his lyrics while neatly fusing Eastern and Western ideologies into a simple repetitive line without any fuss. The title cleverly pays homage to the traditional Christian hymn "Will the Circle Be Unbroken" (by Ada Henderson and Charles Gabriel circa 1905 and popularized by the Carter Family in 1935), while directly adopting the Buddhist phrase "May the Circle Remain Unbroken" (the karmic cycle of rebirth). Although there was a fuller set of lyrics later published in Roky's book *Openers*, the recording's only lyric is the title sublimely and mesmerizingly repeated over a series of gentle undulating rhythms to create a foreboding reflection on the band's status. Typically, in the band's last moments together, they gave their recorded legacy one final twist, a glimmer of what could have been.

With Lelan gone, either Fred Carroll or Jim Duff took turns to mix and edit the material they had personally recorded. Stacy returned on February 29 for an all-night session and recorded several complete takes of "Never Another," essentially a love song which lyrically alluded to the eternal cycle of life ("Freedom palace burns our souls and makes up all the new ones"), but omitted a verse from the original demo:

Right now with Robin Hood, a woman's on the run,
never rested in our hearts and our love turns to die,

It's in the ark of us together, many eyes can see,
Another world when we're together, give your love to me,
Never another like you, never another like you...

On March 2, it was Tommy's turn in the studio to overdub jug parts, and the following day Roky overdubbed his vocals on "Never Another" and "Livin' On." Then Stacy and the rhythm section returned to record several more backing tracks on March 12. These consisted of several incomplete takes of a new Sutherland/Hall collaboration, "Dr. Doom," and further attempts at the ill-fated "Moonsong" and "Sweet Surprise." By now Tommy had learned to play some rudimentary guitar, and was able to contribute some of his understanding of composition, rather than simply embellishing existing songs with his lyrics. Interviewed in 1977, Stacy seemed positive about Tommy's input: "Tommy generally wrote most of the words and did background vocals, jug. Ah, he got toward the end where he wrote some with the guitar; he was just starting to learn it when the group fell into disbandment." The next day, the 13th, Roky laid down the vocal and guitar part for "Dr. Doom," while the band re-cut "Sweet Surprise." The band then played a few live shows in the interim, at the "Blue Underground" held at Rice University Memorial Center with Lightnin' Hopkins (which Danny Thomas recalls was one of the their best gigs), and two nights at Love Street in Houston on the 15th and 16th. By this point, despite being landlocked in Texas, the Elevators' reputation as pioneers was already cemented outside the state boundary and, as Danny recalls, their Love Street shows were always attended by touring bands such as Grace Slick and members of the Jefferson Airplane and Iron Butterfly. After another session on the 20th, and overdubbing on the 23rd with ten tracks in the can—just enough for a new album, but without completed vocals—the project was put on hold. The HemisFair had come to San Antonio.

> *San Antonio Express:* Visit the pavilions of American industry, browse the wares of foreign countries, then thrill to the view atop the Tower of the Americas, 622 feet above the pageantry of the Southwest's first World's Fair. All this and more is yours at the HemisFair '68."

The band were booked with the Sherwoods to play a one-off show in the Houston SDS on April 1 before they headed to Love Street in San Antonio for a whole month's worth of shows. The plan was to take full advantage of the staging of the world's fair exhibition, which ran between April 6 and October 6. With the papers forecasting daily attendance figures in the region of 30,000, the Elevators weren't the only band hoping for increased attention by playing at satellite events. Other local clubs, such as the Pussycat, found themselves able to book international acts such as the Jimi Hendrix Experience and the Electric Prunes.

Phil Krumm, who was running the Y Project (youth) tent, knew the Elevators through Love Street and booked them to play the HemisFair at 9:30 on the evening of April 8. But the band disintegrated before they set foot inside the HemisFair.

Sibyl Sutherland made the trip to San Antonio and witnessed one of Roky's last moments with the band.

By this time it was increasingly trying to get Roky to show up for gigs. When they had a booking, someone would ask him whether he wanted to ride with them to the store to pick up cigarettes, and then drive him to the venue. Often Roky would cower by the side of the stage and Stacy would chalk a line for him to follow on the stage. Often this backfired because he'd simply hide behind the amps when he saw the audience.

Sibyl: They got a chance that year to play at HemisFair and that was a big thing, every now and again they have a big to-do in New York or Chicago, but it was San Antonio that had this one, and they were asked to play at it, which was quite an honor. They had dozens and dozens of stages with different things happening on them all the time, and I was always interested in theatre. Anyway, they were playing and Roky just walked off the bandstand. He was very paranoiac; he thought they were out to get him. He said, "They're after us," whoever they were, and he wouldn't come back, so they had to dismiss them and finally get someone else. Stacy was very annoyed.

Danny Thomas: The San Antonio Love Street was a great idea, it was right across the street from HemisFair. A great venue, with a balcony, great sound system, that's when Roky would not go up on stage. We were scheduled to play HemisFair after we did a few gigs at Love Street, but never did. I wouldn't even call them a full gig... I think our equipment was set up and we got up there and messed around a little bit, but we never did a full show. Oh, he didn't freeze, he just wouldn't go out.

Occasionally the band went on as a three-piece anyway, and jammed in the hope that he'd join them. By the time Beau made it down to see his brother play there was no sign of the band at all. Phil Krumm remembers what he believes was the last attempted Elevators show at Love Street:

Phil Krumm: April 8, two days after the opening of the fair... the Elevators blew apart. It was the last time I saw any Elevators all summer. Sebastian [who ran the club] was chewing Tommy out and excoriating him, calling the Elevators washed-up losers. Charlie Powell and Roky Erickson asked if they could use my Cadillac hearse for a trip to Austin. I said sure, and about twenty minutes later Tommy Hall came in and said, "Where's Roky, we've got a concert at Love Street tonight!" Roky took off and forgot about having a concert to do. At that time he was wrecked pretty solid from tons of acid and from time to time had a bandage over his third eye. Charlie Powell was a shell-shock case, Vietnam veteran who was incredibly sweet and incredibly spaced out, and he and Roky hit it off since they could communicate spatially... Roky couldn't go anywhere without teenyboppers giving him acid or worse, and it pickled him out pretty seriously in those days. But what I called "the final gig" was actually no gig at all, since Sebastian threw Tommy and the others out.

(1968) Handbill for Houston Love Street shows, October 25, courtesy Susan Chelf

Q: When were you first aware Roky had problems?

Evelyn Erickson: '68, when he came home from the HemisFair. I had taken Ben to see the band, and he looked really tired... and I asked him, "Do you want to go home tonight?" And he didn't come home then, but he came home the next day. And he was just... exhausted... and I could tell something was wrong... [Roky] slept all week, friends took him out and got him high. This went on about three weeks.

As soon as Roky felt rejuvenated enough he hooked up with Dana again, and shared a house by Deep Eddie pool with the legendary Townes Van Zandt. Townes caught Roky cheating on Dana, so Dana ended up cheating on Roky with Townes. Roky continued to drift back and forth around Austin until, between three a.m. and five a.m. on the morning of April 20, he was heard screaming out by the pool in the backyard of Arthur Lane.

Evelyn Erickson: It was the middle of the night when he started talking gibberish, out by the swimming pool, and it scared me to death. And I called the emergency hospital and said I have to get an emergency psychiatrist... and I talked to a psychiatrist and they said I can't see you until eight o'clock in the morning... just keep somebody with him, keep him calm, and I got so tired I woke up Mikel and I think he stayed with him a while. [In] the morning I got him to the car and got him over to the Holy Cross Hospital. And then the psychiatrist met us over there and knocked him out with drugs.

At 9:30 a.m. that morning Roky was examined by Dr. Kerr, who kept him heavily sedated and under observation for two weeks. While everyone waited to see what the outcome of Roky's situation would be, the band entered an extended period of inertia. Tommy and Stacy's relationship became polarized between mind and body—while Tommy "lectured" on his ethereal ideas, Stacy sought to keep the band in existence by organizing rehearsals, gigs and overdub sessions.

To kill the boredom Stacy formed a rehearsal jam-band called the Eagles, with Danny Thomas and fellow IA labelmate John David Bartlett, which gave him a platform to develop new material outside the vacuum of the Elevators. When he couldn't get studio time to rehearse, he'd idle around Goldstar, and he and Jerry Lightfoot would often play Frisbee with the unsold boxes of records that lay piled up in Studio B. Alternatively he'd liberate boxes to sell to fans or sell canaries by the roadside to make the bill money. As John David Bartlett recalls, "There was one time, and it sounds so stupid these days, everybody signed to IA who was at the studio that day refused to record anything apart from this opus called 'Hamburger.' And it was 'Hamburger, hamburger, hamburger, hamburger, we want a hamburger, hamburger, hamburger, hamburger, hamburger,' 'cos they weren't feeding us. And they finally brought us some beer and hamburgers at the studio." With no income Stacy, Duke Davis and Danny Thomas found themselves garrisoned at "Funky Mansions," a dilapidated two-story house set back on the Old Galveston Road, which was used by IA as an even cheaper option than the Western Skies Motel. A regular

evening's entertainment would consist of setting fire to a pound of grass in a pan, and then eight or ten people would jump under a blanket and inhale until they rolled out giggling. Then they'd bash out old rock 'n' roll favorites on Danny's upright piano well into the early hours. But as band activities dwindled, so did Stacy's resolve, and the black cloud settled over him once again.

> **Stacy (K):** I felt emotionally upset about what we were doing... I felt we really had a lot of negative, satanic force... I didn't feel like we were doing the people a bit of good. It hadn't benefited us all. I felt the message in the band was not what I want, you know what I mean?

> **Jerry Lightfoot:** IA had a house on Old Galveston Road and they let Stacy stay out there, like that ended up being a horrible drug den, speed freaks... I used to go in there [IA] with Stacy and beg for twenty dollars... and then at one point, to show you how shitty things got, he wanted a Burny Castle Gibson and he went down there and he argued with them, he said I've honored every bit of all of this, I'm the only one out of everyone and all I want is a Burny Castle Guitar and I don't think it's too much to ask at this fucking point. And anyway they finally relented and got him one, and the first night he had it some speed freak knocked it down the stairs and knocked the head off it and broke his heart. And that's when he got real disgusted with everything, and he had every right to be.

In April, with the sessions essentially over, IA set about selecting tracks for consideration as the next single. With Stacy's album essentially recorded, Tommy had begun to formulate the next part of the equation. The lineage of his Elevators projects had faltered: it needed a simple beginning, middle and end. If the first album centered on interpretation and analysis, the second was a unifying signpost for information leading to ultimate spiritual truth and the divine energy that maintains existence, then the third was to be the culmination of the quest. His work had followed Gurdjieff's template for the three volumes of *Beelzebub's Tales to his Grandson.*

> **First Series:** To destroy, mercilessly, without any compromises whatsoever... the beliefs and views, by centuries rotted in him about everything existing in the world.

> **Second Series:** To acquaint the reader with the material required for a new creation and to prove the soundness and good quality of it.

> **Third Series:** To assist the arising, the mentation and, in the feelings of the reader, of the veritable, non-fantastic representation not of that illusory world which he now perceives but of the new world existing in reality.

Although Tommy had become preoccupied with Christianity, he was studying the early Gnostic Judaic and Christian texts—esoteric scripture

simply omitted when the Bible was compiled because it had fallen out of use. Gnosticism was the logical progression for the third project. Generally accepted as predating the Christian era, the guiding concept behind Gnosticism was that all human beings contained a divine spark, a fragment of the one divine essence and that all religions ultimately pursued the same spiritual truth. The Gnostic tradition had clearly driven the *Easter Everywhere* project, and now Tommy needed to make his end statement, the culmination of his work.

As Mayo Thompson (of the Red Crayola) understood it, IA had a triangular logic of the geography of North America in relation to the music industry. San Francisco on the West Coast and Boston on the East (the much-hyped "Boss-town" sound) formed the top of a huge triangle with Houston at the bottom indicating it would be the next big musical capital. Tommy had formed a similar idea and, fueled by Christian Gnosticism and the work of William Blake, he had transcribed a map of the Holy Land over Texas. If Tommy had begun the band with the Blakeian philosophy from the epic poem "Jerusalem" ("I must create a system or be enslaved by another man's"), he was now implementing it. No one can quite recall if Austin was Bethlehem or Damascus, but Houston was definitely the New Jerusalem. As David Bowie cashed in on the first lunar landing with "Space Oddity," Tommy acknowledged Houston's status as "space city" with "Jerusalem (Supersonic Highway)." Many friends and fans recall that it was more of a mantra or drone than a song. Although it was performed live at Love Street on several occasions, it was never recorded. While the diehard Elevators audience had remained faithful through the chaos, "Jerusalem" was the step that began to alienate them.

John Bartlett: There was a lot of talk about "Christian mysticism" in the final days. The Theosophical Society (founded 1875 to study the world's religions), Mahavatar Babaji (from *Autobiography of a Yogi*, 1946), Baba Ram Dass (Richard Alpert after his spiritual rebirth) the Gospel of Levi (Aquarian Gospel, 1908), the Essenes—all were discussed. The lost years of Jesus' life were a common topic. Did he make it to China? The line that runs through all beliefs. Polynesian sailors in Chile. Elephants in Mayan Hieroglyphs. The man crowded my brain for life… "Jerusalem"? It wasn't much like other Elevators tunes. I saw Tommy sing it. I still try to sing it to friends to explain what it was like. The lyrics were "Jerusalem," wailed, moaned, screamed and cried. It was almost a mantra, a song cycle and a glass bead game. One of the most pleasant memories I have of their live performances. Tommy wasn't driving me nuts; I could see where people would lose interest in what he was saying pretty quick.

Duke Davis: Oh yeah, (Jerusalem) [laughs]. I remember that. The only thing I can remember about it was it was so weird, one concert Tommy went into that, and even the audience went "what the heck's he doing?" It was just so crazy, it really didn't make any sense. It was almost a discomfort…

Jerry Lightfoot: Tommy came up with the idea that Houston was Jerusalem, and Austin was Damascus, so he wrote a song called "Jerusalem." And he had this whole thing built up and not even using it as imagery... but you have to understand that he was right. There's a philosophy rule of thumb that if you come up with an idea, you should be able to explain it from a couple of points of view, and Tommy had always done that... and then when he got into this Jerusalem thing he started to say, well, you've just got to believe me. Tommy was one of these guys who would initiate a project, and if you didn't do "THAT," and Stacy got tired of doing "THAT"... then "fuck you," and Roky was having these terrible mental spells that were never dealt with properly. The spell broke; that's when [Tommy] gave up on the project and gave up on everybody and started having a very patronizing attitude to everybody. Because if you didn't see it Tommy's way, you just didn't get it.

John Lewallen: The New Jerusalem thing I never understood. Everyone else wanted out of Houston, but Tommy and the band were forced to live here by the record company. It was all they had. Perhaps he needed to be positive about being stuck in Houston when everyone else was in Austin or Frisco.

Fred Hyde: When [Tommy] was writing that, everything was Biblical, Houston was Jerusalem, I think Austin was Bethlehem... he knew exactly where all these places were and they all related Biblically to each other, and Houston was going to be the most happening spot, because it was Jerusalem. Everything had a meaning. Colors were a big deal to him. Orange was the color of evil; if a person wore orange then they were an evil freak, they were out of hand, you would never find Tommy wearing orange ever.

Gay Jones: I really was quite happy with him. We spent a lot of time alone, we had a very intense relationship in the beginning, but I think for me it was hard to handle him when he had done a lot of acid.

Q: Were you taking it?

Gay Jones: Not really... Well, you felt like you were, anyway. There was so much paranoia with him... he and Roky... that you really couldn't have a rational conversation. As I'm sure you've heard, that "everything meant something." And whatever it was, whether you wore red or wanted tea or sausages... everything I ate had a meaning to him. At first it was a funny thing, everything I did, and it just got too much for me. For him, it all meant that I wanted to be with somebody else. Like, this is really crazy, but I ordered sausages for breakfast—that meant I wanted another man. And I just got to where I couldn't even eat. "Be careful, because that could mean this," and then later it was, "Oh my God, you ordered that?" or "You put THAT on?" Or "You wore THAT color?"... and if you wore orange that was the highest ego color, so it meant look at me. Purple was his favorite color, purple was royalty. He was king of some kind and it was all

about royalty and your place in the universe, how high you were, he did relate everything to that...

Tommy was separated but not divorced from Clementine, so in order to reinforce his relationship with Gay, he contrived a bizarre ceremony following one of the band's irregular appearances at Love Street.

Gay Jones: Love Street was happening, I so loved going there... you walked in and they had these huge pews with these long pillars, so you walked down this hall with a huge screen at the end, where the band would play. We were leaving there one night and Little John was there, he was usually our chauffeur, and we were leaving, and about eight six-foot black men surrounded us, literally, and they made a circle and they were dressed in this satin, like genies. They were probably basketball players—we all got apprehensive apart from Tommy, and the next thing I know he's talking to this guy and he had this Bible and he's performing a marriage ceremony... no paperwork!

While the others chose to disappear into their own private realms, Roky didn't have a lot of choices. He was released from the Holy Cross Hospice into Evelyn's care on May 4. However, when Evelyn called the hospital to get a repeat prescription of Roky's medication, Dr. Kerr was unavailable and she spoke to a Dr. Scarborough, who was furious that Roky had been released while so heavily medicated. On May 23, Roky was no longer the family priority when younger brother Mikel was arrested on serious drug charges, and a week later Roky was driven by Evelyn to see his brother in prison in Laredo, Texas.

Q: What were you busted for?

Mikel Erickson: Conspiracy to smuggle 229 lbs. [of marijuana], but I went to prison for two caps of LSD, Blue Cheer acid, that I'd given to a guy and an old acquaintance of mine from high school for a dollar and fifty cents apiece. He thought he could get off the rap by turning me in...

Mr. and Mrs. Erickson made an appointment on June 4 to confront Dr. Kerr about Roky's treatment.

Evelyn Erickson: I got really upset with Kerr because he said he'd be a vegetable the rest of his life... no hope at all. And I said, "Well, who would you recommend that thinks completely differently from you?" He said, "Well, there's a Dr. Hermon in town, came from Europe." So I went to him and he was kind, able to talk normally to me, a lowly patient's mother, and took Roky off most of the medication Dr. Kerr had him on, gave him a very low dosage, and he improved so much... it was amazing. He had a nurse, Robert Williams, who had heard Roky's music and was a fan; so he said I'll help you with Roky, take care of him. He took him for about a week and let him live over there with him and two friends... but Roky walked away from them and was gone again...

Although Stacy had completed an album's worth of backing tracks, he no longer had a singer to complete the project. Nevertheless, in early April IA decided to cull a new single from the sessions and "May the Circle Remain Unbroken" and "Wait for My Love" were selected for release. However, the thought of one of his songs being used as a single sent Stacy straight back to the studio to endlessly re-record and overdub "Wait for My Love." The track was remixed again on May 3 and 5 and the title was crossed out and changed to "Someday My Love" on the session sheet. Despite the state of their relationship, Stacy and Tommy collaborated on new lyrics which would be recorded yet again and eventually appear under the title "'Til Then."

IA were impatient and passed over the track, instead unearthing Lelan's proposed choice of second single. The result was a bizarre coupling of Roky's ethereal tune on one side and the band's rendition of Buddy Holly's "I'm Gonna Love You, Too" from the 1966 Contact sessions on the other, which sounded completely out of date with what was happening musically in 1968. Stacy continued to struggle to keep the band alive throughout June while he waited for Roky's return. Another unspecified overdubbing session took place on May 19 and Stacy booked Studio B for a rehearsal June 2 and every evening from June 18–22. However, the surviving studio sheets reveal little and it's possible with little to do and time to kill that during these sessions the controversial horn arrangements were added to "Livin' On," "Never Another" and "Dr. Doom." Danny Thomas suggested expanding the band's sound in order to make them sound more contemporary by embellishing it with members of the Houston Symphony Orchestra. Two trombone players and one trumpet player arrived at the studio around one a.m. one evening, having stopped off for a few drinks after a performance directed by Andre Previn. Still fully tuxedoed, they took their cue from Tommy's jug runs and added horn arrangements.

Regardless, International Artists wanted a new album complete with Roky's vocals, and effectively took artistic control away from Stacy and commissioned Fred Carroll to compile a fake "live" album from material already in the can. Work began on July 8 when material from the January '67 and Contact '66 sessions was overdubbed with totally inappropriate applause from a boxing match. The result made a mockery of the band's former live reputation. Stacy was utterly disgusted by the recent turn of events after having honored his part of the deal.

With Roky's fate still uncertain, Stacy did his best to carry on until he returned. The band had played a couple of live shows without Roky—as Duke recalls, "They were truly atrocious."

Duke Davis: I think the band had pretty much dissolved; there were no more gigs because Roky was in hospital and Tommy had been out of the picture for some time. We were finishing Bull of the Woods with just Stacy, Danny and I. I didn't want it to break up, that wasn't my choice. Stacy, he could have been the saving grace of the band but there was so much dark energy round him.

After nearly a three-month gap, on July 1 Roky headed to Houston to find the rest of the Elevators. Finding no bass player, he suggested Townes Van Zandt.

Townes (T): I shared a room with Roky in Houston—he was often sleeping on my records! He was really a friend at that time, we played some guitar together. Some say he asked me to play bass guitar with the Elevators. I was a guitar player only, but Roky took me to Austin where the band was doing some rehearsal. When Tommy Hall found out that I was not a bass player, he put me out of the room.

Stacy was finally placated by the return of Ronnie Leatherman on bass. After failing to find a new musical career in San Francisco, Ronnie had been hauled up in the hill country waiting the outcome of his draft board hearing. He was playing in a "heavy" three-piece with ex-Golden Dawn drummer Bobby Rector and old school friend Terry Penney on guitar called "Killer Chicken and the Dumplings." They churned out back-to-basics Cream covers and other radio tunes so in the interim he agreed to re-join the Elevators and finish the album. He flatly refused to sign another IA contract, and instead demanded a standard musician's union salary as a session player instead of as a signed member of the band. As Ronnie rolled into Houston in his VW Beetle, he found himself lodging at Funky Mansions. Ronnie pooled his wages with Stacy and Danny and joined the speed-fueled madness.

In order to stave off starvation, they played under the Elevators' name as a three-piece.

Ronnie: Tommy didn't want to be a part of the band. He was spreading his word, teaching his classes there in Houston. His way of thinking. His ideas on life—you know, gathering followers. They had all been doing quite a bit of speed. There was a lot of that involved, and we did a lot while we, you know... were recording. They didn't give us enough money to hardly eat on, so we'd go buy speed with it.

During this period, Stacy began to date a stripper called Bunni.

Ronnie: He first met her, I think, when we were doing *Bull of the Woods*. We were out there on the Old Galveston Road, at the house... and we'd had a bunch of people over and they'd all left and it got to, "Where's Bunni?" "I don't know." Anyway, Stacy went back in his room and opened up the closet door—and this is the story I always tell my kids to stop them from shooting up—and she was drawing blood out of one arm and shooting it in the other because she didn't have anything to shoot up. She just liked the needle, and he ran her off after that night... I moved back [to Kerrville] and then he started dating her [in1976] and I was going, "Stacy! Why are you dating that girl?!" And they got into heroin after the speed, and that's when it really went downhill.

The band was booked to play on Friday, July 12 at the Safari Club in

Baytown, supported by the Cambridge Lads (from Beaumont, Texas). IA gave Evelyn the assurance that Roky would be kept under constant guard to prevent him from taking any substances, even going to the extent of hiring a security van/mobile home with child locks. Despite Roky's return no one, let alone the promoters, was taking any chances. IA had even come up with an understudy, Steve Webb (the ex-Lost and Found drummer), to cover all eventualities. However, a day before the gig Roky was mysteriously committed to a private mental hospital in Houston.

> **Jerry Lightfoot:** I don't know what their day-to-day working situation was like by the time, but I was around them. Roky was beyond being told what to do, not that Tommy ever acknowledged that, but he still thought you could, you know. And it was the day before they played in Baytown; they came by and took Roky to Hedgecroft. They played Baytown, Steve Webb was singing... Tommy had made him a little book with all the lyrics in it, a little brown book... he checked them because sometimes Roky didn't always sing exactly what was on the page. Tommy said that was because neither of them was right. [Laughs.] Tommy even handed over the vocal duties for "Jerusalem" to Steve to perform, and he did a great job of it live.

What actually happened that night was even more confusing. Evelyn (in her diaries) claimed Danny Thomas gave Roky drugs after his return to Houston which, in her opinion, led to him being admitted to the private hospital. As usual, the diehard fans had commuted to the show, including (Little) John Lewallen who, also as usual, chauffeured Gay Jones.

> **Danny Thomas (77):** I've been busted but I've never had it stick. It was a gas in some ways (Baytown) because they sat there and listened to the rest of the set, they were polite enough to stand there by the edge of the stage... which I thought was a gas because I was worried about them coming up there and taking me off in the middle of a song. And we got through the set, and they came down and said, "We're from the State of Texas and we've got news for you sir, come on down."

> **John Lewallen:** The Baytown show was where I was arrested for U.S. federal drug charges, along with the drummer. I had taken LSD that night. Baytown was the result of Roky's mom's concern about the band providing drugs to Roky. The record company reps had a recreational vehicle at Baytown and overheard me offering to provide DMT to band members. During the break, the drummer [Danny Thomas] left with me and the Baytown police followed us and took us down. Of course, the drummer was released as part of the deal. My arrest was reported in the Houston Sunday paper the next day, and Gay's mother read the story. I was permanently banned from Gay's house after that. I spent the night in jail and never called my parents. They also read the story and came to bail me out. At that time I was working at a wholesale drug company. Unfortunately, my boss heard the story on the radio. I showed up for work Monday morning, but was quickly fired; no questions asked about the drugs.

(1968) *Baytown Sun* July 11 ad for last attempted show with Roky

I claimed I was framed. When I was arrested in Baytown, Stacy notified the local motorcycle club, the Banditos, of my need, and they contributed several hundred dollars for my bail. I never forgot that, and felt loyal to Stacy forever.

The record company had decided that the only way to deal with Roky's condition was to remove him from harm's reach and "rest" him in a private hospital and rehabilitation center (Hedgecroft on Montrose) in downtown Houston. Although it was well-intentioned, Roky's treatment under Dr. Crow was yet another misguided attempt to help him. Roky was voluntarily admitted with his family's consent on July 11, but when the Ericksons traveled to Houston to visit him they were shocked by what they found.

Dana (NFA): Well, Roky's mother was in on that business too, thinking he needed a rest. And she'd go to the record company and say you're pushing him too hard, look at him, he's falling apart.

Roky (NFA): She was like a straitjacket, that's the best description I can give of my mother at that time, was a straitjacket. You know what I mean; she was like the wrong person to tell about anything.

Roger Erickson: Yep, I remember visiting there. Hospital with bars on the window, it wasn't advertised as having guards, but there were obviously guards around if I remember right.

Evelyn: [IA] had him convinced he should go to their psychiatrist in Houston. I thought they meant just to talk to him, but I found out later that they wanted him to commit himself to Hedgecroft under Dr. Howard Crow for a week or two, and after that he'd be back with the band. International Artists said they had a big van with sleeping facilities and a bodyguard for Roky to keep him away from drugs. I protested vehemently, saying we were doing so good in Austin; with another month I thought he might be ready to go back with the band, but I wasn't sure [that was] God's plan for him. Dr. Crow looks at me and says I'm the cause of all of Roky's problems, that I'm too religious. I get angry and fire back, "Don't you have any faith?" And I ask Roky to please not put himself in the hands of a man without any faith. It's all very dramatic and charged with hostility. I ask Dr. Crow if I may call my husband to tell him what is happening, or Reverend Sumner, whose prayers for Roky were so helpful, but he screams at me—"Don't you dare use my phone, get out of my office—this boy is twenty-one years old and can sign himself in." I reply, "He won't be twenty-one until July 15."

Upon admission Roky was subjected to X-rays and "laboratory treatment." On Roky's twenty-first birthday Evelyn called to wish him a happy birthday but was denied a phone call with him. Roky was sent for a second laboratory treatment session with two further sessions the following day. Tommy was suspicious of what was happening to Roky and decided to visit with his friend Fred Hyde to judge the situation for himself.

Fred Hyde: I was totally in the dark as far as what was happening. So we went down to visit him, and I'd never met Roky, I'd known Tommy for quite a while, but we went in and we saw him. And he was just this weird guy, long hair and a real spaced-out look, and he was walking around smoking a cigarette, walking, walking, walking. He got these shock treatments when he was in the hospital. He was so drugged up. He and Tommy talked, and we talked about how to get him out.

Tommy: So they had given him shock treatments and that really brought me down, you know, in those days we were wary of shock treatment. I was trying to help him, so I thought we'll get him out and get him in the open air and maybe he'll clear up, and he didn't.

Tommy called Evelyn and explained what he had seen (to her horror) and discussed breaking him out of the hospital. On July 21 Tommy, aided

by Fred Hyde and David Green, decided to execute their rescue plan. When visiting the hospital they had cased the security and discovered the exterior doors could be opened from the outside and therefore decided to go up the fire escape, let themselves in, find Roky and lead him out to a waiting getaway car.

> **Fred Hyde:** And the plan was we were going to come up the back stairs... so I was inside that stairwell and I opened the door and there was a guard or one of the guys working there that was standing there, and he ran me right out of the place, I don't really remember how Roky got out of the hospital, that was our best bet to get him out...

Although plan "A" had failed, Tommy got inside and, as Roky recalls, "He took the door off the hinges with a screwdriver and snook me out of the hospital and left some money to pay for the damage."

Jerry Lightfoot was waiting at a safe house on the edge of town but as they failed to turn up he assumed they'd taken off directly to San Francisco; instead they disappeared under a veil of secrecy.

Meanwhile, IA had booked Stacy, Danny and Ronnie with Steve Webb on vocals for a mini-tour of Texas in the new mobile home they had acquired for Roky. They headed down to the coast and played the beach-front in Corpus, then traveled up to San Antonio to support the Hombres and went back to Houston for one gig. After a few shows it was clear it wasn't working, and they returned to tread water in Houston.

> **Ronnie:** Stacy and Danny and I played every week at Love Street... but we were only a trio. We played one night; Johnny Winters played the other night. That was how they made money to live on while we finished the recording. We surprised them a couple nights. Stacy surprised them with a rock 'n' roll version of Johnny Cash's "Ring of Fire." We ended up doing it every week. It was pretty cool. We were doing some of Stacy's new stuff. Then we just did some cover songs that we liked, then Stacy liked to jam a lot which was always fun. We didn't really sing much.

The music listings from the time illustrate the uncertainty that surrounded the band's very existence. From the *Rag,* dated July 18: "Love Street—the 13th Floor Elevators may be there. Why don't you go and see?" and August 1: "Love Street—keep your eyes and ears open for the Elevators' coming."

50. Several projects had been proposed for LP release. The idea was the label could record albums for as little as $100 operating costs. These included Lelan Rogers recording the Starvation Army Band in January, which was rejected by IA because one of the members was about to be drafted; a new Lost and Found album, which was left partially recorded and unreleased; an album by Beauregard, which featured horns and strings, from which only a single was released (IA 123 Jan '68 "Popcorn Popper"/"Mama Never Taught Me to Jelly Roll"); and albums by the Pattern and the Blox from which nothing was released. Over February 7–8 Mayo Thompson (Red Crayola), the Lost and Found, the Treeks, the Patterns and Jilln Orris and Dale Mullins all demoed new material.

17.
THE BULL OF THE WOODS

Everything the Elevators had stood for—redefining the source of the divine and realizing new dimensions of reality—had eluded them. Fathoming the sources of "unknown" human creativity usually stems from altered states of reality—originating from divine revelation, chemical stimuli or mental disorder. Momentarily, the Elevators almost had them all working to their advantage. But now Tommy was fooling with orthodox religion, Roky was mentally unstable and Stacy was a drug addict.

Following the "heist" to free Roky, Tommy wasn't risking his probation, which ended on August 8. Instead of fleeing to San Francisco immediately, they idled at David Green's house in Houston for a few days, and then moved from house to house, hiding and acting as fugitives until he received the court order discharging him.

Instead of discussing his plan with Stacy, Tommy made the mistake that he could dictate the band's future with a unilateral decision to relocate in San Francisco, taking a new rhythm section and making bookings at the Avalon. His intention was to return and collect Stacy and Gay once he'd gotten established.

Fred Hyde: Tommy and Stacy seemed at odds with each other during that time. My first trip [to San Francisco] was in a VW bus, with Tommy, Roky, David [Green], Jack Scarborough and Harry Buckholts (Roky's friend from Travis High). Jack was supposed to be the new drummer and Harry the bass player, I suppose, in the Elevators... The bus exploded in Big Springs, Texas. We decided we didn't want to go back to Houston, so we'd have to hitchhike—we'd have to split up. Jack and Harry went together, Tommy and David went together and I got stuck with Roky. Everybody got their rides; I was riding with Roky and he was just a basket case, he was just this wide-eyed guy. I was just freaked because I knew we were never going to get to California; because every time we got in a car Roky'd freak the people out and they'd stop the car and tell us to get out, in the middle of nowhere. So, by all the luck in the world we ran into Harry and Jack in El Paso. So I went out and started hitchhiking and a guy stopped in a sports car, with room for one guy. And I just couldn't

bring myself to get in that car. So, I put Roky in that car, and he was going all the way to San Francisco. I gave him the number and said, "Call this number—Clementine." So we hitchhiked on, got to Clementine's house and Roky still wasn't there! The guy had let him out in Los Angeles, 'cos he'd freaked him out... Somehow Tommy got Roky picked up and got him to San Francisco."

They regrouped at Clementine's house on Schrader Street, off Haight. Everyone registered for food stamps at the post office, since all the girls from the house worked there. They all met at the Garuda Tearoom on Haight Street, and as they walked in the jukebox played "Time Has Come Today" by the Chambers Brothers. Tommy instantly took it as an acid synchronicity and a good omen of their fortunes in San Francisco. Tommy set about re-acquainting himself with his old contacts and tried to get the band up and running. David Green and Fred Hyde were designated to watching Roky, who dubbed them "Tommy's henchmen."

Q: What about Roky? I hear everyone was "looking after" him...

Fred Hyde: Tommy did it, too. Everybody did. Go to a bar, go to a club, everybody's just taking care of Roky, "What's Roky need? How's Roky, is he all right?" That's all you ever heard. But I guess that's why he and I never got along, because I stand on my own two feet and he has never stood on his own two feet.

Tommy: We took Roky to this dude, this Indian mystic, and we hoped he would help him, but he didn't. And I don't know, I was so confused. I didn't know what to do or what my responsibilities were to him and it was all really a mess. And I had my chick, too... oh man!

Clementine: They brought Roky to me. I wasn't that much older than he, but yet I felt so much older than he because he was so young mentally. And so I kept him in my house with my son, and I treated them very much like that except that he was more fragile than my son was. What was really sad was he was saying things like "I'm picking up transmissions from the Russians in my tooth and they are telling me to kill Jacqueline Kennedy and I don't want to do it." And then he'd turn to me and he'd go "You look like Jacqueline Kennedy, Clementine," I'd go "Ah, Jesus Christ!" So whenever he'd get really distressed and really upset at what the Russians were saying to him, my friends and I would take him in the car and drive to the beach and stand him in the water and let the waves pound on him. And that was the best therapy I've ever known—he would be all right for a while, he'd be talking normal for a few days. It was good, and he loved it!

Although Chet Helms welcomed them with open arms, he wasn't prepared to book them. He introduced Tommy to an entertainment lawyer, Brian Rohans, who handled the Jefferson Airplane, for help. Tommy left Roky in Clementine's safekeeping, sitting on her sofa strumming "Take That Girl," and returned to Texas to persuade Stacy to join them.

Stacy was furious. If he left the state boundary he would become a fugitive and be hunted down by the authorities. Tommy and Roky had fled to Frisco because of the situation with IA and now due to their absence he was stuck to fulfill their contractual obligations.

Tommy: I came back [to Texas] because I'd been given this money by this big lawyer and I was supposed to get Stacy. But he was shooting smack and stuff, so I was just sitting around trying to figure what to do. At that time I didn't know enough about smack and what that has to do with your responsibility and all that kind of stuff, but smack, you can look at it like, intellectually, it's shortening your life, so if you want a short life, same with coke and of course speed. We were like a self-destructive group... although Stacy and Roky were good musicians, we were, like... amateurish in what happened to us... and the whole situation. We had certain things we could do with the words, and the music was able to live up to that, but it was like we were outside the door or something, so we had to work harder and so we didn't necessary go where we were headed.

Unfortunately, Stacy's mood was still reflected in his choice of drugs—opiates taken intravenously, the warm cathartic high sheltering him from his growing list of terrors. Although relations between Tommy and Stacy had become almost non-existent over the last few months, neither of them had imagined the band was actually over. But now they were in a standoff situation over who the Elevators would be. Tommy's rash decision to vanish in a web of secrecy betrayed his lack of understanding of Stacy's role in the band. Roky and Tommy couldn't continue without Stacy and Tommy admits he was left feeling stupid. Now Stacy had a decision; Roky wasn't coming back to finish the vocals, and he was obliged to deliver the third album even though he foresaw a backlash from friends and fans alike. He bared his teeth and set about finishing the third album as a three-piece.

The final recordings were swift; there were none of the old arguments. The bulk of Stacy's new songs originated from jam sessions worked up with Ronnie and Danny in June. Somebody thought the band might need augmenting and Spencer Perskin (the fiddler from Shiva's Headband) was summoned to Houston in case his violin could add something different. But there were no frills, the sound was kept plain and simple with most of the vocals being sung ensemble between the three of them. Stacy made final overdubs to the old recordings on August 9 and held a final rehearsal on the 12th in Studio B at Goldstar, and then seven new songs were recorded on August 13, 14 and 26. "Down By the River" was a snippet of a much longer forty-five-minute jam session they'd recorded earlier. The lyrics were simply Stacy reflecting on his youth hanging out by the Guadalupe River back in Kerrville. "'Til Then" was the final title for "Wait for My Love"/"Some Day My Love," with a new set of Sutherland/Hall lyrics. "Scarlet and Gold" was arguably the best of the new recordings and addressed the band's fate, particularly Roky's. Ronnie also contributed a song, "With You"—"I guess the music for 'With You' probably came from the Ramsey Lewis Trio song 'Take Five.' I just liked the 6/8 beat. The

lyrics came mostly from my experiences during my last year in school and getting to California. It seems like everybody was always talking about something they heard from somebody who heard it from someone else. But they were always trying to spice up the story."

While the recordings don't fulfill the potential psychedelic sound of the demos recorded at Andrus in January '68, they perfectly blend into the progressive blues rock sound of '69. The new recordings lacked rawness, but displayed a fluidity and ease of playing. While Danny Thomas' drumming occasionally harked back to John Ike's trademark bell sound in the ride cymbal, he otherwise retained his own distinct style throughout. Stacy's solid guitar work throughout avoided any unnecessary guitar heroics and his playing fused perfectly with Ronnie's bass to form a powerful combination. However, it was a shame they didn't have more time to work on the arrangements and record an entire album as a trio; the result has been underappreciated for years. The project was titled *Bull of the Woods,* a comment on Stacy's staying power and resilience at finishing the project.

Stacy published one other song, "End of the Road," during 1968, which he didn't record because he felt it was "too sad and uncommercial."[51] It was a shame, as the lyrics would have been a perfect end for the band.

Despite Stacy's best efforts to deliver the album as required, IA went ahead and issued the fake live album they had mixed in July as the band's third album in August '68. Simply titled *Live,* it was issued with a bizarre jacket that attempted to continue the band's esoteric lineage of ideas. It depicted a desolate landscape with a tree bearing a single red apple, while several charred-looking figures scare off crows and a serpent lurks in the background. Worse still, the back slick tries to dispel the lie by attempting to adopt the hippie lexicon. *Psychedelic Sounds="Hard as Rock," Easter Everywhere="Poetry in Motion," Live!="Excitement Personified."* While none of the actual content is terrible, everything is rendered simply unlistenable because of the appalling fake applause. However, some material proved interesting purely because of its rarity value; an early Roky/Tommy composition "You Can't Hurt Me Anymore" and Powell's "Make That Girl Your Own (You Gotta Take That Girl)," from the Contact sessions.

With recording complete, IA dispensed with Ronnie's services at $25 an hour, so he split back to Kerrville to await the draft. To advertise the fake "live" album, IA decided to cobble together a fake lineup to launch it, consisting of Stacy, Danny, Pete Black and James Harrell from the Lost and Found. Sadly, neither the album nor the band were the genuine article. Still under obligation to the label and unwilling to let the Elevators die, Stacy gritted his teeth and performed.

James Harrell: We were still under contract from International Artists and still had to do what they said. I didn't feel comfortable about taking Roky's place and playing rhythm and singing and remembering all them words and singing right in his place, but that's the job they gave me, being Roky Erickson. Yep, it was terrible for me. I didn't feel right. That was under extreme pressure—under protest—under contract.

(1968) POSTER BY GILBERT SHELTON FOR SHOWS AT VULCAN GAS COMPANY, AUGUST 30–31, AUSTIN, TEXAS

The re-launch gig at the Vulcan Gas Company, on August 30 and 31, was billed as the "Delightsome, Demonical, Grackle Debacle, featuring Stacey [sic] and the 13th Floor Elevators." The era was clearly drawing to a close and the poster by Gilbert Shelton portrayed it perfectly. The Vulcan itself was going through a bad patch and instead of the usual myriad of colors the poster was cheaply printed, black on newsprint. It depicted a pair of dancing grackles that loom like revenants from the Day of the Dead, adorned with beads and top hats. The band performed a few old Elevators tunes, some of Stacy's new material and some blues jams. The general consensus was that the band was good, but that it was a vast disappointment because "it wasn't the boys." Nevertheless, the show was re-booked along with the same support (New Atlantis, featuring ex-Elevator Danny Galindo) on September 30. Despite this lineup continuing for another ten shows (even, on occasion, without Stacy) they never returned to the Vulcan, and Johnny Winter took the headline billing instead.

James Harrell: Stacy was out of the picture for quite a while after his overdose; heroin, I believe. He didn't say much about it. We were doing psychedelics and he wanted to do the big heavy stuff.

On September 10, *Bull of the Woods* was mixed and Stacy went into the studio for the last time to listen to the tapes completed on September 26, and the project was concluded. The tapes were eventually sent to Columbia in New York for mastering in early November—in the meantime Stacy still tried to keep the Elevators alive and played Love Street on October 25 and 26.[52]

In Tommy's absence Roky had moved from Clementine's sofa to the stage at the Avalon and was still tentatively strumming "You Gotta Take That Girl." Although Roky, Jack and Harry had been hanging out at the Avalon, the nearest anyone remembers to them rehearsing was in late August when Doug Sahm was warming up for a show at the Avalon (Sir Douglas Quintet, August 23–25, 1968.) Meanwhile, everyone was expectant of Tommy's return. Although he's now proud of Stacy for finishing the album, apparently at the time he was furious. The grand plan had failed and Tommy was beat. Instead of being "in charge," he simply wanted some tender loving care and slipped into an affair with a new girl in San Francisco.

Fred Hyde: Tommy was pissed; he didn't like it at all [*Bull of the Woods*]. He was writing stuff like "Jerusalem" and he had new stuff coming out, and as far as he was concerned it was still all happening... Roky was going to get on top of his game, Stacy was going to come out to California, they were going to be billed at the Avalon... it was all going to keep happening. But Stacy wasn't coming back. I don't remember how we all split up. Tommy came out and he had this girl with him and that's the girl Tommy started coming on to and moved in with. And that's when I asked Tommy, "What's the deal? Gay's your other half, what are you doing sleeping with this other girl?" That's when I started realizing he started justifying this kind of stuff, which is OK, but it didn't fit the rest of the scheme, so I started

seeing holes in the whole philosophy. The whole time I was with Tommy he was in love with Gay, but Gay was just a little girl.

Roky had rallied with Clementine. Chet recalls, "Roky was beginning to get out there. He was hard to talk to," but he took him into town, bought him new clothes and set about trying to find him somewhere to live "in the woods," as Roky described it. In early September Roky wrote home asking if they could pay for his bus to get out of hock for his birthday present. He reported in the letter that "I'm safe and sound and healthy and happy," and highlighted in green felt-tip "God it's good to be out of the hospital." Evelyn responded by wiring $25 to the Superbar Food Market on Haight, requesting they only give him food—no cash. Clementine wasn't aware that Tommy was back in San Francisco until he contacted her for a divorce (which never happened). Soon Roky moved into a tiny house tucked behind the Golden Gate Park and Clementine continued to visit him there: "The couple were performing the same function that Tommy and I had done—that is, to be the parents of Roky. He wasn't great, he was still talking about Martians talking to him in his teeth. But he seemed to be in good hands, so I released him, I let go of him. So I do not know what happened after that point, because I hunted for him and I asked around for him and then he disappeared—he must have gone back to Texas."

Roky and Tommy still met up, but this often led to arguments about their lifestyles and goals. Tommy ran occasional "errands" to Texas and Roky joined him on at least one to Houston. Tommy was spotted by Phil Krumm in San Antonio on October 6, the last day of the HemisFair, but there was no further mention of the band. However, Vulcan was still running advertisements in the *Rag* for the band to play on October 11 and 12, and the gig listings optimistically read "13th Floor Elevators (with Rocky [sic] maybe) and New Atlantis."

Meanwhile the Texan music scene felt the vacuum of the Elevators' demise. Dana Morris got restless and decided to head to San Francisco to find her comrades. Upon arrival the Texan network directed her to a house on Claybourne Street off Haight, where she found Tommy and Roky in mid-argument. She handed Lenicia to Tommy and dragged Roky out to see the Dylan documentary *Don't Look Back*, but they never saw the film and instead circled the block chatting endlessly. Roky now had Dana, and Tommy absolved himself of any further responsibility.

Dana: I was a dancer over on South Beach, Tommy used to take me to work there... I was making a lot of money, had a nice apartment because I wanted to get Lenicia out of that drug scene and I had hired a young hippie chick to look after her.

Chet Helms (K): The last time I saw Roky, I was stoned on acid at a party and I got scared, wanted to run away, so I stumbled out on the street and sort of realized I was near his apartment. I ducked in his door, he was really spaced out, and there was a meth-freak chick in there with him who was sort of supporting his trip. Actually being in there for a while made me realize that I was more together than I thought. After a while he was sort of getting into my head, so I split.

Roky had moved into a house with Dana and Big Ricky, "The Guacamole Queen" from Texas, and things carried on as normal.

Dana: Roky and I had one of our best acid trips in that house... had some kick-ass acid, LSD-25...

Without Tommy's constant presence and his scorn for hard drugs, it was Roky's turn to fall prey to the changing drug culture. In late 1968 the party was over in San Francisco. Many on the scene had acknowledged this by the staging of the "Death of Hippie" on October 6, 1967, the anniversary of California banning LSD. Any serious attempt at setting up a new culture had been overloaded by the sheer influx of people. This was further undermined by unwanted attention from the authorities that pursued both runaways and draft dodgers. Where turning on had been about the individual's development, it had now become a commodity just like anything else. Before, the hippie ethos had validated selling drugs in terms of spreading enlightenment, but now it was simply a business. Worse still, many in the underground firmly believed that the CIA was covertly introducing cocaine and heroin onto the streets to undermine what was left of the counterculture. Roky had abandoned Tommy's distinctions between drugs in favor of devouring a pharmacopoeia of substances at any opportunity.

Dana: Roky wants to try heroin... and he introduces me to this girl, Red... he says go with her... and this is where he and Tommy would argue. He'd want to explore and Tommy would say no. Once I explored with some methedrine and Tommy said, "Don't you know, Dana, it's taken the sparkle out of your eyes? I don't want you to do that." That hit my vanity; Tommy knew more than I did, so I listened to him... I went with this girl, we went up this tower of stairs, way up to the top, and she knocks on the door. The door opens and there's this huge soul brother standing there, and he goes, "Hey, Red." Well-known on the street. And there's this man sitting behind this table with red velvet on it, with every drug you can imagine and syringes. And I'm already going, "Wow." And the guy closes and locks the door. So she goes, "My friend has $13 and she wants to buy her boyfriend some heroin and a needle." And I'm like, that's okay, we'll just go. "I'll give it to you, but you have to shoot up with us." So, the next thing I know is she's shot up and is down on the couch. And the guy's behind me and the other guy's coming at me with the needle and he ties me off, I can't run, I don't even try, I'm thinking the only way I'm going to do this is to go along with these guys. They shoot me up and I feel this rush go to my head and then it hits me, and I'm holding this guy. So anyway, the Beatles' *White Album* was on, I remember the windows were open and I was vomiting out this window... and this one guy goes, "Dude, you overdosed her! You gotta help her." So the guy comes over and starts walking me, "You gotta walk, you gotta walk," and we go in this bathroom and it's filthy, and I'm hugging the toilet, then walking, then vomiting. Then all of a sudden, it was morning and I was okay, I'd made it. I held him in my arms and said, "You've saved my life." He could have

~ 334 ~

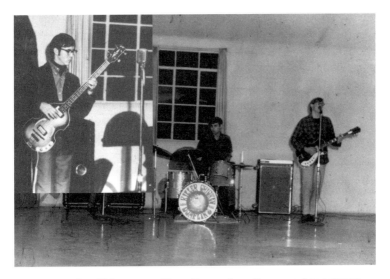

(December 28, 1968) Ronnie with Killer Chicken & the Dumplings: Ronnie (inset), Bobby Rector (ex-Golden Dawn, drums) and Terry Penny (guitar), Kerrville, Texas, courtesy Bobby Rector

left me to die. And you know what he did? He said, "Now I'm going to walk you home with a syringe of heroin for your boyfriend." And he walked me home and Roky said, "Where have you been?"... The guy had serum hepatitis, he gave it to me and he gave it to Roky. I went down. He's, like, got sores... and I'm on the couch having a relapse... because all you can do is sleep. And George [Kinney] comes in and says, "Dana, wake up, I'm taking Roky back to Texas." And I'm yellow, he's yellow, I said, "He's got hepatitis, that what he's got." I said, you've got to take care of him.

On Christmas 1968 Stacy made his usual trek to Kerrville to spend time with his family. Just before Christmas Day he was visiting friends and was blind drunk, so his friends stuck him in their car to take him home, but he'd forgotten his coat and went to go back in the house to retrieve it. Unfortunately he got the wrong front door and burst in on a woman who was so startled she immediately rang the cops. Although her husband realized what had happened and dropped the charges, the cops relished in his misfortune.

Sibyl Sutherland: They put him in jail and they were trying to make this man file charges, because they had to have something to hold him on, and he said no, I refuse. So they held him up here ten days and that was long enough to miss Christmas and they wouldn't let me take him any Christmas candy or anything, so he was crushed. Laurie told them at least ten different ways they were violating his civil rights when they hadn't filed charges.

By late 1968 Ronnie had finally received notice he would be drafted for active service in Vietnam. Prior to 1968 it had been possible to dodge the draft—Fugs singer Tuli Kupferberg had even published a book entitled *1001 Ways to Dodge the Draft*—but by '68 the Selective Service System had adapted to many of the possible avenues of avoidance.

> **Ronnie:** It didn't bother them a bit that I told them I took acid every day! I tried to tell them it was every day... I was with an infantry unit—the 199th Infantry Unit. I was eventually in the finance office, but we did guard duty and went on patrol and did finance—did the payroll in the spare time!

> **Q:** That must have been totally horrifying, to have to go out there.

> **Ronnie:** Yeah, it was... we were right next to a big helipad where they had a lot of helicopters and we got a lot of rockets, stuff like that, mortar fire all the time. So it kept you on your toes!

There were sixty people in the finance office; fifty-seven had "turned on." Opium was readily available and the barracks stank of weed day and night. The sergeant turned a blind eye to the soldiers smoking joints in front of him and there was always advance warning of monthly "shake-downs" (which were shams anyway because they weren't allowed to body-search the troops).

Terry Moore, Roky's old Travis High School friend, was in San Francisco. He and some friends had driven from Texas in an old Beetle to score acid and go to the New Year's Eve concert at Winterland.

> **Terry Moore:** San Francisco was like paradise when we got out there; you could go hear a different psychedelic band every night. We scored our acid and went around house to house sitting around smoking, that's all you did in those days. George and Tom Ramsey [ex-Golden Dawn], they were both fugitives from the law, wanted in Texas on felony drug charges. I had not even seen Roky. Everyone spoke of him in reverent tones, almost like the second coming, his kinetic energy, he could open a door without touching it and levitate and on and on and on. So George approached and said, "Hey, Roky's really in a bad way. We need to get him back to Austin, can we ride back with you?" "Sure, we don't have much room but we'll figure something out." This was the height of Tommy and Roky being in the same house, but they wouldn't even be in the same room together. When I finally saw him, he didn't look good, his lips were all dry and cracked and caked and he really looked wasted. This was the first time I'd seen Roky since Austin, when he was bright and articulate, just a different person, he didn't even recognize me, he was babbling and incoherent, withdrawn. The next day it turned out there were six of us riding back in my little VW Bug. We were packed in there and got pulled over for going too slow on the highway... and the highway patrol got us all out of the car and Roky was barefoot and Roky couldn't even tell them his name. We said he's sick and we're taking him back to Texas, George had a fake ID that he gave him, so did Tom Ramsey, they were just shaking their heads,

just a bunch of flaky guys. Anyway, we stopped at a gas station in San Jose and made a pit stop and Roky and George were in the bathroom for a real long time and I thought, "What the hell is going on?" And George came out and admitted to me that Roky had been strung out on speed for the last three weeks, and he took him in there and hit him up with his last hit. That just appalled me, 'cos we smoked pot and did psychedelics, but to do a needle? That was just a big NO to our standards, and to think Roky, who was preaching the psychedelics and the right way, was doing hard drugs really set me back. I was indignant with George for allowing him to do it. That was the reason his lips were all cracked. So we got into Arizona right at dusk, beautiful sunset, and I reached to break out the acid that we'd scored, looked like a good time for a trip. So Roky was sitting shotgun on the side of me, and I took out the bag of acid and gave everybody one and I had reservations about it, but Roky... you could feel his eyes burning in the back of my head, so I turned and said, "Roky, would you like one?" He reaches in the bag and takes a handful and stuffs them in his mouth. I mean literally, I don't know how many but at least ten, these were little thousand micrograms of acid, each one you could split in half and have a good trip. Anyway, when he took the acid he really went into a bad way. From there until we got to El Paso he was hugging himself and holding his arm and hitting on his arm and telling the demons to get out of his body. So we got to El Paso and George made a call to this girl we went to... high school with, Ginger Pane, she was married and living there, she was doing heroin. George called her for them to take care of him, and we left him. I'm sure they gave him some heroin to calm what the speed was doing, and when they got him in a more stable state they took him on to Austin.

"Whereas it is all front for Winter and the (Moving) Sidewalks, it is all behind for the 13th Floor Elevators, one of the earliest of the 'psychedelic' groups. At one time a tight, powerful stage group, they are most prominent for their influence on the regional scene rather than for their music (though 'Slip Inside This House' is an excellent piece of lyricism). The group has been significant in steering young groups from the traditional Gulf Coast sound."

—*Rolling Stone*, December 7, 1968

51. **End of the Road:** *I fled aimless, falling, followed/Fleeing from the future of my name/All my dreams were strewn and scattered/Cast among the dust of love's remains/ But then the days grow old/And the night bird is a-calling/Somewhere at the end of the road/Somewhere at the end of the road/Time has burnt the tattered pages/Casting some of them into flame/And from the fire the smoke is churning/While the rock of truth lies aging in the rain/But I wish this day the sun would shine/Upon the road that would lead us through the pain/But the days grow old/And the night bird is a-flying/Somewhere at the end of the road/Somewhere at the end of the road.*

52. On the 25th with the Shayds and 26th with Naked Letus, lights by Jelly Wall Eyes Pack. The flyer for this gig is the last known piece of ephemera relating to the Elevators as a live band.

18.
YOU'RE GONNA MISS ME

It is a man who has preferred to go mad in the socially accepted sense rather than give up a certain higher ideal of human honor. That is how society has organized the strangulation in lunatic asylums of all those it wants to be rid of or protect itself from... Because a madman is also a man to whom society does not want to listen. So it wants to prevent him from telling intolerable truths...

—Antonin Artaud

Releasing the final Elevators album in 1969 was merely a formality. IA had a potential new hit on their hands, their first glimmer of hope since "You're Gonna Miss Me."

Following the demise of the Bad Seeds in 1966, Rod Prince formed a new lineup called the New Seeds, who eventually became the ridiculously named Bubble Puppy. By '68, psychedelia was last year's sound and the new "heavy" blues-rock groups fueled the underground airwaves. Regionally, Bubble Puppy fit the description perfectly, longhairs playing meandering rock, punctuated by heavy moments before drifting back into pedestrian soft rock. Having played the Houston-Austin underground circuit, they inevitably wound up signing to IA. Their first single, "Hot Smoke and Sassafras," was released in January '68 and began to take off nationally, causing alarm bells to ring at IA as they strove for a second hit. As usual, IA wanted an immediate cash-in album to follow the single and by their standards they spared no expense in promoting the band. In January and February they spent $1,825.33 on full-page advertisements in *Record World* and $1,722.75 in *Cash Box* announcing "Bubble Puppy, Underground Explosion" and "their first album coming soon!"

With the focus on Bubble Puppy, the last Elevators single, "Livin' On" (b/w "Scarlet and Gold") was released sometime in February '69, paving the way for the final album, which slipped out without a traceable mention in *Billboard*. The cover proved to be as mysterious, if not as baffling, as the previous albums but for the wrong reasons. Stacy was merely consulted about the new album's title and cover. His concept was to portray the band's Texas heritage by using the silhouette of a longhorn bull to similar effect as the familiar representation of the proud Spanish bull.

Dillard took the title literally and lifted an image of a bull's head poking through a wooden fence, from a steakhouse menu he swiped.

> **Evelyn's Diary:** January 2, 1969—Some friends come in from California, bringing in Roky. He's covered in sores and he mumbled something about having a venereal disease. I put him in the tub with lots of Tide, getting him to take off all the scabs very gently—then I'll doctor him with ammoniated mercury. I think the sores are impetigo and if I'm right, this will cure them. He keeps saying, "Don't touch me, I'm unclean." The next day I take him for a blood test. It's OK. Thank goodness, and thank God!

After a period of rest Roky felt well enough to venture out, but yet again he made his usual mistake of overindulging, showing no ability to abstain or any self-preservation instinct. Jerry Lightfoot ran into him in Houston and the cops ran into him in Austin.

> **Jerry Lightfoot:** The next time I saw Roky after Hedgecroft, he was walking around Houston barefoot, when it was cold. I remember it was in the Montrose area, and he was walking around in white pants, shirt and a vest, no shoes or socks, and he had a syringe of speed sticking out of his pocket, without a point on it, and he was wanting someone to give him an injection.

> ***Austin Pair Arrested on Drug Charge:*** A small plastic vial reflected a little too much light early Saturday morning and resulted in the arrest of two twenty-one-year-old Austin men in connection with possession of marijuana. Roger Erickson of 2002 Arthur Lane and John S. Kennedy of 611 Wood Lane were charged with illegal possession of marijuana in Justice of the Peace Bob Kuhn's court Saturday morning. Kuhn set a $3,000 bond on Erickson and a $1,000 bond on Kennedy. Both remained in Travis County Jail on Saturday in lieu of bond. Patrolman Vernon Sigler said that he drove to the top of Mt. Bonnell at about 2:50 a.m. to investigate a parked small foreign car. While following the car north on Mt. Bonnell Blvd., Sigler saw one of the occupants of the car toss something light-colored out of the window and into the grass, the officer said. After stopping the two men in the auto, Sigler said he went back to the spot he had seen the object tossed and located a small, plastic vial containing what he believed to be marijuana. The contents of the bottle were sent to the Department of Public Safety for analysis, he said. —*Austin American*, February 23, 1969

Regardless of the cat-and-mouse game the Elevators had played with the cops for the past three years, the police had failed (despite many near-misses) to actually land any of the band in jail and keep them there.

Steven Kennedy was a freshman at the University of Texas on a track scholarship. He'd grown curious about the underground and was hanging out at Robert Williams' house, a fringe religious type, when Evelyn called around with Roky. Evelyn wanted to leave, so Steve offered to drive Roky home. They decided to stop at the top of Mount Bonnell (to get "closer to heaven") when they noticed a patrol car and panicked.

Roky: I was arrested for marijuana… when the Policeman said he found the vial. I think I was set up for that.

Q: How?

Roky: Well, it doesn't seem right that I would throw out a vial of grass into the weeds and a policeman would stop and set his flashlight on it and get it.

Q: Are you saying he planted it?

Roky: That sounds real good.

Q: Were there other people in the car other than Steve Kennedy?

Roky: Just he and I, he was driving. I don't know if we were even smoking; we could have just had the weed on us.

Q: You definitely did have grass on you.

Roky: Yes.

Q: And threw it out?

Roky: That just seems impossible that that happened.

They were taken to jail where Roky sat cross-legged babbling incoherently until a Mexican inmate headbutted him and punched Steve in the face. Steve managed to avoid further trouble and was let out on bail the following day; he never saw Roky again.

Whereas it was plausible the police had planted marijuana at Roky's old apartment in January 1966, three years later he was no longer a poster boy for drug culture, and friends had noticed Roky was unable to measure his behavior to the point of drawing unnecessary attention to himself.

John Kearney: I would see Roky periodically at people's houses, while we were smoking. Roky was totally uncool all the time. If he saw a uniformed policeman then he'd freak out. Not the way to be, you'd be cool all the time, and they're not going to throw stuff out the window.

Roky didn't take the implications of the bust seriously, which resulted in catastrophic and life-changing consequences. He continued to play a dangerous and antagonistic game, testing the state's tolerance until the situation escalated out of proportion for what would now be considered a minor misdemeanor.

Roky: Stacy was always worried we were going to get busted. We would say if you're gonna worry about being busted, you're gonna get busted. And they would point at Stacy and say that's what he was doing.

While the band had been fortunate enough not to go before the dreaded Mace Thurman in 1966, there was no escaping him now. At 10:30 a.m. on the morning of March 12, Roky went to his hearing alone. He had no funds to hire an attorney and no family support this time. Thurman duly appointed Philip Sanders (a state attorney) to represent Roky. Sanders, being paid $100 for two days' work, gave him advice straight from the pages of *One Flew Over the Cuckoo's Nest*—plead insanity to avoid time at the dreaded Huntsville Prison.

That afternoon it was "ordered, judged and decreed" that Erickson should be sent to the Austin State Hospital for observation to have his sanity evaluated, before his competency to stand trial could be judged. Roky was put on a bond of $3,000, while his associate Kennedy was placed on a $1,000 bond. Unable to raise the bond, Roky was bound by court order to stay on the grounds of the State Hospital. Admitted to the Austin State Hospital on March 13, Roky's mental health was evaluated the following day by an independent M.D., Erwin Taboada, who certified he was mentally ill, the diagnosis being "schizophrenia acute, undifferentiated" and recommended that he required hospitalization because he was likely to cause harm to himself or others. However, Dr. Donald Vajgert, the clinical psychologist evaluating Roky for the State Hospital, disagreed, stating "Mr. Erickson is a character disorder who is faking paranoid schizophrenia. His talented display of the symptoms suffers mainly from exaggeration." On April 9, Margaret Sedberry, M.D. of the state hospital reported to the court that although Roky suffered from a "defect of reason rendering him incapable of defending the charge against him," she felt that on February 22 he didn't, and therefore "probably knows that the said act was wrong." Kennedy's mother had worked for both Governor Connally and LBJ, and had managed to secure the "right lawyer." On April 10, Kennedy's defense returned a plea of not guilty on the basis that it was Roky who had been in possession of marijuana and had thrown it out of the car.

After tolerating life as an inmate for a few weeks, the threat of imprisonment seemed to have evaporated and Roky simply wandered off without making bail. On May 23, a warrant was issued for his arrest.

Dana: I'm in San Francisco, healed from hepatitis, and I went back to work. I met this beautiful Leo man, Jerry—Roky's gone—he wants to take care of me. This man moves in; I still loved Roky, but I was grateful. One day I come home and there's a message on my door from Western Union; they said, "You've got a message from Texas, it'll cost you..." I said, "I don't have any money!" and they said, "OK, we'll read it to you." It was from Roky, it said, "Dana, I have been busted, come home." That's all I needed to hear so I packed up and Jerry's coming home and I have "Heard it Through the Grapevine" by Marvin Gaye playing. And he goes and sells his flute to buy me a ticket to get back to Texas. So I rent an apartment and go out to see Roky and I drive up, it's raining. And I don't know where to park and I see this fence, and then I notice Roky's walking around in this courtyard in circles. So I get out, he jumps the fence and jumps in my car! Marijuana was a big deal and if he went to prison he would have been abused. They thought he had mental problems, so they got

him off on insanity, rightfully so, to keep him in a safer environment. Roky didn't know what was coming down on him; schizophrenia was a dark disease. My mother wouldn't let me tell my aunt that my boyfriend had schizophrenia: "Just don't say that..."

Mikel: So Roky's in the State Hospital and there's friends, supposedly his friends, they go out there and talk him into leaving the hospital. And the State Hospital people say, "Hey man, you better watch your act because we're gonna put you out." He's supposed to stay on the grounds and he'd walk off. So, my father would get me, "he's gone again," and so of course Mike would have to go and get Roky, right? And all these people would be sittin' there and it kinda got to be a thing they did, "You Gestapo! You cop!" I had to physically get Roky and take him back to the State Hospital amongst all these people. So it was a strange trip for me to get into with my older brother, who I never would ever mess with. But he was so screwed up from what the State Hospital was doing and then whatever drugs they'd give him when he got out, and then I'd feel real stupid when I got there because the State Hospital was popping him full of all this other crap to bring him down. You know he was like a guinea pig for all this stuff, up and down, up and down, but they never would leave him alone. I mean Dana and all those people wouldn't leave him alone and if they had he probably could have got out of that little pot bust, that little matchbox of pot from Mount Bonnell.

Sumner Erickson: Mom told me that they would say, "Well, you know if your boy keeps leaving here then we're going to have to put him in some place he can't leave."

Roky was now a fugitive with no one he could trust to turn to for help apart from record company lawyers. Following a meeting on June 26, Dillard and Ginther recommended that Roky should return to Hedgecroft in an attempt to appease the court that he was held in a suitable environment. So reluctantly, a year after his escape, Roky returned to Dr. Crow at Hedgecroft while IA set about organizing his solo career.

Dana (NFA): I called the DA and said we didn't want to wait at the Austin State Hospital for trial, Roky wanted to get his head together and if he'll tell us the date of the trial, we'll be there. And they said, well, we're not going to tell you the day and you're gonna miss it, and they said they would file a fugitive charge on him, which was a second federal offense, but then they said if you turn yourself in to a psychiatrist, we won't do it. So we went to Houston and got with Bill Dillard and Nobel Ginther and called Dr. Crow up.

Roky (NFA): They said Hedgecroft would be the best way to get out of it... yet Hedgecroft was really an insane asylum. You'd be sure to call it an asylum. It's a positive way of looking at a word that would scare you into a straitjacket...

Dana (NFA): And then they did drop their charge of fugitive. And from there everything got real vague, Nobel Ginther and Bill got vague, and all we knew was they got him a band together, and sent him to Austin.

Steve Hall at AMCI (Artists Management Company Incorporated) was quick to incorporate Roky into IA's ever-changing roster of live acts, which momentarily included ZZ Top, Todd Rundgren's Sixties band the Nazz and former national chart act the Left Banke. Steve booked Roky for a series of solo shows in Austin and Houston, culminating in the lucrative KRIO radio "Show of the Year" on August 23 with the Nazz and Bubble Puppy. His first solo performance was at Love Street in Houston on July 18. The bill included IA bands Big Sweet and Endle St. Cloud in the Rain. Endle St. Cloud was former Misfits/Lost and Found members Peter Black and James Harrell's new project, and once again they were shanghaied by IA to perform as Roky's backing band. At least this time James Harrell wasn't required to imitate Roky. Roky's stage persona was modeled on Abe Lincoln, with his now-trademark disheveled tailcoat, bare feet, top hat and full beard. While no one recalls exactly what Roky played, guitarist Paul Tennison saw him perform: "Yeah, yeah, it was different, that's all I can say, it was way-out rock 'n' roll! He was singing his new stuff. That's what he was doing. I can't tell you what; it was just some driving stuff... Roky had a great voice, the voice thing."

Following his first performance, Roky demoed some new material at Gold Star Studios (July 25 and August 14). Although one of the songs, "I Love the Blind Man," was later revisited, the others, including "With No Fuss" and "Peace," remained in the can. Although it's obvious that "With No Fuss" is a disposable ditty, it's important because it marks the beginning of Roky's obsession with pitching Jesus against the Devil. "Peace" was a Vietnam song with an Erickson twist (referencing a hammer and nail), which bore more similarity to his later horror-rock than a protest song. Another song written during August 1969 and recorded at Rusk in 1971 by Evelyn was "Unforced Peace,"[53] a simplistic Erickson masterpiece, containing what would develop into familiar imagery:

> It takes nothing to get there
> No remedies needed
> No killing, hurting, nor scaring
> No blood to be bleeded
> It's always needed
> It's understood in the creed it
> It's called unforced peace
> Unforced peace everywhere...

Following his second demo session, Roky was due to travel to Austin for his comeback show on August 15. IA had been uncharacteristically running advertisements in the *Statesman* weeks before his performance, but it wasn't until the last minute that everyone started panicking about how he might be greeted by the authorities. On July 29, the State Hospital had officially discharged Roky as "absent without authority." Nobel ad-

vised him not to go, but Roky decided to fly into Austin. He safely made it to the Action Club where he was met by a packed crowd, grateful for his return to the Austin stage. Having closed the first set with his old favorite "Baby Blue," he was approached by an older man claiming to be a friend of his father's who wanted to speak to him outside. When he got to the parking lot he was met by a circle of cops ready to execute their Travis County arrest warrant. The audience had begun to drift outside, and when they realized what was happening a minor riot ensued and two police cars were damaged in the fracas.

> **Roky (NFA):** Nobel said don't go back, they'll get you. So I flew to Austin. And a friend of mine picked me up, at the place that used to be the Action Club… and it's like the police were waiting for me. This policeman says, "Hi man, I used to be a good friend of your father's, you used to ride horses on my land. All we want to do is ask you some questions, just come down and answer the questions." Soon as I got down there they put me in a cell. And I didn't hear from them for a week. So, I was just shafted, I was just run over.

Roky was hauled before Thurman on September 4, accompanied by his counsel Roy Minton (who had acted for Stacy's parole revocation in May '67). At the pre-trial hearing he returned a plea of "not guilty." This time Evelyn's prayer group was powerless, so she placed a call to a Nixon aide at the White House in desperation. The insanity plea—which had started as bad advice from a state-appointed attorney—had gained a life of its own.

This time there was no escaping Thurman, and at 9:30 a.m. on October 8, Roky returned to the 147th District Court of Travis, where the band's fate had rested in the balance three years earlier. Roy Minton called Dr. Wade to give his testimony…

> **Roy Minton:** Would you give the jury, doctor, the results of diagnosis and prognosis?

> **Wade:** This young man has had a considerable amount of psychiatric treatment. He has been in a private hospital in Houston and he has had psychiatric treatment in California and he has been in the Austin State Hospital. In all of these places he has been diagnosed as having a schizophrenic reaction, which is acute and undifferentiated; undoubtedly a condition has been in existence for a long time. The remarkable problem in this case and the problem that makes it so very hopeless is that in all probability the illness has been fixed—set—by the use of marijuana and/or other hallucinogenic drugs. We see here a classic example of a schizophrenic reaction, a mental illness, mixed with drugs. Of course, there is always the question of which came first, the chicken or the egg—which came first, did he start using marijuana first and then become psychotic, or did he become psychotic and then use marijuana? It is in my opinion in this particular instance that he had some illness prior to beginning the use of this drug, and that the drug is the thing that has carried him down so far and so irretrievably. I feel that he is definitely mentally ill now, unable to distinguish right from wrong, and that he was in such a state on

the 22nd February of this year and I am sure that he doesn't have the capacity to understand the nature and quality of his acts, nor the consequences thereof, and under no circumstances could he possibly assist his counsel in the preparation of a rational defense.

Mr. Minton: Pass the witness. Cross-examination questions by Mr. Cantrell [prosecution].

Cantrell: Doctor, on prior occasions we have sent this defendant to the Austin State Hospital and he has been unable to stay there, or he walks away because it is a minimum-security hospital, is that correct?

Wade: Yes.

Cantrell: Is it your opinion that we need to send this man to the Rusk State Hospital where there is such security and where he may be treated?

Wade: I feel that this should be done. This man needs to be in a maximum security unit, not because of any real danger to others, but because of the fact that it would be impossible to keep this man in a minimum security unit. He doesn't have the amount of judgment necessary to stay and avail himself of such treatment procedures, as he needs.

Cantrell: That's all I have.

Mr. Minton: Thank you very much, doctor. [Witness excused.] One, do you find from a preponderance of the evidence that the defendant, Roger Erickson, is insane at this time?

Charles E. Smith, Jury Chairman: Answer: Insane.

Mr. Minton: Two, was the defendant insane at the time the alleged offense was committed?

Jury Chairman: Answer: Insane.

Mr. Minton: Three, does the defendant require hospitalization in a mental hospital for his own welfare and protection or the protection of others?

Jury Chairman: Answer: He does.

Instead of penitentiary time at Huntsville Prison, Roky was incarcerated indefinitely in Rusk Maximum Security Prison for the Criminally Insane. Later that morning, Margaret Sedberry M.D. of the Austin State Hospital wrote to Dr. Connolly, Rusk's superintendent, thanking him for taking Mr. Erickson concluding, "Please feel free to send us one of your Travis County patients in exchange." It's difficult to determine how truly misguided or simply spiteful these people really were.

The next day, the case against Kennedy was dismissed in court because there was no evidence that the marijuana thrown from the car by Mr. Erickson had been in his possession. On October 13, Roky was transported to Rusk.

Gay Jones had waited patiently for Tommy's call to join him in San Francisco, and by Easter she felt she'd waited long enough; she decided to gather the faithful to set off for Frisco. Accompanied by girlfriend Cynthia Smith, she set off with Jerry Lightfoot, John Lewallen, Jack Scarborough and Steve Webb in an old bread truck.

Tommy's plans in San Francisco had failed and he'd become just another hippie guy trying to wheel and deal a living from the remnants of the underground scene. Friends became panicked when they had to retrieve acid from children, as Tommy had been liberally dispensing it at the school gates. For Gay it wasn't what she'd expected, and Tommy's behavior was hard to tolerate.

Gay Jones: He looked pretty much the same, it seems he wore the same thing always, pull-on boots and just tight jeans and a jacket. He kept me in little places; he was always looking for a place. I don't know, probably part of the "other men" thing. We were in Berkeley first, and I thought that was lovely. He was just trying to survive, to make money, and I guess he was selling drugs but he wouldn't talk to me about it. I'm assuming, I think he was, and trying to hide it from me. Thing was, he was going from hotel to hotel, eating in dives, he didn't have a place… if he did he never told me, I don't know if he was seeing someone… and we kept going back to the Haight for some reason and he'd always say, "Have dinner or lunch and I'll be back." And it never dawned on me; eventually it did start to and I figured it out. Finally, I got so fed up with the "Why are you having sausage?" and everything I did, if I put eyeshadow on it meant I wanted another man, he had me under a microscope, every little thing. At one point I got lice and I was mad and horrified and I thought, where is this leading? It seems that one day I literally started running, and he was running down the street after me yelling my name and I kept on running.

Q: That was the last time you saw him?

Gay Jones: Yes… I'm sure that I called my parents and got a ticket and went back to Houston.

Tommy: Gay, Gay Jones… well, see we were still going out, we hadn't split. She came out here and I wasn't ready. And so we have to split up because I can't support her. So I just realized I could do that [deal drugs] and I could do my ideas, see? And so to involve her was too dangerous at the time, 'cos I didn't have it too together, you have to have people you buy from and sell to. Well, I didn't have either, so it was scamming.

By 1969 the bonds of Texan solidarity that had supported so many in San Francisco were in tatters. By the time the Conqueroo had arrived

from Texas in late '68, they felt the change. Despite playing a large show supporting Janis Joplin in Golden Gate Park and Chet Helms offering to manage them, they soon ended up playing coffee bars to struggle by. The era was drawing to a close, and by the end of November 1968 the final shows took place at the Avalon and the lease was lost. Tommy drifted down the coast south of Los Angeles and lived in a cave on Laguna Beach, which was part of a commune owned by the Brotherhood of Eternal Love. The Brotherhood had started in 1966 as a registered non-profit religious outfit that viewed marijuana and LSD as religious sacraments. Their aims were acutely similar to and as idealistic as Tommy's, the focus being to spread enlightenment through the distribution of acid. However, the police and even *Rolling Stone* magazine dubbed them in 1972 the "Hippie Mafia" because they dealt with large shipments of marijuana from Pakistan and Afghanistan, which they then sold to fund the large-scale production of "Orange Sunshine" LSD. Leary was a figurehead for the Brotherhood and he was arrested on December 26, 1968 in Laguna Beach for possession of over two kilos of marijuana. Having spent a short time in jail, the Brotherhood was supposedly instrumental in his escape to Algeria, where he was held ransom by remnants of the Black Panthers who were also on the run. Tommy's fate followed a similar path; at some point in 1969 Tommy got busted walking into a festival with a large amount of controlled substances and disappeared into a jail in Seattle until 1972.

> **Tommy:** Well, see, we can't talk about certain things, just to do with having to make money, that kind of stuff you know... Well, it has to do with drugs, all right? So, you know, it's probably not a good thing. But I was taught all those things way early, so was able to do it.

> **John Lewallen:** Tommy was living in the basement of the Chinese Communist newspaper in Chinatown, San Francisco, that was the last time I saw him... Several times I went to the Old Galveston Road House (in Houston). I once remember Stacy sitting in a chair on the front porch without moving for an entire day. He rarely ever spoke a word. His guitar did all the talking for him. Galveston Road was dead like "H" is dead, and the band was dead by then. That was the last time I saw Stacy.

"Funky Mansions" was a disaster and the house became notorious. There were rigs hidden in the walls; Stacy even let two friends from Dallas who'd robbed a bank hide out for a week, which ended in a gun battle inside the house. Stacy still hadn't given up on the dream of the Elevators and was still making occasional performances until mid-1969. With a core band of himself and Danny Thomas he'd cobble together new lineups, which included former band boy Cecil Morris for one-off gigs. However, there was one last attempt at saving the band when he met and recruited a young guitarist from Houston, Paul Tennison (a.k.a. Paul Vivian/Vivano).

> **Paul Tennison:** I knew the Elevators, I'd seen them. Later Stacy called me and asked me if I wanted to play in the Elevators, and I said OK.

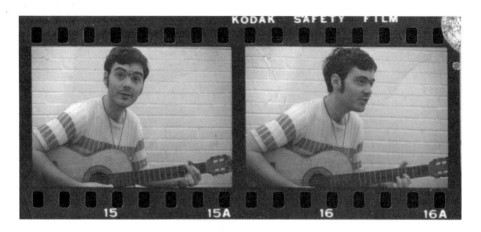

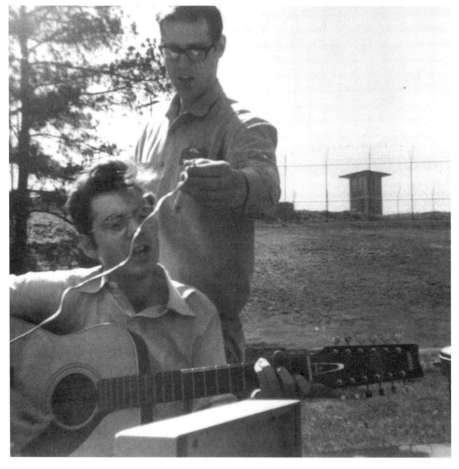

Roky at Maximum Security Unit, Rusk State Hospital for the Criminally Insane:
Top: (September 1972) In his cell, photo by Joe Kahn; Bottom: (1971) Roky & inmate being recorded by
Evelyn Erickson, courtesy Sumner Erickson collection; Opposite page: (September 1972) Reverend Roger
Roky Kynard Erickson outside Rusk MSU Chapel, courtesy Sumner Erickson collection

We went to their record company, International Artists, and they had to sign me. I think I was twenty; I was underage when I signed their contract anyway, and they moved us into the Old Galveston House. Oh man, I used to have nightmares there. I felt like a very young kid, I was still living at home when I moved there. Stacy and I lived upstairs. Once I was asleep and I woke up to glass shattering, someone had shot a shotgun, I don't know who they were after, I never put my head up, in fact I crawled under my mattress, and finally went down the stairs and escaped out the back and into the woods. I think Stacy hung around, he was kinda into that stuff, and those were his buddies. There were weeklong parties; it was very much a drug den. Then there was one real big drug raid. Somebody had robbed a drugstore, and there were underage girls and everything else, everybody was asleep, and I woke up first and I walked down the stairs and the door flew open, and there was a .45 in my face. They came on in and there were about fourteen people in the house and they took everybody to jail. Except for one guy, who escaped on the front porch; in all the confusion he ran off into the bushes. I actually had a chance to do that myself, I was out on the front porch and everybody went upstairs and left me out there, but I thought they might shoot me in the back, so I thought I better hang around. They could have put us away, there were some people on probation, the cops thought it was a hippie house and so they had no warrants, no anything, and it was illegal everywhere and they had to let us go in forty-five minutes. Horrible event...

The Elevators name stood for nothing anymore. The Lavender Hill Express (who had the Friday night slot at the Jade Room and included former Wig, Rusty Weir) had been booked instead of the Elevators to support Led Zeppelin on August 14 at the Municipal Auditorium, and the Elevators' new lineup returned to the Jade Room in mid-August. The only Elevators tunes remaining in the set were ones that suited Paul's voice, "You're Gonna Miss Me," "Fire Engine" and "Slide Machine." The rest of the set consisted of Stacy's new material and cover songs; as Paul recalls, "Basically, it was a rock 'n' roll lineup, 'Not Fade Away,' you know." At one of his first gigs they were joined by an unexpected special guest—Roky—who bounded onto the stage during the second song, plugged in a guitar, cranked the volume to ten and proceeded to let rip with furious feedback and distortion before setting the howling guitar down in front of the amps and disappearing off through the doors of the club. Although it was obvious what Roky thought of the band, he and Stacy discussed performing some of Roky's new material, maybe in a new project. However, Roky was arrested at the Action Club and it was time for Stacy to concede that the Elevators dream should be laid to rest. A new band lineup was put together known as Ice.

Q: Who was in the last Elevators lineup?

Paul Tennison: Well, Stacy Sutherland and Danny Thomas. I didn't consider myself an Elevator. They just wanted to go on playing; Stacy, being the last real member, Danny left quick, lasted about a week.

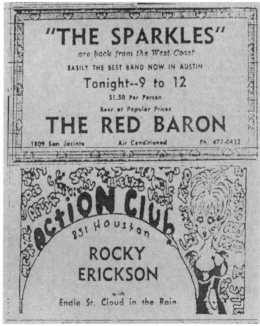

TOP: (1969) HANDBILL FOR ROKY'S JULY 18–19 SHOWS WITH ENDLE ST. CLOUD AT HOUSTON'S LOVE STREET, COURTESY DENNIS HICKEY COLLECTION; BOTTOM: (1969) *AUSTIN STATESMAN* AD FOR APRIL 15 AUSTIN COMEBACK SHOW WHICH RESULTED IN ROKY'S CAPTURE BY THE POLICE

(1969) BILL NARUM'S MOCK-UP FOR PLANNED *EASTER EVERYWHERE* REISSUE, WITH GLOW-IN-THE-DARK JESUS, COURTESY PAUL DRUMMOND COLLECTION

Stacy and Max were pretty much heading this new thing up, Max didn't last long—he made one rehearsal out of three months. He came out a few times, but really just to see what was going on. We actually changed the name to Ice because I was not Roky, he was the Elevators. I was the singer, singing the songs we were working up. Stacy and I were writing some together which we were doing as well as cover tunes. We were playing Sunday night at Love Street Light Circus. I say that we only lasted three weeks. I think from the time I came in as Ice, it only lasted three months. The record company was giving us $10 a week to live on, I mean not apiece, I mean as a group. It was bad; it started cool, they gave us say $10,000 and we bought a lot of equipment, because we were re-equipping the band. They put us in the house and said get ready for an album, Danny left real quick, then [we had] David "Bubba" Brown on drums, Mike Marschell, no bass, and Max Range singing also. The original plan was to send us to a ranch near Crystal City and rehearse for a few months and come back in and do a really good album. We recorded at their studio there with the engineer Fred Carroll [IA Studio sheets October 16 and 30]. And I remember the first, we weren't really doing anything, we just jammed—we probably worked on five songs in three months and never finished one. Stacy, at that point, he was dealing with a lot of things mentally... the Elevators went in the studio, they always threw a big pound of weed on the floor and started rolling, and still did the same thing in Ice. That was a must for Stacy. One morning we woke up at that house and all the equipment had gone. But there were some magical moments we rehearsed, we did recordings; there was definitely some magic but it was not the Elevators.

The cops sat outside Funky Mansions day and night watching the human traffic. There were multiple near-miss heroin busts and junkie

(1969) Stacy's police mug shot

stories of doors being kicked in by cops. On one occasion Stacy called
at a friend's to see him spread-eagled on the floor and five federal agents
lining the room. Stacy threw up his arms in genuine fright and the half-
gram of heroin he was holding shot across the room unnoticed and landed
under the base of the floor lamp. On another occasion Stacy tried to
convince Paul to join him and some Banditos on a raid of a Hell's Angels
pad—where they knew there was a large amount of grass stashed—armed
with plastic toy guns.

 Finally the authorities curtailed Stacy's lifestyle as the Sixties drew
to a close. IA had kept him out of jail since May 1967, but in September
1969 he was busted again and they raised $6,000 bail. However, IA was
failing. They'd survived on a policy of only paying invoices when com-
panies threatened to withdraw their services. Andrus learned to demand
payment or withhold the tape; but Sumet Studios still hadn't been paid
for the Elevators' first album by March 1968. By late '69 final demands
were piling up, and "International Artists" had become very localized.
In a bid to survive they'd bought Love Street in January 1969 and sold
shares in the club. They set up AMCI to raise revenue from acts both
signed and unsigned to the record label by promoting them live. They had
engaged Ray Rush as a producer, who had backed Roy Orbison on his Sun
recordings and recorded and toured with Buddy Holly. But nothing had
worked, so in early 1970 Dale Hawkins was poached from Bell Records
to re-invigorate the label: "IA hired me as a consultant when they were
in deep trouble. I wanted to help them as much as I could but IA had too
many owners and were too deep in trouble for me to save." He organized

a promotional tour of U.S. cities and reissued "You're Gonna Miss Me" in the Midwest, where it hadn't been played to death.

The house of cards was collapsing and Dillard wrote his letter of resignation as president on April 28, 1970. Cliff Carlin resigned from Love Street the following month—by the fall of '70 IA had disappeared completely.

Exactly four years after the pot bust of January 27, 1966, Stacy was finally arrested for parole violation and sent to Huntsville Prison on January 28, 1970—the prison Roky had pleaded insanity to avoid. He was transferred to a Travis jail on February 25 to face charges on March 5 and was sent back to Huntsville. Stacy was dragged back into court on April 17 to be sentenced to two years.

Relieved, he set about playing the authorities' game. He volunteered to do fieldwork in the Texas sun and joined the prison band. He was disturbed to find his IQ had dropped ten points. By late June he'd racked up enough points on the incentive program to be recommended for early parole. He drafted a sufficiently polite letter to the board in which he acknowledged his mistakes, reinforced his good Christian upbringing, and promised the field labor had made him good and strong and that he'd secured a job with the Harold Martin Construction Company upon his release.

Inmate 208574 Stacy Sutherland, Eastham Unit Gentlemen Letter to Parole board: Gentlemen… I have been playing music for a living for the past five years. During this time I enjoyed a short-termed amount of minor national success in recording. I had been using narcotics only slightly prior to this period and somehow connected it to what success the band I was with had. When our short-lived popularity ended and our band fell apart for financial reasons I was deeply disheartened as the vision of security faded from my grasp. After this I used drugs for comfort, similar to the reasons of an alcoholic.

Sibyl Sutherland: I tell you what I was resentful about: Every member of that band was guilty of what Stacy was, there were kids who did everything he did, mine's the only one that went to prison, and I resented it. I was born here, my mother was and my grandmother came here when she was two. So I felt like this was my town, and when this happened I pulled my window shades down, they're still down and I don't have very much to do with anybody in town. And I resent that.

On August 27, it nearly "blew his mind" when he was in his cell listening to the radio and Dylan's "Baby Blue" came on followed by "You're Gonna Miss Me." Later that night he was woken at 3:30 a.m. by the prison guard beating on his bars to inform him he had been granted parole and he was going home.

53. The version of "Unforced Peace" that appears on the album *Never Say Goodbye* (Emperor Jones, 1998) was recorded on a portable tape recorder while Roky was incarcerated at Rusk Maximum Security prison in 1971.

19.
MAY THE CIRCLE
REMAIN UNBROKEN

"Dear Legislator,
You are an ass. Your law serves only to annoy druggists all over
the world without lowering the level of drug addiction in the
nation, because the real addicts don't get their supplies from
drugstores... Pharmaceutical restrictions on drugs will never
bother pleasure-seeking and organized addicts... There will
always be pushers... There will always be people who become
addicts through weakness, through passion... Sick addicts have
an inalienable right, which is that they be left the hell alone. It is
above all a question of conscience. All the bleatings of the official
charter are powerless against this phenomenon of conscience:
namely, that I am the master of my pain, even more than of my
death. Every man is the judge, and the exclusive judge, of the
quantity of physical suffering or of mental emptiness that he
can honestly stand... get back to your attics, medical vermin,
and you too Monsieur Sheep-like legislator, it is not the love of
mankind that makes you rave, but a tradition of idiocy.
And now choke on your law."
—**"Letter to the Legislator of the Law on Narcotics,"**
Antonin Artaud, 1927, France

T he insanity plea had conjured up a
horrendous piece of theatre, with Roky coerced into playing the role of
madman while simultaneously psychologically crumbling. By possessing
a small amount of marijuana, he was charged with offending "the peace
and dignity of the state." The band's activities had made a mockery of the
law and while his only real crime was being naïvely immature and guilty
of having no self-control, he was now experiencing their full force. Roky
had fallen victim to the end of an age of innocence. Drugs were no longer
a positive force for change, and what had started as a brave new world had
descended into a toxic free-for-all. Following sentencing Roky had no idea
what was happening to him—he figured he'd been removed from Austin
to prevent his friends from having access to him, and after three weeks
of watching TV he'd surely be released. He was searched, inoculated and
fumigated with DDT powder...

Roky (K): When I got there [Rusk] I had long hair and a beard and I was wearing that top hat, so they didn't know what to think. I looked like Abe Lincoln. They had a slave colony there. They shaved me and cut my hair so I looked like a girl from the Kremlin, then they led me down dark hallways and up long stairs.

Rusk is a nowhere town in East Texas, established in 1846 to define a boundary with Cherokee County. The town's economy was boosted by the construction of a penitentiary in 1877 and a railroad to link the prison work camps in Rice and Woodlawn. In 1913, when the iron foundry built in the prison grounds was no longer able to pay for the facility, it was converted into the Rusk State Hospital for the Criminally Insane. The maximum security unit where Roky was sentenced had opened in 1954. The hospital's three barracks-like buildings were set on two acres of grounds, surrounded by two fifteen-foot-high electrified fences topped with barbed wire. There was also a small chapel, an occupational therapy shop, a classroom and a picnic area to receive visitors. The town's population was roughly four thousand, bolstered by an extra two-and-a-half thousand semi-permanent inmates. "Brawn and bravery" were considered the two main requirements for staff working at Rusk because the inmates were dangerous murderers, rapists and psychopaths. Roky needed retirement into careful psychiatric care; Rusk was for serious offenders, not some boy who jumped the fence.

Roky: It was too severe. When I first got there I put my clothes underneath my bed and one of the attendants, Dan Ball, came by and pushed me down and started kicking me and said, "Don't ever put your clothes underneath your bed." That was the Rusk thing. Once you got to know 'em, they wouldn't bother you; if they didn't know you, they would really take it out on you. Some people had it pretty bad. One time I came back to go to bed and there was blood all over the place and Dan Ball had attacked this guy [because] he wouldn't be quiet. He kept nagging Dan, so he went back and beat him up.

Following the shock of the prison regimen came the medication. Drugs were used to create a controlled environment and regimens were rarely reviewed—they just kept medicating. 75–80% of the patients were given Stelazine, Thorazine or Haldol. Roky was prescribed Thorazine, the first antipsychotic drug introduced in the 1950s, often referred to as a "dirty drug" because it acted on so many receptors, causing a heavy, sedative effect, which led to the phrase "Thorazine shuffle." There were plenty of side effects, including muscular rigidity, loss of memory and blurred vision. Roky's muscles locked from the shoulders down and as he recalls, "They were giving me Navaine, which made my tongue go to the top of my head and my eyes roll back." He was also given a mild stimulant to counterbalance this and allow him to complete his chores.

Mikel Erickson: Of course I was one of the only people left on his guest list, Mom and me, they'd busted pretty much all the other people for trying to sneak stuff in. I didn't know any of the technical

words—but I do know they'd give him one drug and it'd stiffen up his neck, and then they'd give him another drug to loosen him up. He was screwed up; he was like a walking zombie…

The inmates were woken at six a.m. and Roky spent most of his time mopping the endless halls, sponging the toilets and doing farm work. Fieldwork consisted of twenty prisoners laid out in two work squads with "strikers" at each end. A guard on horseback would ride down the rows and holler "get it!" to which they commenced attacking the hard ground with hoes. Roky proved totally inept and the other prisoners, all "lifers" who resented him because he might get out one day, would keep up his patch. When the whistle was blown they'd run to the next field. "Is this going to go on all day every day?" Roky wondered. It did.

Following work there were regular "finger test" inspections of the cell bars for dust and the beds were checked in military fashion. Failure meant standing in the hall with your nose to the wall all night, and if you fell asleep on the floor they came and kicked you. When Roky refused to work one day because his eyes were swollen from poison oak, he was put in the hole with a guy who was serving four life sentences for armed robbery and the murder of two guards when he had previously broken out. There would be random outbreaks of violence in the recreation area, which Roky managed to avoid as he slowly became more accepted. Patients were amazed that he had been sent to Rusk and often came up to him and commented that the staff were the crazy ones for keeping him there.

Roky wasn't yet willing to concede to his fate but hadn't been able to work out a long-term strategy. All he could do was concentrate on avoiding his head becoming a torture box while he adjusted to heavy medication and incarceration. When confronted by Dr. Hunter, the maximum security unit's director, he took the wrong strategy by lying about his past drug use in case it incriminated him further. Resistance was futile; there was no hope of release until they had total control.

Roky: When they asked me to talk to get things out of my system at Rusk, I wouldn't do it. One bad word in there keeps you there another year.

J.A. Hunter (Nov. 28, 1969): This patient was felt to be floridly psychotic at the time of his admission here. Hospital records received from Austin State Hospital indicated that this patient had been using various drugs over a period of about five years. The diagnosis on admission was psychosis on a toxic basis, due to multiple drug abuse; however, a chronic schizophrenic illness could not be ruled out. This patient consistently denied any use of drugs except amyl nitrite, which he admitted he had used on only two or three occasions. Following visits, his psychosis became much worse for several days, and we began to suspect that his visitors were smuggling drugs to him. Erickson is legally sane but I feel he still requires hospitalization for the welfare of himself and others.

Hunter's dry view of the inmates is easily illustrated by the following story: a fifty-five-year-old epileptic fell out of bed and severely damaged his foot; three months later maggots were found eating the wound. When questioned, Hunter replied that it was therapeutic, since maggots only feed on dead tissue.

Roky naturally looked forward to seeing visitors and always put on a good show for them, presenting himself as optimistic and positive; as his youngest brother Sumner recalls, "I always felt like he was trying to make me feel good or better, maybe about seeing him in a place like that." At first he was allowed a stream of visitors, including Evelyn, his brothers, Dana and George Kinney, but this was swiftly restricted when he was busted with a single joint of marijuana.

Roky (NFA): [The staff] lived in the small town of Rusk, and they never got out of it. A penitentiary-like thing... cold, man. It was nice sometimes. She (Dana) came up to visit me every two weeks, that's all they'd allow. We had from eight a.m. 'til four p.m., and she'd bring me a carton of cigarettes and she brought me a television and a twelve-string guitar. But you wouldn't wanna watch television, because by the time you got it set up and passed all the regulations, you didn't wanna watch it. And then with the guitar, you couldn't be inspired. You wouldn't wanna sing "Gloria."

Dana: He did great. I'm probably the only one that would testify to that. Of course he was in prison and he wanted out, but for the first time he was off drugs. He had me bringing him books and books and books... The first year he was in there I snuck some mescaline up, because we were still into the drug thing, we were twenty-two at the peak of it. We got really high and everything started disappearing, we couldn't see the lines of people. Roky said, "We can't see anything, it's turning too white." Then we see these two guards come round and they tell me I have to leave. And then they tell me I can't visit again. Roky was real depressed when I'd leave and they suspected drugs, so the next time I got to come, Roky said, "Let's never take drugs again." Every time I saw him, he was fine.

George Kinney: By the time he was in Rusk I hadn't been able to have a meaningful conversation with Roky for about a year or two. It would completely astound me if Roky ever actually sat down and said, "OK, here's what I'm going to do, I'm going to fake insanity." It just didn't happen. I don't think he calculated his defense with his lawyers, because I couldn't talk to him, and I know they couldn't. I doubt Roky was that aware of the proceedings, or realized he was being put in maximum security in Rusk... It may have been that had Roky not gone to Rusk, he might be dead! By that point he was a total victim of [his drug use]. It was "Roky Erickson, psychedelic god—let's go do speed with him or we haven't lived yet." I went to visit him probably more than anybody else. I bought him a guitar and took it to him and he ended up giving it away three days later. I was pissed off with him for years about that.

In reality, Roky was depressed for days after visits, and he was frequently given shots to stop him becoming agitated and make him sleep. He hadn't been forgotten on the outside—the underground had lost its hero, and the first of several benefits took place on February 28, 1970. But the outside world was fading as Rusk was established as his reality. His visitors became increasingly restricted and his family became distant. Mikel Erickson had married his high school sweetie and moved to San Francisco in 1969. With her first grandson on the way, Evelyn decided to relocate to San Francisco, taking Ben, her fourth son. She wanted to investigate the counterculture (or "Children's Crusade") first-hand, and wrote in a personal missive to Richard Nixon, "I feel like a lamb before the slaughter here in the Haight-Ashbury, but I felt I had to find out for myself."

> **Mikel Erickson:** My mother has tried drugs. She'll deny the whole thing. I remember a time when she walked into my house with this bald-headed Indian guy, and I'm telling her, "Mother, what's going on?" And she says, "Oh, he's a homeless person." "Mother, this guy's just asked me where to buy heroin, get him out of my house!" "Oh Mike, you're just so physical..." So eventually I had to throw this guy out. And from then on I'm hated. "Oh Mike, you're just too..." [Laughs.] Oh yeah, and she was into Scientology...

Roky desperately tried calling home several times, only to discover that the line was disconnected. It wasn't until Dana's next visit that he found out his mother was in San Francisco, while his father remained "at the office." In a letter to his parents he remained optimistic, stating that Dr. Hunter had said he might even get out within a month. However, the shock of the Rusk regimen was made worse by a sense of abandonment. In June Roky bought some pills from another inmate and collapsed into a stupor.

> **Roky (NFA):** Roky's in Rusk Concentration Camp. "Roky, what's today?" Why do I have a need for knowing the date? I'm never going to get out. So I would just forget. I'd say, "Roky, you're in here forever, you might as well not remember any kind of success you've had or anything. You're a talented rock 'n' roll singer? Forget it! You might as well think you're Joe Schmoe. Make sure you're obscure, because they're making sure of it. Just forget it, man, because you don't have a chance."

But Roky wasn't giving up; he decided to knuckle down and work his way out of the hospital, proving his sanity by achieving as many goals as possible.

> **Q:** Did you feel safe in Rusk?

> **Roky:** After a while good people would hear about you. And we had this young guy and he was the night attendant... and he would come and get me out and let come and watch television in the attendant's room.

Q: So keep your head down, keep your nose clean?

Roky: Yep. There was this one guy, his name was Marvin Roselle and he had a certain, his own way that he was in prayer all the time... He was in charge of the clothing room and so he would get me a pass so I could go and sit with him and play the guitar and he'd play and sing songs in there.

Roky went to classes and finally gained the general education diploma he'd skipped at Travis High. His natural talent and personality started to become recognized by both inmates and staff alike. The staff rewarded him with a warped old acoustic, a Bible and a record player. Every guitar he'd been given up to this point he'd passed on to other prisoners. Gradually he spent more and more time with Brother Bacon in the chapel; he needed a new focus and every time he read the Bible, he wrote a song. Roky listened to the fire and brimstone preachers broadcasting their highly theatrical renditions of the struggle between good and evil on his radio at night and eventually studied enough to achieve a minister's card and become the Right Reverend Roger Roky Kynard Erickson.

Q: What prompted you to become a Reverend?

Roky: I just did. It would make you feel real religious to be in a place like that. All you would have would be your religion. You'd want God and Jesus with you at all times to help you through the times.

Roky managed to palm enough of his stimulants and store them up so he could write at night and sleep off the days. He began a series of books—one of which, *Openers*,[54] was published in April 1972, after George Kinney smuggled the manuscripts out in his boots. The book was a collection of poems and songs designed so that the title of each song would open the reader to a new idea: "I wrote *Openers* in Rusk because everyone was telling me that I was crazy and I had to have something to tell them I wasn't." Many of the songs bear a religious overtone (thee, ye and thy) and most are lyrically simple and repeatedly call for peace and love. There are occasional drug references, such as in "Devotional Number One" ("Jesus is not a hallucinogenic mushroom"), "God is Everywhere" ("Ye don't need bad drugs to be high, not addicted to some drugs, spiritually high it be") and "It's With the Wind" ("No drugs around, not from fear that they be found").

Evelyn Erickson: He had a band called the "Missing Links" while he was in there, and the doctor was very proud of him and took him out [to] play around the town. I just wanted him to stay in his music. I thought that was his salvation.

Having joined a psychotherapy class for couple of weeks, Roky enrolled in the prison band. There was an existing traditional country band but Roky started a rock band, calling it the Missing Links. Although the lineup varied, the most stable one featured Roky backed by a collection

of truly crazed and sick individuals. Roky's new friend John Walcott, second guitar (shot and killed his father, mother and sister while high on glue; Roky wrote "For Jimmy" in *Openers* for him), Charles Hefley, bass (raped a policeman's daughter, stabbed her with a screwdriver and killed her two infant sons by throwing them into the Trinity River; he later won custody of his own two children and disappeared, and is still at large), a deaf tambourine player (participated in the gang rape and murder of a twelve-year-old Houston boy and stuffed his body into an abandoned refrigerator) and a drummer (shot and killed an impound clerk after his car was wrongly towed). Beyond simply showing a willingness to toe the prison line, there were advantages to participating in the prison band. Roky was allowed a half-day off work per week for band practice and on occasion they were able to leave the prison grounds. The recreation director Jack Ball and an attendant named Bob Priest (on pedal steel guitar) accompanied them to shows at high school proms, festivals, rodeos and even three television appearances.[55]

> **Roky (K):** Our band at Rusk was even on television three times, but we sang an antiwar song and about a million straights called up and said "That's a bunch of shit, we believe in war so let's not have any of that peaceful shit on TV."

Roky seriously pulled the act together musically, considering the rest of the band were degenerates too wretched to even play their instruments. As his brother Donnie phrased it, he was "the head of a bunch of murderers." In his current surroundings he no longer possessed the will to employ his trademark scream and desperately needed a new template to emulate. Dylan had "disappeared" after his near-fatal motorcycle accident in 1966 and the Beatles had also disappeared into the recording studio never to re-emerge as a visible band, but his old favorites the Stones toured the States extensively in 1969 and evolved from a "pop group" into a fully-fledged rock band. Jagger had matured his role as "peacock male," with his Tina Turner strut, into the template for a professional rock icon. While trapped in Rusk, Roky obsessed about obtaining a copy of their latest album *Let It Bleed* (December 5, 1969) and began an infatuation with Mick Jagger, vicariously equating his development as performer with that of Jagger's. Just as Tommy had previously imagined that Dylan was communicating to him via the lyrics of 1968's "John Wesley Harding," Roky commented that the Stones' 1972 song "Rocks Off" was about him being off drugs.

The Missing Links name not only harkened back to Roky's early Travis High band, but also reflected his appraisal of his current status. As he explained in 1975:

> "A couple of groovy guys managed to get me out to be in a rock and roll band with some of the patients, and we called it the Missing Links. We performed, you know, but I couldn't perform. I tried; it was so funny. And I'd try to scream there and I'd be under so much tension that I couldn't scream. I wouldn't do my own material in this band I'd do others'. You know because I had such a pessimistic

attitude, I said, "Well, they can learn this, they can't learn the other thing, they don't know what I'm talking about." Because you were in with people that were there for murder. I mean vicious murders. "Well all right, here's the guy with the vicious murder and here's Roky. His circle is just as big as Roky's circle, they're equal, and they're in here for the same thing. They're crazy. It's like 'The Lonesome Death of Hattie Carol,' there's injustice in injustice..."

Mikel, who was earning good money working for the Teamsters' Union engaged Simons, Cunningham and Coleman to look into Roky's case. Their junior partner, John Howard, had studied law at the University of Texas and completed his internship at Rusk. However, it was a tough place to solicit new work, as once prisoners were in, they stayed. During the entire summer of 1971 he noted that only two lawyers visited clients and that virtually none of the inmates had any form of legal representation. While touring the wards, Howard was amazed to recognize Roky Erickson.

Mikel Erickson: At this time I had money, so I decided to go ahead, and there were these people starting this law firm—so I said, whatever you need here, you need a psychiatrist, let's get them. Dr. Alexander and different people like that came into town, because they didn't have any psychiatrists at Rusk; it was all psychologists. Of course that went on and on. It took three years, and my mother didn't want to get him out.

In late 1971, under Howard's guidance, Roky decided to fully admit to Dr. Hunter the true extent of his drug usage. Following his good behavior, Roky was moved to a more privileged ward in the hospital and was allowed more personal freedom—according to Roky, this was like being "given a tastier brand of poison to drink." On February 28, Evelyn was allowed to take her tape recorder into Rusk and record Roky singing one of his new compositions designed to appease the authorities.

Evelyn Erickson: He wrote one called "I Pledge Allegiance to the Flag"... everybody questioned your loyalty to the United States if you were a hippie or were the mother of a hippie, it's just a weird time.

Later she returned and recorded three selections featured in *Openers* and two other new songs. In March she began a letter campaign to national magazines to draw attention to Texas' mental health program. Meanwhile Roky's defense, identifying Dr. Hunter as the only actual psychiatrist on the staff, prepared to bring in outside psychiatrists to challenge his prognosis—the doctors at Rusk couldn't agree whether Roky suffered from simple or chronic schizophrenia, the difference being a hopeless case or not.

Howard and Simons first brought in Dr. Richard Alexander to privately diagnose Roky's condition on September 27, 1971. Alexander reported back after having spent an hour and a half interviewing Roky that he suffered from simple schizophrenia and "He is not out of contact with

reality and is not given to false beliefs or delusions as was the case on his admission to Rusk. His condition is a stable one at this time, and I do not feel he is apt to change in the near future. I feel an attempt should be made to bring him back into the community; he should remain on medication and under the supervision of a physician."

On January 28, 1972, Dr. John Rollyson visited Roky, also interviewing Dr. Hunter and the Rusk psychologists. Although Rollyson concluded, "Mr. Erickson now meets the legal requirements of sanity, namely he doesn't have a mental condition requiring hospitalization either for the welfare and protection of himself or others. This is not to say that Mr. Erickson is completely free of emotional problems, but rather that the psychological difficulties he suffers are not sufficient to justify considering him insane." In short he evaluated Roky as suffering from a hysterical personality disorder, which was usually found in women and commonly misdiagnosed as simple schizophrenia in men. Also that Evelyn being overly involved with Roky had caused him to be a dependent child-man; and that Roky had a dislike of the mundane, and was playing the role of a schizophrenic to placate what others expected from him. Rollyson then brought in a friend, Dr. Joseph Rickard, for a third opinion. Dr. Rickard concluded that Roky was below average in judgment, lacked in self-control, was impulsive and that his imagination was somewhat autistic. However, he found that Roky was not grossly psychotic, was only mildly schizophrenic, was above average in non-verbal communication and recommended that he be discharged and placed in an outpatient program.

In May 1972, the detailed psychiatrists' reports began mounting up at the law firm. All concluded the same thing—Roky was legally sane, but there were issues that would require future medical attention. The reports also highlighted the evaluation of Dr. Donald Vajgert, the clinical psychologist evaluating Roky in March 1969 at Austin State Hospital, that clearly stated "Mr. Erickson is a character disorder who is faking paranoid schizophrenia. His talented display of the symptoms suffers mainly from exaggeration." Satisfied that they had sufficient proof of Roky's sanity, the legal team requested a sanity hearing before Judge Thurman. Hunter duly responded in June and requested consultations from Dr. T. Grady Baskin and Dr. Karr Shannon. The first recommended "dismissal from hospital" and the second stated that Roky suffered from simple schizophrenia but that "prognosis is poor. He is a follower and would return to drugs soon after release." Hunter then wrote to Judge Thurman on July 7 under provision of the criminal code, stating that Roky had requested sanity restoration proceedings.

J.A. Hunter (to Thurman): It is in my opinion at the present time that this patient meets the requirements for a legal finding of sanity and has the mental capacity to communicate with his attorney. It is my understanding that the code of criminal procedure requires that, in order to be certified back to court, a patient must not only meet the requirements for a legal finding of sanity, but must no longer require hospitalization for the welfare and protection of himself and the protection of others. It is this circumstance that has prevented us

from certifying this patient. He has consistently managed to obtain unauthorized drugs… Continued hospitalization with continued efforts to motivate the patient to refrain from taking any unauthorized drugs is recommended.

Roky's trial was set for November 27, 1972 and Jim Simons requested a motion of discovery to obtain the medical charts at Rusk and details of all laboratory work performed on Roky, including brainwave tests or tests for brain damage or malfunctioning.

The 147th Court was once again the scene for the next round of the drama. Simons had requested trial before a jury so that Thurman couldn't make a unilateral decision. Both sides questioned Dr. Alexander, who explained that Roky had used methamphetamines that had produced hallucinations, after which friends had given him heroin to bring him back down. The extent of Roky's drug use was examined and it was stated that he'd not only used the drug (marijuana) he'd been sentenced for, but also amphetamine, heroin and LSD (more than 300 times). Roky then took the stand himself and testified that he was reformed. He stated that drugs had messed up his mind, but he now felt he could abstain. Copies of *Openers* were given to the jury and Roky testified he had failed his GED at school, but passed it in Rusk. Dr. John Tawlinson, a Californian psychiatrist, also testified that he did not feel Roky needed to be hospitalized. Simons and Howard concluded that hospitalization wasn't required under law but that it was being enforced simply because it would protect Roky from the possibility that he might return to drugs if he was ever released. The District Attorney for the prosecution concluded in his final summation to the jury that to allow Roky "back on the street was to sign his death warrant, and that he'd probably overdose on drugs in three months."

At quarter past one, Thurman questioned the jury: "Do you find from a preponderance of the evidence that the defendant is sane at this time?" The four-man and eight-woman jury retired for half an hour to consider their verdict.

Evelyn Erickson: They had their own psychiatrists saying that he'd OD the minute he left. I thought it was just really bad, I could see their point of view that putting him back on the streets right away... and I said well, where can he go, like when Mikel got out of prison two years ago he had to go into a halfway house, you orientate yourself away from the family and into the environment, but there wasn't anything like that.

Verdict of the Jury, 1:52 p.m.: We, the Jury return into open court the following answer to the question submitted to us and the same is our verdict in this case: We, the jury, find that the defendant at the present time is sane. Christine Gay, Foreman of the Jury.

John Howard (K): We got him out free and clear. It was beautiful. Jim [Simons] said that in his ten years of practicing there had never been a more exciting moment than when he escorted Roky up to the judge and the judge declared Roky sane. He is now home living

with his mother, who is watching him like a dog. She got upset the other day when I was visiting him and we walked out of her sight. She won't even let him have cigarettes.

Evelyn accused Roky of betraying the principles he was raised with but he replied that he was simply examining them from a higher place. Gradually Roky managed to start slipping out to see his friends again. Within a month, having been given the all-clear as an outpatient, he was living with Dana.

> **Evelyn Erickson:** Oh, he was free with the knowledge that he would be in my care. He was what, twenty-three? [25] Dana came over and took him off right away.

> **Jerry Lightfoot:** He was staying at Evelyn's and I would call him and he would sneak out and we'd drive around and smoke a joint. It was a sad scene.

> **Roky (K, 1973):** I called Dr. Hunter the other day. My goodness, you can't believe how nice I was. I just kept turning the other cheek. I said, "Dr. Hunter, you'll be happy to know that a month after I was released from Rusk, my private psychiatrist released me as sane." He said he was glad to hear that and hoped I hadn't smoked anymore heroin.

Meanwhile, Ronnie arrived from Vietnam on July 16, 1970 after eighteen months' involuntary service. He had written to International Artists to authorize his friends to collect his equipment from their studios, but as usual he was given the professional runaround and when he turned up in person, he was told his equipment must have been stolen. Back in the hill country he formed a power trio, Justice, with Terry Penney and Bobby Rector.

Despite being told "pack your things—you are going home," Stacy was forced to serve another few weeks pre-release. "At least I knew I was on my way out. They sent me to another farm, where they give you watermelon and the bosses curse you. You could go out in the field, pull a little cotton, shoot the shit with your friend and the bosses would ignore you…" Finally, on September 23, 1970, he was freed. Upon his return to Kerrville he and Ronnie began rehearsing a new band at Robert Eggar's ranch, called Raincrow. Stacy didn't bother with the job he had lined up, and by his own admission he "started drinking, and didn't get a job, like I should have. I was so happy to be out."

Raincrow featured Stacy on lead, Ronnie on bass, Bobby Rector on drums and the Elevators' old roadie Cecil Morris on harmonica. There was an unspoken conformity to the band's material; their only ambition was to earn a living performing honest blues-based music, no higher ideals. Their repertoire consisted of blues, R & B, rock 'n' roll covers, Dylan and current Stones numbers. As before, there was a shortage of good singers in town, but they began performing locally—until one night at the Famous Door, Obie Holdeman joined them from the audience for one song.

Obie "Chief" Holdeman was born in Kerrville and was twice their age. He'd started singing in a choral group in Barnett before traveling with the Hill County Gospel Singers. He went on to singing the blues, performing with both Fats Domino in St. Louis and Little Richard in Midland. Obie: "The blues I kind of picked up on my own, and the talent I have to give to God. I was the only black dude in the band…" Obie didn't like leaving town to perform, which seriously restricted the band's progress. Despite searching for authenticity and honesty in the blues, they needed to cover new material to get gigs. Although Obie could be persuaded to cover a few current Rolling Stones songs, he didn't want to perform much beyond old blues covers, which he performed in a decidedly pedestrian manner. However, they managed a show in New Braunfels and made it to Austin to play the Jade Room.

Eggar's ranch was the center of musical operations once again. Kerrville had evolved a fully-fledged drug culture, which differed greatly from the halcyon innocence of the mid-Sixties. Stacy's friends would drive to San Diego and pick up pot, then run it to San Francisco or Tahoe and triple their money, then buy LSD by the gram, make up their own blotter acid and take it to San Diego, sell and buy "reds" (downers) and "white crosses" (speed) and then come back to Texas to try and triple their money again. At night the pasture of Eggar's became a landing zone, pickup trucks parked in each corner with the headlights providing a target while sacks of marijuana were thrown from a plane. Inevitably Stacy left the isolation of prison for the isolation of heroin, and Tommy McDaniels, the local narcotics agent, spent most of his workdays trying to send him back again. Although McDaniels was clearly the *enemy*, he gave the kids a chance. If he suspected something he would shop kids to their parents before the law. He'd even attempt to go undercover, dressing up in army fatigues and a ladies' wig, but would always be recognized and ridiculed.

Greg Forest: I met Stacy… they were out at Eggar's ranch rehearsing in '71 and that was when I got into that circle. Stacy was a traditional blues guy at that point; he'd had enough of rock 'n' roll. He was my heroin connection. It was '71, '72; we were shooting heroin, it was the drug du jour, everyone was shooting heroin in Kerrville at that time. Couple of years later, everyone was shooting speed; then everyone did coke. I'd say we started with a business relationship before we actually played a lick together. And you know, boy, he'd take me to some places down in San Antonio in the projects down there, where we'd go and score, that were really, really scary places. Stacy was welcome down there and well-known by the blacks and Hispanics and everybody else, he was one of them, from the underground. Everybody liked the Elevators. And he's not the kind of guy you'd figure as a rock star, he'd been around the block so many times and he regretted a lot of it. He was a really sweet, sweet man. Really gentle, sweet disposition, pretty much a Christian, that was his bottom-line religious thing. He knew Christianity, as we do, nothing to do with Christ; he found the correlation between the religion and the icon, which very few Christians do.

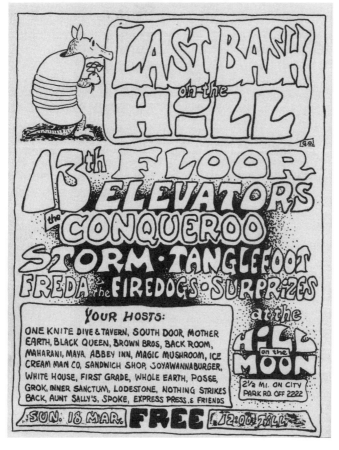

TOP: (1971) RAINCROW, L–R: RONNIE, CECIL MORRIS, BOBBY RECTOR, STACY,
OBE HOLDEMAN, KERRVILLE, TEXAS, COURTESY BOBBY RECTOR; BOTTOM: (1973) HANDBILL, ELEVATORS
REUNION SHOW, MARCH 18—THE LAST STAND OF THE SIXTIES UNDERGROUND IN TEXAS

Despite having a job selling parakeets and toys, Stacy found it impossible to avoid doing dope almost every day. As Stacy confessed, his parole officer "pulled me out of some stuff I couldn't believe." It all ended when Stacy had a knife pulled on him following an argument over drugs. He managed to fend his attacker off with a broom handle but the neighbors called his parole supervisor. Stacy was told to get out of town and was put on a methadone program.

> **Stacy (K):** One night I took a hit of dope and got a rig just like that. I hadn't been out two months before I was shooting dope again. I got strung out and my parole officer said, "Look, we know what you're doing, I don't care if you ruin your life but you better leave town or we're gonna send you right back." Anyway, I split, went down to San Antonio. My parole officer down there was real groovy, he used to come to all our shows, smoke weed, had all our albums.

Raincrow was folding anyway; Obie was put away for four years after bouncing checks to keep his barbeque restaurant afloat. Paul Tennison came in at the end as the new singer but the project was soon dead and he and Stacy took off to join Cecil Morris in Tennessee. Their next project, Tejas ("all who are friendly," a name given to the native Hasinai Indian Americans by the Spanish), ended up being three guys from Texas and three from Tennessee playing R & B in the middle of the Nashville country scene. Ronnie was summoned to join them, but he returned after a couple of weeks and when the band folded Stacy and Paul headed to Wyoming to perform as a duo.

> **Sibyl:** They'd say, "Why don't you get out of town," and he'd say, "This is where I was born, and where I've lived all my life, why should I get out, this is my home." So they just followed him everywhere. And he gypsied and he wrote us cards from Tennessee, and he walked off and left his car in Minnesota, stopped and couldn't start it and walked off. I got a card from him in Cheyenne in Wyoming and he was freezing to death and sent him some long handles, hoping that would keep life in his body till he got back.

> **Paul Tennison:** His attraction to me was he could sing with me for the first real time. Wyoming, it was a happening town—the oil thing. As a duo, we sang Eagles tunes, folk tunes, we sang two original tunes of mine. He played acoustic, he wouldn't play electric anymore. He got too cold and bored and in '72, '73 he came back to Houston.

In 1973 *Rolling Stone* was already re-assessing the Elevators' legacy in the wake of the inclusion of "You're Gonna Miss Me" on the *Nuggets* garage rock compilation, labeling them "mystic punks" and "one of the strangest groups in the history of rock 'n' roll," and demanded a full-scale reissue of their albums.

For John Ike the dream of the Elevators had never really faded, it had just become unworkable. Musically, he'd done little since the band—tried out with Shiva's Headband in 1970, but found them lackluster and dis-

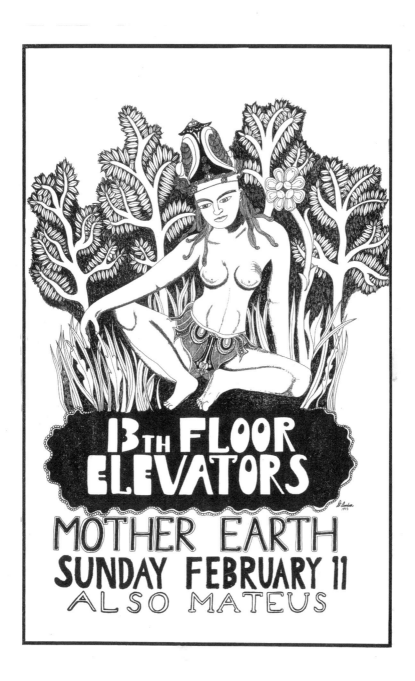

(1973) POSTER FOR FIRST REUNION SHOW, FEBRUARY 11

appointing. He gave up playing drums and started picking banjo with a former county DA, a "redneck radio man" and the head of the local mental hospital. He dabbled in furniture carpentry but ended up obsessively trying to craft an African thumb piano called a kalimba. Roky had slipped Evelyn's leash and was living in a hippie house on 37th Street with Big Ricky, the Guacamole Queen. John Ike ran into Roky hanging out at the Armadillo World Headquarters in Austin. Roky seemed really together and the conversation soon gravitated toward resurrecting the Elevators. Everyone had been damaged and upset with how the band had ended and wanted another chance to wrestle back the dream. However, John Ike refused to allow Stacy back in the band. Marijuana had caused enough trouble the first time around, and there was the added risk that Roky might start partaking. Ronnie was married, his daughter Khristie had just been born and he'd succumbed to day-job responsibilities, so without concrete bookings, couldn't commit.

Roky: I just felt there was something I hadn't said, and wanted to get together and say it.

Q: Why wasn't Stacy in the band?

Roky: Oh by that time, they had figured the things they were thinking about being busted were real. They didn't want to chance it.

Stacy had always been one of Donnie Erickson's idols, so he was drafted in on guitar. They needed an "extra" instrument to replace the jug and form the "third sound." A young piano player, Johnny Mac [McAshan], lived with Roky at Big Ricky's and joined on electric piano. Donnie brought in a jazz bass player, John McGiver, and the new 13th Floor Elevators began rehearsing at Donnie's house in Austin in January 1973. Within a month they were performing at the Mother Earth Club in Austin on February 11. "You're Gonna Miss Me," "Splash One," "She Lives (In a Time of Her Own)" and "Levitation" survived from the old days and the rest of the set consisted of Roky's new material and Dylan covers. The demand for the band proved overwhelming—they booked the club again for another sell-out appearance.

Donnie Erickson: John Ike Walton was the chief on getting that together I guess, and they said Stacy would be a bad influence because... a tiny problem... Well, they were successful. I wasn't very uncomfortable up there on stage. Well, Roky and I got in an argument onstage. I thought Roky was the singer and I was the guitar player and I started, "you are outta tune..." being Mister Imperfecto... I thought his voice was enough but he wanted to be lead player too.

Over the coming weeks the band performed at least two undocumented gigs and one at the Armadillo World Headquarters in Austin; *Rolling Stone* reported the reunion, calling them "true rock psychedelic crazies." They attempted new recordings at the Sonobeat Studios over the road from the club, which included a reworking of "You're Gonna Miss Me"

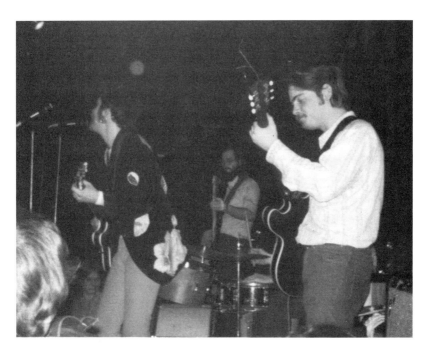

(1973) Reformed Elevators lineup, Mother Earth Club, Austin, Texas;
Top: Roky, John McGiver, John Ike (at kit), Donnie Erickson; Bottom: John McGiver, John Ike,
Roky & Donnie (not shown: Johnny "Mac," piano), courtesy Sumner Erickson collection

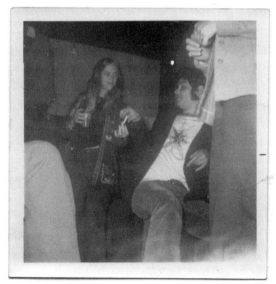

(SPRING 1973) AFTER HOUSTON COMEBACK SHOW, LA BASTILLE, APRIL 1–3;
TOP, L–R: ROKY, JOHN IKE, GEORGE BANKS; BOTTOM: THE MOMENT ADORING FAN
RENEE BAYER MET ROKY. SHE WOULD GIVE BIRTH TO HIS FIRST CHILD, PHOTOS BY JOE KAHN

but, unhappy with the bass player, they decided they needed Ronnie back. The Austin shows had been a financial success, bringing in over $1,300 a night, so John Ike called Ronnie to let him know they had three nights booked at La Bastille in Houston for $3,000. Ronnie played his last gig with Savage and rejoined the Elevators in Houston. He was impressed by the strength of Roky's new material and had a clear vision of what they needed to do—get Stacy back in the band, spend two months practicing at his ranch and then go directly into the studio and record new material. His only problem was that Roky had to stop phrasing everything like Jagger. As usual, with no manager, the reality became a frenetic dash, with John Ike booking whatever he could, and everyone tried to find a dependable car and make the gig in time. The band's next show, "Last Bash on the Hill" at the Hill on the Moon on March 18, was a massive festival organized by Roger Collins of the One Knite in Austin. This turned out be the last stand of Austin's Sixties counterculture, as fifteen thousand people witnessed the Elevators, the Conqueroo and Doug Sahm bow out and the "Cosmic Cowboy" take over. The rednecks now smoked dope and the hippies and the cowboys co-inhabited the Armadillo World Headquarters, and the unbilled arrival of Willie Nelson signaled the end.

John McAshan: The Hill on the Moon concert was the biggest thing we headlined. It was a unique mixture of cowboys and hippies… all these poor hippies in their blankets… and then we see RVs rolling down and everyone's moving their blankets out of the way, like everyone had seen a spaceship. It was Willie Nelson and nobody had heard of this guy.

The band went on so late that many were falling asleep, but when they struck up, old material was delivered with new urgency and drive while the band's rendition of Slim Harpo's "Shake Your Hips" via a Stones version verged on an Iggy Pop and the Stooges punk/metal sound. Following the show, they attempted a second recording at Sonobeat Studios. Bill Josey was funded by Columbia to make test quadraphonic recordings, or "Sonoquad" as he named it. It was primitive, still using a four-track deck, but the idea of experimenting with new sound techniques suited the Elevators perfectly, and the only song recorded, "Maxine," hasn't survived.

The band were booked to make their Houston comeback at La Bastille on April 1–3. Shockingly, at Roky's request, John Ike sacked Donnie and hired Terry Penney without consulting Ronnie.

La Bastille was the first time Stacy had seen Roky since August '69. He was staggered and overjoyed to be witnessing his comeback.

Stacy ventured backstage, and as a result joined the band the following night for a brief twenty-minute set. KAUM, the local radio station, broadcast a thirty-minute retrospective of the band and caught the madness in an interview with Roky backstage.

John McAshan: Roky was face down on the carpet conducting the interview. It was sad. The last thing Roky needed was for people to give him drugs, and everywhere we went people gave him drugs.

Roky (KAUM broadcast): Hi, I'm criminal Roky, we're interviewing... what radio station is this? K-A-U-M, we're the 13th Floor Alleviators and we're interviewing KAUM.

KAUM: What do you think of the future of the band?

Roky: We're all going to be turning into road lizards...

The broadcast did feature snippets of the band performing a new song, "Stumble, Smoke the Toilet," which parodied flushing marijuana during a bust, a situation they knew only too well.

John Ike had tried to run a no-nonsense regime, but failed. If you were late (as Johnny Mac found out) you had your money docked. Roky supported Ronnie about Stacy's return, but John Ike still wasn't convinced and effectively put him on probation, keeping Terry Penney close to the band. Following the Mother Earth show, John Ike had also installed a secret switch so that he could limit Roky's volume, which was soon discovered...

Johnny McAshan: Roky, he would just take his finger and run it on the top of the knobs on his guitar so every single one was on ten. John Ike installed a secret volume knob after the first gig and we were sailing great and then, at the Bastille gig, Terry Penney went and fooled with it, and Roky caught him and gave it away.

Roky was taking mescaline and anything else anyone cared to offer him, and one night at the Bastille failed to show up at all, having disappeared sailing in Galveston that afternoon. The band busked their way through a few rock 'n' roll covers until people began to walk out. By all accounts, for John Ike it was depressing—back to the bad ol' days. Roky had written dozens of potentially good new songs but was never around to work them up. As an article in *Abraxas* magazine observed in April 1973, the band had suffered from having their practice run hyped as the second coming of the psychedelic gods.

Stacy (K): He seemed more like the Roky that I'd known when I first met him. Then I got scared, because he's still an impressionable kid. Somebody has to take care of him. I know now there are times when he's completely normal and other times when he's just gone. If he doesn't quit messing around with whatever he's taking, one of these days he's going to go lulu and that'll be it. It's really gonna break my heart if this band doesn't work. It would really be pathetic after all these years to have a second chance and then go out and blow it all again. I wouldn't want to see it happen. I see problems right away. John Ike and Roky have a real bad communication problem, for one thing. When Roky played me one of his new songs, it rocked, I was climbing the wall it was so fine. A little bit later we were over at John Ike's and I asked him to play the song again. God, it didn't even sound like the same song, it was flat. But Roky can get that way around John Ike.

1973 REUNION SHOWS. TOP: TICKET FOR APRIL 15 SUNKEN GARDENS SHOW; BOTTOM: JOHN IKE'S HOMEMADE POSTER FOR FINAL REUNION SHOW, EASTER PORT, ARKANSAS, COURTESY JOE KAHN

Joe Kahn: I guess the logical question is, what if Tommy gets back in touch with you guys now?

Stacy (K): Well, erm, I love ol' Tommy, deeply. I mean, he's one of the closest friends in my life. We would have to learn to know each other again… He'd have to change his ideas about drugs, otherwise it's really obvious where it's heading… because of the control Tommy had on Roky.

Roky: What I feel with Tommy is, walking up to him and saying, "Tommy, I need my home back. I've been on every drug in the world, every place but home."

Their next show, featuring Stacy, was at the Sunken Gardens Amphitheater in San Antonio on April 15 and had sold several thousand advance tickets—the only problem was that Roky didn't show in time. He got busted at the Laredo border with seeds and stems littering the floor of his car, but got off by pulling his minister's card.

Dana: He told me while he was in Rusk never to take drugs again. That's when we found Christ and our lives started healing. And then one day, after he'd got out of Rusk, I went over to see him and it was obvious he'd been up all night, and I said, "What are you doing? You're going back." He said, "Well, you have, too..." Like we were blaming each other for taking drugs.

The day after the San Antonio show a summons went out for Stacy to face drug charges on April 30. He'd been caught red-handed with a used heroin rig in his pocket.

John Ike targeted the spring break audiences in Port Aransas and booked the band for April 22, Easter weekend. His homemade poster read "Ling Kong Presents 13th Floor Elevators and Rapunzil (Fort Worth)" in homage to the Lingsmen. No one seemed to know who was playing—Stacy? Terry Penney? Ironically, the band ended at Easter, the time of rebirth, where Roky had first taken the stage with the Lingsmen in 1965.

Joe Kahn: First time I ever saw the Elevators was down in Port Aransas. I saw Roky and he was so gone. He looked like someone had woken him up in the middle of the night after twelve hours in a deep sleep. He came on... heavy-lidded and his hair was just thrown back and he'd walk up to the microphone and he'd come in four bars late and he'd try and shout like Mick Jagger and he was phrasing everything just like Mick Jagger and then he'd walk back and turn his back to the audience. And then all of a sudden, he'd come in and start playing lead guitar, you know, out on the left field, just playing a different song. And I just sat there and went, "Oh, fuck!" Why is anybody getting Roky to get up on stage to do that? Nobody needs to make money that bad.

John Ike had always gauged the band's success by the amount he could book them for. Having tasted the big money in Austin and Houston, he had to concede, "Everything else we did was, you know, $25 apiece." Although any serious hope of the Elevators continuing was finally gone, John Ike still booked himself, Ronnie, Terry Penney and a new singer as the Elevators at Mother Earth for one last show, but no one was buying his dream anymore.

The end of the Sixties had been an extremely painful *fin de siècle*. The reformed Elevators had made a brave last stand, but made the same old mistakes. The cosmic cowboy was the legacy of the scene: turned-on rednecks, enlightened hicks. Many of the Texas musicians from the Sixties had been forced to give up trying—they'd made their heartfelt psychedelic offerings and few had recognized them. If they wished to continue playing music, they had to perform pop tunes the clubs demanded. While the 13th Floor Elevators, Golden Dawn and the Red Crayola albums became the innovative material for cult legends, some of the Texan scene went on to sign with major labels and enjoy a wider career. Janis Joplin recorded a fine musical legacy before her untimely death in 1970. Former Ghetto mainstay Powell St. John wrote for Janis and signed to Mercury in 1968 with Mother Earth. Doug Sahm made albums for several major labels

throughout the Seventies and Eighties. Shiva's Headband, from the Vulcan era, signed to Capitol and released *Take Me to the Mountains* in 1970, and continued into the 1980s. Charlie Prichard of the Conqueroo, immortalized as Fat Freddy in the *Fabulous Furry Freak Brothers,* went to tour with Cat Mother supporting his hero Jimi Hendrix in 1970. Love Street in Houston spawned Johnny Winter and the Moving Sidewalks, who evolved into ZZ Top. The Elevators' backup band Fever Tree recorded five albums between 1968 and 1975.

By the early Seventies, the scene was set for bands like the Eagles, Chicago, Emerson, Lake and Palmer, the Electric Light Orchestra, Rod Stewart (*sans* the Faces), Pink Floyd (*sans* Syd Barrett) to dominate the music scene, until overinflated egos encouraged the advent of punk. Instead, the Elevators joined artists such as the Velvet Underground and the Stooges as bands whose success couldn't be measured in record sales during their lifespan, but by their continuing influence over successive generations of musicians. The Elevators had always bordered on hard rock. Their sound informed punk in the same way that the 1973 "Raw Power" Stooges reinvented loud rock for the pre-punk generation. The main difference was that Iggy Pop and the Stooges and the Velvets' Lou Reed had a well-funded mentor in David Bowie, whose production company facilitated their excesses and gave them a platform to resurrect themselves; in 1973 the "acid-metal" Elevators were buried in Texas, without a David Bowie to rescue them.

Iggy Pop: Sometimes people write something kind about what we [The Stooges] did, and I think, "Why not the Seeds, why not the 13th Floor Elevators?"

54. **Roky, April 1973:** *So I wrote a book* (Openers*), it was about the beliefs of my friends and myself. And I had three more books, one's called* Love Paintings: A Positivity Mirror for the Harmless (Non-Commercially Speaking)*, and the third one's called* TOP*, which is* Tis-Only-Peace*, which is like the top level and the fourth one's called* Stink Bug *and* Amazing Love *and it's far out.*

55. Known performances and rumored performances: November 6 and 7, 1970, " Indian Summer Festival" East Texas, reported in the Rusk *Cherokeean* newspaper. At a rodeo in 1970 recorded by Evelyn and Donnie Erickson, songs played are "Thank God for Civilization" (Erickson Rusk/Openers composition), "Unforced Peace" (Erickson, 1968), "Everybody Needs Somebody" (Russell/Burke/Wexler), "Honky Tonk Woman" (Jagger/ Richards), "Tell Me" (Jagger/Richards), "Love in Vain" (Robert Johnson as arranged by Rolling Stones on *Let it Bleed* LP), "Let's Spend the Night Together" (Jagger/Richards), "I'm a Man" (Bo Diddley), "She's Got It" (Little Richard), Alto High School, Texas circa late 1970. East Texas TV: *The Johnnie Lawrence Show,* KTRE Channel 9 Lufkin, Midday July 5, 1972. *The Glenn Earle Show,* KJAC Port Arthur Channel 4 Midday July 6, 1972; also reportedly on WBAP (Ft. Worth) and KLTV (Tyler), but no records exist.

20.
MEETINGS WITH REMARKABLE MEN

The Elevators' reformation clearly came too soon after Roky's release from Rusk. Having been denied three years of freedom, it's easy to understand why Roky wanted to live again through his music and how he became the victim of his celebrity by being unable to control his own excesses. Instead he needed to rest before he could successfully reinvent and resurrect himself as a performer.

Evelyn Erickson: After he got out he began playing various places. He went to Houston and she [Renee Bayer] was in the front row and they got acquainted, and he went home with her and they had several nights together. And then she found out she was pregnant, which was pretty devastating, not to have a father. Her mother called me and said "Well, we're gonna put Roky's name on the birth certificate," and I said "Good."

Dana: Roky asked me to marry him in Rusk. Evelyn didn't want us to be together, wouldn't let us date—Roky snuck out. He'd been locked up for three years, I didn't want to crowd him, so I just kinda waited. So Roky goes to Houston and played a gig and this little fan takes him to her apartment and has a picture of him on her wall. So what... he couldn't help it, he was young, rock 'n' roll... the next thing I know, Roky's going to get married. I can't believe what I'm hearing. I felt so betrayed. I was driving through town and pulled up at the lights, and in the car next to me I see a tuxedo in the back seat and Evelyn's driving and Roky's sitting there. Roky and I see each other and he goes, "Dana! Dana!" And Evelyn goes, "He's going to Houston to get married," and I look at Roky and he jumps out of the car and gets in with me and says, "Let's get out of here, it should be you and I getting married." And I said, "Derrr, yeah!" And we drive off.

Evelyn Erickson: Well, I think we were all terrified of Dana. Very irrational. We didn't know you could get a restraining order to stop this woman. I hate to be so... but you just can't deal with someone on drugs, when they get angry.

Dana: We didn't get married right away, we had to go through the hell of Renee having this baby [Spring] and Evelyn taunting, "Today your baby was born." It was a nightmare, we were on the run. Roky and I went to this preacher's house and got married. Roky was starting to get real crazy and we couldn't find a place to stay, there was no home, it was January and we'd have to go into the 7/11 to warm up. He was starting to become unglued and no, we weren't taking drugs.

Dana and Roky finally got married on January 22, 1974. When they began to reacquaint themselves with the scene they hung out at Soap Creek Saloon, near their Travis Heights home in southern Austin.

Over the years Evelyn has been blamed for much of what's gone wrong in Roky's life. The accusations range from her being overly religious, possessive and controlling, to mental and even physical incest. One thing is true—however unhealthy their relationship has been, Evelyn has picked up the pieces of Roky's life on countless occasions. While she may have lived vicariously through her son, one can only imagine how Roky's illness has impacted her own life. While Evelyn is eccentric (in the 1970s she took to sleeping on the roof of the family house), she hasn't been diagnosed with any mental illness. The treatment of Roky's mental health has been a comedy of errors, leading to toxic overload, which tested his system and mind to the limit. For most of 1974 Roky was off drugs and medication. Although Dana observed the onset of the symptoms of mental disorder, she did not intervene and observed Roky's wish to be himself again: unmedicated and free from the horror of Rusk.

Without trying to artistically romanticize madness, Freud regarded it as a healthy, organic impulse, the unconscious outworking. Roky choose to accept his condition as such, and untamed he entered one of his most creative periods. No one is exactly sure how many songs Roky wrote between '73 and '75, but the number is estimated at over 200 (he is credited with more than 400 to date). A common aspect of what is termed "schizophrenia" is an uncontrollable creative urge. Roky's songbook is a unique reading of the human condition; somehow he managed to harness the genius of the unconscious through all undefined creative forces within—madness ("the sickness of the soul as expressed by art"), spirituality and the chemically induced. Even during his worst moments Roky never appeared to lose his unique sense of humor. He uses humorous wordplay for many reasons—either to make people feel at ease, or for diversionary tactics (if he doesn't want to do something he'll respond with one of his stock phrases, such as "Oh, I'll be here relaxing for you").

By the end of the 1960s, rock 'n' roll was proven as the devil's music. Mick Jagger had clearly sold his soul to Satan—witness 1967's *Their Satanic Majesties' Request* LP, 1968's *Sympathy for the Devil*, 1968's starring role in *Performance*, his soundtrack for Kenneth Anger's film *Invocation of My Demon Brother*. The former student of London School of Economics has continued to sign countless corporate deals ever since. The era ended with the murder of an audience member at the Stones' '69 Altamont performance followed by the untimely passing of Mama Cass, Jimi Hendrix, Brian Jones and Janis Joplin.

Meanwhile Roky survived hell at Rusk. His resurrection was simple—Horror Rock. The whole point of good horror is that the audience is meant to suffer and, in turn, horror could be viewed as a subtle form of revenge for what had happened to him. One of Roky's biggest problems was countering his sense of the mundane, and horror offered a highly theatrical cast of monsters and gremlins to express himself. Although he prefers not to elaborate on the background of his songs, it's not hard to spot the adaptation of horror titles from his youth into autobiographical metaphors: 1943's "I Walked With a Zombie" for the "Thorazine shuffle" and 1957's "Night of the Demon" for Rusk and 1955's "Creature With the Atom Brain"[56] for electric shock treatment. Screamin' Jay Hawkins employed voodoo and the macabre in his songs and Roky's hero Joe Meek used extraterrestrials. In 1975 Roky lost all his manuscripts in a huge fire and set about a marathon typing session assisted by Billy Miller in which he recalled all of his songs. What's intriguing was that Roky had become absorbed in the twin motion of acceptance and rejection and typed many of the songs with the lyrics "God" and "Jesus," which were then crossed through with red pen and replaced with "Lucifer" and "Satan."

> **Q:** In a lot of your manuscripts you replace God with Lucifer, how much of that was a rejection?
>
> **Roky:** I would look at it and think maybe… my fans wouldn't understand it if I would be praying to Jesus all the time, so I was thinking of Lucifer more in the vein of horror movies. When I was young I wanted to go to horror movies and my mother would say, "No, I don't want you going to these horror movies, they're bad for you and you could get too scared from watching them." So, I was comparing that, what my mother would let me do, to the horror movies. I would try and make my songs into horror songs.
>
> **Q:** Were you also addressing your own internal demons?
>
> **Roky:** That I had an internal demon? That would be Rusk.

Although this was supposedly a new direction it retained much of the core essence of the Elevators. Roky might not have understood everything Tommy was talking about, but he'd been a good student and was now evolving his own unique tangent to the previous themes of eternal life and enlightenment. If LSD was known as the heaven and hell drug, Roky had certainly experienced both during his career and set about reclaiming himself.

> **Roky (NFA):** In my writing, like "The Wind and More," it talks about Beelzebub sitting on his throne. I write these things down and I like it so much because it gets me into the realm. You know, into the spirit world—of talking to dead people, which I've never done, but all of us have had the feeling of being able to talk to an ancestor, and it's a wonderful, warm feeling to be able to feel that they haven't died and that things continue.

The term demon in Chinese does not necessarily have an evil conno-tation—the point at which a soul re-enters a womb to start a new existence is known as "the state of the demon." Roky put this theory into practice with a new band, Bleib Alien. He completed his new persona in 1975 when he had a lawyer, Peggy Underwood, draw up an official document declaring he was actually a Martian.

Roky's Declaration, June 13, 1975: I am NOT a member of the hu-man race and am in fact from a planet other than earth. I hope that this will prove to the person who is putting electrical shocks to my head that I am an alien.

Roky (NFA): Bleib Alien, we were brand new in the psychedelic sense. And while Bleib Alien will talk about the fire demon rising into the clouds... The cloud-filled room of smoke; you may infer that, you know fire into your heart's desire. Now the Bleib part works with Satan and the Alien is just, I find so much thrill in finding life on other planets. And of people being aliens, maybe myself, I would say, "being an Alien" like being an Alien member, the band. It would be cool if anybody thought they were an Alien... 'cos they have Alien groups, the Aliens of America or the Aliens of Russia, there's really not much more to say...

Roky had been staying in Houston in late 1973 with Jerry Lightfoot and drafted him on bass, Steve Webb from the Lost and Found on drums and Rocky Hill on lead. Rocky's former band, the American Blues, had split and his brother Dusty and Frank Beard had gone on to join Billy Gibbons of the Moving Sidewalks to form ZZ Top. Everyone highly anticipated the outcome of Roky and Rocky forming a band.

Jerry Lightfoot: Roky was all right, you know, he was kinda edgy... he had just written "Don't Shake Me Lucifer" and stuff like that, and we rehearsed it and went and did a little gig in this old horrible place in Houston called the Cellar. So everyone was excited to see what Rocky was going to do with Roky Erickson. When we rehearsed I had always tuned Roky's guitar down or unplugged him, and it sounded great. So, the gig—we're doing great; we open with "Don't Shake Me Lucifer" and go right into "Little Red Rooster," and then one of those bikers noticed we'd unplugged Roky and suddenly all this hor-rible squawking shit [started coming out] and Rocky unplugged and walked off and said "I'm not doing this." [And] before you could even talk about it, Roky had busted his hand through a window.

Roky's old friend Patrick McGarrigle introduced him to Billy Miller, another veteran of the Austin psychedelic scene. Roky took Miller's band Cold Sun[57] and rechristened them as the new Bleib Alien, with Billy Miller on autoharp, Mike Ritchie on bass and Hugh Patton on drums. Follow-ing his experiences with John Ike's secret volume switch and being un-plugged, Roky decided to play lead himself and not engage their guitarist, Tom McGarrigle. They made a successful unbilled debut at the opening of

the Ritz Theatre on October 18, 1974 and made further appearances at the Ritz in April '75, Soap Creek in May and the Armadillo in July.

Doug Sahm had managed to navigate his way out of the 1960s better than some artists, maintaining a career in Texas and California. In July he decided to help Roky's career and record a debut solo single. This was basically a bunch of longhair guitarists all riffing around a single microphone, long before such grungy lo-fi recordings were considered artistically credible. The record was declared an instant classic within months of its release. Both songs—"Red Temple Prayer" (a.k.a. "Two-Headed Dog") and "Starry Eyes" remain amongst Roky's best-known songs, and those most demanded by audiences. While the A-side satisfied Roky's more left-field fans, "Starry Eyes," written about Dana, became his perennial radio-friendly classic.

The Spades' 45 was also re-released, and a copy found itself in heavy rotation on the jukebox of Malcolm McLaren's and Vivienne Westwood's shop SEX in London's Kings Road—the virtual birthplace of punk. In the early to mid-1970s Texas music was dull. Most of Roky's contemporaries were forced to play in cover bands reworking tried and tested blues-based rock "in the Texas style." While Sahm could effort-lessly bridge the gap between the cowboys and the hippies, Roky was simply too odd, too eclectic and too individual to bow to the constraints of Texan musical trends—until the dawn of punk. Doug prepared to head back to L.A. for gigs in North Hollywood and asked Roky to join him. His road manager Craig Luckin was keen to get into band management and offered to look after Roky. Dana had been struggling to make ends meet in Texas, which Roky termed a "Gestapo state," so they departed for new adventures in California.

Meanwhile, in 1971 Benny and his now-wife Yvonne "went a couple of times to Frisco to try and follow up but we just couldn't fit in, her and I." When Yvonne became pregnant with their daughter, they moved back to Texas and she took a law job at University of Texas. In 1974, after years of avoiding music, Benny joined Plum Nelly on electric fiddle, which included former rivals Johnny Richardson (ex-Wig) on guitar, Ernie Gummage (ex-Sweetarts) on bass, Billy Stoner on guitar and Jerri Jo Jones on vocals. As Gummage recalls, "It was sort of a psychedelic country band, and Benny fit right in." They often shared the bill at the Red River Inn in Austin with Tary Owens' band the Paradise Special, and if Stacy were in town he'd sit in with Tary and Benny on fiddle.

> **Benny:** I [didn't go] back to music for about eight years. The Plum Nelly band was country, we didn't really try and amount to much, just had fun. We went on tour for four years 'round Texas; we went to Nashville, got around a little bit. In that four years I re-established that I didn't want the musician's life.

Although Screen Gems [the Monkees' label] in Nashville showed interest, they never signed a recording contract,[58] and when they morphed into a rock band, Mother of Pearl, Benny dropped out. By the end of the 1970s, Yvonne wanted to move back to San Francisco and the couple

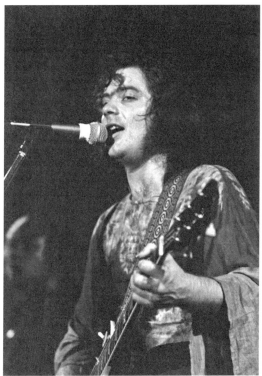

TOP: (CIRCA 1975) DANA & ROKY, COURTESY SUMNER ERICKSON COLLECTION;
BOTTOM: (1974) ROKY PERFORMING WITH BLEIB ALIEN, RITZ THEATRE, AUSTIN, TEXAS,
PHOTO BY STEPHANIE CHERNIKOWSKI

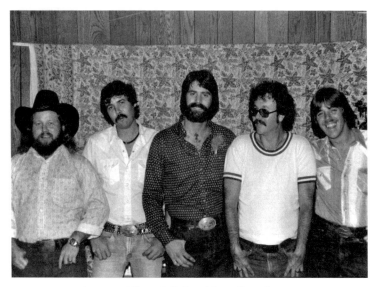

divorced. Benny ended up taking residence in a wooden trailer adjacent to his family home in north Austin, where he still lives and regards himself as a recluse. Benny hadn't spoken to John Ike since leaving the Elevators in 1966, but following the death of his father in 1999, he began to unravel his thoughts and feelings about the era and decided it was the time to confront his past and make sense of it. Despite his redneck background, he saw the experimentation of the 1960s as a release from post-WWII gloom and a way of reacting against the impending casualties of Vietnam.

> **Benny:** I was just floating along. I had the feeling then that I've still got today—I didn't realize how deep in my heart, that it's something that stays with you the whole time. And people want it! There's got to be a practice around where people can be turned on naturally and feel the good feelings of the Elevators. Roky had just a fine voice, you know. He was almost like a choirboy. They say he stole his voice from an angel, and they tried to steal it back. [Laughs.] We had the pyramid and the eye up there, and we were trying to get to God... It was as close to God, the feeling of God.

Of the all Elevators' bass players, Ronnie was the mainstay, the one that understood the music and the band. Although he admired Roky and Tommy, his long-term loyalty lay in his friendship with Stacy. After the collapse of the 1973 reunion, he formed Harbor, a heavy rock three-piece featuring Barry Below on vocals and guitar, and Chris Stash on lead, which became "Travis" with the addition of Paul Tennison, Bobby Rector on drums and Cecil Morris on harmonica. Despite writing and recording original material, the band realized it was over at the beginning of the punk era.

Ronnie's second child, Weslie, was born in 1978 and is now a bass player and artist. Ronnie still happily lives in Kerrville with his second wife Amy, rides his motorcycle and plays in various bands formed from the old crowd of Hill Country Boys.

Ronnie: It's still positive to me, I liked everybody and they all had a direction they were going in. And that's what I liked about the Elevators. Everyone was looking for a future, ahead—instead of going "this is it?" Even when we split up everyone still had that positive attitude about going somewhere. I can't believe how well it's lasted for so many years... Such a short period of being out in public. There's still bands wanting to cover what we did.

Post-Elevators, Danny Galindo remained a cornerstone of the Austin music scene for many years. In 1970 he joined Fast Cotton, an R & B band that featured ex-Sweetart Ernie Gummage, ex-Wig Johnny Richardson and Texan legend Townes Van Zandt on keyboards. They recorded for Sonobeat and, typically, the recordings remained unreleased. In 1972 he joined Storm with guitarist Jimmie Vaughan, and played blues-rock covers mainly in support of touring out-of-town acts. Following a failed attempt at hanging himself in '73, he returned to music with a typical Austin blues bar band, Walter Higgs and the Shuffle Pigs. After a bar fight landed him in a coma, he decided it was time to clean up and be taken seriously.

Danny: I finally did graduate from medical school... and I'm kind of proud of that, too, because nobody ever thought I'd finally do it. My parents had given up. I graduated just to prove to everybody not only that I could do it, but also to prove I had more attributes than they gave me credit for. I started nursing in San Antonio in '84.

When Danny moved back to Austin and "got in trouble," he finally admitted he had a drug problem; he was put on a recovery program by a nurse's organization to recover. Tary Owens, himself a former victim of the changing drug scene, became a substance abuse counselor and helped Danny, amongst others, break the habits of the old days. Although Danny stayed clean, he admitted: "Yeah, my usual bedtime is about three, because I still live musician's hours. I'm a club player now... I play beer joints." Unable to get the liver transplant he desperately needed, Daniel Raymond Galindo died peacefully in San Marcos on May 17, 2001.

Danny: The Elevators—the agony and the ecstasy, because it was both. I've been clean and sober for eight-and-a-half years now, I know there's an awful lot of people out there that suffer from the same illness I suffered from, so if there's anybody out there that can take a little hope from that, I want to tell them that recovery is possible.

John Ike Walton never found another band after the 13th Floor Elevators that he wanted to drum with. His wife Betty worked for the DA's office. Meanwhile, John Ike and his mother maintained a steady lawsuit against International Artists until the family money ran out. After leaving

the band he'd only received a royalty check for $4.06 in December 1967, which bounced.

John Ike vacillates between his goofy dry humor delivered in his slow drawl and bouts of depression. He attends a Pentecostal church where he "speaks in tongues," and has been treated with lithium for years. When he's down he frets over the "lost millions," and fantasizes about recouping his family fortune.

In 1974, Lelan, dissatisfied with the way he'd left IA, purchased the rights to the back catalogue but did little with it despite strong interest from outside the U.S.. Although Andrew Lauder finally released the first two Elevators albums in Britain in 1978, it was mainly bootleggers that fulfilled the demand and interest in Europe, Scandinavia and Japan. It became impossible to tell legitimate releases from bootlegs, and Lelan more or less allowed the situation to stay that way until John Ike tried to rectify it in 1978, supported by his former band members, but he ran out of funds and settled for far less than his original demand. Over the years, John Ike had continued to pursue the Elevators' legal case and has tried to instigate two more reunions, one that happened in 1984 and another failed attempt in 1987.

Lelan, having sold the rights, died in Nashville age 74 in 2002, just before the last big courtroom drama involving all the Elevators. Because of his shady business practices in the 1970s and '80s, Lelan had unfairly received a reputation as "the man who ripped the Elevators off" when, in fact, he was only one at IA to help them. For Lelan they were the good old boys, something he was immensely proud of.

John Ike occasionally brings his original Elevators kit out of retirement for one-off gigs, but mostly sticks to his "Zulu drum" at the odd hill country bash. He's married for a second time and he lives happily with Alice in the hill country.

After the Elevators dissolved, Danny Thomas remained in flux in Houston in 1969, not sure of his next move.

Danny Thomas: As the result of an anonymous call to the authorities stating that I was in a "catatonic" state—when in fact I had chosen not to communicate with anyone of my own free will—I was bound in a straitjacket and carted away in an ambulance. I was forcibly committed by Texas law enforcement under court order to the psychiatric unit of the Methodist Hospital in Houston, where four electroshock treatments were administered under the supervision of Dr. Crane, before I was released after ten days.

An invitation to attend what turned out to be Janis Joplin's last birthday party on January 19, 1970, brought Danny Thomas back to Austin, where he decided to join Headstone, George Kinney's new project after the Golden Dawn. The ever-changing lineup also included Danny Galindo and Mikel Erickson, but beyond playing a couple of benefits for Roky in Rusk, the band achieved little success, despite Kinney's new and original material. The band folded following a drug bust in the hill country from which Danny Thomas escaped but, discovering there was a warrant out

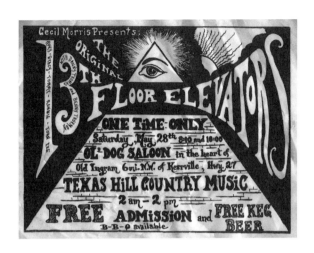

TOP: (1977) BUNNI'S HANDBILL FOR STACY'S BIRTHDAY AND THEIR WEDDING DAY "REUNION" BASH, MAY 28, COURTESY JOE KAHN; BOTTOM: (1978) HANDBILL FOR STACY'S LAST-EVER GIG, JULY 15, COURTESY GREG FOREST

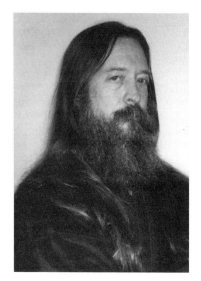

LEFT: (1990) DANNY THOMAS, COURTESY D. THOMAS;
RIGHT: (2000) DANNY GALINDO, PHOTO BY PAUL DRUMMOND

for his arrest, handed himself in only to have the charges dropped in court. After his drum kit, which had been co-signed by Danny Galindo, was sent back to the music store, he moved back to the Carolinas and gave up rock 'n' roll. He settled into a job as an accounting clerk at a medical center in North Carolina where he met Juanette, and they married in 1981. In 1991 Danny Thomas set up a new band, "Dogmeat," which he described as "a heavy metal version of the Elevators," but soon tired of performing, preferring to be the proud father of three, and is now a grandfather.

After the Elevators split, Stacy embarked on a rather darker saga.

> **Beau Sutherland:** In 1973, against my advice, [Stacy] had some things going on with his probation, the state narcotics agents approached him about working as an informant and helping them arrest some of the dealers around Kerrville. Having worked with informants myself, seeing the treatment they get with the system, I told him that it's really a no-win situation. From what I know about it, I think he sort of paid them lip service. Stacy had a real sense of loyalty. To my knowledge I don't think Stacy ever turned in one of his friends.

Meanwhile, Beau was working for the FBI and instigated a huge heroin bust in New York.

The fate of the '73 reunion was sealed with his heroin bust in April, and Stacy moved to San Antonio, where he was involved in a relationship with a girl whom he considered marrying, but when he got clean, realized that they had nothing in common apart from drugs. He was proud to

have kicked heroin but began to drink; alcohol was one drug he couldn't control, so he followed his parole officer's advice, and left town in April '74, heading to Odessa in west Texas to stay with his cousin Ramona. He worked in the oil fields "cutting pipe" and, as his mother noted in a letter, "he was away from the dear law." After little more than a year in exile he ventured back to Austin in August 1975, where he was immediately arrested and fined for public drunkenness. He then moved back to Houston where he ran into an old flame from the late 1960s.

Ann Elizabeth Bunnell, known as Bunni, was four years older than Stacy and moved to Texas from New Jersey. She had been through a lot since Stacy had thrown her out of "Funky Mansions." She had married, divorced and then worked as a topless dancer to support her two kids, Ralph and Elizabeth.

> **Sibyl:** She was an educated girl. She spoke several different languages and she played the piano beautifully, and they had a lot of good times, but she was also a strange sort of character. She told me her previous husband had had her put in a mental institution. He used to say, "Momma, be good to her, she's had a bad time of it, she's had it rough."

When Bunni moved in with Stacy, he began working up his songs "End of the Road" and "Nobody to Love," dueting with Bunni on Townes Van Zandt's "Close Your Eyes" and Porter Wagoner's "Satisfied Mind." Sometime in 1976 they ran into Dillard and Ginther who announced, "We thought you were dead, Stacy." Dillard was working with Porter Wagoner at his studio in Nashville and offered to record Stacy if he got another band together. Ginther was also keen to get Stacy to ask John Ike to call off the lawsuit because he was running for mayor of Houston in 1977. Stacy asked for a job and figured the least they could do was afford him an amp. Ginther offered him a job on an oil rig to which Stacy replied they wanted him dead.

In June 1976, Sibyl couldn't help coming to the rescue and funded equipment for a band. Stacy was so paranoid about it being ripped off that he got their lodger to acquire a .22 rifle for protection.

> **Sibyl:** He said, "I've never had the musical equipment I wanted," and I went to the bank and borrowed $10,000. He didn't live in a great big house, and it was a bad part of Houston. They were so afraid they were going to lose their musical equipment that they had a canoe strung up in the ceiling of their living room, and the musical equipment was in it.

In 1976, the year before punk went public and ten years after the Elevators' heyday, the musical reputations of many of the major bands of the 1960s lay in tatters, dismissed by the new wave of the music press. Despite a new generation of punks discovering the Elevators' records, Stacy didn't feel like a pioneer. He was simply a bored, poor, overweight ex-con, with thirty-six drug-related arrests against him, struggling to find

work at an all-time low. Divorced from his hill country hometown, he existed in a low-rent Houston bungalow. Bunni returned to school to train as a court transcriber and in Christmas 1976 they got engaged.

> **Beau:** I wasn't that close to Stacy until the middle 1970s, when I started going to see him quite often. He had an old wooden frame house. It was rather unique because it was a big old frame house, in the hippie section of the Montrose area of Houston. We'd be sitting out on the front porch there talking and there would actually be kids coming up asking for his autograph. Through it all, when Stacy had fought these tremendous battles with alcohol and heroin and everything else, he still believed that he was going to make it back to the top. He still had all the equipment, the guitar and everything that Mother had helped him buy. They didn't have much furniture. They slept on mattresses on the floor. He had the living room set as a sort of a stage and I think he was teaching Bunni to fiddle around a bit with his guitar.

Cecil Morris had moved to Old Ingram outside Kerrville and figured an Elevators reunion would be a suitable draw for the opening of his new bar, the Ol' Dog Saloon. He called up the various band members and Stacy agreed to participate.

The reunion was never meant to be a real attempt at relaunching the band or making money. Having contacted everyone, Stacy and Bunni decided to make it a triple-special occasion: May 28, 1977 was Stacy's thirty-first birthday and their wedding day, all celebrated at Cecil's club opening. Bunni designed the flyer, which advertised the appearance of all the Elevators (with the exception of Danny Galindo and Duke Davis); but only Stacy, Ronnie and John Ike performed.

The wedding ceremony took place at the Sutherlands' ranch in Kerrville, where the Elevators had hidden out during the summer of '67 before a half-hearted Elevators reunion took place that evening.

Stacy and the old rhythm section blasted through "You're Gonna Miss Me," "Baby Blue" and "She Lives" with Cecil on vocals; when Obie subsequently joined them it became a Raincrow set: "All Along the Watchtower," "Slippin' and Slidin'," "Sea Cruise" and "Stagger Lee." After the set, everyone headed to the banks of the Guadalupe and the band never came back for the second set.

> **John Ike:** Cecil went ahead and told everybody that Roky was coming, and he wasn't coming, and I told him to call it off. But Cecil gets up there and tries to take Roky's place in the Elevators. Cecil tried to sing "She Lives" and didn't know the words. [Laughs.] Played his harmonica real stupidly. He was drunk. Stacy was stoned. It fell flat on its face and I got down [laughs] before the beer bottles started comin' toward the stage. It was a good, friendly gig. See, it was a Kerrville festival, really; all the people that showed up were friends of the Elevators. And they didn't really care if Roky showed. And they wanted to go sit down by the river smokin' joints and drinkin' beer... having a good time.

TOP: (1977) STACY & BUNNI, COURTESY SUTHERLAND FAMILY COLLECTION; BOTTOM LEFT: HOUSE WHERE
STACY DIED ON AUGUST 24, 1978, 516 PACIFIC, MONTROSE, HOUSTON, PHOTO BY PAUL DRUMMOND;
BOTTOM RIGHT: STACY'S GRAVE, CENTERPOINT CEMETERY, TEXAS, PHOTO BY PAUL DRUMMOND

Stacy and Bunni moved back to the house in Montrose and were happily married for over a year. They wanted to get out of Houston and move to the Sutherland family ranch in Centerpoint in the hill country. Unfortunately both of them wrestled inner demons with alcohol. After one of their big rows, Stacy would take off for a few days to his parents' in Kerrville and Bunni would arrive to collect him. Sibyl advised them to separate if they weren't getting along, but Stacy was determined not to let the marriage fail.

> **Sibyl:** I had told him, if you don't get along, and you don't have children, then quit. I told him she'd called me twice and told me she was going to kill him. And so I said, "What's the matter, what do you want to kill him for?" And she said, "He scratched my face up." Well, my other son was living in Houston, too, and I said, go over there quick and find out what's happening. And he said, not a mark on her, she's playing piano and he's playing guitar and they're happy. Next time she said he'd broken her fingers, and I sent him over there again and he said they're nimbly playing the piano.

Stacy was no angel, and when he was in one of his bad moods, Bunni would either sleep under the house or in the attic when she couldn't escape in the car. Knowing his maternal grandfather had been a functioning alcoholic who continued to work beyond his eightieth birthday, Stacy decided to confront his demons and get medical help.

> **Sibyl:** So he went up there [the clinic], and they said that while he had tried practically every drug, he was not addicted to any of them, but that he did have an alcoholic personality and that was probably the way he'd go, and it was. Frankly, I liked him better when he was on drugs.

During the summer of 1978 Stacy and Bunni were broke, living on spoiled vegetables their roommate Tony brought home from the store he worked in. There was no money coming in apart from Bunni's typing work, which she conducted at home. The constant tap, tap, tap of the typewriter drove Stacy mad, so he'd go out and drink during the day. In July, Sibyl had bailed out Stacy to the tune of $900 against Bunni's wishes, knowing he'd put the money to bad use. Stacy put a band together with Greg Forest in Austin.

> **Greg Forest:** I'd seen them a couple of times before, they'd get into this... dare, dare you kind of shit. Like "I wish you were dead," "Well, if you wish I was dead, here's my fucking gun, just fucking shoot me." That's the kind of abuse they'd heap on each other. Stacy was playing with David Summers, Rock Savage and me; he's a really good drummer. That was "Sutherland, Forest and Friends." We did a couple of gigs in Austin, and Stacy was having a lot of trouble with Bunni. And that's why he moved in with me, in Austin for a couple of weeks, shot a load of methamphetamines and got drunk a lot together. And just one day he said, "I'm going to patch

it up with Bunni and make things right, I'll get back to you in a few weeks."

Stacy played his last gig with the band on Sunday, July 15 at the "Hill Country Rites of Summer" festival at Bull Creek in Austin. He was eighth on the bill.

According to Bunni, when Stacy got back to Houston he spent the next few weeks sitting on the couch moaning about his troubles, only getting up to purchase liquor. He reviewed the notes he made about his time with the Elevators with the view of writing a memoir, which he jokingly referred to as "Elevators: Up and Down." They argued about Stacy's frustration with Houston and how they should move to the Ranch in Centerpoint. Bunni broached divorce in a bid to provoke him in to action, but he was suffering from terrible nightmares, which continued to haunt him during the day. However, one Sunday morning Bunni went out and returned with the Sunday papers, pecan rolls, hot chocolate and an album Stacy wanted—Gerry Rafferty's *City to City,* featuring the track "Baker Street," a song about a man who wants to own a house in a certain neighborhood but realizes he's a drunk and will never achieve his dream. Stacy woke with a smile.

On the morning of August 24, 1978 Stacy and Bunni were arguing again. Her fifteen-year-old son Ralph had antagonized Stacy over the divorce threat and the possibility of him having to move out. Tony Bevan the lodger got up and suggested he and Stacy go out for breakfast, which led to several beers. Stacy was distraught by the reality of his failed marriage and they talked about moving out together, as Tony couldn't tolerate Bunni's hysterics much longer. They were joined by Mike Knust (ex-Fever Tree) and they continued drinking throughout the day while Stacy, passively drunk, wallowed in self-pity. When they left the last bar Stacy went into a rage, complaining that the barman hadn't been putting any liquor in his drinks and when they returned to the house they found Bunni in an awful mood. Mike left them to it and Stacy and Bunni began yelling. Tony, knowing that Stacy was directing his anger at Ralph, went to his room. Ralph said he'd fight Stacy, but Tony got him to agree not to interfere. Tony headed for his room, but saw Bunni sitting at the picnic bench in the kitchen brandishing a 12" knife. He started talking to her, but Stacy burst in yelling, "What are you talking to my wife for?" Tony sheepishly said goodnight, went to his room and put on his headphones, safe in the knowledge that the next morning Stacy would be "terribly apologetic" for being so inebriated.

Bunni would normally have left at this point but, worried that Stacy would direct his rage at Ralph, she fetched the rifle and sat guarding his bedroom door with it on her lap. According to Bunni, she was trying in "dramatic fashion" to ward Stacy off and make him go to bed, but she plugged the trigger as a reflex action when he charged her.

Bunni (letter September 21, 1978): The only comfort I have is that Stacy made the decision himself. He put that gun in my hand, showed me rather badly how to use it. I emptied the clip and thought

I was going to bluff him, but he rushed me and I panicked and pulled the trigger, not realizing there was a bullet still in the chamber. I warned him not to keep coming; he paused a minute, then rushed at me... I didn't aim, had the gun resting in my lap.

Upon hearing the shot, Ralph ran from his room, took the gun from his mother's hands, rang an ambulance and then summoned Tony, who entered to find Stacy lying on the kitchen floor. Stacy showed him the tiny wound in his solar plexus and tried to raise himself up on one arm to embrace Bunni, who was hysterical by his side. Stacy fell back, eyes glazed, but remained conscious for approximately twenty minutes. The ambulance arrived, led by a cop. They complained about his size and weight (225 lbs.) and asked Tony to help them move him onto a stretcher and wheel him to the ambulance. Stacy had died on the kitchen floor. Bunni, Ralph and Tony were ordered to the sofa. There was an issue over whether Ralph had in fact fired the gun because his prints were also found on it, but only Bunni's fingerprint was on the trigger. She was held in jail for thirty hours before being released without charge. She refused to believe that Stacy was dead, because he had informed her that if she needed to use the gun on an intruder she would need to fire several times, as the .22 hollow-tip bullets were not enough to actually seriously hurt somebody. Unfortunately, the bullet had severed a major artery causing massive internal hemorrhaging. It was only when she visited the morgue she realized the terrible truth. She signed the release for the body to return to Kerrville for burial.

Gregg Turner: The truly ghoulish moment when Stacy's wife phoned to tell Lelan she'd shot Stacy—he'd put her on the speakerphone to "impress me," believing this was just gonna be a social call—was just unreal. She was shrieking, and he was doin' everything he could not to puke his guts out; he finally raced outta the office to the toilet, and I just sat there as she kept hollerin.'

Bunni remained alienated from most of Stacy's friends and family. As Jerry Lightfoot remarked, "It's like trying to say something good about that guy that shot John Lennon." She was later admitted to a psychiatric ward for suicide watch after trying to slash her wrists. She considered taking a massive heroin overdose by one of Stacy's favorite streams on the Guadalupe River, but had promised Stacy she wouldn't kill herself. Three years later the Harris County DA tried to bring her to trial claiming that she was a fleeing felon, but she produced bank records to prove she still lived in the same house Stacy had died at on 516 Pacific Street. She later remarried and died of cancer in 1987.

Ellis Stewart (Bunni's second husband): When I met Bunni, she said, "You know, I come with a ghost." I'll tell you this, this house on Pacific Street, his ghost, I'm not trying to sound kind of crazy, but his ghost still lives in the house. I took Bunni's daughter to the house so she could see the house where she lived, and the woman who lived there said, there's a ghost here and I can't get him out of the kitchen.

The house, riddled with termites, was due for demolition in 2000. Although everything had been stripped from the inside, strangely only the kitchen from the 1970s remained intact. Upon rereading the harrowing first-hand accounts of his death, his mother and sister Heather concluded that there was an element of suicide in Stacy's actions. He'd simply had enough. It's almost certain that his untimely death was the third of the prophetic visions experienced at the Houston Music Hall back in 1967. Stacy, "the quiet one," had proved an immense influence on many of his generation in Texas. Stacy's popularity was shown by the immense turnout at his funeral in the small hill country town, estimated at over a thousand people from all over the country.

Sibyl Sutherland: [The undertakers wanted] to know how to dress him and I said he never liked a suit, I don't think he ever had one on. What was funny was he had found an old denim coat somewhere in a second-hand store that was kinda wine-colored, and so he bought it for $5 and I went to town and found some wine-colored jeans, and we got a pink shirt and left it open at the collar. I said he hated neckties, wouldn't wear one for anything in the world, so don't put one on. And they wanted to know if I wanted his hair cut and him shaved, and I said no, this is the way he chose to look. So leave him like he is. I clipped a little piece of hair to keep, and kids started putting things into his pockets like red bird feathers, seashells, a peacock feather, and my son was horrified. He said, "Mother, you know they're putting stuff in his pockets," and I said "I don't care, they were friends." I put something in there too, a baby locket and class ring in his pocket, and his girlfriend Laurie's picture was over his heart. And they said, "Well, what about his pallbearers, how do you want them to dress?" and I said, "Well, dress the way you think he would want you to dress," and they showed up in T-shirts and jeans. Obie sang at his funeral, "Just a Closer Walk With Thee." I'm sure people were criticizing far and wide, what a strange funeral it was. [Laughs.]

The pallbearers included Ronnie, Bobby Rector, Paul Tennison, Cecil Morris and Johnny Gathings. The honorary pallbearers were John Ike, Robert Eggar, Wayne Walker and Max Range. The turnout was estimated at around a thousand people. None of the pallbearers had the forethought to roll a joint to smoke in Stacy's honor after the ceremony but mysteriously when they got back to the car there were three ready-rolled joints in the ashtray. The cop who led the ceremony through town was Stacy's archenemy Tommy McDaniels.

Stacy's friends raised money for a monument to be placed in the cemetery in Centerpoint. One of the inscriptions reads: *My heart is a melody, beating a tempo yet unbroken, and my mind is a wing, a seraph with a golden note, thought but still unspoken. By Stacy.*

Stacy: There reached a point where we HAD to suffer. I would guess it was a form of religious madness. I know I suffered. I took acid and blew my brains out for other people because I thought we had to

do that. We had unleashed some incredible energy, and I thought I was going straight to hell. Maybe so many years of rock just does that to any given human being. Really I have a completely mixed viewpoint on the whole Elevators thing. Mostly I look back on it as expansion. I can't say that it wasn't good because the experiences I had during it were definitely some of the greatest I've had in my life. How can I say something was "bad" when it helped me in ways I've never been helped before or since? You can straighten your life out with drugs. They can put you in a better place. But, if you abuse them later on they can wipe you right out. I know that too well. As far as psychedelics and weed go, I don't regret using them at all and never will. I certainly don't recommend acid for everybody; I wouldn't try to get anybody to take it now. Because when somebody turns on, they're on the road, and when you look back at your own life and see all the things that drugs have put you through, you wonder if you want to put somebody else on the same road. It's a gigantic responsibility. The best I can say is that everybody's experiences are different. There was definitely a mystical element of some sort, I will say that. They believed in God the source, I believe in God the being. But I studied these messages to get myself higher. I studied to get myself higher to the light.

Tommy Hall had his own share of difficulties after the Elevators, psychic and economic. The American music market was the worst minefield to negotiate and most of the biggest bands of the 1960s fell prey to unscrupulous managers and record companies. Many large chart acts, such as the Animals, hardly saw a penny of their income despite regularly charting and even the mighty Beatles never saw millions due to them because of the free-for-all in a newly evolving market. Many counterculture musicians had sold their music to the record companies and had nothing else to give and in an era that was effectively about to commit suicide, there were few choices left, so for many it meant dealing drugs.

Stacy: All I ever heard about Tommy were rumors. Once I heard he'd sunk into dope and gotten ten years for armed robbery. Then I heard he was living in a cave, designing a car that ran on static electricity. But he'd have to be the one to explain himself. The rest of us were more or less apprentices of his ideas. He had beautiful ideas. There just came a point where he couldn't live them very well.

By his own estimation Tommy had taken LSD 317 times from 1966 to early 1970—this was pharmaceutical LSD, not street acid—an average of six times a month. While Tommy had been hip to the politics of ecstasy, he'd now fallen victim to the ever-changing drug scene. The path to enlightenment had become a self-deluding objective and he was now forced to deal drugs through personal necessity. After his disappearance to jail in the early 1970s, he'd become one of the army of hippie refugees drifting around California; as he commented, "I came up here [San Francisco] and for about a month I lived in a sleeping bag." Luckily, in the fall of 1972 he ran into an old friend, Jack Scarborough, who moved into an apartment

with him. Tommy took a job as a janitor at a kindergarten in Oakland and although, according to Jack, he'd get a kick out of working with the kids, letting them ride on the sweeper, he'd get really depressed when nothing was happening in underground culture—until punk.

Tommy: I liked the punks, I backed them, it was cool, but kinda nuts. I guess what I did in the 1970s... maybe I wandered away... and I was coming up with dumb ideas because of where I was at the time. [Laughs.] One of the ideas I had, and this is really stupid, was that reality would all compress, and it was all taking place in a thin film and that once we would realize this, we would all lift out of this thin film, see...

Chet Helms: I have no idea [what Tommy was doing] other than a lot of psychedelics, and I think he sold small amounts of drugs. He was someone that quite frankly I tended to avoid, because he tended to ramble and was really out there. He's fairly pugnacious and insistent about his opinions. I'm not sure when he and Clementine separated, but she used to live upstairs above my brother. I kind of maintained a relationship with her.

Q: When did you really cease to have contact with Tommy Hall?

Clementine: I was staying with a group of Scientologists who rented a really beautiful house in the Haight-Ashbury. Tommy's the one who turned me on to Scientology. My life was wonderful; Tommy came to see me, and I wanted to have a two-way communication with him and couldn't. He had no time to hear anything, and wanted to save me before it was too late, before I went straight to hell.

Gay Jones: Someone told me he was working for the city, sweeping the streets. I moved back out to San Francisco and married and I hadn't seen or heard of him, and after about a couple of years of being there, a girlfriend went down to the laundromat, this was four blocks, and came rushing back and said, you're not going to believe this, there's a sign saying that if anyone sees Gay Jones, to call Tommy Hall. It scared me to death, and then I thought I saw him down in Union Square, because I was working down there, and I thought I was losing my mind. I'm sure it was, he looked like a madman, with the hair and the beard and all that.

By the mid-decade Tommy was reviewing and re-evaluating the position of his work.

Tommy: You have to reach this place where all you want to do is contact the other people who are in on the information. There's a chance there's no such thing as reincarnation, as much as I hate to say it. [My songs] were done with a certain thing in mind, like this should sink in. You would use these recordings as a booster; you'd be reminded of all these things... [The band] was really a device for our own education. Basically we were just saying to everybody,

look, review this information and we'll meet you back at the pass at daybreak.

If he was now dubious over the central theme of immortality, Tommy was clear about LSD and being "twice born"—to die on acid and be reborn.

> **Tommy:** All we want to do is get high... and start evolving. But you have to understand it and understand how to express it. American scientists are not looking at the thing coming from their minds, and most of the philosophers are. It's just a stonewall, a typical East-West head-butting. Acid is a snap [into] above what everyone thinks is reality. It's a teaching machine. It's all for you. When you have a thought, it generates this warmth and understanding, that you have more energy and that energy is distributed to the body. The atoms in your body all have a structure, so that when you eat you take in that energy and that when you have a thought you distribute that energy.

For many years now Tommy has lived down the street from the old Avalon Ballroom in the Tenderloin district of San Francisco, which as any tourist guide will tell you, is regarded as the worst neighborhood in the city, full of drug dealers, prostitutes and mentally unstable street people. He lives in a one-room apartment in a $7-a-night "flop house" hotel. No visitors are allowed after five p.m., and many of his fellow inhabitants are refugees of the 1960s and Vietnam. However, none of this is important to Tommy. He still holds solid to his belief that "you endanger yourself by making money off your information." His room is crammed to the ceiling with books and classical music tapes; he's still passionate and knowledge-able about modern classical composers. There are two main posters on his wall: a vintage Mickey Mouse poster with a swirl of images depicting him through the decades, and a Chinese Buddhist poster depicting the levels of enlightenment, which Tommy explains with a dry, ironic smile...

> **Tommy:** There's something else I wanted to explain. It's the Mickey Mouse... that's what I look at when on acid; actually, it's like a galaxy, the figures are in your subconscious, and you go to the background, the yellow swirl, so it makes it really psychedelic, and I don't know why that would be better than [the poster] on the left, which is an ancient Eastern image...

Even to this day, entering into conversation with Tommy is an over-whelming experience. First, he prefers not to talk about himself and has to be convinced to proceed further than "cool conversation," but still enjoys a platform to express his ideas while sipping Bigelow's "Constant Com-ment" tea. Soon the surroundings begin dissolving and the cockroach on the back of your neck ceases to be an issue.

Although he lost contact with Clementine throughout the 1970s and '80s, for the last ten years they've regularly met up to visit museums and go out to dinner. Through the research for this book, Tommy and Gay have

spoken for the first time since the 1960s. Although Tommy is dismissive of the Elevators as his immature work and has declined to be filmed or interviewed for documentaries, it's because he's incredibly paranoid about being misrepresented. He briefly entertained writing something for this book, but when he realized the magnitude of making a profound statement after such a long silence, he declined. However, he's slowly warming to his cult status. As he says, he'd hate to be remembered as just some hippie!

Q: If there's one statement you could make about the Elevators as a band, what would it be?

Tommy Hall: Genetics and information with mind-altering or consciousness-expanding drugs. We were able to objectively and scientifically approach acid, where other groups couldn't do that.

Indeed, Tommy remains an enigma. Maybe the Elevators had transcended to a new reality. Or maybe, as Tommy started to demystify mysticism, he ended up concocting an entirely personal vision that alienated him from conventional society. Within the genre of psychedelic music Tommy's lyrics exposed the lack of content in all of his contemporaries' offerings. The band's influence and the continued worldwide interest in them has far outweighed that of many of the era's other bands.

Whether we will ever see another word in print from Tommy is doubtful. There are plenty of notes that litter his apartment, but he dismisses them, indicating that the real work lies locked in the vast organic computer of his brain. Maybe one day he'll solve the riddle of existence and be able to wrestle it back from the "other side" to reveal it.

By the mid-1970s, the musical temperament had changed again. Music journalists had banished glam rock back to the dressing room, rejected kitsch as unnecessary fluff and started looking for something more genuine. By 1976 a wave of pre-punk groups were gaining collective recognition, including the Modern Lovers, Suicide, Patti Smith Group, Television, Talking Heads and the Cramps. While punk determined to kill all hippies, the Elevators survived the cull and many of the innovators of punk were covering their music and citing them as an important influence.

Stephanie Chernikowski, who had helped kick off the underground music scene in Austin back in the early 1960s, was now living and working as a photographer in New York and was delighted to witness Television regularly performing a cover of "Fire Engine" at the infamous CBGB club in the Bowery. Tommy's intention of each side of *Easter Everywhere* to be played as endless loops worked for Patti Smith, as she later acknowledged in 2006, in the documentary "You're Gonna Miss Me," "I didn't have the simple poetic skills of, say, Smokey Robinson. I sought to work more in the 13th Floor Elevators style of writing. And the thing I like most about them was, they inspired me to work. I would put on *Easter Everywhere*, I would just listen to it over and over and fall asleep, and the next morning it was still playing. And every now and then you can catch a 13th Floor Elevators reference in some of my cerebral spewings. There was intel-

ligence, an obvious intelligence and humor." While a new generation on the East Coast was getting hip to the Elevators, Roky was starting his solo career in San Francisco, where arrogant punks were busy chastising the old hippies for still existing.

Roky was reunited briefly with Tommy in 1975 and put together a new band called the Aliens, with Billy Miller on autoharp, Duane Aslaksen on guitar, Morgan Burgess on bass and Jeffrey Sutton on drums. They began making regular performances in Berkeley in 1975 and started demoing new material. Roky and Dana returned to Austin for the birth of their son on December 6, 1976, who Roky declared should be called Alien when he found out Dana was pregnant, but settled on naming Roky-Jegar (Biblical: "Witness of Our Love"), although Roky called him R2-D2 for a over a year.

Back in California in June '77, Roky obsessed in nearly all of his interviews about touring the States and Europe, which amounted to a handful of Californian gigs. Four demo tracks were released in France as the "Sponge" EP, supposedly without Roky's knowledge. Despite Roky's indignation, the record was heavily imported to the United States, where it found a new audience and helped confirm Roky as one of the many godfathers of punk. This was closely followed by the single "Bermuda"/"The Interpreter," released during 1977's summer of punk in both Britain and America.

Peter Buck (of R.E.M.): When punk came in, Roky started putting out singles, which I got at the time—the EP and "Two-Headed Dog"—and that stuff was just purely fascinating. I loved the songs, I mean they kind of sounded like Buddy Holly on acid, which, essentially, Roky was. And the Elevators, you know they were kind of influential on the whole Fleshtones, DMZ and Lyres [scene], about 1976 to the mid-1980s. It just seemed that every other week someone was doing a cover of "You're Gonna Miss Me" on one record or other.

While punk had reactivated interest in Roky, 1978 spawned an onslaught of less abrasive New Wave/post-punk bands that embraced the experimentation of the 1960s. British bands including the Stranglers, Joy Division, the Teardrop Explodes, Echo and the Bunnymen, Psychedelic Furs, and American bands Pere Ubu and the Cramps displayed an obvious link with the harder, garage edge of the 1960s. With the re-release of the Elevators' records and Roky's new output, he had made an almost unique achievement in resurrecting a career without apologetic commercial compromise.

Will Sergeant of the Bunnymen recalls that "the name *Psychedelic Sounds of the 13th Floor Elevators* always sounded like an interesting place. It did sound raw and it was garagey—it went alongside punk really well. I suppose a combination of being compared to them and the fact that Television did "Fire Engine," who were a massive influence on me, and realizing "Fire Engine" was a 13th Floor Elevators song—it all sort of tied in nicely."

In July 1978, Roky was scheduled to play his first "proper" L.A. show at the famous Whisky-A-Go-Go in L.A. which nearly had to be cancelled

after he'd seen the killer-bee movie *The Swarm* and declared he couldn't sing anymore, because the bees had come through the vent in his bathroom that night and when he escaped his brain fell out and had to be sewn back in by a passing surgeon. Luckily, the show was a huge success.

Gregg Turner: When Roky played the Whisky-A-Go-Go there was a scheduled press party at the *Crawdaddy* magazine offices. Lelan was so excited and psyched about being reunited with Roky; he had to change his undershirt three times before going down to the Sunset Strip. I'll never forget when I pulled Roky over and led him to Lelan. Roky burst out: "Oh mah gawd, Lelan is that you? How come you're not DEAD YET?" Lelan almost fell to his knees laughing so hard. When Lelan heard "I Walked With a Zombie" for the first time, he looked like he was gonna start crying. And there was no mistaking the paternal sense of incredulity and pride at Roky's comeback that I think Lelan felt.

Roky was seemingly in good hands, largely off drugs (except speed), off medication and mostly retaining his focus by amusing all those around him with babbling stream-of-consciousness stories of bloody hammers, meat hooks and bouncing heads (as in one radio interview on April Fool's Day 1978, when he stated "I think two heads should roll down a staircase at the same time, I think if you can get lots of heads bouncing down the stairs real, real fast, people like that a lot... I guess if you have a party, axes should swing all the time," before jovially suggesting that a posse should be assembled to beat up Lou Reed, who fortunately had just left town).

By 1978, though, Dana couldn't take the pressure anymore and returned to Texas with Jegar.

Dana: I'd had an emotional breakdown... I had a doctor's appointment at a psychiatrist's because I was having counseling for living with a person with schizophrenia. I remember I'd left Roky with the kids. Roky was fine, the kids were fine and I was driving down the street in Marin County and I was feeling great. I was only going to be gone a couple of hours. It was a beautiful day and the sky started turning black, and I thought it was a weather condition coming in and so I put my signal on to exit the highway and I wondered why none of the other cars were pulling over, and all of a sudden I realized it was only happening to me. The psychiatrist told me that if I didn't get out from under the pressure it would happen again.

Dana informed Roky she had to leave him for her and Jegar's sake and that there were plenty of people around to support him. Instead Roky went back to live with Evelyn in Texas. Roky was directionless, bumming around Lake Austin with the homeless people, and returned to the Austin State Hospital after another bout of illness. Roky's manager Craig Luckin didn't give up, and put a tie around the neck of Stu Cook (Creedence Clearwater Revival's bassist) and took him to met Roky in the state hospital. Cook agreed to produce Roky's first proper solo album and sessions commenced between Texas and California.

Cook recalls that as soon as Roky was out of hospital he stopped taking his medication: "He doesn't like taking the medication, because it gives him the shakes, he wobbles when he walks. Roky would often say that he'd rather be nuts, he'd rather have the out-of-control problems than the way he felt taking the medication. But he just really didn't have a choice, 'cause if he doesn't take it, he ends up back on the inside again." Cook was renamed "Buzzy" and set about the ominous task of trying to achieve what Roky was trying to express in each song. It was the same task Syd Barrett presented his producers a decade earlier. Barrett would perform a handful of completely different takes of a song and then, without any further input, the producer had to embellish the song with a band arrangement without detracting from the original essence of his performance. While Syd's producers succeeded in capturing a most sublime portrayal of the fractured human condition, Roky's material was slightly marred by late-Seventies production values and synth sounds. Despite Cook's excellent work, what Roky really needed was to be transported back in time to the early Sixties to work with Joe Meek, who could conjure ethereal soundscapes with nothing more than a shoebox.

In Texas during 1979, Roky became an honorary member of the Bizarros, an outfit put together by Speedy Sparks that featured ex-Velvet Underground guitarist Sterling Morrison (then teaching Medieval Studies at the University of Texas). Roky dispensed with the burden of rehearsing a regular band, instead luxuriating in the informality of using pickup bands (including the Reversible Cords and the Nervebreakers) for one-off shows at punk venues. The problem with Roky's solo career was that he never maintained a constant set of musicians beyond his association with Billy Miller. He never allowed his sound to develop with one band and it seemed like he gave up on performing for an audience and instead continued for his own benefit. His lack of concern over his backing band echoed his attitude to the Spades and later incarnations of the Elevators when he simply blasted his own way through the set without any concern for his band's ability to keep up with him. Possibly he was using his role as a performer to screen his mental symptoms. Luckily, he discovered the Explosives, who stuck with him despite not being used for recordings.

While playing in Austin at the Continental Club Roky met the second Mrs. Erickson-to-be, Holly Patton, a University of Texas student. Although his manager was in negotiation with Warner Brothers in the States, only CBS Records in Britain and Holland released the eventual album in 1980. In August Roky and Holly headed to London for what turned out to be a disastrous promotional trip. Floods of excited music journalists were dispatched to the Portobello Hotel to meet him, only to find an uncommunicative Mr. Erickson. Articles duly appeared with titles such as "The Creature With the Atomized Brain." Gone was any hope of a European tour for the album as the Aliens no longer existed and Roky returned to California to play live with the Explosives instead. While the CBS album didn't appear to have a title, just some ancient runic script, the lyric sheet bore the title "TEO," which stood for *The Evil One*. Eventually most of the material was released in the States on the tiny San Francisco label 415 Records in 1981 under that title. The songs about vampires, zombies,

demons and Lucifer started the cult of Roky Erickson—not the Elevators—and a new legion of fans, including Goths. In Scandinavia, home of the black metal scene, he is virtually a household name—his music has been licensed for national television advertisements and there is even a Roky Erickson cover band, "The Rokys," in Gothenburg, Sweden.

Throughout 1981, Roky continued to use the Explosives as his backing band while touring the West Coast in the fall. Back in Austin he played what appears to be his final gig with them at Club Foot before debuting his new backing band, the Resurrectionists, at the same club. Roky left the band in Texas and returned to California to record his follow-up album with two of the old Aliens, Miller, Aslaksen and some session musicians. The result, *Burn the Flames*, suffered from clipped 1980s production instead of opting for a more earthy rawness, despite containing strong material. CBS passed on the material, which remained in the can until it was retitled and released as *Don't Slander Me* in 1986. Back in Austin Roky formed yet another band, Evil Hook Wildlife, which marked a career low point despite their sound fitting the thrash-punk sound of the day.

Since meeting Holly, Roky had been taking Prolixin, an anti-psychotic drug that appeared to have stabilized his condition; much to her horror, she soon realized that he'd stopped taking his medication and started using speed and heroin again. As usual, sad lowlifes were supplying Roky with hard drugs and, as usual, Roky lacked the willpower to say no.

June 16, 1984 saw the return of the "13th Floor Elevators" at Liberty Lunch in Austin, Texas. This time the band consisted of Roky, John Ike, Ronnie, Stacy's pal Greg Forest on lead guitar (who had a pair of sunglasses especially made with a third eye). The band struck up with "Before You Accuse Me," and Roky screamed, "If I could live my life all over again, I'd do the very same things, the very same things I did…" After forty minutes and no Elevators songs having been played, Roky decided to end the first set. The band returned with "Splash One" and, apart from two renditions of "You're Gonna Miss Me," Roky remained true to his policy of not performing Elevators songs without Tommy.

The much-hyped psychedelic revival of 1981 spawned a collection of new bands collectively dubbed the "Paisley Underground," and one of these, the Dream Syndicate, supported the Elevators at their second reunion gig at the Consolidated Arts Warehouse on August 11. The band certainly wasn't the 13th Floor Elevators as advertised. Ronnie opted out and the band consisted of Roky, John Ike, Brian Beach (bass) and an old friend who ran the music shop in Kerrville, Stan Morris (guitar). The set opened with the longwinded "Before You Accuse Me," followed by several Roky songs, and "You're Gonna Miss Me" and "Splash One," both performed twice. After the show, John Ike entered the dressing room to find Roky passed out on the floor. After he resuscitated him with his cowboy boot, he walked out in disgust. The Elevators show in Houston proved enough for everyone, and no one got paid when the door returns were scammed by the security.

George Banks: I went to see them when the band tried to get together one last time, and it was pretty bad.

Speedy Sparks noticed that Roky was becoming increasingly dis-heveled, and "started growing his hair out and a drifting, kind of a home-less person." Speedy wasn't a fan of Roky's California work and in September invited him into the studio, thinking a more honest, rockabilly sound would suit him better. The result, "Don't Slander Me"/"Starry Eyes," released on Dynamic Records, was a refreshing return to form and something to be celebrated—a new release by Roky Erickson. Although the record was well-received and was even reviewed by Elvis Costello, it was nothing more than a postcard from the edge. Roky attempted to exorcise his demons, picking up projects he'd started writing in Rusk, such as *Love Paintings, A Positivity Mirror Non-Commercially Speaking*, and revisited songs he'd written during that period for a radio broadcast in April and June 1985 for Austin's Cable Vision channel, broadcast in November. Again the Elevators' last reunion had come too early, and in reality Roky had retired from the music industry. It was as if he'd chosen seclusion. Having fulfilled the romantic notion that genius equals mad-ness, he'd paid the Promethean price for his gift of creation. Music had sustained him but was also the demon that had burnt him out.

By the middle of the '80s, interest in psychedelia hadn't ceased. There were a slew of bootlegs and new releases of old Elevators material all over the world. But since Roky had effectively stopped issuing new records, his stock of live and unreleased recordings provided an almost limitless source of material to be plundered for retrospective compila-tion packages, some of which were equally abusive to his reputation and his loyal fans.

However, covert references to the 13th Floor Elevators had become synonymous with KNOWING. In the 1985 film *Desperately Seeking Susan*, Madonna answers the door in a hotel room—it's room thirteen on the thirteenth floor. She packs up her things and marches to the elevator. The back of her leather jacket is an embroidered with a huge pyramid and eye, and she calls "*Hold the elevator!*" The myth of Roky and the Eleva-tors had taken a strong hold in Europe where yet another wave of bands began incorporating references to them, one example being Glasgow's Primal Scream. Frontman Bobby Gillespie explains:

> I first heard of the 13th Floor Elevators through reading interviews with the Cramps, Echo and the Bunnymen and the Teardrop Ex-plodes. As fans of these bands, me and my friends went out and found *Psychedelic Sounds of...* and it totally blew our minds, from the cover art to the wild desert freak-out weirdo R & B music. *Psych-edelic Sounds* was the godhead, psychedelic-iconic trip album for us all. Some of us started a club called "Splash One," after the song. It was supposed to be a clarion call to all the other "heads" existing in isolation. As this was 1984, there was nothing going on in youth culture except Frankie Goes to Hollywood or the Goth scene. You can talk about "underground music," but these guys were so fucking mysterious, we never even knew what they looked like until we came across a copy of *Easter Everywhere*, still leaving no clues apart from Tommy Hall's index finger raised to his lips as if to say "shhhhh, let's keep this a secret." There is a truly ecstatic, religious feeling to "Slip

Inside This House" and, indeed, the whole of *Easter Everywhere* that is too hard for me to express in words. Nearly a quarter of a century later, the 13th Floor Elevators are still a mystery to me.

Primal Scream successfully mutated "Slip Inside This House" into a dance anthem for their 1991 breakthrough album *Screamadelica*, which even ended up being used on Cindy Crawford's workout video.

Also in Britain, Spacemen 3 spearheaded a new wave of bands that deconstructed psychedelia to a drone, working on the philosophy "three chords good, two chords better, one chord best." The Elevators' sound was central to their philosophy, their logo and posters referencing their pyramid and eye imagery. Their first releases contained covers of "Roller Coaster," clocking in at over eighteen minutes, which took the song to new limits. The band's co-leader Jason Pierce continued the chemically enhanced experiment in music into his next project Spiritualized, and commented, "The Elevators took me to 'DMT' places I never could have gone with drugs alone."

Peter Buck, guitarist with R.E.M., has remained a committed fan, and joked on occasion that an alternative acronym for their mysterious name could be "Roky Erickson's Music."

While there was strong rumor in Britain in 1987 that Roky was booked to play his first European shows, by the mid-1980s he only made one-off appearances around Austin at special events, including a Spencer Perskin appreciation gig, when he shared the bill with Townes Van Zandt. Roky developed a trembling and shaking condition, and with a wobble in his walk came off his medication completely. In early 1986 Holly left him, taking their daughter Cynde with her.

Daniel Johnston: When I saw Roky at the Austin Music Awards it was so unbelievable, I couldn't believe it, he was just rocking "Don't Shake Me Lucifer," you know, and everybody was screaming, and he said "I've been drinking some blood!" You know, this is cool!

Speedy Sparks: His illness started to punctuate and after '85 he went downhill. In 1986 I let him stay six months, he was all right, he stayed in his room, but I was worried. In the 1970s he was sociable, tried to be funny in his strange way, but by this time he'd withdrawn and now he wouldn't even come out of the house or say hello to anybody. Then he ended up back with Evelyn.

Evelyn refused to allow Roky back on medication, preferring that he be left in "God's hands." Roky hung around Arthur Lane watching TV and videos of horror movies, often joined by celebrated fellow "outsider" singer/songwriter Daniel Johnston (who later commemorated their friendship with the song "I Met Roky Erickson").

Daniel Johnston: Yeah, I was working at McDonald's and a guy came in and he said I've worked with Roky Erickson, and I said, really? I'd love to meet Roky Erickson, so we went out, and he was so

cool. And everybody is really weird about Roky, like they're really delicate; they walk on tiptoes around him, you know... we'd rent out horror movie videos. There was the movie *Last House on the Left*, and it was pretty hardcore, I'd seen a little bit once, and I'd like left the drive-in theater because I felt it was going a little too far but I thought he might enjoy it since he was hardcore horror in his songs. And once it came to the end he rewound it three or four times, you know, to see them die. Roky went into the other room to work on some insects, he would like dissect them, you know, bring them back to life and stuff like that, his little experiments... I love his music, it's supernatural... and it's scary...

With no control over his catalogue, the floodgates were open for the next decade and a series of cash-in releases. While some were respectful the majority by small labels were badly released, poor-quality live shows and old recordings. Even his own mother was in on the act, licensing various lo-fi home recordings. Roky's last big show back at the Ritz on February 21, 1987, featured the Butthole Surfers and should have been a night to remember, but Roky didn't want to perform and it was back to the bad old days of asking him if he wanted to go by the store to pick up cigarettes and then bundling him through the back door and onto the stage. When the band struck up "You're Gonna Miss Me," Roky stood there looking dumbfounded. In August 1988, he moved into Federal Housing in Del Valle on the outskirts of Austin. John Ike and Ronnie decided to go and visit Roky to see if there was another chance of a reunion. He didn't perform again with a band for eighteen years.

John Ike: After the Houston reunion I hadn't seen Roky for a while, and I went over to his house. They said Roky's doing OK, but he was in pretty bad shape when we went over there. When I say bad shape, I mean he didn't want to do any music... that's bad shape. He was listening to all these TVs and radios that were all tuned to different stations. It was madness, I don't know how he could stand it, and we cut out, and had a bunch of radio sets and televisions going, and we could hardly talk, and it was hard to communicate there in the house. He didn't seem disturbed, but it was disturbing for me to be there... so we took off early...

By December, Roky was in trouble again. According to Tary Owens, "Roky was delusional. He's so mentally ill and his mother will not allow him to get any treatment. He was ostensibly collecting mail for his neighbors, but it was ending up tacked up on his wall. Finally one of the neighbors had enough of it and filed charges. That's a major federal offense. He was arrested and put in jail in San Marcos." He was found to be harmless and Tary, in his capacity as counselor, set up the first trust fund, which ensured Roky was taken out every week and looked after. Tary soon realized Evelyn wasn't prepared to allow any psychiatric or medical help. "He desperately needed dental work. His teeth were just rotting. The idea was to help get him some help. It just ran into a stonewall with his mother."

(SEPTEMBER 24, 1987) ROKY'S MUG SHOT FOR DRIVING ZERO MILES AN HOUR

The news of Roky's arrest spread like wildfire leading several bands, including ZZ Top, Doug Sahm, R.E.M., Julian Cope, Primal Scream, the Butthole Surfers and the Jesus and Mary Chain to record covers of his songs for a benefit CD entitled *Where the Pyramid Meets the Eye* (Roky's definition of psychedelic music). After being sent for evaluation in Missouri it was ruled he was unfit to stand trial and the charges would be dropped if Evelyn signed him into the Austin State Hospital. He was put back on Prolixin, which he immediately stopped taking following his discharge. Tary despaired and with his own health failing (a combination of diabetes, hepatitis C and Parkinson's disease), handed Roky's cause to Casey Monahan.

By the mid-1990s, when any release bearing Roky's name needed to be carefully scrutinized for rip-off value, there was suddenly a brand-new single followed by an album containing newly recorded material and a comprehensive book of Roky's lyrics published by Henry Rollins. Better still, the new material was excellent, the voice was clearly intact—this was pure Roky.

Casey Monahan: Tary Owens called me up and he says, "I'm getting real burnt out, can you help?" I say sure… So basically I replaced Tary. For his birthday show that year, we wanted only Roky's music. So everyone was asking for lyric sheets, so I went on the search for lyrics. So a couple of months later I'm still putting together lyrics, and I ask him, "Roky, [what if] we put this all together in one book and we publish it?" And he said, "That'll be real nice, Casey, *Openers II*."

Work on the book uncovered the true extent of Roky's songwriting, literally hundreds of undocumented songs Roky still owned the rights to and Roky agreed to record again, "as long as it was fun." Although

(1999) CHRISTMAS, ARTHUR LANE, ROKY OPENING PRESENTS DURING FILMING OF *YOU'RE GONNA MISS ME* DOCUMENTARY, PHOTO BY PAUL DRUMMOND

the album *All That May Do My Rhyme* lacked the harder, darker edge of Roky's earlier music, it was a credible comeback from a true survivor. However, Casey found himself being cut out for no good reason and was forced to back off.

> **Casey Monahan:** I thought, I'm not going to leave here without having a long chat with Evelyn. And I went over there and told her if she cared anything at all about her son she would get him on some medication and would stop trying to control his life... I thought everything she was doing was increasing his dependency on her. Dana said he was one prescription drug away from having his life back. Holly got Roky not only off speed and cocaine but also on Prolixin... happy... Holly will tell you, as Dana will, that any time someone is helping Roky be independent, Evelyn will fuck it up. She wants to maintain his dependence on her. She said during our last sit-down discussion that he needs to pray.

Indeed, by Christmas 1999 Roky was in a terrible state. Evelyn, the gatekeeper, had allowed Keven McAlester, a music journalist, to start making a documentary about Roky. The problem was that there was nothing to film other than to record Roky's awful condition. His hair was matted into one huge clump on the back of his head; Evelyn had clearly dyed it with the same color she used for her own hair. His skin was an

awful greyish color; his teeth had almost completely rotted out. His arms were scalded halfway up his arm, from his obsessive-compulsive disorder of washing his hands at every opportunity. His appearance was that of a homeless person, his clothes dishevelled. He repeatedly asked for his medication, to which Evelyn replied, "We'll go to the store tomorrow." (She used aspirin as placebos.) "No, mother, I mean my O-T-H-E-R MEDICATION. Next time you check me into one of those places, be sure to check me out!"

In 1996 Roky's landlord had slung him out of Del Valle and he moved to a subsidized housing project on Tahoe in South Austin. Outside the door, you could hear the cathartic symphony of an array of electronic gadgets, radios and TVs blaring away. The door opened to reveal a spectacular collection inside: mail tacked to the wall, dancing Frankenstein's monster toys and a huge Christmas tree which played Wham's "Last Christmas" on approach. Nothing could compete with the collective cacophony of sound, which Roky used to counter whatever was going on in his head.

Family and friends have differing opinions about the origin and true extent of Roky's mental illness. Brothers and longtime friends have witnessed Roky turn on and turn off his "symptoms" as an avoidance technique. Others recognize aspects of his eccentric and highly anxious personality as products of his neurotic upbringing. His monosyllabic behavior is reminiscent of his silent and emotionally unexpressive father, who would simply answer "positive" or "negative." There was also suggestion of a hereditary predisposition linked to his paternal grandfather, who supposedly regularly suffered from bouts of mental disorder. Equally Evelyn often gets blamed for his symptoms, genetic and emotional. Many blame drugs. Both Roky's approach to illegal drugs, that of a self-medicating kid with a chemistry set, and the intense medication he encountered at Rusk and various institutions, have had a profound and long-term affect upon him. Regardless of the root cause of Roky's problems, it's clear that Roky has chosen to suffer his mental difficulties rather than have his natural being subdued by a continued regimen of medication. Although it's difficult to make generalizations about the symptoms of mental illness, there are distinct categories of sufferers: those who experience intermittent bouts, those who encounter one big breakdown, and those who suffer from chronic and continued symptoms. Roky's difficulties appear to fall in the first category. However, as he grew older and band members and wives weren't there to pick him up during the difficult periods, he inevitably fell into Evelyn's care. By the mid-Nineties, he'd literally become phobic of everything and isolated himself completely. Instead of performing ("transmitting but not receiving") in public as he'd always done, he'd created an audience in private, an accumulative cacophony of television sets, radios and gadgets all switched on at the same time, forming a layer of white noise that would simply flatten whatever he was experiencing from his illness. As he said in 1994, "My house is a church." Here lies another problem—Roky is naturally quite lazy, and when unchallenged he is happy to isolate himself and watch cartoons all day.

Roky's youngest brother Sumner escaped much of the family madness by becoming a world-class tuba player with the Pittsburgh Sym-

phony. By 2000 he'd decided Evelyn's care was bordering on neglect and that it was time to act.

Sumner was forced to confront the same issue Tary and Casey had encountered: his mother. She wouldn't entertain any medication, refusing to believe in any advances in antipsychotic treatments, which Sumner had carefully researched. Zyprexa, a second-generation antipsychotic, appeared to be the answer. Even if Roky could be "cured," she wasn't prepared to allow it. She foresaw the same old cycle perpetuating, people wanting to profit from him performing again, and exposure to drugs.

While Evelyn stoically maintained her position, she ignored a potentially life-threatening abscess in Roky's mouth and Sumner was left no alternative but to fight to become Roky's legal guardian. He had modern science, she the power of prayer. It was going to be a tough battle that would lead straight back to Travis County Court 147. The film crew finally had something to document.

Roky was somewhat stunned when a fleet of police cars arrived at his house in mid-May 2001, but when Sumner explained what was happening he went willingly. The abscess in his mouth desperately needed treatment. He stayed at a private clinic in Shoal Creek for a number of weeks. Following the guardianship hearing on June 11, the judge found in Sumner's favor and Roky moved to Pittsburgh. Roky seemed happy during his thirteen-month stay and underwent weekly somatic treatment with Kay Miller to get his body physically working again and facilitate his mental recovery. Henry Rollins personally funded Roky's dentistry and soon Roky was smiling again without fear of exposing years of neglect. Given his history, his progress has been spectacular, incredible even. While Roky has maintained his incredible memory for songs, his ability to recall his own life has been marred by years of repressing his memory from which he is beginning to emerge. Although the details of the 1960s still remain elusive and Roky isn't an anecdotal storyteller, his memory and ability to recall names and places has improved immensely in the last few years. It seems that with his brother's support Roky is no longer looking for a mentor or someone to fulfill a parental role, and Sumner has allowed Roky's recovery to happen slowly and naturally. In July 2002, Roky found new accommodation in southern Austin. Evelyn seems to have acknowledged his improvement, and any family rift appears to be healing. Evelyn's life has improved immensely too; now in her eighties and amazingly agile, she's a testimony to the power of yoga. She's restored the family house back to its former glory and even built the extension designed by husband Roger in the Fifties. Meanwhile, Roky got his driver's license back, bought a car and new furniture and even went to vote for the first time in his life (Bush winning a second term was real horror). While these may be mundane functions of everyday life, this is Roky Erickson and this is possibly the first time Roky has been free to be his own person.

Roky has taken everything that has happened to him in his stride and his decision to pick up a guitar and play music again has been entirely his own, although everyone has waited in anticipation. Now it's on his terms, as a true veteran and rock 'n' roll survivor enjoying all the kudos he deserves. Sumner's confidence in his brother's return was proven when

Roky agreed to play one song, backed by the reformed Explosives, at his
annual Ice Cream Social benefit on March 19, 2005. He brought tears
to the eyes of a delighted audience as he blasted through three songs,
confirming that his voice and stage presence were still intact. No one
could believe it—Roky really *was* back. Afterwards, he sat beaming on
his Gibson tour bus, signing autographs, meeting and greeting his fans,
young and old alike.

At the annual South by Southwest Festival and Music Conference in
2005, Roky was reunited with Ronnie, John Ike and Powell St. John when
the 13th Floor Elevators were inducted into the Texas Hall of Fame. Benny
Thurman also made his first appearance in public for years when he joined
them on a special SXSW panel to discuss their history.

In May 2005 Powell St. John recorded versions of many of the songs
he'd given away, including four of his Elevators tunes (with Ronnie and
John Ike as the rhythm section), and Roky sang a duet of the "lost" song
"Right Track Now"—his first session in twelve years.

If this wasn't a timely ending for this book, then Roky's continued
recovery has been. His performance at the 2006 Austin Music Awards
dominated the event when he played a short set with the Explosives before
being joined by Powell St. John for a duet on "Right Track Now," and
they blasted through "You're Gonna Miss Me," with Powell's howling
harmonica adding that extra dimension. This was Powell's first perform-
ance in Austin for exactly forty years. The following day at the annual Ice
Cream Social, Peter Buck's Minus 5 performed and Powell performed a
set of Elevators material with Ronnie and John Ike. Although sadly Roky
didn't join them, it provided a chilling reminder of how powerful the
Elevators' sound was.

Today Texas is a state in love with itself. The Lone Star flag is ap-
plied to everything it can be adhered to. Although Austin has christened

(March 1, 2007) Roky briefly reunited with Tommy Hall, Great American Music Hall, San Francisco, photo by Scott Conn

itself the music capital of the world, the music scene is extremely local and self-congratulatory. The Texan musicians who took the sound beyond the state boundaries—Buddy Holly, Roy Orbison and Janis Joplin—don't appear to be the most applauded, nor is there much evidence of the Elevators' legacy. Similarly, the myth of the Elevators has perpetuated mainly outside the United States through endless foreign releases and interest through internet activity. However, his music has clawed its way into the broader American arena via its use in films (*Return of the Living Dead, Drugstore Cowboy, Boys Don't Cry* and *High Fidelity*) and even a recent national Dell Computers television advertisement.

Roky's condition continued to improve until he decided to stop medication on Christmas Day 2006. Sumner realized his dream of resigning guardianship in February 2007 and Roky achieved the near impossible when his rights were fully restored in court (only 5% of people achieve this). Sumner's satisfied that now all he has to do is maintain his "brotherly eye." Drugs are not an option, and he is very clear that he doesn't want his fans to glorify him for his previous drug use. Roky views them as merely a catalyst from the era. What happens next is up to Roky. He's begun writing again and everyone hopes he'll decide to record again. It's simply a case of when or if he fancies doing it. Under new management his return to the stage has been progressive, playing his first big show by headlining the Austin City Limits Festival in September 2005 and then his first out-of-state shows since 1982 in Chicago in June. He's been back on national television, performing on VH1's Halloween special in 2006.

After Roky's sell-out West Coast comeback show at the Great American Musical Hall in San Francisco on March 1, 2007 he was briefly reunited with Tommy for the first time since 1975.

Roky's started to take international bookings, in Canada at the Montreal Intonation Festival in October 2006, and then dates throughout Scandinavian in June 2007 before playing the Meltdown Festival in London, England. Roky has also rekindled his relationship with Dana, and finally has the sparkle back in his eyes.

As to the question of his mental difficulties returning, only time will tell, but his counselor and psychologist John Breeding is confident in Roky's continued good health without medication.

Sumner: I don't think of Roky as schizophrenic.

Roky: I never had schizophrenia.

John Breeding: There is no schizophrenia.

When the research for this book began, all of the former 13th Floor Elevators were fed up with the state of their back catalogue and tired of fielding silly questions about the band. Getting them to start wanting to talk again and remembering was a long, slow process. In some cases a thirty-year silence was broken. Some questioned whether a book should be written at all and there were jokes about the "jinx" or "curse" of the Elevators. However, the general consensus was that the band had been an incredible undertaking by all involved. A concern was whether a modern perspective would understand the mindset of the era without condemning them.

Maybe it's an eternal and unanswerable question, but why do human beings choose to alter their natural state of perception? The Elevators' mission had been a genuine, youthful challenge and desire to examine higher forms of reality. The relationship between art, madness, religious ecstasy and psychoactive substances is a complicated one. While increasingly entertainment has replaced religion as a sophisticated form of social control, there has always been an elite group of free thinkers who has striven to break this. Many artists and musicians have explored the use of drugs to give them a unique perspective, but it is rarely creatively productive. It can be argued that any form of creative impulse or religious ecstasy is a refined form of insanity or dehabitualization. Historically a repetitive form of prayer, mantra or dance is employed to reach this state. Alternatively, many ancient civilizations employed a psychoactive compound as a form of sacrament to disengage the mind and body. The extent to which different cultures value and benefit from recognizing these "states" varies and changes. Certainly "altered states of perception" are not currently considered normal or beneficial to modern Western society and today we are only legally allowed to indulge in the lowest forms of intoxicants and stimulants—the ones which severely effect our health.

Certainly modern society economically dictates that we have no time to dedicate to "ascending a pyramid of knowledge." We are required to look but never *see*. However, for a brief moment in the Sixties all this

changed, if only for a fleeting moment. Tommy embraced LSD as a form of functional neurosis at the crossroads of mass experimentation, but he seriously questioned whether it should have been released from Pandora's Box for public access. The chance of re-introducing a psychedelic sacrament into modern Western society seems absurd. Sadly, it seems that "Hitler's drugs" have prevailed in our current drug culture, which has opted for less challenging and thought-provoking substances, taken for purely onanistic and recreational use.

The Elevators' story encompassed all this territory, and for a rock'n'roll band that was extraordinary. To conclude the Elevators' story with a profound statement about them being victimized psychedelic pioneers castrated by a repressive society is pointless. To some this will be a cautionary tale. Their story is incredibly sad at times, but what prevails is the courage of their convictions. They took risks and experimented to a degree most people are too scared to consider, and the implications were life-changing. None of the band regret their past. The continued level of interest in their endeavors has proved their immortality, while the music still speaks volumes.

Maybe until a time of elitism for all, the 13th Floor Elevators will remain a vicarious dream, an escape from the mundane.

> **Roky:** What I was thinking was that the songs were kinda like prayers... if you said a prayer, you would have good luck. And I wanted to add that. Our songs could have been like prayers too.

56. Both *I Walked With a Zombie* and *Creature With the Atom Brain* were written by Curt Siodmak. Roky also mentions his 1942 novel (also a film in 1953) *Donovan's Brain* in the lyrics to "Creature With the Atom Brain." While these were clearly classic arthouse horror which Roky enjoyed as a kid, there are deeper threads. On several occasions Roky likened various hospitals as "*Jane Eyre*–type places." *I Walked With a Zombie* was loosely based on the plot of *Jane Eyre*. Jacques Tourneur, the director of *Night of the Demon* and *I Walked with a Zombie,* was also one of Roky's heroes.

57. Cold Sun was one of several bands, including the 1973 Elevators, Johnny Winter and Mariani that Bill Josey recorded in the early Seventies with the hope of signing them to Columbia Records. John Ike had considered joining Cold Sun after the Spades' old drummer, John Kearney, had left. Instead he introduced them to Josey to demo. The subsequent Sonobeat recordings remained unreleased until the 1989 issue on Rockadelic Records. Johnny Winter did eventually sign to Columbia, and made several albums throughout the Seventies.

58. Benny is featured on fiddle with Plum Nelly on two cuts: "Will the Circle Be Unbroken" and "There's Nothing I Can Do" on the 10-CD set *Kerrville Folk Festival 1972–1981* (1998, Silverwolf Records).

DISCOGRAPHY

ROKY ERICKSON & THE SPADES

45 rpm: "You're Gonna Miss Me" c/w "We
Sell Soul" (Emil Schwartze =
Roky Erickson)
Zero Recording Co # C10002A/B, 24/25th
Nov 1965, TX

13TH FLOOR ELEVATORS: 1960S RELEASES

*Over 60 titles, spread over 130 different
formats have been released posthumously.
Check rokyerickson.net for full detailed
discography.*

1) 45 rpm: "You're Gonna Miss Me"
(Erickson) c/w "Tried to Hide" (Hall/
Sutherland)
(13 different U.S. pressing variations
exist for this single; see official website)
Texas: Contact Records #5269, Jan
1966
International Artists #107 (two-tone
blue labels) circa May/Jun 1966
California: Hanna-Barbera #492,
International Artists #107 (yellow &
green label, later solid blue), July 1966
Canada: IA#107X (Quality Records),
later IA#107 (London Records), Sept 1966
Germany: Hansa Records #19 188 AT:
in artwork title sleeve, 1975

2) 45 rpm: "Reverbaration [sic] (Doubt)"
(Hall/Sutherland/Erickson) c/w "Fire
Engine" (Hall/Sutherland/Erickson)
International Artists #111, Oct 28, 1966

3) LP: *Psychedelic Sounds of the 13th Floor
Elevators*
International Artists LP #1, Nov 1966

4) Extended Play 45 rpm: *The Thir-
teenth Floor Elevators*
Riviera No. 231240, circa Jan
1967 France, title cover with generic photo

5) 45 rpm: "(I've Got) Levitation" (Hall/
Sutherland) c/w "Before You Accuse
Me" (E. McDaniel)
International Artists #113, Feb 7, 1967

6) LP: *Easter Everywhere*
International Artists LP #5, Oct 25, 1967

7) 45 rpm: "She Lives (In a Time of Her
Own)" (Hall/Erickson) c/w "Baby
Blue" (Dylan)
International Artists #121, Nov 1967

8) 45 rpm: "Slip Inside This House" (Hall/
Erickson) c/w "Splash 1"
(C. Hall/Erickson)
International Artists #122, Jan 1968

9) 8-Track Cartridge: *Psychedelic
Sounds of...*
IA8S-1, Apr 1968

10) 8-Track Cartridge: *Easter Everywhere*
IA8S-5, Apr 1968

11) 45 rpm: "May the Circle Remain Unbro-
ken" (Erickson) c/w "I'm Gonna
Love You Too" (Maudlin/Petty/Sullivan),
International Artists #126 circa June 1968

12) LP: *Live*
International Artists LP #8, Aug 1968

13) 45 rpm: "Livin' On" (Hall/Sutherland) c/
w "Scarlet and Gold" (Sutherland)
International Artists #130, circa Feb 1969

14) LP: *Bull of the Woods*
International Artists LP #9, circa Mar 1969

15) 8-Track Cartridge: *Psychedelic Sounds
of...*
ITTC 62-1, July 1969

16) 8-Track Cartridge: *Easter Everywhere*
ITTC 62-5, July 1969

17) 8-Track Cartridge: *Live*
ITTC 62, July 1969

18) 8-Track Cartridge: *Bull of the Woods*
ITTC 62-9, July 1969

19) 45 rpm: "You're Gonna Miss Me" (Erickson) c/w "Tried to Hide" (Hall/Sutherland)
International Artists #107, Apr 1970

ROKY ERICKSON SOLO DISCOGRAPHY

Only records recorded and released by Roky Erickson are listed below.
For full discography including 50+ titles of archive recordings, bootlegs etc., refer to the official site
rokyerickson.net

1) 45 rpm: "Red Temple Prayer (Two Headed Dog)" c/w "Starry Eyes"
(Erickson)
R. Erickson & Bleib Alien
Mars Records No. 1000, 1975 U.S.

2) 7" EP: The Sponge EP
Sponge SPEP-101, 1977 France, in white/purple sleeve (later green) and lyrics insert

3) 45 rpm: "Bermuda" c/w "The Interpreter" (Erickson)
Roky Erickson & The Aliens
Rhino 003, 1977 U.S., in picture sleeve & lyric insert
Virgin VS180, 1977 UK, in picture sleeve, no lyric insert

4) 45 rpm: "Creature with the Atom Brain" c/w "The Wind & More"
(Erickson)
Roky Erickson & The Aliens
S CBS 8888, 1980 UK

5) 45 rpm: "Mine, Mine, Mind" c/w "Bloody Hammer" (Erickson)
Roky Erickson & The Aliens
S CBS 9055 1980 UK, in color picture sleeve

6) LP: *TEO* (The-Evil-One, title given as five symbols on front cover)
CBS 84463, 1980 UK / Holland
AS "I Think of Demons" Edsel LP ED222, 1987 UK

7) LP: *The Evil One* (differs from CBS LP)
Roky Erickson & The Aliens
415 Records A005, 1981 U.S.

8) 45 rpm: "Don't Slander Me" c/w "Starry Eyes" (Erickson)
Dynamic DY002, 1984 U.S.

9) 12-inch single: "The Beast" (Erickson) / "Heroin" (Reed)
Roky Erickson & Evil Hook Wildlife (ET)
Live Wire LW-5, 1985 U.S.
One Big Guitar OBG 004, 1985 UK

10) 12" EP: *Clear Night For Love* EP
New Rose 69, 1985 France

11) LP/CD/Cassette: *Don't Slander Me*
Pink Dust 72108, 1986 U.S.
Demon FIEND86, 1987 UK
Restless 73792, 2005 U.S.
The eventual release of the canned CBS second album *Burn the Flames*

12) 12" single: "You Don't Love Me Yet" c/w "Clear Night For Love"
Roky & Evil Hook Wildlife (ET)
Fundamental PRAY7, 1987 U.S.

13) 45 rpm: "We Are Never Talking" c/w "Please Judge"
Trance Syndicate TR28, 1994 U.S.

14) LP/CD: *All That May Do My Rhyme*
Trance Syndicate TR33, 1994 U.S.

INDEX

AUTHOR ACKNOWLEDGEMENTS

Thanks to:

The 13th Floor Elevators:
Roky Erickson, Tommy Hall, Benny Thurman, Ronnie Leatherman,
John Ike Walton, Danny Galindo, Danny Thomas, Duke Davis,
Stacy Sutherland

Their Supporters, Colleagues, Family, Friends:
Walt Andrus, Billy Angel (Miller), Pam Bailey, George Banks,
John David Bartlett, Gordon Bynum, Stephanie Chernikowski,
Donnie Erickson, Evelyn Erickson, Jegar Erickson, Mikel Erickson,
Roger Erickson, Sumner Erickson, Greg Forest, Jim Franklin,
Dana Morris, Robert Galindo, Johnny Gathings, Clementine Hall,
Dale Hawkins, Billy Hallmark, James Harrell, Chet Helms, Liz Henry,
Lynn Howell, Fred Hyde, Jack Jackson, Gay Jones, Daniel Johnston,
Bill Josey, Jr., John Kearney, George Kinney, Phil Krumm,
Jim Langdon, Andrew Lauder, Diane Lazelle, Amy Leatherman,
John Lewallen, Colleen and Jerry Lightfoot, Sandy Lockett,
Johnny McAshan, Terry Moore, Tary Owens, Charlie Prichard,
Bobby Rector, Lelan Rogers, Rayward Powell St. John, Bob Simmons,
Speedy Sparks, Bob Sullivan, Beau Sutherland, Heather Sutherland,
G.C. and Sibyl Sutherland, Paul Tennison, Mayo Thompson,
Steve Tolin, Russell Wheelock, Houston White

Their Detractors:
Harvey Gann (Head of Vice Squad)
Burt Gerding (Head of Surveillance)

Research Enormously Aided By:
Joe Kahn, Sumner Erickson, Andrew Brown, Max Fredrikson,
Patrick Lundborg, Keven McAlester, Chris Meerbot, Doug Hanners,
Dennis Hickey, Bill Allerton, Peter Buesnel

Thanks to all the photographers that granted permission for their work
to be used:
Walt Andrus, Stephanie Chernikowski, Guy Clark, David Craig,
George Craig, Evelyn Erickson, Joseph Kahn, Jerry Lightfoot, Betty
Shumate, Bob Simmons, Bob Snider, Russell Wheelock, the Sutherland
Family. All other photos or posters and ephemera from the
Paul Drummond collection unless credited otherwise.

Extra Thanks To:
Heidi Berry, Scott Conn, Julian Cope, Stephen Curran, Tim Drummond,
Louise Edge, Bobby Gillespie, Lucy Nicholas, Michelle Pillay,
Jason Pierce and Megan Slyfield.

All interviews were specially conducted for this book between March
1999 and November 2006 unless noted below. Within the book, the
interviews conducted by the people below are noted by the use of the
parenthetical letters.

(AB) Andrew Brown
(AC) *Austin Chronicle* 2004
(AV) Alan Vorda
(K) Joseph Kahn Interviews: Roky 1973, Tommy Hall 1975,
Ronnie Leatherman 1973, John McClellan 1973, Stacy Sutherland 1973
and 1974, John Ike Walton 1973, Emma Walton 1973.
(KUT) L. Munroe KUT-FM, Austin, July 7, 1985
(*Air Guitar*) D. Hickey, published 1997 by Art Issues Press
(M) *Mother* magazine 1967
(MF) M. Fredrikson
(NFA) *Not Fade Away* magazine 1975: D. Hanners, K. McDaniel,
J. Patoski
(RNR) *It's Only Rock 'n' Roll*: December 1979 C. Kimsey
(RU) Chapter 12 1/2 R. Unterberger
(SP) Savage Pencil 1980
(77) Stacy Sutherland and Danny Thomas 1977, unknown
university students
(T) Townes Van Zandt